FERENCE ARE PICTURED HERE?

NEXT SUNDAY'S "PRESS."

JOHN SLOAN'S
NEW YORK SCENE

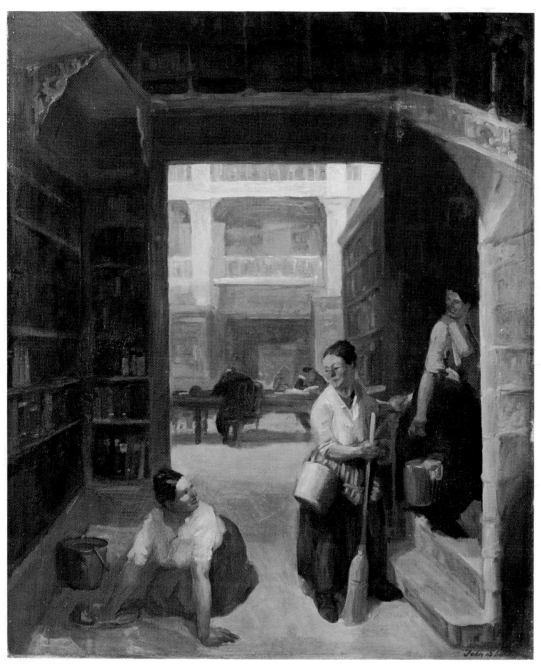

"Scrubwomen in the Old Astor Library," 1910

JOHN SLOAN'S
NEW YORK SCENE

from the diaries, notes and correspondence 1906–1913

EDITED BY BRUCE ST. JOHN / WITH AN
INTRODUCTION BY HELEN FARR SLOAN
illustrated with paintings, drawings and photographs
HARPER & ROW, PUBLISHERS / NEW YORK

CONTENTS

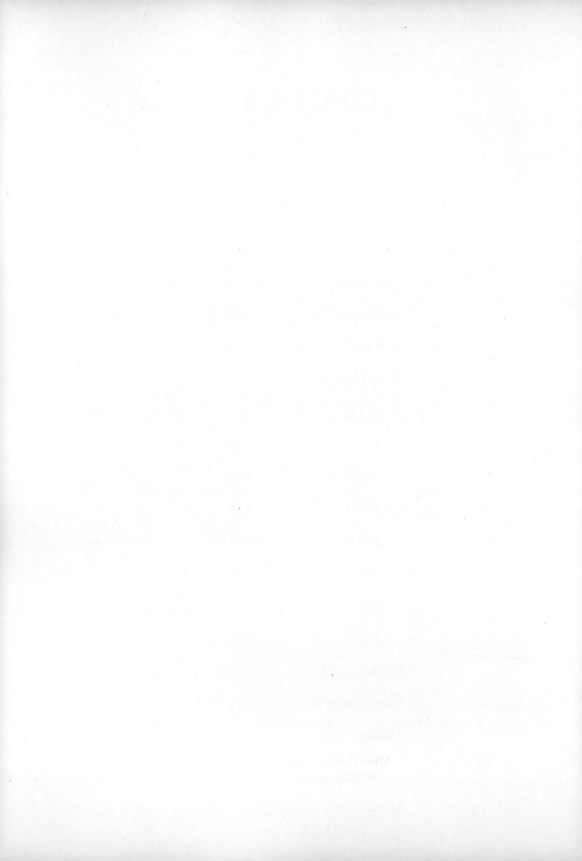

ILLUSTRATIONS

vii

viii

Photographs following page 50:

FOREWORD

Although I was never privileged to know John Sloan personally I feel as if I knew him well, since I have spent many hours with his library, studying his notes and comments and his diaries. My studies have given me the feelings of respect and admiration for him that were shared by his friends and students. I know, too, that he was a direct and honest man, not afraid of expressing his opinions. In his day, when a newspaper wanted a thought- or argument-provoking comment on the art world, it knew it could get a good one from John Sloan.

Helen Farr Sloan, the artist's widow, turned over to the Delaware Art Center, about two years ago, the Sloan Collection, and since I began the work of editing the Sloan diaries she has been a constant source of help. I have been much impressed by and grateful for her sense of responsibility toward this important record of the life of a foremost American artist. Mrs. Sloan has spent many years preserving, gathering, and organizing the Sloan papers, so that a documented memoir, not only of John Sloan but of the other artists he was associated with, especially the men known as "The Eight," could be made available to the public. For this wisdom and foresight we owe her a debt of gratitude.

At the time these diaries begin, Sloan was thirty-four years old. He had never sold a painting, and, although he was known as an illustrator and had done the excellent series of fifty-three etchings for the illustrations of the novels of Charles Paul de Kock, as well as free-lance illustrations for many magazines, he had to work very hard to eke out a respectable existence. The puzzles that he did for the Philadelphia *Press* were his only steady source of income. Finally, in 1913, when he was forty-two, Sloan sold his first painting, *Nude and Green Scarf*, to Dr. Albert C. Barnes. But by the time he was fifty he had sold only six paintings.

The diaries are in large part the record of John Sloan's life as an artist, and they include the record of his professional struggle. But they tell us,

xi

too, of his daily routine, apart from his work, and of the city in which he was living and painting. They reveal Sloan as a very human being, with the likes and dislikes, changes in attitude toward things and people, mistakes and apologies for mistakes, that exist in all human beings. Nothing of importance in the picture of the man and his times has been edited out.

The brevity of the diaries in the years 1912 and 1913 may be explained by Sloan's increased activity in his own work during this period.

BRUCE ST. JOHN

INTRODUCTION

John French Sloan was born in the small lumber town of Lock Haven, Pennsylvania, ten years after the start of the Civil War. His father's Scotch-Presbyterian ancestors had come to America at the beginning of the eighteenth century. They were cabinetmakers by trade. The name Sloan is of ancient Celtic origin, Scottish or Irish. During the Revolutionary War period, two Sloan brothers married sisters of Captain John French. While he had been christened John French in memory of this Revolutionary ancestor (it was a name to be proud of, going back to the days of Robert Bruce), Sloan preferred to mention his Irish forebears when using humor to make serious points on the lecture platform. He felt that the talent for drawing was inherited from his father's family, but he dropped his middle name, considering it "a romantic encumbrance," when he started to paint seriously.

The American *avant-garde* of the nineties was led by Whistler, who made much of the "art for art's sake" philosophy. It was fashionable for art students to study in Paris, even if they did not become expatriates like Whistler and Sargent. But Sloan made the independent decision to stay in America, keeping his roots in this democratic country where he found the motives for painting pictures of the places and people he cared for. He never went abroad, although his mother's family offered him opportunities to seek artistic and financial success.

On the maternal side, Sloan was of English background. His great-grandfather Samuel Priestley (a cousin of Joseph Priestley) settled in Smyrna, Delaware, in 1816. He had been trained in the family business, paper manufacturing, before he left Leeds. Before coming to America, he had lived in Belfast for a few years where he married into a family named Ireland, also in the paper business. The Irelands were strong Church of England people, very sensitive and proud. Sloan once said, "My mother's family rather looked down on the Sloans because they

xiii

were Presbyterians and because their business was being endangered by the competition with factory-manufactured furniture. My Grandfather Sloan's business began to feel this pressure after the Civil War, so my father had to give up his hopes of going to college."

The Irelands got John Dixon Sloan a job as a traveling salesman for the Marcus Ward Company (social stationery, greeting cards, books), of which Sloan's uncle was the American representative. The Sloan family moved to Philadelphia to live on Camac Street after spending a year with Grandmother Ireland in Germantown.

Sloan speaks of one of his fondest and most important memories of those years: "I used to spend happy hours visiting my great-uncle Alexander Priestley, considered a failure because he drank sherry and did not make money. He had a wonderful library, and a print collection with elephant folios of Hogarth, Rowlandson and Cruikshank. . . .

"After years of struggle, with low income, as a traveling salesman, my father finally had what we would call today a nervous breakdown. My mother's family then set him up with a little stationery store, but he couldn't keep track of his debtors, and was always letting the neighbors have too much credit. There was a general business depression in 1886 and the business finally failed. The family decided that I would have to leave school to help support them. I don't think I ever felt bitter about giving up a college education. It was a real blow, but not completely unexpected. For some strange reason, I had hoped that I might become a dentist. I might have been a doctor, lawyer or preacher. My uncle, the Reverend H. Hastings Weld, had rather hoped I might become a clergyman. He was a wonderful friend to me and I used to like to visit his library. He died in 1888, a great loss to me just at the time when I had to take over as head of our family. Dr. Henry Batterson, our rector at the Church of the Annunciation, was a great help to me when this change in my life occurred. I cannot bear to remember the expression of defeat on my father's face, when he told me that I must leave school at the age of sixteen. . . ."

These recollections of Sloan's youth, which reveal so much about his character, I drew from him bit by bit and wrote down. One of the pertinent comments is the plain statement, "We were poor, but not underprivileged. My sisters and I always knew that we had the confidence and affection of our parents. They were not demonstrative but they loved us."

John Sloan had a "home library" from the age of five. Every Saturday was spent at the public library and he had read all of Dickens and Shakespeare before he reached the age of twelve. When he was thirteen, to help the meager family budget, he started to work in the summers. "I

had a job in the railroad yards, checking and sealing freight cars. I was happy in school but didn't work too hard for marks. My first semester in high school, William Glackens and Albert Barnes were my classmates. In high school I read more than ever, of course. Glack went on ahead of me, remaining friendly with Barnes because they both liked baseball. I was never much interested in competitive sports. I preferred to stick around with my chum, Will Carver, making drawings for our 'book of inventions' and building things. It was a happy, carefree youth. I don't regret anything about it."

Looking back on the years when he worked six days a week to help support his family, Sloan said that he enjoyed the associations with men who dealt with books and prints. He spoke of his life as a newspaper artist (from 1892 to 1903) as "my college years." "I liked my work as an illustrator for the *Sunday Supplement,* and I liked the fact that the long hours kept me away from the problems of going around with girls. I didn't have any ambition to be an important artist, but I didn't want to get tied down with a wife who would prevent me from doing my own work."

When Sloan was twenty-seven years old, he met Dolly (Anna Marie Wall–spelled Walls by some members of the family), a dynamic and charming little Irishwoman who was working in the auditing department of Lit's store in Philadelphia. After an engagement of three years, he was finally free of the responsibility of supporting his family. John and Dolly were married in 1901. When they moved to New York in 1904 Sloan was thirty-two years old, and for the first time since he had started to paint seriously (about 1896), under Robert Henri's inspiration, he was now free to spend time on his own work. Dolly was confident that his work as an artist was to be important. Her trust in Robert Henri's judgment and her love for Sloan sustained her through all kinds of hardships. There were to be long years of financial worry and illness borne with deep loyalty to each other.

Dolly was really Irish and her parents were Roman Catholics from the old country. She had the milk-white skin, blue eyes, soft voice and the tenderness and temper of her racial stock. She and her two sisters lost their father and mother when they were very little and were raised by an older half-brother and his English Quaker wife. This "aunt" was a second mother to Dolly, but the brother was high-tempered. His daughters told me, years after Sloan died, that their father had never been able to understand Dolly. She had a tendency to drink, and started to drink when she was fifteen years old, which led to bitter misunderstanding with her family. By the time Sloan met her, Dolly was estranged from the Church. Very fortunately, she had come under the care of an excellent physician,

Dr. Collier Bower, who recognized that she had a neurosis "too deep-seated to be cured," he told Sloan, and advised him to think of Dolly as his "game leg."

It was Dr. Bower who recommended that Sloan keep this diary as a safety valve for his melancholy and periods of worry–a prescription similar to that of the doctor who treated Robert Burton, author of *The Anatomy of Melancholy*. The second purpose for Sloan's diary was to please Dolly, to give her confidence in the place she filled as his wife. "When we first moved to New York, Dolly was very lonely, always going back to Philadelphia to see her old friends. I would be frantic with worry when she was out of my sight. Here in New York she felt ill at ease with the wives of my artist friends. She felt they were more intelligent and had more education than she did. I tried very hard to write things that would make her happy when she read through the pages of this journal. It was really made for her, to show her importance in my life."

Toward the end of his marriage to Dolly, they lived out West. Santa Fe was a convenient place for Sloan to go in summer because, during prohibition, it was necessary for them to live someplace where Dolly's drinking problems would not cause so much embarrassment. Out there, people understood such problems. Sloan built their house six miles out in the country so that Dolly would be away from the temptations that existed for her when they lived in the Garcia Street house in town. He always hoped that she might get better as she grew older. And the last few years of her life, when he had so much illness, constant attacks of jaundice and terrible pain, Dolly was having heart trouble too. The last two years she was much better. She seemed to be at peace with the world, feeling that they would both go together. Sloan said, "I was proud that she rated three-quarters of a column in the *New York Times* when she died." In Sloan's journal, May 4, 1927–"Dolly died today." She passed away quietly, of a coronary, while nursing him through an attack of jaundice. He was too sick to attend the service, where Max Eastman spoke words of heartfelt appreciation, but after seeing Dolly lying in her coffin Sloan wrote–"She looked noble."

The first time I heard John Sloan teach at the Art Students League in 1927 is still as clear in my memory as though it had happened yesterday. It was by accident that I was in his class; the registrar had recommended him as a substitute for another teacher, who was on leave of absence. The studio was a large room with two models, one holding a week's pose for the painters and the other taking short poses. Many of the students had worked with Sloan before and they were all earnestly preparing for the first day of criticism. The classroom was completely silent, each student absorbed in the problem of creating a picture of the model on the posing stand, when we were suddenly drawn together as a group by the realization that

xvi

someone else was present in the room. A wiry man of middle height stood quietly in the door. He had a large head (someone once remarked that he looked like Jefferson), tanned by the sun and framed with a mass of carefully combed iron-gray hair. As he leaned his walking stick in the corner I noticed that his hands were those of a craftsman. He was neatly dressed in a tweed business suit. His first words were addressed to the monitor. "Why didn't you notice that the model is standing in a draft?" And then he began to lecture to the whole class.

After the first few sentences were spoken I was busy taking notes all around the margin of my timid pencil drawing of Susie, the famous old League model who had once been a slender beauty in musical comedies. She was by now rather monumental, which made things easier for the beginner who knew very little anatomy. I was so absorbed in note taking that I didn't realize the teacher had been walking around the room and was now approaching my chair. He was saying things that reminded me of Whitman and Dickens, Thoreau, Shakespeare—and I felt at home with these minds studied so recently in high school. "I don't usually like students to write down what I say because it gets garbled. You have to read between the lines to get the real meaning because I am apt to use a humorous turn of phrase just when I am most serious." But I kept the notes, and I went on noting what he said, and thus I began the work that eventually was published as *Gist of Art*.

Nine months after Dolly died, Sloan had made a remarkable recovery from an emergency operation to remove adhesions of the gall duct. It seemed as though he had a new lease on life, and he started to write me from Santa Fe that he was not very happy living with a servant house-keeper. I was teaching school in New York, so after consulting a doctor, and a friend who had made a happy marriage with a man many years her senior, I took a leave of absence during the mid-year examination period to make a trip to Santa Fe. Nineteen forty-four was leap year, when a lady is permitted to make a proposal of marriage. After five days, the morning of my return to New York, Sloan phoned me at the friend's house where I was staying—just as I was sitting down reluctantly to eat a large Spanish omelet. "Helen, I saw a great light last night. I would be a fool not to marry you. I want you to go back East as Mrs. John Sloan." Mrs. Eckert was so excited when she heard this news and the story of my love for Sloan, which was a surprise to her, that she ate my omelet as well as her own. Then she loaned me her gold cross to wear during the ceremony and gave us her blessing.

That night I was a wartime bride. Sloan drove me through the snow-covered desert country to the little station at Lamy, N.M., where we waited five hours for the California Limited. Finally a blacked-out troop train

arrived and the kindly conductor found a seat for me in the observation car. It was full of Navajo Indians who were being trained as bombardiers.

I came back to New York alone, for at school we were short-handed and I had the job of repossessing Sloan's living quarters in the Hotel Chelsea, which had been sublet when he went to Santa Fe after Dolly died. It was a dismal rainy night when I went down to the Chelsea after a hard day's work, to start negotiations with the landlord and to go up in the studio to find some business papers Sloan needed for his income tax. "I want you to go through the desk to become acquainted with my affairs, now that you are my wife." The desk was hemmed in by all the other furniture brought up from the downstairs apartment. Everything was under a pall of New York soot. Dolly's evening clothes were piled on a couch. Racks of pictures lined every wall. Memories and worries surrounded me. And that is when and where these diaries of 1906–1913 (which Sloan had never reread) were discovered.

After the first introduction to my new position as John Sloan's wife– the visit to the Chelsea studio and exploration of the desk to become familiar with the business papers–my next assignment was to meet his sister, Marianna. Sloan warned me that she was a "character." Not knowing quite what to expect, I made the trip to Germantown. I had the impression that my new sister-in-law had a keen intelligence, and she seemed to have her brother's tough, nervous vitality, although I noticed she was slightly hunchbacked. She looked me in the eye with a penetrating expression. Apparently coming to the decision that my background was of good stock, these sharp eyes silently asked whether I really cared for her brother. Finally, she spoke. "You are a lady." It was right for her to wonder what kind of person had become responsible for the care of the brother she adored, but I knew that she had been cruel to Dolly Sloan because she was not quite a lady and because she was an alcoholic. And Dolly had been a good wife to John Sloan for forty-two years; tender and generous, her only faults had come from feelings of inferiority and the fight to control a tendency to drink. It was going to be very hard to take her place.

In the winter of 1944, we were getting settled in the studio apartment in the old Hotel Chelsea on West Twenty-third Street, a block away from 165 West Twenty-third Street, where Sloan was living in 1906 when he started the diary. It was only a few weeks since our marriage and I was still teaching full time. In the evening after a day's work in the studio, Sloan liked to walk up and down the apartment listening to the radio to rest his eyes. Now and then he would come to chat with me in the kitchen while I was doing the dishes or ironing his shirts. It was at such times that he talked about the past, so that I would have more understanding

xviii

of things. I remember something he had told me about old Mr. Yeats. "He used to say about friendship that when you meet a new person you should make his acquaintance very carefully–as though you were holding an oyster in your hand and were opening it up, little by little, very patiently, very gently." While Sloan knew perfectly well that I was "digging into his past," and was pleased that I was interested in taking care of his papers, I had to be careful not to do it too much or too obviously. Sometimes I kept notes on scraps of paper that I then tucked into *Joy of Cooking*, bon mots overheard while serving guests, my kitchen diary. When research scholars came to interview him I could take verbatim notes, but one can't take notes when a man is talking from the bottom of his heart. The memories transferred leave an indelible impression.

We went on long rambling walks through the city–in the daytime and at night, to all kinds of neighborhoods–and each time we went to visit friends, either here or in the country, Sloan talked when he felt like it. These memories he gave me are different from the material for notes which were written down immediately; of these there were hundreds of typed pages, which I transcribed verbatim from remarks made at interviews, lectures, etc., in the chronological order in which they were taken. What I am drawing up from recollection now is almost a book of visual and verbal "impressions" which Sloan deliberately and skillfully placed in my hands. He did this in such a way that it would not disturb his creative working moods, and in a very thoughtful desire not to overburden my creative painting with his own personality. This had always been one of the special characteristics of his teaching, that he did not dominate his pupils and used a very light touch with those he hoped would have the initiative to do original work.

As his wife, an artist myself, I had a very special responsibility to John Sloan–to free him to do whatever work he chose during these years. There were plenty of friendly critics who hoped that I would influence him to paint the city again. As we walked down Twenty-third Street to Madison Square Park for the first time, passing the building still at 165 West Twenty-third where he had lived in 1906, of course this thought was in my mind! When we strolled down Fifth Avenue and looked up at the Flatiron Building, and saw the wind brush the skirts of shopgirls flying across the street on the way home from work, of course he talked about seeing "new pictures." But he could not see very well, because for twenty years he had been suffering from double vision. Whenever he wanted to take in the impression of a whole scene, or study the features of a portrait model, Sloan had to close one eye or simply ignore the weaker image. His double vision was not merely on a parallel plane, but also doubled on the diagonal. Because he was working more and more for "plastic realization

and significant form," he hated to give up the sense of stereoscopic vision which would be the result of working with only one eye.

In 1945, an operation was performed which gave eighty percent improvement in his vision. Sloan was thrilled to be able to exercise his eyes and bring the focus together again. "I can see one moon for the first time in twenty years, and still keep the sense of seeing the mysterious clusters of stars hanging in space!"

Sometimes we walked through the old Chelsea neighborhood, and sometimes we explored the lower East Side. One day we were watching the sad outdoor life of derelict men who live on the Bowery. Sloan said, "It makes me heartsick to see them. . . . I painted one picture of the Bowery, a rainy night with beautiful subtle color in the sky. You hardly realize that there is this old man walking down the street under the elevated. . . . I have never liked to show human beings when they are not themselves. I think it is an insult to their human dignity. . . . One of the things I so dislike about most socially conscious pictures, is that the artist is looking down on people"

When Sloan was actively interested in socialism, back in 1909 until the First World War broke out in 1914, he was often *pressed* by doctrinaire-minded party members to put political propaganda into his work. Again and again, he told them that he would not put that kind of social consciousness into his work. When he saw a picture, it was of a place or neighborhood he had studied for a long time. And then he waited for some human incident to give him the idea or final concept for a picture. All his years of work as an illustrator made it possible for him to take this kind of visual experience, to re-form it in his memory, finding the composition that would tell what he wanted to say.

He said, "I never brought models into the studio to pose for figures in any of my 'city pictures.' They were all painted from memory. . . ."

Sloan picked up this theme from time to time, in various ways. "It bothers me that scholars writing about the period from 1890 to 1920 assume that I was influenced in my thinking and working habits by Stephen Crane or Theodore Dreiser. I never liked their idea about the artist needing to have experiences in order to understand or to gather subject matter from life.

". . . I have never gone slumming to get subject matter. I was in McSorley's ale house about ten times in my life and painted five pictures of the place. It is like an old English pub, only ale is served, and only to a man who can stand up at the bar talking in a quiet tone of voice–the place closes at midnight, and no woman has ever been allowed in it. . . . It makes me furious when I hear that my name is associated with the painting of bar room brawls. I like to drink socially, and never alone."

xx

When his father's business failed, Sloan, to support the family, got a job in a book store. He read all the latest translations of Balzac, Zola, Hugo, and in the print room he also began to make pen-and-ink copies from Rembrandt etchings which sold for five dollars each. Using his hobby for drawing and composing light verse, he began to make humorous greeting cards, which also brought in some extra money. It was in this way that he drifted into using an interest in drawing to earn his living. A. Edward Newton, who was to become the famous bibliophile, worked in the print room at Porter and Coates. When he left to start a fancy goods business he asked Sloan to work for him as a designer of novelties and calendars. Sloan joined a night class at the Spring Garden Institute to gain some skill in freehand drawing.

While Sloan was reticent when questioned about his consciousness of being a special person, he had saved the documentary evidence of a career that had a place in history. And now I was becoming the custodian of Sloan's life story, as I studied all the manuscripts, correspondence, clippings and periodicals which he had preserved.

Van Wyck Brooks, who I'd hoped someday would write Sloan's biography, had encouraged me in the work of taking verbatim notes of Sloan's teaching, so I had had experience in this work when I began to collect biographical materials after I became Sloan's second wife. Sloan constantly supervised the transcription of these notes from longhand as I typed them out. In addition there were the journals which we both kept during the years from 1944 to 1951. Information from these sources (and some historical research) has been added to the complete text of the diaries to make the whole more understandable for the contemporary reader. All of this material would make several volumes. It is from this great quantity of original material that Bruce St. John has done the formal editing of the diaries. He is in no way responsible for any of Sloan's opinions. I don't agree with all of them either. Where Sloan had an afterthought which has an important bearing on things that happened long ago, this change in judgment has been noted wherever possible in his own words.

Like many men of strong moral feelings, he was sometimes gullible in his judgment of people and he sometimes put enthusiasm for good causes ahead of prudence. But he was also straightforward about admitting that he had been mistaken in such cases.

Sloan said that Dolly had planned to do his biography but had never been able to settle down to it. Now and then she had apparently started to sort a few letters and stapled them together, but the work had never progressed beyond this. Unfortunately, she had never added any notes of explanation. So there was this wealth of material which I was becoming superficially acquainted with, collecting notes when Sloan talked to me

or was being interviewed by scholars who now came for background material on the period from 1890 to 1920. The idea of working with someone on a definitive biography really upset Sloan. It was only natural that he wanted to spend his working energy in the studio, and this talk about his history reminded us that he was living on borrowed time. He had had many years of illness in the last twenty years before Dolly died in 1943. Now he was enjoying excellent health, working on his feet eight hours a day, but as he approached his eightieth birthday he would often say that he was an old man in a hurry. "I feel that I must continue digging into this problem of drawing, the separation of form and color–the concept of the thing in its integrity, the realization of plastic existence. These problems which the artists of the early Renaissance solved with such dignity, before the decadence of the eyesight painting made artists lose their innocent idea of truth. . . . Later on, I hope that young artists will find something worthwhile in this late work; not to imitate the way I have done it, but to understand the mental technique. What I am thinking about is not new, it is in the tradition of the great art of the past."

It required a good deal of tact to ask Sloan to spend hours with me going over photographs with no names, sorting batches of letters and clippings which I had found tucked in the dozens of places where things are put away in the course of moving.

I knew that this was the kind of material that Van Wyck Brooks would enjoy working with. I could not resist whetting his appetite.

It was from these materials and diaries Sloan had kept that Van Wyck Brooks wrote *John Sloan, A Painter's Life*, in which our old friend has drawn a fine picture of Sloan's personality and historical background.

In the last years of his life, after a lifetime of criticizing the Catholic Church for being slow to work for social justice, he began to question himself. Observing that "the Catholic Church is the largest spiritual institution in the world that could combat Communism," he added, "It is the only church I could join because it has an open door for everybody, and for the beauty of the ritual." I became a convert soon after Sloan died.

In editing the diaries, I have felt that Sloan's ideas with all their fluctuations should be preserved in this record of a man of good will. It has not been easy going through all the papers, deciding what must be omitted because of space and what should be annotated. Much work has gone into checking details, but if there remain some errors of fact, I hope that the reader will accept them as a part of the human document. Bruce St. John has shown tremendous patience and insight while going through all the material. Without his heroic efforts this book would not be ready for publication.

I want to express my gratitude to the thoughtful team of editors at

Harper & Row, M. S. Wyeth and Joan Kahn, who encouraged me so graciously "to keep on writing it down," while I produced the quantity of recollections from which this introduction has been formed. To my friends who listened through all the years to my questions and quandaries. And to my family, whose professional experience in the medical field has often helped me understand the unique problems of people doing creative work.

A special word of appreciation to those no longer alive, who gave me courage to continue through the years: Van Wyck Brooks and my uncle, Professor Hollon A. Farr.

Most of all, for both John and Dolly Sloan—I have done the best I know to tell the story with the truth and dignity their memory deserves.

<div align="right">HELEN FARR SLOAN</div>

New York
August 2, 1965

EDITOR'S NOTE

Personal reminiscences of Sloan's later reactions and comments were written by Mrs. Helen Farr Sloan or taken from her notes by the editor. Others have been written by the editor for clarification of personalities and events. Whole days of the diary as written have been eliminated without ellipses in order not to make the book too long.

DRAMATIS PERSONAE

(*Editor's note*: The following "cast of characters," a list of persons most frequently referred to in the diaries, is presented before the beginning of the first year so that the reader will be more familiar with the references to these people.)

"The Eight"–a group of progressive independent artists who were leaders of the avant-garde in American art at the beginning of the twentieth century. Led by Robert Henri, they promoted many group and "open door" exhibitions–the most famous of which were the 1908 exhibition of "The Eight" at Macbeth Gallery, the 1910 Independent Artists Exhibition, and the Armory Show in 1913. (Robert Henri, Arthur B. Davies, George Luks, Ernest Lawson, Everett Shinn, William Glackens, Maurice Prendergast, John Sloan.)

Robert Henri (1865–1929), leader of "The Eight" and an important influence in Sloan's work. His parents were Mr. and Mrs. Richard H. Lee; his brother, Dr. Frank Southern. The family name had been Cozad.

Charles Fitzgerald and *Frederick James Gregg*, newspapermen on the New York *Sun* who were sympathetic to the work of The Eight.

Friends of the Philadelphia reporter-artists who had worked with them before coming to New York: *James Preston, Byron Stephenson, George Fox, Joe Laub, Sherman Potts, William Magraw*. Also *Edward Wyatt Davis*, their old editor friend, father of the painter Stuart Davis.

Thomas Anshutz, teacher at the Pennsylvania Academy who carried on Eakins's philosophy of traditional realism.

Rollin Kirby, cartoonist, credited with the invention of Old Man Prohibition.

Jerome Myers, Rockwell Kent, Walt Kuhn, and *Walter Pach*: artists active in the movement for more progressive ideas. Walter Pach became well known as an art critic and historian. After working on the Armory Show,

he was a founder of the Society of Independent Artists (1917) along with Marcel Duchamp.

James B. Moore, a bon vivant who owned the Café Francis, which was a rival to the Café Mouquin. A friend to artists, writers, and musicians, he frequently held salons in his home on West Twenty-third Street.

Albert Ullman, a promoter.

Mary Fanton Roberts, editor of the *Craftsman, Touchstone,* and *Arts and Decoration.* Her salons were meeting places for artists and patrons of the arts. One of her protégés was the famous dancer Isadora Duncan.

John Quinn, lawyer and art collector.

John Butler Yeats, lawyer, artist, author, and conversationalist. Father of the great Irish poet William Butler Yeats.

"Dolly" Sloan (Anna Maria Wall), John Sloan's first wife–from 1901 until her death in 1943.

Her cousin, *Mary Kerr.*

John Sloan's family: his parents and younger sisters, Bessie and Marianna.

1906

January 1

Played golf today with Henri and Davis. We welcome the New Year at James B. Moore's "Secret Lair Beyond the Moat"—450 West 23rd Street. A very small party: James B. Moore, Henri, Barney Moore no relative of Jim's with Miss O'Connor, John Sloan, Mrs. John Sloan. Pleasant evening and early morning. I'm going to try to do a bit less smoking this year. Mr. and Mrs. E. W. Davis, Old Wyatt of the old "806" days, to dinner with their boy Stuart. *[Sloan met Edward Wyatt Davis when they worked on the Philadelphia Inquirer in 1892. Henri and Sloan shared a studio at 806 Walnut Street in Philadelphia through the summer until September 30, 1893. They had met at the home of Charles Grafly, Philadelphia sculptor. Sloan really got to know Henri when the Charcoal Club was formed in March, 1893. Most of "the gang" were included: Henri, Sloan, Glackens, Luks, Shinn, E. W. Davis, Joe Laub, William Gosewisch, and several others. Moore was a kind man, interested in artists and a help to them when he had the money. He encouraged this kind of salon in his home. It was frequented by the interesting world of artists, writers, etc. Those mentioned even decorated the walls.]*

January 2

I am working rather fitfully on illustration story for McClure's Magazine—"Idella and the White Plague"—a girl who rids her family of the imputation of the popular ditty:

Everybody works but Father
And he sits around all day
Feet upon the fender
Smoking his pipe of clay.
Mother takes in washing
So does Sister Anne
Everybody works in our house
But my old man.

January 5

Henri, Dolly and self attended party at Jim Moore's—in cellar (shooting gallery), wall paintings by Glackens (the Frog Game) Luks

3

(café interior) and Lawson (two landscape subjects). Glackens and Luks have used figures of Henri. . . . Hear that the Pennsylvania Academy have accepted full length "Girl in White" and "Boy with Piccolo." Invited "Coffee Line." *[Sloan destroyed "Girl in White" many years later because he felt it was not typical of his work.]*

January 7

A sad but very beautiful afternoon. We went to Henri's studio at the Sherwood building–where he shows us many of Linda's little laces, etc. He gave Dolly several hats and gowns. We went to the Francis for dinner, 9 P.M. Mr. and Mrs. Preston, Fuhr, Stephenson. A beautiful planked steak in sight, when, alas, "Willis" (the waiter) slips (a bit fuddled) and we dine on roast beef. *[Linda Craige Henri, Henri's first wife, had died in 1905. Ernest Fuhr was an active painter and illustrator, working on the New York Herald and the New York World.]*

January 8

The first snowstorm, about two inches fell today. This evening George B. Fox and Ernest Lawson to dinner. Talk of the exhibition next year–each of say some seven of the "crowd" puts in $10 per month for a year–makes a fund of $840. *[This entry in Sloan's diary is the first reference to the organization of two famous exhibitions: The Eight and the 1910 Independent Artists Exhibition. But this was not the first time that various group shows had been held under Henri's inspiration. The 1901 exhibition at the Allan Gallery in New York was really the precursor of these "independent" shows.]*

January 9

Took in drawings to McClure's "Idella etc." Russell approved of them. Worked in evening and night. Dolly read to me as I made one more drawing for "Idella." A clear, very cold day, and the streets very beautiful with snow. Madison Square at dusk with lights and snow. The old Fifth Avenue Hotel as seen across the snow covered place, the electrical signs against the western sky looking down 23rd Street from 6th Avenue.

4

January 10

Wrote to Mother and sent on two ball coasters for Pop to put on her easy chair which we, Dolly and I, gave her for Christmas this last past. We go to Gallard's, small plain French "pension" on 28th Street between 6th and 7th Avenues. The crowd was interesting, all French and German with exception of three friends of Jerome Myers'. *[Myers was one of the original organizers of the Armory Show of 1913. He and his wife Ethel, also an artist, were good friends of the Sloans.]*

January 11

Up late as usual and as model is not coming—work on "Roof Tops, Sunset" started last fall. Paint. Henri brings J. Alden Weir (who has called twice finding me not in). He is a fine, big hearty man—and likes my work. Etchings are a big success with him. Henri at dinner and through the evening. We sit up until 3 o'clock A.M. for no reason whatever.

"Sunset, West Twenty Third Street," 1906

January 12

After breakfast at 2 P.M.–working on roof tops picture. After dinner George Fox comes in to quietly entertain us as is his usual good way –his amusing experiences in Savannah, Georgia. The bell rings and Stephenson and Anshutz come–Henri arrives later and we have some interesting talk, mainly between the two (H. and A.). Anshutz spends the night, or what's left of it (3:30 A.M.). *[Thomas Anshutz was an outstanding teacher at the Pennsylvania Academy of the Fine Arts.]*

January 13

Anshutz up and away after a short night's sleep–in order to be in Philadelphia for his class at the Academy. Feeling badly myself from these last few nights of late hours. Work on "Twenty Third Street Roofs, Sunset." Davis at lunch, and I go with him to "Judge" office where he is "art editor" and then to the exhibition of the National Academy of Design. A poor show dignified by two of Henri's canvases. "The Actress," clear white face and spark of white feather in hair, and "Woman in Brown," seated in profile full length, large canvas, poorly lit. A sketch head by Sargent is right good. Snow and horses by young Koopman (student of Henri's). Dinner, Dolly and I to Gallard's, thence to the Francis. George Luks, Stephenson, Henri, J. Moore and others. Luks too much fuddled to be his best amusing self. Home by 11 P.M. and to bed early.

January 14

We have slept late to make up for past irregularities I hope. My short walk to the Hoffman House to get the Philadelphia papers. Dolly is making a stew for dinner, a good stew as hers always are. Started sketch for etching–memory of the evenings of last year at Henri's, when about the old table from the "Charcoal Club" and 806 Walnut Street, would gather Mrs. Henri (just died from us), Henri, Dolly (my wife) and myself. Mrs. Henri reading aloud.

January 15

Went on with sketch for "Family" group plate. In the evening Jerome Myers and his wife called. Myers speaks of using his brain in his work. I wonder if I ever do in the sense of heavy thought. But perhaps it is only a difference in temperament.

6

January 16

Expect Prestons and Henri to dinner 6:30 P.M. Henri can't come to dinner. He has forgot it and is taking his brother, Frank Southern, to the Great Hippodrome. *[Mari Sandoz's biographical novel* Son of the Gamblin' Man *tells the story of Henri's family.]* Mr. and Mrs. Jimmy Preston to dinner however and a fine merry evening we spent playing "Hearts." About 11:45 Henri and Southern came in. Henri is pleased with the Family Group plate so far as 'tis finished.

January 17

Today proved the "Family" etched plate. Henri came in at 5:30 and liked the memory of Mrs. Henri and thinks the plate is a good one. I can improve the portrait of Dolly in it. And hope that the plate will go on and be one of the important ones.

January 20

Anshutz and Henri at dinner. After . . . Anshutz gives the first of a series of six talks on anatomy at the New York School of Art. He takes the thigh and hip and with clay builds each muscle to the skeleton of that section. Very interesting . . . *[Later, in 1912, Sloan made a fine etching titled "Anshutz on Anatomy." The plate includes portraits of Linda Henri, Henri, Dolly and John Sloan, and George Bellows.]*

January 21

This morning a great rush for the train as we are all to go to Fort Washington, Pa. to stay with Anshutz and see the Annual Exhibition of the Pennsylvania Academy. . . .

January 22

Into the city of Philadelphia to meet Henri at the Pennsylvania Academy of Fine Arts and see the exhibition. It was a good show—full of interest. Henri's "Lady in Black" (Mrs. Henri) is hung in one of the three "honor spots" at the west end of the large west gallery. My "Girl in White" is satisfactorily hung in the hall as one starts to the left of the stairs. My "Coffee Line" is hung rather too high to suit me. The "Boy with Piccolo" is in large west gallery above the line but o.k. Trask, the "managing director" (Morris having resigned

7

and gone to the art management of the *Ladies' Home Journal*), goes out with us and talks well and a bit too much perhaps. Tells Henri how near he came to being awarded the Temple Medal.

January 23

Sleeping sound after Mrs. Anshutz' punch. At Anshutz's we rise at 9:30 or so. In the afternoon Henri makes a sketch of Anshutz's head –proposed to make a full length canvas later (in a month or so). I meet Dolly at the station.... Henri, Dolly and I run over to see Breckenridge who lives in the next house. Clymer comes to dinner and stays the evening and the night. He is antagonistic by nature and riles me in argument. Taking rather the stand that one who does great paintings should not "talk shop." It is my opinion that 'tis best to "talk shop" than to make pictures which do nothing else than that. *[Hugh Henry Breckenridge was a teacher at the Pennsylvania Academy and the Women's School of Design in Philadelphia. Edwin Swift Clymer had been a pupil at the Academy.]*

January 24

Rise at 8 o'clock and Henri goes to N.Y. on the 8:50 train. Self and Dolly, the wife, decide to say farewell to my Mother (she, father and my sisters live in Ft. Washington). We stay at Anshutz's to lunch and after lunch come to town (Philadelphia). I go (Dolly also) to the exhibition again ... take a general look at the pictures– two good Whistlers, water night things, one little nude, not so important and rather bad in influence as so many of his things are setting folks to love "art" rather than expressed ideas (those unexpressible otherwise). Several evil canvases by one L. Genth–poisoned paint. It is strange–Breckenridge tells Henri that the Temple Medal was lost to him by the vote of Weir, F. Dumond and two others out of ten jurors.... Well, he should have had it and will yet. Dolly and I, after sitting and dining at the Rathskeller in Batz Building (reminiscently) home to New York on 7 o'clock train and to bed. *[Frank Vincent Du Mond was for many years a teacher at the Art Students League in New York.]*

January 25

Back at home 165 West 23rd Street, N.Y., again. Slept thirteen hours to make up deficit. Dolly not well, stays in bed. Henri and I to Café

8

Francis for dinner. Wrote to Chapman of Quinby Co. with intention of starting up work for them again if they so wish. Should hate to be out of the De Kock edition if they go on with the work. *[Between 1901 and 1905 Sloan produced 53 etchings and 54 drawings as illustrations for special editions of the novels of Charles Paul de Kock, which were published by Quinby & Co. of Boston. There was much difficulty in getting paid and a final settlement was made in 1905.]*

January 26

McClure's say that $200 is a very high price for the illustrations of "Idella and the Plague"!!!! Hear that Howard Pyle is to have control of McClure's!!! *[Howard Pyle was a very successful writer and illustrator of historical books such as* Men of Iron *and other stories for children.]* George Fox stays to dinner and Potts comes in during the evening. I lay a ground on a plate which he is making for Quinby De Kock Edition. They have been meeting his bills so hope that if they tell me to go on there will not be the difficulty of last year in regard to payment.

January 28

Stopped in to see a panel which George Fox has made (with Bailey) for decoration of Hudson River Boat. One panel of seven pleases architects and owners. . . .

January 29

Showed Clymer some of my stuff. He seems to be brusque and appreciative. I must see some of his work. It seems that he is after the full "shock" of color and sunlight. No reason why it should not be good. Henri came to take dinner with us and after dinner Potts came and Henri made a sketch to help me out in my portrait which I'm attempting with much disaster in the "Family" group etching. . . .

January 30

A lady representative of the N.Y. Herald Art Notes came to see me, sent by Henri. I was rather at a loss to show much work. Showed one or two failures which now seems a foolish thing to have done. . . . We went together, Dolly and I, to Gallard's for our dinner. . . . Thence home and worked on the plate *["Memory"]* till 2 o'clock.

The head of myself is perhaps passable, at any rate looks somewhat like me, I think. Tho' it seems easier to suit me than any one else.

February 1

Saw Mrs. Joe Laub in a play at the Empire Theatre. She did very well I thought. A new play never before produced called "The Measure of a Man." Whether she will be a success if she gets a start at acting is an interesting problem. A velvet dress she wore in third act Joe Laub had painted with poppy design. She certainly looked mighty well. *[Sloan met Joe Laub on the* Inquirer *in 1892. Both artists, they decided to rent a studio together at 705 Walnut Street, Philadelphia, until they moved into Henri's studio at 806 in 1893.]*

February 2

A COLD DAY—one of two or three this winter so far. After dinner at Gallard's, Dolly and I called on Mr. and Mrs. Lichtenstein (L. was

10

manager of publication, Quinby Company, up to last spring. He has most extraordinary appreciation of my etchings for the work, and also for Glackens.) We found them "not in" so came downtown and called on Rollin Kirby and wife. K. has a great collection of Charles Keene's work which is very interesting and some of it rare. I am inclined at present however, to put John Leech above him as the freer thinker. *[Kirby was a successful illustrator at the time and is credited with being the originator of "Old Man Prohibition."]*

February 3

Dolly ... seems to be getting grippe.... Gets dinner for Anshutz, Henri, Fox, Davis. After dinner I went to hear A. lecture and when we came home Dolly was in a very nervous feverish state, don't know us. Telephoned Dr. Westermann–he comes, prescribes, and then sat with us until 2:30 A.M.

February 4

Henri called to see how Dolly was ... better. I go out to dinner at the Francis by arrangement with Henri. Jim Moore sent Mrs. Sloan a quart bottle of clam broth and came home with me ... said Good Night and with his beautiful Irish gallantry raised his silk hat to the fifth floor window–where Dolly is lying sick.

February 5

Dolly was better but the doctor's advice is staying abed. In the evening, I went to the Francis escorting Mrs. James Preston who brought Dolly some beautiful flowers. At the Café she joined James.... I sat down with Henri who had Charley Grafly one of· the "old crowd" from Philadelphia along. Henri has sold the "Dial" cast by Calder to Mrs. George Sheffield for $225. He's (Calder) in Arizona fighting tuberculosis–the money will help. Grafly and Henri came down after dinner to see Dolly. I brought her some savory of chicken which she enjoyed.... *[Charles Grafly, a well-known American sculptor, had introduced Sloan to Henri at his studio in Philadelphia in 1892. Grafly was one of the "crowd" from the old 806 Walnut Street and Charcoal Club days. Calder was Alexander Stirling Calder, a fine traditional sculptor whose father was the sculptor of William Penn on top of Philadelphia's famous City Hall and whose son, Alexander, has created the great mobiles.]*

February 7

In the afternoon I went a part of the rounds of the publishers. No work for me. . . .

February 8

Carl B. Lichtenstein and his wife came to dinner and brought along M. de Brunoff . . . head of the Tissot Bible Publishing Co. He has known many French and English artists and was, a few years ago, proprietor of Lenvercier & Co., Paris Lithographers. He is a count, they say. Very interesting . . . quite interested . . .

February 10

Anshutz came and spent the night. . . . Henri came in and took us to dinner at Shanley's, then he and I went to Silo's and I bought the Géricault for fifteen dollars which is very cheap I'm sure. *[Many years later, during the depression when he needed money, Sloan sold this painting to Smith College for $500.]* Dolly went alone and saw Mrs. Laub at Carnegie Hall and says she did finely.

February 11

Cleaned up my Géricault and it looks very well indeed. Anshutz and I went around to Fox's studio—Anshutz was interested in his work in the Italian influence. Coming away, passed Hoffman House café and was hailed by W. Magraw of the Philadelphia Press Art Department. Left Anshutz to catch his train and went in and had a drink with Magraw—he had been married here in New York yesterday—says he's well fixed—been elected president of the Pen and Pencil (newspaper) Club of Philadelphia, etc. (many of his interesting stories of the Press I take with "grano salis"). . . . Man (Pisinger) called. Starting gallery —wants some of my stuff.

February 12

Davis came in this morning and took Dolly over to East Orange to see Mrs. D. Henri was one of three Society of American Artists jurymen sent to Philadelphia today to arrange to have a certain number of things they should select sent from the Academy of Fine Arts to N.Y. in time for the Society exhibition. He was pleased with Isham

and Jones' attitude . . . nine out of fifteen are very good works. My "Girl in White" was considered but not elected on account of size, H. says. . . .

February 13

Went downtown to see about surrendering my Mutual Life Policies. . . . Walked through the interesting streets on the East Side. Saw a boy spit on a passing hearse, a shabby old hearse. Doorways of tenement houses, grimy and greasy door frames looking as though huge hogs covered with filth had worn the paint away and replaced it with matted dirt in going in and out. Healthy faced children, solid-legged, rich full color to their hair. Happiness rather than misery in the whole life. Fifth Avenue faces are unhappy in comparison.

February 14

. . . Dolly and I ate at Francis, met Henri, Ernest Lawson and Jim Moore. Enjoyment of the evening rather spoilt by a row in which J. M. is called outside by a belligerent diner and J. M. says he hit same customer severely. Back home alone with Dolly. Start work on "Sleeping on Roofs" etching.

February 15

In afternoon Henri took self and wife Dolly to matinee at Proctor's. Saw "Radha, Hindoo barefoot dance of the Senses." It is done by a friend of one or two of his girl students at the New York School of Art. It was very good. The rest of the show was of extra interest also. . . . Henri to dinner. . . . when I had finished a set of puzzles we played hearts till 3 A.M. which is surely a bad time to turn in. When will we reform?

February 16

Letter from Davis. "It's a boy. John Wyatt Davis born Wednesday." . . . In the afternoon a letter arrived from sister Marianna saying that Mother is worse than usual. . . . Dolly thought one of us should go over so, as I have to get drawings for coming Watercolor Club exhibition in Philadelphia, and see Pisinger in regard to sending him pictures for his shop, Dolly catches the 5 P.M. train for Fort Washington. I worked 'till four A.M. on the Roofs-Summer Night etching.

February 17

In the morning I rose at 10 o'clock and went to McClure's and Scribner's and got originals for Water Color Club Ex. Appleton's I got last evening before dinner. *[Most of the magazines retained ownership of the original drawings. Sloan kept a very complete file of reproductions of all his published work, which is kept on deposit in the Sloan Collection at the Delaware Art Center. He was very careful about keeping such records, having the common sense to know that someday drawings with his signature forged on them would appear on the market, when his work would finally be appreciated in a financial way. This began to happen in his lifetime. Several mediocre, but competent, water colors by an unknown hand were brought to us by a "runner." This is the name for one of those colorless agents who do a kind of twilight business between reputable galleries and those shady sources which turn up both authentic things and dubious works of art. It made Sloan furious that he had no legal right to scratch out the "forged signatures" on these works. But the fact is that even the artist himself can only say that he repudiates such a work. He is in the negative position. The owner of an "alleged Sloan" can claim that his property is injured if it is questioned, even by the living artist!]*

Took list of paintings and plates to Pisinger this morning; saw Everett Shinn there. We seldom meet, but when we do I always warm to him tho' he's mighty different from the scalawag that worked with me ten years ago on the *Inquirer* and *Press* of Philadelphia. He left me saying that he had an engagement with a ten millionaire up town. Davis came in the afternoon, a proud father for a second time. His first boy is fourteen years old. R. Kirby called–and Miss Raymond to see Dolly.

I printed eight proofs of the "Roof" plate. Anshutz came with his boy Ned, just a call on his way to Brooklyn where he stays to dinner before his lecture this evening. Good old Henri came in at 12 o'clock and talked. Then he went home and I to bed.

February 18

... I went over to Fifth Avenue and bought the Press and then up town to Henri's studio. Found him sorting and arranging canvases

14

into his new sliding groove boxes. Toward dusk we sat silently. The room is filled with suggestions of Mrs. Henri. Then we went to the Francis for dinner. . . . Got home alone at 12 o'clock. Sat till 1:30 making sketch on the "Bride" plate which I think of doing. *[The church in this etching was St. Vincent de Paul Roman Catholic Church, on Twenty-third Street between Sixth and Seventh Avenues –before the front steps were cut off.]*

February 20

The proofs arrived from Peters of the Mrs. Henri and group plate. *[Sloan was an excellent printer, but when he wanted to have a number of proofs made, he employed Peters Brothers in Philadelphia. They did printing for him until both of them died in 1925.]* They look very well and Henri seems to be pleased with them. . . . I started a portrait of Henri. Seems like a fair beginning. *[But it was evidently scraped out. Sloan found it very difficult to paint portraits of his friends without having many sittings. There is no record of this being a completed picture in Sloan's catalogue cards.]* Wrote to Dolly. . . . Her letters this morning tend to put my mind a bit easier as to my mother's condition. To dinner with George Fox to Renganeschi's Italian table d'hôte near Jefferson Market. . . .

February 21

. . . Pisinger sent for pictures today. I hope that he may sell them. I sent "Look of a Woman," "Woman Sewing," and "Independence Square, Philadelphia." Also six etchings framed. I will be able to send him four more in the course of the next week, I think . . . dined at Shanley's . . . home and worked on "Little Bride" plate . . . a long distance call from Dolly, before dinner, was very unsatisfactory. Couldn't hear what she said nor she me. Think she is coming home tomorrow. . . .

February 22

Proved the "Little Bride" plate and it seems all right to me.

In the afternoon, I was surprised by the arrival of James Wilson Morrice of Paris and Canada. *[James W. Morrice, sometimes called "the Canadian Prendergast," was a friend of Maurice Prendergast. He introduced Glackens and other American artists to many of the well-known artists in Paris.]* He has been "home" to Canada for a

couple of months and is staying a day or two in New York, intending to sail Saturday for Liverpool. He waited with me, having made an appointment with Henri to meet for dinner. Henri came in about 6:45 and at 7:00 we went out. Before dining, Henri and Morrice played a game of billiards. Meanwhile, Dolly had arrived back from Philadelphia–found me out, read note–couldn't find me at Shanley's, went to Mouquin's looking for us,–then Café Francis where she had her dinner, meeting J. Moore and Mr. and Mrs. Johnson, Sunday editor of the *World*. They all came to the studio and took us, Morrice and self to J. Moore's house. We played poker. Morrice went away early.

February 23

Went up to 33rd Street and saw the new Pisinger shop "press View." The place looks right well–not enough daylight but Luks's, Henri's, Glackens' things look well. I took up proofs of "Little Bride" and another former plate, making ten which he has to show. "The Modern Gallery" is the name. Dolly and I went on J. Moore's invitation to dine at Francis. Morrice, Henri, George Luks and Stephenson were with us. The two latter and Dolly and I stayed late and came home in a cab, discovering that we had had a great deal to drink. Morrice eating onion soup with cheese in it was an amusing bald head and strings of cheese that hang to his beard. George Luks discoursed on the merits of "Ingoldsby Legends" and was amusing and quiet.

February 24

I woke with a much deserved headache. Mrs. S. also, worse than myself, stays in bed all day, little dear. Morrice came in just before sailing and I gave him one of the "Group" proofs and one of my De Kock proofs to take with him. He says he will send me a panel when he gets to the other side. I hope he don't forget it for I regard him as one of the greatest landscape painters of the time. . . . In the Evening Sun, Fitzgerald has a notice of the Pisinger Gallery show and comments favorably on the etchings.

February 25

There is an amusing caricature of my "Girl in White" in the students caricature show in Philadelphia. The "Press" reproduces it in

16

today's issue. . . . Wrote letter to Mother and told her that I would come over Monday a week hence.

February 26

Made out entry blanks for the illustrations which I am sending to the P.A.F.A. Water Color Exhibition. Twenty-four entries which are invited... stopped in at Collier's Weekly–Clinton, Art Manager, handed me a story to read and make rough sketches on. . . . Henri and Lawson came in during the evening. Henri goes away South to paint portraits of Mrs. Sheffield's children in a week or so. Says I am to take his place at the New York School of Art during his absence.

February 27

Sadakichi Hartmann, the weird art critic and poet, whom I have known now and then during the past twelve years, came in, accompanied by A. L. Groll, who just got the Sesnan Prize at the current Academy exhibition, Philadelphia. Groll seemed interested in my etchings and Hartmann also. Strange man, Japanese and German combination. Went up town with Joe Laub where he tried some flash light photographs of me. Phoned Dolly to come to Laubs to dinner. Fox came along and we had a pleasant evening. *[Hartmann was one of the first critics to recognize and write about Sloan's city pictures. Albert Groll became well known for paintings of the Southwest.]*

February 28

Dolly was sick today. Dr. Westermann came and said it was neuralgia–a great pain in her head. *["From time to time, quite often, Dolly returned to Philadelphia in search of cures for her nerves, consulting doctors, for, having no children and no causes to serve, she was living at this period in a state of constant neurotic tension. But Sloan, who felt 'aimless' when she was away, as he felt she kept him going, was happy when she bustled about with the carpet-sweeper and came every now and then to give him a kiss, and he worked all day once making a copper plate into a buckle design for a hat for Dolly"–from Van Wyck Brooks's John Sloan, A Painter's Life.]* I varnished "Roofs-Sunset" which I am sending to the jury of the Society of American artists exhibition. Went alone to Shanley's for my dinner. . . . Brought Dolly fried oysters which she enjoyed. At about 12 o'clock, Henri came and he, having had no time to dine on account

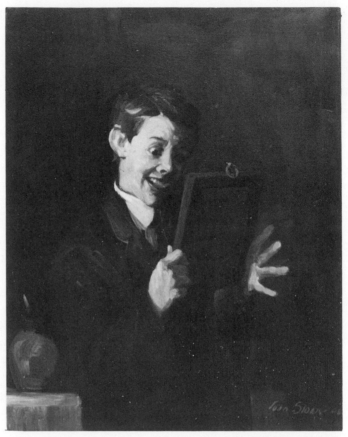

"Making Faces," 1907

of a busy day at the school, where he was attending to many of the
students who are sending to the Society exhibition–I went out to
Shanley's with him and had a scotch or two while he ate. Home at
2 o'clock, finding the little wife perfectly content.

March 1

Pictures were collected for Society jury. Henri and B. Stephenson
were invited for dinner by Dolly but as she was hardly well enough
to get dinner we all went out to Shanley's where we had a pleasant
meal. *[When Sloan had read this far in his journal, written nearly
forty years earlier, he said that he could not bear to reread the whole
thing: "It reminds me of the sad and terrible times we had in those*

18

first New York years. Dr. Westermann was so kind. He knew and I knew that Dolly was having D.T.'s. Whenever I needed him he would come, and stay with us as long as necessary. . . . Some of our friends knew what the trouble was, and they would not ply Dolly with too much to drink. Others were her worst enemies, getting her started on drinking bouts. I never knew where she got the liquor she hid around the house, or the money to buy it. I tried to repay friends who loaned her money,–so often she would be doing some act of charity behind my back, but promising to give more than we could afford. It makes me feel miserable to think that there may be people I owe money to, through the years. I tried to repay people directly, or indirectly. It is the thought of debts I know nothing about, which is unbearable." I am sure that the reader will understand why I never pressed my husband to reread the whole manuscript. I asked him questions about art events, now and then; or reinforced his memory about details concerning exhibitions.]

March 2

Wrote to Trask of the Pennsylvania Academy of Fine Arts to hold my "Boy with Piccolo" and "Coffee Line" subject to my order as I wish to send them to Washington Society Exhibition. . . . Henri came in and took us to dinner at Shanley's. Says that my things went in number 3, which makes them uncertain in their hold as the hanging committee may drop them.

March 4

This was Henri's last day of duty on the Society Jury. He says that he is quite sure that one of mine will be hung. Anshutz went home on 4 o'clock train. Ernest Lawson dropped in in the afternoon. Dolly and I went to dinner at Shanley's. Henri came along. Says that Glackens' full length seated of Mrs. Glack was rejected and made a big row in the jury meeting. After dinner H. came home with us and played cards with "Mrs." while I made some sketches on Collier's story.

March 5

Went to Philadelphia, Dolly and I, on 1 o'clock train. Upon arriving, I went to see Peters and delivered him seven plates to print for me, and paid him for the printing on the "Memory Group" plate.

19

Dolly and I stopped to see Mrs. Dawson. *[Dolly's old landlady from the days when Sloan was courting. Mrs. D. was a kind, wise woman who often looked after Dolly to keep her out of trouble when she was drinking. Dolly had lived with her from the time she left the institutional school where she had been "boarded away from home" from the time when she was fifteen until she was nearly twenty. Dolly was twenty-one when she met Sloan at a party given by Ed Davis.]*

I saw Trask at the Academy and he said he would arrange with Washington Art Society and send my two pictures over in a shipment he is sending.

Went home to Fort Washington and found Mother very ill indeed with neuritis, suffering dreadfully every moment. A most sad sight, and nothing but opiates seem to give her relief.

Dolly in town, went out to Hoffman's from Kerr's, and Nell Sloan came out and met her. She called me on the telephone after dinner at Kerr's. Spent a nervous uneasy night, being much disturbed over my mother's sufferings. *[The Kerrs were Dolly's cousins, on her father's side.]*

March 6

Spent the morning at home in Fort Washington with Mother who has her wits and her sense of humor tho' in dreadful pain. . . . In the afternoon . . . met Dolly at Dr. Bower's. He gave me tablets for my nervous condition of the last two weeks. We then went down and called on James Fincken, my friend, the engraver. He is a fine man certainly and has always been so much help to me technically from his great knowledge of the mechanics of etching. . . . *[Dr. Collier Bower was a very far-sighted medical man who told Sloan that Dolly had a neurosis too deep-seated to respond to therapy–that she needed to drink now and then to release her tensions. He told Dolly that Sloan was being a wonderful and understanding husband to her. There were times, of course, when Sloan had to be very firm with Dolly about not having any more to drink, or not going places where people would give her too much, or start her on a drinking bout. She had a complete blackout about the years she had spent in the boarding institution run by the Good Shepherd nuns. She never mentioned that period of her life; it was completely blocked off by the unhappy memory of how severe her half brother had been to her when he found that she*

20

had started drinking at the age of fifteen. It was no wonder that Sloan suffered from nervous indigestion when he was worried about Dolly, and trying to conceal the cause of her illness from passing acquaintances.]

March 7

Said goodbye to Mother and left Fort Washington on an early train. Came to Philadelphia . . . looks well to me, a livable old look, tho' impossible, of course. Back to New York on 1:40 P.M. train. Fox came in in the evening and also James Gregg, editorial writer on the "Evening Sun." *[Gregg, along with Fitzgerald, did a lot to bring pioneering art exhibitions to the notice of the general public. Fitzgerald later married Mrs. Glackens's sister. His articles on The Eight helped to publicize the work of Henri's crowd; and his writing was very influential in putting across the importance of the Armory Show.]*

March 8

Saw a bill poster at work on his ladder with a gaping crowd. Brilliant, tragic, dramatic color of bills and sunlight–a very interesting thing. Henri came in in the afternoon late. He tells me that my "Sunset Roof" and "Foreign Girl" will probably be dropped in the hanging Committee of the Society Exhibition. Talk with him on the just effected amalgamation of the National Academy of Design and the Society of American Artists. It seems to me that it narrows things down until a large new gallery is built. H. thinks that no difference will be felt. Supper at home. . . . Worcester, Mass., summer exhibition has invited my painting "Girl in White" (full length of Eleanor Hartrauft). This pleases me very much.

March 9

This afternoon, Dolly and I took a walk down Broadway. Stopped in Brentano's and bought the fountain pen which is making these marks –bought also a copy of the Studio which contains a reproduction of my sister Marianna's "Water Willows." A short article about her by my uncle W. H. Ward of London. On 23rd Street we met George B. Luks and he walked home with us and sat for an hour. Many oaths, much good wit, a great character, doing great work, for the future. Dolly cooked dinner, panned oysters and mutton cutlets, very good. *[Sloan once said, "Nan really had more talent than I did, and*

it is not a good thing. If there is too much ease, in the first place there is an ability to imitate the work of other people. She could paint in the manner of Henri, or Breckenridge, or Corot. An artist, even though we do need skill, is better off with less of that kind of talent we associate with the virtuoso. The reason I accomplished more than some of the others in my generation, is that I had less talent than they did, and so I had to work harder." William H. Ward was the son of Marcus Ward, manufacturer of Royal Irish Linen, the social stationery; he was married to one of Sloan's maternal aunts.]

March 12

Henri left for the Sunny South. . . . Working on Collier's drawings, having all sorts of trouble with a shoemaker at his bench. . . .

March 13

Walked around to Fifth Avenue and saw exhibition of a number of Mrs. Shinn's drawings *[Florence Scoville Shinn]*. Very quaint portraits in pen and ink, colored a little. Beautiful gray day in the streets, snowing some. Heavy gray sky. Madison Square looked fine. Made two Collier drawings today. A bit better than the first attempts.

March 14

Peters sent me by express a box of ink for etching printing. Letter from Marianna says that Mother is not any better, still suffering dreadful pain. Went to the New York School of Art to take Henri's place criticising the men's life in the morning. Portrait class in the afternoon, a very crowded class and many of the pupils show the results of Henri's tremendous ability as a teacher. The men's life class at night is full of good men. J. Moore invited Dolly and I to dinner. After dinner I went to school . . . home at 11:30 or so, tired, awfully.

March 15

Went and criticised the "picture class." A lot of good stuff, which if gone on with in coming years will mean something worthwhile in American Art history. *Is* something now, greater than is found in the Annual Exhibition. Dolly in bed today. Got up tho' to make my dinner in the evening.

22

March 16

Another long hard day's work at the school. Henri earns his salary is my opinion after trying it. It is a tremendous strain on me to say things that will be of some use to these students.

March 17

Was feeling pretty well used up after these days of school work. Read "Irrational Knot" of Bernard Shaw. His first novel, I believe, and full of things I like to see stated but somewhat drawn out, tho' it held my interest all right. . . .

March 19

A very heavy snowstorm swept over the city and between noon and 6 o'clock had dropped three inches of snow. A very dramatic and beautiful storm. I delivered my drawings at Collier's—no verdict. . . . Walked around through West 4th Street neighborhood in the storm and afterward about Madison Square. Rain followed the snow and Dolly and I had a slushy trip around the corner to Fox's studio. He cooked an elegant dinner—steaks on charcoal fire and some delicious salad after dinner. We came home at 10 and I did a little tinkering on "Man, Wife and Child" plate. Dolly read to me De Maupassant's "Fort Comme la Mort."

March 21

Went to the N.Y. School of Art to start my second week in substituting for Henri. It did not seem quite such a severe strain on me as last week's work—growing more accustomed to it, I suppose. . . .

March 22

A trip to Collier's. The drawings seem to suit right well—but Clinton asked me to do a little strengthening of one or two of them—for the sake of reproduction and printing. The Picture class at school brought out a great number of paintings and drawings—of really high degree of merit. . . . Sent off three plates to Peters Bros. to have finished proofs made.

March 23

Another day at the N.Y. School of Art, finishing my second week. After the class in the evening, had a talk with some of the members.

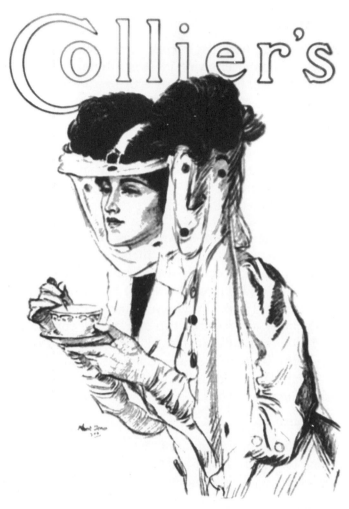

Collier's "play" cover, October 13, 1906

Hatch, Van Sloon, Boss, Pach, Levy. They are all of interest. Hatch is older than myself, the others younger and with good ideals. In Pach, I think it is all ideals, he don't work up to them–and yet, it is difficult to say. He might turn out the best but I miss my guess if he does. *[Walter Pach became a distinguished art critic, historian, and lecturer. He was vitally important to the organization of the Armory Show. Later, he helped to found the Society of Independent Artists, of which Glackens was president for the first year, 1917. From 1918 on, Sloan was president.]*

March 24

Walked in Central Park, snow covered and rather bleak, tho' a beautiful day. Watched crowds of boys, running races about the fountain at the end of the "Mall." . . . In the evening Dolly and I eat dinner at Café Francis . . . quite a crowd . . . met A. Koopman whom I've not seen for several years. Millard and Gregg argue on the possibility of educating a man for journalism.

March 25

Stopped in to see George Fox and became interested in going over with him a pile of "Gil Blas," "Courier Français," and other French periodicals. Dinner at home, after which I started on drawings for Saturday Evening Post which Thornton S. Hardy has ordered.

March 26

Rainy, disagreeable day. Called at Collier's and left the two drawings which I have tinkered with to suit Clinton. Met Reuterdahl, who had been abroad for a year. *[Henry Reuterdahl, primarily a painter of naval scenes and landscapes of seacoasts, was a correspondent during the Spanish-American War.]* He was very cordial to me—said he was glad to see me "getting hold" on Collier's Weekly. . . . Dropped in to see Mischke, the print and bookseller on 23rd Street. I like the old German. He says I must get Keppel or Wunderlich to handle my etchings if I want to sell them. *[Keppel was the brother of Frederick P. Keppel, who became head of the Carnegie Corporation. The present Kennedy & Co. is the successor to Wunderlich.]*

March 27

Prints arrived from Peters and look very fine indeed. A letter from Henri says:

15th March 06

AIKEN,
SOUTH CAROLINA

Dear John,

Hope you are getting along well at the school and like the job. I may come back some time. I haven't time to write. Best wishes to you both. Thanks for sending the etching.

YOURS,
Henri. Ex-Prof.

March 29

A most interesting human event in 23rd street this morning. Funerals of several firemen killed by a falling wall at a fire a few days ago–at the Roman Church of St. Vincent de Paul in our block. Great crowds in the street. Picture class at the school–many very good things shown. A number of people "taking an interest in Art" at a picture gallery, a Chinese Restaurant, two river scenes which looked a bit too much like Glackens and Luks.

March 31

A hot argument with E. Lawson over Henri's work as a teacher. L. says H. is hurting his own work by teaching, wants to teach everybody. I said that he was capable of doing so and that he was the greatest American painter. I hate this tendency of smaller men and women to yap at Henri. This all fell out at the Café Francis at dinner. J. Moore invites us down to his house where we play cards awhile and see an amusing decoration added by Glackens–probably to the ones in the cellar–owing to the breadth of the humor J. M. says it will be painted out. . . . Mr. and Mrs. Jimmy Preston and Mr. and Mrs. Glackens came in later in the evening at J. M.'s house.

April 2

Dolly and I took a stroll in the afternoon, stopped in Fishel, Adler and Schwartz Gallery. Saw A. Koopman's work, met him. His stuff is too much concerned with qualities of paint as paint, I think. Some things are of interest. . . .

April 3

Letter from Henri says that group of children he has painted seems to please everyone well. Went with Dolly to the Society exhibition. A very tame show it seems to me, perhaps on account of my own having been excluded. We went to call on Jerome Myers, found him in, Mrs. M. out. Says he has sold two paintings at Macbeth's beside one sold at the Society show. . . . Went to Gallard's for dinner. *[Sloan once commented, about The Eight, that Henri and Davies were both in Macbeth's "stable." The fact that Myers was exhibited by Macbeth made his omission from The Eight almost a deliberate rejection on the part of Henri–who really chose The Eight.]*

26

April 9

Balance of printing on the ten plates (N.Y.) arrived this morning and I start to make some mat folders for them all. Worked pretty nearly all day and evening on folders. Dinner at home. Letter from Henri. . . .

<div align="center">

AIKEN, SOUTH CAROLINA
APRIL 5, 1906
</div>

Dear Sloans,

I enclose tickets I have just received for the SAA which you may make use of.

Not much doing here at present. It's soft summer. Birds singing all about. Air laden with fragrance. And altogether it's too damned peaceable.

I may have lazyness in me but I never have been able to enjoy eating lotus. Sweet and dreamy peace–beautiful still moonlight–inactivity–standing still. I would rather be damming a creek. Just to give it the pleasure of cutting a new bed.

I have been playing tennis–enough to know. But it is not a philosopher's game like golf. Lacks the romance. It's made up of too much sun on a flat yellow bottom of a wire cage you jump about in. A net always so high and in the same place. A certain kind of shoes. White trowsers, taste in socks. No hills to go over to other views–no crush of grass under foot–no spring to drink at the end of that long stretch. Golf might have its Isaac Walton. Tennis could only have a Beau Brummel.

<div align="right">

YOURS,
Henri
</div>

That was pleasant to hear–of that sale of yours in Philadelphia of the etching.

<div align="right">

[CIRCA APRIL, 1906]
</div>

Dear Henri,

I think that you have a calling–Golf writer–or as you suggest Isaac Walton of Golf. You made my hands itch for the grip of a driver, the swing from the spine, the crisp click of the contact, and then that long easy slice to the impenetrable, inscrutable rough at the right of the fair green.

Potts and "we" about decided to go to Kittery Point, Maine–lowest point on the coast of Maine, across harbor from Portsmouth, N.H. furnished cottage for $100. the season, four months if we wish. I think that "we" will be much better for the radical change of air this summer, and

though I'll have to keep my studio rent going in town here–I think the gain in health should make it worth the expense.

I suppose and hope that this will be my last week at the school, looking forward to your return about the 15th.

Saturday I painted Mrs. Hencke–posed for me. Found her very interesting and I think I have a right good start. Have had two good games of poker with Mr. and Mrs. Hencke.

We are having the usual rather chilly showers of April up here today–yesterday fine.

I have had a dozen portfolios made for the etchings and am making hinged folder mats for the proofs. I think they will look very fine. See you soon I hope. Mrs. Sloan sends her special regards.

YOURS,
JOHN SLOAN

April 12

Picture class at the New York School. Not a great number of things shown. Fine Hogarthian sort of drawing of Mott Street, Chinatown, made by one of the young men whom I've talked to but whose name I don't know (since found it to be Coleman). [Glenn O. Coleman had worked as an illustrator in Indianapolis.] Walked over the Avenue to Keppel's. . . . said etchings interested . . . personally but could not see any business, sales of any account. Sent me to Mr. Hellman of the Cooperative Society 34th Street Fifth Avenue who said he could not handle the etchings but would like some drawings and paintings as he liked my work. Showed the ten plates and portfolios to Pisinger and left them with him. He says that with definite proofs in folio to show, he thinks he can sell them. . . .

April 13

At the school. Henri popped in just from a twenty-six hour trip from Sunny South. We took him to dinner at Shanley's after which he went to Francis and I to the school. . . .

April 14

Henri and I went up town to the Sherwood to see if his group portrait of the Sheffields had arrived from the South. It had not which was a disappointment as I am anxious to see it. We went to the Society Exhibition together, I got home by six o'clock and Dolly and I went to Hencke's for dinner. . . .

"Dolly Walks with Us," by Robert Henri

April 16

After breakfast Henri went uptown and I finished up a set of the Japan proofs of the ten plates in portfolios and folders. Then Dolly and I went up to see the group of children of Mrs. George Sheffield which Henri painted in the South. It is a splendid thing. Ingenuous as great art is—unassuming and fine, the three children in a row across the canvas in white dresses and back of them green with red flowers here and there, a path that they stand on beautiful in color. Stopped and left Japan set of etchings at Pisinger's. Then Henri, Dolly and self went to G. B. Fox's studio where he cooks us a shad roe dinner— elegant. And a pleasant evening, which by the way suggests that G. Fox carries pleasant evenings about with him, a gentleman is Fox.

April 17

We have a letter from Nan which gives rather good news of Mother's illness. She says she is a great deal better–this means far from well, of course. We have about decided to give up our trip to Kittery, Maine. Took a walk. Madison Square is thronged with Springtime–setting out pansies in large circular bed. The people stop and watch the flowers as they did in Philadelphia Independence Square when I painted my first exhibited picture, "Independence Square." . . .

April 18

Real spring day here. Earthquake in San Francisco, California. Great destruction and loss of life according to despatches. . . . Potts came to dinner . . . told him of our change of mind in regard to the trip to Maine. I feel that three or four months is too much to cut out of my New York life and, in event of Mother's taking a turn for the worse I'd be so far away. . . .

April 19

With a portfolio of my ten etchings I called on Klackner Art Publisher. I was told that they would not be available–looked them over without interest. Then to Wunderlich, art dealer, especially of engravings. The clerks were interested . . . saw the manager, a Mr. Kennedy later, and he threw cold water on said hopes. Mischke the younger said they would take some "on sale" and make a window display. Chapin of Scribner's was interested in them apparently and gave me a letter to Russell Sturgis who edits the "Field of Art" section of Scribner's Magazine.

April 20

Pisinger Modern Gallery have sold the set of etchings to Henry W. Ranger, the landscape painter. Sent note asking me to sign the set as a favor to Ranger–I did so. Possibly this will be very good advertising as Ranger is very well known. Walked downtown, walked for an hour or so about Mulberry Street, Mott Street, Elizabeth Street and the vicinity. Curious incident–a large wagon takes fire, contents paper boxes. The first evidence was small tongues of flames coming thro heart-shaped opening back of driver's seat. Great crowd gathered, finally the fire engines came, one length of hose attached to hydrant does the work of extinguishing. . . .

April 21

With my portfolio and Mr. Chapin's letter of introduction, I called on Russell Sturgis, art writer. A handsome old house opposite Stuyvesant Square, a large parlor in good taste, not tasteful. Mr. Sturgis is a healthy looking old gentleman and received me most kindly. He looked at the etchings with interest. He has·the art critic's annoying breadth; likes things I like and things I don't like in art. I spoke of my De Kock etchings and he said he would much like to see them. Invited me to call and show them Tuesday P.M.

April 24

Alden Weir selected picture for sale for benefit of San Francisco artists. *["Burning Autumn Leaves."]* Called on Russell Sturgis and showed him my De Kock etchings which he had asked to see. He looked them through but did not seem impressed. He says that my work lacks charm and seemed to suggest that many of the set of ten plates on New York life could be best expressed in words. I differ with him. He has the art critic's way of pointing out line combinations and light and shade arrangements as the "charm" of the picture. He showed me Liber Studiorum plates *[by Joseph Mallord William Turner]* and gave me a copy of Dickens' Cricket on the Hearth, with pictures by Leech *[John]*. He is most kind. . . .

April 25

Mr. Sturgis sent around a copy of his book "Appreciation of Pictures." Painted in the afternoon at bust picture of Miss Rozenscheine, the Caucasian model. Got a fair sort of start. . . .

April 26

Called on Pisinger who said he sent my paintings back for space to put in salable stuff tho' he says he will go back to his original idea in the fall. Painted again from Miss Rozenscheine. Don't think I have anything of importance done. Cut out fifty mats for etchings this evening.

April 27

Check for $100. from Saturday Evening Post for story illustrations arrived. Sent 2.50 for two years subscription to the same. "One good

turn deserves another." Finished fifty hinged mat folders this afternoon. . . .

April 28

Went out to Van Cortlandt Park intending to play my first golf of the season, but found such a crowd at the course that I felt too much of a beginner to go on, so I just walked about enjoying the springtime air, baseball games, boating on the lake. The "Autumn Leaf Fires," decorative sketch which I contributed to the sale for San Francisco *[earthquake]* relief was collected in the afternoon. . . . Dolly sewed my trousseau for the trip to Atlantic City Publishers Association dinner next week.

April 29

Down to Waverly Place and called on E. Shinn and Mrs. S. . . . Shinn showed me a lot of his red chalk drawings . . . many of them erotic in nature. Had a very pleasant evening. Mrs. Shinn is always so even and amusing.

April 30

"Girl in White" (Miss Eleanor Hartrauft) was collected for the Worcester Summer Exhibition. Left two sets of etchings at Keppel's. . . .

May 1

Alden Weir called, asked me to lunch tomorrow at the Players Club to meet a few and talk over a scheme of annual exhibition, Water Colors, Pastels, and Etchings. Gave Mr. Chapin a set of etchings (10). He seems much pleased. Went over to Mr. Sturgis's and left a set for him as a gift. If he does not value them now he may in the future if he lives long enough. Made my first call on Howard Pyle, who is now Art Editor of McClure's Magazine. Showed him my proofs, illustrations, etc. He treated me with courtesy. Said my work was good in "character" but just at present, you know—everything—not giving out much work—supplied ahead, etc., etc. Call again. *[Howard Pyle was firmly entrenched as a successful illustrator, with a school of younger men imitating his way of working.]* Drunken woman in Madison Square, policeman stern. She offers a drink from brown bottle. *[Sloan never got over the feeling of compassion for*

pathetic women alcoholics. "It makes a knife go right through me whenever I see one of them, alone and exposed to trouble. I am re-minded that Dolly might be in their same situation if I had not looked after her."] After dinner Henri took us to see a poor play, "Mr. Hopkinson." Stopped in the Francis on the way home. . . .

May 2

Alden Weir stopped and told Henri and I that the lunch at the Players Club is postponed until tomorrow. A perennial youth about Weir makes him good company. Walked over to Collier's . . . thro' Greenwich Village, West 4th Street, etc. In the afternoon four etchings of the set which had been invited by Mr. Mielatz of the committee on etchings at the Water Color Society Exhibition were returned to me. Great surprise as he had even furnished the frames. In the evening, I attended the "stag" Private View, saw Mielatz and asked for an explanation. He said other members of the committee had thought these four were rather "too vulgar" for a public exhi-bition. I asked to be introduced to some of these sensitive souls but he would not comply. I was madder than I can describe. Asked to have the remaining six taken down but this is against the rules. . . .

May 3

This morning, Russell Sturgis, Art Critic–returned to me as "too costly a gift" the set of etchings which I had left for him–retaining only the "Turning out the Light," which was the one he liked. And thereby breaking a set. I note this here for future reference.

Alden Weir invited me to lunch at the Players Club to meet and talk over the proposed Water Color and Etching Exhibition. A limited Society was formed, these being present: Weir, Glackens, Henri, Sterner, Metcalf, Smedley, R. Reid and Sloan.

I wrote to Carlton Chapman, Secretary of American Water Color Society, protesting against the return of my etchings.

May 4

This morning Chapman responded to my letter saying that works could not be removed after exhibition opened. That he felt that I would, on further consideration, see the wisdom of the committee in sending back the four. I think not. I know that these plates are not vulgar–not indecent. Dolly and I went to Jersey City together. She

goes to Philadelphia and I on the special train to the Periodical Publishers Dinner at Atlantic City. On the train I met many men of the magazine world. . . . White, new editor of Appleton's . . . Lavering, F. D. Steele, J. R. Shaver, E. C. Carpenter, R. D. Towne . . . too many others to mention . . . huge affair . . . at the Marlborough-Blenheim Hotel . . . after speeches had begun, Glackens, Preston, Shinn and I started off to find Jim Moore at Young's Hotel. . . . found him, did some bowling in dress suits. . . . Back to hotel, got larger crowd out again. . . . had very gay time in a café near the boardwalk. S. G. Blythe presided most wittily.

May 5

A headache today. Came up to Philadelphia on the special train. Stopped off . . . Press Art Department . . . out to Fort Washington in the afternoon late. Met Anshutz on the train, napping and nodding. Mother sitting up and seemed better than when I last saw her . . . called on Anshutz. Hear that Snow has refused to sell proofs of my "Memory of Last Year" tho' people had inquired of him for them.

May 6

California sufferers sale of pictures opens at the American Art Association today. Stayed quietly at Fort Washington. Went over and saw Breckenridge. . . . Dolly came out in time for dinner.

May 7

Started from Fort Washington intending to come to New York but after an afternoon at Fincken's and Peters' (paid bill $16.20) and seeing March (Sunday Editor, Press) we met at dinner at the Rathskeller and Eleanor Sloan took us home to stay the night.

May 8

Back to New York. . . . lunch on dining car . . . pleased Dolly very much. Fox called . . . dinner at Gallard's, he along. Then up to the American Art Gallery . . . sale of pictures for California Fund. . . . So many there we couldn't get inside. . . . Letter from New York Public Library asking me for etchings for their collection of American etchers.

34

May 10

Walked over to Mischke's who says he has a man who will likely be interested in a set of the etchings ... received a letter of apology or extenuation or something from Mielatz in regard to the W.C.S. [*Watercolor Society*] sending my *invited* prints back. Frank Crane, the old, one time manager of the Press Department, called this afternoon. [*Crane married Mrs. George Luks and adopted Luks's Kent. The boy did not know who his real father was until he reached the age of eighteen. Sloan was very fond of young Kent, and was delighted that he came to see him now and then in later life. He grew up to be an architect.*] ... A Miss Lathrop, representing Broadway Magazine, called wanting New York Paintings. Told her to get photo of "Coffee Line." Suggested my etchings. She showed them to the editor but he thought them unsuitable for his magazine.

May 12

"System" Chicago want estimate on cover design. Wrote, stating $100. my price. Wrote Chapman of Quinby Co. in re sending me proofs for N.Y. Public Library, also reminding him of my letter of Jan. 25 re work. Madison Square Throbbing Fountain with men and women and children watching it and in many cases feeling its sensuous charm. It seems to have a hypnotic property in fixing the gaze.

May 13

... Dolly and I decide on a trip to Crane's at Bayonne. We had a very pleasant afternoon and evening with them. Very interesting, coast of New York bay, some old buildings and shacks, yachts being overhauled for the summer time. White piers gleaming against the water with the sun low, water dull and hulls of yachts brightly lit. ... Had dinner at a café overlooking the Kill von Kull. Washington Park, small amusement booths, swings bright red and circus blue— lads and lasses in Sunday gear. Mrs. Crane, once Mrs. Geo. B. Luks, very pleasant. I had not seen her for years. Painting by Henri which Crane bought in Philadelphia in circa 1897 show at Academy. Geo. Luks' son Kent, a fine light haired boy now. Wonder which of his father's attributes he will inherit?

May 14

Rainy ... Walked out 23rd street, picked up copy of "Val Vox" which Crane had said he wanted, sent it to him by mail. Met Russell

on the street [*Charles Edward Russell had been city editor with the New York* World]. We spoke of the disruption of McClure's. He has stayed with the magazine; Steffens, Phillips, Tarbell and the rest have gone, but H. Pyle remains, I fear. Little chance for my work under the "boiler maker." Fox called after dinner. Oddly, while we were visiting Cranes, he was at Luks', he calling on the sonless father, we on the fatherless son.

May 15

Pisinger writes that he has a customer who wishes three etchings from the set. I wrote that I would not break sets ... played golf ... came home feeling tired but much better than I have been ... a beautiful afternoon in the country.

36

May 16

Walked up town at noon and stopped in at the Water Color Society Exhibition in response to a note from the salesman, Mr. Allison. He asked if Miss Cary of "The Scrip" could reproduce the "Memory" plate with a short article on my work . . . yes. He tells me that she will buy it. Waited until Henri came out from school. Had lunch with him, first I had seen of him for some days. Tried to paint in the afternoon but made a bad start. I know it is fortunate that I don't ever "learn how" but it is very discouraging nevertheless, this "falling down."

May 18

Breakfast, Miss Perkins and Henri here *[Mary Perkins]*. Dolly and Miss P. went up town to Henri's studio . . . took lunch with him. H. and Miss P. hand in hand go to the cake counter to "pick out" cakes. Sent off three Puzzles today to the Press, Phila. Dolly and I went out to Shanley's for dinner. Took a little walk after a very hot day and evening. Went to bed early quite used up by the heat.

May 19

My cousin, Eleanor Sloan, arrived to pay us a visit.

May 20

Dropped in for my Sunday call at George Fox's . . . dinner at home, then out for a walk on Broadway, showing Nell the "Great White Way," we ended up at the Francis. . . .

May 21

. . . Tried to inveigle Henri into a game of golf. He is starting to pack up for storage, giving up the studio. Preparing to open another Chapter of Life. Goes to Spain this summer with the N.Y. School class. . . .

May 22

Well, the Pisinger Modern Gallery incident is closed, I guess. Note from him this morning says he is selling out his interest–come and get my etchings. He has failed because of not going into the thing in a pure way. Had he stuck to Henri's, Glackens', Luks', Shinn's and

absolutely kindred good stuff the tale might have been different. He told me to write to F. A. Tolhurst, 24 Irving Place, in re set of etchings offered 20% discount on set. J. B. Townsend of American Art News, 1265 Broadway, spoke to him in re exhibition in the fall to go from place to place. Have just read G. Bernard Shaw's plays. Unpleasant Widowers' Houses, Mrs. Warren's Profession. Splendid works, I think.

May 24

Went up and "collected" Henri . . . all went over to Crane's in Bayonne . . . very pleasant evening. . . . the little bookshop up the street a few doors has one of my etchings in the window each day changed. A card beneath says "An incomplete set was shown at the American Water Color Society Exhibition."

May 25

Dolly and Nell went up to Henri's to see the Sheffield Children picture. Nell says she likes it very much. Finished two Puzzles for the Press. . . . Poker after dinner, a good lively game with large hands out. Henri made out a list of names of those who are to be given copies of the "Memory of Last Year."

May 26

Sent off two Puzzles to the Press. A fire in the afternoon at 25th Street and 10th Avenue–went down and watched the crowd. Boys thronging, the hook and ladder wagon, smoke, hot sun and all sorts of people. . . .

May 30

"Decoration Day." We were invited to spend the afternoon at Crane's in Bayonne. A walk to the shore with its yachts and boats launched now. Then we went to the Newark bay side and watched picnic grounds, dancing pavilion, young girls of the healthy lusty type with white caps jauntily perched on their heads. . . .

June 1

Went up to the Sherwood early with Henri to help him send his things to the storage warehouse. Put in a long day, knocking the shelves apart for lumber which he has given me. It seems very sad

38

to be leaving the old studio, where we have had such pleasant evenings, where Mrs. Henri died. . . .

June 2

Started painting a memory of the little Picnic Grounds at Bayonne and think I have a good "go" at it. *["Picnic Grounds," collection of the Whitney Museum of American Art.]* In the evening, we, Dolly, Nell and I, went to the Café Francis and sat a while thinking to meet Henri. Went on down Broadway, stopped in the Hoffman House, a vulgar place in crude German style.

June 3

Started a painting of an excavation for basement of large building which is to be in the site of the church at 34th Street and Sixth Avenue. Men working at night, the effect was most interesing. *[This painting was not finished.]* Henri came in at 9 o'clock and had no dinner . . . asked us to Shanley's to watch him feed . . . played "Hearts" till 12:15 when we said good bye. Tomorrow early he goes to Boston and sails Tuesday or Wednesday for Gibraltar.

June 4

Two volumes of the De Kock arrived today. They are the ones Potts illustrated. Worked on the Bayonne Picnic Ground picture. Cranes came in evening to dinner . . . right good time. . . . Beer and Highballs. To bed quarrelsome.

June 5

Sister Marianna arrived for a visit today. She and I went to the Metropolitan Art Museum and walked thro' the Park. Enjoyed the pictures much–not having been there for more than a year.

June 7

In the afternoon we go to Coney Island, Eleanor Sloan never having seen its wonders. Nan same ignorance. We went down on train. Went in "Dreamland" and "Luna Park." Ate popcorn and peanuts, frankfurters and roast beef sandwiches. Peeped in the Concert Halls, listened to the forceful talk of the Fortune Tellers, watched the people watch the surf. Saw the beautiful tawdry magnificence of the night illuminations. Nell and I went on the "Dragon Gorge."

June 8

Nell Sloan went back to Philadelphia today. Presented me with a necktie. Nan sketched at the Battery. I worked on an advertising drawing for Joe Laub. The old table from the Charcoal Club (1893) and "806" arrived from the Sherwood Studio today. Henri thought I had better take it back. The old table should be commented on. I have lived with it for thirteen years or more now and it has solidly stood and seen many happy times at the "club" (in its four months or so of existence). At the "806" studio, in Henri's studio and now back to me. I hope it will see more happiness than otherwise. It is shown in the "Memory of Last Year" etching.

June 10

In the afternoon, walking on Fifth Avenue, we were on the edge of a beautiful wind storm, the air full of dust and a sort of panicky terror in all the living things in sight. A broad gray curtain of cloud pushing over the zenith, the streets in wicked dusty murk. About 8:30 in the evening we (Dolly, Nan and I) went down to the Bowery and walked through Chinatown and Elizabeth Street. It was the first time I had been down there at night—found it right interesting. Perhaps Chinatown is a bit too picturesque for my purposes....

June 11

Started to paint from memory of the Wind and Dust Storm that we saw and felt Sunday. Across the backyards in a room on the second floor I saw a baby die in its mother's arms. The men of the house powerless, helpless, stupid. She held it in her arms after it had started to pale and stiffen. Hope tried to fight off Fact, then Fact killed hope in her. They took it from her. The men smoked their pipes—sympathetic with her anguish and trying to reason her back to calmness. A bottle of whiskey, and a drink for her. I could hear nothing—but the acting was perfect.

June 12

Called at Myers' in the afternoon. He showed us some sketches and paintings. To Renganeschi's for dinner. A new experience for Nan which she enjoyed much. Walked up from West 10th Street along Seventh and Eighth Avenues—full of life—children dancing to the music of street pianos.

40

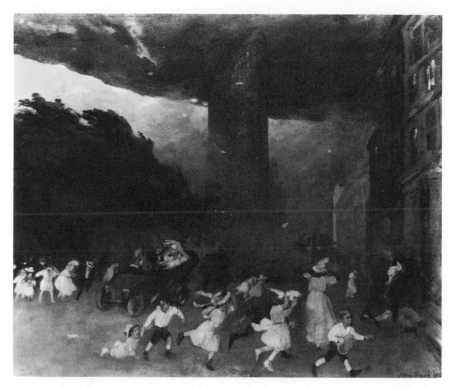

"Dust Storm, Fifth Avenue," 1906

June 14

Worked again on the Wind and Dust Storm on Fifth Avenue. Rather hopc to get something out of it finally....

June 15

I had a fine time today making a box for portfolios and drawing paper for the studio. Dolly is most pleased with it as it will tend to make cleaning a little easier. Marianna went down to Trinity Church but they would not allow sketching in the church yard–tho' girls come there to eat their lunches....

June 16

Marianna returned home today.... Mr. and Mrs. S. Walter Norris of Germantown, Philadelphia came in this afternoon ... have not seen him since leaving Philadelphia, April 1904.... Norris' opinions

41

about art are valuable tho' I think there is some little tendency to find the rules and exceptions to rules which go to make great pictures . . . not enough centering of the mind on an important idea about Life–rather than Art. . . .

June 17

Visited Henry Reuterdahl at Weehawken, my first trip to the heights of the Hudson. The prospect from the cliffs is fine. The popular sculptor, Bitter, has a house that rises sheer from the cliffs. *[Karl Bitter made the fountain in front of the Plaza Hotel, N.Y.C.]* . . . Mrs. Reuterdahl is extremely interesting . . . an Icelander. . . . Reuterdahl has shown a great deal of consideration for me and my work.

June 18

Went on with my "carpentering" and finished up my cupboard for frames . . . not a fine specimen of cabinet-making but . . . strong. . . . Fox came in the evening bringing Mr. and Mrs. George Luks. Luks seemed to like the things I have been painting lately. We went out to "Cavanagh's" and had something to drink and a bite to eat. Luks– drank nothing. Fox says that Shinn is making drawings for the De Kock–that Foreman has charge of the illustrations. If he has I fear that I'm "all in" on that work.

June 19

Worked on my canvas and frame shelves, strengthening and adding to them . . . me to a "stag" party at J. Moore's. Went up and had a fairly good time. Luks, Fuhr, Chapin, Gunn, L. Glackens, Hassman, W. A. Rogers, Stephens, Dirks, Stein (who was on the Herald while I was there in 1898). Luks got pretty well filled with beer, quarrelsome and nasty. . . . Painted out one end of the famous but hardly delicate "Coming of Spring" and will try to contribute something to the walls of the cellar which are now nearly covered. . . .

June 20

. . . Went to J. M.'s and painted in the cellar . . . to Shanley's for dinner. . . . Hardy of the Saturday Evening Post sent me a story to picture. Promised it for July 3.

June 21

Working again in J. M.'s cellar, finished large panel–J. M. leading a soul to the Burning River's Brink. Jim in the character of the "angel of the darker drink" a mirror in the face of the misguided soul–devils rejoicing. . . . In the evening, Dolly and I went down again and I painted a smaller panel. Girl combing hair at a window, a cat on the leads outside. . . . Gregg was there, told Dolly that J. Huneker was thinking of buying a set of my etchings, having seen the set Gregg bought.

June 22

Jerome Myers came in and while he was here–a red headed enthusiast and "hustler" called–said his name was Gray, that he had decided the time had come for a publication in this country like "Jugend" of Germany, that he was thoroughly competent to select the drawings and procure the capital. I mistrust his judgment of good stuff on his general style. Myers had already got Mr. Kent, who is secretary to Roger Fry, Clarke's curator at the Metropolitan Museum, interested in a project to start our scheme of a cheap good picture paper and I feel that it will be best to choose this rather than Gray's scheme. Especially as Myers and I really did the preliminary dreaming on the subject and the proposed name of "The Eye" is my suggestion. Myers took a set of etchings to show to Kent who has shown interest in them. . . . Invited Mr. and Mrs. George Luks to dinner. . . . Mrs. Luks and Fox arrived on timeno George . . . three quarters of an hour . . . we start to dine . . . enter George with so much of J. Moore's convivial sirup inside him that he could scarcely stand. We sat him down and proceeded to fill him with food. Mrs. L. comically indignant. The whole evening amusing and yet how tragic to her who has to live with *[him]*.

June 23

Across the roofs two girls in their night robes clean their few breakfast dishes at twelve o'clock noon. Hanging loose and clinging close to their backs, their gowns are very full of humor of life. With Laubs to Renganeschi's then to Hammerstein's crowded roof garden. Strange to see New Yorkers paying big money to see such a miserable show.

43

June 26

Walked down to the East Side this afternoon, enjoyed watching the girls swinging in the Square, Avenue A. and 8th Street East. A fat man watching seated on a bench interested in the more mature figures.

June 27

Started on the drawings for the Saturday Evening Post. Zenka Stein came in and paid us a call. *[Stein was a fine warm-hearted woman from old Bohemia; a favorite model for Henri who also posed for Sloan—when he could afford models.]* She had on a "such fine blue dress." Got talking to Stanford White, the well-known architect who was shot down in Madison Square Garden by Harry Thaw, millionaire's son. Evelyn Nesbit, his wife, was a model and White, among others, used her. Fox says that White was the kindliest sort of man tho' sensual.

June 28

Went to Jerome Myers' for dinner. Bryson Burroughs and wife were there. We talked over the project to start a paper "The Eye." Myers sold the set of etchings to Mr. Kent, secretary of Mr. Fry, curator of the Metropolitan Museum. Said Kent liked them very much. *[Burroughs was also on the staff at the Metropolitan.]*

July 1

Fox carried the valise, I carried the roll of canvas, the Yellow Portrait . . . to the Ferry House, where I said good-bye. . . . The river is gay with excursion steamers under a blue sky with lumpy white and gray clouds. The air is clear and cool today. Miss Kitty Yoder, Dolly's boarding house friend from Philadelphia (and whose head I made a portrait of about six years ago), called. . . . Dolly took her to Coney Island. . . . I stayed home . . . to dinner at Shanley's, watched the little band of Salvation Army girls at the corner—and work on finishing my S. E. Post illustrations.

July 2

Sent off five drawings to the Saturday Evening Post by Express. Quoted $125. as price. J. Laub went around to the Presby Co. and

44

saw Blackman—have the advertising agency drawing to finish. Wish it was done, am afraid there will be trouble suiting him. Worked on a Puzzle for the Press (Phila.) in the evening. Stopped in New Gallery today and saw work of Van D. Perrine. Rather interesting, some quite so—but rather greasy and morbidly affected looking stuff. . . .

July 3

Sent off a Puzzle to the Press (Philadelphia). Manuscript from Appleton's Magazine arrived.

July 4

Spent the Glorious Fourth at Bayonne with the Cranes and had a very enjoyable time. Croquet games in the afternoon. Moonlight and fireworks over the Bay.

July 5

Saw Mr. Brennan of Appleton's and he ordered five drawings as per a roughout I showed him.

July 6

A caller this afternoon, a lady who asked me if I remembered her. Mrs. Doench of N. Y. now—was Miss Soest in Philadelphia, worked at Newton and Co.'s fancy goods when I was there about 1890—after leaving Porter and Coates Bookstore. I remember how frightened I used to think myself. There were about sixty girls employed—watercolorists, sewers, and pasters on boxes and calendars, etc. I was the only male in the painting room. She says she wants to take up painting Ideal Heads in Oil. I told her what I thought best! *[A. Edward Newton, who later became famous as a bibliophile, had worked at Porter and Coates when Sloan was assistant cashier in this bookstore, which was the Scribner's of Philadelphia.]*

July 8

Went down town to East Houston Street and had a very good dinner at "Little Hungary," a quite interesting place, and Dolly and I felt that we had enjoyed ourselves. Three kinds of wine served in peculiar bottles with a glass "teat" that hang in sacks and pressure at the nipple fills your glass. Expensive tho'. $1.50 each for the dinner.

July 9

On my way to the Astor Library, I met Walter Sedwick, now a M.D. in New York, a schoolmate of mine in Philadelphia High School. Rollin Kirby called. . . . gave information . . . he is the father of a girl baby. Wrote to Chapman of the Quinby Co., quoting him $250. a volume on De Kock provided I got four volumes more to do. A fine pipe from Schofield in Cornwall, England–arrived today. *[Walter Elmer Schofield was a landscape painter.]*

July 10

Stopped at the N.Y. Herald office and saw Morgan. He arranged that I look over San Antonio pictures for Appleton story. Mr. and Mrs. Frank Crane took dinner with us and Mrs. Hamlin, who was Miss Garrett of Landsdowne, Dolly's friend and music teacher, was in town and spent the night. A magnificent thunderstorm in the afternoon, heavy fall of rain, dramatic and beautiful.

July 11

Read Bernard Shaw's plays "Candida" and "Arms and the Man" and was much pleased and entertained and admire the work very much. In the evening, read "Wild Duck" by Ibsen, another great thing and seems more deep in philosophy than Shaw.

July 13

Oh! Lucky combination "Friday" "13" and I am going to work on the Appleton story "Taps to Reveille" if I can get up the steam. Made two drawings, so so. Mr. and Mrs. Jerome Myers came in after dinner. . . . An answer from Chapman's secretary in answer to Quinby Co. letter . . . says Mr. Chapman is out of town till August. A fat bleached blond woman and a thin man with only one hand live in a one window room back on 24th Street. I have rather fancied the notion that he is something of an outlaw.

July 14

Worked on Appleton drawings.

July 15

Kirby came in in the afternoon. Mrs. H. Reuterdahl called and asked us to Weehawken to dine with them. I felt that I should stick to my

work on Appleton drawings, but was easily persuaded to go. We had a pleasant evening.

July 16

A story from Hardy for the Saturday Evening Post, a very good thing to illustrate tho' I felt rather disappointed to get more work–would like to etch or paint. . . .

July 17

Finished up the Appleton story "Between Taps and Reveille." Reuter-dahl came in having shown my etchings, especially "Roof Tops, Summer Night" to Mr. Collier, who said that while he appreciated them himself, he felt that his millions of readers were not educated to that point–which (comment by myself) is all rot–and merely shows that he don't really believe they are good. The people have always taken the best that has been offered. The reason that it's hard to reach the "common people" is that educated idiots in droves block the path–protecting them.

July 18

With Mr. and Mrs. Frank Crane, their daughter Roma and Kent *[George Luks's son]* to Rockaway Beach–our (Dolly's and mine) first visit . . . enjoyed the day very much . . . at the studio about 8 o'clock. Crane and I went out and bought some materials for a cold supper. After which . . . Dolly, who happened to be in the hall, came in the room white faced and beckoned me. I went into the back room and there, smiling . . . stood Mr. and Mrs. George Luks. A comedy drama indeed. I explained as best I could to Mrs. Luks. Mrs. Crane had meanwhile recognized G. B. L.'s voice–consternation. Father and son (Kent) were within five yards of each other. We did not tell George that the children were here and Luks withdrew, and the meeting was avoided. But it might have been unavoidable, if Cranes had not happened to be in the front room.

July 20

Walked down and sat a while in Washington Square. The Saturday Evening Post story by Ernest Poole has part of its scene there. Saw young girls at their lunch hour strolling through the paths arm in arm–benches on either side filled with all sorts of men interested in

them and not interested. Shade of trees, heat of sun, odors of human life and sweat. . . .

July 21

Reuterdahl and wife to dinner . . . gave a very amusing account of the private view of the International Society of Painters, Sculptors, and Engravers Exhibition in London last year. The eccentric "Bohemian" get ups.

July 22

A very hot day and I did not go out save for the Sunday Papers and sat in the Square (Madison) for a few minutes. Worked on two drawings for the Saturday Evening Post.

July 25

. . . I worked on Saturday Evening Post drawing and in the evening wasted my time over a novel.

July 26

Stopped in to see Reuterdahl and Penfield whose studios are next door to me. Penfield and I had our usual mild disagreements on art subjects in general. Dropped in at Mischke's bookshop . . . prints are not sold yet. They have had them in the window. Only appreciable effect being soiled mats from a leak in a heavy rain . . . Made a Puzzle for Press.

July 27

Worked on Saturday Evening Post drawings. In the afternoon Dolly and Mary Kerr went over to call on the Crane's. . . . I dressed and went over for dinner. The mosquitos thronged to greet me. . . .

July 28

In the house all day. This is Dolly's–my little wife's birthday. She is thirty years old and says she's happy. She makes me so anyway–and lives in a garret studio with me–keeps it clean and fresh and home-like and loves me. May she live to see many many happy returns, is my selfish wish.

48

July 30

Sent Saturday Evening Post drawings by express. We went to the Bronx Zoo today, our first visit, and we were much pleased with our afternoon. The buildings are new . . . some are in the process of building. . . .

July 31

A letter from Mother this morning.

FORT WASHINGTON

MONDAY

My Dearest Jack,

Your letter received this morning I did not write yesterday as I was afraid our letters would cross. John and William Starr came out on Sunday. William looks fine, he has now paid up all he owed me. We did recognize my picture in your puzzles. It must have been very interesting to see the big steamer move off. I hope you and Dolly will come to make your usual visit in August. We are enjoying Aunt Nina and Anita's visit very much. Nan says she is awfully sorry but that she can not possibly get off to make your jam this year. We have had a few lovely days really like June but still my neuritis goes on I guess it has come to stay. I hope you will soon be getting some money for all the paintings you have been doing. Well I can think of nothing more to say so with much love to Dolly and lots to yourself from your loving

Mother

August 1

Walked out in the morning and met Davis and Mr. Towne on Lexington Avenue. Towne is editor of "Judge," writes under name of Perkin Warbeck. Hencke came in after dinner and gave me the Mss. of a story to illustrate for Gunther's Magazine, of which he is now Art editor.

August 2

Letter from Mother. My thirty-fifth birthday, not counting the one on which I was born. Tom Daly writes from Philadelphia . . . would like me to illustrate a book of his poems which he is going to get out

in the fall. Pay, if possible, for the work. I wrote that I'd be over next week and see him.

August 5

The papers are making a great fuss over Anthony Comstock's action in suppressing a periodical issued by the Art Students League containing reproductions of drawings from the nude. His objection is, of course, in the main, ridiculous, as all his acts have been in the Suppression of Vice. But the drawings were certainly indecently bad studies made under bad influences, no thought and no effort to say anything but copy, baldly, the model. The N.Y. American has an interview with Everett Shinn in which he says that the drawings are indecent (meaning in the art sense, of course). A man was stabbed on 23rd Street in front of our place this morning, I heard loud groans and jumped from bed. Robbery was the motive, we heard. Caught the assailant.

August 8

Weather cooler. Made a trip over to Appleton's to hurry them up on payment for the last illustrations as we must have funds for our trip home. Made another Puzzle. . . . In counting up today I find that our assets reach $1200, twelve hundred dollars. There are liabilities, of course, but we feel right solvent. Today sent "Independence Square," "Violin Player," and "Woman Sewing" to Dallas, Texas State Fair.

August 9

Received a set of postcards from Gosewisch in Hanover. Have heard from Henri only in this way. Rather dislike the postcard fad. Would rather have had a letter from a friend than a damaged photograph of a street in the town they stop in, or a canceled ink stained reproduction of a painting. Bought a wooden sketch box today and put in the afternoon and evening making alterations in it. I am going to make some tries at outdoor work while in Fort Washington. *[From 1906 to 1911, Sloan made a number of landscapes during his short summer vacations. They are all nine by eleven inches in size, made on a fine-grained linen which he mounted on cardboard himself. Most of them are identified with his Roman numeral code number, which is in addition to the title he kept in his record book and card file catalogue system.]*

Saturday, Feb. 1, 1908

The pictures left for Macbeths in the morning.
Now the time that we have all
waited and worked for months past
is here — Paid Cohen $20.00 on ac. rent
for 7th Feb. After an early dinner I went to Mac.
-beths and assisted in removing
shadowboxes pulling nails and putting
in canvasses. Later on Lukes came
then Lawson Henri Prendergast and
Glackens

Finally the deed was done and we thought
it looked well — what the critics
or art reporters may think will probably
be awaiting matter.

Byron Stephenson's article in the Post came
out and is pleasant chat.

After the hanging Lawson Lukes Henri Glack
Shinn and I went to the "Tavern" a cafe
which is fitted up in an oldfashioned way and
there held forth over ale till we saw
by such hints as turning out lights putting
up chairs - barkeep putting on street togs Etc.
that our departure would be appreciated
Shinn had left before. and we were
then by Glackens treated to oysters across
42nd St. whence we bought a dimly
lit side entrance on 41st and having now
dwindled to three Lukes Glack and myself
had a "night cap" and parted

This last saloon was interesting and
was evidently an under cover sort of place
saw two officers of the Police these blue
coats and brass buttons and red typical
faces strong against a gray wall paper
with color prints of fish. as they sat
behind a screen

Sunday, Feb. 2, 1908

The Herald prints five pictures today
I had furnished 8 and am sorry that
they did not use all — the article is
non-committal

Dolly made a trip across the ferry to see
Mrs Dawson from Philadelphia who is on
her way to Brooklyn on a few hours visit

After dinner Dolly and I were reading
which was interrupted about 10 oclock
by the appearance of Henri and Lawson
Henri seems quite nervous over the ex
hibition, his manner was very nervous,
they sat for half an hour or so and
then went to visit the Shinn's

Lawson Lukes and Glackens had gone
to the Pen and Brush Club and been
received by the ladies of that organ-
ization - an honor which Hen. Davies
and myself had declined - as Dabo
was promised — but Lawson says that
Dabo was not there - and that the
affair was pleasant enough.

February 1 and 2, 1908, diary pages

EVERETT SHINN

WILLIAM GLACKENS

JOHN SLOAN

GEORGE LUKS

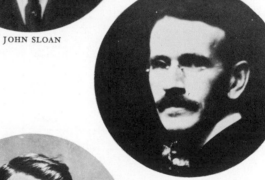

ARTHUR B. DAVIES

ERNEST LAWSON

MAURICE PENDERGAST

ROBERT HENRI

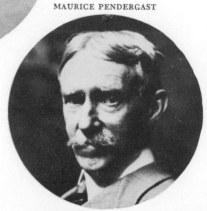

The Eight

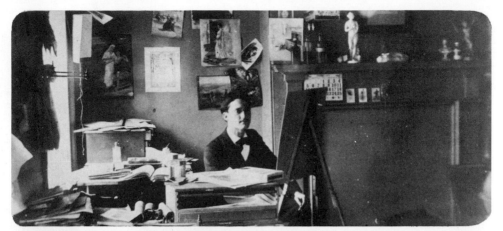

John Sloan in his studio: 1892–93; 1895; 1950 with Helen Farr Sloan

John Sloan and Thomas Anshutz

Robert Henri and William Glackens

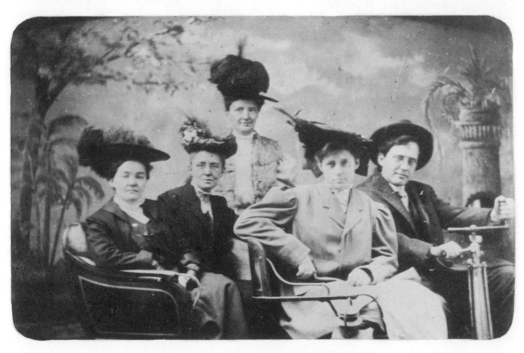

Sunday, October 7, 1906, at Coney Island

Cousin Eleanor Sloan,
her mother Mrs. Albert Sloan,
Dolly Sloan and Mrs. Lee, Henri's mother

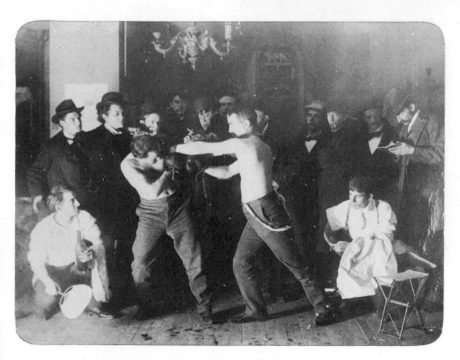

George Luks in prize fight

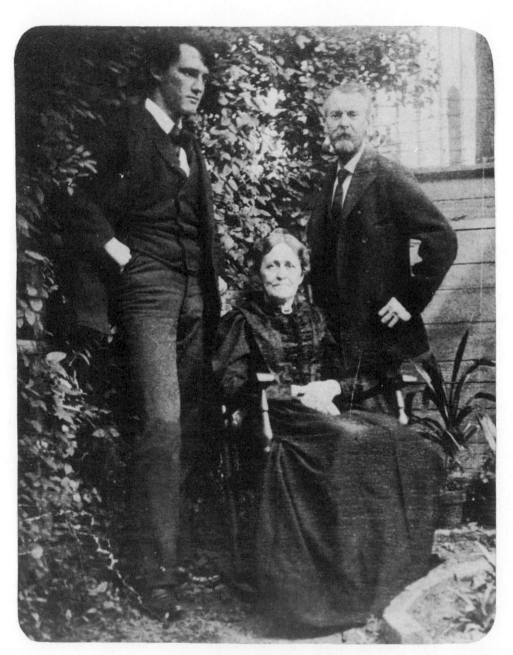

John Sloan and his father and mother

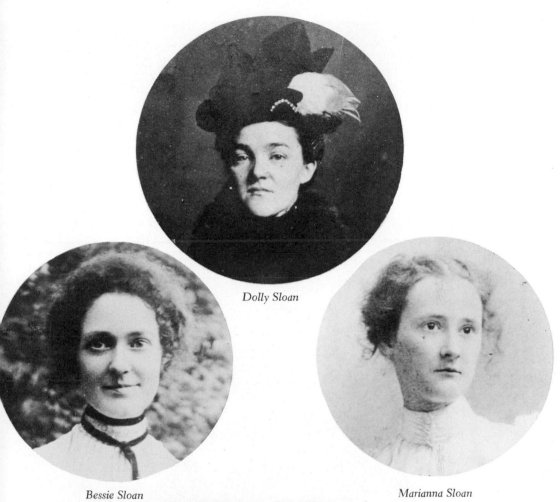

Dolly Sloan

Bessie Sloan

Marianna Sloan

John Sloan's mother, December 25, 1906

John Sloan, 1950

August 10

Getting ready to go to Fort Washington today. We arrived in Philadelphia, changed cars and got to Fort Washington in the afternoon. Had a nice dinner with vegetables from the garden.

August 11

Made a try with my sketch box and find it quite a new thing to paint outdoors. My work of this sort has usually been of city subjects from memory. Can't say that my attempt at the chicken yard back of the house was successful. Went over to see Tom Anshutz. The Derby Summer School at Fort Washington has been quite full this year and he has been busy. . . .

August 13

Went into Philadelphia and tried to see Daly about the Poems he wanted me to illustrate but he is on his vacation. . . . Hardy of Saturday Evening Post is away also. . . . Met Magraw who has left Press and has just returned from a trip to Europe with his "rich wife."

August 16

Went in to town. . . . Nan expects Miss Anita Sargent, a cousin of John S. Sargent, the painter, and a painter herself. She has been in Europe the last five years–Was a friend of Nan's at the School of Design for Women, Philadelphia. I think that the influence of Daingerfield at this school has probably hurt the working out of Nan's better self. . . .

August 18

These are days in the country and one much like another. . . . Dolly, Bess (my older sister), Miss Sargent and I called at Anshutz's. Mrs. A. was charmed to have "somebody's relative" of the party–"last and not least, Miss Sargent" in introducing her. Anshutz says that he hears that Calder, who went to Arizona with tuberculosis, is better and in Los Angeles. Thinks of taking up his work again.

August 19

Jim Fincken and Mr. Bower called to see Nan's work in the afternoon. Dolly and I called on the Breckenridge's this evening. . . . In

59

conversation Trask *[of the Pennsylvania Academy]* asked Brecken-
ridge who should be his choice for painter of E. H. Coates portrait
for the Academy. "Sargent," says Breck. "Henri," says Dolly Sloan
and I chime in.

August 24

Started a new drawing of Mother on tissue paper for tracing on plate.
Laid ground on plate under difficulties on the kitchen stove–they–
Dolly and Bess–were ironing clothes and as there is no gas in the
house, I was forced to use the uneven heat of the stove. Consequently
when in the evening I was ready for the first biting my ground proved
burned in places so I just let the acid bite away, hoping to fix at
least a start on the plate. *[The preliminary drawing for an etching
was made on tissue paper, which would be impregnated with paraffin,
becoming transparent, so the drawing could be traced on the grounded
plate in reverse. Then the print would face in the direction of the
original drawing. "I don't usually like a perfect study, it doesn't leave
you free to draw with character–you tend to imitate rather than to
invent the lines which are to be bitten with acid. Then the transla-
tion of tonal shading made with the pencil, into hatching and cross-
hatching–requires careful study of the right types of linework.... I
am not a great technician, but I have a great deal of patience in re-
working passages of drawing or linework that don't satisfy me."]*

August 25

Went into town and had Peters prove my plate of Mother. It may
go on all right but the bad ground laying will cause me much labor
in correcting wild bitings and over-bitten portions. Daly is still
away....

August 27

Today Dolly and I left Fort Washington. Mother seems to be some-
what better in health. Dolly stayed with Nell Sloan in Philadelphia
and, after seeing Dr. Bower, who gave me some medicine for blood
disorder, I came to New York and opened up our little attic. Am
glad to be home in this great life full city. I spent the evening in
trying and finally succeeding in balancing my bank book. I found
that I, in my account, was mistaken by $100. or more–errors in fig-
ures made my account greater than the bank's. This is a blow. Wrote

Daly in re his poems. Said I was rather busy–to handle speculative work.

August 28

Arise at nine-thirty and it took me till 12 o'clock to dress, bathe and the pottering which the absence of Dolly seems to make me do. I seem to feel aimless without her. She has a dear way of keeping me going ... see Reuterdahl ... tells me the joyful news that Howard Pyle has stepped down from McClure's. ... *[Sloan felt that Pyle favored his own pupils.]*

August 29

Met Mrs. Hencke on the street. ... After dinner Hencke and she and I went around to their place on 21st Street and I spent the evening. ... Hencke handed over a Mss. for me to illustrate for Gunther's Magazine.

August 30

Jim Preston came in this morning. He returned from Paris Saturday. Mrs. P. is still on the other side. ... Worked on etching of Mother this afternoon and evening. ... Went up to Madison Square and took a look at the crowds waiting to see and hear W. J. Bryan who is being welcomed back from his "Trip around the World." He seems to be the Democratic nominee for President in 1907 or is it 1908? I dunno.

August 31

Arthur J. Elder of London, late of San Francisco, shaken from his studio there in the disaster of April last, came in with a card of introduction from A. Koopman who lives in London ... seems to be a decent sort. ...

September 1

A letter from Henri at last. In Madrid. Says: he is painting a Bull fighter, Gypsy, Dress maker type–girl of street type, and a Spanish officer in uniform. That he is not going to Paris with the class but will sail sometime about October 1st (indefinite) from Gibraltar. Says he has a book of Goya's etchings for me. ...

September 5

... Started on drawings for Daly's Poems but was interrupted by Hardy arriving from Philadelphia ... dined at Café Francis. Saw J. Moore first time for many weeks. Left Hardy at Mouquin's. ... Waited his home coming having asked him for the night. He came home at 1:30 a bit "phazed."

September 6

... Hardy went over to see the McClure's. ... Reuterdahl brought Albert Sterner in and he wanted to see my etchings. He spoke very appreciatively of them. Said it did him good to come into a studio where the work was free from Commercialism. It must be true–not much commercial value. ... Told Schrag's man *[the landlord]* that I'd sign a lease for next year provided some painting, etc. were done. ... *[Albert Sterner was a skillful portrait painter.]*

September 7

Schrag, the Real Estate Agent of the property agreed to my list of painting and repairs to be made at 165 W. 23, "Our Garret," so I signed a new lease. Worked steadily on drawings for Daly's Poems and finished several.

September 9

Sat in Madison Square. Watched the Throbbing Fountain. Think I'll soon tackle a plate on this subject. The sensuous attraction of the spurts of water is strong subconsciously on everyone. Made another Daly drawing.

September 10

Expressed drawings to Daly in Philadelphia. Expect Dolly back tonight. ... Met Dolly ... Jersey City. She looked very pretty to me and we were mutually glad to see each other.

September 11

... Tom Daly came in. Had not seen the Drawings as they had not yet arrived ... we had a talk over the size and placing of the cuts. Suggested a frontispiece etching and he jumped at the idea. ...

62

September 12

Peters, the plate printer, called . . . said that Daly had seen him and given him the order to print the plate for frontispiece. After dinner Jerome Myers called. He is certainly a good fellow and likes me. . . . Dolly and I went down to the Lower East Side about 10 o'clock this evening and saw some of the interesting life at night. I wanted to see material for the Daly frontispiece, which I made a pencil sketch for on our return at 12 o'clock. . . .

September 14

Finished the plate for Daly's Poems and after making a few proofs took it downtown to 23 Barclay Street to have it steel faced for printing. . . . I spent the afternoon in an attempt to find some pictures of Chicago Slums for use in the story which I have to illustrate for McClure's Magazine.

September 15

. . . Joe Laub paid me $20. on account for the "Ad" drawing that I helped on. Letter from Tom Daly expressing his satisfaction with the drawings. I wrote to him and sent back his galley proofs.

September 16

. . . Made some rough sketches on the "Debts of Antoine" story for McClure's.

September 17

Took sketches to McClure's. Saw Russell and he approved them. Showed him two water colors of Nan's which he said he liked but could not use. Stopped in at Mischke's and he gave me the immense pleasure of looking at a number of volumes (12) containing the Daumier, Jacques, Gavarni, etc. lithographs from Charivari. Wants $150. for them. Wish that I could afford the purchase. . . . Dolly and I called on Myers on 59th Street and had a pleasant call.

September 18

Arthur J. Elder of London . . . showed me a lot of his work, mostly in poster lines. . . . "Stein" came in and entertained us in her usual amusing way. Her chance acquaintance with Le Gallienne *[Richard]*

was most romantic, at least on his part, according to her . . . she didn't know how celebrated he was. This afternoon . . . Mr. Cartwright, Art Editor of "Times Magazine," which is one of the new ones in the field, called and asked me to undertake a story, Christmas Memories by Ellen Terry. Said that Jimmy Preston had sent him to see me. . . .

September 19

. . . I made a few sketches from Stein who came before lunch. Then painted her leaning against the etching press in the dark corner of the room. Got a very good thing, I think.

September 23

My usual walk around to Broadway for the Sunday papers, followed by an hour or so seated on a bench in Madison Square. Watching the summer die, watching the fountain pulsing and jetting with its little personal rainbow gleaming and fading, coming and going in the sunlight on the spray.

September 24

Went to Gunther's Magazine to see about collecting my bill. Hencke said I had better write a stiff note to them, which I did in the evening, enclosing a bill for $225. for the two stories. Worked in the afternoon and evening on McClure drawings. Proofs arrived from Daly in Phila. They look pretty fair *though far from perfect* reproductions. Two or three of the drawings seem to be good on second sight of them but the whole lot were done too quickly (I suppose) to be important.

September 25

Went to Gunther's today and not yesterday as I remember on second thought. You see, I let this record get three or four days in arrears and then have to hark back with Dolly's assistance. Bought a book with fine (halftone) reproductions of some of Rembrandt's etchings at Brentano's, Broadway and 14th Street. Then bought tickets for Mme. Kalich, in the Kreutzer Sonata. Dolly and I went to the Theatre after dinner at Shanley's for a treat. We turned the day into a gala day in miniature. The play was thrilling and terrible, but not great. Kalich is a Yiddish Actress. The play a translation from the Yiddish. She's good.

September 26

Cleaning day... Joe Laub came in. Looked through my four parts of Audsley's Ornamental Arts of Japan and took it up to Mischke's for him to see and appraise with an idea of a possible bargain so that I may secure the Charivari Lithograph volumes which I so long for, and really cannot afford to buy....

September 28

Sent entry blanks to Chicago Institute, entered "Coffee Line" and "Foreign Girl." Went out 23rd Street to Mischke's and closed with him on the "Charivari Lithographs." Sent him a check for $60. on account. Delivered the "Antoine" drawings at McClure's Magazine and Russell seemed very much pleased with them indeed....

September 29

...rose early and went with Joe and Mrs. Laub and Hattie Laub, sister of Joe's to Englewood. Miss Lawrence met us...up hill walk through a pleasant old town to her uncle, Mr. John Ditman's residence...a beautiful estate, most comfortable and elegant house with bad pictures on the walls, so homelike bad pictures seem to make things...took a three seated station wagon or bus to Croton Point on the Palisades–here we picnicked for the afternoon, ate our lunch on those terrific old cliffs–to look straight down at the wooded shore below you–the trees seemed to be mosses. It made my head swim. The Hudson River below us spreading down to New York Bay, the Spuyten Duyvil emptying into it just opposite, the distant Long Island Sound and Connecticut beyond. We walked back stopping at a curious place Helicon Hall built by a Rev. Dr. Craig as a school for wealthy sons but a failure now...for sale it is $75,000 with land....

September 30

Spent the evening gloating over my Daumier lithographs. The twelve volumes contain nearly eight hundred of Daumier's best....

October 1

Having only carried home eight volumes of my recent acquisition (Charivari) I stopped at Mischke's and brought away the balance.... Met Jerome Myers on 23rd Street and he came down to the studio

with me and Dolly asked him to share our small lunch. Arthur Dove called in the afternoon later and I showed him some of the Daumiers. He seems to be a nice sort of young chap. *[Arthur G. Dove was to become one of the "Stieglitz Circle," a group of young moderns, influenced by European innovations before the Armory Show of 1913, who were sponsored, shown, and encouraged by Alfred Stieglitz.]*

October 2

"Coffee Line" and "Profile Stein (Foreign Girl)" were called for and go before the jury for Chicago exhibition. Dolly received word from Nell that her mother (Aunt Mary) will come over to visit us on the three o'clock train this P.M. Dolly went over to meet her in Jersey City. In the evening we took Aunt Mary for a walk on Broadway to 42nd Street, then a subway ride down to the Battery. We walked through Battery Park which was extremely lonely. Returned by way of the Bowery and Third Avenue.

October 3

... Went around to Proctor's Fifth Avenue Theatre and saw Mrs. Langtry in a one act Tragedy, a "Tabloid Tragedy" as she is said to call it. She is over fifty years old but beautiful and so attractive it seems impossible that she could be that age. ...

October 4

Dolly had Mrs. Rothermel, Aunt Mary's sister from Duluth, to lunch. She is in New York establishing her daughter Eleanor in the Horace Mann School. ... After ... lunch, we all went over to Crane's in Bayonne ... got back at 7 P.M. and Dolly "made a few passes" in the kitchen and behold an elegant steak, cocktails, claret, cheerful meal. ... Took Mrs. R. to the subway. Strolled back, watched the searchlight from Madison Square Garden scratching the belly of the sky and tickling the buildings, glaring in the eyes of the promenaders.

October 5

Drew a Puzzle for the Press and sent it off ... to bed early in order to catch some sleep in advance for my trip with Crane to see the Motor Races for the Vanderbilt Cup. ... Dolly took Aunt Mary to the Hippodrome. I got up at 1:30 A.M. ... Have often gone to bed later than this but I never got up as early ... Started out to meet Crane

and the others at a café on 6th Avenue.... Bought R.R. tickets from speculator to avoid the crush and gain time. Got the 3:30 A.M. train in Long Island City. Crowded, jammed, all the roads in sight from the train a steady stream of automobiles with their lights glaring. An hour's ride ... to Westbury, L.I. Here the roads were crowded in the foggy night with an army all bound one way ... autos so thick we had to pick our way through them ... dawn commenced ... and unveiled the crowds. We found a place to stand, the start came at 6:15 A.M. Each car came up sputtering flame and firing broadsides–leaping away. After we had seen the start we walked along the course toward Jericho turn. Amusing incidents all along the road. Now and again the shout "Car Coming!!" The foolish people thronged the road ahead of the cars leaping back just in time to save their craning necks. Such speed I never saw to this day. No doubt the future has greater speed in store for those who then will be alive. The French drivers are wonderful though the fastest "lap" was made by Tracy, an American. Wagner won the cup for France. One spectator was killed by Shepard's car, one out of 250,000 is not a great percentage when the foolhardiness of thousands is taken into consideration. A girl full of figure in a tight white sweater was one of the incidents of the day. She was as much of a show as the cars. The road was dotted with crooks with gambling outfits, vendors, etc. All the trains were crowded back to town....

October 7

Slept about nine hours or more. After breakfast Mrs. Rothermel and her daughter Eleanor came and we all started for Coney Island as they had never seen that resort. It is late in the season–it's over in fact—but we all had a right good time. The day was chilly. We had several warm drinks, a dinner of oyster stew, our photos taken, started home about 5 o'clock. Dolly had broiled chicken for dinner. After dinner I took Mrs. R. and Eleanor R. to the subway station.

October 8

Made a drawing for the "Times Magazine," new publication of which the first number appears in November. I have six to make for the Christmas number. On Saturday last the first number of another new weekly appeared, "Ridgeway's" published by the firm that produce "Everybody's" Magazine. Letter from Henri:

Dear Sloan,

I expect to sail back about the 8th of October. Can't say for sure, it is a matter of getting the berth–it is likely I will get it all right. In that case I should arrive about the 18th, possibly the 17th. Have been very busy lately since the hottest weather passed and could have a lot of things that would carry me on for some time with most interesting subjects if I would stay. I hope to do a bull fighter and a Spanish dancer this coming week– have done one of each of them already–am anxious to do others of them –you have already heard of the bull fighter Asiego–the dancer is La. Reina Mora one of the successful dancers of Madrid–rich (for a dancer) thousands of dollars in costumes, etc. I have done one large full length of her which I think is a good one and did also a small 26 x 32 of her to give her–the latter turned out fine–think it is one of the best pictures that size I have painted. Am sorry to leave it behind but am glad it is a good one I am leaving. They have all been ready to do a lot for me, and I have filled a very pleasant position among this group of Spaniards and can say of them that they are an awfully fine set of people.

I suppose Connah has asked you to take my place at the school and hope you have taken it.

I will let you know as soon as I know precisely the date for my homecoming.

With best wishes to Mrs. Sloan and all.

YOURS,
Henri

October 10

Walked down to 14th Street and went in to see A. Hencke to find out why my bill has not been paid by "Gunther's." He says they promise to pay on the 12th Oct. Working on fifth drawing for Times Magazine. "Helicon Hall," which we saw on our trip to Englewood has been secured by Upton Sinclair and a small community in order to try out a plan of common interest, Housekeeping to solve the "servant girl problem." Sinclair is the author of "The Jungle" a book which has caused a great investigation of the Packing Business in Chicago (according to the papers at least).

October 11

Bought the first coal of the season today–a flutter of snow early in the morning (we are told). *[There was a coal stove in the studio–the rest*

of the apartment was heated by fireplaces–lighting was by gas.] Miss
Lawrence here . . . for a day or two. "Stein" called . . . says that Glack-
ens and wife are back. . . . Delivered the drawings to the Times Maga-
zine today–approved by Cartwright. Sent bill for $150. "Canzoni" by
T. A. Daly by mail today. Etching and illustrations mine.

October 12

In the afternoon . . . to call on the Glackens's. W. J. was out, the place
upset as they have not yet settled properly. Mrs. G. was very cordial
and as usual full of her wit of expression. I think she liked Miss
Lawrence. . . . Stopped in Waverly Place and saw Everett Shinn and
Mrs. S. Shinn has painted a large ceiling among other things this
summer past. . . . Stayed at home in the evening. Miss Lawrence
laughing over every page of the Charivari lithographs. George Fox
had come in early in the day on a flying trip. Brought a very small
water turtle with him and gave it to Dolly. The pet, small as it was,
has proved too much for us. We had a terrible hunt for it on our re-
turning from Glackens's. Moved the whole place and found it behind
a trunk.

October 13

Started a Puzzle in the morning. . . . James B. Moore came in and
hauled me up to the Francis for lunch. There I met Glack. He tells
me he bought a Louis & Co. pipe for me in London. I like his thought
of me. Says he has about five things painted in Spain this summer.
Dove came in. . . . we all went to 450 West 23 (J. Moore's house)
and played shuffleboard and shot at target with a pistol. Took Miss
Lawrence and Dolly to dine at the Francis where Hardy turned up.
He has left the Saturday Evening Post now and is unattached. Home
about 9 o'clock where I finished and mailed the Press Puzzle. A fine
free day.

October 14

Up early and I went across the Ferry and saw Miss Lawrence off to
Englewood. She took the turtle away with her. Walked over and
bought the Sunday Press and other papers. On the way out 26th
Street I saw eyes between the slats of shutters and soft voices called
me. A good subject for a plate. . . .

October 15

Put in the whole day working and polishing the studio floor. Much pleased with the result. Mrs. Crane came in. . . . Mailed my entry blank to Chicago, having mislaid it and forgotten all about sending it earlier in the month.

October 16

Today I made a book shelf for the front room, for the accommodation of the Charivari volumes and magazines, etc. In the afternoon . . . Dolly to Weehauken to call on Mrs. Reuterdahl. I was invited to come over to dinner. Miss Hoch of Duluth is still there and will pose for me tomorrow. . . .

October 17

Miss Hoch turned up about 2:30 P.M. and as the days are growing very short I put the blame of an unsatisfactory start at a portrait on this fact . . . a letter for Henri to his Madrid address came today forwarded from Spain which proves that he has left for home.

October 18

Miss Hoch came again today and posed splendidly for me for about five hours and I'm afraid I have not caught her yet. On toward dark, after Miss Hoch left a voice in the hall says, "Have you heard that Henri's back??" His own voice! Dolly and I made a rush and in a few seconds he was sprawled out on the couch in his accustomed pose and in five minutes it seemed as though he had never been away. Seems to have enjoyed his summer in Spain very much. He was persuaded to stay to dinner and left about 10:30 P.M. A happy event indeed.

October 19

Entered "Roofs, Sunset" ($500) "Picnic Grounds" ($250) "Fraulein S." *[Stein and Press]* for the Fellowship Exhibition of the Pennsylvania Academy of Fine Arts. Henri dropped in for a little while . . . wondering where his next studio will be. He very much approves of the picture of "Stein in the Corner" by the etching press. Scratched out my bad attempt at Miss Hoch.

70

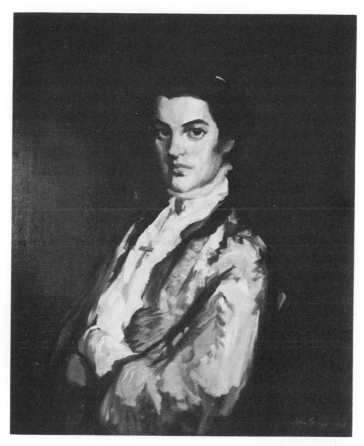

"Miss Hoch," 1906

October 20

Miss Hoch posed until 1:30 P.M. when Mrs. Reuterdahl and Miss Blommers called and took her and Dolly out to lunch at an Italian table d'hôte in the neighborhood. I went on after . . . and think I have at last got a good head started. I feel much better about it at any rate. . . . To Crane's on the 5:15 train . . . had a fine German sort of dinner and a right good evening punctuated by too many highballs however. Dolly stayed for the night but I came home . . . so that I might get a proper night's rest before working on my proposed portrait of Mrs. Lichtenstein. . . . Have decided to stop drinking in this life.

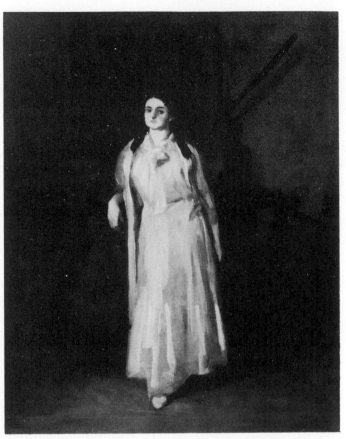

"Stein and Press," 1906

October 21

As usual bought my Phila. Press on Broadway. When I returned . . .
a messenger had left a note from Mrs. Lichtenstein begging off on
her pose . . . invited us to take lunch with them on Tuesday at the
National Arts Club in the old Tilden Mansion, Gramercy Square . . .
previous engagement with the Reuterdahls. . . . Stretched a canvas
and in the evening, after dining at a café on 6th Avenue, Dolly read
and dozed and I made and mailed a Puzzle.

October 22

Miss Hoch came in and I got to work again on the portrait. Henri
came in and brought the three Goya Etching Collections, "Capri-

chos" "Disastres" and "Proverbios." They are great additions to my "collection" and I feel so good over his kindness. He took lunch with us after which I started to work again.... Henri and I took a long walk in search of a studio for him. Found nothing ... thinking of going into the Bryant Park Building ... a rent of $2500. per year rather staggers him.... H. took dinner with us. Dolly prepared a nice meal ... a nice time for our little family of three. Felt the absence of Linda Henri from among us. Letter from Daly enclosing notice of the book.

October 23

Miss Hoch posed again today and I again failed to paint her as she should be.... Brought Dolly a beautiful bunch of carnations.... At dinner we had also Mrs. Reuterdahl, Miss Blommers. After dinner, Bayard Jones, W. L. Jacobs, and Mr. Benson (who I met for the first) and Mr. and Mrs. Crane.... a very nice evening. They all looked at my Charivaris and the Goya's which Henri gave me.... Reuterdahl handed Dolly a fine bouquet of roses. Flowers are certainly graceful gifts. I never seem to think of them for that purpose and yet I always appreciate the kindliness of thought when they are given to Dolly.

October 24

This morning went to Appleton's and met Mr. Lopez and Mr. Ullman. I am to meet Ullman [*Albert E.*] tomorrow evening and go to an Italian Opera performance on the Bowery to make sketches for an article which they have written for Appleton's. Miss Hoch came in the afternoon and I think I have a fair start at last. It being a rainy day the light failed after an hour's work....

October 25

Miss Hoch posed and I went on with the portrait. Think it is on the right way now. In fact am quite pleased with it. Henri called. Mr. Ullman, who is one of the authors of the Appleton's Italian opera story called after dinner and we went down to the Peoples Theatre in the Bowery and saw three acts of Rigoletto. He is (Ullman) a very interesting fellow, a newspaper man once on the North American, Philadelphia. He took me to an Italian restaurant on Grand Street as we were too late for the marionette show on Mulberry Street.

Stopped in at the old Occidental Hotel on the Bowery, a house with a shady reputation although Sullivan and another big politician live there. An air of old time hangs about the place . . . a painting in the bar. Ullman lives at 5 East 8th Street. Met the manager of the opera, D'Amato, who is in the license bureau of the city, a type of the "self made" politician who started as a bootblack.

October 26

Got up late and Reuterdahl came in accompanied by a Mr. Hight of the Youth's Companion Weekly paper of Boston, Art Manager. I showed him some of my proofs and he said that he'd probably have something for me to illustrate. Reading McClure's and American Magazine. In the afternoon, Miss Hoch came and I did a little work on the portrait. . . .

October 27

Went up to 42nd Street and stopped in the Times Magazine where I got a set of proofs of the Ellen Terry Memories illustrations. Also stopped in at Appleton's–met Mr. White. Home to lunch. . . . Ordered a new suit of clothes. . . . Kirby came in, he had been hunting for me next door and Dolly had sent him to Reuterdahl's. The Evening Sun Book Review column today notices "Canzoni" rather disparaging Daly's verses but speaking too well of my work. The Mail on the other hand gives Daly a very nice puff, and prints one of the drawings.

October 28

Rose rather late . . . had to take quite a walk to get my Sunday papers. A fine cool day with big gray clouds. In the afternoon Henri came in and approved of my Miss Hoch portrait, said very nice things of it. Dolly went out to call on Mrs. Ullman but found them to be out. Henri stayed to dinner and I finished up a puzzle and mailed it. He showed us some amateur photos of some of his paintings done in Spain. They seem to indicate big things in store when the pictures arrive. Henri has leased the Bryant Park studio, rent $2500. I know he will come out all right for he always moves ahead. *[This studio building overlooking the park behind the New York Public Library, 42nd Street, is one of the few left in New York. Henri was always secretive about his financial affairs. Sloan thought he probably had*

74

money from his father (Mr. Lee, who ran a very successful real estate, business in Atlantic City), as well as the income from teaching and portrait painting.]

October 29

Went down town and bought some cardboard on Bleecker Street. Miss Hoch came in during the afternoon and I put one or two little touches to the portrait. It is now finished. Reuterdahl stopped in on me with a lady from the Chicago Record Herald, Miss McDougall, who looked at some of my work and talked with the knowing stupidity of the average Art Critic. Said that artists might, by the titles of their pictures, point out their motives to the public. She referred to Whistler's "Nocturne in Green and Gold" or some title of that sort. I told her that my "Girl in Studio" would then be "Effect of Light on Stout Healthy Wench." Don't sound so bad, though, after all. Might try it! Mr. Ullman came in late in the afternoon with a bunch of chrysanthemums for Dolly.... Invited us to the Vaudeville Show at Proctor's and called for us with Mrs. Ullman, who is a young woman with a full female forehead and very gentle and pleasant. We enjoyed the show very much, a song very well sung and very funny, "And I lost Another Chance to be a Hero!" Also, "Are You Coming Out Tonight, Mary Ann?" After the theatre, we brought them to the studio and had tea and crackers and talked till nearly 2 A.M.

October 30

The painter came today ... coat of paint in the front room. Henri came in. ... Got a start on the Bowery Opera drawings for Appleton's. Two of Henri's pupils at the New York School of Art called while Henri was here, very nice girls. Kent Luks Crane also stopped in rather hoping to stave off our dinner tomorrow evening as he, I knew, would have liked to have us, as well as Crane or Mrs. Crane, home tomorrow evening Hallowe'en.

October 31

Worked on Italian Grand Opera story illustrations. Mr. and Mrs. Ullman and Mr. and Mrs. Crane to dinner in the evening. They brought a Jack o' Lantern in honor of the day, Hallowe'en. We had a very pleasant evening.

November 1

Sent statement ($225.00) to Gunther's Magazine, saying I would put the account in lawyer's hands by the 10th of Nov. Sister Bess, who has been with Mother's cousin, Grace Priestley (Mrs. R. W. Carroll) *[daughter of Alexander Priestley]*, in West New Brighton for a few days, stopped with us on her way home to Fort Washington. . . . Saw her on the Ferry to Jersey City. Nan says in letter she is wanted home. In the evening, we went . . . to Ullman's . . . thence to the opera on the Bowery. "Ernani" was on and the music was very good I thought. After the opera . . . to a Chinese Restaurant . . . stopped in Ullman's apartment and talked. Dolly and I walked home arriving about 3 o'clock A.M.

November 3

. . . Kirby came in and I arranged a lot of etchings to take to the Lenox Library Collection as they requested some months since. W. J. Glackens and Mrs. G. came in in the evening. Mrs. G. looked very pretty and was handsomely dressed as usual. . . . Glackens is on the Pennsylvania Academy of Fine Arts Jury for this winter's exhibition. Redfield is Chairman.

November 5

Walked up to the Times Magazine, 42nd Street, and saw Mr. Franklin, the cashier. He says he is going to send me a check at once. Got my suit from the tailors . . . seems to be satisfactory. Henri was out when I stopped at the Bryant Park Studios. In the evening I got to work on the Opera Story pictures for Appleton's. Hardy came in to sit a while but as Henri also dropped in, we talked till quite late, an extended argument on the ethics of bull fights was the principal topic.

November 6

Today is election day and the interest is particularly great. Hearst millionaire, who through his newspapers declares himself the champion of the common people, Hughes *[Charles Evans Hughes]* who was chief inquisitor in the Insurance Investigations: the goal, the governorship of New York State. Dolly and I walked up to Bryant Park Studios and found Henri in . . . helped him move beds and other furniture about. He is not satisfied with the light in his studio, it is

76

very large but not clear enough glass. After dinner we went down to Jim Moore's for an Election Night festivity. . . .

November 7

We got Henri up and fed him and started him off to school . . . walked over to see the young bookseller, Mr. Harbison, who is on 23rd near Lexington Avenue. He has a set of my etchings, having been with Havens and taken the set that I had left on sale there. A young lady spoke to me in Harbison's, asking me if I was not Mr. Sloan. She said she was opening a gallery in connection with the New York School of Art in their new building, 80th St. and Broadway. Wanted my etchings on sale, to which I agreed. Her name is Miss Meade. Stopped in Mischke's. He showed me a new volume of caricatures on Women by Fuchs, a German work of which I have already the first three volumes. I took it and also nineteen lithographs, 18 Daumier and 1 Gavarni. In the evening . . . a pleasant time at Ullman's. He told me of being hard put a year ago in New York and getting a job in store windows acting as a tramp drawing crude pictures. Very plucky, and he goes up another notch in my good opinion.

November 8

The Penn. Academy Jury has Glackens on it, which is fine, but oh, the rest of the list is out today. Redfield, chairman, De Camp of Boston, Benson of Boston. Oh the poor Boston Brand of American Art! Childe Hassam, who owes debts of kindness to last year's Juries, Julian Story the temporary Philadelphian. Oh sad outlook! Redfield on the Hanging Committee!! S'death. *[Joseph De Camp, Frank W. Benson, and Hassam were of the "older generation," having been members of the group known as "The Ten" who exhibited in 1895 —primarily as American Impressionists. Redfield was a follower and admirer of this group and not sympathetic to Henri's "school."]* In the afternoon to the New York School Gallery, saw Miss Meade, met the brother of D. J. Connah who (D. J. C.) owns the school. Left a japan set, a plain set and three "Memories of Last Year," one framed; on sale. Then walked across the Park which is very beautiful now. People on horseback for various purposes, reducing their fat etc. A whole lot of subjects which should be etched. And so across to the Lenox Library. Met Mr. Weitenkampf who is in charge of the print collection and handed over to him as a gift to the City Library 58

proofs of various plates. Got home and found E. W. Davis who has resigned from "Judge" Co. He stayed to dinner and Potts came in. We were glad to see him in our little circle again.

November 9

Went to Gunther's Magazine and Hencke said that Mr. Gunther says that I will be able to get a check on Tuesday 1 P.M. Davis at the studio when I returned . . . stayed to lunch . . . has a scheme to get rich. A chewing gum laxative . . . still on a hunt for a capitalist to back the scheme. . . . I got a start on the Bowery Opera drawings and before bedtime I had made four more.

November 10

Dolly put up 13 jars of quince jam today. Kent Luks came in and I tried to get a start on a portrait of him but he is just at the age when a boy is very trying so that I finally quit in despair . . . took him out to dinner at Palmer's. . . .

November 11

Kent Luks came over about 11 o'clock and I tackled the portrait again in the afternoon. It grew so dark, being a rainy day, that I let him go before 3:30 and don't feel very much pleased with the work. After dinner I made another Opera drawing for the Appleton story. Then as I had received a telegram "Rush Puzzle" I started in at 11:30 to make one, finished it about 1:30 A.M. Went to bed very tired with my day's work. Dolly read to me while I was working.

November 12

Dolly got up early and mailed the Puzzle to the Press. I cleaned up Appleton drawings (Opera on Bowery) and took them up town. Mr. White, the editor, was very much pleased with them and, as he had attended one of the performances, I felt right good over it. Billed them at $225.00. Dolly and I went out to Palmer's for a cheap dinner. . . . In the evening Mr. and Mrs. Ullman called for us and took us to Proctor's Vaudeville. A Creole dancer and an Octoroon were perhaps the most interesting. . . . After the show Dolly spread a nice lunch and Ullman as usual entertained us with his talk. To bed at 3 o'clock A.M. which signified . . . Ah Me!

78

November 13

Up at 11 o'clock with Davis outside waiting. . . . Dolly made a lunch and breakfast combination. Henri joined our party and Hardy dropped in. . . . Davis, Henri and I started down town together. I went to Gunther's and they came up with a check for my drawings at their rate $135. (signed A. C. Gunther Pub. Co., E. L. Gunther V.P.–Mrs. Gunther). Davis and I walked up 5th Avenue to Keppel's where we saw a fine lot of Rembrandt's etchings. In the evening Mrs. Ullman took dinner at Palmer's with us and Ullman joined us . . . went to Yonkers to see a performance of a cheap show in which Ullman is interested. . . . Met there Mr. McGill, the artist, who organized the comic series with "Journal" from which the play originated . . . looks like a "pool shark," wears a straight-edged hat . . . came home to our place and Ullman listened with great appreciation to my reading of "The Widow Cloonan's Curse" which was given at "806" long ago. *[On December 29, 1894, "the gang"–Henri, Sloan, Glackens, et al.–gave a play,* Twillbe, *at the Pennsylvania Academy, an entertaining burlesque of Du Maurier's* Trilby. *Sloan played Twillbe and Henri took the part of Svengali, years before John Barrymore created the part for the silver screen. Among the cast of* The Widow Cloonan's Curse, The First Production on Any Stage of Charles S. Williamson's Grand Operatic Tragedy in Eleven Acts and Two Tableaux, *were Henri, Sloan, Davis, Alexander Stirling Calder, Charles Grafly and others.]*

November 14

Went up to Appleton's in response to a cry of "too large a bill!" from Brennan and saw him (in spite of himself) and came to an agreement on $200. instead of $225. Stopped in the Times Magazine and Cartwright told me he'd have a check sent me at once! From there I went to Macbeth's Gallery and saw an interesting bunch of paintings. One of Davies *[Arthur]*, two or three H. Martins, very fine. . . .

November 16

Davis came in . . . out to Anderson's Auction rooms so he came along. Saw several books that would have tempted me, had I been in funds. . . . The agent of the landlord has installed a nice new grate in our

front room and we have started a fire there. It has a mighty cheerful look. In the evening . . . called on the Ullmans . . . found Ullman arrayed in a big red bathrobe which made him look something like the Balzac by Rodin.

November 17

Kent Crane posed today and (making a new start) I got a right good portrait of him. Finished up a puzzle which I started last evening early and mailed . . . to dinner (at Palmer's). Henri came in the evening . . . enjoyed a quiet evening. He showed some photos taken by Miss Niles in Spain. Two of them show Henri and the other preceptor (Monte) of the class imitating monkeys on an old Spanish barred window. Very funny indeed. I suggested that he start the old "Tuesday nights" at home but he rather rejected the idea. I suppose that the wonderful evenings of our past in "806" Walnut Street cannot be recalled on demand. I suggested also that he try to arrange to paint "Mark Twain." The scheme seemed to stick in his mind right well favored. Henri says Trask of the Penn. Acad. of Fine Arts called on him today.

November 18

Rose late and after buying the Sunday papers I walked up to Henri's. He showed me a number of little panels he had painted in Segovia this summer. Little townscapes under typical Spanish atmosphere, also some sketches, many humorous. Then he produced a hundred photographs of Goya's paintings which gave me a further impression of the immense scope of the work of this great painter and artist. Also he had many Velásquez and Greco photos. Dolly came up late in the afternoon. . . . After dark we came down to our place and had dinner and then all went to Glackens'. Saw a splendid lot of work which he did this summer in Paris, some Spanish subjects also. Very full of wonderful observation of life. . . . Glack was most cordial and so was she, nice as could be. A most pleasant evening. . . . Henri, Dolly and I walked up Fifth Avenue which, owing to rain and repairs, is quite like an electric lit morass or quagmire. Elevated Station on a rainy night, good subject. *[Years later, in 1911, this familiar subject was used as the background for the picture "Wet Night, Bowery."]*

80

"Robert Henri," 1905

November 20

Jerome Myers called today. He's looking rather played out. Says the
baby and Mrs. M. are doing well.... Took Mr. and Mrs. Ullman to
dinner at the Francis.... Henri was there also. Met James B. Moore
and he took us all to his house.... A scheme for having pictures on
sale in the Francis was suggested and we did much talking on it.

November 21

... Started in to fix the frames that Henri gave me. Mixed plaster for
the broken places. Called in at the Times Magazine office, saw Mr.
Franklin who is cashier, I think. He promises to look into my account
and send a check. Mr. Richardson is the man who signs checks, I
understand. The first number (Dec.) of the Times Magazine is on
sale today–very ordinary. We went up town to see Mrs. Myers and

the baby, Virginia. Mrs. Myers is still weak. She had a very close call for her life and the baby also. *[Ethel Myers was a fine artist in her own right, working in water color, oil, and ceramic sculpture. She was represented in the Armory Show.]*

November 22

After dinner Dolly went down to Ullman's and I went to Café Francis to meet Henri, J. Moore and Glackens. We were to talk over the Sales Gallery in the Francis scheme—but for some reason or other the subject was not broached at all. Mrs. G. was there which may have been the reason. . . .

November 24

Bronzing on the frames today. . . . Reuterdahl took me in to his studio next door and wanted my opinion on a painting he is starting for the National Academy exhibition. I told him what I could. I ordered fifty frames in white enamel from the frame maker. Cost to be $25.00 which seems pretty reasonable. Best glass, he says. Dolly and I to dinner at the Glackens'. Henri also. . . . A fine turkey of which I ate a great lot. Everything is so rich and fine in their South Washington Square apartment. After dinner . . . to J. Moore's where Mr. and Mrs. Chapin (he is the "selector of illustrators" for Scribner's), Mr. and Mrs. Judd . . . Mr. and Mrs. Preston, Lawson and Fuhr, Bachelors of Art. Shuffleboard, etc.

November 25

Wrote to Miss Meade (N.Y. School of Art Gallery) saying I had ordered frames for the exhibition of my etchings which she has asked for. Ordered carpenter to go on with shadowboxes for the new frames. *[Shadowboxes were considered necessary "frames for frames" in any dignified exhibition of oil paintings, at this time.]* Dolly called for Mrs. Ullman . . . took her to Henri's studio. He is going . . . to paint a portrait of Mrs. U. today. Worked on a puzzle a while. . . . Stopped next door for Reuterdahl and Bayard Jones came in. We three went to Reuterdahl's . . . very nice dinner. Mrs. R. looked fine in a black dress which showed her beautiful shoulders a bit . . . arrived home about 12:30.

November 26

Went on with the Puzzle. Miss Sehon called . . . took Dolly to see a little Japanese play this afternoon at the Garden Theatre. Arthur Dove called, asked what my experience with the Times Magazine had been so far. I told him they seemed to be bad pay. He said they paid his first bill. Dolly, Henri and I . . . to Miss Pope's studio on S. Washington Square. Henri had extended us her invitation . . . rang her bell and knocked on the door and we threw pebbles at her window. No answer. We waited and wondered. Then suddenly Henri said, "I forgot to write that we were coming, as I had agreed." So after consideration . . . to Macdougal Alley "Gonfarone" restaurant . . . had dinner on him . . . back to Miss Pope's. This time we found the door open, upstairs she was still waiting dinner for us . . . had not waited to receive a letter but prepared for us, such a mix-up Henri made of it . . . nice evening. Miss Bessie Marsh who does very good work and is a very pretty bright girl walked us over to her apartment on Charles Street, Greenwich Village. *[Bessie Marsh Brewer, mother of Sam Pope Brewer, news correspondent.]*

November 28

Painted on "Madison Square Spring" all afternoon. Also repainted background on "Kent" portrait and touched up several things, getting them in shape to try on the juries this fall . . . after dinner at home I cut out twenty-five mats for etchings while Dolly read out loud "Tess of the d'Urbervilles," T. Hardy, which we both liked very much.

November 29

Today being Thanksgiving Day we are invited to Crane's to dinner. Mrs. Ullman and Dolly started about 5 o'clock. Ullman called for me later and we got on the subject of the Poster Period of 1894–95–96. I showed him "Moods," the pretentious effort of Bloomingdale and Lewis in Philadelphia which had my cover on the second issue. Got out some "Larks," Chap Books, etc. Before we knew it we had to rush to get to Bayonne before dinner time. We made it all right and sat down to a real old fashioned turkey dinner. It certainly was a triumph for Mrs. Crane. Everything was fine and we all had a very pleasant evening.

November 30

Oh fine! A check from the Times Magazine which settles that incident. Stirred up the carpenter who I find has not yet started my shadow boxes for frames. Cut out mats for etchings. In the evening Hardy came in and made a clean sweep of all the liquor in the place.

December 1

Carried home four shadow boxes and paid for the whole lot (8) $9.00 check. Stained them light oak color. All the day Hardy paced up and down with a "head" and the consequences of drinking hard. Ullman came in in the afternoon and Mrs. Ullman followed after finishing posing for Henri.... To dinner in a party at Shanley's... back to the studio and had a good evening....

December 2

Went up to Henri's where found him at work on Portrait of Mrs. Ullman. While I was there he seemed to get hold of it. It has been a hard struggle for him ... brought H. to dinner which was very nice steak and chops too! After dinner Henri went home as he had letters to write to some of his Spanish acquaintances ... to Ullman's ... home about 2 o'clock and stayed up till 4 A.M. varnishing pictures which are to be collected tomorrow (today as it was).

December 3

Up at 10:30 and had a struggle with my coal fires especially the open grate in the front room. Tinkered on the pictures a bit and Davis came in and talked "chewing gum" finance. He has a nibble in the business and it may go. To the barber's and had my hair cut, an event of note as I hate to come under that ordeal. Down to S. Washington Square to dinner at Miss Pope's, the same party as last Monday. Everything went well, a bitterly cold night however and coming home at 1:30 A.M. it was very cold. Coldest this winter so far. We took Miss Marsh home on our way.

December 4

... Dolly went ... with Mrs. Ullman ... some shopping for Christmas. I called next door to see how Reuterdahl was getting on with his painting for the National Academy exhibition. Penfield came in, he

has the back studio. He took some photographs of R. and me. Reuter-dahl is going to get a cab tomorrow morning and take his picture to the exhibition jury. In the evening . . . Ullmans came and took us to Proctor's Vaudeville where we saw a show. Not very interesting . . . back to the studio where we had tea. . . .

December 5

Started on framing etchings in white enamel frames. Fifty frames $25.00. Next door framer made them. French glass. They make up nicely. Dolly washed all the glass for me, the hardest part of the work. George Fox came "out of the woods" . . . to spend a few days with us, and look for some work. He says that $25.00 a month will keep him nicely down there in Pennsylvania . . . to dinner with him at Renganeschi's Italian table d'hôte, then walked home and I went on with the matting of etchings while he chatted comfortably as is his manner. Henri phones Dolly that my picture "Dust Storm, Fifth Avenue" went through the National Academy of Design jury No. 1, the portrait "Kent" No. 2 and "Madison Square, Spring" No. 3. "Miss Hoch" rejected also "Girl and Etching Press." The last is the best of the lot and it seems strange it should not have gone through and yet not strange either, I'm satisfied.

December 6

Wrote to Mother and mailed presents to the little motherless girls in California [Dolly's nieces, children of her sister, Helen Wall Hitchcock]. Went on with the framing job. Mrs. Ullman called on Dolly. . . . Davis dropped in . . . Kirby called. Also young Pach [Walter], a student of Henri's at the N.Y. School of Art. Fox was out during the day. Says he called on Geo. Luks. After dinner Henri came in and told us that "Dust Storm" had gone to No. 2 on revision, the others to No. 3. . . .

December 7

. . . Ernest Lawson called and asked whether we had heard from the jury of the National Academy as to his pictures. We did not know the fate of them. Dolly has a very bad cough since the night at Miss Pope's cold studio. I went on with my framing of etchings. . . . After dinner Ullman and Mrs. Ullman called. He is enthusiastic over the scheme which I had suggested to him some time ago of a series of

85

articles "Adventures in New York" something after the manner of the old "Tom and Jerry" book. Etchings to be by me. He says that Broadway Magazine is very anxious to see the thing started.

December 8

Dolly was so bad with her cough that she stayed in bed today. Fox and I went up to Henri's studio stopping on the way for Dr. Westermann. Henri says that the pictures which he painted in Spain this summer are now in the Customs House and he hopes to have them in about three days. We had to postpone the dinner which Dolly was to cook for Miss Pope and Miss Marsh and Henri. . . . Henri, Fox and I went to Shanley's for dinner and, while I thought to get Dolly's prescription filled, I forgot to get her any dinner, which made me feel like a selfish pig. Fox's stories of the characters in the country bar-rooms are fine. He should write them but he's slipping into habits of inaction.

December 9

Fox and I prepared breakfast and served it on my drawing table in Dolly's bedroom. Then he went up town and I for the Sunday papers. . . . Henri and the Ullmans for dinner which Mrs. Ullman cooked to save Dolly who is up today but still coughing some. After dinner . . . a very interesting talk. . . . Henri taking the stand that man's highest form of intellect is the subconscious, that it is discredited by being called "instinct." . . .

December 11

Wrote to Tom Daly (mailed the letter by Mr. and Mrs. Myers in the evening) asked for a check. . . . Ullman and I got up some notes (for the use of the Broadway Magazine) on Henri for their monthly list of notables. Dolly went to a violin recital. Some Hungarian count had given Stein tickets and she took Dolly to hear him play. She (Dolly) came home too late to cook dinner so we went to Shanley's, taking Fox. After we returned Mr. and Mrs. Jerome Myers called, the first Mrs. M. has been here since baby Virginia was born . . . a pleasant evening looking at Daumiers in my collection.

December 12

. . . Letters from Mother and one from Nan to Dolly. I ordered five more white frames for etchings . . . bought Ullman's Christmas pres-

ent, a nice drop light for his desk. I don't like this "Christmas present" idea but I believe he is going to give me something so as he is irrepressible in his way I must retaliate. I think a great deal of him though our friendship has been so short. And Mrs. U. has been lovely to Dolly. Postcard from Miss Meade saying that she will send for pictures for the exhibition on Friday morning. Henri phoned me that "Dust Storm" and "Spring, Madison Square" were the only ones hung of my things, both above the line. His father is very ill.

December 13

Wrote to Miss Meade (N.Y. School of Art Gallery) and told her prices. Forty percent discount. . . . Henri called me on the phone and I explained that we expected him to dinner but his father is still very sick. . . . After dinner I read Zola's "Thérèse Raquin." It is powerfully written but it seems to me that the murdered man's wearing on the reader as well as on the murderess.

December 14

. . . Donaldson's Express, 4 E. 31st Street came for pictures. I took a receipt for the frames in good order. Check arrived from Tom Daly $75.00. He says there will be more after the first of January, that the book is in the second thousand. Check from Appleton's $200.00. Sent to Mischke $25.00 settling the Charivari bill. . . . In the evening we took the drop light Christmas present down to Ullman's. She, Mrs. U., is in bed quite poorly. He struggled over a gas radiator cooking a can of soup. After various efforts to get the drop light burning clearly, we were given a cigar moistening box and a chafing dish which were certainly fine thoughts for our Christmas presents. Late in the evening stout Ullman sets about making tea and runs out to buy some extra treat. Goes to an Italian Grocery and gets a can which looks inviting . . . it proves to be string beans. Very funny lunch tea crackers and string beans.

December 15

By the invitations which arrived by mail this morning I find that Shinn and myself are to be exhibited together in the N.Y.S.A. Gallery. This should be satisfactory I think though since I have sent no

paintings he will have a monopoly of the color attractiveness of display.... Ullman stopped in.... Dolly who had been with Mrs. U. to the doctor's ... made us some lunch ... mailed about forty cards of invitation (to the exhibition). If any sales result I'll be very much surprised. Potts came in in the evening and seemed rather blue. Picture fired from the National Academy of Design exhibition has hurt his chances in other portrait work.

December 17

... Ullman came in ... we all had a nice chafing dish lunch, panned oysters. Mrs. U. did all the dishes while Dolly was ... at Mrs. Foster's being fitted for her dress and coat ... started to see the N.Y.S.A. Gallery where my etchings are now exhibited. Dolly ... said that she had just called Henri up at Bryant Park but that the phone girl there had told her that there had been a death in his family. I called up Henri at Mr. Lee's [Henri's father] apartments Golden Gate, 111th Street and offered my sympathy. Asked for his mother. He said she was bearing up well. Saw the show where I was disappointed that Shinn did not have a greater number of pictures. The etchings are hung right well. Met Mrs. Nathan Meyer [Annie] who writes on art and is now with Broadway Magazine. She is interested in the work and will call on me tomorrow, look at some New York pictures. ...

December 18

Mrs. Meyer came at about 12 noon and talked a streak ... bright very nervous woman. I don't feel sure of her judgment about pictures, at least not of the soundness. But then after all it's about this way—if she likes what I like, she has good judgment and if she don't, bad. Each of us can hardly have any better test than that. With a card from her I sought the Art Manager of Broadway [Magazine] Mr. Halsey. He treated me very well indeed ... coming tomorrow to look at the "Ferry Slip, Winter" [painted in 1905 and now in the Joseph Hirshhorn collection] to decide whether to make it in color ... or just halftone ... stopped with an order from Mrs. Meyer at a photographers, Juley, 106 E. 23 and told him to call for ... paintings on Thursday A.M. Stopped in Shanley's and had my dinner. The streets are nervous with the Christmas trading spirit. It seems to enter in the horses, the "chauffeurs," the police, everybody ... saw Dolly off on train to Phila-

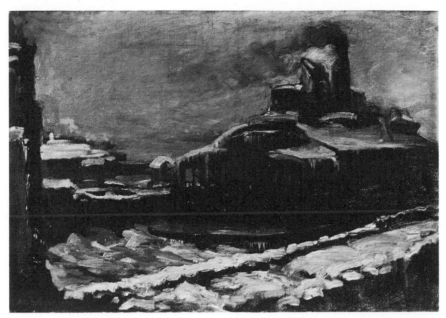

"Ferry Slip, Winter," 1905–6

delphia, bought a 1,000 mile ticket $20. Left four etchings with Halsey to be submitted to Dreiser.

December 19

Mr. Halsey is to call at noon today...await Mr. Halsey about an hour and a half...he don't come. The artist who asked me for a print of my "Turning Out the Light," Mr. Blashki *[M. Evergood Blashki, father of Philip Evergood]* called and I gave him one. Mr. Harbison called and asked if he could sell a part of a set of etchings. ...I told him I opposed it. Ullman came in...to Greenwich bank together. I put away the Appleton check. We walked through the Christmas shoppers...when I returned I found a telephone message from Henri asking me to take dinner at Shanley's with him.... found him much "cut up" over his father's death...says that Mr. Lee was buried in Mays Landing a cemetery much used by Atlantic City folks. He is therefore among those that knew him and in the end respected him for his long holdout against the Corporation of Atlantic City in regard to his Riparian Rights over the Boardwalk. "Fort Lee" his house was called there. Made a Puzzle at night.

89

December 20

Juley the photographer is to send for pictures to reproduce for Broadway at 9 A.M. which he did.... I got my breakfast ... went up to Henri's and had a fine show. He had the things in now that were painted in Spain this past summer and a great lot of work it is. "La Reina Mora" is a big full length of a dancer without a taint of the "picturesque" in it. All good sound life of the animal. A Spanish officer is a fine thing, the blue uniform and the helmet and trappings done in fine complete suggestion. The Matador is rich, a fine head and splendid painting of the cape, etc. A full length of a gypsy with guitar, smiling, is fine. Also a strong head of the same man. Gypsy woman and child is also fine. Several of this subject. The finest perhaps is one with intense expressions, brown background.... From Henri's to the bank (to subtract) and then to Ullman's. Said au revoir to Mrs. U. who goes this evening to the hospital. Henri, Ullman and self dined at Shanley's and afterward did a long talk fest "in the studio." The Lithograph and Etching Monthly was talked over. . . .

December 21

After phoning and finding that Mrs. Ullman's operation was O.K., Ullman and I breakfasted at Coddington's on 6th Avenue. Then to the Post Office to see why my mileage ticket had not arrived from Dolly ... ticket arrived in time for me to catch the 3 o'clock train to Philadelphia ... arrived in Phila. at 5 o'clock or thereabouts. The City (uptown) where I left the train looked so small I felt as though I should be able to look in the second story windows of the houses —yet this is the neighborhood in which I grew up from seven years old to thirty years about.... Went to Nell Sloan's and found Dolly busy with invalids.... *[The Sloan family moved to 21st and Camac Street, Philadelphia, when John Sloan was seven years old.]*

December 22

A dismal damp chilly day. . . . Dolly in town . . . examined by Dr. Bower in relation to her lungs' condition . . . He called me . . . tells me that she is sound, that the trouble is bronchial. I went over muddy roads to see Anshutz. He spoke of Clifford Addams, the Academy student

who is gone daffy with the idea that the mantle of Whistler, under whom he studied ("apprenticed"), has fallen on his shoulders. . . .

December 23

A very clear cold day. Dolly came out . . . in the afternoon . . . put on her new "crepe de chine" dress to show it to Mother. It is a fine white gown. I must try to paint her in it. John Starr (my cousin, Father's sister's son) came for dinner, bringing Christmas presents to Dad and Mother and The Girls. I took photographs of Mother, also of a big lemon that Pop has raised. After dinner . . . Dolly and I went over to Anshutz's. Hear that Calder's doing well in health out in California.

December 24

In to town today. Went to the Press Office and J. Schmittinger, who was on the Press years ago, now back, developed my negatives taken yesterday. There were two good ones of Mother. Saw Tom Daly . . . took Dolly and me to lunch at Dooners'. Dolly left to go to Kerrs' and Dr. Bowers. I went back to the Press. Trains were very much delayed on the Reading–to Fort Washington after 7 o'clock. Dolly not there . . . phoned that she would stay at Nell's all night. . . .

December 25

Christmas Day. Went with Nan to church in Whitemarsh. A cold fine morning. . . . Nan has made us a nice wool quilt. Mrs. Drayton *[one of Marianna Sloan's patrons]* gave her a white coral necklace. Dolly had brought presents for the rest and they had arrived, save Mother's which was an invalid's table. I went down to the station in the afternoon and found it boxed up and lugged it up. She was much pleased with it. Dolly and Bess came in together before break-fast. So that we were all home for Christmas Dinner, a fine turkey. Mother today put on my finger her wedding ring (which her hand has grown too large for). It was made by Pop from gold from his own dead mother's false teeth plate. It just fits my little finger. *[Sloan stopped wearing it around 1948. Then asked me to wear it for him when he lectured at the Art Students League in 1951–"for good luck."]*

"My Dad," 1906

December 26

Today we said good bye to the folks at home and came into town. Stopped in to the Press. . . . Dolly and I took lunch at Sallie Kerr's. She's looking well and presented me with a fine fruit cake as is her usual custom. It is a thing I appreciate greatly. I keep it in a tin box and now and then have a piece or two. Called on Dr. Bower with Dolly. . . . To the terminal and waited for the 5 o'clock train. Arrived in New York a bit after 7 . . . dinner at Shanley's . . . glad to be back in our "Garret."

December 27

A postcard of welcome from Ullman is funny. . . . We feel at home. The usual contrast between Phila. and New York with the usual victory for the latter. Ullman comes in, glad to see him and he us . . . tell him to fetch his clothes and stay with us. . . . In response to telephone from Henri, Dolly and I went up to Manhattan Ave. to the late apartments of his father and mother. He gave us what we wanted of the furniture there. A very sad affair, the second within a year for Henri, poor old man. His stricken mother is with him at present. . . .

December 28

. . . In the afternoon Dolly went with him *[Ullman]* to the Polyclinic Hospital to see Mrs. Ullman. They found her looking right well . . . dinner at home . . . made a Puzzle. The Sun of yesterday morning has a very commendatory notice of my "Dust Storm, Fifth Avenue" in the N.A.D. Exhibition. . . .

December 29

Sent off Puzzle. . . . Dinner at home. . . . We went up to Henri's to see his Mother. Mrs. Lee is much broken with the death of Mr. Lee and Dolly did her a lot of good by letting her talk about him. I seem to have caught a bad cold with aches all over me, seems like the grippe. Henri made me take a big drink of whiskey and when we got home . . . (Dolly and I walked down 6th Avenue) I took some quinine. Had a bad night. . . .

December 31

Four pictures collected by the Penna Academy of Fine Arts Ex. "Kent," "Miss Hoch," "Girl and Press," "Ferry Slip" . . . spent the day in bed . . . Reuterdahl came in twice to persuade me to think I was well enough to come to Weehawken for New Year's Eve party. Altogether a rather melancholy end to the year. Worked on a Puzzle though and was working as the old year died and the New Year came in.

1907

January 1

Got up this morning feeling some better than yesterday. Went around to 32nd Street and saw Dr. Westermann. He sprayed my throat, sounded my chest and told me to come again Thursday, a prescription also. After dinner at home, Henri called up and asked Dolly and me to come to Shanley's to take coffee with him . . . finished up a Puzzle later when we came in.

January 2

Indoors all day not yet feeling well. Dolly . . . with Mrs. Lee to Macy's . . . some shopping to amuse the old lady. When Dolly returned . . . went to a Chinese Restaurant. . . . These three days have been horrible to me, so depressing in weather and my health so bad it really seems too much trouble to try to exist.

January 3

Still sick. Wrote to Mother. Went to see Dr. Westermann. He told me to take whiskey punches which I did. A big stiff one–kind of fuzzed me. James Gregg came in, so did Henri. Gregg says the N.Y. Sun notices of my work were written by Huneker.

January 6

Out of bed today and feel better though still far from normal.

January 7

Got up feeling fairly decent. Arthur Dove came in while we were finishing breakfast. I gave him a proof of "Roofs, Summer Night" etching. He talked of lithograph press to me. I told him of my scheme to publish a few proofs monthly. . . . After dinner Henri came, also Jerome Myers. More talk about the lithograph publishing scheme.

January 9

Called in Harbison's book store to see if set etchings was sold–no. Went up to see Chapin of Scribner's–nothing to do. Hardy came in after dinner. Dolly, Ullman and he played poker. I started a Puzzle.

97

January 10

... I went to Collier's to see Mr. Summers. Waited an hour or more. When he came in he said he'd rather I called again. After dinner we played poker for an hour, then I finished up a Puzzle.... "Girl in White" and "Look of a Woman" went to Corcoran jury this morning.

January 11

Wrote Schrag, Agent, that I would (Feb. 28) vacate premises unless hot water, water and hall lights were attended to. Went to Collier's and had an agreeable talk with Summers. He showed me certain drawings made by Dove to be reproduced in color. Says that they are putting in new press which will give them facilities for using eight more color pages which will *no doubt* be "delicious." Worked on a Puzzle in the evening.

January 12

Ullman went out to see Dr. Taylor ... had very bad news in regard to Mrs. Ullman's chances for permanent recovery. Dolly and I were as much affected as though it had been our own kin involved.... Called on Mrs. Oscar R. Meyer at the Hotel Wellington 55th Street and Broadway, in relation to making a booklet illuminated or etched on the Ninety-first Psalm. She tells me that it is the keystone of Christian Scientists' belief. I spoke to her of a series of plates on the verses of the psalm. She said that there would no doubt be a sale for it among Scientists. I wrote in the evening quoting a price of $300. I am to own the plates and in the event of a sale of 600 in a year I am to return her $300.

January 14

Letter from Mrs. Meyer says she has decided not to order the Psalm etchings. (She had not yet received my letter of course.) I'm just as well satisfied. Carnegie Art Institute notices of opening new galleries, entry blanks, etc. Went with Mrs. Preston [*May White Preston, Mrs. James*] to dinner at Jack's–Henri, Dolly, Ullman and I–then all to her studio in the Sherwood Building where we played poker. J. Moore and Lawson [*Ernest*] joined us there. A jolly time. J. M. took Dolly and me home in a cab.

98

January 15

Today Mr. King came in and I grounded a plate and started and (in the evening) went on with the etching of "Old Woman and the Ash Barrel," finding corsets *["Treasure Trove," 1907]*, did it to show him the method of biting, laying ground, etc.... Myers has just sold three pictures which is fine to hear.

January 16

... went out and called on Chapin at Scribner's. He was polite but I shook down nothing.... Went to see Russell at McClure's. He said that now and then is all the public will stand of me. Finished plate of "Old Woman and Ash Barrel" in the evening....

January 19

Up early and had to start without breakfast for Philadelphia, 9 o'clock train. Met Henri and his mother Mrs. Lee by arrangement. Had breakfast in Phila. with Dr. Southern at the Reading Terminal Station. I went to Dr. Scott's to have my tooth attended to. From there to Dr. Collier Bower to call and at the same time get a bit of medicine. He always gives me the right thing. Dolly went to Anshutz's.... Mrs. Anshutz kind as usual. We had dinner at Fort Washington and then dressed and went in to city to the great Private View at the Academy. My painting "Kent" is stuck away in a corner on a fence, bad light. Henri's magnificent "Reina Mora" is shabbily treated in relation to its merit. Altogether not a good exhibition. The Whistlers are "H. Irving" and "Count Robert" and a woman's head lightly done. They are not important to me. The display of gowns and ladies was elegant. I was interested, charmed one minute and then bored then pleased then disgusted. I enjoy slipping from sympathy to contempt on a thing of this sort. Met Morris and wife. Miss Lawrence, Mrs. A. N. Meyer and Dr. Meyer. Talcott Williams was very pleasant. Mary Perkins gets the Mary Smith Prize for "Cows." E. Lawson gets the Sesnan Medal. GOOD. Henri, Dolly, self, and Anshutz's back to Fort Washington.... Clifford Addams is a theme of interest. His nude in the show is a fine thing. If Whistler had done it it would be a great Whistler.

January 20

... Cleared up and was a beautiful day. (Yesterday and night bad.) Sunday Philadelphia papers review exhibition in the usual asinine vein. "N. American" takes up the cudgels for the "refused" ones– very absurd though there may have been better stuff turned down than hung in some cases. Of course the display of Melchers' work (a whole roomful) is a great shame and a waste of space. I have come to the conclusion that where Redfield is connected with an exhibition I will not send pictures. *[Sloan was hurt because Redfield frequently voted against his work when serving on art juries.]* We went over to see Mother and the folks in the late afternoon. She looks nicely but is still suffering. . . .

January 21

... Had breakfast and lunch then went in to Philadelphia and I to the dentist. Dolly to the Academy and met Dr. and Mrs. Southern and Mrs. Lee. I joined them later. Golz, one of Henri's students, has a fine thing "Blackwell's Island." *[Julius Golz was born in Camden, New Jersey, studied at the Pennsylvania Academy and at the New York School of Art under Robert Henri.]*

January 22

After breakfast we had to rush, I over to Mother to say good bye and Dolly to the station as there was not time for the two of us to get over home. Dr. Scott finished up my tooth and Dolly and I met at Dr. Bower's. We took the 4 o'clock train to New York and the great Annual Private View Event was over. (I went to the Academy again to take a last look at the show.) Met Golz. Insisted on saying "howdedo" to Trask who has avoided me, probably on account of the hanging of my picture. . . .

January 23

Well, New York looks good and big and prosperous but the prosperity don't seem to come my way. . . .

January 24

Today I called at the Cosmopolitan. No good. Century-old fossils. Everybody's, Brown out. Came home feeling pretty blue. Henri came

to dinner . . . the rest played Hearts and I proved the "Old Woman and Ash Barrel." Gave Henri a proof, he likes the plate. Played Hearts myself later.

January 25

Fixed up a bit and then we all went to Jerome Myers's to dine . . . the baby is getting on nicely and is a cute little girl. At 10 o'clock we all went up to 80th & Broadway to see Henri's exhibition. It looks mighty grand. One of his Gypsy Mother and Child pictures, the dark one, red-skinned—is a magnificent work. I'd like to buy it as a speculation—in 20 years it will be worth at least $20,000 is my prophecy. Mr. and Mrs. Myers went home and we to Henri's studio where we looked over some of his play time drawings. I have suggested Ullman's getting a magazine to publish some of them.

January 28

Made a "hunting trip" among the Art Editors of American Magazine, Associated Sunday Magazine and Everybody. Had a rather long chat with Brown of the last; he treated me more decently than on my former visit. After dinner Hardy came in and spent the evening. He is a reporter on the Morning World now. . . .

January 29

Notice that the building in which we are living has been sold (165 W. 23rd Street) received from the new agents, Goodale Co. Appleton's write for return of my drawings "Barney of Bruges," etc. which I borrowed last Spring. Walked up there in the afternoon. Coming back met Kirby and went to Durand-Ruel Galleries to see Monet's several fine things. Foolishly, brazenly, modernly dressed women laughing at costumes of squaws who pass Fifth Avenue corner of 34th Street. The squaws seemed the more rationally rigged. Ullman showed Henri's "play time" drawings to Appleton's and White liked them. Said that Century or Scribner's would be more likely to desire them, being higher priced. . . .

February 1

Entered for Carnegie Institute "Dust Storm," "Spring, Madison Square," "Girl and Etching Press," "Ferry Slip." Price on each $750.00. Mrs. Crane came in, and had lunch with us, going to the hospital to see Mrs. Ullman.

February 2

Started a portrait of Ullman in the afternoon. Got a decent start on it. To raise the wind I am attempting some designs for magazine covers. Don't feel very hopeful.

February 4

Went to Appleton's and showed the two cover sketches. Turned down. Said they had covers ordered ahead for a year.

February 6

Painted in the afternoon on Ullman's portrait. Late in day, Miss McClelland, Miss Bell and Miss Knowlton called and asked us to come up to their studio 244 W. 14 Saturday week–3–5 P.M. to see a "collection of paintings not shown at the National Academy exhibition."

February 7

Ullman leaves today. Mrs. Ullman came from the hospital. In the evening Henri came and I went to Anderson's Auction Rooms and picked up some fine old French watermark (G) and a lot of Japan paper also.

February 8

Pleasant meeting with Carl Moellmann, a young man who is in Henri's class at the school. A lithographic artist. He came at Henri's suggestion to see me and tells of a press for sale $40.00. He accepted an invitation to lunch with us and stayed quite a while. A very interesting fellow. J. Moore, Ernest Lawson and Thos. Millard came in in the P.M. Frank Crane also. . . .

February 9

Henri came in in the evening feeling low spirited he said. Dolly proposed that he come here every evening for his dinner and he accepted.

February 13

Took in drawings to Munsey's. Saw Mr. Tate and he was satisfied with them and gave me another story to do. In the evening felt like a little "celebration," so we went out to dinner, "25 cent table d'hôte"

"*Collick's, The National Weekly,*" (signed) Mary Kippered Herring,
by Robert Henri

across the street, and then went to Proctor's and saw a vaudeville show. Trixie Friganza was interesting. Picked up a copy of "The Lake" by George Moore.

February 14

Check for $60.00 for the four drawings for "Woman" (Munsey). Good prompt pay. Stopped over at the Flatiron Building, saw Tate and settled on the pictures for the next story for "Woman." Wrote to J. Walter Norris. *[An old friend from the Philadelphia days.]* Henri came in to dine...left him alone to write letters. We went to a concert with the Cranes at Carnegie Lyceum. On our return Henri still in midst of his writing. We had lunch and Scotch Whiskey.

February 16

What Henri called the "Privatvutea" at Miss McClelland's, Bell, Knowlton and Magner this afternoon. We went and it was the real inane affair. A letter from Mrs. Norris today says that Walter is seriously ill. The doctors give her no hope....I suppose as I grow older more and more will pass away till my turn comes–or mine may be the next....

February 17

Met Moellmann on Fifth Avenue and made an appointment to go and look at the lithographic press Tuesday A.M. Went to Glackens' in the evening, and with them, to Shinn's where we had a nice time. Shinn is now making complete models of stage settings. The one he is at work on is for Mrs. Leslie Carter. If she accepts the scheme, he will make a tiny painted working model of each scene in the play. Everett is certainly a wonderful man–seems to be still the Kid he was years ago on the Philadelphia Press. He has a big Watteau-like tapestry painting that he did in two weeks. His speed is terrific. Glackens' account of Redfield's bossing policy on the Phila. Academy jury is interesting *[Pennsylvania Academy of the Fine Arts]*.

February 18

Delivered drawings to "Woman," Munsey's and they were approved. They are pretty bad but one must make the money. Thornton Hardy came in in the evening. Chatted a while. I was working on the "My Mother" plate started last summer.

104

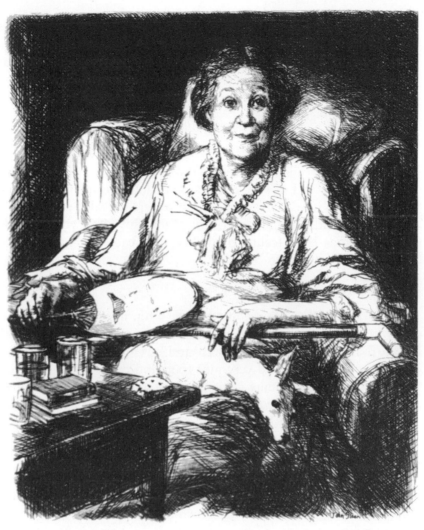

"Mother," 1906

February 19

Down to 463 West 21st St. to meet Moellmann and then went with him down to see about the lithographic press. The one he told me of was sold but there will be another in today which will cost $35.00. We are to see it tomorrow if he sends word that it is on hand. Worked on "Mother" plate.... Through the kindness of Mr. Pach [*Walter*], Dolly and I passed a very enjoyable evening at the Berkley Lyceum

Theatre seeing "The Reckoning," from the German of Schnitzler. Katherine Grey is Christina and a very good company. The small size of the theatre makes the play most intimate in its effect. Young fellow Fritz somewhat interested in Christina who loves him "madly." He is killed by husband of another inamorata. She (C.) was "also in his thoughts."

February 21

Phoned Siebold, called on Moellmann and we went down and saw the litho. press. It is a very old one and don't seem to be in good order. He is to have it overhauled and we are to call Saturday afternoon. Henri and Moellmann at dinner tonight, after which a rather dull evening as H. is feeling tired. We kept each other up till 1:30 A.M., then to bed.

February 22

Jerome Myers called. He is going to take a top floor in 23rd St. across from us. It will be nice to have him as a nearer neighbor. Made a Puzzle drawing in the evening. Dolly and I went to a little 8th Avenue bakery for dinner and had very nice food and only cost twenty cents each. "Cheaper than home cooking" says she. We met Moellmann there (he had introduced me to the place) and he gives us tickets to a dance at the New York School of Art for tomorrow evening.

February 23

Working on the "Mother" plate. Reuterdahl called in and asked me to come and see a start he has on a painting "Coming into Port." Too early to decide what it might turn out to be. He is going to give up his studio next door and fit up a studio in his home in Weehawken.

February 24

Snowing quite heavily today. Henri phoned for us to come up.... He has a fine thing of Colonel Perry (Miss Perry a student at the school gave him the commission). Also a new Spanish Girl just painted from "Bustamente" and an unfinished "Girl in Grey" from Miss Jessica Penn. We three walked down Fifth Avenue in the snowstorm from 40th Street to South Washington Square. Miss Pope and Miss Niles have a fine dinner.... After eating to excess almost, we

106

"Reading the Evidence, or Mrs. Sloan at Home," February, 1907,
by Robert Henri

sit about and try to amuse each other . . . all seem dry. Dolly gets in an argument (quite senseless) with Henri. A horrid evening on the whole, and they are all invited to dine with us on Tuesday next.

February 25

Got out the "Picnic Grounds" canvas which I started last June and worked on it trying to get it into shape for the National Academy jury to deliberate upon as I have nothing else on hand to send them for the coming exhibition. Moellmann and Peterson came and I went down to Siebold's again with them, but when we got there the press was in no better shape than on our first visit. So after stopping at Ault & Wiborg's and asking prices of stones, etc., we came home. Dolly had a nice dinner waiting for me and the evening I spent reading the detailed testimony of the Thaw Trial which is now going on and is quite interesting. The whole brunt of the thing is on the "artist-model, chorus girl" wife, Evelyn Nesbit Thaw.

February 26

Finished working on "Picnic Grounds." It seems to be much improved. . . . Henri, Miss Pope and Miss Niles to dinner. . . . I felt proud of Dolly as its producer. A crown roast of lamb most gorgeous to see. After dinner the talk waxed interesting on the topic of the day the "Thaw Trial." Then we went into the studio and I read aloud two of the "Plays," "Widow Cloonan" and "Twillbe." Henri and I enjoyed the reminiscence and the others seemed to be also sympathetically amused.

February 27

Took out another canvas, "Woman Combing Her Hair" which I tried to go on with. It was started from the Russian model Miss Rozenschein, but she is such a poor sitter that I am trying to complete the thing without her. Jerome Myers called late in the afternoon and tells me that they are moved in to their new studio across the street.

February 28

Sent "Foreign Girl" and "Picnic Grounds" to National Academy Jury. Walked out on errands for Dolly. Stopped in at Reuterdahl's. He is finishing up a picture for the N.A. Exhibition. Old seaman in canvas shielded bridge of steamship coming into port, passing lighthouse. Bright color without much depth of intention. Although that should pass the average jury. Printed some new proofs of "Mother" plate in the afternoon. Am not very much satisfied with the state of the plate. Henri came to dinner . . . a right pleasant and quiet evening around the table in the studio. He made a few pencil "play" drawings. I worked on a Puzzle. Dolly played solitaire.

March 1

Mailed Puzzle. Worked on "Woman Combing Her Hair." Dolly posed for one of the arms. But after it was all through, it didn't seem to be right. I foolishly painted on through the evening trying to better that into shape. Reuterdahl came in looking for a N.A. entry blank which I fortunately happened to be able to supply. Henri phoned that my "Profile Stein" ("Foreign Girl") was "fired" and the "Picnic Ground" got a #2. He says that about 1500 pictures are submitted

to the jury. Tom Daly of Philadelphia came in, with him Mr. Bert Adams who is on the Evening Mail in New York. Daly says "Canzoni" is in its fourth thousand and that there will be another payment to me when he gets accounts straightened.

March 2

. . . Painted again on "Woman Combing Her Hair" and think I have it finished now. Henri and Dolly had dinner. He took her to Proctor's for I went on Reuterdahl's invitation to a dinner of the Society of Illustrators at the Francis. . . . After just about enough Scotch highballs I came home with Kirby, Anderson, B. Jones, Dove. Found Henri and Dolly back and waiting for me.

March 3

I went across to see Jerome Myers' new quarters this afternoon. He seems to have made a good move. More space, steam heat and quite comfortable. A very moderate rental but no lease. Henri came to dinner after the third day of Jury work. He found it advisable to withdraw two of his paintings. The puny, puppy minds of the jury were considering his work for #2, handing out #1 to selves and friends and inane work and presuming to criticize Robert Henri. I know that if this page is read fifty years from now it will seem ridiculous that he should not have had more honor from his contemporaries. I know that "The Gypsy Mother and Child" (red skinned, red black dark canvas; intense life in woman's face) will be honored as it should be. Not put #2. We three went to Glackens' in the evening and were pleasantly entertained. Invited them for Monday week dinner.

March 4

After a friendly talk with old Mr. Goodale, paying him the fifty dollars of rent his due, I sallied forth to seek work from some magazine. First I walked up Broadway seeing many well dressed people, to 58th St. and saw not Mr. Maxwell. The boy was told to shift me to the "side stepper," Cassamajor (not a cigar, an editor). I had seen him before and knew his excuse. Then down Broadway spending five cents for a car ride, to "Everybody's." Mr. Ray Brown in charge. He talked to me in his usual talkative conductor or barber style–gave me his excuses. I pardoned him, carelessly. Next door, after a slight hesi-

tation to the quiet parlor of the "Century." Here is rest from the world and its riot, yet I always feel that Poverty is closer on my heels in the comfortable silent repose of the "Century" so I slipped away without annoying anyone. And turned back, heading home– and stopped in on Chapin whose cabbage intellect presides over the pictures in "Scribner's." He stood me off and here I am back home.

March 5

After writing very despairingly of Ray Brown yesterday in these leaves, I am today rather surprised to get a note asking me to call to talk over a "story" to be illustrated. I go, of course. The story is a sort of instructive discourse on Criminals and Punishment by Brand Whitlock, the present mayor of Toledo, Ohio. We went to dine with Miss Niles, who is in a very nice boarding house, 56 West 48. She entertained us and Henri. . . .

March 6

Up early and down to Tombs Court. Met Judge C. S. Whitman and he was most courteous. He sent his probation officer Al. Thomas to show me through the building. The Tombs prison and last but not least important–The Thaw Trial before Judge Fitzgerald. This was a great experience and opportunity. After running home to lunch, I came back and heard some of the testimony of Mrs. W. Thaw, the defendant's mother. A fine old lady. Jerome, the prosecutor, is de- cidedly a player to the Press representatives. I was disgusted with him and put him down as a sham. Thaw himself impressed me as not mentally regular though it's hard to look at a man in this sort of fix dispassionately. . . .

March 7

Saw editor of "Woman" and got order for "Death and Millionaire" sketches. Went to Jefferson Market Court and watched the "poor things" served with snap justice. Then to "Everybody's," saw Brown and talked it over. Coming home found note from Tate of "Mun- sey's." Worked on "Everybody" drawings, finishing four by 10 o'clock. Then Dolly (who had been at Mrs. Myers' pouring tea) came home and we went down to J. Moore's . . . a great crowd . . . but empty of interest to me. . . . didn't stay. . . . Henri came home with us, liked the drawings. . . .

March 8

Around to Ray Brown of "Everybody's," and he liked the drawings of "Jefferson Market" types very much apparently. He talked and was quite interesting in his accounts of old days in Chicago. . . . Editor Davis of "Woman" and Tate got me to make a less price on the story I am to illustrate for them. $60. . . . Across the street to dinner and then to Proctor's where we saw a fearfully bad show.

March 9

Jerome Myers called. Took a stroll on Ninth Avenue through the muck covered streets with dirty heaps of melting snow. Children swarming in the pools of dirt, sledding down three or five foot slushy heaps–having lots of fun. The curb vegetable market, meat wagons and blue looking chickens–in the mud and the sun that gets by the elevated railway structure. A small boy sees a huge wagon loaded with empty unused crates. "My, I wish I had that wood!" Kent Crane came in for a visit every thirty minutes during the later part of the afternoon. He had a boy friend who disappeared in one of the amusement parlors across the street and Kent divided his time between watching for him and going upstairs and down to me. . . . Dolly not feeling well, a bilious attack we suppose.

March 10

The weather started in on a prologue of light snow, stopped then took it up and in real earnest got at the thing and made real blizzardy looking weather. Dolly was not so well . . . stayed in bed till 4 o'clock . . . got up and busied herself with making a nice dinner for us. After dinner I started and made two drawings for Munsey, but don't think they will suit. So will go around in the morning to consult Tate on them.

March 11

Tate of Munsey's agreed that the drawings won't be the thing desired so I started fresh and made five today. Bad things in clean outline as near as possible, but what I think they want. Mrs. Myers called and brought the baby with her. It is getting to have a very live look and seems to take an interest in things. Glackens and Mrs. G. and Kirby to dinner . . . crown roast, white wine etc., all fine and

a pleasant evening talking things over. The advisability of a split exhibition from the N.A.D. *[National Academy of Design]* since they seem to be more and more impossible. Everybody went home at 12:30. . . .

March 12

Finished up and delivered Munsey drawings and while waiting for Tate to come from lunch I strolled out Broadway, passed 19th Street; then thought, why not go see Willing, Am. Lith. Co., Sunday Magazine. I did so and strangely enough he gave me a story to illustrate. In the evening I finished reading "Tess of the d'Urbervilles"–Thomas Hardy, and went to bed broken in heart. I have never been so moved by a novel, it is a wonderful work.

March 13

Home Life Premium $34.94 due today. (Which I will not pay as I have not the proper financial basis.) Today I went down and had myself excused from Jury duty in the courts, saying that I did newspaper work, etc. Spent a couple of hours at the Astor Library looking up material on "Siegfried" which is the opera treated humorously in the Assoc. Sunday Magazine story I am doing. I have never seen a Wagnerian opera. Nell Sloan arrived at about 5:30. Dolly met her in Jersey City . . . looks well. We had a bottle of wine for dinner to celebrate. . . . After dinner I started on my Siegfried drawings. Nell dozed on the sofa. Dolly struggled . . . with the problem making a new hat out of old.

March 14

All four of the pictures I sent to Pittsburgh are rejected. Reuterdahl called in the afternoon and sat quite a while. He is extremely grouchy over his exclusion from the N.A.D. exhibition. Showed me newspapers, Sun, Post, etc. with columns of account of the disturbance which Henri has made by withdrawing two of his paintings. The air of the art circles is apparently full of the topic. I think he's right. In the evening, dinner at Crane's . . . an elegant dinner. . . . The main fault with the Cranes' hospitality is that there is too much to drink at hand. . . .

March 15

Today the National Academy of Design opened. We attended. Miss Perkins came over from Philadelphia or New Hope, rather, where she is now working. Cranes, Nell Sloan, Miss Pope–we went to the private view in the afternoon–a great crush. Very few good pictures. My own "Picnic Grounds" is above the line, but plainly to be seen and I think it looks right well. . . . After the crush, we went to "Maria's" on 21st Street and had dinner and a very good time.

March 16

Worked on a Puzzle. Met Kirby, and Reuterdahl who had Henri and Norman Hapgood to lunch at the Yacht Club this afternoon. Henri says that he said he had nothing further to say in the controversy with the N.A.D. Jury–but that he tried to explain just how he stood on the subject of art. Reuterdahl says that Hapgood went away wiser on the same. We will scc in the future art tone of "Collier's Weekly." Henri came to dinner and spent the evening with me, while Dolly, Nell and Miss Perkins went to see Vesta Victoria who they report as just as entertaining as she is reputed to be.

March 18

Delivered the three drawings for "Seegfree"–humorous–to Associated Sunday Magazine. They seemed to please Willing all right. $65.00. Henri came to dinner accompanied by George Luks whom we pressed to stay and was entertaining in his usual manner. Some talk after dinner of an exhibition of certain men's work. The time seems to be quite ripe for such a show.

March 19

Went across the ferry to Jersey City seeing Miss Perkins . . . to Philadelphia. She told me that . . . she thought Henri should marry again, he seems to her so helpless and lonely. Dolly thinks that she (Miss P.) is rather fond of him. I think that she is too much interested in her future work to marry an artist. . . . Back from the ferry ride, I made a start on a canvas. "The Wake of the Ferry" it might be called if it is ever finished. . . .

March 20

...had another go at "The Wake of the Ferry" and have hopes that it will turn out all right....

March 21

A letter from Walter Norris in his own print of hand–says he has had a narrow squeak but is gaining weight. I hope that his recovery is assured. A very beautiful day with a strong touch of Spring. I walked down Broadway to Union Square. Got proofs from "Everybody's" which are quite unsatisfactory to me. The engravers have made "rush" halftones. Worked on a Puzzle, finished it in evening. Henri came in to dinner.... There is a fine appreciation of George Luks in the Sun this morning. A beautiful example of Huneker's ability to interest in art criticism. Though appreciation is what he does he's different from the average critic in that they usually think that they are sent by God to shield mankind from what they don't care for themselves.

March 22

Mrs. Montgomery arrived today to stay over night. Nell and I crossed the ferry and met her and after lunch Dolly and Nell and she went out to see the town ... painted in the afternoon on "The Wake of the Ferry." In the evening, Mrs. M. treated us to a trip to the Hippodrome. A huge playhouse and a spectacular show. Am puzzled as to how they manage to have people rise up from the water in the big stage tank. A storm off the coast of France is a big piece of stage effect. After show we went to Churchill's restaurant and saw the Gay Ones of Broadway.

March 23

We all started down to the Aquarium at the Battery and then came up by subway to Café Francis and had lunch. Met Lawson, Glackens, Preston, Fangel and the girls left and I stayed the afternoon which was very agreeable–reminiscences of the Philadelphia "Press" days. ... Home at 6:30 P.M. Mr. Montgomery came from Phila. and we all went to "Maria's" for dinner. Then to the Chinese quarter, Bowery, and Pell Street where our visitors were very much interested in the streets and shops. We ate in a restaurant, gorgeous in teakwood carving, mother of pearl, gold and rough customers.

March 24

Today to the Metropolitan Museum of Art. My first visit for a long time. Rather dreary–there was little enough to interest me and very little to our company–and galleries are tiring at their best. We rode down in the Fifth Avenue Bus displaying the houses of the rich to our Philadelphians with a sense of pride (as though we were entitled to the credit). To the Francis where we had lunch. Then the Montgomerys left by the 5 o'clock train and Dolly, Nell and I went by ferry to Weehawken. Dined at Reuterdahl's. Met a Swedish author, a name that sounded like "Wrangel" who is writing a series of essays on the U.S. Benson was there and it was a good dinner. . . .

March 25

Dropped in to Macbeth's Gallery and among other things saw a Luks picture, mare and foal, wagon at brow of hill. A fine Spring day. Fifth Avenue looked fine. Murray Hill is a fine sight up or down. Sat in Madison Square and watched the children at play. Two young nurse girls playing ball, watched by bums, self and others–varying reasons. . . . I started on a memory of the paths of Madison Square. Evening at home. A letter from Connah of N.Y. School of Art Gallery asks for pictures for an exhibition of the work of the "crowd" which I am doubtful about. Seems to me that it would not have sufficient importance and yet perhaps every chance should be taken to exhibit the work.

March 26

Walked out to lay in supplies in the liquid refreshment line. Loafed in Madison Square a while. Painted in the afternoon. . . . Henri, J. B. Moore, F. J. Gregg to dinner which Dolly prepared in elegant style. Henri showed proofs of G. O. Coleman's drawings in portfolio. Very good things, $3.00 a set. I ordered one, so did Gregg and J. Moore. . . .

March 27

I slept until 11 o'clock through the kindness of Dolly and Nell who rose when Mrs. Neville came to put the house through its stunts with broom and cloth. Kirby called and he and I took a fine afternoon walk, to Durand-Ruel Galleries where we saw a fine Monet '77 and a very interesting lot of Moufra paintings. The exhibit of Ten

Painters at Montross's. Alden Weir has a beautiful little thing of nudes in gray mist by stream. Hassam's showing is good. We sat in Madison Square to our great pleasure. The games of the children are very beautiful. Walked as far as 14th Street into an old bookshop, then home. Dinner at home. Jerome Myers spent the evening with us and his soothing way was most pleasant.

March 28

Worked on the Madison Square picture in the afternoon till very tired. The weather is very enervating, quite the spring sort. . . . Rained in the late evening and I saw an idea for a picture in the Flower Shop across the way. Stock out in front and open all night on account of Easter.

March 29

Nell went to church, "for luck" I guess. Jerome Myers came over in the afternoon talking on the subject of the proposed exhibition. He is more in favor of a rival Society or Academy but I think we have not the businessmen among us. Stein came in with tiny little Easter hats, miniature creations of hers, very clever . . . and gave us each one. . . . We invited her to dinner. She trimmed over a hat for Dolly. In the evening made a Puzzle. Started painting the "Flower Shop at Night."

March 30

Check for $65. from "Everybody's." It seems like a good deal of money for them to pay for the way the proofs have come out on the drawings, though the drawings were well worth it. Put in the whole afternoon and evening repairing some of the chairs and a table, a big job, for they needed attention very badly. Kent Crane came in and Dolly and Nell took him to the Metropolitan Museum. Late in the evening started out, walked to 14th Street along Third Avenue, stopped in a little restaurant where we enjoyed some bottles of ale and a lunch.

March 31

While out for papers as usual, I stopped on Fifth Avenue and stood for nearly an hour watching the Easter dressed throngs coming from their honorable Easter services–very funny humans. I didn't feel at all one of them, just then. But after all, I turned down a poor rum

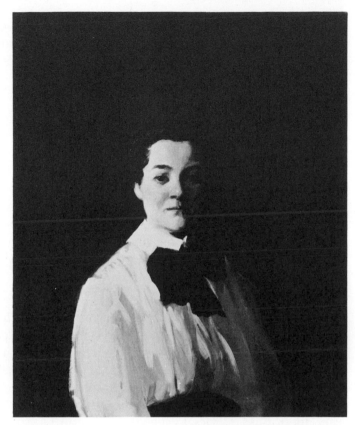

"Dolly with the Black Bow," 1909

soaked bum who asked me for money–and regretted it and slunk home feeling below cost. Henri came to dinner and he and I were much tickled by a surprise in the form of chocolate eggs with our names, "Bobbie," "Johnny," "Nellye," "Dolly." ... Henri, old man, feels a bit gloomy, prospects not very good. The game of getting portraits to paint is beyond his or rather beneath his powers.

April 1

"April Fool"–caught Nell on an imitation express package–great success. Took an hour to get it ready. Painted on the Flower Stand picture. Have pushed it on some, I think.

April 2

Painted in the afternoon. In the evening to Cranes' in Bayonne ... fine dinner. . . . a surprise party for Crane's fiftieth birthday. W. Walsh

[William], the Literary Editor of the Herald, a one-time Philadelphian, was there. Also Wallace Morgan of the Herald's artist staff. ... Right good time as usual though there was too much "wet goods" in sight to suit my taste.

April 3

... Went down to the bank and drew money. Bought a pair of heavy shoes which have started in to hurt me at once—wore kid ones all winter. While ... out, a Mr. Turcas called and asked for a picture for the Settlement exhibition in the "Slums." I will send "Wayside Station" in which I am not immediately interested now. I hear that pictures are not well cared for down there and I'm sure the show does no good whatever. Reuterdahl called and brought a copy of "Collier's" which has an editorial praising Henri's stand in the N.A. Jury matter.

April 4

Painted on "Madison Square" *["Throbbing Fountain, Madison Square"]*, nurse girls playing, amusing the loafers. Mrs. Reuterdahl called in the afternoon. Dolly and Nell Sloan went to Myers' "at home," also the Henri's which they said was crowded like an "at home." I called on Myers later. After dinner I went to a meeting at Henri's to talk over a possible exhibition of the "crowd's" work next year. Henri, Luks, Davies, Glackens, Sloan and Lawson were present— and the spirit to push the thing through seems strong. I am to take charge of the moneys for the purpose. Henri to do the correspondence. After leaving Henri's—the rest of the bunch went to J. B. Moore's house.

April 5

Last night Henri delivered the set of Photo prints from Coleman's drawings. I feel that this young artist will and, in fact is, doing important work, and that I do well to buy this collection of ten street life pictures. Dolly, Nell and Mrs. Crane met here and went to lunch at the Francis after which they went to see Mrs. Ullman and collected Crane at the "Herald" office, and came home here to dinner. Evidences of the gay cocktail. Dolly earnest, Nell boisterous—and Mrs. Crane dignified. Dinner very good and went off well. Henri here. After dinner, Crane and I went for beer and drank whiskey while on

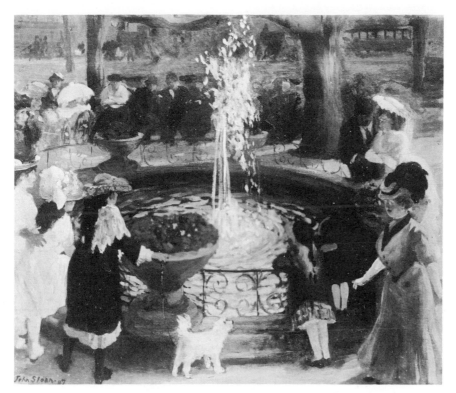

"Throbbing Fountain, Madison Square," 1907

the errand. I grew riotous, then sick, a messy ending all round. I feel that I have given Mrs. C. a bit of trouble–too bad. Threw a rocking chair through "The Wake of the Ferry"–fool! *[In Sloan's unpublished notes he says that he had had a row with Dolly–Mrs. Crane often let her drink too much. This was the only time Sloan ever damaged anything in the course of a scene like this. The picture was damaged in the sky area, repaired years later, and is now in the Detroit Institute of Art, the gift of Miss Amelia Elizabeth White, an old friend of John and Dolly Sloan's in Santa Fe.]*

April 6

The day after–Nell S. turned in like a Trojan and cleaned up the whole place as well as a lot of dishes. Dolly bed-fast. I made a Puzzle. Henri to dinner. . . .

April 7

Dolly and I saw Nell across the ferry on her homeward way to Phila-
delphia. It seems quiet without her constant chatter in the place.
Henri came to dinner in the evening and we had a little monotype
fun with the etching press. Mailed letter acknowledging receipt of
$50. to Arthur B. Davies. This is for the proposed exhibition fund.

April 8

Letter from Tom Daly, a check for $25. on account "Canzoni" draw-
ings. He thinks of starting a syndicate service of verses. Wants to
know what I'll illustrate such for. I wrote and told him that I'd let
him have copyright and newspaper publication rights—I to own orig-
inals and hold *book rights* subject to further contract. Two drawings
a week for fifteen dollars *till further notice.* Dolly and I went over to
Heyer's Bakery Lunch on Eighth Avenue for our dinner and enjoyed
a good meal for twenty-five cents.

April 9

This morning a heavy fall of snow starts and keeps up steadily all day.
Outside the slush is ankle deep on the pavements and worse on the
crossings. Went over to see Willing at the Sunday Magazine, got
proofs of drawings. Henri phoned that he saw Kirby, manager of
American Art Galleries, but that an exhibition could not be arranged
there. That Davies saw Macbeth and it looks as though we could
have two of his galleries next February. Jerome Myers called in the
afternoon. Dolly was in bed all day with a cold so that I went out
to dine alone at Heyer's Bakery.

April 10

Went to the N.Y. School Art Gallery to see the pictures by Lawson,
Twachtman, Weir, Mora, Sloan, and last but not least, Davies. Was
not satisfied with the hanging of my "Girl in White" and said so to
Jos. Connah, the manager. Met a Mr. Dunstan who loaned the
Twachtman pictures which he is gradually selling for the estate of
the artist. He says his studio is right across the street from me, 146
West 23, and invited me to call. After dinner Jerome and Mrs. Myers
dropped in on us and sat a short while, leaving at 8 o'clock. Dolly

and I are feeling the weather's unkindness. She has a bad cough and I feel poorly all over. It snowed again today.

April 11

We slept till very late.... I felt like doing some "carpenter work," so turned in on a shelf for Dolly's kitchen which I turned out satisfactorily. A reporter from the "Times" named MacAdam called to talk to me of the recent elections to the National Academy of Design in which many of the names (Davies, Lawson, etc.) were defeated for membership. Thought there was a feeling against the "younger" element. I told him that it was resentment of good work; that a young man with "fossilized" ideas had no trouble getting in. He came back and had a talk with Henri who was here for dinner. Miss Niles called ... brought a box of fruit for Dolly ... a fine thoughtful kindly sort. Check for $65. from Assoc. Sunday Magazine.

April 12

Manuscript from Tate of Munsey's "Woman." A very poor story to illustrate. Went up to see him. Dolly and I ... to see Mrs. Ullman today. She is despondent, not a cheerful thing to do, visit her. Told her to tell Ullman that Henri wants his drawings returned.... The Times prints interview with Henri and myself today (and with Reuterdahl). Went to the Broadway Lunch Room for dinner and then to Proctor's where we heard a clever English Vaudeville woman, Alice Lloyd, some clever songs. Left there and went down to J. Moore's ... a pleasant time....

April 13

Went over to Ninth Avenue to pay butcher and grocer bills and order supplies for this evening. Then to Clausen Galleries where Rockwell Kent, a pupil of Henri's, has an exhibition. These pictures are immense Rocks and Sea in fair weather and in winter. Splendid big thoughts. Some like big prayers to God. I enjoyed them to the utmost and accept them as great. I'd like to buy some of them. Henri ... said Glackens had been in and suggested that I go to look at the vacant store across the street to see what kind of show room it would make. Went over and think the place would make a very decent exhibition room. There is a studio in the rear. The rent is $1500 a year. Phoned Henri who said he would see me tomorrow and look at the

place Monday. Mr. William Walsh, the Cranes and Charles Vorath (Mrs. C.'s brother) came for dinner. We had a good dinner by Dolly and things went finely. Jerome Myers called before dinner.

April 14

Around to Broadway for my Sunday papers as usual. Stopped in Madison Square. A fine day.... Dolly don't feel at all well. Her cold has taken a turn for the worse apparently. Henri and I ... to Shanley's for dinner. Excitement is high with us over the possible venture into a Gallery of "the crowd"–our crowd. We talked over the probable expenses, etc. of running such an exposition for a year. He left at 12:30.

April 15

Glackens came in in response to a note mailed last night. He, Henri and I went over to the proposed gallery on 23rd St. "West 23rd St. Gallery." Glack seems a bit skeptical as whether he could "afford it." I'm sure if I can, he can. After looking over the place we phoned J. Moore to send Lawson down to my studio this evening. Then Henri and I ... to get Davies ... couldn't find him. Henri came to dinner ... we sat and waited. At last Shinn and Glack arrived. Shinn had a bucket of cold water for Henri's and my childish enthusiasm and gave us a fatherly speech on getting on in the world, etc. Very funny when I think of the days when Shinn's underclothes were unspeakable, when he lived weeks in advance of his salary borrowing–and yet he has got on and will get on. Shinn suggests the possibility of an empty gallery on Fifth Avenue, lately occupied ... Silo Auction Company.

April 16

Lawson came in this morning and is very much in favor of any thing. Luks, we hear, is ill though Mrs. Luks said he would be for the scheme. Worked on the drawings for Munsey today. Henri ... to dinner.... While I worked, he cogitated on various plans for next winter in the exhibition line.

April 17

Delivered the drawings for Munsey, and they asked for one more which I finished today. Dolly called on the Myers. A high wind this

morning and the pranks of the gusts about the Flatiron Building at Fifth Avenue and 23rd St. was interesting to watch. Women's skirts flapped over their heads and ankles were to be seen. And a funny thing, a policeman to keep men from loitering about the corner. His position is much sought, I suppose. . . .

April 18

Delivered extra drawing to Tate, special low rate. Stein came in and I started on a full length of her in new lace and silk and embroidery gown which she has acquired. Very much exhausted at the close of the afternoon's work. Henri . . . to dinner. . . . Started a set of Puzzles for the Press but was too tired to do much. Henri says that Macbeth told Davies we could have his galleries next season for two weeks.

April 21

Over to the newspapers and stopped in Madison Square to watch the people and soak up a little sunlight. A beautiful day—the trees are not budding yet—it is still rather cool. Henri to dinner. He and I went up to the N.Y. School of Art Gallery and looked at a collection of pictures by students of his. A great show. Fine stuff by Golz *[Julius]*, Sprinchorn *[Carl]*, Bellows *[George]* (who may grow academic), and others. If these men keep on with this work (they don't need to "improve") it means that art in America should wake. Henri is as proud as a hen with a brood of Ducks. After . . . to Henri's studio where a young Spanish friend of his called and *[I]* was much entertained by their talk of that country.

April 22

I expect Mr. Walsh to pose for me this afternoon *[William]*. After dinner we call on the Ullmans. Found him home and talked country house after a walk. . . .

April 23

Went downtown to Devoe's and got some varnish and turpentine. Walked by a round-about way home, keeping between the Hudson and West Broadway. Struck some districts that were new to me. Jerome and Mrs. Myers came in as we were finishing dinner. Brought the baby along and spent the evening. After they went, I started a Puzzle.

April 24

Expect Stein to pose for me but gave her up and went down to Collier's where I sat in the "cooler" and then got a frosty interview with Summers. Then went to Century where, after an hour's wait, saw old Drake, poor old fellow. He's always so pleasant and nervous and utterly useless. I had to scold him today. To Bayonne for dinner at Crane's. "Bill" Walsh was also a guest. We had a fine dinner as Mrs. C's always are–chicken with dumplings and stuffed peppers. Walsh left at nine . . . played "hearts" til 12:30.

April 25

Check from Munsey Co. for $64. "Mrs. Dunnett's Subscription" illustrations. Walked over to Andersons and looked at some printing paper to be sold at auction next week. Then up Fifth Avenue midst the apparently opulent on foot and awheel. Back to Madison Square where I sat.–The day is warm and spring surely is here to stay, some buds on the trees. Called in to see Russell at McClure's. He was not at all encouraging. The same might be said of Chapin whom I called on at Scribner's. I'm out of humor with the conditions of things. A paper last night says that the exhibition at the N.Y. School is bad, gloomy. If it is, if there is no good in the paintings of Sprinchorn, Bellows, Boss *[Homer]*, Golz, etc., then I am all wrong–but I am not.

April 26

Sent $5 (which I can little afford) to the secretary of the Society of Illustrators to which I have recently been elected (oh joy!!?). Loafed in Madison Square and walked on Sixth Avenue. In the evening, read three chapters of George Moore's "Leaves From My Dead Life" and enjoyed it very much. It makes me wish to see Paris. But then, in reading, I do see his Paris which is what I wish. My own does not exist.

April 27

Over to Madison Square. It's lovely these days. The fountain, the leaves just putting out on the branches of some of the trees. The handsome women, well dressed and "New Yorky." Met Reuterdahl. . . . He is about to move . . . to work at home in Weehawken. The dry little Penfield was there. He takes the studio when R. leaves. Curious,

fossilized young man about 39 or 40, still doing "posters" which in 1895 he did right well. Now they're fossils too.

April 28

To Weehawken (Clifton Heights) for dinner at Reuterdahls'. Mrs. R. is promised to sit for me on Tuesday. A nice, informal dinner with a cocktail before and seltzer during the meal. W. L. Jacobs and "Col." Benson were the other guests. A very pleasant evening. Mrs. R. was in her best mood, not so dramatic and strange as is sometimes her way. Benson "reminisced" of his days in Paris, very interesting. Jacobs has a fine vein of humor.

April 29

Put in a good day's work on a picture of the Throbbing Fountain in Madison Square and have a thing which I like. Used gold size as a medium and think that I'm going to like it. It dries very quickly and keeps my color from getting muddy, I think. Note from Henri says to meet the crowd at his studio Thursday evening. Tonight there is a beautiful fog over the city. The electric lighting looks fine through it. *[Sloan usually used a medium of linseed oil and varnish (damar, mastic, sometimes a little copal). This is the only picture I know of in which he used gold size as a medium.]*

April 30

Mrs. Reuterdahl sat for me today but after a wild struggle I find that I have not got anything important. She posed splendidly and I worked for about five hours to no purpose apparently. Henri came . . . and had dinner . . . and added to my gloom as he is not feeling well. . . . rather disgusted with things in general. He is uncertain about the Bryant Park Studio, whether to keep it another year or not. The expense is great and he says he won't do the five o'clock tea drinking that is necessary for portrait work in this country today. After mutually sitting in the shadow of each other's glumness for the greater part of the evening, we played "hearts" and he went home a trifle better spirited.

May 1

Today I must register another total failure as a result of another attempt to get Mrs. Reuterdahl on canvas. Head in a whirl, lost in my palette; unable to really "see" the thing that I was after. Altogether

dismal. During the afternoon, William Macbeth, the Fifth Avenue dealer in American pictures, came in. Asked to see the "Dust Storm." Said that he had someone who was interested in it and is going to send down for it and the "Nurse Girls, Madison Square," a recent thing. Suppose–suppose he should sell one–foolish thought. I can hope and so can Dolly.... *[From* Gist of Art, *Sloan's comment on the above painting, "A group of young hoydens on an early spring day are very consciously entertaining the men of leisure who occupy the benches. Meanwhile their young charges shift for themselves. Paintings of this period show my resistance of the Impressionist influences."]*

May 2

Worked on the "Throbbing Fountain" today.... After dinner I went to Henri's to meet "the crowd." Glackens, Lawson, Davies, Luks, and Henri. Later on Shinn came in. Each man, save Shinn, "forked up" his fifty dollars towards an exhibit at Macbeth's Galleries next February. Lawson will give check tomorrow, Shinn also. Shinn drove me home in a hansom cab. Said he couldn't resist riding in a cab when he's out alone. "Floss won't let me do it when she's along." Dolly had stained the bookshelves in the front room and gone to bed tired out.

May 3

Lawson woke us in the morning ... his check for $50. Tells me ... he had a row with J. Moore. Mrs. Whitney *[Mrs. Gertrude Vanderbilt Whitney, founder of the Whitney Museum of American Art]* bought of Lawson one of the pictures which J. M. paid a nominal sum for and the excess over the amount paid by J. M. was divided equally between Lawson and him. J. M. got ten times as much as he has paid –and wants Lawson to give him another picture. This Lawson won't do and justly I think. Davies came in. He says that Macbeth will let us have both galleries with a guarantee from us of $500. He is to get 25% of what sales may amount to. This seems fair. We walked down Fifth Avenue and across Washington Square to dinner at Miss Pope's. A very good dinner. Henri there. A right pleasant evening.

May 4

Made another start at Mrs. Reuterdahl's portrait and I think it is the best of three attempts....

126

May 6

Walked down to Liberty Street Ferry, crossed the river–raining–and then took a ferry to 23rd Street. A long trip for three cents. I must have passed Dolly in Jersey City ... for she had received a letter from Cranes saying Mrs. C. was sick, so she made the trip to see her. Henri came and we waited for Dolly ... when she arrived ... went to Maria's. Henri grouchy about "Bohemia" which is supposed to be at Maria's. . . . Home and played "hearts."

May 7

Mrs. Reuterdahl came and I worked again on her portrait, but it is going to "punk," I'm afraid. Miss Niles called and we invited her to dinner. Henri here–and we played "hearts" after a visit from Golz and Dougherty *[Paul]* who wanted points on etching. . . .

May 8

Working on the new "Wake of the Ferry." Dolly housecleaning with Mrs. Neville. After dinner I painted the kitchen floor and shelves. The weather is cold and raw. We have had hardly more than two or three days of real spring weather this year. Note from W. S. Walsh (Herald) inviting us to dine with him on Saturday.

May 9

Mrs. Reuterdahl telephoned ... postponed posing till Saturday. Dolly ... to Bayonne to see Mrs. Crane who is quite ill. Mr. George L. Berg, State Art Commissioner of Seattle, Washington, had been referred to me by Henri, called. Looked at some canvases, liked the "Coffee Line" probably because I told him of its having been honorable mention at Pittsburgh. A big fine specimen of American he is. They are to have an exhibition in Seattle in 1909. He is in charge of the picture end. At 10:30, after painting shelves and floor and washing up brushes Foster from below came in his night shirt to call me to the phone. Frank Crane says Mrs. C. has taken a turn for the worse and Dolly will stay the night as it is late to start home. I offered to come over for her but he seemed to think I had best not. Uneasy evening alone. To bed at 2:30 A.M.

May 10

My first caller this morning was a very interesting English-Japanese girl sent by R. Henri. She poses, and is charming, very. Miss Kaji her name. I must try to paint her. Miss Bell along with Mrs. Homer St. Gaudens called. Mrs. St. G. is interested in etchings, is studying it herself. Dolly came home after five o'clock. . . . We went to the 8th Avenue Lunch Room to dine. After dinner Pach called and the little fracas between Henri and an ex-pupil (and stocking manufacturer) which was described from one side and in bad taste published in the Tribune this morning, was spoken of. Pach is always a good visitor. I sat up late and worked on a Puzzle for the Press.

May 11

W. Walsh postponed the dinner. Mrs. Reuterdahl posed again and I had hopes, but subsequent view of the canvas don't justify them. Dolly took Kent Crane to Eden Musée *[wax works]*. After dinner . . . Henri came in. In regard to the Sock Merchant's story H. said that in the street he waited for said Sock artist and repeated his opinion of him. That Socks wanted to go to a secluded nook and fight, that H. said here was good enough for him, more language from "Socks," that H. saying that there was nothing to be gained in talk, went to dinner.

May 12

We went to Weehawken to dine at Reuterdahl's. . . . As usual the prospect from the Palisade Boulevard is beautiful. A white French cruiser lying off and the beautiful grays and blues of water and shore make something worth seeing. Mr. Wrangel, the Swedish author (brother of the Swedish Ambassador to London), we met for the second time. He is a caricaturist as well as writer. Mrs. R. put on an Icelandic costume which is very becoming to her.

May 14

Mrs. Reuterdahl posed this afternoon, but after working until tired out foot to head, I had nothing to hold onto. The Evening Mail (Henri phones) has an account of the formation of the "Eight Independent Painters" as they call it.

128

May 15

The Sun this morning has a long article about the "Eight Painters."
It is very appreciatively handled it seems, although they evidently
think that rejection of pictures by the N.A. *[National Academy]* has
brought about this association. The Evening Sun has a nice editorial
notice of the thing. Altogether there is no lack of incentive for plenty
of hard work between now and the time of the exhibition at Mac-
beth's. . . . Arthur B. Davies dropped in and showed me a letter from
Prendergast who says he is in for it strong, will pay later.

May 17

Mrs. Reuterdahl phoned that she would be unable to come in to pose
today. In the evening, after dinner, Dolly and I walked out to Miner's
Eighth Avenue Theatre and found all the reasonable priced seats
were sold out. It is "Amateur Night" and we declined to spend more
than 50¢ each on places. So we walked out Broadway, calling on Ull-
mans being our intent, but they have moved away. On our way back
Sixth Avenue, we stopped in the "Manhattan Theatre" which is soon
to be torn down for some of the underground railroad work, and
upon the stage where once appeared Mrs. Fiske, we saw a cheap (10
cents) moving picture show.

May 18

Painted a bit in the morning. Jerome Myers came in after lunch and
we went out Fifth Avenue with him, to the 30th St. new gallery, Mrs.
Ford's enterprise. Saw an exhibition of work by a man named Higgins
[Eugene]. Melancholy sameness and lack of fresh sight or personal
point of view. Work all looks as though it had been done on one day,
in one mood. To Montross Gallery, where we were introduced to Mr.
Montross. He is just as agreeable and soft and suave as George Luks'
imitation of him. After dinner I rubbed down the plate of "Mother"
taking out the head, which is unsatisfactory.

May 19

The Times art critic has a sarcastic article on the "Eight" whose
names he recounts, save Prendergast and mine. His patronyme (De-
Kay) is a compliment to him, for decay implies some original quality
gone by. . . . After dinner . . . went down to Glackens'. Met a sculptor

named Brooks and his wife. Lawson, Jim Preston and Mrs. Preston, who told me that Hunter Breckinridge, Esq. of Fincastle, Virginia had seen my etchings at the "Francis" and told her to get a set and send them.

May 20

Went up Fifth Avenue and stopped in to see Mr. Macbeth who is back today after an illness. He has Luks' "Boy and Parrot," the "Spielers" and "Pawnbroker's Daughter" in the gallery. They are fine things. He said he had no paper for me to sign but that when he got back to his work he would. That we would have two weeks in February 1908 for our exhibition. . . . [*The "Picture Buyer," one of Sloan's well-known and popular etchings, is of Mr. Macbeth.*]

May 21

Mrs. Reuterdahl posed today and I got a thing some better than here-tofore of her. An article from Willing of the Sunday Magazine to illustrate came my way today. Glad tidings–bread and butter prospects have been poor lately. Dolly and I to dinner at the Lunch Room on 8th Ave. and met Moellmann. He knows of another litho press for sale $60. but I'm afraid I can't afford it just yet. And in view of the exhibition next year I should probably give all my time to painting. . . .

May 22

Went up to the N.Y. School of Art and brought away with me the Imperial Japan set of etchings which they have had on sale. Packed them up and sent them to Mr. Breckinridge as Mrs. Preston sent address today. Told him in a letter that the price would be $75. Walked through Central Park. A little girl covering up a small boy with grass –with the "Babes in the Wood" in her mind, no doubt. Went in to the Metropolitan Gallery [*Metropolitan Museum of Art*], where the "Copyists" at work are very amusing. Illustrators Society at Francis Café, my first attendance as a member. They put me on the entertainment committee to bring out an annual. Each page to be contributed by a member, a suggestion made by me. I don't expect much from the bunch, they are so various in their absence of ideals (that's not a good word, "forces" better). To the lower café after meeting.

Lawson and Fuhr there. On the way home, into a Chinese restaurant, a man telling "fortunes."

May 23

F. Foster, agent for the litho press called. But I had to tell him that I couldn't afford the price $60 just now.... Reuterdahls to dinner. She in a weird sort of mood. Henri says "she is both interesting and tiresome" which is true ... interests and at the same time is a constant strain ... not a pleasant evening.

May 24

Walked today, and, at a distance, shadowed a poor wretch of woman on 14th St. Watched her stop to look at billboards, go into Five Cent Stores, take candy, nearly run over at Fifth Avenue, dazed and always trying to arrange hair and hatpins. To the Union Square Lavatory. She then sits down, gets a newspaper, always uneasy, probably no drink as yet this day. My study is interrupted by Davis, who, satchel full of "Gum-Lax" and accessory advertising, comes by with one of his stockholders in the Gum-Lax Company, a Mr. Kendall. Walked up Broadway home....

May 25

Made a puzzle and mailed it. After dinner Dolly and I walked out on Sixth Ave., Broadway, 42nd St. to Eighth Avenue, on Eighth Avenue which on Saturday night is quite interesting and distinctly different from other crowded night streets. 24th St. to Sixth Avenue and home. My knee (right one) gives me a great deal of pain when I walk. It may be rheumatism. Ah, me! Ah, me!

May 26

Rainy and gloomy day. We expected Henri for dinner but ... phoned ... he'd not be here.... Gregg called in the afternoon ... tells me that J. Huneker wants a set of my N.Y. etchings. He brought us, to read, G. Moore's "Memories of My Dead Life," a presentation copy to James Huneker–the English complete edition. At nearly 12 o'clock, Henri turns up ... had been at Miss Pope's....

May 27

Two volumes of De Kock arrived per express this A.M. I am shipping them back, writing to them that "I want no further deliveries of this

work" (copy on file).... To East Orange to Davis's to dinner.... A nice dinner.... The newest baby is doing finely, Stuart is a big fellow, and "Gum-Lax" promises to be a success. Henri's portrait of Davis is not hung, not framed, and I was surprised as he had lied to H. about this just Tuesday last. And he wants us to lie for him—perfectly ridiculous. If he has been too busy or is too poor to have it framed, why not say so?

May 28

Mrs. R. came feeling not at all fit to pose, so, as Henri was here and wanted me to go out with him, it suited all round. With Henri to Davies' studio where he showed me several of his canvases. He is certainly a great man. Henri and I ... to Gertrude Käsebier's photo studio where I found Mrs. K. a very pleasant, middle aged lady, who is doing some fine things in photography. An Indian head she showed me was fine. Am to pose for my portrait on Saturday. Henri's proofs are very good, best photographs of him yet. Walked with H. to look at top floor on West 39th St. where he is offered a studio. Thence to Bryant Park and sat in his studio until time to walk down to 23rd St. to dinner where Dolly waited us. After dinner H. moped, Dolly sewed, I worked on Sunday Magazine illustrations.

May 29

Got up late and went down to the Astor Library for data on Sunday Magazine story. After dinner worked on drawing for Sunday Magazine, then read George Moore's "Confessions of a Young Man" till asleep.

May 30

C. J. Brainard, a publisher (427 Fifth Avenue, New York) writes that he has sent me 2 volumes De Kock invoice for $15. Enclosed a note, says I owe him $135. I have mailed the letter and invoice back, as my contract was with Quinby Co. and they have failed to keep their agreements. Feeling out of sorts today, uneasy, and unable to work. The streets have a terrible holiday look "Decoration Day"–like American Sunday. The people may be enjoying themselves but appearances are against them.

May 31

Today Mrs. Reuterdahl posed and I got a thing that will last at last. That's my present feeling. It is a great relief and satisfaction to have accomplished the thing. Henri liked the picture when he came to dinner. . . .

June 1

Check for $75. arrived from Hunter C. Breckinridge, Fincastle, Va. for set of Japan vellum proofs. Went to Mrs. Käsebier's studio and she made a number of negatives from my "interesting head." She knows her profession, sure gets you at your ease. After dinner, Henri took us to Proctor's where we saw a very poor show.

June 3

Delivered drawings to Willing at Sunday Magazine ($85.) He was satisfied. Met the editor, Mr. Taylor. Went to Glackens' where I returned umbrella, then up to Mrs. Käsebier's where Henri was posing for more portraits. She showed me proofs of my photo. Right good. . . .

June 4

Got up late and decided to amuse ourselves. . . . To Bayonne to see the Cranes. Went to a new "pleasure park," Melville Park . . . dinner at the Cranes'. . . . Too much to drink as is usual there. Sorry we didn't choose Coney Island for our trip.

June 5

Walked up to Henri's studio. On the way saw a humorous sight of interest. A window, low, second story, bleached blond hair dresser bleaching the hair of a client. A small interested crowd about. *[The idea which resulted in the painting, "Hairdresser's Window" now in the collection of the Wadsworth Atheneum, Hartford, Connecticut.]* Henri and I . . . look at a studio, 135 E. 40th St., top floor. The building has been a church but is remodelled. Tonetti, a sculptor, has a huge studio. It should be just the thing Henri wants when he moves next fall. Mr. and Mrs. Davis and Stuart and Mrs. Miles, their guest, to dinner. . . .

June 6

Walked out to take another look at the Hair Restorer's Window. Came back and started to paint it. . . . Mr. Wrangel called, brings a book of Maeterlinck's for Dolly to read which he had promised her. Mr. Lourvik or Lurvick of the Evening Post called with Mr. Coburn, the photographer who is to make some photos of paintings for an article by Lourvik. I showed a lot of my pictures to them and Wrangel. Jimmy Gregg called later while they were here. Said Huneker's wife is very ill so that he had not spoken of a set of etchings yet. . . .

June 7

Mr. Coburn took a number of photographs of me this morning. He is a pleasant fellow. Knows Bernard Shaw very well. Worked on the Hairdresser's Window picture till Cranes came. . . . All went to Maria's where W. Walsh invited us to dine with him. . . . After dinner Walsh went to the Herald office and we went . . . across the ferry. . . . More drinks and I drank a cup of coffee that kept me awake after going to bed at 3 A.M. I got up at 4 o'clock and when dawn came, painted for an hour or more, then back to bed and slept the sleep of the damned.

June 8

Up late . . . after dinner, Dolly dictated and he *[Henri]* wrote into an American edition of George Moore's "Memories of My Dead Life" the part cut out, from a copy of the English edition loaned us by Gregg. . . . I made a puzzle. Went out to mail it at 11:30. Came back and Dolly being used up, I went on with the dictation.

June 9

W. Walsh came to give me a sitting. I worked, but fell down again. After dinner Dolly and I went down to Glackens'. Mrs. Brooks, sculptor's wife, was there, her sister, Miss Macpherson, Mrs. Shinn, Shinn, Lawson and Charles Harley, sculptor whom I have not seen for years. He dates back to the old Academy of Fine Arts days in Philadelphia. I knew him not very well, then. I remember that he rather discouraged the "Charcoal Club" idea. Taking the stand that we were hurting the Academy Schools.

June 10

Worked on "Hair Dresser's Window" in the afternoon.... Henri and Miss Pope to dinner.... Wrote (Dolly did) to Mrs. Lee, Henri's mother, to come over and stop with us to see Henri off on the "Finland" Saturday evening.

June 11

Worked today on the "Hair Dresser's Window." Dolly not feeling well today.... Telegram from Mrs. Lee saying that she would leave on 7 A.M. train from Philadelphia....

June 12

Up at 7:10 (we thought it 7:30, clocks fast). Dolly went across the ferry and met Mrs. Lee. I went for a walk along Sixth Avenue.... Mrs. Crane and Roma ... to lunch, and Roma to pose for me, while the rest went up to Henri's studio. Ullman called ... is press agent of the Royal Italian Opera Co., now at Grand Opera House on 23rd St., D'Amato, manager. Reuterdahl called. He doesn't think Mrs. R.'s portrait is like her. Told him it suited me. Henri to dinner....

June 13

A visit from a bride and groom from Philadelphia, Dr. and Mrs. Grady. She was Miss Taggart. Pleasant to look at them, young and happy love–just as ours still is and surely will always be.... I painted, starting a "gray day Sixth Avenue" "Tenderloin" section. Jerome Myers called. Henri ... to dinner....

June 14

Coburn is to take photos of paintings to 10 A.M. Lourvik with him, magazine article in view. Dolly and Mrs. Lee to Henri's studio. I followed about 4:30.... Mr. Sheffield came.... Henri says that he thinks $3,000. too much for the children's portrait group. Offers to deposit check for $1500. to be accepted by Henri as he sees fit on account and that he may have to sue for the balance. Henri to dinner. After, H. and I go to the Shinns, he to say "good bye.".....

June 15

Up at 6 o'clock–and with Mrs. Lee and Dolly went to Pier 14, American Line, and saw Henri off on the "Finland." Miss Niles going, we

saw her but not Miss Pope. Met Miss Berlin, an old friend of Henri's, though of the Atlantic City period of his life. A great moment when the vessel backs out from her dock, whistle blowing, band playing, people waving hats, hands and handkerchiefs–a lump in your throat and tears in some eyes. We came back and had a second breakfast at Cavanagh's on 23rd St., a block below us ... finished up a Puzzle. . . .

June 16

Mrs. Crane brought Roma and after I went to Broadway to buy the Phila. Press (taking Roma), we started to work on the portrait. Worked steadily all afternoon, and, though not satisfied with the result, I don't feel badly about it. . . .

June 17

Very hot today and I don't feel at my best, tired and weak ... went out, walked on 6th Avenue and 14th St., stopped in Union Square. Stopped in Everybody's magazine. Brown is still away. Went to the Century where I played for a half hour with the office cat and Drake, when he was ready for me, was kind, as usual. Introduced me to Miss Jackson, said I should have a story to picture. Stopped in to Sunday Magazine, proofs from Willing. Chapin of Scribner's was out. Back home. . . .

June 18

Worked from "Stein" "Zenka" today. Took up the nude on the bed started months ago and painted out the figure, putting drapery on stooping figure. Rather like the thing now *["The Cot"]*. Mrs. Reuterdahl called to tell me that R. would like to see me. He has an offer to teach in Pittsburgh and can't take it and wants to know if I will. After dinner, I went over to Weehawken alone and told R. that I would if they wanted me on the job. He wrote a letter to Mrs. Estelle L. Thomas, 512 Euclid Avenue, Pittsburgh. Mrs. Lee left for Philadelphia today. She seemed to have enjoyed her visit and we liked her as a visitor.

June 19

Miss Mary C. Blossom, a friend of Miss Raymond's, came today and bought a set of etchings on Japan paper, the only set of this sort.

$35, and two extra proofs for a wedding present, $5. She is a great admirer of the work. I gave her a "Memory of Last Year." Dolly invited her to lunch on Friday. Mrs. Crane brought Roma over and I worked unsuccessfully on the portrait–fagged out, done up. Dolly and I went to Shanley's to dine. . . .

June 20

Painted on "Sixth Avenue Tenderloin" picture till tired out. In the evening I went over a lot of foreign stamps that Bill Gosewisch left for me to add to my old boyhood collection. A very hot day.

June 21

Jerome Myers came in. Said that Mrs. Annie Nathan Meyer wanted us to come to her house, thence to the Park, tomorrow evening. We postponed it till Thursday–we are to be patronized, perhaps? Though she has always been nice in her nervous way. Worked on the "Tenderloin Sixth Avenue" old girl in white with beer kettle, etc. and have it about finished–and think it a right "good one." . . .

June 22

Ullman called. Sent off Puzzle to Press. . . . went to the old Gould Grand Opera House to hear the Italian Opera Company. D'Amato and Ferrara, Managers. Ullman is press agent. We went behind the scenes, saw the old "green room," an institution that doesn't exist in new theatres. "Lucia de Lammermoor," met her, Mme. Bonato. The prompter in box looks like a musical potato bug. Off stage the performers look like Philadelphia "New Year Shooters." Letter from Pittsburgh saying that they want an instructor, "100. per month and expenses." Have decided to take it if offered.

June 23

Wrote to Miss Estelle L. Thomas . . . saying that I'd accept position if offered. Dolly and I went to Staten Island, South Beach this afternoon by Municipal Ferry and Train. Our first visit and we found the place quite to our liking. Reminds one of Atlantic City years ago. It is not so touched by the "refinements" as Coney Island. We walked along the beach and came home in time to have dinner about 8 o'clock.

June 24

Dolly went over to Bayonne to lunch. I worked on a picture, started to make a memory of South Beach. While working, H. Pretty, ex-newspaper reporter and now book agent, came in, stayed quite a while. I handed him a set of the New York etchings. He said he would like to try to sell them. (Also one Japan in frame.) . . .

June 25

Willing of Sunday Magazine sent me a story to read and talk over with him, which I did.

June 26

Painted on South Beach picture. After dinner, Jerome Myers called for us with a M. Guislain, son of Belgian consul to Peru. An artist, very nice fellow he seems. We all went up to Madison Avenue and 68th St. to call on Mrs. Annie Nathan Meyer. Had a rather amusing evening (arguing most of the time with my hostess). Her husband, Dr. Meyer, is a fine little man and well known tuberculosis specialist.

June 28

Miss Mary C. Blossom came by invitation to lunch with us. I showed her a number of my pictures and liked her appreciation of them. She is a strange personality, very interesting. Finished up a Puzzle. After dinner W. S. Potts came in and spent the evening. Things seem to be still in bad shape with him. Went to Mrs. Käsebier's and she gave me a bunch of proofs. Not satisfactory photos either to her or me. She says she'll try again.

June 29

Wrote to Garrett, Tax Collector of Lansdowne, in re notification of taxes due on E. Lansdowne lots. Rained all day and quite cool. In the afternoon, worked on South Beach picture. Walked out in the evening alone. Went into a five cent show of Kinematograph pictures [*silent*] on 6th Avenue. Think it might be a good thing to paint. After return, I worked on some Puzzle ideas. . . .

June 30

Cloudy weather and rather cool. After getting the papers on Broadway, sat around. Had lunch at 2:30. As there is no rain and the wind

westerly, think of going to Coney Island. As we started out we met M. Guislain, whom Myers introduced the other evening. We walked over to the East 23rd St. Ferry. The Garbage Collectors strike has been on for several days and filth is heaped on the streets, fearful odors. It looked so much like rain, that we came back. G. likes my work and is full of French enthusiasm. Dolly and I went to Shanley's for dinner. Made a late afternoon start on the interior of Moving Picture show.

July 1

I worked on the Moving Picture show. Potts came to dinner and spent the evening. Went out after dinner with him and looked at the Moving Picture place on 6th Avenue. . . .

July 2

Note from Reuterdahls invites us to dinner this evening . . . phoned and declined. Note from Mrs. Crane invites us to spend the 4th with them. Walked over to Mrs. Käsebier's, she gave me another proof of photo. Stopped in to see Mischke. He says if I want to dispose of my Daumiers, he can make a profit for me.

July 4

Up early . . . and started for Bayonne . . . elegant lunch of crabs . . . nice dinner, hot boiled tongue, young chicory, potatoes, cauliflower and watermelon. Walked over to the Newark Bay Picnic Ground, very beautiful in the late afternoon.

July 5

Sent taxes for 1907 on E. Lansdowne lots #130 and 131 to W. H. Garrett, Lansdowne, Pa. Telegram from Glackens dated yesterday "July 4th" son born, mother and child feeling well.

July 6

Received word of my election as instructor in Pittsburgh Art Students League, Miss Estelle L. Thomas . . . secretary. She says that a Miss May Rogers and Mr. Glen Keeple have been in classes of mine. I suppose, of course, when I took Henri's place at N.Y. School of Art. Made a Puzzle and took some photographs of some of the things I've been painting on.

139 JULY 1907

July 7

Made a lot of prints from my negatives taken yesterday ... not very successful (the prints) stained yellow. Dolly and I went down 23rd St. to Cavanagh's ... nice dinner and enjoyed it very much, after which we took a walk on Sixth Ave. and Broadway. Went in to one of the Moving Picture shows, five cents.

July 10

Up to Metropolitan to look at musical instruments for Sunday Magazine story. Saw the Renoir picture. Like the woman. Rather disappointed. In the afternoon ... a M. Tisne called. He was referred to me by Mr. Chapin of Scribner's. A friend of his, M. Heuret (I think that's it) has written a book on America. Hachette and Co. are going to publish it and they want some 30 illustrations for 3,000 francs. $600. Colored drawings or paintings. I showed him some paintings and etchings; and made proposition to do the work in etching provided I am to have all American rights to the plates, they are to have book rights and foreign rights. Trusted him with set of N.Y. etchings and set (6) De Kock etchings to send over to be returned to me. Up to see Mrs. Käsebier, who gave me three more prints of my photos. Said she had heard from Henri. Worked on Sunday Magazine drawing in evening.

July 11

Sent off photos and portrait photo (Mrs. Käsebier) and two etchings to Raymond Gros, 5213 5th Avenue, Pittsburgh, Pa. Worked on Sunday Magazine drawings, have one finished. Three postcards from Antwerp from Henri. They are two Rembrandts and one Frans Hals.

July 12

Miss Blossom came in and paid for the etchings. Stein has finished weaving a hat of raffia grass or palm for Dolly ... a very pretty job. Paid her $3.25 for her work ... finished the two drawings for the Sunday Magazine today.

July 13

Up rather late. A beautiful day so we think we will go out this afternoon. To Coney Island hie ourselves and have a very pleasant afternoon and evening. The concert halls with their tawdry, gaudy, bawdy

140

beauties are fine–and on the beach, the sand covered bathing suits of the women who look and "cavort" are great–look like soft sandstone sculptures, full of the real "vulgar" human life. Crowds watch the people coming down the Bamboo slide in Luna Park–lingerie displays bring a roar of natural "vulgar" mirth. The crowds near kill you in the rushes for the trains going and coming. One must strive for good nature.

July 14

Stopped in to see Myers. He is getting "material" in shape to start on some paintings soon. Wrote to Henri in the evening. . . .

NEW YORK, JULY 14, 1907

Dear Henri,

Your postal from Antwerp arrived, also the illustrated note. I see that you gave up your plan for crossing the sea by "land" (Finland), and judge by the bag of gold beside you that you travelled by "bridge." . . .

Two or three things have transpired since you left–of first importance, perhaps, Mrs. Glackens cleared of a boy on the fourth of July. . . . About a week after you left, I heard from Reuterdahl that he had been asked if he would consider a position as instructor in the Pittsburgh Art Students League. He told me that he was too busy–should he name me as a likely man for the place? I considered and said "yes." . . . A friend of Miss Raymond's named Miss Blossom bought a set of etchings. . . . Dolly leaves for Philadelphia tomorrow on her "annual tour of the Provinces." Have been working on two or three new canvases since you left. Can't feel sure of them yet; and have done a story for the Sunday Magazine last week. . . . Dolly tells me to say that you are very much missed at our evenings here at 165–and you certainly are. We hope that you are having a good time. How goes "The Dutch" as painting material? I suppose you have a wonderfully clean studio where you leave your shoes outside the door. Remember us very particularly to Miss Niles and Miss Pope. I'm now out of subject matter so will cut off right here with a hope expressed that I may hear from you soon.

I'M YOURS,
John Sloan

July 15

Dolly left for Philadelphia on the 3 P.M. train . . . left a loving letter on my pillow in our bed, to cheer my loneliness. Delivered drawings

to Willing of Sunday Magazine. $75. Had a long chat with him, his favorite subject, "Phila." Ate dinner at the little bakery on 8th Avenue. . . . Into a five cent moving picture show and afterward came home where I put in the evening working on Puzzle ideas. Mr. Barrell, a magazine writer, called this afternoon and left (6) photos belonging to Henri. He knows Traubel, Whitman's Literary executor.

July 16

Took a walk in the morning, 8th and 9th Avenue. Made a Puzzle today. Dinner at a lunch room on 6th Avenue. Took a walk in the evening as far as Broadway and 42nd St. The gay fast throngs are fine. The automobiles waiting at the curb for passengers for the night trip to Coney Island. Stopped and bought a Panama hat $5. The one I have is worn or rather done out by acid cleaners. Came back at 9:30 and, after watching out my studio windows for a time, started on Puzzle ideas.

JULY 16, 1907

Dear Honey:

Your short note announcing your safe arrival came at 4 P.M. today. Now on my way to dinner I'll mail this (about 7 o'clock) so that perhaps you'll get it tomorrow morning.

I ate dinner at the 8th Avenue Bakery last night, right good dinner. Then took a walk and stopped in and had five cents worth of theatricals at our familiar 6th Ave. Picture Show. Then came home and worked on Puzzle ideas–to bed at 12 o'clock. Your little note was a great thing to have when I turned in. I "affectionated" it.

Remember me to all the folks and have a big "wireless" hug from your

VERY OWN,
Jack

July 17

Made another Puzzle. . . . Out in the hall in the morning, rapping on the pipes for water for my bath, top floor–no good supply. The studio door shuts with a snap, Yale lock, no key, naked as the day I was born–desperate and perspiring, trying to break in the doors–footsteps coming up the stairs–I dive into a closet in the hall. It's the ice man. I try to explain my case and he goes downstairs and climbs up the

fire escape and lets me into my home. Oh, the excitement, the agony, but the fun in accounting this adventure.

July 19

Made another Puzzle today. . . . Started for a walk and met Glackens, "paterfamilias." . . . said he was going down to J. Moore's, so at his invitation I went down . . . met a Mr. Clapp . . . and three young ladies, perhaps, of the chorus girl type. One of them none other than the famous Mazie Follette who has been mentioned in the infamous Thaw trial. . . . We played shuffleboard. . . . The party broke up at 1:30. . . . Walked down 6th Avenue with Glackens, talking. The subject of teaching came up and he said he thought Henri had taught too much, giving up himself, etc.

July 20

. . . A gray day, and it rained hard for about an hour. . . . Made a Puzzle. . . . A splendid dinner at Glackens', very good cooking and things so nice. He should be happy, a wife, a baby, money in the family, genius. After dinner to the Francis where I met Hunter Breckinridge of Fincastle, Virginia, a very fine fellow, like him. Walked back with Glackens, stopped at Shanley's, sat and talked for more than an hour. To bed at daybreak.

July 22

Note from Mr. Barrell says he will call this afternoon . . . which he did and went over some of my things with view of writing an article. I loaned him a set of etchings and also five negatives from pictures. . . . Made another Puzzle.

July 23

Right hot today. Jerome Myers called, and later Barrell came in again to talk over article. Jim Gregg of the Evening Sun came in . . . said he'd like me to come up to the Francis after dinner. . . . Ate at Shanley's . . . then went up. . . . Gregg and I left and walked down Broadway . . . went into a café . . . and talked quite a while. Got home about 2 A.M. . . . it seemed but a few minutes later when I was wakened by fire engines going by. Looked out the window. Saw that the Furniture Store Building next to Myers was burning. Slipped on trousers, shoes, and coat and went over. With difficulty was allowed to go up

to see how Myers were faring. Found Mrs. M. alone, Jerome having gone out early to walk as he often does. Mrs. M. and I got some of his drawings, etc., together ready to get out if necessary, but the fire was controlled in a half hour or so. Myers came home. We had coffee and I came home and poorly finished my sleep till 12 o'clock. *[Mrs. Myers never forgot this. She told me about it one day as we breakfasted in the Hotel Dupont at the time of the 50th anniversary of the 1910 exhibition at the Delaware Art Center in 1960.]*

July 25

Miss Estelle L. Thomas, secretary of Pittsburgh Art Students League writes from Lakedale, North East, Pa., for photographs of me for notices of opening of school . . . sent one by mail. Finished up a Puzzle. Went to the bakery for dinner . . . boiled out a few Puzzle schemes . . . to bed at one o'clock.

July 26

Charles J. Caffin was an early visitor this morning. Wants to have some photos of my work to use one or two in a book which he brings out this fall. F. A. Stokes, publishers, I think he said. I had never met him and found him quite agreeable. He looked at a number of pictures and seemed to like them. Called at Myers and after taking a walk with Jerome, stayed to dinner. . . .

July 31

Visit from the new owner of 165 W. 23. He agrees to give me one year's lease at $50. I am to see to it that the water heater does not leak into the hall. His name is S. L. Cohen, 205 W. 116th St.

August 1

Got up at 7 o'clock and after getting myself "packed" and breakfasted, caught the 9 o'clock train . . . Dolly met me . . . in Philadelphia . . . out on the 4:09 train from Columbia Avenue to Fort Washington. Mother seems about the same though her interest in things does not seem so keen as formerly.

August 2

My 36th birthday. Went in town in the afternoon . . . to Dr. Bower's. He gave me some medicine for my bronchial cough. . . . Dolly is to

144

come in again on Wednesday. . . . Caught the 5:02 to F.W. Dolly treated me to ice cream to mark my Birthday dinner. . . .

August 3

In the evening we went to Anshutz's and had an amusing time. Miss Henderson the cidevant art student and now "critic" of the Philadelphia Inquirer staff, was as usual amusing in her ignorance coated with sarcasm. . . .

August 6

. . . A letter from Munsey asks me to call today or tomorrow. Decided to go to N.Y. but . . . found that the only train would land me in N.Y. at 3 A.M. so will start early in the morning.

August 7

Up at 5:45 A.M. and caught the 7:20 A.M. train at Jenkintown. Reached the Flatiron Building about 9:45. Saw Munsey's (Tate) and came right back after looking in the studio (165 W. 23). At Wayne Junction caught train and strangely enough there sat Dolly coming from the City. She had heard by phone of my hurried trip. . . .

August 9

. . . Saw Peters and ordered 6 sets etchings printed. Stopped in J. E. Barr & Co. print dealers, and showed the etchings to him and to Harry Hampshire and J. M. Shellenberger. These are all from Porter and Coates' old business–where I spent near three years of my youth among books. Hampshire was my boss then, I being assistant cashier and retail bookkeepers assistant. "Captain" Barr was a salesman and Shellenberger was assistant wholesale bookkeeper. The business has discontinued now, though I am quite sure from something they said that H. T. Coates or Joseph Coates is back of J.E.B. Co.

August 15

Today we returned to New York and the place looks good to us. The weather is cool and the air fresh and invigorating. . . .

August 16

Stopped in to see the Myers. Attempted to show my knowledge of photography but on developing the plates was greatly disappointed.

Worked in the afternoon and evening on Munsey outline drawings, very poor jobs but under instructions as to handling–it is hard to do one's own work.

August 17

Paid Road Tax–Upper Darby Township to George T. Wadas, Township Treasurer, $1.24.... Finished up work for Munsey ... stopped in at Mouquin's. Met Brooks, Lawson, Fuhr and Cartwright with a "popeyed skate" on ... to a Chinese Restaurant on 6th Avenue, then home and to bed. Altogether a right good "welcome back to New York" extended by ourselves to ourselves.

August 19

After an annoying day with Tate of Munsey's–repairing and redrawing under his criticism–I finally landed the drawings. $45. and a poor lot of things they are. In the evening ... Dolly and I went to the Lyceum Theatre and saw Grace George in "Divorçons," a very amusing play. Enjoyed it–some few little Americanisms are faults. ... To Shanley's and had a "rickey" with Dolly, then to Mouquin's on 6th Avenue, and a couple more and lobster Newburg. Came home merry and to bed at 1:30 A.M. A jolly evening altogether, just the two of us.

August 22

Letter from Henri and some picture postcards which were very interesting. We went to Cranes after dinner ... after the children were put to bed, we went down to the café on the N.Y. Bay Shore and watched the full moon lighting the water and the boats riding at anchor. Now and then laughter would come to our ears from some little merry moored party in one of the yachts. . . .

August 24

Walked out and tried to find some book that would be a help to Nan in doing the decorative panels for Mrs. Norris of Philadelphia. Not very successful in my search. Nan writes that Mother is worse, suffering dreadful pain, day and night. I suppose the beginning of the end.

146

August 26

Letter from Marianna:

FORT WASHINGTON

Dear Jack and Dollie,

Mother is no better. She has been unconscious for 48 hours and is yet. The doctor calls it a stroke. She lies perfectly still simply breathing–and though we move her and try to rouse her, a little cry is all we can get. . . . I don't know what to advise you. It looks dreadfully serious but the D. thinks she will come out of it. I would not have you regret not coming for the world. . . .

WITH LOVE
Nannie

I went and called Nan on long distance . . . she says I had better come, so Dolly and I are going at once . . . arrived in Fort Washington about 4:30 P.M. Mother was unconscious, though I like to think that there was some recognition of me when I spoke to her. Under her closed eyelids, the eyeballs made two or three movements. We sat up taking turns watching at her bedside during the night.

August 27

And so morning came with no change, the quick breathing and inert body just the same. Everybody eats their meals just as usual but over us all there hangs this dreadful shadow–the approach of death is felt. The day went by and another night when we sat up in twos. During the two nights I had six hours sleep–curious, the selfish noting of the fact–and Dolly and the girls had less. We made Daddy rest about six hours each night. He gets the heaviest blow and he is sixty-seven years old.

August 28

About seven or eight o'clock in the morning Mother's breathing got very much labored. The Doctor (Godfrey of Ambler) comes each day twice, but gives no hope. After lunch, the death is drawing in all the corners of the net and Mother's brave strong heart and sound lungs are making an awful fight. They are all that is alive of her. At 1:20 P.M. she died–the first death I ever saw–a mighty sight for

mortals, a great mystery. The top of the head warm after death. I want to express my thanks for the great aid rendered us by Miss Ramsden, a trained nurse, and a neighbor. She did everything, things we knew nothing of. We went to bed and we all slept, I believe.

August 29

Yesterday the undertaker (G. C. Davis of Fort Washington and Ambler) had closed Mother's room and asked us to keep out. There is a frame there and a sheet cover, she's under it–not she, but the shell in which she lived and suffered and on which she left the beautiful impressions of her goodness and serenity. It forces itself on me that essential life of her must go on, a part of the great God which it always was. In the evening yesterday, after an errand in the village, seeing Dolly and Eleanor off on train–I dropped on my knees on the grass, under her window–the stars were every one out. I did not pray. . . .

August 30

The black coat I got for Father didn't fit so I took him to Philadelphia and we had it made right. We had two hours to wait so went to E. Lansdowne, looked at my lots. The place looks prosperous. Came home by way of 60th St. and the Market St. new elevated railway. He has not been in City for three years so it did him lots of good. Took his mind off Mother's death a bit, perhaps. The nervous strain on all of us is very great, a sense of tension, almost angry. Each word is taken up. The girls and Dolly are preparing their black ugly gowns and veils for the funeral. Aunt Annie is here, staying with Registers around the corner. This sewing began within an hour of Mother's last breath–but it is well, it distracts the mind. In the evening a terrible nervous condition of affairs arose. Nan had asked for certain hymns, Mother's favorite old tunes not in the Church hymnals. Robinson, the organist of St. Thomas, Whitemarsh, came out and he and I, Nan and Mr. Bordjensky, copied music–my head aswim–Robinson tired to near death (he is an engineer and has several motherless children, one is insane). "Hark, Hark! My Soul," "Oh, Paradise." The whole thing seemed so different from what Mother would wish. She would never have had so great a strain put on anyone as was on Mr. Robinson.

148

August 31

Today the funeral. Malcolm Stewart kindly acted as one of the bearers. Uncle Al. Sloan, cousin John Starr and myself. The Church and Cemetery of St. Thomas's Whitemarsh, where Mother's money bought a lot two years ago, are beautifully situated on a little hill by the turnpike. The services were, of course, beautiful. The hymns nearly broke me down, by suggestion and the fact that I had been reminded that they were her favorites. I was very nervous and physically weak–the walk through the narrow graveyard paths was about all I could do. The girls say that a stranger was weeping in the back of the church, elderly man. "A love of her youth" 'tis therefore romantically imagined. My little wife watched over me, saw to it that the gentle undertaker kept near lest I give out. A good smoke in the carriage coming home. Tobacco is wonderful!

September 1

Up early and went to the church. Mother's grave a raw mound with flowers upon it. The flowers that will be associated with her death to me. Hydrangeas, great clusters, then too, the beautiful white roses, sent by Malcolm Stewart. The fine fellow I'll not forget, a real big gentleman. In the evening, Bess and Marianna hiked off to church–the church which gets all their "demonstrations" of love–learning nothing but the unseen love for others. Dad will respond to love from Dolly–she forces him to come out of his shell some. They use this quality in devotion. I am convinced that religiousness and goodness are very different things. *[Sloan was what you call anticlerical, in the sense of being critical that churches did not carry out the teachings of Christ. But the philosophy of life which inspired his work for socialism and pacifism had been formed during his childhood under the influence of ministers he admired, the rector of the church he attended in Philadelphia and his uncle, the Reverend Weld. Although he might have called himself an agnostic, Sloan was not an atheist.]*

September 3

Went over with Dolly and saw the Anshutz's, and Malcolm Stewart's bungalow "The Box Stall," built on Tom Anshutz's grounds. Hear that Breckenridge and E. W. Redfield are quite "thick." Foxy "Breck" is going over to *[him]* after all he has told of him. Wonder what Schofield would think. Bah! The "Politics of Art" are disgusting, at

least when one's not in them. After dinner, Dolly and I left for New York. . . .

September 4

Wrote Nan that I was sending Dad a check and that I will send one each month to make him feel less dependent, that I never regarded Mother as dependent for the last ten years as she had in her own right (from Uncle Alfred's estate) what would amount to $6. a week for ten years.

September 5

Letter from Henri–Ostend to Dover. Interesting letter.

ON A STEAMER FOR DOVER FROM OSTEND
August 26, 1907

Dear Sloans,

According to schedule I am just a little more than one hour from Dover–having had a very easy passage–the trip from Ostend to Dover is only three hours and a half–these trembly little boats–long and narrow are very swift. Ostend was brilliant, rich and gaudy–tremendous display of sporty people. Brilliant hotels, restaurants in which dined the latest fads and fashions and all in the full extreme. Good sight for a short trip. There is a magnificent Kursael–music pavilion and gambling establishment. But the sight was the bathing beach this morning where it seemed to me it was cool enough for clothes–the bathers seemed warm enough though some of them were beautiful, some fat, but there was no doubt about any of them for they were draped less than the possibility of fraud –some were

(sketch)	skin tight and other were	(sketch)	and others more modest like this	(sketch)

But to be fair to No. 1, she was a beauty–and she was numerous–you would approve the garment, John–one piece, union, skin tight, but shorter at both ends than you wear them–shorter than in my drawing. The tremble of this boat and its slight bump is not in sympathy with the genius of drawing. They all, fat, fine, and flabby enjoyed being looked at and to please them I should have liked your opera glasses–many of my fellow watchers did have them and used them at both close and long range. There was one star sylph–long of back, and fine of hips, round and plump of legs, of a beautiful whiteness of skin that showed perhaps more by the slightness of her suit–she had all eyes for a time and many of our

feet were wet by the unheeded encroaching tide. I expect to be in London tonight–will have a quick look at the National Gallery tomorrow morning and will be in Halifax, Yorkshire, in the evening. There I am to paint the portrait of the wife of the ex-mayor etc., etc.–she being the sister of Miss Fisher. I believe I have written of this before. I ought to get on well with it for I have had a steady practice now for a long time. Yesterday I was in Bruges (Mrs. Niles and Miss Pope came as far as Ostend with me). Bruges is not half as good as you drew it. In fact, the place is for water color, and German sketch book artists–as Miss Pope said for those who love moss and vine grown ruins–why the place has such a reputation save for a few fine pieces of architecture in church and town hall–I can't see.

At Brussels things seemed rather dead for a "Northern Paris" but we managed to see some good pictures among the best–and the most to my interest, Hals great portrait of a Professor of Leyden–you know it by reproduction. We went to a fine variety show in a handsome big hall–it would make Kurt's or Proctor ashamed of their bills. There was an unfortunate accident at the end–flying trapeze stunt–they were preparing the net and one of the helpers was running with a rope to the corner of the net when the corner hook slipped and the poor fellow went headlong. He fell on his head among the seats. He was covered with blood and looked dead when they carried him out–next day it was said he was not fatally injured–the show went on.

In Antwerp we visited the museums.–I see a fine ship out there–I shall return to Amsterdam when I finish in England–I expect to work there two or three days–and then to Paris, sailing as I believe I have told you from Boulogne via "Potsdam," Holland America Line–September 28 to land in New York about 6th or 7th October. I am sorry the berth was so hard to get for I should have liked to sail early enough to save you your job of moving. I wanted to get back soon enough to relieve you of the task you have been so good to take on for me. I consider that this trip has been a valuable one–although I bring home no large imposing canvases, most of them about 22 x 26. But among them there are good ones and the study has been excellent. They are nearly all heads–I am sorry I have not had more time to do some street pictures or landscapes. Of course, in England I will have my hands full with the portrait although I am told the landscape in that part is fine–large, sinister Scotchlike, they say.

My address will be still Thos. Cook & Son, Amsterdam. Hope you are both happy.

YOURS,
Henri

P.S. I have just landed in Dover, rushed through the customs with an opening and a closing–and am on the train for London–long seats in red plush, figure against the windows and a sort of narrow table down the middle–a uniformed young man rushed in "will you have a basket, Sir?" I didn't seem to know, although others wanted baskets. "Will you have a cup of tea?" I said yes and I got a large square basket with a zinc pan–when I raised the lid–divided to hold tea pot and bread, raisin cake, sugar and cups and saucer, all very good and sold by a big hotel company–the Gordon Hotels–it cost a shilling.

Out with my "samples" to look for work but got caught in a rain and came home after calling at Scribner's (Chapin away) . . . met Lawson. . . . He's looking for a studio. Stopped in at "Outing" but the art editor is only there Tuesdays and Fridays. Stopped in and met Mr. Macbeth in his galleries. He tells me that the two pictures he has of mine were not sold to the Albany man but that he will want one later, sure. He says his health is good now, a charming little man is Macbeth. On to Tonetti's studio where Henri is to move. He is out so that I could not arrange for moving. Stopped at Appleton's. Went in Bonaventure's Print Dealer. "Do you buy modern etchings?" "We never do!" I left. Copy of Pittsburgh "Index" August 31 contains article on me as coming instructor.

September 6

Made arrangements to move Henri's things to 135 E. 40th Street. Met Mr. Tonetti, the sculptor, who has the large studio and leases or owns the building, once a church. Morgan Bros. will do the moving Thursday morning. I bought tickets to the New York Theatre where . . . Dolly and I saw a vaudeville show. A troop of Spanish dancers was especially fine. The women full blooded, strong creatures with splendid costumes. La Esmeralda, Sevittianita. In the afternoon I made a start on picture, front of "Haymarket" on Sixth Avenue. *[This painting is in the Brooklyn Museum. In later years in* Gist of Art *Sloan commented on this picture, "This old dance hall on Sixth Avenue, famous through infamy, was a well-known hangout for the underworld. Ladies whose dress and general deportment were satisfactory to the doorman were admitted free. Gents paid."]*

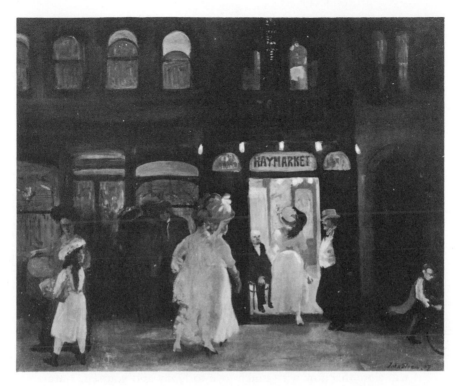

"Haymarket," 1907

September 7

Worked on the Haymarket picture all day. Myers and Mrs. and the baby came in for a little while in the afternoon . . . took a walk up 6th Avenue to have another look at the Haymarket.

September 10

Up at 7 o'clock and to Bryant Park where the movers of Henri's effects were already at work. Twelve hours of hard work for five men with some help from me, saw his stuff in 135 E. 40. The movers told me they were the best paid in the city, $2.50 and $3. per day–but a day's work such as they did there, ten short flights with turns in each, is a terrific thing to watch. They were good natured about it, though. Henri certainly has a lot of work to show for his life as a painter. . . . A letter from my father today–dear old Dad, letters are a rare thing from him.

My dear son Jack,

I received your letter with the check enclosed, as Nan has no doubt told you. I am very much obliged to you for it, but, my dear boy, don't put yourself in a hole as my wants are not very many.

I did want to get a new pair of spectacles as my old ones are broken and too young for me now.

What you say about your Mother, I can fully agree with you. I miss her very much. It is so lonely. No one to fun up and help carry any more. When I close in the shutter, my first thought is don't make a noise and waken Mama. Yes, I miss her in a hundred ways. I try to keep at work at something to keep my mind from thinking too much of her that is gone. The worst time is at night when I am alone with my thoughts. I often think I have done all I could for her, I'm afraid not. Yes, Jack, she was a good wife, a Mother and will be sadly missed. If any one reaps as she has sown, Nettie surely is the one.

Jack, you must excuse this letter as I don't think I have tried to write for at least fifteen years and it is not an easy job. I would sooner dig garden.

We are getting along as usual. I am at work on the tables and have near ready to put together.

I will close this now with much love to Dolly and yourself, I am

YOUR LOVING FATHER,
James D. Sloan

Excuse all the mistakes as I am not as young as I used to be.

September 12

Dolly went up to Henri's and put in another day at cleaning up. I went down to East 13th St. and 2nd Ave. to look at apartments but did not think much of them. Cheap enough but not nice. On the way back bought hinges and handles for the mahogany desk and put in the afternoon repairing it. Worked on the Sunday Magazine drawings in the evening.

September 15

Walked out for papers. The leaves in Madison Square are commencing to show the touch of fall, very beautiful rich color and the brass trimmings of the automobiles dashing by on Fifth Avenue suggest

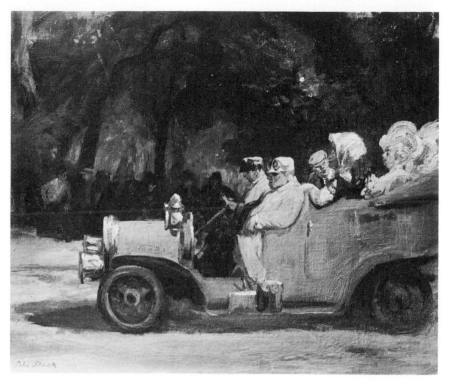

a picture to me. The brass of the life of those riding. Finished the Sunday Magazine Bull Fight drawings.

September 16

Delivered the drawings to Sunday Magazine. They went through all right. Worked on the Haymarket picture and about finished it. Then took a start on an idea which crossed me yesterday, a brass-trimmed, snob, cheap, "nouveau riche" laden automobile passing the park.

September 17

Letter from Henri written on the train coming to London from Halifax. The portrait is done and is well liked. He speaks again of the Laurence Sterne *[Tristram Shandy]* house there. Went on with the touring car picture. Potts . . . gave me some practical criticism on the construction of my auto in the picture.

September 19

Mrs. Neville is at work throwing out all unnecessary dirt so I went out on some errands for Dolly and to the bank. Later . . . Julius Ouderdouk and his father from Dallas Texas State Fair called and selected "The Wake of the Ferry, #2," "The Picnic Ground" and the picture I'm working on ("Gray and Brass," I guess I'll call it) for the art exhibition. . . .

September 20

Miss Emma Lawrence came in like a breeze . . . jolly to have about . . . made Dolly three hats for winter in a jiffy. Lawson called. Also Ernest Fuhr dropped in to tell me that Burr, McIntosh Monthly, wanted one of my pictures to reproduce with one of his Shinn's. Later in the afternoon the editor called and with him, Walter Kuhn *[Walt Kuhn]*, and selected the Haymarket which I have just finished. Mrs. Will Low called and charged me for the oilcloth and curtain poles in Henri's studio, $5. . . . Cohen brought in a lease for me to sign, which I did. Dolly and I put up 23 jars of peach jam in the evening.

September 21

The Ouderdouks came in and I told them that the Dallas Fair could have the portrait of me by Henri *[later a gift by John Sloan to the Corcoran Gallery, Washington]*, and the Head of a Woman (French girl) and the little one of Dolly's which he gave us. They were well pleased . . . tinkered with broken frame and put on a new corner. Scraped the front room wall as we have found one or two visitors of an unsavory sort from the dirty wench who dressmakes in the room below. Mischke writes me to take away the set of etchings which he has had on sale. Harry Hart who was once on the Press in Philadelphia came in or to the door, a sad figure "needed a drink," all trembling and shabby looking. Yet with a spark of his wit, he speaks of the climb upstairs "remarkable what physical weakness one can enjoy" he said. I gave him some change—I couldn't take him in somehow yet it seems as though a heart should (I intended no pun here. It came and called my attention to itself after writing the word) dictate that kindness. Poor Harry Hart, he's a clever pen draughtsman, or was.

156

September 22

After my regular Sunday errand for the papers, walked to Fifth Avenue. Came back and worked on the automobile picture, Gray and Brass. Then when I had it finished, I made a photograph of it. I want to have some record of it to show to Henri when he returns. Got a good negative. Dolly worked on the wallpaper in our room. After dinner I started a Puzzle.

September 24

Before we had our breakfast (we were late) the Myers came and left the baby in our charge and we enjoyed Virginia's visit very much. We imagined ourselves the parents and owners of the little mite and decided that we liked the idea. Of course she was very good all the time she was here. If there had been a squall we might have felt differently. I made some prints from photos and also took two more. Got a good one of "The Hungry Boy." Rollin Kirby came in, back from his outdoor treatment in the woods . . . says he is going West for a few months, then South for the winter. He liked the things that I have painted this summer. . . .

September 25

George Fox, who has hidden himself in the country for more than a year, arrived and says he is going to take a studio . . . spent his money in retirement and now must get to work . . . accepted our invitation to stay here while he is in town. . . .

September 27

An astonishing and exciting discovery. Our ice box (which held all our jam) and our refrigerator in the hall, were robbed yesterday while we were away. Nine jars of our precious "jam" gone, a basket stolen to carry them in, a long drink missing from our milk bottle and four peaches . . . foolish to leave it unlocked in the hallway! I got wire and attached the electric bell to the ice box lid so that opening it will give alarm. This was amusing but too late! That thief may never return, he may eat too much of the jam at a sitting!!! . . .

September 28

Still regretting our loss . . . bought locks for the refrigerator and box and attached them. . . . Henri sails today on the "Potsdam" for this port. "Bon Voyage" to him is our wish. . . .

September 30

Miss Lawrence brought in Miss Barnes and Mr. Naething *[Nathan]* and we had them to lunch. Dolly made panned oysters–and we had our chance to study rich people of the time. A turmoil, playing on the piano. Miss Barnes posed after lunch and I made a sketch of her, not very successful. Mr. Barrell came in and I read his article about me. He wants some large photographs. . . . It doesn't seem that these young people with money have any real good times–not such as we do–who can afford to be artists–a luxury. In the evening Dolly and I dined at Mouquin's and enjoyed ourselves greatly.

October 1

. . . Stopped in several pawnshops looking for a camera 8 x 10. Bought a lens for $4. of L. Rothman, 136 Park Row, which he says will fill an 8 x 10 plate. . . . Spent most of the evening trying to find out what the lens would do but can't just tell though I suspect I have been "stung."

October 2

Yes, I find "stung" is the word. Went to Ullman. . . . He introduced me to Mr. Ashton who sent me to Willoughby, 10th and Broadway, where I am authoritatively told that the lens is not a photo lens at all–a mere projector, price $2. *new*. I am indignant, and proceed downtown. Another clerk in charge, so I hang around the neighborhood for about one and a half hours. At last reconnoitering from the far side of the street, I see my man and he refuses to return my money. Then I hasten to see D'Amato, Deputy Chief, License Bureau, where a clerk takes my plaint on a slip of paper and tells me to call Friday, 2 P.M.

October 3

Bought an outfit for 8 x 10 photographs from Willoughby and at once tried two negatives. Pretty fair results. At any rate I feel pleased with my bargain.

October 4

George Fox came back to stay in New York.... At 2 o'clock to License Bureau, City Hall. Ullman and I ... before D'Amato, whom now I see in his guise as Deputy Commissioner of Licenses in contrast to the Benign Impresario with the Opera, I put my case. I get the Commissioner's decision, my money is ordered returned, as misrepresentation is shown in supplying me with a stereopticon lens. But the recovery is not forthcoming. D'Amato orders the clerk to revoke the license of the pawnbroker's store and there the matter ends.

October 5

Chicago Institute Exhibition entries should be sent today or tomorrow–October 8 last day for receipt. Went to ferry and met Mrs. Lee who is going to stay with us to see Henri return and a couple of weeks more. Photographing all day and rigging up shield for light in studio in the evening....

October 7

A letter from the Mayor's office ends my troubles with the Pawnbroker of the Bowery. I am informed that $4. has been deposited there waiting my return of the lens. Ha!! Vengeance! Potts and Fox to dinner. Barrell came in and I handed over photos of about five pictures for his article on my work. I read his manuscript on Henri and think it right good–so far as I can tell should be satisfactory.

October 8

We were in an excitement of expectation of Henri all morning–his Mother at the front window all the time. *Henri arrived here about 3 o'clock in the afternoon.* Storm last night delayed them. Miss Niles with him. We all went to the new studio (E. 40 St.) with him, Dolly so anxious to see what he would think of her arrangements and cleaning. He was much pleased.... Henri brought Dolly beautiful laces, handkerchiefs and silk stockings.... brought me a book on F. Rops and some Rembrandt reproductions.

October 9

Down to the City Hall to get my $4. which I did and spent it at Willoughby's buying more photo materials. This has certainly been

a photographic week. Nothing else have I done. But I don't feel like painting until after I've had my first day at Pittsburgh and my two nights of travel.

October 10

Photographing till late in afternoon . . . went up to Henri's. . . . Henri showed us his Holland work. . . . We all enjoyed looking at the paintings of little Dutch children, a wonderful series of heads painted for the most part in solid ability, not clever, but moved and inspired by life, human, vigorous emotions. Henri came to dinner and spent the evening. His mother became vexed with him because she got a notion that he was not giving her, and certain "secret" business, enough of his time. She was unreasonable in a truly womanly way, and I was amused to see Henri unable to cope with it—such an unanswerable, intangible thing as a woman's pouting.

October 11

Barrell came in and I furnished him with more photos for his article on my work. He has 11 photos and 11 etchings and is on his way to see an editor with the article. . . . Henri came to dinner and left to go to N.Y. School (of Art).

October 12

Postcard from Barrell says that editor of the Studio seemed to look favorably on the article, said I was a "desirable citizen." It would certainly be useful for me to be represented in this magazine as it has the greatest clientele of all the art periodicals.

October 14

Miss H. Henderson and Miss Kuntz came in to invite pictures for the Fellowship Exhibition, Philadelphia. It came about that I gave way and let out a tirade against Redfield—she being "a good friend of his" as she put it. I showed her very plainly how I thought of [him]. Warned her against him. Altogether was most incautious and unpolitic. I hope that I showed an honest fool. I know that I seemed a fool. She took "Haymarket," "Portrait Sketch" (Mrs. Reuterdahl), and "Girl and Etching Press" for the exhibition, to be called for tomorrow . . . made purchases for my approaching Pittsburgh trip. In

160

Pittsburgh trip. In the evening I made my will–a very short document–everything to Dolly.

October 15

Letter from Tom Daly says that about this time next year he will have material for another book of verses–"string the public again,"–he calls it. Dolly reports that Henri gave Miss Henderson a very cool reception yesterday and did not show her any pictures. She affects a familiarity with him which he rightly resents. Henri and George Fox to dinner. I had them both sign as witnesses to my "Will" and H. made great fun of the document (not knowing the contents) but I think it wise.

October 16

This day unable to do anything with the excitement of getting ready to go to Pittsburgh tomorrow night. I start on the 9:55 train. Peters came from Philadelphia with some sets of etchings from my plates. I paid for them. Barrell came in with the sad news that the "Studio," after consideration, decided against his article on my work. Why–not stated.

October 17

My first impression of the city Pittsburgh is one of great interest. It seems to be a part of the United States, an "organ" some part of the anatomy–"heart or bowels"–that was entirely new to me. The mills give great character to the atmosphere. In the evening, it is splendid to look down over the Monongahela River and see the sun set red over the hills or mountains to the west. The "comforts" of the Pullman sleeping car are not much. Only two pupils when I arrived. The League seems to be lacking in any interest in the work. I'll try to make some. Don't know whether I'll be able. Miss Craig, Treasurer, Miss Arnold, Miss Thomas, Miss Wilson. Night class very small. Mr. Paulin, Byrne, Sort, McCrackle. Took the 10:10 train for New York.

October 18

Back before Dolly and Mrs. Lee had their breakfast. . . . Tom Daly called with Mr. Adams of the Mail and C. A. Robinson of the Cleveland Leader. Showed some paintings. Adams spoke of sending J. Chamberlain the Art Editor of the Mail to look at my stuff. Went

out with them and joined them in a highball. Daly says "Canzoni" is still selling. Henri at dinner. Sent two Puzzles to the Press. . . .

October 21

. . . Henri came in to dine in place of his Mother who we expected. We had a nice evening with him. His good old company is never tiring–seems to make us feel good, as though there was one real friend in the world for us.

October 22

No ticket as yet from the Pittsburgh School and I am wondering whether to go if they don't send it. Suppose it would be best to invest the money and then have a clear understanding with them. Took a short walk in the afternoon . . . read Mrs. Lee some of the Dago verses from "Canzoni." Started a Puzzle in the evening. . . . Fox is lonely and drops in very frequently. . . . He is not inspiring to me but he is quiet and kindly withal.

October 24

In Pittsburgh. The attendance was better in classes than on my visit last week. The composition class in the afternoon was very largely attended and I hope that I made a proper impression in my talk about the pictures. Only about ten of them were shown. Took dinner at Sotter's. . . . Back to the night class, only four men there. Started them on a half hour sketch. Most of them did better work in that time than in the three night drawing. Caught the 10:10 train and went right to bed . . . slept very well indeed.

October 25

. . . Mrs. Lee went up town to see Dr. Southern who is with Henri . . . both here last evening, Dolly says. . . . Painted on Pittsburgh memory . . . fagged out in the afternoon. . . . Henri at dinner. . . .

October 26

Worked again on the thing I started yesterday. Approach to Pittsburgh, smoky hillside with workmen's shanties, etc. . . . after dinner worked on a Puzzle. . . .

October 27

Bought all the Philadelphia papers to see what is said of the Fellowship Exhibition. Miss Henderson throws me a bouquet of thistles "in paint again," "no sense of color," reproducing in the Inquirer (where she discourses on art at the rate of about $5. a column) the sketch of Henri in crayon on tissue paper. The Ledger and Record are easier on me. Henri came . . . says he is feeling nervous and tired. We talked wildly of moving to Los Angeles, California, and starting an art school. He remarked on the fact that Prizes were never, in art exhibitions, awarded by those who might know. Manet never awarded a prize, Velásquez never did, etc. The prizes are always given by a number of those who don't know.

October 30

Went to the Waldorf and helped hang the work of the lady illustrators. The villainous work of Misses Green and Smith, George Wright and Ed Ashe. Ashe and I left a little before 4 o'clock, walked up Fifth Avenue, went to Wright's place on 23rd St. . . . Started for Pittsburgh on the 9:55 train.

October 31

In Pittsburgh, struggling to convey something worthwhile. . . . The picture class had some interesting things. . . . Enjoyed walk . . . looking over the Monongahela River . . . arrived for night class. Model and myself had quite long wait before the four students turned up. . . . Took berth for Phila. . . . to see Fellowship Exh. . . .

November 1

Arrived at Philadelphia before 7 A.M. . . . went to the Academy of Fine Arts and looked at the Fellowship Exhibition. It was of considerable interest. My pictures are hung nicely. Glackens' "Skating Rink" a good thing. Henri's head of Dutch Girl looks well. Did not particularly like Clymer's. Bryant has good thing "Bill Boullier." Walter Norris came in to meet me at the Academy; glad to see him, he looks right well. Went to Fort Washington, had lunch with Nan and Dad. Dad looks well. Nan's decorations for Mrs. Norris seem to be coming all right. Back to New York on 4 o'clock train. . . .

November 2

... Read most of the day, Huneker's "Melomaniacs"–rather amusing. Jerome Myers dropped in. Kent Crane came in.... An instructive talk with our ubiquitous semitic landlord on the financial situation. I paid him by check in Philadelphia. He discoursed on the present financial flurry. ...

November 4

Anshutz and Mr. Stewart came from Fort Washington. Showed A. my work. I don't feel that he is very enthusiastic over it. They stopped with us for lunch, then went to Henri's. I went to the Staten Island ferry to meet Bessie, who was coming from Cousin Grace Carroll's. Mrs. Carroll was with her, and came to the studio. I have only met her once or twice since "boyhood." Went up to Henri's and remet Anshutz and Stewart. All came to dinner at our place.... Stewart is very young and very big and has been encouraged to state things in an authoritative way. He asserted that art juries were dishonest. To Henri this appeared a slur on Henri's honesty, and he became very angry. Stewart said that he had no such intention and the row was quieted.

November 5

Election Day. Took a walk in the afternoon and saw boys in droves, foraging for fuel for their election fires this evening ... an old lady –a bull dog had a hand bag tearing it up–apparently hers. She wrested it from him, and then discovers to the uproarious amusement of the crowd that hers is safely on her arm. After dinner ... out again and saw the noisy trumpet blowers, confetti throwers and the "ticklers" in use–a small feather duster on a stick which is pushed in the face of each girl by the men, and in the face of men by the girls. A good humorous crowd, so dense in places that it was impossible to control one's movement. A big election bonfire on Seventh Avenue with a policeman trying to keep its creators from adding fuel. They would creep through the dense crowd, and when he was busy, over the heads a barrel or box would sail, into the flames. And a shout of ridicule would meet the policeman's angry efforts to get at the culprit stoker.

164

November 6

A rather dismal rain all day. In the afternoon went to Collier's Weekly . . . met for the first time Will H. Bradley. He was famous as a poster artist in 1894–1895 and thereabout. My name and his were bunched in many a newspaper and magazine article on the "Poster Craze" of that day. He was most pleasant to me and said that he would call to see some of my paintings. Met Joe Laub for the first time for nearly a year . . . doing work for Collier's in the office there. . . .

November 7

In Pittsburgh, meeting of the directors of the League at which I was not present. I suppose they decided whether I would do or not. Met Mrs. Pears who is President of the League, an agreeable middle-aged lady who spoke well to me of my efforts.

November 10

Got up quite late; went for my papers. Henri came for dinner and after dinner he was so low spirited and depressing, that I think he was so informed. He went home quite early. . . . I regret being cross to him but he got on my nerves and his own are in bad shape. Started a Puzzle.

November 11

. . . Henri took us to the N.Y. Theatre where we saw a variety show. Press Eldridge was the chief attraction to Mrs. Lee. She knew him. . . . Harry Lauder, a Scotch character man, very fine–great in fact. Such a manly, sturdy little fellow, his costumes were so well conceived. "I Love a Lassie," "My Bonnie Daisy," etc. The house went wild.

November 12

Got to work in the afternoon on a picture of Election night on Broadway, and got the thing to suit me right well. Think it one of my best things. So that I felt happy in the evening, that good all over feeling that only comes from satisfaction in work–the real happiness, the joy of accomplishing or thinking that one has accomplished, which amounts to the same thing.

November 14

In Pittsburgh. Went up to the Carnegie Institute and looked at the collection of drawings by American Artists. They have three Winslow Homers, very fine; two Glackens. Some painful examples of the labors of "K. Kox." My classes seem to be doing a bit more interesting work than at first. Left my first bill for salary and expenses. Five days of hard work in the past month, traveling 4,350 miles for $100. Doesn't seem very handsome pay, but it keeps me from too much worry over money affairs.

November 15

Henri came to dinner and I went with him up to the New York School to refresh myself as a "professor of art." Interesting work being done by the night class. Listened to Henri talk to them after class. Walked up to 42nd St. with him. Met Joe Laub and wife on Broadway.

November 16

An idea for picture "Boy with Mirror" making faces at himself—saw it out the back window. Went downtown to Devoe to buy varnish. Walked down, rode back. Fine city. Nassau Street, narrow, teeming with life. . . .

November 17

Henri came and dined with us, then went to a reception to a little Japanese lady, an actress who was with her company on the ship he came home on. The affair is at Ben Ali Haggin's studio.

November 18

Took up picture started last summer "South Beach Belle" and worked on it. Henri and Fox to dinner. The last . . . for Fox . . . he is going to take a position on the Philadelphia "North American." Henri and I discussed the question of sending or not sending pictures to the National Academy this year. He says that he has about decided not to do it. Fox says that he visited the Luks and that Luks has been painting several new things for the exhibition in February. "Don't tell what they are," says George.

166

November 19

Worked pretty much all day on "South Beach Belle." Mrs. Lee went up to spend the afternoon and night at Henri's. George Fox came in to bid us final "good bye." He goes to Philadelphia tomorrow. . . . After dinner at home, Dolly and I went out . . . into moving picture show. Then to Mouquin's . . . some lobster Newburg and white wine. . . .

November 20

. . . Miss Craig, treasurer Art Students League of Pittsburgh, writes sending my expenses for last month but says that on account of financial troubles in Pittsburgh she will have to defer my salary payment till next week. . . . A telegram from Miss Craig says that on account of work on gas connections, I am not to come to Pittsburgh until next Wednesday. Went down and surrendered my berth on the Pullman. Dolly arranged with mother of little boy back on 24th St. to pose for me Saturday.

November 21

Yesterday's "American" had a big display article on R. Henri having supplanted Chase in the N.Y. School of Art. Interviews with each. Henri has the best of the thing though he is misquoted. This is the truth. Henri has been the "drawing card" in the school for three years and Chase's nose is out of joint. Worked on the "South Beach Belle" and have it in better shape now. Henri came to dinner and we talked over the Chase matter and the question of sending to the National Academy Exhibition. . . .

November 22

Kirby called. He is looking for a studio in N.Y. Is going to live in Flushing. He gave an amusing description of some revival meetings he attended in the West. Bill Sunday, an ex-baseball player turned preacher. His prayers, offhand familiarity with God, "Say, God– Old feller!"–sort of thing. $6,000. for his share of six weeks work in Galesburg, Ill. . . . Took Dolly and Mrs. Lee . . . to see some of the five cent moving picture shows in the neighborhood and Mrs. Lee enjoyed them very much.

November 23

The little chap from 24th St. came to pose today. I painted but with no result. Very tired, done up. Henri came to dinner and afterward we concocted a letter, a sort of challenge to the Art Students League and the National Academy schools to hold a comparative exhibition of work of students. Then Henri went out to Mouquin's to see if Fitzgerald of the Sun was there, and talk it over with him if he was. I worked on a Puzzle.

November 25

Have decided to send the "Gray and Brass" to the National Academy Exhibition. Worked a bit on it. Kirby called. He has taken a small studio next door, good light, steam heat, $15. We had cakes and tea while he was here.... Finished up a set of Puzzles and we went to bed early.

November 26

Worked on new canvas, Picture Store, night. *["Picture Store Window," collection of the Newark Museum, Newark, New Jersey.]* Davis came in and spoke very agreeably of my work which I showed him. We are to go to E. Orange to Thanksgiving dinner with him. Henri came to dinner and he wrote a letter to the Phila. Ledger afterward, correcting some erroneous statements. I took the 9:55 to Pittsburgh.

November 27

Saw the Mountains! Today my train was delayed by a freight wreck so that we lost four hours. Got up as we left Altoona . . . but the view of these great living earth members compensated for my long tiresome ride. I have never seen mountains of this size before, though I believe that the same range is near to Lock Haven where I was born. Missed the morning class at the Pittsburgh League but made up for it by giving a criticism of some life drawings before the "picture class" work was taken up. In the evening, I gave the night class of men a good "shaking up."

November 28

Got off the train at Newark and rode on the trolley car to Davis's in East Orange . . . had breakfast with them. His latest boy, John Wyatt,

168

is a baby wonder, a fine, very intelligent child. Davis and I went to see a football game in the morning. His older boy Stuart's school won the game which pleased us. A fine dinner. Dolly and Mrs. Lee came to the house while we were at the game. Spent the afternoon and evening. . . .

November 29

Century sent for me and old Drake, "dear old soul," gave me an "Irish humor" story to illustrate. This will help "boil the pot" which is just at present down to the simmering point. . . .

November 30

Put in four hours on the "Little Boy and Mirror" ["Making Faces"]. Made a new one which seems to be better than the first though the first has some good points. I may go on with it too. . . .

December 1

Worked again with the Boy and Mirror and am fairly well pleased with it. Funny incident yesterday, while he posed he was much interested in the work. During a rest he picked up a brush (no paint on it fortunately) and went to the first canvas I started of him and tried to paint down a stray lock of his hair which I had made, with purpose, in a sticking up way at the top of his head. Paint was dry fortunately. He got a good scolding. Henri came to dinner and then went down to the Glackens. Mr. and Mrs. Lichtenstein called, as well as Joe and Mrs. Laub . . . very pleasant evening. I am scared by Lichtenstein's accounts of the money situation, "hard times" seems to be with us. The Sunday American has a full page about the Chase-Henri question. Very amusing and good ad.

December 3

Made "rough out" of ideas for Century story and took them down to them. Left sketches to be shown to Gilder. Henri came to dinner. After dinner I tried to decide on some Puzzle idea. And H. and I also worried our heads with the aim in view of a set of "comics." There is a good field and demand for these things in the newspapers. But we could not hit on anything we saw success in.

December 4

Miss Niles wrote Dolly and sent her a nice pair of shoes and two pairs of gloves, little worn and useful. While poor, we are thus proved not proud. Worked on the Boy and Mirror #2. Henri came to dinner. Left ... to go to Pittsburgh. A cold night with snow on the ground.

December 5

Train reached Pittsburgh about 30 minutes late. At the school some of the girls, particularly one or two of the youngest ones, doing work that is of considerable interest. I lit into them for talking while I am criticizing others' work. Dined with Miss Sellers and her sister ... met a Miss Latham ... connected with the Carnegie Institute and who asked me to come ... next Thursday and be shown around. Men's class dull and very unpromising. . . . Miss Craig, the treasurer, gave me another stand off today. Says she will pay my salary, three weeks overdue now, next Monday or Tuesday.

December 6

Last night I woke while the train was going through the mountains, a star lighted night and snow on the ground not very thick nor fully covering–very beautiful. The steam from our engine flying by the window, the near snow strip and the looming masses of the mountains. Letter from Peters says that Mr. Buck would probably give me some plates to do for his work on historic houses, etc. Will go and see him. . . . Schofield [*Walter Elmer Schofield–successful landscape painter*] came in, unheralded and more than welcome. Still living in England, he has moved to Ingleton, Yorkshire. Pays the enormous sum of forty dollars a year for his 30 x 40 studio, $150 for a house.

December 7

Schofield left to meet his father-in-law who arrives by steamer this morning. Scho. gave me this receipe for wax varnish finish for paintings: 2 oz. copal or amber varnish, 5 cakes white bees wax, melt together, let harden. When using, take brush and turpentine and rub on cake till milky, then apply to picture. Worked on Boy with Mirror till after 4 o'clock in the afternoon.

170

December 8

All theatres, dancing schools, moving picture shows, concerts, etc. closed by the police enforcing the old "blue laws." Makes N.Y. quite quiet today. The side doors of the saloons are open and the "Raines Law sandwich" justifies the title of "hotel." Queer state of things in a metropolis like this. The church virtuous ones who are mostly shams, knowing and unknowing, forcing all to abstain from amusement. Oh, well. Started on drawings for Century Magazine in the evening, finished two. Not very enthusiastic. I suppose that I should go in to do things that I like, but I can't get rid of the idea that they want something else. They "cut out" the drawing that I was most interested in.

December 9

Worked again on the first Boy with Mirror and rather think it is in pretty fair shape now. Kirby came in . . . went out together. Walked to Fifth Avenue then up Broadway to 43rd St . . . an interesting gray day. Each color of the street its own self, each face beautiful and individual. After dinner, I made a third drawing for the Century.

December 10

Out along Sixth Avenue to buy drawing cardboard . . . worked on the last of the Century drawings. Reuterdahl called. Says he is going on the fleet which is about to sail to the Pacific. "Gray and Brass," the new rich or American rich in automobile–rejected by the N.A.D. Exhibition. I showed it to him; he rather agrees with the jury. Told him he was a born academician. He says that "while it's interesting and good color, it is not a thing that will help my reputation." We will see whether it won't serve as one of my works. It's the work, not the man's temporal advancement that is important. . . .

December 11

Delivered the Century drawings and they were much pleased with them. Walked out with $100. on account, the balance in a day or two. . . . Henri came to dinner and I left for Pittsburgh. . . . Carl Sprinchorn, whose picture of Snow Storm caused much of the trouble on the Jury of the N.A.D. last year–brought it for me to make a photo from it. . . .

December 12

Train an hour late. Had a talk with Mrs. Pears and Miss Craig about my salary which is yet unpaid. Told them that if no check appeared before Tuesday, I would have to discontinue my visits to Pittsburgh. The men's night class is a heavy small class, hard to get any results in the work. . . .

December 14

Saw Dolly dear on the ferry on her way to Philadelphia. Sorry to have her go, but the rest will be good for her. She's had a pretty severe strain with Mrs. Lee here. A horribly stormy day, snow, then wind and rain. . . . Went up to Henri's and went to the Grand Union to dinner, after which same, back to his place and talked and smoked and looked at pictures. . . . Found a check from Century for the balance of my bill, $35.

December 15

Still rainy weather though not nearly so bad as yesterday. Went for the Press and N.Y. Papers. It appears from the absence of any notice that Glackens' beautiful painting has been refused, if he sent it– though he may have neglected to send it to the Jury of the N.A.D. Hear that Harrison Morris is to take charge of the project of raising funds for a new building for the National Academy of Design. This is a bad scheme. No organization of artists should have charge of an institution for National Exhibitions of Pictures. . . . To the Chinese restaurant for my dinner. . . . Wrote the "Craftsman" re pictures for reproduction in article on the eight artists to exhibit at Macbeth's Gallery.

December 16

Phoned to Henri to meet Kirby and me at Mouquin's . . . we had a nice dinner, snails and suckling pig. (Dolly'd better come back and rescue me from myself in eating.) We went to the N.A.D. exhibition after dinner–awful show. Bellows has two good things, Prize Fight and P.R.R. Excavation. In the two hours we were there, about twelve people visited the galleries. Came back to Mouquin's, and I wrote a letter to the Evening Sun. The cry for larger galleries from these

dealers in undesirable, unworthy, unmanly wares. It would be criminal to give them what they ask.

December 18

Stopped in to see the Craftsman editor Mrs. Roberts. She is to send for other photos tomorrow.... Went to Macbeth's. A decent man if ever was one. Reduced the guarantee which we are to give him from $500 to $400. He has great hope of a successful exhibition.... To Mouquin's to meet Henri.... *[Mary Fanton Roberts, through whom Sloan was to meet John Butler Yeats' was editor of* The Craftsman, Touchstone, *and then of* Arts and Decoration.]

December 19

Mrs. Neville came early to clean up. I went to Henri's to get the pictures he wants photographed but he had people coming this afternoon so he thought I had better not take any away today. I walked down home, went in Brentano's new store, Fifth Avenue and 25th or 26th St. Saw a copy of Caffin's story of American Art. He gives me quite a notice. Almost too much prominence in the "impressionist" movement as he puts it. My "Easter Eve" is vilely reproduced. Sent four more photos to Craftsman. Letter from John Nilson Lourvik, as chairman of exhibition committee, National Arts Club, asks for two pictures. Went to Chinese Restaurant and enjoyed "Yoc a Maing" and "chop suey" dinner. Lonely evening doing Puzzle.

December 21

Developed plates of H.'s paintings.... Boy came, so painted on mirror subject. Painted one entire new thing, seems better. Worked till 4 o'clock.... check for $50 on account, salary received from Pittsburgh. Tom Daly sent another check on the "Canzoni" account. Very decent of him I'm thinking. Mailed a Puzzle today. Paid grocer bill out of Century check $35. Bill, $15.48.

December 22

Painted the Boy and Mirror again and really feel that I have caught it now. At any rate, the best attempt so far. Henri brought two canvases down (for me to try photos of tomorrow) and we went to a Chinese restaurant for our dinner. H. doesn't like the food as well

as I do. After dinner we dropped in to Mouquin's, met Mrs. Preston, Jim and Fitzgerald of the Sun . . . sat until closing time. . . .

December 23

Got up at noon. . . . Lourvik came in and asked for six pictures for the National Arts Exhibition to be collected Monday (30th). Kent, Foreign Girl, Girl and Etching Press, Look of a Woman, Sixth Avenue and Thirtieth St., Gray and Brass. Dinner at Mouquin's where Glackens, Fuhr, the Prestons, Lawson and Henri came in. A very pleasant time together. Henri and I . . . back to the studio and talked of the Macbeth show till 11:30. . . . Wrote to Lourvik changing the Hungry Boy for Sixth Avenue and Thirtieth St. above; will reserve the Sixth Ave. for our own show in Feb.

December 24

Left early on 8 o'clock train to Philadelphia. Saw Tom Daly and he took Dolly and Nell Sloan and Mrs. Daly and Mr. Finley to lunch at Dooner's. Mrs. Daly is as nice as I felt she would be. Saw March. He said he would like an article on the Eight at Macbeth's exhibition, pictures and portraits for the Sunday Press. . . .

December 25

Anshutz called in the evening. He is "sore" evidently. He said to me, "Well, I suppose you will want to save all your work for the Macbeth exhibition of the Eight." Other sarcastic references to The Six, The Two, The One . . . "stuck on oneself" etc. Under the circumstances I had to say yes, everything for that show.

December 26

In the city to see Nan's decorations on the wall at Mrs. G. H. Norris's house, 22nd and Locust St. They look very well indeed. Lunch at Mrs. Kerr's, who gave me a fine fruit cake for Christmas. To Anshutz's in the evening. He seems to be huffy about something; probably, as Dolly solves it, Henri refused to give him new pictures so that he won't even ask me for anything for the Academy exhibition this year. Mrs. Anshutz got up a nice lunch for us late.

December 27

Left Fort Washington at 10:26 A.M. Rode in with Dolly to Wayne Junction where we kissed goodbye and I went on to New York arriv-

ing there at 1 o'clock. Note from Trask says, as they would like an "entry blank" for the picture from me, they will extend the time to January 1. Sent bill December 16 to Pittsburgh . . . to Mouquin's for dinner. . . .

December 29

Still working on frames. And proved the negative of H.'s Dutchman. Made a photo of Kent which is going tomorrow to the National Arts Club Exhibition (picture, not the photo). Sent Lourvik prices for National Arts Exh. Kent–$500, Look of a Woman–$750, Girl and Press–$600, Gray and Brass–$500, Foreign Girl profile–$500.

December 30

National Arts Exhibition collects today. Wrote to Shinn telling him that I'd like to have his check for $50. and $1. interest. Macbeth exhibition at hand and he, who boasts of being a "business man" and artist combined, has not paid. Postcard from Calders in Pasadena, Cal. which suggested to me the idea of writing a letter to them. I did so. Sent N.A. Exh. prices for etchings (Arts Club); limited Japan vellum $215.; Japan Vellum $75.; Regular edition $25; frames $20 per set. Sold in sets only. Henri dropped in . . . has manuscript of Mrs. Roberts' article for Craftsman on Macbeth exhibition, and I read it. He is busy worrying over about ten lines quoted as his, straightening, correcting, rewriting them. Curious "old Hen." He off to dinner. . . . I ate at the Chinese, a number of Japs dining there interested me. Came home and read Poe till late.

December 31

Note from Willing, Associated Sunday Magazine. Went to see him. He gave me the Mark Twain Autobiography pictures to do. Have to do them by tomorrow night. . . . To Chinese Restaurant for my dinner. Came back and got to work on the Sunday Magazine story above. Twelve midnight–outside as I write is the awful roar of the City's welcome to the New Year. In Philadelphia Dolly hears the same impressive sound. How many more will I hear? Will she hear? This is the first for ten that we have not heard together. May we *happily* meet many more New Years.

1908

January 1

I am going to treat myself to a real book this year. Last year and the year before, I used a tablet diary but they seem so ungainly. I start the year quite alone, Dolly being detained by the dentist in Philadelphia. There is work to do–which should be a good omen–a story to illustrate for the Associated Sunday Magazine. I worked pretty steadily all day on it and then went to the Chinese restaurant on Sixth Avenue for dinner. The city about here seems to have relapsed into a lonely, quiet condition–the American city's "holiday spirit."

January 2

Today Miss Mary Perkins, who is teaching in a college at Spartanburg, S.C., came in–sorry Dolly was away. She is going to give an exhibition at the college in May, invited my "Coffee Line." I took her out to lunch, warning her of the fact that I had but seventy cents in my pocket. We lunched lightly and then started up to Henri's. I found, as we were going on the car, that I still had the check for our lunch. We had calmly and serenely walked out without paying. . . . To Mouquin's to dinner, Henri, Miss Perkins and I; then took her to the Martha Washington Hotel, a curious hencoop, ladies only. Then back to Henri's where the eight who show at Macbeth's in February are to meet. Luks, Shinn, Lawson, Davies, Henri and myself were present. Pleasant evening, Luks entertained with some of his imitations of melodrama. We talked over catalogue which Davies has planned out. Will cost more than $200. but will be a good feature. Home at 3 A.M.

January 3

Today I welcomed back little wife Dolly, with her face smiling with joy at her return and lined inside with a completely overhauled chewing outfit . . . as a celebration of the day we went to Mouquin's for our dinner. . . .

January 4

Today is Opening View of the Special Exhibition of Contemporary Art at the National Arts Club, the show got up by Lourvik, the art

179

reporter of the Times. So with Kirby and Dolly to see it. "Gray and Brass" returned, damaged frame. On entering I am confronted by a row of Luks' canvases . . . though he has sent too many, taken the edge off his debut at Macbeth's next month in our show. But, horror! Here on either side of a rather poor Whistler lady, with eyes fighting for the center of her face, is a row of Dabo's execrable stuff— and around in an alley, Henri's portrait of Mrs. Henri in black. When I saw Lourvik, I told him he had offered Henri an indignity, objected to the Dabo's and Steichen's (a photographer who paints boogaboos) and we have a hot quarter of an hour. Poor fellow, he doesn't know, and, like most art critics, is bumping around like a blue bottle on a window pane, seeking the light. The simile ends there for he could not fly outside for one moment. My own stuff is well hung but the show is a mixup. My etchings are hung atop photographs, to make point for art "phuzzygraphy," I suppose. Mrs. Dr. Meyer [*Annie Nathan*] is there and talks and is very amusing in her efforts to learn names as associated with pictures. "I should know that it's by–by–by, now don't tell me–I'm sure I know that handling, etc." This lady writes for the edification of the people on art subjects. God protect them, and keep them stupid! To Mouquin's for our dinner. Mrs. Preston, who speaks of the trouble she has had balancing her bank book (checks, etc.)–her shares of U.S. Steel which are "very low" just now. James P. [*Preston*] and Fitzgerald, the critic of the Evening Sun–so far he is in my good esteem.

January 6

Today a notice from the energetic secretary of the useless Illustrator's Society, tells me as Chairman of the Entertainment Committee to decide on menu and furnish fun for these young fossils at a dinner next Friday. Bayard Jones, whom I consult, doesn't see anything to be done. Orson Lowell, another type whose work shows the present condition of illustration in this country–nice enough fellow, but should have been a priest–decided that the only thing we could do would be to invite some people who might brighten the occasion by their wit. I think Luks might be persuaded to go. The election of myself as Chairman of the Entertainment Committee was a great mistake, a joke on me. I can't want to entertain them. After 11 o'clock . . . door bell is rung . . . there's Henri with a suitcase. He has just returned from Wilkes Barre, Pa. where he was to paint a portrait,

180

but the old codger who is to furnish the features is sick so Hen. had his trip for nothing.

January 7

After 11 o'clock in the morning, the bell rings. I hop from bed and, in pajamas, open the hall door. A lad from Macbeth's with a Davies and a Luks for me to photograph for the catalogue. "We rise rather late here," I say apologetically and the lad, in a squeaky scream, "Why! It's dinnertime!!! It's dinnertime!!"–He's Welsh–"Tis bad luck to get up so late the first week of the year." I hope not. . . . Late in the afternoon, Davies and Henri came in, meeting here. We talked of the catalogue and other "show" matters. Whether more than a single line of pictures should be hung, etc. . . .

January 8

Lawson brought a painting for me to photograph, which I did. Not as easily as that seems, for each one of my plates is an uncertainty. I don't seem to improve in the craft. . . . Dolly and I went up to Luks', as I want to invite him to the Illustrator's dinner. But "The Luks" is out and Mrs. L., who is always a bit formal at first, finally told us that he was off on a "jag" (not her words). He once told Dolly and me that it was necessary for an artist to "see life." He has long spells of abstinence, then breaks loose. It only takes one drink to start him and then he gets in a hurry to be drunk. Poor Mrs. Luks, she loves the man, that's plain, and his work has all been done since his marriage to her. She entertained us well and we had a good evening. She said she was sorry he was not home "for he makes things so lively." And he is wonderful when he's sober. Then there is his gargantuan conceit, so huge that it is Burlesque. You can't resent it. It's one of the attractions, though a lesser one. *[The only time I met George Luks was at a fund-raising benefit in 1933, six weeks before he was found dead in the doorway of an abandoned store on Sixth Avenue. (Sloan said that he had probably started one of his barroom arguments, and, being unable to escape the consequences as nimbly as he had in his youth, had been knocked down by an irate customer.) Luks had volunteered to paint a portrait of Doris Humphrey, the dancer. He arrived an hour late, supported by two faithful students. After messing around on the palette with a two-inch brush ("Luks would use tubes of expensive cadmiums to make grays that are better found*

among the earth colors."–J.S.), he gave up the project and the audi-
ence disbanded. I was invited to join his friends in a nearby speakeasy
saloon, where he was to be sobered up on beer so they could deliver
him to his home. It was an extraordinary six-hour session. Here was
this ribald character, in a black Amish-type hat and pince-nez spec-
tacles attached to a long black ribbon. Hour after hour, he passed
back and forth between being maudlin and being a gentleman of
the old Philadelphia school, intelligent, interested in current events,
and with simple courteous manners.]

January 9

The whole day went in photographing. Sent notes to Glack and Shinn
that they should have photos for the catalogue and their lists ready
for same at once. Sent list of prices to Lourvik which he asks for,
though I had already done so before. I have heard that Henri's full
length has been given a better place in the Nat. Arts Club Ex. by
Lourvik–which makes me feel that my row with him was not a waste
of spleen. Dinner of Illustrators postponed to Wednesday the 22nd.
. . . A letter from Calder who says he is weighing 170 pounds and
able to do a day's work–but wants to get East as soon as he can. He
is still at Pasadena, though his letter was postmarked Los Angeles.

January 10

Davies called in reference to catalogue. He tells me of a thing which
has transpired in the last two days–and has been printed in the Times
which I have not seen since Sunday. It seems that Van Deering
Perrine, the man who paints "Jugend'isms" of the Hudson with his
backer and exploiter, Mrs. Ford (she runs the New Galleries for his
benefit), came into the exhibition at the National Arts Club–found
a picture of his on the wall and he or she seized it from the frame and
punched a hole in it. The picture, which he claims was not a good
example of his work, he had given to a Mr. Lamb of the Club and
Perrine having refused to send to this exhibition (a wise point, for
I wish I hadn't) Lamb loans it and now threatens civil or criminal
actions against these freak advertisers. . . .

January 11

Such a day–I went to Luks' this morning having found by telephone
that he was home, my purpose being to photograph a painting of his

182

for the Herald and Press to use in notices of our show. Luks was in a "mess" just off his carouse or "bat" and with a blacked eye (the college athlete who served him with it was properly annihilated according to George)—with a strange hat (a better one than his own, says Luks) and an odoriferous breath—the skin scuffing off his face—bad stomach and unsteady gait. First he bumped into the camera, crash—the ground glass was broken . . . both went out after he had dressed, to find ground glass. He sought a drug store and had a bottle of "Bacci-lac," a germ killer of soured milk. The whole of the afternoon was most interesting. He showed me his Wrestlers, a magnificent picture—one of the finest paintings I've ever seen—great. But he won't send it to our show at Macbeth's. He says, "I'll keep it till I'm invited to send to some big exhibition." Then this will show K. Cox, W. H. Low and the other pink and white idiots, that we know what anatomy is. I painted it to vindicate Henri in his fight for my work on the National Academy juries." I argued with him that he could never convince these people, they don't know great work when it is contemporary product. They bow, of course, when the celebrated work of the old masters is before them, but that's merely educated into them—they don't really see it. Luks won't see it my way. He is a great painter when he is purely himself. The phase (and it's only a phase) of his things that I don't like so well is where he is too much influenced by the tradition of painting. I told him (in response to his invitation to come home to dinner) that I would like to but that we had folks to dinner; that I would ask him and Mrs. Luks but we were entertaining the Cranes . . !! He asked after the boy, Kent (his son) and said he's seen my picture of him at the N. Arts Club. Great old Luks! We talked of Fielding, writings of which he is a great reader. He lied to me most entertainingly. . . . Cranes to dinner, Henri and Miss Pope. . . . Perhaps not wisely, I spoke of Luks, of his great work. (Mrs. C. his first wife.)

January 12

A quiet day. Developed the negative made at Luks' yesterday and it tells the tale of his walking about the room. It shows constant vibration as though taken during a mild earthquake. Made a Puzzle for the Phila. Press. . . .

January 13

I received from Mrs. Ernest Thompson Seton, a president of the Pen & Brush Club, an invitation to be entertained as a guest of honor with such other men ... as Leon Dabo!!!!! Ye Gods. I want to go very decidedly on record as against this feeble, old fashioned, narrow and altogether detestable work which has been called the greatest since the Greeks by Lourvik, and it is constantly being associated as modern evidence with the work of real men like Henri, Luks, Glackens and such. Shinn came to the studio in the morning–well dressed, sparkling, versatile–light Shinn. Glackens came after dinner–quietly, witty, reserved, wise on statistics and as to mushrooms edible. Pleasant evening.

January 14

To Luks. He's straightened up and a little bit "grouchy." I took away with me his small canvas "Mammy Grooby" which I am going to photograph, though I made two attempts today and failed.... Davies brought in photographs of two Prendergast pictures and one of his own.

January 15

I wrote to Alden March, Sunday editor of the Press, Phila. that if he had not changed his mind since I saw him at Christmas time, I would send him photos and portraits for an article on the coming exhibition of "The Eight" as it is called by the papers. Went to Juley's (the photographer on East 23rd St.), paid him $1.75 I owed him and asked him to make a print of Glackens' coasting picture.... Dolly and I went up to Joe Laub's ... had a pleasant, comfortable evening and a fine lunch–currant bread which his mother sent from Philadelphia, the sight of which took me back to 705 Walnut Street, third floor front, where Joe and I had a studio together–where I smoked my first pipe and would hang out the window dizzy and look out across Washington Square. How well I have mastered the weed since! In this studio, the Charcoal Club of Philadelphia was born and lived one spring and summer, and did so worry Harrison Morris of the Pennsylvania Academy, so that he was glad to buy our chairs and Welsbach lights when we failed. And though we were credited with evil intent toward the alma mater, we had none I swear! We had forty pupils

184

at night (all at night, no day class), the Academy not near that number. But cooperation schemes at $2. per month won't stand hot weather. Guess I'm getting old at 36!! This is reminiscence, but there was no record made then.

January 16

Another attempt at photographing.... I've been thinking the last two days of Joseph Andrews by Fielding–having begun and half finished reading it again. Thinking how necessary it is for an artist of any creative sort to go among common people–not waste his time among his fellows, for it must be from the other class–not creators, nor Bohemians nor dilettantes that he will get his knowledge of life. I should like to know two or three plain homes–well. My own home was plain enough–and I have that subconsciously within me. Wrote to Artists Packing and Shipping Co. asking about the damaged frame of Gray and Brass. Busy photograph printing all evening.... Tomorrow will see the end of this siege of puttering over bad negatives, wasting time.

January 17

Artists P. & S. Co. say frame was delivered in damaged condition by the N.A. Club. Wrote to Lourvik about it...got photographs ready, took them to Macbeth's and there got Mrs. Käsebier's portrait photos to send to the Press. Jerome Myers' exhibition in on view there now and there are several very fine things among them, though he slips into sentimentalism and there is a "decorative" or a piece by piece look here and there. Dropped in at Cooperative Gallery to see collection of engravings. Four by Callot are fine, full of humor of life. The Dürers I do not like. He seems to me to be a mechanic... met with Jimmy Preston out for his walk on the avenue. I can't help feeling sorry for him–always have had that feeling–no good reason. ...Found that Luks would be in this evening, so up town we went. Luks was very entertaining. Showed pictures and a bunch of panels made in Paris four years or so ago, very good things....

January 18

I met Davies at the printer's this morning and we decided on type and general matters for the catalogue. Paid $100. on account.... Stein (Zenka) called and we enjoyed her visit as usual. She's a great

girl, so ingenuous, so paintable, the best professional model in New York probably, though my own experience is small. Henri, Glackens and Mrs. Lee to dinner. Glackens complimented me on my salad, which I wear as a feather in my cap for Glack's a connoisseur. Henri was most exacting in getting into the details of mailing lists for catalogue of show. The necessity of another assessment on each man before the exhibition comes off was decided. $45. each in addition to the $50. already in hand will do it.

January 19

Quiet day at home with Dolly. Did a few touches on the Hairdresser's Window painting. Notices of the Penna. Academy of Fine Arts Exhibition now open in Philadelphia Press. As I have nothing there, I received no prize or other honor. Henri has a painting there but he is not on the list of fortunate ones. Read further in Joseph Andrews in the evening. And then wrote letters to Glack, Lawson, Shinn, Davies and Luks, announcing a meeting at Henri's on Thursday night to pay in $45. each. Made drawings in each letter to try to take off some of the shock.

January 20

To Macbeth's and found his opinion of Dougherty's marines, etc. which are now on view to be the same as my own. Pot boilers–"leather," he called it. And people buy these things. At the Greenwich Savings Bank today I was hit by the idea that it would make a good subject for picture–and, indeed, I have thought it before. A great number there, and each an interesting life. The old woman, lifting her overskirts and carefully putting her bank book in a white bag suspended from her waist. The old fellow in workman's jumper, another hard faced old rascal with a silver headed cane growling about red tape–a miserly villain. Old woman in threadbare skirt and faded red shawl painfully writing her signature. The vast buff and gold interior of the bank, the glass hooded gratings about the counters where the clerks under electric lights handle the book and money. ["*Savings Bank, 1911*"] . . . to Chinese restaurant for dinner. . . .

January 21

Dolly is going to stay in bed as she is not very well. Jerome Myers called and borrowed my saw. He is going to treat himself to the

relaxation of making some frames. Seemed quite cheerful now his exhibition is over at Macbeth's. No sales–which speaks for the present condition of judgment in picture buyers. Certainly, some of these canvases of his are important. Gilded frames and sent off my list of addresses for catalogues to Macbeth. Davies brought proofs from the printer's and the catalogue is going to look very fine. The pictures are reproduced very well indeed, better than those in the February Craftsman, which brings out a very good notice on our show, though the lady who writes as Giles Egerton (Mrs. Roberts) makes the mistake of thinking that E. Higgins *[Eugene]* is of our kind. His work is absolutely vacant: a bowed figure, a piece of archway, a chunk of shadow, a dingy, colored, brownish gravy art–rot. . . . Henri came in from Wilkes Barre, says that he is finished to the satisfaction of family, but that he will go next week and paint one for his own. He has about "landed" a full length portrait after this.

January 22

This has turned out to be quite a lively day . . . a visit from Bayard Jones. I was just about to sally forth to see art editors. So we went together and had a highball of Irish whiskey at the corner, followed by another. A pleasant and potent liquor for I came home merry. Kirby came in ready to go to the Illustrators' Dinner which I had already declined. Dolly dressed and we went to Mouquin's. . . . Fitzgerald came in with T. Knox . . . afterward Gregg and Lawson. All came to our table and we had a fine powwow, with much fun over a letter similar to the one sent me by Mrs. Seton of the Pen & Brush Club, this one Lawson's. He says that Bellows was voted the $300.00 Lippincott's prize in Philadelphia, but that after lunch Trask suggested a reconsideration and he lost it, the prize going elsewhere. Fuhr and Lawson left to see a boxing match, Fitzgerald and Knox to go home, and finally, Gregg left–promising me a postcard written by Walt Whitman, the Poet. . . . Lawson proposed Henri for the Temple Medal but was not even *seconded*–with Anshutz there, this is notable. Suppose Anshutz does not like the Spanish Dancer picture.

January 23

Up late, naturally and feeling out of sorts–naturally. After dinner . . . went up to Henri's to a meeting for assessment of $45. each. No money made its appearance, however. Luks entertained and went

from the sober stage to the other (though not the limit). He told some experiences of his, when a boy, tramping the South–"the only natural life"–"I'm a hobo now, but I'm unfortunate in having a home." He mentioned John and Henry Wall, Dolly's brother of race-track fame, and was enthusiastic over them, knew them in Philadelphia. A snowstorm has set in tonight, the first of the winter–looks like the real thing. Flashes from the third rail on the electric trains, caused by snow, are very dramatic, their reflections shoot across the night sky. Note from Carnegie Institute that their exhibition will be held at the end of April this year.

January 24

Still snowing and bitterly cold day. Tinkering with paintings. Worked again on the Boy with Mirror. K. Wetherill, who was in the Whistler class in Paris, on a visit from Philadelphia. . . . His ideas about art are a bit too stilted, I think, and yet he seems to have some things of the right sort of mind. He says that Whistler's affected manner was only put on to repel persons he wished to be rid of. . . . 2 o'clock when we turned in. I reading Tom Jones and she, in De Maupassant.

January 25

. . . Painted on the Boy and Mirror. Kirby called and gave a short account of the Illustrator's dinner of Wednesday night. Glackens, he said, shocked these nice commercial gentlemen by suggesting that the Society have a room, and a case of whiskey or a barrel of beer be now and then broached, doing away with these unpopular dinners. The Club room idea did not appeal. Some said that when they were through the day's "work" they wanted to go home, not to see other artists–in other words "don't talk shop." And when one considers the sort of products their "shops" put out one can't blame them. Dolly and I took a walk in the afternoon. There are great heaps of already dirty snow and the horses have terrible times. The automobiles go undisturbed by slippery surfaces. We came back by way of Fifth Avenue. Such well dressed people, in the sense of wealth's evidences at any rate. I came home with just a touch of discontent but a cup of tea and a few kisses, a nice hash for dinner and a pleasant evening–both reading, I in Fielding, she in De Maupassant–and I'm perfectly happy again.

January 26

Jerome Myers called, said he had been at a gathering at some woman sculptor's studio, met a number of art struck ladies–described them right aptly as "restless females." ... Henri dropped in on his way out to Wilkes Barre. ... He wants me to take his classes on Wednesday at the school if he does not return by then. He says that he has agreed to take the class from the school to Spain again this year.

January 27

Stopped in at Davies' studio on 39th St. today and he brought out a number of canvases for me to look at. And I enjoyed them, he is wonderful in his mastery of color, a poet. Just what his meaning is in many of his pictures, he only knows–but they are beautiful even though you do not grasp the meaning. I feel like an infant in oil compared with him. His pictures, many of them are based on a visit to California two or three years ago. The big Sequoia trees have inspired him. He owns about three drawings by Auguste Rodin which are fine things. Went to Macbeth's and find that the addressing of envelopes for catalogues is about finished. Varnished three or four pictures when I returned. Sent back Luks and Davies paintings to Macbeth's. ...

January 28

This morning a bill for dues from the Society of Illustrators–twenty dollars–save the mark! I can't pay it–and am getting nothing for it. I'd best let them have my resignation. Finished up a Puzzle and then Kirby called to take us out to dinner. ...

January 29

An exhausting day's work–on account of Henri's stay in Wilkes Barre, Pa. ... Had agreed to take his place at the N.Y. School of Art today. At about 11:45 I started in to talk to a crowded room on the pictures submitted in the composition or picture class. Two hours of criticism a great strain, especially as I felt it necessary to interest myself in every one of the pictures, fully fifty. Then, after lunch ... went up to the portrait class and men's life class–the last a small class. The portrait class is crowded as it was last year, more in fact. I came back to Dolly for my dinner and left at 7:30 to criticize the men's

night life class, an interested lot of fellows. After the class they brought out sketches done apart from the school work and sit around for an informal talk. . . .

January 30

Out to the bank and bought $49. worth of stamps, took them up to Macbeth's for mailing catalogues. Here is a crying shame. The beastly daubs of Paul Dougherty, N.A. (with whom I have no acquaintance personally) are selling–five of them have been bought. If posterity ever reads these lines, I know that the heirs of these buyers, when they look at the shrunken values on these pot boilers will know that I knew them for what they are–vile–low–and, come to think of it, not worth this much comment. . . . Friend Byron Stephenson came in to see what I am sending to Macbeth's for our show. Says he is going to write something in his Saturday Chat in the Evening Post, N.Y. A letter from Henri says he probably won't be back tomorrow so I go to School again. Wrote to all the eight to send stuff to Macbeth's by Saturday noon.

January 31

Taught at the School in the afternoon. . . . Davies dropped in to give me printer's bills. Sent them an additional check for $90. To the night class in the evening, where the men do good things, at least several of them. When I came home at 11 o'clock, Henri was already arrived from Wilkes Barre. He finished the portraits of Mr. and Mrs. Smith to their satisfaction, and in the case of the old gentleman, his own. Henri is very much disappointed with the reproduction of his painting in the catalogue and it is not very good–but as usual in these affairs, one or two do the work and the rest criticize.

February 1

The pictures left for Macbeth's in the morning. Now the time that we have all waited and worked for months past is here. Paid Cohen $20. on account rent for Feb. After an early dinner, I went to Macbeth's and assisted in removing shadow boxes, pulling nails and putting in canvases. Later on Luks came, then Lawson, Henri, Prendergast and Glackens. Finally the deed was done, and we thought it looked well. What the critics or art reporters may think will probably be another matter. Byron Stephenson's article in the Post came out and is pleasant chat. After the hanging, Lawson, Luks, Henri, Glack,

190

Shinn and I went to the "Tavern," a café which is fitted up in an old fashioned way, and there held forth over ale till we saw by such hints as turning out lights, putting out chairs, barkeep putting on street togs, etc., that our departure would be appreciated. Shinn had left before–and we were then, by Glackens, treated to oysters across 42nd St., after which we sought a dimly lit side entrance on 41st, and having by now dwindled to three–Luks, Glack and myself– had a "night cap" and parted. This last saloon was interesting and was evidently an undercover sort of place. Saw two officers of the Police, their blue coats and brass buttons and red typical faces, strong against a gray wall paper with color prints of fish, as they sat behind a screen.

February 2

The Herald prints five pictures today. I had furnished eight and am sorry that they did not use all. The article is non-committal.... After dinner Dolly and I were reading, which was interrupted about 10 o'clock by the appearance of Henri and Lawson. Henri seems quite nervous over the exhibition, his manner was very nervous. They sat for half an hour or so and then went to visit the Shinns. Lawson, Luks and Glackens had gone to the Pen & Brush Club and been received by the ladies of that organization–an honor which Henri, Davies and myself had declined, as Dabo was promised. But Lawson says that Dabo was not there and that the affair was pleasant enough.

February 3

Exhibition at Macbeth's opens. Paid off the balance of the printer's bill. Davies called, said that he thought the show looked quite well but a little crowded in some places–which is true enough but don't seem to me to matter in a group arrangement–hang "taste" anyway! Mrs. Kirby, Kirby and Dolly went to see the exhibition in the afternoon. I felt that my clothes were not of the prosperous aspect necessary in this city. The appearance of poverty is the worst possible advertising these days. They report a great crowd at the gallery, and young Du Bois, the artist and critic of the American, came in most enthusiastic over the show. He wants photos for article but I have very few of pictures which are there. Dolly and I went to Mouquin's and had a nice dinner. At another table Henri, Abrams, Adams and Fuhr were sitting. Henri came over later and we went up to Preston's,

for a "party." . . . Fitzgerald, Knox, Samuel Hopkins Adams, Mrs. Morgan (Grace Dwight) and husband, Shinn and Mrs., Glackens and Mrs., Prendergast and brother [Charles], Lawson, Zinzig, an attractive and sensual looking woman, Mrs. M. E. Beckwith, Jimmy Gregg . . . a half pleasant evening–curious that I don't see more in these affairs. Plenty to drink. Glackens got full, he announced it very decidedly. Prendergast, a dear old fellow, also lost track of things. Everybody was noisy for a while, then all became quiet. In fact, at two o'clock when Dolly and I left, I remarked to Mrs. Preston that it was time all left as they had all become drunk and were now sobering up on the same spot, a rather melancholy condition of things. We walked home down Sixth Avenue.

February 4

Macbeth at the phone wanted me to say whether Journal photographer could take photos of paintings for article. I said yes. Hunter, who is writing the Press story of the exhibition, sent proofs over. I read them and made a slight change or two. A writer for the Literary Digest called, looking for photographs. Spoke as though he liked the show. His name, King. Dolly took Mrs. Lee to see the show. A fine attendance still. . . . Macbeth seems to be very pleased with the interest in the exhibition. . . .

February 5

Went to see Davies as a letter from him says that more catalogues will probably be needed. Found him not very well, touch of pleurisy. Spent an interesting hour with him. Speaking of George Moore's "My Dead Life," the mention of names in the accounts of mistress of Dr. Evans, Manet, etc. He felt it was good, better than without the personal touch. "My boys will probably be no better than I am, but what of it. What if someone discloses the names of ladies that have been pictured nude by me in some of these paintings?" Then he spoke of his family, two boys now, lost three by spinal meningitis. Then in talking of our exhibition, he said that its success should bring about more "group" exhibitions and in that way destroy the prestige of the National Academy. Thence I went to Macbeth's, found the rooms well crowded. More than fifty people were there, and coming and going. Pictures look well. The Tribune has a sermon for us in this morning edition. Advised us to go and take an academic

192

course, then come out and paint pictures–(like all the rest of the salable things). It is regrettable that these art writers, armed with little knowledge (which is granted a dangerous thing) can command attention in the newspapers. I'd rather have the opinion of a newsboy. . . .

February 6

There is an error in my "stub" bookkeeping. I find I've overdrawn my Philadelphia Union Trust account, so I've got to go to the Green-

"Gentlemen, I intend buying some of your pictures if my wife likes them,"
by Robert Henri

wich [*Bank*] and get cash to take up the check of $90. . . . Worked on Press Puzzle in evening. The idea suggested by a lawyer in Reading, Pa. I am glad to have help now and then, wish people would do more of it.

February 7

Finished up a Puzzle and mailed it. While Dolly and Mrs. Crane went up to the exhibition, Schofield came in on his way back to England. I took him up to the show which he said was fine, though he was not enthusiastic over Prendergast or Davies work. We came back,

Dolly came in, and we waited for Henri to go to dinner with Scho. He came, seemed nervous and fatigued and was extremely touchy to say the least. To Mouquin's where we had a sad dinner. Should have been a merry one, but it was not. I will not soon forget this evening– that is, the impression of it– the details will not stay with me. I have not a good memory for unpleasant matters. Schofield says he will probably be on the Carnegie Institute jury this year. Says that Trask wonders if we would send the show (8) to Phila. Academy if invited –the expense to be borne by us–*think not.*

February 8

Up to Henri's this morning where we had a good talk which has "cleared the air," to some extent at least. I then went to Macbeth's and it is an extra crowded day at the show. The thing is a splendid success. Later on I called up and they tell me that 300 people were coming in every hour, about 85 people constantly in these two small galleries. *[The Macbeth Gallery was at 237 Fifth Avenue, New York.]* An offer from Rowland Galleries in Boston to take the show. If it costs us nothing, we should take it I think. . . . Henri's attitude this morning was not what I had hoped for–it was one of shifting the blame, explaining, excusing himself at others' expense–but not an apology for rudeness. This is a thing which comes very hard to one of his dominating character–and the attitude of students in the school, as well as my own, have brought him to regarding himself as the law.

February 9

The Sun today has an article on the exhibition at Macbeth's which is fine. Huneker first strips off the ideas of "rebels," "outlaws," "outcasts," etc., which the "yellow" papers have constantly harped on and says that each of these men has been represented in the N.A.D. exhibitions. He then goes on with a fine support of the work. Wrote to Rowland Galleries, Boston. Pay all expenses and insurance and you can have a show of our selection. A quiet day at home. The apprehension of what may arise from our misunderstanding with old Henri seems to hang over us both. The Phila. Press has a half page of pictures of the "Eight" (as they persist in calling it–that is, the papers in general) and it seems to me the best looking arrangement yet.

194

February 10

The Sun this morning has a second article on the exhibition. Very good, indeed, though he erroneously states that some of my things have been shown before. Dolly seems to be in such a nervous state that I have advised her to keep to bed today. Her condition is the result of Henri's violent outburst on Friday night. I took a package of "samples" under my arm and went out to hunt work. Bradley of Collier's gave me a story to look over by Mrs. A. W. Vorse, whom I met at Shinn's more than a year ago. It's a sentimental thing. Letter from Mrs. Clara Ruge, American correspondent of "Kunst und Kunsthandwerk," Vienna, writes for photos of things in the exhibition for use in her paper. Wrote her to call. . . .

February 11

Wrote to Miss Craig, treasurer of the Pittsburgh Art Students League, in regard to my long overdue salary. I can't say that I regret the hard times result so far as my visits to Pittsburgh are concerned, for I have felt a great relief in not going there. Reading Tom Jones today, and I am certainly enjoying it. Mr. and Mrs. Rollin Kirby came to dinner . . . talked with them about the struggle to make ends meet here in New York. It seems as though we were wasting a great deal of money in rent when we might live so much cheaper in some other town, or in England perhaps. Though the question arises whether I could make a small living there.

February 12

Today I went to take Henri's classes at the New York School of Art. There were less pictures today than last time so that I got over the ground by one o'clock. In the afternoon, in the men's life and portrait classes, and home early as I did not feel like pow-wowing after the hours of pose. . . . After dinner I went up to the night class. On my return Ullman was there. . . . *[Sloan's first experience as a teacher was in 1893, when he organized the Charcoal Club—a breakaway from the Pennsylvania Academy. Henri taught figure drawing while Sloan gave the criticisms on composition. The depression of 1893 was too much for this independent venture.]*

February 13

Nell Sloan and sister Nan came over from Philadelphia. Nan is making the trip for just a few hours to see the exhibition at Macbeth's.

... Called at Collier's to see Bradley but he is not ready to plan the illustrations which I am to make. Said he would write for me to call. To the exhibition, which Nan thought very fine. She especially enthused over Henri's things. One of his (small Maine coast) is sold. We went to the Van Rensselaer Hotel on 11th St. to see Uncle Howard Wells, my cousin Lily Wells and Aunt Nina. ... A meeting in the evening at which I had thought to collect another assessment to pay Macbeth's guarantee, $400. But Davies left a note under my door which says that sales will be sufficient to pay Macbeth. We are curious as to what has been sold. Glack, Lawson, Henri and I are all that put in an appearance. The joke is on the absent, purse-affrighted ones, Shinn and Luks.

[Note from Arthur B. Davies to Sloan on back of letter from Prendergast to Davies]

I will not come tonight as another engagement will prevent. I am sorry. Sales at Macbeth's will remunerate him, so we shall only have the printing and each will have rebate. Will write Prendy. Read other side.

<div align="right">A. B. D.</div>

My dear Davies,

As I can judge by Sloan's letter, $32.50 to pay. I will send the money so you will receive it on Monday morning and pass it to Sloan.

I received the art criticisms which you sent with many cordial thanks. I have not read them yet, but after a while, when things cool off, I will read them carefully. Send some more and be sure and sign the names, if you can.

During the meeting of the boys, if anything important comes up, please let me know. Only we made two mistakes, the gallery should have been larger and *[we should have]* got up more expensive catalogues and charge 10¢ a piece for them—comme ci, comme ça. I hope you are all satisfied with the experience. Give them my love and good luck.

If I can judge from this remote neighborhood, we have made much more noise than the last show, and people will be looking for still greater things, but I hope we will give them more art.

Take good care of yourself and best wishes.

<div align="right">

Maurice B. Prendergast

February 12, 1908

</div>

Manet: Life is Great

196

February 14

At the School again today, and the more I do of it the greater wonder
I feel at Henri's keeping at it for all these years. It is no easy matter
to sustain interest in all the work. Eleanor Sloan tells us that Mrs.
Corbin's death was announced in the Philadelphia papers last week.
This is sad news but inevitable. Those whom we associate with our
past experiences in life drop away–away. Out in Overbrook at Cor-
bins', the long table where on Sunday, thirty people would sometimes
feast on the plain good French cooking. The wine which flowed so
free, made from grapes grown on the place. Billy Gosewisch and
Adèle Corbin, his wife; her sister Louise, who was one of the futile
fancies of my youth; Paul who loves the wine–old Corbin, tyrant of
it all, he's dead too. The friendships of our youth are like the pleasant
warm water of a bath, they come up around our chins and we are
content. Then death opens the sluices, the friendly warm water sub-
sides and leaves us chilled and alone in the cold air of the world.
This is sentimental. Besides which I've still got Dolly. Her love is a
gentle shower spray over me.

<div align="right">

FORT WASHINGTON
FEB. 14, 1908

</div>

Dear Jack,

I am sending you by express today ½ dozen cans of tomatoes and a
chicken for your Sunday dinner.

Tell Dolly that I do not know if it is a young or old one, so she had
better stew it to be sure of it being cooked.

I hope you get it all right and on time. The box was not prepaid.
We have a beautiful day overhead, the walking is awful.

I got the furniture off at last and do hope the lady will like it. Bess
is calling me to lunch so must close.

<div align="right">

YOUR LOVING FATHER

</div>

with love to Dolly

There is a more satisfactory heart in the chicken. I hope you will
enjoy it.

<div align="center">

Dad.

</div>

February 17

We've made a success–Davies says an *epoch*. The sales at the exhi-
bition amount to near $4,000. [*The paintings sold: "Laughing Child,"*

"Coast of Maine" by Henri; "Old Woman and Goose" by Luks; "Redwoods," "Autumn River" and one other by Davies; "Floating Ice" by Lawson; and "Blue Girl" by Shinn.] Macbeth is "pleased as Punch." It's fine. Had this been a normal financial year, he says there would have been a landslide our way. I feel almost as glad as though I had sold some myself. I am sorry that Glackens did not. It would give him better standing with his wife's commercial, new rich family. Any way, everything's great!! Trask wants the show for the Philadelphia Academy, we to pay expenses one way. Phoned Shinn (Mrs.). Saw Davies who says for self and Prendergast. Saw Lawson and phoned Luks. Glack out of town. So we will send it. What joy to say that "pictures sold will make some substitutions necessary"– oh, fine! . . . I painted Billy Walsh, got a fair start. The portrait I had started of him some time since, I have painted out. Dolly came to the door of the studio dressed in white furs of Mrs. Laub's and asked if I used models. I started to say I would take her address, when I recognized her. The strangest shock it was to me, can't say why. . . . Henri came in. . . . I told him the news of sales at exhibition. He was "tickled to pieces." . . .

February 18

Artists P. & S. Co. will move pictures, pack and ship them for $83.30. So ordered them to take them from Macbeth's and hold till we put in pictures in place of ones sold. Wrote to Trask accepting offer of Penna. Academy. Kirby, I called on him at lunch time, seems to be quite cut up over the fact that I have not been one of the chosen by buyers in the exhibition. Henri came by invitation to dinner–and we had a chicken from Fort Washington which Dad sent with some canned tomatoes. We enjoyed it very much. Much jubilation in talking over the exhibition. The pictures left Macbeth's today. . . .

February 19

A note from Mr. Mills of Artists Packing Co., says he had 55 paintings, 2 canvases, 1 panel. . . . To see him in regard to insurance and other matters. . . . At Macbeth's I got the price list used in the show, with valuations. Lawson's prices seem very low. The weather today is phenomenally awful, snow first, then rain. . . . Waded over to Lawson's but he was not in. Wrote to Luks and Lawson to make up their

lists and send substitute paintings to A.P. & S. Co. Phoned Shinn the same.... Glackens still out of town. When I got home things were in an awful state. The roof had started to leak in a half dozen places. Dolly was distracted catching water in buckets, moving frames to points of safety. The plumber whom I called in says "can't do anything till roof dries." I went to the roof and pushed off slush which had a beneficial effect.

February 20

Mrs. Luks called me on the phone and told me that George was started on a tear again since yesterday. I told her to send a picture or two in frames to replace the Mammy Grooby and Gentleman of Fashion which came unframed from Macbeth's. A pathetic request from her to tell Macbeth not to pay G. B. L. the money for the picture sold in the exhibition, but to send the check to the house by mail. I did so and Macbeth says that he will. All the sales (7) in the exhibition were to three buyers. Mrs. Harry Payne Whitney, the rich sculptress—at least she has a fine studio for the purpose—bought four. Henri's "Laughing Child" bought by her, he told me.... From Henri's I phoned A.P. & S. to get two frames from me.... Henri is to take the two canvases from Macbeth's; they are also to stop for panel at H's. They have not yet got picture from Lawson or Luks. Henri agrees to no insurance....

February 21

...I sent Puzzle to the Press.... With my samples, I went to McClure's, Moffatt and Lords, where I was received by Moffatt, I think. He looked over my etchings without turning them right side up. A brilliant specimen of the publisher today. Then saw Brown (Everybody's) who was "come againish." Felt most downhearted and disgusted with the whole business. The outlook is fearful. I called up Trask of P.A.F.A. on the telephone. He said, send the pictures as soon as we choose, that he would pay return charges or an equivalent rate if the exhibition was invited elsewhere. He phoned that in the matter of hanging, we might not agree. Thinks that the "groups" need not be strictly observed; that he would be in N.Y. on Tuesday, would call....

February 22

... Pittsburgh heard from at last!! Two checks, $114.10 and $25. equals $139.10, which pays me for the two months that I served to Dec. 16, 1907. This makes me feel a little less near starvation. Sent check to dentist Beale in Phila. for Dolly's work in Dec.; also paid Strawbridge bill to date. Walked up Broadway. A beautiful day, Washington's Birthday–and everyone seemed to be out, crowds going to the matinees at the theatres. Watched a moving picture photographer set up his camera. He waited and I did also, to see what he was after. Soon around 34th Street, into Broadway, turned a little parade–Volunteer Firemen of the old days of New York. Most pathetic old chaps in helmets, blue coats, red shirts. Others in fawn colored coats. Some of them quite feeble and shrunken, white beards, white hair. The band struck up "Onward Christian Soldiers." Something about the whole brought tears to my eyes. Then they marched up New Broadway with towering buildings where once had been small houses, the roofs of which, the feeble streams from their old pumps could reach. Made a start on a canvas when I came home. Children in backyard. But scraped it out. . . .

February 24

To the A.P. & S. Co. paid $60. on account, and to Macbeth's. Made a second painting of the head of Billy Walsh of the Herald, but as it did not go right, I scraped it out. Went out and came back, took a drink or two of Golden Wedding whiskey to cheer me up–was cheered and went out again. Strolled up Sixth Avenue and watched a new Rotisserie window where they broil meat before an open fire. On the way back met Worden Wood, a marine artist. Couple of Martini cocktails with him–perfectly careless now. Came home and was about to go out again when Dolly and Nell returned . . . all went up to Café Francis and had a big planked steak. . . . Met James B. Moore–he was much surprised to see me under the "influence" which speaks well for my usual habits. He got my name as a stockholder in the "Francis" for $100. share in the new company. . . .

February 25

Answered a letter from the Art Students League of Pittsburgh (asking what I'd come out once a month for). Told them I'd do it for

$35. and mileage and berth expenses. Billy Walsh posed in the afternoon and I feel that I have got a good thing from him.... to bed quite early as last night's wearisome effects were still upon me.

February 26

Worked four hours on a portrait of Nell Sloan and thoroughly exhausted myself—which means that I am not satisfied with the result. *[This painting is not extant]* ... we went out for a walk. The streets were quite muddy, damp weather and so much tearing up being done. The first of the Tunnels under the North River was open at 12 midnight last night and a new era has dawned. From Hoboken to 19th & Sixth Avenue, N.Y., in 10 minutes. *[Hudson–Manhattan Tube]* ...

February 28

Rose rather late and went in to get Kirby.... K. read me a short story which he wrote for Good Housekeeping magazine. A young married couple in their many trials and experiments in the making of coffee. It was right clever and amusing. After Kirby had left Nell got up on the stand and we put in the afternoon on the portrait, which advanced some ... cold supper late, and afterward Billy Walsh and Frank Crane came in.... Crane was a wee bit illuminated, so was Walsh I think.... Walsh wanted to show the portrait of himself to Crane, but as I sent it to have the seal of disapproval of the National Academy jury, this was impossible. Walsh seems to be fond of it. And he invited us to dine with him at 29th St. Monday evening.

February 29

Mrs. Glackens sent Dolly a nice photograph of Glack's baby boy. She is much pleased. Henri called in the afternoon and fixed up his list for the Philadelphia show.... Have been feeling badly all day as though I was on the edge of grippe. Wrote to Trask, sent list of pictures and prices. Told him to let me know when hanging would be done, as I'd probably run over to Philadelphia. Wrote Lawson and Luks to send names and prices of the pictures they are substituting. Told Lawson to send his picture over at once. Nell and Dolly and I had hot punches before going to bed (to cure my "grippe").

March 2

Though the grippe still hangs to me, I got to work on the portrait and think that I will get a fairly good thing out of it. Worked several

hours and then quit, quite used up and ill. In the evening, however, we all went out, Mr. and Mrs. Crane, Dolly, Nell and I to a dinner by Billy Walsh at a restaurant, table d'hôte French, on 29th St. We had a fine dinner. Mr. Walsh had to leave us a while to see one act of The Doll's House—Mme. Komisarjoski, a "new Russian actress" to New York. Mrs. Walsh was there and she certainly is refreshing with her lack of sophistication. . . . came home to my studio and had a pitcher of beer. Not I, I was feeling too badly. . . .

March 3

I painted a little on Nell's portrait and it pleases me right well now. I had not washed my hands free of paint before a stream of visitors began to arrive which kept up till seven o'clock in the evening. First came Davies, who said that if I could not get to Philadelphia, he would, so that the hanging of our exhibition would be satisfactory to us. Mrs. Ullman came next looking very well and pretty. . . . Miss Sehon all in red with a big red hat and furs came next. . . . Joe Laub followed. He had another invention on his mind and now "to make a fortune"—a clothes line that won't be out in the dust and rain. I did not give him encouragement, maybe I'm wrong. After he left, Dr. Howard Wells and Lily dropped in. . . . Last, but not least, came Zenka Stein, our friend and model. . . . Before we finished dinner Mrs. Crane came to go with Dolly and Nell to Myers' "musical" this evening. . . . I read Rabelais while they were gone. . . .

March 4

Mr. Abbott of Current Literature called to get some material for an article on the "revolt" in art, as I think he termed it. I gave him the cuts of Glack, Davies and my own as used in the catalogue. He was a fine big, enthusiastic sort of fellow. Jerome Myers called to see my portrait of Nell . . . seemed to like right well. A letter from the secretary of Pittsburgh League, shaving my price to $30. a visit a month which I wrote would be satisfactory but must be paid the Monday previous to my criticizing. Eleanor Sloan ended her visit today. . . . As I still felt very poorly with my grippe we decided to go to bed early . . . were punished for this extraordinary behavior. At about 11:30, the bell rang violently . . . there stood Henri. Dressed myself in "negligee." . . . Trask and a "taxicab" were out at the curb. I asked them up and we sat up two hours talking over the hanging, catalogue, etc. of the

Phila. Exhibition. I am going over Friday to see the hanging. Trask, though affable, doesn't really think much of the exhibition in his heart. He will stand a little mild looking after, I think.

March 6

To Philadelphia . . . in poor health with my grippe (no pun) and in a damp snowstorm which turned to drizzle. The exhibition was nearly all hung when I arrived, and it looks well. The rooms are ever so much larger than those we had at Macbeth's—and though the light was poor on account of the miserable weather, the arrangement seems to be just as well as could be. Trask took Grafly and me to lunch. . . . On arriving near there, we quite by chance met Redfield, worse luck. This spoiled my lunch for me as he and I never addressed a word, one to the other. Made me feel like a bad-natured person—but it couldn't be helped, I suppose. My whole inside nature is revolted by *[him]*. Others, who haven't found him out, wonder at my attitude. Some who know him are able to dissemble for their best interest. I can't. (Breckenridge, who knows what he is, seems to be taking the latter course.) I heard from Grafly that John Lambert, by his will, left A. Stirling Calder $10,000. This is good news. . . . Back to N.Y. . . . tired and "grippy." Dolly had a nice dinner ready for me and we went to bed early. . . .

March 7

. . . Henri called—to hear how things looked in the Philadelphia show. He showed with proper pride new togs, suit and overcoat. Henri says that some of his men who have been working away from the school have now opened an exhibition on 42nd St. in rooms of an auction company. Golz, Bellows, Sprinchorn and others, Coleman, etc. . . .

March 8

Another day still with the grippe in sway. Dragged myself out and got two Phila. Sunday papers. The Inquirer has a few lines, not at all appreciative. The Press, not a word. This is a marked contrast to the way the newspapers here in New York noticed the show. Philadelphia is small and dull. . . .

March 9

Miss Dreyfous, a student at the N.Y. School, bought a set of etchings this morning. She seems to be very enthusiastic over them. Said that

she had asked for them at Keppel's–they showed her some Pennells.
. . . Lawson came in with a painting, "Harlem Flats," wash hanging
out in sunlight. Bully little thing. He wants me to photograph it for
use in Putnam's Magazine. Dolly and I called at Mrs. Käsebier's new
place, about 32nd St. and Fifth Avenue. . . . She gave me proofs of
the Times page of portraits of the "Eight." . . . After dinner we went
up to see the Laubs . . . pleasant evening. . . . Home and to bed about
1:30 A.M. An hour later I woke with dreadful rheumatic pains in
both arms and shoulders, nearly set me crazy . . . finally got so bad
that poor little Dolly put on her clothes and at 4 A.M., still night, she
went out to hunt a telephone to call Dr. Westermann. He came post
haste and, though the paroxysm was not so great, he gave me medi-
cine which Dolly got from a drug store as soon as one opened in the
neighborhood. From five o'clock to eight, however, not one was open.
Seems a rather bad condition of affairs in a big city like this.

March 10

The medicine did me good, but the doctor ordered me on milk diet
and to stay abed. Jerome Myers called in the evening, also Potts. The
check from Pittsburgh arrived and they want me to come for Thurs-
day. I wrote and told them I'd have to put it off to next week.

March 11

Eleanor Sloan sent us a little bunch of clippings from the Phila. pa-
pers in re the exhibition. Nothing very important in the lot. . . . Still
nothing to eat but milk says Dr. Westermann who called again this
afternoon.

March 12

Today I got up and dressed and hung around the house. Still weak
and living on milk only. Lawson came and I had two prints of his paint-
ing ready for him. . . . In the evening, though feeling very bad, I
started a Puzzle for the Press. It came hard, very hard.

March 13

Went to Henri's studio and looked again at the full length of Wilkes
Barre girl in brown velvet. He has a beautiful frame for it now and it
is a fine thing and a real "Henri." . . . H. and I stopped in at Fahy's
auction house and looked for a few minutes at the exhibition of work

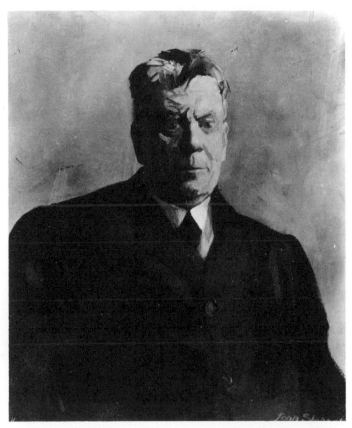

"William S. Walsh," 1908

by some of his ex-pupils . . . good lot of stuff and full of interest. . . .
I'd like to be rich enough to buy some of these things by Golz,
Dresser, Keefe, etc. They would be fine to own, so different from the
"regular picture game." From here we went to the National Academy
exhibition . . . they are evidently crowding the walls to demonstrate
that they need more gallery space. This very crowding and the variety
that the increased acceptance of work has brought, give the place a
more interesting look than usual. Though there is lots of rotten stuff
–if it were thrown out, there would be plenty of room. But who's to
judge? That's so! Still the National Academy should not be given
any more money. My portrait of W. S. Walsh is on the line, though
the Haymarket is "skied"–still I'm lucky. Genial secretary of the
N.A., Harry Watrous, spoke to me graciously. Harrison Morris did

the same. Jimmy Preston has a small landscape hung. Walked up to see Dr. Westermann in P.M. He tells me to keep outdoors more. . . . Finished Puzzle. . . .

March 14

Oh, fine! Another set of etchings sold–to Miss Flora Lauter, 257 W. 86th Street. She also is a student at the N.Y. School and had spoken to me of wanting them some weeks since. As she sent check for $20, I sent her a portfolio with her set–signed proofs. . . . Dolly and I took a long walk in the afternoon along Ninth Avenue to 59th to the Circle. Went in Pabst's Café and had coffee and ice cream . . . bought a very "spicy" light brown hat, very "daring" for me. . . . It is a beautiful early spring day, and the poor city folk look as though sunlight was just pumping new hope and courage into them at the moment when Winter had most done for 'em. I'm weak, but I feel as though there were chances for me after all. . . . Kent Crane dropped in on us after we came home. K. is a nice boy. I made a little brush and ink silhouette of him to "show him how they're done." . . .

March 16

. . . Today I went to see Benjamin F. Buck, to whom Peters (Philadelphia etching printer) referred me some weeks since. Mr. Buck seems to be a fine man and honest, if one can judge by impressions. He wants me to undertake some etchings of historical places, to be paid for at the rate of 25 cents for each proof pulled from the plate and sold. I will make one and see if it pleases him. He took me to lunch at the Fifth Avenue Hotel . . . met the strange Sadakichi Hartmann on 23rd Street. He told me he liked my "Cot" picture very much. . . . Worked on Puzzle in the evening but don't seem to be in good trim yet. Work tires me so, shoulders and neck still rheumatic, I suppose.

March 17

Rode down to Dey Street, and got a 10 x 14 plate at John Sellers & Sons. Charged it to B. F. Buck. Walked up as far as the Astor Library and looked over some histories in the matter of Swedish settlement of Wilmington, which is one of the subjects I'm to try for Buck. Worked on Puzzle a little while. Dr. Howard Wells and Lily came

to dinner. Dolly got up a very nice meal, chops, spaghetti, peas, salad. Very nice and it was well enjoyed. . . .

March 18

James B. Moore came early and I paid him $100 as I had agreed to be a stock holder in the Café Francis. I can little afford this but as I had promised, I had to make good. Don't think there's much chance of seeing my money again. Mr. Buck called after noon. . . . I am to go ahead on one of his etchings as soon as I get back from Pittsburgh. On the 8:25 train to Pittsburgh, passed a very bad night. . . .

March 19

. . . They said they were glad to see me back among them again. The work is about the same. . . . Painted a head in the portrait class for Mrs. Wilson. The men's night class had an interesting model but the work is not very hopeful. I made a drawing to try to show them my idea, but hardly came up to my hope. . . . To Philadelphia where I will see "our" show again. . . . The League say that they will want me again in about three weeks.

March 20

. . . To the Academy of Fine Arts and looked our show over. I spoke to Trask and arranged for him to send the "Cot," which hangs above the line among my stuff, to Pittsburgh. . . . stopped in the Press after lunch with Fincken. . . . Back to New York on 2:20 train in afternoon. . . . Dinner at the Rotisserie on Sixth Avenue. . . . Glackens called and brought us photo of his ballet girl painting. . . . Note from Bradley of Collier's. Wants to see me about the story I am to do for them. Wrote to Beatty of Carnegie Institute in re the "Cot."

March 21

. . . Saw Kirby next door. He tells me that Reuterdahl, whose article in January McClure's had made so much racket in the Navy Department, has returned from the cruise with the fleet. He left at Callao, Peru. . . . Went down to Collier's and saw Bradley. He wants the illustrations for the story in a hurry now, after letting me sit waiting orders for weeks. After dinner at home, I started in on a drawing for Collier's but wasted a whole evening on a bad drawing. I get so little magazine work to do, that it frightens me when I do get it.

March 23

Working on Collier drawings. When I had them in fit shape to show (they are bad though), I took them around to Bradley and, with the exception of a detail, he approved of them. Dolly . . . stopped in to see Mrs. Jerome Myers. Glackens came by invitation to dinner . . . we sat and smoked and talked and looked over some of my books till one o'clock when G. went home. It is agreeable to entertain Glackens. I have a sense of comfort in his company.

March 24

This morning Dolly is not well, headache which the doctor whom I called on says is probably neuralgia . . . the weather is fine today and Doctor Westermann tells me with an oath that I must get out each day and walk four or five miles or I'll break down. Davies called and suggested that I write to W. M. R. French of Chicago Art Institute in regard to having our exhibition out there. I did so and sent letter by special delivery. Phoned Henri (out). Glackens came in for a while late in the afternoon. He said he had been to the National Academy exhibition. I liked the fact that he says he likes my portrait of Walsh. Kirby dropped in while Glack was here and, oh! before either of them, came H. Reuterdahl and I say! he's proud of the fuss he has made in the Navy Department. He is a good soul though an uncouth one. To his credit, I think it is, that he has refused an enormous sum for salary to write for the N.Y. American. At least, he says so, and takes credit for refusing. . . . Worked on Collier drawings and have them whittled into possible shape. I don't like them. They seem to be the best I can do on the story at this time.

March 25

Well, I took in the drawings to Bradley and he seemed quite well pleased. In fact, during a talk with him . . . he promised to send me another story to look over. Met Laub and Reuterdahl at Collier's. After leaving Bradley . . . stopped in at Macbeth's—and saw three Whistler's. Two ovals, The Widow, one of them. Another a little girl's head with tawny hair; the other oval is nice in color but dirty on the whole. Whistler's a great man for himself but not a very good influence. Am I wrong? I don't know. Stopped in to see the show of the New York School ex-pupils. Met Golz there. He has some fine

things in color. Dresser has two heads (one a smiling little urchin) very good. Bellows is already too much "arrived"–it seems to me . . . started a Puzzle. The story, "Eggs à la Casey" arrived from Collier's. It seems more interesting than the last one.

March 26

Mr. Beatty sent me duplicate entry blank to fill out for my Pittsburgh entries (The Cot, $750; Throbbing Fountain, $650; Making Faces, $700; Portrait of Miss Eleanor Sloan, $500.). . . . Today *[Kirby]* and I took a walk along the North River Piers. The city has just made a "square" at 23rd Street, and the waterfront from there down to the Cunard Piers, seems to be under improvement, surveyors and grading in operation. We walked a little through Greenwich and then home. . . . Finished up Puzzle. . . . After dinner, Dolly and I dressed in our best and went to Carnegie Hall to a symphony concert, Volpe orchestra. Tickets from Mrs. Alfred Meyer (Annie Nathan). The Myers were there (Jerome and Mrs.) and Miss Florence Levy, the editor of American Art Annual. The music was good, I suppose, but it made me dizzy after a while. Dolly and I walked home. . . .

March 27

After breakfast, Dolly and I, for our health's sakes and incidentally to look up the matter of Dr. Ayllon, the Spanish Explorer (Mr. C. G. Chevallier of Baltimore queries the Press on the name in my Puzzle February 23 last), took a walk to the Astor Library and back. After we had lunch Frank Crane came and took me to see pictures at Clausen's by Malcolm Fraser. These are bad. Pictures of God and Christ and angels–insincere, vile, cheap color, not ingenuous nor ingenious, nor religious. . . . Crane made me a present of Caffin's book "Story of American Painting" which I have much desired to own. Caffin gives me a prominence among the impressionists which I think is hardly my just due. Still it's pleasant to read well of oneself in a "real book." . . .

March 28

Rather rainy morning but, in obedience to Dr. Westermann's orders, I walked out and with an umbrella, which I secured for United Cigar Store coupons I had saved, I walked from 18th St. on Fifth Avenue and Broadway to Sixth and 39th, where I called at Davies to tell him

that French of Chicago Art Institute had written that the dates of that institution were full until July 20th. He says that from July 20th to October 20th he would like to show our exhibition. Davies was out . . . back to 23rd St. and stopped in at Kirby's . . . the day was now beautiful, rain had ceased and the spring sunshine made everything look fresh. K. and I went to see Loiseau's work at Durand-Ruel Galleries, 36th Street. This work is quite interesting, in marked contrast to the exhibition of the Ten American Painters now on exhibition at Montross' which also we saw. It looks like New York taste today—like spring hats with less utility—seems so lacking in enthusiasm. Next went to the youngsters exhibition on 42nd St., where I've been twice before, Kirby doesn't take to it readily. He admires professionalism too much. . . .

March 30

. . . Dolly and Mrs. Ullman . . . to . . . Crane's . . . for lunch. I went to Collier's and Bradley approved my rough sketches. Then I took a walk along the waterfront. A fine clear day. The Mauretania, the largest ship afloat, was in dock at 13th Street and I got my first close sight of her. She is certainly a huge thing and graceful as a racing yacht. . . . A letter from Rowland Gallery, Boston, offers to have our exhibition but we pay expenses.

March 31

Answered Rowland, Boston. He must pay all expenses. Wrote Miss Perkins, Spartansburg, S.C. and entered Coffee Line and Boy with Piccolo for exhibition. Wrote in answer to Trask, Pennsylvania Academy of Fine Arts, to send the paintings to Artists P. and S. Co. . . .

April 1

A beautiful day. Spring seems to be right in place now. Still necessary to have a low fire in the stove in the north studio. . . . Took a walk to Central Park . . . it looks fine, the grass is quite green and the sun is warm. Stopped and looked at the people passing St. Patrick's Cathedral, which represents a temporal value of several million dollars. Noticed the poor men who touched their hats with the customary, half ashamed, furtive air in passing the central door. A baby in carriage has a small parasol held over it by its nurse in passing the same spot! Made a Puzzle in afternoon and evening.

April 2

... Davies called during the day. He is in favor of trying to launch our "show" on a circuit next fall.

April 4

... *[Kirby]* and I took a walk ... to the National Academy exhibition. Looked over the show again, and think my Portrait of a Man holds its own very well among the rest of the heads there ... stopped at the Van Dyck Studios and saw Carl Anderson, who works from a model and turns out his popular illustrations in good popular form though he is a very nice fellow personally and I like his liking for Henri's work.... dinner at home and in the evening I started on the Collier drawings. Got one about finished. Henri phoned for me to look up time of trains for Wednesday and I wrote to Schofield and let him know that we'd be on the Penna. Limited leaving here at 10:55 A.M. That is, I'll be there if the Pittsburgh League sends transportation money.

April 7

Nice friendly letter from Schofield and a long letter from Nan, my sister, to Dolly. Then a telegram from Press that Puzzle had not come which I sent last week. I made another in a rush and sent it, registered this time. Transportation and salary from Pittsburgh and Dolly went out and bought tickets, etc. Mr. and Mrs. Crane, Miss Vorath and the Laubs to dinner.... Dolly did some dancing and nice little imitations of Vesta Victoria. She is going to spend Wednesday night, Thursday and probably Friday night with the Cranes.

April 8

And now from Henri comes the phoned information that he has a telegram from Carnegie Institute to come tomorrow instead of today ... a trip up to the ticket office to have his ticket changed and my own replaced.... Came home and finished up Collier's drawings and then delivered them. Will Bradley was much pleased with them and gave me a heading piece to do. Oh, Fine! Busy Time! Prosperous illustrator!! When I came home I saw fire engines and smoke and crowds in 23rd Street nearly in front of 165, Little Dolly at the front window.... The fire was, or had been rather, in a building nearly oppo-

site . . . Dolly had a fine dinner for me, chicken giblets and mushrooms . . . got myself a bottle of ale to drink on the train to see if it makes me sleepy.

April 9

Slept better than usual last night on the train. The classes' work was about as usual . . . not so many students as there were in the fall, perhaps on account of the "hold up" in the winter when money was so scarce, perhaps because they don't like the instructor. After the men's class in the evening. . . . Went to the Liberty Station to see if I'd meet Henri and Schofield arriving in Pittsburgh. But their train had come in some time before. I came back on the 10:40 to New York.

April 10

. . . started in on a drawing for Collier's after walking out and looking at the harness arrangements on horses. . . . After dinner, Glackens came in and spent the evening with us, though he was left to amuse himself as I had to go on with the Collier drawing. He is going to give up his studio next month, store his things, and go to Cape Cod for the summer. Davies came in in the afternoon. He is anxious for the pictures to arrive from Philadelphia. The Artists P. and S. Co. say that they have not received them yet.

April 11

Invited to send "Sixth Avenue and Thirtieth Street" to the Cincinnati Museum exhibition this year. . . . Lawson came in. He has just been elected an "A.N.A." [*Associate, National Academy.*] Got the Hallgarten Prize and sold the picture. He looks the same as usual. Delivered heading drawing to Bradley and he was much pleased with it and handed me over another article for me to read, "Making of an Actress" by Gelett Burgess. Wrote Trask to find out what had become of our pictures from the exhibition in Philadelphia. Suppose he sent them by freight. . . . Wrote to J. H. Gest, Director Cincinnati Museum. Entered at his invitation, "Sixth Avenue and Thirtieth Street," $650; "Hairdresser's Window," $600; insurance value $250, $200. Also offered to send a group of etchings if he so desired. . . . On Sixth Avenue passed a sale of shoes at Paisley's and bought two pair for Dolly, fifty cents per pair. One pair fits perfectly. We went to Marie's on 21st St. and had a fine big dinner . . . people interesting, "vulgars,"

"bohemianapists," many of them. This heavy dining took all the work out of me. Came home and read.

April 12

Page at a time this plain dull true story of a living is written. And I can't tell nor guess, what the next chapter will contain, nor the next page. This evening, Henri came in with the news of the Carnegie Institute Jury on which he and Schofield served. I came near it again—near it! My picture, "The Cot," was set aside with fifteen others (250 were accepted out of 1200 that were submitted), set aside for "honors." Henri and Schofield voted for it for first prize and second prize. For third prize, Davis and Alexander joined them, making four votes out of nine so that I was just beaten. Then they were all for giving me the first honorable mention, but this could not be done as I had had that in 1905. I feel pleased at being in the race at the finish, at any rate. Lichtenstein and Mrs. L. called in the afternoon. He says that the Toledo Art Museum would take our show this month, and that Detroit would also probably want it. But as I don't know where the pictures are I'll have to let him know later.

April 13

Went in and saw Kirby. He showed me some numbers of "Once A Week," published in London (circa 1860) which have some fine work by Leech, Walker, Millais, and the beginning of C. Keene. Made some small "rough outs" to show Bradley at Collier's but phoned and found that he'd rather I'd call tomorrow. After dinner Dolly and I went to call on Uncle Howard and Lily Wells. Found them at home, Aunt Nina Ireland at church. This is her busy time, as there are about "four performances a day in the Church this week." We had a very pleasant time. Lily gave me the watch chain which "Bo," her brother (Howard), who died while going to college in Philadelphia fifteen or more years since, carried with the watch which I have had since then, given to me at that time.

April 14

Walked down to Collier's and showed sketches to Bradley which seem to please him. He will pay $250. for the whole article which is to be in three parts. He gave me another Beer Saloon heading to do

in a hurry. Started right in on it and took him tracing of the general form so that he could go ahead on type setting.

April 15

Cincinnati wrote inviting ten etchings. I changed my entry to this: "Sixth Ave. and 30th St.," $650; "Picnic Ground," $650; set of etchings, $100. Held the Hairdresser. Mills of the A. P. & S. Co. tells me that the pictures have arrived from Philadelphia. Walked up to Davies' . . . told him of the Toledo Exh. possibility. He agreed to it. . . . Glackens called in the evening and I worked on the Collier heading. Glack hears that Jim Moore is "down and out," lost all his money–the Francis is to be sold and also his furniture and furnishings at 450 West 23rd St. It seems hardly possible that J. B. M. could have let himself run into such bad financial straits.

April 16

Delivered heading to Bradley at Collier's. It seemed to please him. Walked out 14th St., stopped in bookstore and picked up some old copies of Pall Mall Magazine with Raven Hill drawings in them. . . . Went up to Joe Laub's to get some data about School of Acting for the Burgess story. . . . Artists P. & S. Co. called and took away "Coffee Line" and "Boy with Piccolo" to send to Spartanburg, S.C., exhibition which opens April 27.

April 18

Miss Bryant came and posed for some sketches which I made in preparation for the Burgess article in Collier's. . . . During my absence Lichtenstein must have called for I found a telegram to him from the Toledo Art Museum (George W. Stevens) which says, "Sorry but are full. Could take exhibit in fall gladly," and a letter from the Detroit Museum of Art (A. H. Griffith) which says, "Mr. Burroughs spoke to me regarding the collection of the Eight. The season is too late however to take the matter up at this time, but I would be pleased to have them with us some time during the next season if arrangements can be made to that effect." . . . Passed most of the evening looking through some of my John Leech pictures. He's Rembrandt's peer in line work. As fine an example of the clean artist mind as ever lived.

April 19

A raw, blustery day with a shower now and then, but with a beautiful sky, huge cloud masses. At 4:30 in the afternoon, Dolly and I started to the 23rd St. ferry to go to Mrs. Crane's father's home in Hoboken ...a wonderful sky breaking open in the West, heavy-laden blue clouds and south above the horizon a strip of gray-orange. Against this the huge Mauretania silhouetted with vermilion stacks and black hull. I think I have never seen a day that made the city and the works of man so beautiful.... Dolly and I came home by the new "tube" under the Hudson, quite a novel sensation. Smells like a damp cellar. We came from Hoboken to 19th and Sixth Ave. in about fifteen minutes.

April 20

Pictures came back from the "Eight" exhibition and also the W. S. Walsh portrait and The Haymarket from the National Academy. Finished and mailed a Puzzle. Glackens dropped in and told us that Jim Moore's household effects had brought ridiculously low prices. A little Maine Coast painting by Henri, $16. Two Lawsons at same or less.... Started on drawing for the Collier Burgess story this evening.

April 21

A. B. Davies called. He is enthusiastic about a traveling exhibition in the fall with some of the new fellows who are good in it, such men as Golz, Dresser, etc. In the evening, we had at dinner Glackens and Mrs. G., and Davis and Mrs. D. The conversation naturally turned to the old days on the Philadelphia Press. Davis says that he always looks back on the time as having an eventful and distinctive quality in his life.... Mrs. Glackens was quite apparently bored. She always is when the old days at the Penna. Academy are talked of. In fact, the past in Phila. is to her a subject tabooed.

April 22

Dolly went to the Cranes' to help Mrs. Crane sew Roma's dresses. ...I worked on Burgess article pictures. Went to the Chinese restaurant on Sixth Ave. for my dinner. Came home and spent the eve-

ning working till one o'clock. Then after reading for an hour, went to bed.

April 23

A little letter of loving thoughts from Dolly and a note from C. Gallup, Coxsakie, New York, requesting my "autograph." I complied at once. This seems like the rapping of Fame on my door! Worked on the Burgess pictures. . . . In to Haven's book shop and, as he is giving up the store, he let me have John Leech's "Mr. Brigg's Fishing Series" of twelve plates for $3. This is right cheap, and I have had my eye on them for about two years. Now they're mine. To the Chinese again for dinner and on my way back went in to the moving picture show on 23rd St. and was edified by several very stupid sets of films. Came home and worked to 12:30. . . .

April 24

Today I received a horrible letter from March, Sunday editor of the Press. My Puzzle of last week brought it out. It appears that certain foul minds are able to force double meanings into some of the Puzzles. I wrote a sharp answer to it and have kept a copy. His letter should be kept perhaps, but it's too filthy. I wish that I felt prosperous enough to give up the Puzzle work but it is the only regular income I have. . . . I took the drawings to Collier's and Bradley seemed well satisfied with them. . . .

April 27

Today the Café Francis passed out of existence. I went up to the sale with Frank Crane. It was a very interesting day. Paintings by Lawson sold at dirt cheap prices, not comparatively, for in that sense his prices were pretty high. I bought in the lot in which my etchings were sold for $20. Crane bought an "Excavation" by Lawson; Preston got three of them; Mrs. Glackens, one; Gregg, two. Mrs. Glackens got his "Bull Fight" for $6. . . . Crane and I went to Keen's Chop House to dinner. . . .

April 28

Went to the Francis to pay up my own and Mrs. Glackens' ($27) accounts. Crane's also . . . had a carter take all the pictures to my studio. . . . Went over to 23rd St. and Lexington Avenue and called on

the Lichtensteins. Asked him to take up the arranging of a series of exhibitions in the West this fall. He said he would. . . .

April 30

. . . I finished up a set of Puzzles. Stayed in all day. Jerome Myers called and said good-bye. They leave tonight for the country. It rained quite hard in the afternoon and evening. I had my dinner at a restaurant next door. Went across the street and took another five cents worth of moving pictures, then came home and started on another Puzzle for the Press. . . .

May 4

Another day "on the Floor" of the studio. I applied one coat of wax and polished it. Looks very fine. Dolly "hustled" all day finishing up cleaning. . . . Miss Beal, a tall narrow girl, called. Wants to pose, so I told her to come tomorrow afternoon. . . . Mrs. Glackens sent check for $17. settling her account for the auction sale at the Francis Café.

May 5

. . . At one o'clock Miss Beal called and I made some pencil sketches of her for the Collier story till two. Then started in to paint which was more to my liking. I worked till nearly five o'clock and I rather think that I have an interesting canvas, green straw hat with rosette, a long face with blue eyes and heavy lids, long upper lip. She is not pretty but I felt that there was a very interesting point of view to be taken of her. . . . Shinn around 9 P.M. with a "big scheme" and his "press agent," Mr. Calvert, the latter a weak-faced chap. Shinn had invented a "Teddy Roosevelt Third Term Puzzle." Head of Roosevelt, big eyes with glasses, two steel balls to make pupils of eyes. You juggle the balls till they fall in the sockets. He wants me to say I'm interested in politics to the extent of third term for Roosevelt. He is going to see the rest of the crowd. I fancy Henri and Davies won't care to have their names used. I said he could say I was interested as above. He's nervous–but he is bright.

May 6

The weather is worth noting, so cold for this season . . . dropped in to see Kirby next door . . . he is worried on account of not having anything ordered just now. Seems to be quite rattled, when he might be

painting or amusing himself. I, myself, am too liable to worry when there is no bread and butter coming in. But to paint at such times is a great relief. After dinner (all vegetable as we have been trying to cut out meat as much as possible) lit gas radiator in studio . . . started on Collier drawings. Finished one. . . .

May 7

Today is a cold, rainy day, a settled storm from the East. Jerome Myers wrote me from Hunter, N.Y., in the mountains. He says that he is enjoying the change, and that the baby and Mrs. Myers are looking better already. Worked on drawings for Collier's.

May 9

I delivered the drawings to Collier's today and Bradley approved. He gave me a heading for a Newsboy article to do. After dinner, "imitation Turkey Hash" I called it—lentils mixed with rice, very good—Dolly and I went to the Grand Opera House and saw Olga Nethersole in "Sapho." We had very poor seats, around a corner in the balcony. But we enjoyed it right well. I had never seen Nethersole before, she's getting stout they say. The play is not a good version. (Fitch did it.)

May 10

Stopped in to see Lichtenstein . . . out of town. I have made a rough sketch for an ad hangar for him. Made the Newsboy heading in the afternoon. After dinner, which was a fine broiled chicken spread which I particularly enjoyed as we have had no meat for some time, Henri called and announced that he had sold the big "Reina Mora" painting to a man in West Chester, Pa., for his music room. This is fine news. . . .

May 11

Delivered the Newsboy heading and Bradley liked it very well. Went up to A.P. & S. Co. and told Mills to send the bill for returning the pictures to the P.A.F.A. . . . letter from Miss Craig in Pittsburgh says they can't afford to have me there this week as they are still under the hard times regime, mills closed, etc. Two pictures returned from Pittsburgh, Eleanor S. *[Sloan]* and Throbbing Fountain. The Cot and Making Faces are accepted and hung. The Times this morning has a heading "Artists Drop Work to Boom Roosevelt." This is the scheme

which Shinn was talking of last Tuesday. He has shaken them down for a good ad for his "Roosevelt Puzzle." Note the wise words of Glackens! . . . We went out across the street and saw Moving Pictures, five cents; took a short walk on Sixth Ave. Saw a runaway horse stopped. The Elevated railroad pillars made this quite dangerous. One man, fool, got out and waved his hat at the horse–thought it a butterfly. . . . Started a puzzle.

May 13

. . . I walked out up Eighth Avenue. Stopped and watched some tough working girls around a small lunch cart. Very amusing and fine with animal spirits. Then on up to the Penna. Railroad Terminal operation which I watched. They have almost finished the huge hole from 7th to 9th Avenues. Have started on the iron construction work between 7th and 8th Avenues. Watched riveters at work driving bolts rather heading them with pneumatic hammers. Leaving there, I went to Miner's Theatre on 8th Ave. and 26th Street. A "leg show," pretty coarse, though not so bad as the one I saw at the Lyceum in Philadelphia years ago. Living pictures with girls in tights, which make a shocking kind of imitation nude. I think straight naked would be better and more decent. . . . Found a pigeon in the studio. He must have come in the open window while I was out. Cooed to him till he finally began to answer me. Seems like a harbinger of luck.

May 14

A.P. & Shipping Co. write and enclose letter from Penna. Academy who decline to pay the bill for returning the pictures to the artists. I wrote Trask. Told him that we had spent $110 and that this $24.60 would make us bear unfair amount of the expense of the Ex. in Phila. The Penna. Academy probably spent no more than $40. on the show. . . .

May 16

Worked on Collier drawing. Telegram from Trask says that the Academy does not refuse to pay for the return of pictures, mistake, etc. Rather odd considering the fact that I have his letter (his secretary's rather) to A.P. & S. Co. . . . After dinner went to the doctor's as I feel very badly, probably caught cold yesterday . . . saw Dr. Brumeiser. He prescribed pyramidon and a hot bath. . . .

May 18

Finished up Collier drawing and went over to see Bradley. (Delivered the two, completing the Burgess actress story–$250.) He wants to use tint block with the first three pictures in the Dramatic number which comes out next month. . . .

May 19

Got up very late and after breakfast went over to see Bradley in regard to color of proofs. He was not ready for me however. . . . I'm still out of condition with cold in my head and rheumatic pains.

May 20

A. G. Dove *[Arthur G.]* came in today and offered to let me have the use of his lithographic press and outfit while he is abroad. His father-in-law has put up the money for a time in Paris and Dove will be gone a year or more. I accepted with joy and went around, got a moving wagon, had the press (a small proving press) loaded on and delivered to me at 165 West 23rd St. where now it rests in the studio between the north windows and I'm just aching to get at it. . . . Started on a Puzzle for the Philadelphia Press.

May 21

Finished up the Puzzle. Looked up my book on lithography and read up on the subject. Looked over the things that came with the press– and, wonderful coincidence–after dinner, Moellmann, who is a lithographic designer and has worked at the trade for years–called. He has been living in Elizabethport, N.J., for a year, during which time I have not seen him and it seems a good omen that he should "turn up" the very next day after the litho press makes its appearance in the studio. He says that he will come on Monday evening and give me a practical lesson in printing, etc. He and I started graining one of the two largest stones Dove gave me. This evening was most interesting. . . .

May 22

Mailed Puzzle. Went in to tailor's and was fitted for my new blue serge suit, the goods for which I bought fully three years ago. Started a tissue drawing to put on stone. A girl of the streets starting out of

27th Street, early night, little girls looking at her. *["Sixth Avenue and Thirtieth Street," 1908]*

May 24

... I took a walk along the river as far as the upper Cunard pier where the big liner Lusitania is docked. Men and boys are selling postcards of the big boat to the people who come down to look at her. A right interesting sight to watch the small crowd on the street and the big boat back of them—with hot sunlight, for it is a very warm day. Walked home on Eighth Avenue and saw the most charming little sandy haired tot in pink and white with a doll as large as herself all in pink also, standing in a venetian red doorway with a white doorknob, such red, red lips—beautiful. A fine big steak for dinner, after which I ground a stone and made a drawing on it right on the slab where I'd ground it. Woman, primitive, sitting with child at breast. An old idea of mine, Mother of the Man who first made himself Chief or King of Men. *[Background for two other lithographs, "Lusitania in Dock," and "Mother of the First King."]*

May 25

I went out this morning and bought some things necessary for the proving of the litho stone this evening. ... Moellmann came to dinner ... then we got at the litho press. Moellmann found that the can of ink was too old to get any good results and we got no good proofs after struggling till after one o'clock in the morning. ... We worked on the stone of the primitive woman and baby, "Mother of the First King," as I don't want to risk the better drawing on the other stone.

May 26

... Walked down to Warren St. to Fuchs and Lang where I bought zinc and ink for the press. ... Rode home on the elevated. ... Spent the afternoon trying to get a better proof of the stone but without much success. ... Potts called. ... He has three stories to do for Scribner's so that he is a bit more prosperous as he puts it. If we get through this hard time in money affairs, we should never have to worry again in a lifetime.

May 27

Ground and grained a stone and cut down the table on which the litho press is fixed and got ready for Moellmann, who came for dinner. I

roughed in a drawing of himself and myself struggling with the proving. *[The lithograph "Amateur Lithographers."]* And after dinner we struggled to much better purpose as I had some decent ink to prove with. Jerome Myers called. He is on a two days trip to town. . . . Moellmann and I worked with the litho press till about 1:30. Dolly was sewing in the front room. . . .

May 28

Up late. After breakfast, I went on with my training as a lithography artist. Put in a hard eight hours till about 7:30 P.M. when Dolly and I went out to dinner at Maria's on 21st St. I ate like a working man and enjoyed it. Then, as Mrs. Shinn had written that Everett would like me to turn up for an evening at which some newspaper men would be present, Dolly and I walked down to Waverly Place. Mr. and Mrs. Brewer (she was Miss Marsh, met her at Miss Pope's), Mr. Van Vechten of the Times, a very serious and young fellow, Mr. and Mrs. Gwynn, he's a broker friend of Shinn's, and the press agent of Shinn's puzzle, Mr. Calvert. Shinn has a very interesting sort of miniature theatre. He is working on the scenery, in small, of a melodrama. Clever stuff. None other of the "8" was there. I was glad I went, though it's a clear case of being used to advertise Shinn's "Teddy III Term" Puzzle.

May 29

Today's Evening Sun has a most earnest denial of the existence of the "Theodore III Club" as Shinn has been calling it in his press notices. It seems rather absurd to deny it as surely everyone must have known it was a "fake" to sell Shinn's Puzzle. Some of the crowd have evidently been worried by the political notoriety given their names. It's all very amusing, Shinn making hay out of his associates in the Exhibition. Luks' artistic snobbishness "too busy painting to go into politics or trade," Lawson's ditto. My own foolish content to "let it go, if Shinn wants to use me, all right"–also snobbish? Today I fussed with the press some, did some shopping for it, getting ready for another proving afternoon tomorrow when Moellmann is to come. . . .

May 30

Shinn came in a little after noon today, wildly excited over the Sun article last evening. . . . I said that if he should send a reporter to me,

I would say that I had permitted the use of my name as I did. Moell-mann spent the afternoon running off some impressions of the Street Woman or whatever I may call it. I ground off another stone . . . rained hard all day interfering, of course, with the Memorial Day celebrations . . . In the evening we looked over some of my Daumier and Gavarni pictures and talked until 2:30 A.M.

May 31

Today Sadakichi Hartmann, the curious Japanese-German art critic and writer, came to me for a very small loan which I gave him, tell-ing him at the same time that his credit with me was not at all good, as some years since he had got $4. from me for a copy of his work on American Art–kept the money and never sent me the book. He is clever though and I enjoyed my talk with him a good deal. . . . Fin-ished up a Puzzle in the evening.

June 1

Mr. and Mrs. Hamlin of Lansdowne, Pa., Phila. (she was Miss Gar-rett, a friend of Dolly's, taught her music when we were first married and living there) came on a one day trip to New York. Dolly and she went through the shops and . . . we all had lunch at Mouquin's. . . . I worked on the stone, Lusitania in Port. . . . Henri married–I hear it today.

June 2

This morning, before we were up, a phone message was received down in Kruse's Store. Henri left "good-bye" for us. . . . Potts called with the news that Henri had sailed on the Moltke–and married!!! It appears that he has been married a month. Potts arranged for the wedding privately, a J.P. of Elizabeth, N.J. officiated . . . the new Mrs. Henri's name was Marjory Organ. She has been for several years on the N.Y. Journal and World, an artist. . . . I wish him happiness–he has cer-tainly put in a very lonely two years since Linda died and he is a man who needs a wife to look after his comfort. . . . After dinner, Moell-mann and I proved a stone, the Lusitania in Dock, got a few decent proofs.

June 3

Photographed Verplanck home to use in tracing on copper for Buck. Had a copy made for him at the photographer's . . . took his original

to him. *[Buck]*. Grounded the plate and prepared to go on with this job which I don't like much to tackle. . . .

June 4

Worked all day on Buck's plate. . . . Mrs. Brewer (Miss Marsh) called . . . told her of H.'s marriage which did not altogether surprise her as she said there seemed to be something in the air on Tuesday when she saw Miss Pope off on the steamer. Dolly went to call on Mrs. Lee, who is staying at Henri's while he is away. As his mother, she is quite provoked at the clandestine marriage and doesn't seem to think that the new Mrs. H. is the equal of Linda, who, being dead, becomes more perfect.

June 5

Worked on plate for Buck . . . a reporter from the World came to inquire of me what I knew of Henri's marriage. I told him that I knew nothing save that I understood that they were married in Elizabeth, N.J. a month ago. Joe Laub and Mrs. L. called on us in the evening. Invited us to spend next Wednesday with them in Coytesville on the Palisades where they are going to stay a few weeks.

June 6

Took a walk in the morning. The newspapers have the notices of Henri's marriage–"Eloped, etc." . . . worked all day on the plate for Mr. Buck. Shinn called me up. . . . He is wild over a paragraph in the Evening Sun which again raps at him and his business use of the "Eight painters." He threatens to sue the Sun for libel. . . .

June 7

Lichtenstein and Mrs. L. with little Charles Quinby called. He has arranged for Exhibition of the Painters of the Macbeth Exhibition to be held in Chicago September 5 to October 11th. After that a month in Toledo and a month in Detroit. It has certainly been good of him to go to all this trouble for us. He is proving himself to be the right sort. . . . Moellmann came. . . . We did some printing in the night.

June 9

. . . I spent the whole day struggling with the mysteries of lithographic printing of the "Ping Pong Photo" stone with varying success. . . .

224

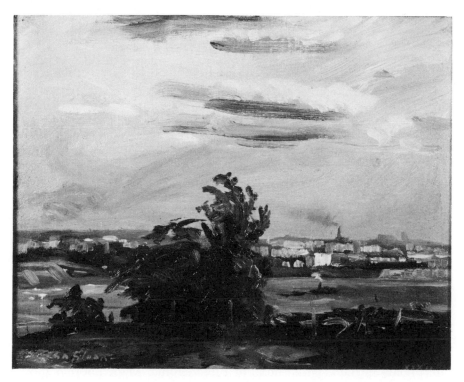

"Coytesville Palisades," 1908

June 10

Today we started at 9:30 A.M. to go to visit the Laubs who are in Coytesville N.J. on the Palisades. . . . They stop with a French family, M. Richard and wife who take in boarders in summer . . . took a walk after a good lunch, along the cliffs. . . . A nice dinner after a climb up the Palisades. . . . Home by way of Weehawken at 11 o'clock. We are going again to stay two weeks beginning Monday.

June 11

Wrote to Davies, Luks, Prendergast, Lawson and Glackens. Henri I will write later. Shinn I'll see on Saturday evening. Announced that C. B. Lichtenstein had arranged exhibition in Chicago, Toledo and Detroit and that lists of titles with prices must reach me by August 15th. Dolly and I went shopping together today. She bought dress material. I bought a bathing suit for next week's trip . . . nice spaghetti dinner at home.

June 12

I got much interested in working with Dolly at her new dress, cutting down the pattern so that it would fit her and then discovering after sewing the goods together that some training in pattern cutting would have saved time. After dinner, I penciled in a Puzzle. The second part of "Making of an Actress" came out with my drawings (2). They look very well.

June 13

Finished up the Puzzle and mailed it ... went down to Shinn's for dinner. They were very pleasant indeed and we had a nice evening. Shinn is wild at Gregg of the Evening Sun. He puts all of Lawson's objections to his use of the "8" in advertising up to Gregg. ...

June 14

Made two dozen sketch boards of canvas intending to make some small things at Coytesville *[All of these sketches made at Coytesville were 9 x 11 inches.]*. I have done very little outdoor work since eighteen years ago when Glackens, Laub, Worden and I used to go out on Sundays in the neighborhood of Philadelphia. Made another Puzzle so that I'd have it out of the way this week.

June 15

All morning we spent in preparations and packing two valises, a sketch box and a grip-bag. ... Made good connections with ferry and Coytesville car at Weehawken and met Joe Laub at the waiting shed in Coytesville, then tramped through the rain the quarter mile to M. Richard's. After a right good dinner we spent the evening in the dining room ... played hearts. ... To bed about 11 o'clock and slept quite well for first night in strange quarters.

June 16

This morning the weather was clear, the sky filled with big clouds. I made a first sketch from the top of the Palisades looking down at a sort of apron of ground made by the earth dredged some years ago from the Spuyten Duyvil creek which was put here by the contractors on that work. After lunch, the sky was quite cleared and the sun out brightly. I made another panel much better than the first, looking

through an opening among the trees at a glimpse of New York City to the south. . . .

June 18

. . . After lunch made a sketch with Noelie and Aida playing, throwing hay at each other–a fine youthful vigor and beauty in their play. I enjoyed watching it. I get a joy from these healthy girls (one of them on the verge of womanhood) that I can't describe–it is as big as life itself. . . . Made a little sketch from Noelie which was most interesting to do. . . . After dinner, on the porch, got Mr. Richard into interesting reminiscence of Paris and his life here in N.Y. as a waiter. He knew Francis, whom J. B. Moore started in the Café Francis, just failed. . . .

June 19

In the morning made a sketch as usual . . . worked on the sketch of Noelie and spoiled it, as I had foreseen yesterday. I get great pleasure out of my industry in this making of sketches. The cliffs below and New York across the river are limitless in the interesting effects of light and haze. In the evening, with Mrs. H. and Dolly, we walked up to the cliff edge. . . . The late evening effect with the two women in white against a white railing, the evening shadow of the earth against the eastern sky above upper Manhattan. This shadow of the earth at sunset was new to my eyes though I had heard of it before.

June 22

. . . Sitting on the cliffs this afternoon I succumbed to the temptation to put D. S. and J. S. 1908 on a rock, small one just north of Richard's boundary line. This is foolish. I think that men may mark the world more effectively by their works, but these Palisades are a great temptation for little passing man to make his mark on the enduring stone. My mark is in Devoe's oil colors so I have the assurance of the durability of my inscription from the manufacturers.

June 23

This evening was made interesting by our going to see the school exercises in Coytesville, held in a shed room called the "casino" and dancing hall. I was very much interested in the recitations of the children. Noelie Richard was the handsomest girl who appeared. She

sang very well a song of "Captain Willie Brown." I sat beside her mother in the crowded hot room and saw that she felt that certain parts of the song might be done better, but I told her she should be proud. The four graduates were quite typical. Two stupid looking boys with large heads, brothers; a smart French girl and another studious sort of girl who read the class history. . . .

June 24

Went in to New York to Chapin of Scribner's–he is away. . . .

June 25

These days are all pretty much alike in Coytesville. I go on making my small sketches, eating well and sleeping well. Having a good rest altogether.

June 28

Mr. and Mrs. Hertzmanns (or some such name) came to spend Sunday with the Richards. Hertzmanns is Mrs. Richard's brother, a big, good-natured French German. He runs a pastry shop and lunch room in the Bryant Building, 42nd St. & Sixth Ave.

June 29

Came to New York to see Chapin. He gave me "The Moonstone" by Wilkie Collins to make four illustrations for. Stopped at our home and got materials for making the drawings out in Coytesville.

June 30

I find it not likely that I will be able to do the illustrating work out here. No proper place to work, and too much likelihood of being interrupted.

July 2

Played croquet and had some argument over the game as is quite usual with this sport. In the afternoon, I made a large canvas sketch, did not finish it however as I started too late.

July 3

Today we left Coytesville and the Richards. I made a final sketch. After dinner in the evening (thereby dodging the extreme heat of the

day) we started for home. Joe Laub came all the way in to the studio with us, carrying two of our bags—very nice of him. We found our place untampered with save for two jars of strawberry preserves which had been taken from the small box in the hallway. A piece of parmesan cheese was also missing but might have gone of its own volition, perhaps? Saw a raccoon come out on the rocks at Richards', first one I have ever seen. Gave Mrs. Richard one of my small sketches as a return for her many kindnesses.

July 5

Dolly attacked the studio with broom and duster and then carried the front rooms with the same artillery, under a heavy fire of hot weather. I made a Puzzle. We had a spaghetti dinner at home, very enjoyable; and in the evening we had a pitcher of lemonade to help us meet the heat with fortitude.

July 6

I made another Puzzle after sending off one by mail as I want to have the week free for starting on the Wilkie Collins. The weather is frightfully hot, almost unbearable. It's too hot to think.

July 8

Kirby called today to say goodbye. He is going to take another rest up in the woods. . . . Lily Wells called. She seemed to be interested in the sketches which I have made at Coytesville. The weather is lovely today, mild pleasant spring sort of day . . . air clear and bracing. R. G. Dun & Co.'s man (Rosenmuller) called on me and asked me questions in re my financial and business affairs. Mrs. Crane dropped in in the afternoon. I took a walk down as far as Greenwich "Village," a nice part of the city. Many of the houses are small and old fashioned. After dinner Dolly and I took a walk up Broadway. On our way back by 6th Avenue, went in Mouquin's and had a couple of Scotch highballs. Then lobster Newburg and a bottle of white wine, then another Scotch, ending up pretty much the worse for wear and both quarrelsome.

July 9

The weather is so hot that I find it very difficult to get started at my work on the "Moonstone." Nan has been operated on for appendicitis

in the Hahnemann Hospital in Philadelphia. She is getting on well according to letter from Bessie. In the evening I got started on a drawing for the "Moonstone"–like "pulling Teeth." I have had a postcard or two from Henri in Granada, Spain. He has not heard from me yet as my letter awaits him in Paris. While out today I met Guernsey Moore of Philadelphia who was on the Press years ago. Same old tall long nosed "Tommy" we used to call him. He was surprised when I told him of Henri's marriage to Miss Organ. He had met her a couple of months ago one night when he was in New York. Said that H. had evidently not known her long at that time.

July 10

Worked on the drawing and then went out in the afternoon to walk. Had not gone far when I met Frank Crane who is in town to take dinner with us in the evening. He and I went to several stores to buy shirts for him. I came home and worked on drawing. He met Mrs. C. at ferry.... Had a nice spaghetti dinner with other vegetables, no meat. Talked at the table for about two hours or more and they went home soon after.

July 12

Dolly not feeling well so she stayed in bed. I went for the Sunday papers as usual and then, after looking them over, went on working on the drawings. A hot day and I saw many interesting incidents in the hot rooms of the people back of us on 24th Street. A young girl, bathing partly hid by an open door but quite unconscious of her beauty. She is one of the sisters of the little fellow who posed for my "Boy with Mirror."

July 14

Working on the last of the drawings for "The Moonstone." A terrific rainstorm came up in the afternoon, the clouds black and gray and wicked green were fine. I went on the roof to look at them ... first rain of any account for a whole month. Dolly and I, after dinner at home, went out for a walk, stopped in Mouquin's.... We had too many Gin Rickeys, too many for us.... Came home and to bed in bad condition. We must quit this....

230

July 15

We stayed in bed till forced to get up to let in Kent Crane who called on us and had lunch with our breakfast. I finished up the drawings and took them to Chapin of Scribner's, who was satisfied with them and handed me the "New Magdalen" to make four pictures for. A beautiful day and the breezes about the Flatiron Building show the beautiful forms of the women in their summer gowns. There are so many lovely women in New York and they dress so very charmingly, I'd like to spend hours watching them. . . .

July 16

Took a walk down town, went along Broadway and 14th St., Second Avenue as far as First Street. The diners in the balcony of Café Boulevard were a fine subject. The sunlight was clear and brilliant but not hot. Streets look clean and fresh. On my way back I stopped to show Mr. Buck proof of plate which seems to suit him better than me. A glass store on Cooper Square East attracted me. I went in and bought some goblets and other drinking glasses. Came home and found that little Dolly had been doing a very hard day's work. . . . Lamb chops and peas for dinner, very good.

July 17

Bess writes. . . . Nan won't be able to leave hospital till end of next week, wound is healing very slowly. Jerome and Mrs. Myers called, with Virginia . . . accepted Dolly's invitation to stay to dinner with us. They have taken a furnished room 236 West 14th St., and seem to be well pleased. Though why they came to the city is not quite clear. Jerome, of course, was not interested in the mountains as he is in the East Side life. I made a Puzzle. . . .

July 19

After I had gone for the Sunday papers, taken a short walk, sat in the Square (Madison), looked at the new tower of the Metropolitan Life Building which is complete with the exception of the upper steeple and the clock. (This tower seems to me as though it were going to have a look like a village church steeple or fire house.) . . .

July 20

In the afternoon I made another start on the second "Mag" drawing. Then, as Dolly made a special request, we went out to dinner at Mouquin's. We met there Fitzgerald and Gregg. Fitz thinks as I do that in the Shinn Puzzle matter, the men gave permission and must need stand for anything within reason or a bit beyond....

July 21

The day started cool and gray, a great relief from the hot days.... Lichtenstein writes that he has made arrangement for the "8" exhibition in Chicago, Detroit, Toledo and Indianapolis. And if things come right he will place them in Grand Rapids and Milwaukee, waiting to get Cincinnati and Buffalo in line first as he thinks it better to work the pictures back East and next year have the exhibition starting in the West.

July 22

Working on the "Collins" illustrations.... Dolly and I went to dinner at a new place, Sutor's, on Seventh Avenue. It is a small dining room on the second floor (and very hot this weather). The cooking is done by the proprietor and his wife, a little French woman, waits on the table. It is a fairly good dinner for the price, thirty cents with wine! Weston told us of it Monday night. After dinner we went up to call on the Laubs.

July 23

Made another Wilkie Collins drawing during the afternoon.... Dinner at home, which after all is much the best, nice chops and peas and salad. Took a walk alone in the evening as Dolly is not feeling very well. Stopped in Lucio's and bought a belt pin for Dolly's birthday present. It pleased her very much indeed....

July 24

Delivered the drawings for "Magdalen" to Mr. Train at Scribner's. Mr. Chapin is away.... Wrote to Henri in re "Eight" exhibition. Told him I'd use my judgment on prices for his pictures. Wrote Lichtenstein in re "Eight" Exhibition. In the evening started a Puzzle.

July 25

Today a welcome and unexpected visitor was James B. Moore ...
looking very well ... full of his late business failure *[but]* in right
good spirits. He says I'm to get back my $100 in about a month and
a half. ... Jerome and Mrs. *[Myers]* and the baby spent quite a while
with us in the afternoon. They say they are about ready to go back
to the country again. ... Potts called and ... was pleased with my
sketches done at Coytesville. Jim Moore tells of the fearful article
about the romantic marriage of Henri to a "comic artist" in the
Journal American of last Sunday. Ridiculous and untrue. "They met
at a Ball," his first wife's "portrait draped in black" and a lot of
absolute rot.

July 26

We are having great trouble with water. For some reason, probably
on account of the gay café which holds forth in the basement all
night and all day Sunday though it's "against the law"—we cannot
get any water for hours at a time. Today, none for about thirty
hours. I worked on my two largest Coytesville "Hudson From Pali-
sades" paintings the greater part of the day. Tired myself out, stand-
ing up. I have not worked at the easel for so long that it was
fatiguing. *[These were size 26 x 32.]*

July 27

No water this morning but I had left the spigot on in the tub so
that there was near a tubfull for emergencies. Mailed Puzzle to the
Press and took a little walk at noon time. A brilliant sunny day not
very warm. The noon hour is very interesting, crowds of men from
the big manufacturing clothiers on Fifth Avenue, girls bareheaded
strolling and buying things from the street vendors of fruits, etc.
Took down the South Beach picture started last year and worked
on it in the afternoon.

July 28

Today we hurried up to Fort Lee Ferry to meet J. Moore and go
with him to Coytesville ... lunch at Richards'. ... Left there and
came in to 42nd St. with J. B. M. *[Moore]*. Dolly and I went to
dinner at Mouquin's for a birthday treat for my little wife, then we

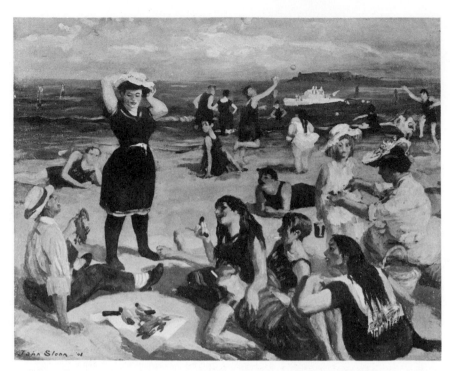

"South Beach Bathers," 1907–8

went down to Shinn's but they are away. We also went around the corner to call on the Brewers but they had retired. . . . Dad sent a box with chicken and some vegetables from Fort Washington. Nannie wrote saying that she was back home from the hospital.

July 29

Wrote to G. L. Berg, Seattle. Told him he could have "Coffee Line" and "Boy With Piccolo" for the exhibition next year, June 1909. Wrote also to Barrell giving him Henri's address in Madrid. Wrote also to Dad thanking him for the chicken, etc. and telling him that we would come to visit them next Wednesday. Started a Puzzle. Worked on the South Beach picture. . . .

July 30

Trouble with the water all day and night. Jim Moore told me to withhold the rent money and see if that would not bring the owner to look

234

out for the water supply. I painted in the afternoon on the South Beach picture, and have it now in the best shape yet. In the evening worked on Puzzle and finished it.

July 31

Rabinowitz, my Jewish paint dealer, borrowed twenty-five dollars of me today. His collections have been very slow during the summer. I feel sure he is good for the loan. Worked on the South Beach picture a little bit. . . .

August 1

Walked out 23rd St. to Harbison's Bookshop and picked up a copy of Taine's English Literature, a book that I have long wanted to read. . . . Since I have here noted the water famine, I must record that today we have had plenty.

August 2

My birthday. The first anniversary of my birth since the death of my mother. I feel in a way alone, though I saw very little of her the last six years, I usually saw her today. Dolly is my wife and mother now. I worked on the "Picture Shop" canvas started last year. *["Picture Shop Window," collection of the Newark Museum (also called "Picture Store Window").]* I got it into very good shape, I think. It seems to me a good thing.

August 5

Today we packed our grips and locked up house and traveled to Fort Washington–rather Dolly went direct, while I stopped in to see Dr. Beale (Clifford as Rupert is in Colorado on a vacation), who started in on and finished the repairs on a tooth of mine. . . . Nan is rather weak yet but her wound from the appendicitis operation is healing all nicely. Dad seemed really glad to see me, he was waiting for me at the station. Tom Daly called on us in New York in the morning. . . . Today is the anniversary of our wedding. Dad treated to a watermelon. These have been seven happy years for me.

August 6

I went in and had another tooth fixed and no more could be found so I'm through with the dentist for this year, I hope. . . . I hunted up

Tom Daly, met him at Poor Richard Club on Camac St. South. Had lunch there. Thomas Martindale, one of Philadelphia's retail grocers, is president and sat at the head of the table. . . . with T. Daly to Press, saw March and J. O. G. Duffy. On my way out Walnut Street met Reginald Kauffman. He has apartment in same building, 11th and Walnut, where he lived with his now divorced wife. She got the divorce and the custody of Hildegarde. *[Sloan did a portrait of Hildegarde in 1903.]* He is married and seems happy, tells me his wife is nineteen years old. Wrote to J. H. Gest, Cincinnati. Told him I wanted "Sixth Avenue and Thirtieth Street" sent to Chicago, not before September 1. Wrote to remind Glackens, Shinn, Luks, Prendergast, Lawson and Davies.

August 7

A showery day and though I had intended to try a sketch, I didn't. Just moped about the house all day. This seems a dull spot in the country and now that Mother's gone, I don't have the same object in coming to the Fort Washington house. My family is rather a grouchy lot "en famille," not much inclined to mutual amusement.

August 8

Went out in the morning and got at sketching. Made a fairly good go at it. Came home to lunch and eating great quantities of fresh meaty tomatoes from Dad's garden; they are fine; the lima beans are also a great treat here, so much tenderer and more tasty. In the afternoon I went out again and made two more sketches. One of them is a rattling good thing and makes me feel quite a landscape painter.

August 10

Made two sketches in the morning and am enjoying the work very much. In the afternoon went in to Philadelphia by trolley. . . .

August 11

Made two more sketches today, at the edge of a little wood not far from the house. After lunch read a very interesting book which I had started a day or two since. "The Return of the Emigrant" by a Miss Mackay. A very good thing, I think. Immediately after dinner, Dolly and I said good bye to the folks and I came home to New York. Dolly went to Philadelphia to spend a while with Nell Sloan and to later

go down to Ocean City, N.J. to visit Mrs. Montgomery. . . . A lovely night on the Hudson, full moon, slight mist. Found 165 W. 23 in good order. Thought about Dolly a great deal, how she takes care of me–everything I needed I found in my pockets–a dear little wife!

August 12

Went to Coddington's, Sixth Avenue, for breakfast, mailed letters to Dolly, the Framer and the washwoman–and started in keeping house!!! . . . The frames for the sketches came and I had a fine time trying them on different pictures. It makes some of them look splendidly to me. . . . Dinner at Coddington's. . . . Walked a while and then came home, read the Evening Sun and mailed it to Dolly.

August 13

Prendergast and Shinn sent in their lists for the Chicago exhibition. Davies called and tells me he will be ready with his list by Saturday. He approved very much of some of my sketches made this summer, a matter of great satisfaction to me for I believe Davies knows a good thing. "Cleaning house" again today. Dined at Coddington's and then walked down to Shinn's where I was pleasantly entertained. . . . Shinn showed some of the miniature stage settings he has been making. They are wonderful little things. Rocks and cliffs, lighthouse, bridges, moats and drawbridges–set in a proscenium with various lighting effects. A shop of Sixth Avenue has a "sheath gown" in the window. It was great fun to watch the different types of people who stared at it. A much talked of innovation in Paris, open to the knee. This wax figure had a queer wooden leg showing!

August 14

Mrs. Brewer called to be directed to Coytesville. Says they are both used up by the heat and want to get away for a week or two. Luks sent in his list. Prendergast sent corrected list. Started to look over my stuff for the exhibition. Think I'll take out "Movie Picture Show" and put "South Beach Bathers" in its stead. Worked at a Puzzle in the evening.

August 15

Davies sent in his list. Glackens also responded, telling me to select from his pictures at Henri's studio what I thought proper to send.

After breakfast, I went up to 135 E. 40 St. and Mrs. Lee was there. She has been staying there in H.'s absence this summer. His old mother she is, and she looks well and beautiful. She was full of "Bob's" marriage, the secrecy, and the fact that she was not told till a month after it had taken place. From his pictures I selected those to go with our exhibition to Chicago. The "Dutch Soldier" was not there and there were only two frames for the smaller Dutch heads. Glack's were all together in the storeroom. Came across a full length, not finished, of Marjory, his new wife–a very attractive girl. Mrs. Lee says it is a good likeness of her. Bought a cheap copy of "Madame Bovary" which I have never read. After dinner I came home and read some in Taine's English Literature. Dolly sent a clipping from the Philadelphia Press which gives me in a list of leading "illustrators." She tells me that *Tom Eakins* spoke *very appreciatively* of my work to Mrs. Schlichter. I like this news.

August 16

Wrote to J. H. Gest, Cincinnati Museum, to send "Dutch Soldier" *[by Henri]* to Chicago, not before September 1, not after September 5; to hold the other two which he has till Henri returns or unless otherwise instructed by Henri. In the afternoon, I went out to Crane's in Bayonne. There was a brisk breeze from south which with the clearness of the day made the Bay splendid. Sail boats and launches and the little landing place with light colored dresses all formed great material. And then Mrs. Crane showed me a little house for rent at about $18. a month!! And I pay $50. for the top floor here at 165 W. 23–and yet, I believe I and Dolly too, are really happier in the city–but on the other hand, the expense. Yet, at the end of a year, there would probably be no larger balance in the bank!! . . .

August 17

Lawson came in and said that he would need another day or two before he could send in his list. . . . Called at Scribner's and got proofs of the Collins illustrations. . . . Walked over to Everybody's. Brown was not in. Then went to see Willing at Sunday Magazine. He says he's using stuff from stock, but will probably have something for me later. Oh yes, and I'll feel that it's necessary to do another poor lot of stuff to suit. After dinner at Coddington's I went up to see Luks

and had an interesting evening though he does get tiresome. Mrs. Luks doesn't look at all well. . . . Luks has some fine pictures–"Il Pagliacci" very good, also his "Girl with Doll." A bottle of whiskey, which Luks patronized more than his guests, made him gradually maudlin. Talked of his boy "Kent" (Crane), wanted me to fix it so he could just see him; said he "would not speak to the boy" and that if I were really a "big" man I'd do it. Maybe I would–but I'm not big enough to run the risk of making the boy unhappy as well as Crane. . . .

August 18

Went to Macbeth's. Saw "Henry" and he is to send two Henris to H.'s studio tomorrow. I will probably send them to Chicago for Henri. Read "The O'Ruddy" by Stephen Crane and Robert Barr. Started by Crane who died, and Barr finished it. I think the first thirteen chapters must be Crane's part. It is fairly good that far. . . . Two post cards from Miss Pope in Spain. She says it has been warm there, 104 degrees one day. Brought "Dust Storm" from Macbeth's.

August 19

Arose very late and not feeling at all in good trim. The day is hot and oppressive. I could not apply myself to any work, just walked after breakfast and came home and sat about doing nothing. Tried to get hold of Lichtenstein on the phone for I'm anxious to know who is to collect the pictures for Chicago and when. After dinner at Coddington's, I walked out on Broadway. There was a great crowd and the summer dresses of the women make the street lit by so many electric lights, look splendid. The theatre goers were in evidence. Went in moving picture show on 23rd St. and saw a most interesting series of films taken in France, of the motor races, Dieppe Circuit. Several cars upset, men carried away on stretcher. Saw Bradley at Collier's. He says he will send me something to do as soon as anything "in my line" comes in.

August 20

. . . While up town buying bronze powder, I saw top of house at 47th and Sixth Avenue for rent, $55 a month. Eight rooms and bath with steam heat. It seems as though it would be an improvement on this place (165 W. 23), were it not so expensive to move.

August 21

At last Lichtenstein and I got together. I handed him over all the lists of pictures save Lawson's, when he came a little after noon. Luks' prices are yet to follow. Luks writes that he is in Newfoundland, New Jersey. I made a Puzzle and mailed it. In the evening, I read in Taine's English Literature and a bit in "Madame Bovary."

August 22

Dolly writes that she will be home soon. I went to Henri's studio and fixed his shadow boxes on. . . . Returning from 40th St. in the early evening, I walked over 35th St. to a Playground Park near the East River. A long row of tenements faces the square which was all gray and melancholy blue. A few children clambering about on the ladder, horizontal bars, etc. Mothers outside the high railing pushing "go carts" with babies. Over all on one end a church steeple and on the east end, the huge stacks of the Edison Power Plant, with clouds of smoke and steam. Everything seemed fine this evening, 34th St. looking west up the hill to the armory. Vendors' stands with flaring torches burning red and smoky. A fine butcher shop, not fine in quality, but in attractiveness, with big price placards and a brilliant array of vegetables under a great glare of red-yellow electric light. The gloom under the elevated structure on 34th St. at Third Avenue. After dinner I came home, but being restless, went out. Saw the flashes and reports of a pistol, Sixth Avenue and 28th Street–a man had shot another, the crowd was terrific in ten seconds.

August 23

As I expect Dolly to come home to her very lonely me tomorrow, I spent several hours today trying to make the studio and the front room look a bit cleaner. I swept and dusted and had the satisfaction of getting a good heap of dust which is always pleasing; to sweep a house and not get a good lot in the dustpan is a disappointment . . . went out in the evening and, for a change, I went to Mouquin's . . . sat with Fitzgerald and his friend, Tommy Knox. Shinn was discussed– and it amused me to hear Knox, who is a University of Dublin man, a Greek scholar, and writes for the Tobacco Trust paper, and will never cause one corner of the world to smoulder. He asks–"Does Shinn really know anything?"–We had been speaking of the wild

versatility of Shinn's accomplishments, mechanic, business man and artist. Knox meant–has he swallowed some book and knows he Greek? Walked over to Madison Square and watched the Throbbing Fountain. I am going to make a try at it tomorrow–night effect with the Metropolitan Building in the background. Came home, read some Taine's English Literature, then to bed.

August 24

... Wrote Lawson to advise where to collect his pictures for Chicago "8" exhibition. To Coddington's for dinner. Walked to 28th Street. Saw Fitzgerald in Mouquin's ... resisted the temptation to go in.

Came back and started on the "Night–Throbbing Fountain"– got it laid in. *["Throbbing Fountain, Madison Square, 1907" was followed by this night study of the same subject which intrigued Sloan so much, this one titled "Throbbing Fountain, Night."]* Walked down Broadway and looked at the Fountain again. Home and read, then to bed fairly early.

August 25

Dolly writes that she will not be home until tomorrow. I am getting desperately lonely ... expecting her each day has made me nervous and wretched. The weather today is melancholy too, a gray sky.... Went in to see Kirby and went out with him ... looked at the apartment which I had seen last week. It is rented now, so that question is settled for me. In the evening, read "Madame Bovary" and finished it. A great work indeed ... now I'll go to bed to sleep alone for the last night, I hope.

August 26

Dolly arrived home about 3 o'clock and we were mutually glad to have each other again. We celebrated our "reunion" by having dinner at Mouquin's. There we saw W. S. Walsh and Johnston of the World.

August 27

Dolly went out to see Mrs. Lee at Henri's studio. Lichtenstein called and together we went out to see if we could find where Lawson's pictures were to be collected. Found them at *[Walt]* Kuhn's studio, 120 E. 23rd Street, then we came down 24th St. and met

Lawson himself and arranged for him to deliver the pictures Saturday, 11 A.M., to the Artists Packing & Shipping Co. My paintings left today. Henri's and Glack's were collected at H.'s studio. Lichtenstein wrote Luks to come to town tomorrow and deliver his to the A.P. & S. Co. So I think we can feel that the exhibition has about started its travels. Dolly made a good spaghetti for our dinner at home....

August 28

Working on the "Throbbing Fountain, Night" a short while today. In the afternoon, I took my sketch box and, with much dread of what might happen, I walked down to the 22nd St. pier of the Coney Island boats and, after loitering about screwing up my courage, I finally got to work. Sat on the string piece and made a sketch of a group of men and boys fishing from a float. The season has been a very good one for what they call "Lafayettes," a small fish, of which I saw several very good "strings." I was, in a moment, the center of a great crowd of boys, etc. "Give us that, Mister?" said one with proper audacity. I explained that while this is a "rough sketch" I earned my living by my work in this way. The "rough sketch" game was a good one; it explained the shortcomings to their minds and they seemed disposed to "give him a chance." About 4:30 I left with a huge sense of achievement in having made a sketch in the face of a mob's criticism.

August 29

Lichtenstein came in to tell me that Lawson had not yet handed over his paintings for the Western exhibits. We talked over the necessity of having some photographs of the pictures made in case western newspapers should desire to illustrate articles. I worked some on "Throbbing Fountain, Night." Dolly and I went to Carlos' on 24th St. to dinner....

August 31

Walked up town after mailing Puzzle, to see Davies. I told him to have a dozen prints made from any photo negatives that he might choose, to send them to Lichtenstein. After lunch I made a few prints from two of my own negatives. I'm a poor printer of photos; it tires me out and I get very poor results.... Rabinowitz called and offered

to return the $25. I had loaned him but I said he could hold it another month....

September 1

Had a telegram from Press. Puzzle had not arrived. So I had to start right in on a new one.... Finished a Puzzle in the evening.... Went out this morning to Central Park intending to get a "permit" and sketch. I found that it was necessary to apply in writing for "permits," so walked up to the Metropolitan Museum of Art. I notice that many of the paintings formerly ascribed to certain masters are now bearing labels, "School of Rembrandt" instead of by Rembrandt, John Constable, etc. I found it rather a blow to discover such changes, a severe shock and, in some cases, it was strange how much it seemed to hurt that painting in my inward estimation of it. Such is Fame!

September 2

...I was busy making proofs from some of my negatives of pictures and from the "Spanish Gypsy" of Henri's.... Walked up to Broadway Magazine, hoping to see Miss Marshall—was told that the art editor was named Plummer. Stopped in at the Metropolitan Magazine and got a frosty reception....

September 3

Ullman phoned this morning and came to lunch. He's looking well, has been doing some work for the Taft Organization in politics.... Made some more prints of the Henri "Spanish Gypsy" plate.... Everett Shinn and Mrs. S. came to dine with us. Dolly had cooked a notable steak with Bordelaise mushrooms, elegant. It made a hit with Shinn. After dinner we amused Shinn by showing him the Fuch's Caricature Volumes....

September 4

I took Henri's photos and my own around to Lichtenstein's office but as he is away to return Tuesday, I expressed them to W. M. R. French, of the Chicago Institute.

September 5

Today I went down to Bloomfield Street Wharf and made two small sketches. I enjoyed the experience very much. Got along with the

crowd very well and made rather good things. Talking to one or two of the loiterers, one young fellow who had been asking the mate of the "Thomas Jones" to let him work his way to Albany, refused. When I parted with him, I offered him ten cents which he accepted with "Yer not robbin yerself are ye?"–not in sarcasm! Walking home on Eighth Avenue I saw an "arrest." Two policemen had a big dark skinned fellow in soft wide hat, one had either wrist nippered. Something he said, apparently, angered one of the "cops." He stopped, turned and with brutal deliberation planted a blow with his white gloved hand square between the poor big "drunk's" eyes–both wrists held, mind you!! I felt mad enough to go along and report it, but I didn't. Dinner at home–Dolly was waiting on me.

September 6

A rainy day. I went out and got the newspapers. The Metropolitan Building Tower really looks high in this weather. Its top was lost in the rain clouds drifting over Madison Square. In the evening, I started to make a plate of a copyist at work in the Metropolitan Museum of Art, crowd around as it is a sheep picture which the lay copyist is "takin' off." Made preliminary drawing on tissue paper and grounded my plate and got the red chalk tracing sketches on the ground.

September 7

Today Dolly and I both felt in the humor to go out to Crane's. I took my sketch box. . . . Mrs. C. gave me a fine bit of pumpkin pie in place of lunch. Crane and I went down near the shore and I made a sketch. The Bay (New York Bay) was beautiful. There are many many more things to be done here. Toward evening the bay becomes still more paintable. The little boats at anchor and yachts and launches sailing by, the water deep blue and people in the boats in white with orange complexions, lit by the sun. . . .

September 8

Today Kirby came in about noon and as he was in a run away from work mood, we went together to sketch over in Flushing. By the time we got over there, he got his paints and we reached the creek, it was 3 o'clock. Made a sketch, rather too picturesque a theme, I'm afraid . . . arrived back at 7 o'clock. Dolly in short order produced a

244

good dinner. In the evening, I started to "needle in" the "Sheep Picture" or "Copyist at work in the Metropolitan" which I drew last Sunday night.

September 9

I decided to go out in search of work today, so with my packet of proofs under arm, I went first to F. Stokes where a young Mr. O'Connor treated me decently but told me that I'd best see Mr. Stokes who was, at present, away. Went to McClure's, then to see Willing at the Associated Sunday Magazine. He was affable and talked but no work was produced. From there I went to 17th St. and for the first time went into Baker, Taylor Co. Here I talked with a Mr. Hackett, a fine young fellow, fond of prints, etc. He did me the honor of asking me if I'd sometime take lunch with him. Says he wants to buy a set of my N.Y. etchings. I told him of the number of Daumier's lithographs I have, and invited him to call at the studio. Altogether I am much taken with him. Went to the Century where Miss Jackson was very kindly. Asked me to tell her where a young man should study art in N.Y. I told her "with Henri, none other." Called at Everybody's, saw young Mr. Campbell, Brown was away. Then to Bobbs, Merrill where Mr. Baker was decent but the work they produce is of an awful popular grade. Came home rather blue–the usual effect of these trips on me. Mr. Hackett is the bright spot of the day.

September 11

Ullman came in today. Fat and cheerful as usual. Mrs. Lee also called. . . . The Cranes came to dinner with us. Dolly had some fine spaghetti and then we went to the next corner (Eighth Avenue) and, at the Grand Opera House, we saw Rose Stahl in the "Chorus Lady." Very good though not an improvement over the twenty minute vaudeville sketch which she originally had. She's a very fine character actress, but the play has a lot of ordinary sentimentality added. To Mouquin's and then to a Chinese restaurant with Cranes.

September 12

Worked on the plate today. A letter from Henri, written by Mrs. Marjorie Henri:

SEPTEMBER 3, 1908

Dear Sloans–

Just to dash off a line to you–the name on this paper does not count because we are in Madrid, and I haven't changed my style of handwriting, because this is Marjorie, who is doing the dashing off for me. In a letter from the Missus, she told me of your getting pictures for the show, although I did not get a very good idea of what you selected–Hope it was quality rather than quantity.

Too bad there was not more to select from here. The work I have done has been done lately or, rather is being done. So far, of importance, full length of a Picador, 3 full length dancers, a few small things–had a cold for awhile, and did little then, and the material was hard to get a start with, will probably have the pictures in New York some time in November, some of them may be before–will arrange for more rapid transit than on the previous occasion–we are enjoying the trip and have had little time to write–class over now–excellent work–we will stay here some time yet–have not fixed dates. Was glad to get your letter and know that you'd been to the country, and that you had work on hand–will write again, expect to have more time now that the class is over–

Best wishes to you both from us both–

YOURS–

Robert Henri

September 13

Today we rose at 9 . . . walked to 34th St. ferry and in Long Island City we took the trolley car to Flushing where we took dinner with Kirbys. After dinner Kirby and I walked out and made a sketch under the most terrific circumstantial discomfort in the way of mosquitos. They almost "ate me up." But I stuck at the job which is not very much of a success after all. . . .

September 14

Printing proof of the "Copyist" plate today–which is overbitten and, I'm afraid, will not turn out much of a success. I worked with the etching press all afternoon. Dolly had gone up to Mrs. Lee (at Henri's studio). In the evening, I took up the plate again and worked all over it. I sat up working till 4 A.M. which is not the best thing for my health, I'm sure. *[Sloan liked to etch at night when it was quiet,*

*without interruption. He liked a small room or cozy corner for this
kind of work. "It reminds me of my days in the first little studio at
705 Walnut St. It was so small I could touch each wall with my
hand when sitting at the table." Sloan kept the old working table from
those first days and it is now in the John Sloan Collection at the
Delaware Art Center, Wilmington.]*

September 15

Up at 11 o'clock and worked at the plate again and in the afternoon
made proofs of the second state. Not a good plate.... Dolly was up
to sew with Mrs. Lee again this afternoon.... A little bit in the
"blues" tonight, no work coming in–and the plate so unsatisfactory.
Still I work to please myself, which perforce makes it hard sometimes
to get the "coin" from the world.

September 16

Took to the "road" again today. Walked down through Macdougal
Street and Sullivan Street which, in spite of their Celtic names, are
principally inhabited by Italians.... I was at last able to see Russell,
once of McClure's, now on the Delineator. He gave me no encour-
agement. Said my work was probably too artistic for the readers!
It's wonderful how these young men know the great public's pulse!!
Amazing! Macmillan's next. Mr. Walton was too busy to see me,
told me to come in the morning. Then, with no hope, I went in to
Scribner's and behold! He gave me a story–Jim Preston was too busy
to do it and as I happened along, I got it. It is "Countess Anne's
Confession" and is, by the way, by Thornton Hardy's father, Arthur
Sherburne Hardy. Dolly and I went to dinner at the Carlos table
d'hôte to celebrate the event and as she was tired, having put up 22
jars of peach jam for my use and abuse this winter. Started on
sketches after we came home.

September 17

Up early after a restless night as I am a little uncertain as to my
ability to please Chapin on the drawings which are to be done in a
decorative style. Made some rough ideas which I took over for him
to approve. When I saw him at 4 o'clock, he said go ahead. $200, the
price I named, suited him so quickly that I had that feeling which
occurs now and then in a bargaining–"I've charged too little." Still,

it's enough. After dinner I started to get out a Puzzle as that will have to be done before I can get at the story, and it went hard with me. When I have other work, I hate the Puzzles.

September 18

Dolly feeling rather poorly, stayed in bed, and I painfully produced a small untidy breakfast. Finished up a Puzzle. . . . Dolly was up and made dinner, after which we went over to the moving pictures show. "The Devil," a long film which is perhaps taken from the Savage production of that title now running. Very poor it seemed to me. George Arliss is also playing the show at the Belasco, but Kirby says that even he is not good enough to make the play worth seeing.

September 21

Walked out . . . went on down and trotted about through Greenwich Village. With an eye open for apartments to rent. Of such signs I saw plenty but none that would tempt me to move. Went in to an old house on Grove Street near Bleecker, once a "magnificent" dwelling or Club. Rooms are large but all so melancholy and the back north light is almost cut off. Home, to feel quite contented with my present location. In fact, I have always been, save that I would like to find a steam heated place of equal size at the same price. Worked on Scribner drawing in the evening.

September 22

Henri sends me a post card with a Goya painting reproduced. Says that he longs for some good New York food. Kirby brought in a Mr. Hopper who writes for Collier's . . . very pleasant and appreciative of some of my pictures. Finished up two Scribner drawings. . . .

September 23

In writing in the two previous days, I have made the mistake of leaving out Monday. I have written Tuesday under Monday and Wednesday's events under Tuesday. I can't remember what was specially notable about Monday, so with this comment we will close the incident. After all one day is not much to lose, especially after it is past. *[September 23, 1908 was Wednesday.]*

248

September 24

By a remark of Kirby's this morning I found that today was Thursday. I had been a day behind in my own ideas as to time's flight . . . walked down to Tompkins Square and vicinity, coming back to Stuyvesant Square and Gramercy Square (Park). New York is just now having Pittsburgh atmosphere. For more than a week the air has been thick with fog or smoke or both. They say it is from the great number of forest fires which are burning owing to the dry season we have had. It makes the color of the city quite different. 'Tis interesting, but I can't say I like it as well as the regular bracing New York air. After dinner, and experimenting with a new sock darning attachment for sewing machine which I bought this afternoon, and which is an indifferent success, I started a drawing which was about finished when I went to bed.

September 25

Worked on Scribner drawings, finishing one in the forepart of the day. Then Dolly and I, for exercise, walked out about 5:30 P.M. across to Third Avenue and 8th Street. By this time we formed the idea that it might be nice to have dinner at Renganeschi's on West 10th Street so we turned that way. Renganeschi has torn out and refitted his place, throwing the whole parlor floor into one large room. Quite an improvement in a business way. . . . Walked home and I got exceedingly busy and made two more drawings for the Scribner story.

September 26

Out for a walk and met Kent (Luks) who was doing some shopping for his mother Mrs. Crane, and was in search of a half pint bottle of ink for Frank Crane. We walked together as far east as Fourth Avenue and then all the way down Broadway asking for the ink in every stationery store we found open. For today is a Jewish holiday, which in New York City comes near closing up the business of the city. Finally we found the drawing ink and, after treating him to lunch, I left him. . . . Walked all the way home, stopping to look at an apartment to let on Grove Street. Rather good. Come home and Dolly and I went down to look at it. It has many facilities, steam heat, dumbwaiter, etc. which our present garret lacks, but there is not much light in the rear rooms. Quite dismal, in fact. Our present

place is very cheerful. After dinner at home, I made another Scribner decoration.

September 27

A day with Sunshine, the first for some time. . . . Dolly and I walked down to South Washington Square, having seen an apartment to rent advertisement in the paper. We did not get in to see it as the tenants were not moved out . . . walked about looking at "to let" signs, finally came home after going to a moving picture show across the way. . . .

September 28

Before delivering Scribner drawings, I took them down to Collier's and showed them to Bradley. He was immensely pleased with them, so much so that tomorrow I am to go and get something from him to illustrate. Chapin at Scribner's was satisfied with the drawings and said he was much obliged for prompt execution of the work. . . . After dinner we went up to the Laubs'. His old mother is visiting them and is working on a painting. Her case is curious, she started to "paint in oils" in her old age about four years ago and it now occupies her whole time–making copies of colored prints and adapting a thing here and there. She has scarce any interest in anything else. A seafaring man, engineer, Haig was calling on them. The talk turned on flying machines, the current experiments of the Wright Brothers and Count Zeppelin and numerous others occupy much space in the newspapers. 'Twill be many many years before any transportation is done by the aeroplane, I think.

September 29

Today I walked out in search of the Hispano-American Museum. At the alleged Bureau of Information of the N.Y. Herald, I was told that it was at 80th and Central Park West. So uptown I walked. There, on inquiring in the Museum of Natural History, I was told to go to 160th West. I rode up by subway and at 160th was told by a letter carrier that it was at 155th St. It was on 156th, at least the main entrance was on that side. I was much interested in the Goya paintings, a full length of the Duchess of Alba with the painter's name marked in the sand at her feet. Another beautiful canvas is a half length portrait of General Forastero, a fine work, splendid head, beautiful red lapels on coat. There is an alleged Velásquez, a head

and shoulders portrait of a cardinal. If he did it, it doesn't show him at all near his best. An interesting portrait of Anna de Mendoza, artist unknown. Called on Bradley at Collier's but he was not ready to hand over the material...walked over the partly completed esplanade over the river uptown. This will be a fine walk when completed, a series of terraces on the rather steep descent to the Hudson at Washington Heights.

September 30

Glackens came in today. He has just returned from Cape Cod, looking brown as a sailor. He has received an astonishing letter from French of the Chicago Institute which says that Lichtenstein sent them a check in the matter of "collection" of paintings by the "Eight" which was protested. I can't understand this for C. B. L. told me that the various museums were to pay all expenses. Glack left me the letter and I went over to see Lichtenstein. He was out so I left a note, asking in a vague way what was "up." Called Bradley on phone but he is still not ready to start me on the Collier article on "Melodrama."...Took dinner with Shinns...in his studio which he has built in the yard back of the little house on Waverly Place (112). Glackens and Mrs. G. came in later.... Shinn is still making scene settings in miniature, and practicing piano playing and painting and experimenting with a small model of an aeroplane and Lord knows what besides.

October 1

Ouderdouk, who invites pictures for the Dallas State Fair Exhibition, interrupted me today in the exciting job of putting up a stove pipe. He invited "Hildegarde" Kauffman's portrait, which I painted about five years ago and have never exhibited, the "Coffee Line" and a small sketch, "Flushing, Canal Boats." After dinner I called up Lichtenstein on the phone as I have not heard from him in regard to the Chicago affair. He was not at home, however, so my mind is still uneasy.

October 3

At noon called Lichtenstein's office. He had gone out. Left me a note in which he says that the exhibition will go all right, that Buffalo wants it, and enclosing a letter from McGuire of Corcoran Gallery

who says he'd like one picture from each man "provided it was really representative." I wrote L. to tell him to send him 8 invitations and say that he would guarantee a good one in each case.... Mailed a Puzzle (registered). Dolly and I went to the 29th St. "Caveau de Paris" and had a very good dinner. This is the best table d'hôte we have found in the city.

October 5

Mr. Oscar Von Gottschalk, a friend of Jerome Myers, called and looked at some of my etchings. Liked them very much and said that he wanted me to illustrate a story for the American Press Association of which he is art manager–"The Yellow Room."

October 6

Mr. Von Gottschalk called again and brought "The Yellow Room" which is a French detective story. He wants ten drawings $200. and must have them in two and a half weeks so I'll have to rush. Bradley sent by mail the humorous Pirate Story for me to read over. He is to plan out the arrangement of drawings and see me later. Started a Puzzle in the evening.

October 7

Finished up Puzzle and made another during the day and evening. This evening, just before we had our dinner, a woman was hit by a street car in front of our place. A great crowd gathered as it was just a little after 6:30. The ambulance came, we looked right down on the whole thing from our windows. It was very interesting and impressive. She died after they got her to the hospital, we heard afterwards....

October 9

I delivered to the Artists Packing & Shipping Co. for the Fellowship Exhibit "Portrait of a Man," "Goldfish," "Evening 27th Street" and "Ping Pong Photos" (lithographs). Also Glackens' "Bull Fight" and Jerome Myers' "Little Picnic." In the evening we dined at the Cranes' in Bayonne–as is most usually the case there we had too much to drink, this time, just before and during dinner, so that we sat down to play hearts in a very quarrelsome mood. Got up from the game in no better frame of mind and carried it by train and ferry

reaching home and bed without having in any way dulled its glittering nastiness. Poor children and fools that we are. But all the rest of the world, drunk or sober, are as bad, so what of it?

October 10

Today, Miss Niles, who has just returned from Spain, came in and gave us the first account of the doings of the N.Y. School class and Henri and particularly of the New Mrs. H. It will be best not to give any detail of Miss N.'s impressions of Mrs. Henri, to wait will be best and form some for myself. He will be back soon, at any rate in a few weeks. . . .

October 11

Mrs. E. W. Davis, whom we have not seen for months, called this afternoon and we prevailed on her to stay to have dinner with us. . . . Today I finally got at a drawing for the American Press story. In the evening, I had a desperate attack of nervous "inability" I'll call it for lack of a better word—just seemed incompetent to draw anything. I suppose it's the modern and American trouble, "neurasthenia." I don't care for the sample. . . .

October 12

Having arranged a bin to hold a half ton of coal, I got my little Italian dealer around the corner to deliver eleven 100 pound bags for $4.00. This will, I hope, prove a cheaper way of buying than three small bags for $1.00 system. Ullman called and amused us for an hour. . . . Miss Niles dropped in to show us some copies which she had made the Prado, Madrid, from Velásquez—and very interesting to me, never having seen the originals. She again, most cordially, invited us to come out and see her this winter.

October 13

G. L. Berg of Seattle . . . paid me a visit of a couple of hours today. . . . He is getting up an exhibition for Seattle in June, 1909. His judgment about pictures is very good in a general way though the money value of certain foreign works has somewhat deceived him in his estimation of their merit. Note from Lichtenstein says they are living at Valhalla on the New York Central and inviting us out for Sunday, but I asked him to postpone it to Sunday week as I am

busy on the "Yellow Room" drawings. Miss Pope came in toward dusk. She returned last week, looks well and, according to Miss Niles, has reconciled herself completely to new conditions [*Henri's marriage*]. After dinner worked on drawing.

October 15

Worked on "Yellow Room" drawings. Dolly stayed in bed half the day and, as she was not feeling well, we went to the "Caveau" to dine. Saw Walsh there. On the way back bought Dolly a new hat which we saw in a window on 23rd St.

October 16

Saw Lichtenstein and told him to write McGuire of Corcoran Gallery that Henri would be back about November 1 and would send in an entry about that date. With Kirby to Brentano's. . . . I bought a small booklet on Watteau. Most surprising thing to find it on sale in this so very careful and refined community! It has a reproduction of Watteau's beautiful picture "Le Faux Pas" and one other of his "Champêtre" things that contains similar incident. Jerome Myers and Mrs. called. They have taken a flat on West 175th Street. Von Gottschalk also came in to see how I am progressing with the drawings. . . .

October 17

Von Gottschalk called . . . asked me to make drawings lighter as their engravers found they would blur in reproduction. This is all rot, of course–merely the old idea of making the artist work to suit the mechanic instead of the mechanic to suit the artist. Note from Bradley to call, so I went down but he said he was too busy to see me. Call Monday. Joe Laub and Mrs., with his Mother, called in the evening, and I got out a number of pictures to show to the "little Mother." She was much interested and it was very curious to hear her talk comparing her work.–She is so wrapped up in this occupation, found in her old age after a life of housework. One thing she said, "I have one picture with fifty trees in it." She is so serene in her belief in her work–quite envy her. Walter Pach returned from France where he has been for more than a year. Wants some photos and three etchings for an article which he is writing for a Paris art journal.

254

October 18

Made two drawings today for the "Yellow Room" story. I don't feel at all pleased with this series, but excuse myself on account of Von Gottschalk's having come in after the first two to tell me to "keep them lighter." The Press (Philadelphia) has a critique of the Fellowship show. I come in for first notice though not particularly favorable. Old Talcott Williams doesn't see the W. S. Walsh *[Portrait]* in a very favorable light, I'm afraid. I know it is a very good thing nevertheless.

October 20

Delivered drawings to Von Gottschalk of American Press Association. He seems to be pretty well satisfied with them. Dolly and I took dinner at the Caveau de Paris, a very good dinner as is usual there. "Billy" Walsh was there with Roper, the Englishman, and a Mr. Hart whom Dolly and I have often seen there before and, on account of a slight resemblance, have called Tommy Anshutz. Walsh tells me he is celebrating the occasion of not being "fired" from the Herald. . . . A bottle of champagne marked the occasion and the waiter let us in on it by Mr. Walsh's direction. . . .

October 22

Made a trip to the American Press Association to convince Von Gottschalk that I was right in my representation of one of the characters in the "Yellow Room." We had quite an interesting talk and he took me to lunch with him . . . invited Von G. to lunch on Thursday next. Dropped in and saw Bradley at Collier's and succeeded in getting the plan of illustrations for "Mehitabel" at last. In the evening, after a good spaghetti dinner at home, I started on the first drawing.

October 24

Miss Lawrence made us her "annual visit" . . . kept things lively . . . trimmed a hat for Dolly and darned a lot of socks. . . . Thought Mrs. Ullman very pretty. I took the three out to dinner at the Caveau de Paris. . . . The ladies then went to a moving picture show while I came home and worked on Collier drawing. Found a copy of Schopenhauer in the Air and other stories by Sadakichi Hartmann in

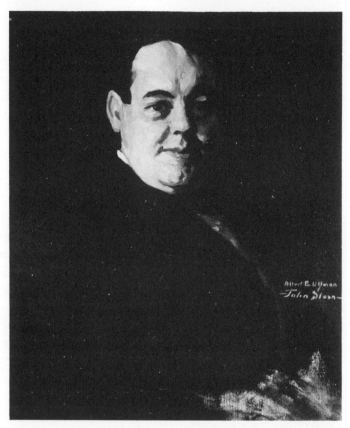

"Albert E. Ullman," 1907–1908

the letter box today.... The artists most of them are proud and feel that they have taken a lofty flight into the higher realms of glorious "Art" when they paint a nude woman. A picture that could only inspire lust in a perverted mind so little is there of humanity in it.

October 26

Working on the Collier drawings pretty much all day, as I am trying to get a sort of wood cut effect I am having plenty of trouble over them. Ullman called while Dolly and Mrs. U. were out shopping.... Then Dolly phoned Mrs. Lee and, with tickets furnished by Ullman, the three ladies went to a political meeting of Italian Americans at Palm Garden where, after a long wait until 1 o'clock A.M., Bryan, the Democratic nominee for President, made an address. Dolly and Mrs.

U. came back at two o'clock full of politics. She could hardly go to sleep so much excited she was and so full of Democratic principles. I guess that any indecision I may have had as to my ticket is quite removed.

October 27

Took my first two drawings over to Collier's and Bradley and I held a "consultation" over them. Tom Daly dropped in. He tells me that John Lane's manager wants to see the stuff for his next book of verse before any other publisher is decided on.... Jerome Myers called. He says that they like their little flat on 175th St. very well....

October 28

Today a phone call came to which Dolly responded–Henri at the other end of the wire–says he arrived yesterday and asked us to come up tomorrow afternoon to see him and Mrs. Marjory Henri. Ullman called again this afternoon to find out if I would go to the Taft Republican meeting at Madison Square Garden for which he had kindly procured us tickets. Working all evening, though I took a little "sprint" to get some fresh air.

October 29

Von Gottschalk took lunch with us today.... In the afternoon at five o'clock, we went to Henri's–and at last, after all these weeks of wondering what she was like, we saw the new wife, Marjory. Well she is attractive–not very beautiful to me but very ingenuous apparently, and she seems inclined to be friendly to us. She seems a very great contrast to Linda Henri in every way. Henri showed some of the things he painted–a full length laughing Spanish girl of low dancing type I imagine–a very good thing. A head and shoulders of a picador is very splendid. Miss Pope was in attendance and Mrs. Lee is about to move to the Martha Washington Hotel....

October 30

Went up to the Lenox Library and looked over a number of Bewick books to help me in my Collier drawings which I am trying to make look as much as possible like free wood engravings. These old vignettes of Bewick are beautiful things, full of humor and "great" art ...sent a check to Lauriat & Co., Boston for a couple of books on

Bewick and a life of Charles Keene. Worked the rest of the day and till near two o'clock A.M. on the Collier drawings.

October 31

Took four out of the five drawings to Collier's and Bradley was much pleased with them, so much so that he says when I deliver the final one on Monday, I am to take another story to do in the same "woodcut" manner. . . . In the evening I started the last of the "Mehitabel" drawings for Collier's.

November 1

Worked all afternoon and evening on the drawing started last night. . . . I wonder if I have a real sense of humor myself–this diary writing which I have done for three years now would seem to disprove it.

November 2

Today I delivered the last of the Collier drawings and he seems to be very much pleased with them. He gave me an order for head and tail pieces for an article on Lincoln-Douglas debates. The books on Bewick arrived from Boston and proved right satisfactory. The Chas. Keene book is a fine piece of book making, one of a limited edition of 250 copies, and it looks as though it would be interesting to read. Henri and Mrs. H. called. . . . He was most pleased with my two large ("Coytesville on the Palisades") landscapes and the small ones also interested him. He rather gave me a shock by saying that I am looking very much out of condition physically–that I might get out of town for a year and do landscape to the bettering of my health. But unfortunately I am not rich enough to do this, nor do I concede that I am such a serious case. . . . Decided to accept Henri's invitation to dine at the Caveau de Paris, 29th St. Henri spoke of the strange freaks of the Salon d'Automne in Paris, says that the Eight exhibition was much more notable.

November 3

Today I colored up proofs of four of the Collier "Mehitabel" drawings, used a tint wood block effect in handling. Henri and Mrs. H. dined with us tonight. . . . Outside on 23rd St. the din of the thoughtless celebrating "Election Night" filled the air and penetrated our walls. Henri and I walked out a few minutes to buy cigarettes for

258

Mrs. H. . . . Bryan is defeated for the third time in his attempt to be President. I voted for him for I feel that some stop must be put to the rottenness in the Republican administration. But, as usual, I'm on the losing side. "Bill" Taft, a jolly looking fat man designated by Roosevelt as his successor, gets the office–and the cancerous growth is to have four more years. I'm not a Democrat, I am of no party. I'm for change–for the operating knife when a party rots in power. I am certainly ashamed of the cowardice of the American voters. And Mrs. H. does not seem to show any hopeful signs on second meeting. I can not see what intellectual help she could be, nor economical household assistance–nor can I even feel that she is beautiful as an ornament. . . .

November 4

After coloring up the last proof of the drawings for Collier I took them down to Bradley and they made an increased "hit" with him. But the wood tint block effect, which he was charmed with, puzzled the engraving people, Walker & Co., so that I had to go over and work all afternoon on the zinc cuts. I drew with transparent ink on the zinc, made three of the tint blocks myself. Worked all afternoon on these. I rather enjoyed the experience of working with the men in the art department. Met a man named Westfall who had worked under Daecke (the German color tint man of the Philadelphia Press to whom I handed over the lease of old "806" Walnut St. in Philadelphia when I gave it up to come to New York in 1904). Miss Pope called at 6:30 to take us out to dine at the "Caveau." Dolly met us there, for she had been with Mrs. Luks at Hammerstein's Theatre. Mrs. Brewer (Bessie Marsh, she was) and Mr. Brewer met us there . . . a right pleasant time. Brewer treated us to a fine ride through the Park and back by Riverside Drive in a hustling little "Taxicab." It was my first ride in this very popular conveyance and, though the present chauffeurs are strike breakers or "scabs," vulgarly, we met with no accident nor murderous assault by strikers. Such have occurred each day since the strike was declared. . . .

November 5

I got up at 7 o'clock and went over to the Walker Engraving Co. to finish the last of the tint plates. Worked till noon. There is a fine view of the East River from the roof of this six story building on 25th

St. This is not high for New York and it is really more possible to paint at this height where the "bird's eye" doesn't enter into it. Dolly is sick today from last night's good time, so I had dinner alone at the Caveau....

November 6

Ullman came in and had need of a loan of $20 which I had offered him before so today gave him a check.... Went up town to the office of the Taxicab Co. to see if I could get track of Dolly's purse with keys which she lost on Wednesday night, but I was not successful. ...At six o'clock we went down to Waverly Pl. and had dinner with the Brewers. Miss Pope was there.... They are a very nice couple. He has seen a great deal of the world though quite a young man. In regard to the election, I notice that Taft has sent a note of congratulation to some Labor organization, patting them on the back for asserting their manhood and not allowing the President of the American Federation of Labor (Mr. Gompers) to hand over the united labor vote to Bryan. The newspapers take the same tone and did so before the election, of course. Fool! Not to see that united they would be a terrific power to be reckoned with. What if Gompers had some selfish motive? The change would have come! Labor Unions should pick a party and deliver their vote united.

November 7

Dolly went down to see how Mrs. Brewer was and found her much improved. Mrs. Luks phoned asking Dolly to go to the theatre with her and her sister, Mrs. Frankenburg...afterward went to Mrs. F.'s apartment. Frankenburg is a successful lawyer. They pay $3500 a year rent and have a "swell" menage. Dolly says many of Luks' paintings are on the walls. Mrs. Luks phoned me to come to dinner.... Luks was in right entertaining form. Played the mouth organ and sang–his own praises.

November 8

Quietly at home today–and am trying to fight off a cold, grippe perhaps, which I dread. Wrote Miss Parker, Greenwich, Conn. that the Kansas, Nebraska Art Association could have my "Haymarket" for exhibition. The Philadelphia Press has a warm note of praise from one of the admirers of my Puzzle Series which appears each Sunday.

260

I finished up a Puzzle today and have it ready to mail tomorrow. Wrote to March of the Press telling him to watch the Puzzle answers more carefully as printed. They have lately been full of typographical and other stupid mistakes.

November 9

. . . Walked down town and covered quite a distance looking for a brush store as Dolly needs a new floor brush for her house cleaning which is to begin tomorrow. Mrs. Ullman came in the afternoon and sat with Dolly. She has decided that she would like to live in the front rooms below us here. . . . Ullman came later and agreed with her on taking the rooms so we will have them as neighbors. The Ullmans stayed to dinner. . . . I worked on Lincoln-Douglas head and tail pieces. . . .

November 10

Took pencil sketches on head and tail pieces to Bradley at Collier's and he approved them. We went down to the press room and watched the "Mehitabel" drawings being rolled out through the presses at the rate of 20,000 per hour in color. I then went to a bookbinder on 26th Street and ordered three scrapbooks to keep my Puzzles from the Press in ($4.50). *[The original drawings remained with the newspaper.]* Ullman moved in this afternoon . . . we all had dinner together in our place. . . . Telegram from March of the Press asks for a new Puzzle, something simple. "Letter to follow," so I made a Puzzle after dinner, worked till one o'clock on it.

November 11

March's letter arrived this morning. They are going to give two hundred prizes each Sunday for five weeks so want me to make familiar subject and rather easy. His letter is sweet as honey in spite of my scolding note of Sunday evening. Made a Puzzle tonight.

November 13

Kirby came in and showed me a pamphlet got up by a man named Chaffee in praise and explanation of his water colored photographs. It was a very absurd thing. I suggested that Kirby send it to Fitzgerald on the Evening Sun, that he might have a little fun with it. We had Mr. and Mrs. Brewer, Miss Pope and Miss Nitsky to dinner. . . .

Dolly got up a fine spread, spaghetti, roast lamb, salad, beer, etc. . . . Brewer tells me that he is convinced that inside of ten years compulsory temperance or rather complete prohibition will be in force over the whole United States. He is working against it for the Brewers Association, but he says it is bound to come. That the Distillers and Brewers are too short sighted to remove all objectionable saloons as they could do by refusing to supply them. Mrs. Brewer was entertaining, telling us of some of the actresses she had met in connection with her poster work. Loaned Miss Pope two volumes of Zola. (Taking Miss Pope home, I saw a blithe perhaps bibulous girl, lifts her skirts and leaps a street hydrant on gloomy 24th St.)

November 14

Went to the binders and got my scrapbooks. He made them an inch and a half shorter than I had ordered which was disappointing but I foolishly took them and paid for them! Letter from my father with a clipping from the Philadelphia Stock Market reports where "Railways General" is quoted at about $8 per share. I have had 50 shares . . . for years, bought at about $6. This is the first time there has been an appreciable rise in all the years I've had it and I can't make up my mind whether to sell or not. *[This was Sloan's only venture in the stock market and this stock was kept until his death when the company no longer existed.]* Henri accompanied by Mrs. H. and in the midst of the first snowfall of the season called this evening. A bad night, as the snow is mixed with rain and the pavements have two inches of slush on them. Mrs. H. in low slippers, and consequently hoarse before eleven o'clock. Henri, though he doesn't say it, feels that some of the crowd are not calling on him since his return. He should not expect this formality when he married with positively no notice or subsequent announcement.

November 15

Ullman and I walked out to buy the Sunday papers, taking a short walk afterward. The Sunday Press offers 200 prizes (jigsaw puzzle pictures) for the best answers to my Puzzle today.

November 16

As soon as breakfast was over, and the stove and open grate fires had my ministrations, I went with my scrapbooks under arm to see what

I could do with the binder in regard to making new ones in more strict accord with my measurements. He was fairly decent about it and so was I. . . . He is to make three new ones for an additional charge of $3. I am to keep the failures. Saw Lichtenstein and showed him both of French (Chicago Institute) letters to Glackens. He said that he did not know of his (C. B. L.) check being returned to French "N.G."—that he had split the charges among the institutions who were to get the exhibition ($18.91 a piece) and had sent French his own check and had been receiving checks from the different institutes to pay their share. We had a long friendly chat. He has voted the Socialist ticket this year. Dolly, Mrs. Ullman and I got at the Ullmans' floor and gave it a coat of stain and varnish. It looks much better. In the evening and not until then, I got under way and worked on the second Lincoln drawing for Collier's. Fitzgerald editorial inspired by the booklet Kirby sent him—appeared tonight. It was quite clever and amusing.

November 17

"Dropped up" to see Kirby and looked through some of his English Illustrators of the "Sixties." Fred Walker, Millais, who afterward went to pot as a painter. A right notable and really English period in English art which today cuts no figure whatever. Lawless is one of the very good ones in the group. . . . Finished the Collier drawings before going to bed at two A.M. It's curious how several times lately I have had such a strong sense of the loss of my mother, though she's been dead now for fifteen months, I seem to realize it more than ever. My heart seems to take little flights to her room with the sunlight streaming in the windows—seeks her in vain, then returns to me with an ache. It probably did the same with different result in unconscious comfort while she was alive. Not till she died and some time after have I come to know that these journeys were made.

November 18

Delivered the Lincoln-Douglas Debate drawings to Collier's. Bradley was very much pleased with them. He said if he were a publisher, he would certainly have me do a whole book, which was nice. Said also that this sort of drawing made him feel a fool staying at Collier's. I told him that he was making a mark there, that the weekly reflected his ability as a planner and architect of type. These amenities of polite

conversation being finished (in all sincerity I think) I went to the cashier and got my check for $225. A rush order for a Puzzle kept me hard at work after dinner near two in the morning.

November 19

Kirby called and we asked him to have lunch. . . . In the afternoon Dolly, Kirby and I went up to Henri's studio, East 40th St. Mr. George Berg of Seattle, his wife and "little" daughter, fourteen years old and nearly six feet tall–were there. Miss Pope came later. Henri showed quite a number of canvases new and some older ones. Landscapes and Monhegan Island surf and rocks. A new phase of Henri's art to Kirby as he knew him only as a portrait painter. Henri not very well, so I went out and bought some Sal Vitae and gave him a dose. We parted at seven o'clock, the Henris going to Pabsts' to dinner and afterward to see Harry Lauder. Miss Pope, Dolly and I walked down to 24th St., got Miss Pope's mother and we all went to dinner at Caveau de Paris 29th St. . . . Went up to see some very good work which Miss Pope did this summer in Spain. . . . Miss Pope gave Dolly an umbrella handle of cloisonné and me a Spanish pocket knife.

November 20

I helped Mrs. Ullman lay the floor covering in her room below us, quite a job it proved. Afterward went for a walk out Fifth Avenue. At 43rd I stopped in an engraving and etching shop, saw a collection of the work of Lucas van Leyden and asked the proprietor if he would care to handle some of my etchings. He said he'd like to see them. The weather is clear and mild, and Fifth Ave. was choked with automobiles, the sidewalk crowded with women in expensive gowns. The present Directoire style (as they call it) is right interesting, giving a dashing look–large hats set down on the head–and the dresses being scant in the skirts, not full as lately, show the legs as they are gathered in one hand to hold the length from the ground. Very little petticoat in evidence, just the skirt wrapping the legs. Dolly joined Mrs. Luks and Mrs. Frankenburg in a "shopping" expedition in the late afternoon–so I had no dinner. The Ullmans hung out with us from eight o'clock on.

November 21

Put in most of today trimming and pasting into my scrapbooks the Puzzles. It will make them more easy to look at occasionally and will

preserve them. Ralph Bergengren, the author of "Mehitabel" (just out in Collier's) wrote me a very pleasant note thanking me for the drawings with which I illustrated the story. He liked them very much evidently.

November 22

Ullman and I walked out for the papers . . . looked in every shop window. He has a sort of passion for the windows, especially old furniture, bric-a-brac, etc. . . . Came back with cakes and had "tea in the studio,"–so romantic! Then Ullman and I started on the job of laying the oilcloth in their bath and kitchen combination room . . . tiresome job, interrupted by dinner. . . .

November 23

. . . Priced a large folio book with suppressed plates–Gillray's Works. $40.–would certainly like to afford it–but and here's something important!–I have today written March of the Philadelphia Press that I *would no longer do the Puzzles.* Brought about by a letter from March saying to avoid pictures of donkeys (ass) and other items which I need not mention. Disgusting to me in showing what a dirty puritanic mind will find to criticize. March says that this is not his criticism "but others in the office." Mr. and Mrs. Rollin Kirby took dinner with us. . . .

November 24

Frank Drake of the N.Y. World called. Wanted me to make a drawing of a head of Jesus Christ. "A firmer, stronger character than is used by painters of Christ. Miss Fowler, phrenologist, has criticized Christ in art." I told him of Rembrandt's Christ, showed him it was not weak. Finally agreed to let him know Friday if I could do it–for $100. But after I had spent the afternoon buying some special drawing papers, etc., looking at the face of each Jew I met on the streets to see some Christlike traits (without finding any) I got a telegram which said never mind about the Christ portrait, time is too short. And so–like a dream, 'twas over! One scheme I had was to base Christ's head on Abe Lincoln. Kirby gave me a portrait of J. G. Phelps Stokes the Socialist, a fine Lincoln-like head. Made a Puzzle in the evening. . . . Sent "Hudson from the Palisades" to the National Academy jury. First landscape I've attempted to exhibit.

November 25

Alden March, Sunday Editor of the Press (Phila.) called shortly before noon. We had a pow-wow on the Puzzles. He asks me to reconsider my resignation. Talked flatteringly and expressed regret that after all these years we should discontinue, etc. I finally told him that –I'd go on and be very careful if the price was raised to $25. per set. He said he'd see what J. B. Townsend, the business manager, said about it.

November 26

Thanksgiving Day. So Dolly and Mrs. Ullman combined talents and worked all day in the kitchen, in order that fat Ullman and thinnish I might be pleased at dinner. We were! An elegant roast turkey with the proper cranberry lubricant, a bottle of white wine, turkey stuffed with oysters and mushrooms by the way! And ended with a huge mince pie which I had ordered from the bakery. A great success and how I did eat! Dining with us we had Mrs. Lee (Henri's mother) and she enjoyed it hugely. Ullman and I took her home to the Martha Washington hotel about 10–When we returned, we found visitors– Henri and Mrs. H2O. Mrs. H2O yawned a great deal and seemed to be having a very dull time–probably was. So they left about 12 o'clock.

November 28

Went down to Wanamaker's and undertook the task of picking out some books for Dolly's nieces' Christmas presents. Finally found some fairy story books which seemed about right. . . . After dinner at home (turkey made its "farewell appearance on any stage") I worked on pasting in of my Puzzles in the scrap books.

November 29

Ullman and I took a walk over 33rd St. to the Hudson River. The Pennsylvania Terminal operation is progressing rapidly. The building from 8th to 7th Aves. is well under way. The façade which is very gloomy is about completed on 7th Avenue. It looks like a gigantic tomb, not a bit of a suggestion that it marks the entrance to anything so modern and progressive as a double tunnel under the Hudson River and a whole Railway System. . . . Lichtenstein and Mrs. L. called in the evening. He showed me a letter from Toledo Museum,

thanking for the 8 exhibition. Carnegie Institute is now in line. The show goes there in March, 1909.

November 30

The great event of the day was our entertainment of Henri and Mrs. H_2O. We had them and the Shinns to dinner and the rest of the Philadelphia gang and their wives came later to meet the new Mrs. H. The affair was a success. Mrs. H_2 wore a very shabby blue suit. I don't know why—a cheap shirtwaist. I think that she is conventional "Bohemian." That she wishes to show us that she doesn't care for social affairs, in fact that she wishes us to dislike her. Like the princess in the fairy story, she has her wish. I believe that, in spite of his loyalty, H. is ashamed of her. Mrs. Shinn looked pretty.... Mrs. Glackens was gracious and used her very unique, clever wits to good purpose. Mrs. Preston, attractive and ripe looking.... Mrs. Laub was splendidly gotten up.... I put in some new gas lights so that the studio though plain looked bright and clean, thank Dolly for that! Miss Pope came and kindly brought sandwiches for the lunch at night.

December 2

At about quarter to one P.M. Alden March, Sunday Editor, the Press, came in and told me that Townsend had agreed to pay $20. each for the Puzzles until April 1, 1909. After that date $25. each. This seemed to me a fair offer so I accepted. Dolly went to pose for Miss Pope this afternoon, who is going to attempt a portrait of her. She's a tough subject. I'm going to tackle her myself next week, I think....

December 4

Dolly went to see Annie Nathan Meyer's play "A Dinner of Herbs" at the Empire Theatre produced by the dramatic school of which Mrs. Laub was a student. She and Dolly went together. Dolly did not think much of the play. She says the artists are made out uncouth.... No account taken of the love that makes the wife part of the artist's self, part of his work. Frank Van Sloan, who was a pupil of Henri's came to see me about etching printing. Says he has been making some dry points and etchings. He is a good sort ... asked him to stop in again. Frank Crane also called.... Dolly and I went to East Orange and had dinner with Davis's. Did not see the baby as he had been put to bed.

December 5

Nothing to record of any interest save the fact that I don't get at any painting or anything else. I am not in good favor with myself on this account. A spell of idleness has held me now for some time and it is wearing on me–for it seems to me that production is the greatest joy one can have.

December 6

... Dropped in at Ullman's and had a discussion on the votes for women ... at present being agitated in England by the "Suffragettes"– and has started in this country. I feel that it would be well to give them votes. In the evening, to Mrs. Preston's on 9th St., wandered ... in search of the house. Dolly had gone earlier as I was working on a Puzzle. They have the basement and first floor of an old house, very fine. ... Jim has been painting landscapes and they are surprisingly good. ... Henri and Mrs. H., Glack and Mrs., Shinn and Mrs., Mrs. Morgan (Grace Dwight) and Mr. Morgan, Fuhr, Johnston of the World had left before I arrived. Glack insisted on staying late and was very amusing.

December 7

Bought a nice old (not very old) necklace of silver and onyx for a Christmas gift for Dolly wife, which pleased her very much. A package of books from "C. T. Brainerd, Publisher, Boston" arrived ... have nothing ordered from such firm, I returned it by express. Budworth Co. called for "Haymarket" which is to go to the Nebraska, Kansas, Exhibition. C. B. Lichtenstein and Mrs. with little Charles Quinby, who is the son of F. J. Quinby (ex-publisher now real estate promoter), and Miss Pope to dinner. ... Charles Wisner Barrell called. He tells me that his article on my work will appear in February Craftsman. I was glad to hear it for his sake and for my own. He has become a Socialist and talked with me on the subject–wants me to attend a Sunday meeting in Jersey City some time. It sounds well to me. I believe my next vote will go to their candidates.

December 8

Dolly not feel very well. ... Mrs. Ullman was very kind, did all her morning's work for Dolly. Kirby called. I made a Puzzle in the eve-

ning. Today, as Dolly recalls, is the third anniversary of Linda Henri's death.

December 9

At Harbison's book store on 23rd St. I told him he could sell my etchings separately at $5. each, he to take fifty percent. We took dinner at Glackens'. They are now at 23 Fifth Avenue, have the second floor in General Sickles' home.... Glackens showed some of the things he had been painting at Cape Cod during the past summer. I received a pleasant letter from Norris in Florida....

December 10

A ring at the studio door bell. I peeked out at the kitchen door. An elderly prosperous gentleman said, "Good morning, is this Mr. Sloan?" ... said he was Mr. French of the Chicago Art Institute—I in my pajamas! ... I dressed and came out. We talked over the Lichtenstein matter of the check returned "no funds." He said that the Art Institute was to pay one fourth of $56., the express charges. That one other institution had sent him the check for one fourth. He is now one half "out." I offered to give him a check for it. He said "No, it was a small matter"—that he would write to Lichtenstein further about it. And now he asked to see some paintings. I showed two or three, and noted that when I could say that they had been accepted and well hung in one of the prominent exhibitions, he liked them. "Hudson from the Palisades," the landscape just refused by the National Academy, he lost interest in on my giving him that information. He liked the "Making Faces," I think, for he put down the title. Kirby came in and worked in the studio as his place has not heat.... A story to read from the Century with a view to making some illustrations. Irish humor—with a caution to bring out the "pathos." It is a very poor effort in the literary way.

December 11

Kirby worked in the studio today ... enjoyed his company and worked on a Puzzle, finishing it in the evening... took a walk as far as the Metropolitan Opera House, got there just as the carriages were drawing up and delivering their loads of swells and others near swell. It was a rainy night so that the number of carriages was very great. The women were interesting with hair prepared with great care and opera

cloaks–red in the majority of cases I think, though that may be an impression due to the force of the color. The front of the opera house is not at all imposing. As I stood watching, E. Fuhr came by and I walked down town with him . . . he sent two pictures to be "fired" by the National Academy. Academy (definition)–an organization of Cads and Demi-Cads, with soft brains and pointed beards.

December 12

Dolly loaned Kirby fifty cents to purchase "rubbers" for Mrs. K. last evening. He returned it this morning with a little note:

> The rubbers were got the feet were dry
> And here's the fifty, Mrs. Sloan
> I thank you with a tear dimmed eye
> For the leave of the have of the little loan
> Mrs. John Sloan
> Stricketly private
>
> > "*Arkay*"
> > (meaning R. K.)
> A drawing attached of Mrs. Kirby's rubber shod feet
> on the way to the Opery

I walked out Broadway to 48th St. . . . mailed the Puzzle to the Philadelphia Press.

December 14

Went in to see Drake at the Century and showed him sketches on the story which he approved. The news is announced that Redfield has been awarded the top prize at the Corcoran Gallery exhibition, $2,000. His friend from Boston DeCamp gets the second $1500. So it's quite apparent that Breckenridge who has been on the jury of award for the two Corcoran exhibitions has gone over to "Reddy." . . . The next move should be–Redfield on the jury–Breck gets the prize. But one small obstacle, easily enough overcome perhaps, intervenes–namely Breckenridge's work must be more popular. It's bad enough, and ordinary enough and perhaps is more popular than I am aware of. Redfield's work has much more solid merit, in fact is better than most work shown by far.

December 15

Walked up town and happened to think of the N.A.D. exhibition so went in. It is an unusually bad collection this winter. And the prizes have been awarded in the most absurd way. A huge Prix de Rome style of picture "Life Overcoming Evil" or some such title gets one. Shinn had something to do with this, worked on it for George Fuller, I believe. S. Potts' cousin Charles (Flagg) gets a prize on a vile portrait–thin, out of construction, bad. Glackens' picture is good, "Bathers at Cape Cod." Jim Preston's landscape is disappointing . . . imitation of Lawson. Lawson has a right good boys bathing picture. Bellows has an interesting River picture, Hudson, I suppose. Schofield has a thing that I didn't care for much, all mannerism. Left after going into Frank Gold's riding "school" next door to see the sculpture section of the show. Went to see George Luks. Davies called while I was there. Luks showed some good things. A portrait of a man with golden yellow hair, especially fine. . . .

December 17

In the afternoon we went to Henri's. George Luks and Mrs. L., Mrs. Laub, Mr. Dryer of Rochester, a pupil of Henri's, and a Miss (name forgotten) and Gregg. Luks was amusing as usual. He is not drinking now and is at his best. Henri tells me that he has left Connah's New York School of Art. Money difficulty I believe is the reason. He said that there was nothing to say as yet in the matter. Gregg, Luks and Mrs., Dolly and I went to the Grand Union, had "highball," then I took Mr. and Mrs. Luks and Dolly to the Caveau de Paris where we had dinner. Met Zinzig and Mrs. Z., had more "highballs" and got home rather the "worse for wear." Luks was very amusing and did not touch any strong drink all evening. He made another sort of touch though. He was paying certain part of the bills, from Mrs. Luks' pocket book which he was carrying after having received change. With a wink at us, Mrs. L.'s head being turned away, he slipped a bank note into the small front waist band pocket of his trousers–remarking to Zinzig, "That's a pocket she has not yet discovered."

December 18

Dolly and I spent a very fine afternoon at Davies' studio. He showed us much good stuff, paintings and drawings–and we were greatly

pleased. Davies is surely a great man and so very industrious it makes me feel puny and weak and idle beyond telling. His work is like music but I feel it is almost greater.

December 21

Have been wondering why sister Nan had not sent us our invitation to spend Christmas in Fort Washington. Today her letter arrived. She says that Dad is not well, been in bed for four days. I hope it's nothing serious. I prize him more since Mother's death. He seems to be part of her, sort of a souvenir. Took a walk on 6th Avenue after dinner. Came back and worked on Century drawings. Kirby came in . . . brought some drawings for me to look at and make suggestions. I did so and required the same of him on my Century drawings.

December 22

Ink arrived from Peters in Philadelphia—bill $1.50!! Today as a model I had an elderly woman, a laundress for gentlemen mostly, bright eyed, good color, spry and interesting. She tells me that she has "in her time" posed for E. A. Abbey . . . for (most important man in America today) Winslow Homer. . . . She speaks of J. G. Brown also and Reinhart also, not the great illustrator but his brother. . . . Jerome Myers called. W. Pach also came and read letter from the editor of Gazette des Beaux Arts, Paris—saying he liked my etchings and would be interested to see others. I gave him six Paul de Kock proofs and seven of the New York series, asking that they be returned. Down to Glackens' to see if I could find my umbrella, saw the baby alert and gleeful—a fine strong boy. . . .

December 24

Up early and caught the 8:50 train to Philadelphia . . . had lunch at Uncle Al Sloan's. Aunt Mary has a bad cold. Nell seems well. . . . Went to the bank and got some money. Then to the Press . . . to visit my friends in the art department. Doyle, Otis and Williams and Birkmire and Pearce the photographer are the only ones there of the old lot . . . delivered Puzzle. . . . Dad I find not very well, rheumatism has held him in the house for a week or so. . . . Christmas presents were shown after dinner and every one was pleased. I fared splendidly. Nan gave me a beautiful pair of cuff buttons, gold chased, elegant in design. Mrs. Drayton sent Dad a canary bird in a cage, he was much

pleased. It brings back his youth. He had many, raised them for sale and after marrying Nettie, my mother, they had one named Dick.

December 25

Bessie and Marianna are, of course, at church most of the time from 7:30 till one P.M. It is their dissipation. We, Dolly and I, did not indulge. Tom Anshutz called on us in the morning. I was glad to hear him state his intention of voting the Socialist ticket in the future. He is a careful thinker and I feel strengthened in my intention to do the same. . . . After the Christmas turkey which was very good, and the proper adjuncts of mince pie, etc., Miss Summers played the piano very well, though by ear. . . . Nan and I walked home with her and I met father and mother. . . . I hear that Breckenridge has a studio in the city now. He is probably prosperous.

December 26

Went in to town with Dolly and with the understanding that I was to meet her with the Hamlins at Green's Hotel, left her to call on Mrs. Dawson and I to see Peters and Tom Daly . . . neither to be seen. I then called at "806" Walnut, my old studio. Daecke was in and I was glad to get a look at the old place where so many happy and so many merry and quite a few dramatically strenuous affairs occurred in my "twenties." Daecke . . . thinks of retaining his place at "806." I told him to let me know if he gave it up. Met H. Neely, now on the Evening Telegraph. . . . The Hamlins and Dolly and I all met at Green's and had dinner. . . .

December 27

Went in to Philadelphia after lunch, where at the Press office I saw March and had a very pleasant two hours talk with him, on the subject of Puzzles. . . . Met King, one time morning editor of the Press, Brannan, Goodebus and Hull. At Montgomery's house in Germantown, we had a very pleasant evening. . . . Dolly's home made gray gown à la Directoire has been decided by all a great success. She looks very well dressed in it. . . .

December 28

Came to town after the good-byes were said. Dad's eyes filled as he kissed us. This Dolly noticed. I am less sympathetic than she, I really

believe. We certainly passed a happy Christmas with them all—all but one, Mother's dead. The most comfortable for some time, a kindlier feeling among us, I think. In Philadelphia we took lunch at Sallie Kerr's (Dolly's cousin). Frank has his tailor business and home in an ex-sumptuous home, Arch above 15th St.... Met Mary Kerr whom I have not seen for about two years. She's quite stout, has long skirts, a grown woman now. I came home on the 2:20 train to New York. The Ullmans were glad to see me back and I had dinner and spent the evening down in their rooms. . . .

December 29

Mrs. Ullman had me down to breakfast with them and then she insisted on making my bed and tidying up my studio. . . . She is so kind, so pretty, and to think that she has this trouble, cancer probably, eating her vitals away—it's sad. I went for a walk and stopped in to see Kirby. A present for Dolly arrived during our absence . . . from Miss Helen J. Niles of Toledo. . . . Post cards of good wishes from Shinns, Laubs, Prestons and others. I can't remember to do this sort of thing—and I don't think that Dolly has done it. Took dinner with the Ullmans. . . . Frightful earthquake in Southern Italy yesterday.

December 30

Got to work on the pen and ink drawings for the Century and worked all day right hard.

December 31

Today Dolly came home about 3 o'clock, turned right in and cooked a turkey dinner for Mr. and Mrs. Crane, and Joe and Mrs. Laub, and Miss Pope. After dinner the Henris came and we had a right merry New Year's evening. Outside cowbells and horns made the streets pandemonium. At twelve o'clock Ullman downstairs, started his alarm clock in the hallway. I answered by placing mine outside the door to augment the din. Dolly says that Trask of the Pennsylvania Academy asked why I had made no entry for the exhibition over there, so taking this as an invitation, I'll send two pictures to the jury meeting at Budworth's. Here endeth 1908, a year of some note among mine, though not a year of great production. I hope that 1909 may see more work of mine.

1909

January 1

A rather sad, dull New Year s Day as Dolly is down in bed with a bad cold. . . . I got her breakfast and mine, making use of a ham which arrived this morning with "Happy New Year from Bisland" our butcher. . . .

January 2

In the afternoon I walked out 23rd St., my object being the Cigar Stores Co. in the Flatiron Building, but I met Lawson at Fifth Avenue and here I switched to frivolity . . . couple of drinks at the old Continental Hotel, went to his studio on 14th St. (21 East). He has a tiny dirty low-ceilinged room and here his work is done. He showed me a couple of paintings which he is at work on . . . intends to have them ready for the P.A.F.A. [Pennsylvania Academy] jury. We started up town and stopped in the Continental again–more drinks. It was now evening, we went into Carlos' on 24th St. where we met . . . Murray the bar tender, a good sort says Lawson, and I don't doubt it. By this time, I had so lost my ordinary senses that I failed to realize how lonely Dolly must be, whom I had left in bed ill with a cold.–So off to Mouquin's we toddled. Sat down with Fitzgerald, Gregg and J. Knox. Fitz and Knox soon left, Gregg stayed a while longer. But Lawson and I sat and drank and quarreled and "made up" and talked too loud–were reproved for it, behaved more quietly. Then, at about two o'clock we went to the Chinese Restaurant, sat for an hour and then, leaving him at Sixth Avenue and 23rd St., I came home where I found my dear nearly distraught with worry. She had phoned Henri at about one A.M. He, kind old friend, had come down, phoned police station and done all he could to reassure her and had gone home at three A.M. I came in about 3:30 A.M. by this time sobered up, and heartily ashamed of myself.

January 3

I remember today that Lawson told me the splendid news that Glackens had sold his painting "Bathing, Cape Cod" now at the National Academy exhibition. This is of great importance to Glack and can't

fail to encourage him and count with his wife's connections with whom money is a great talker. I nursed a rather upset stomach today, the result of yesterday's debauch. Dolly seems to be better. She got up quite early and phoned Henri that her stray lamb had wandered home. In the evening I started a puzzle.

January 4

An amusing, satirical letter from Trask of the P.A.F.A. acknowledging receipt of my entry blanks for "Hudson from the Palisades" and "Making Faces." I had about started to ink in a Puzzle, when Ullman came. . . . Outside, Ullman had a splendid big touring car, a loan with chauffeur, from the "White Steamer" people to aid in the relief committee *[American-Italian General Relief]* work. So by his invitation I took a ride downtown with him. It is a very fine sensation to be carried along with so much speed and power and weight. I found it a bit of a nervous strain though, couldn't get rid of the idea that I must watch each move and maneuver in threading the streets, full of vehicles. I suppose one gets over that. Went to the office in the World Building with Ullman and was introduced to Mr. J. J. Freschi, Italian lawyer. A young bright looking fellow; and to Ullman's freelance friend in reportorial work, Lithschild, an elderly man. I came home by humble elevated train. A beautiful evening in Park Row, great buildings lit up inside, fine sky, hurrying crowds. Finished Puzzle in the evening.

January 6

The papers today have the story of Henri's severing connection with the New York School of Art. Henri says he left because they did not keep their promises in financial matters. Connah, the manager or owner, says that he has backed Henri for five years but that he has at last come to the conclusion of the great majority of successful painters in America and has decided to run the school on the more academic principles, etc. etc. This, as a reason, is purely false. I know that the school has been badly managed for at least three years. The models have been unable to pose at times on account of cold rooms, Henri has threatened to leave several times on account of non payment of his bill. Ullman came in in the evening and said he was sending us box seats for tomorrow night at the Garden. I finished up the largest of the Century drawings tonight. Called in at Collier's and Bradley

278

handed me the mss. of another pirate farce by Bergengren which I am to illustrate.

January 7

Went up to see Henri today as he had phoned that he'd like to see me. Of course, the main thing at the moment is the question of getting classes started. He says that the portrait class wants him to open a school—all stand ready to leave the New York School since he's leaving it. Henri and I came downtown and looked at large lofts opposite my studio on 23rd St. . . . went to see the agents . . . he wanted Henri to make an offer. We went up town then to the Lincoln Arcade Building, 66th and Broadway, where we found a very large suitable room. Henri closed with the agent at once. $65. a month for five months with a privilege of renewal at the end of that time. . . . No lunch, so we went and had two milk punches, then back to his studio. Miss Pope, who is, I understand, ready to back him financially in the new class, was there, Mr. Dryer, also a strong partisan. W. Pach came in with a little Spaniard, a polite fellow. Home, and after dinner we went to Madison Square Garden to see the "Monster" benefit which Ullman's Relief Committee have undertaken for tonight. Vice President of the U.S. Fairbanks spoke, Mayor of New York, McClellan, Congressman Sulzer, Henry Cloos and others . . . attendance was about 3,000 which is a mere forlorn handful in the great auditorium of the Garden, which by the way, I saw for the first time. . . .

January 8

Well, back came the two canvases from the Penn. Academy jury so that incident's closed, with a bump on my head—and I am out of pocket the cost of cartage. Thomas Eakins' opinion is the only one on the jury that's worth while. I'd like to know how he voted on them. . . . Yesterday I had a letter from W. T. Bradley, the coal dealer in Philadelphia for whom I used to write doggerel verses for street car "ads." He wants to know what I'd charge for some verses now. Replied that I'd be glad to do verses for $15. each. I suppose this will be too much for him.

January 9

Tom Daly writes from Philadelphia that John Lane Co., New York, will get out his next book of verse, that they would like to know what

I'd charge for etched frontispiece. I to own the plate. I wrote offering proofs from plate ready to send to binder for $150. per thousand. Also offered in connection with the foregoing to make ten drawings for $100. I reserve all but book rights in connection with his book of verse. Henri and Mrs. H. called in the evening and W. S. Potts dropped in also. . . . Henri is full of the new school which he will open on Monday. I hope that it has all the success which it should for Henri is the best teacher of art in this country, if not in the world– "Them's my sentiments."

January 10

Dolly is preparing to go to Philadelphia tomorrow to take a course of treatment with Dr. Bower. He has told her that it is becoming important to attend to her in order that she may be saved much suffering in the future. After an early dinner of spaghetti, I made a Puzzle for the Press. Looking over my last year's receipts, I find that I've taken in about $2750–this is an average of about $50. per week and seems to me satisfactory when I consider how little effort I've made to make money.

January 11

Took Dolly across the ferry . . . the river was handsome as it always is. New iron wharves from about 12th St. to 23rd St. which have sprung up in the last year look very well from the river but I have objected to the fact that in all that distance, one who is walking along West Street cannot see the river. Now I'm home and alone, and feel it most keenly. This garret of ours seems so desolate without Dolly . . . coming every now and then to give me a kiss–interrupting my work, but not so much of an interruption as reloading my pipe is–and much sweeter. Walked down to Bisland's (our Butcher and Broker), had a check cashed, then took a walk . . . went into the Caveau de Paris for dinner. W. Walsh came in, introduced me to a gentleman of the G. Fox type in a way but older. His name Purdy. I have often seen him here and I think that some one told me he was on Town Topics, the gutter peep paper of scandal. An amusing thing–wagons loaded with coops with live poultry, on top, a lot of geese with their necks poked through the slats cackling and gazing at the city–"Seeing New York" wagon. Letter from Tom Daly. He

280

thinks price quoted on frontispiece etching, $150 per thousand, too much. Says he will be in town this week.

January 12

Went in to Kirby's after taking a walk and he proposed that I should go with him and Mrs. K. to see the Modern German Paintings at the Metropolitan Museum of Art. . . . The German paintings are, with two or three exceptions, pretty bad, I think. There is hardly anything but technical straining in the moderns. Menzel is represented by a very good little picture, a stage with two ladies and a gentleman, actors in a conversation. The King's box is covered with netting, to shield him from bomb throwers evidently . . . met Glackens, Lawson, and a friend of theirs named Eitel, or some such name. . . . I declined a kind invitation to dinner in Flushing. After dinner at the Caveau de Paris, I came home and worked till one A.M. on a Century drawing which did not pan out well after all.

January 13

Today Miss Converse (339 W. 45, Bryant 4565), the model whom I saw while in Kirby's, posed for me. I started a portrait of her. *["Girl in the Fur Hat," New Britain Institute.]* She is a very interesting woman, has been about the world considerably and lived in London and Paris. While in London, she posed for E. A. Abbey, the great illustrator and poor English modern style painter. From Harris Merton Lyon, two copies of his new book, "Sardonic"; one for Henri "with admiration" and other for me "from a clumsier etcher in the same field." . . . Letter from W. T. Bradley, coal dealer, in re "poetry" –he passes away at the price I quote him. Ha! Ha! A nice long letter from Dolly in Philadelphia . . . read during my dinner at Caveau de Paris . . . a beautiful snowstorm started this evening. Letter from March Phila. Press, says that a Western paper is to take the Puzzle. . . .

January 14

. . . Was disappointed by my model today. She sent word that she had caught cold. But I got at Puzzle for the Press and finished it so perhaps it's just as well. Went to Caveau de Paris for dinner. Mrs. Walsh was there and we discussed the merits of my W. S. Walsh portrait.

She, of course, didn't think I had the finer side of his nature. She is about right. She admitted he had the side I painted. . . .

January 15

Another all day attempt to paint from Miss Converse which ended in a dismal failure. Why will a man take on all the agony of mind and fatigue of body which results from the struggle to do something decent in paint? A. Bréal in speaking of Rembrandt calls it an incurable disease and yet—I do hope I have it. I sometimes think I have not any more than a mild attack. . . .

January 16

. . . Carl Anderson sails for Spain today and Kirby went down to see him off. Thus can a man, a nice fellow, treat himself when he's able to make thin, foolish illustrations nowadays! Found a letter from J. B. Moore . . . says he is working as Philadelphia representative of a Chicago firm. He hopes to pay me some of the $100 I loaned him (thinking I was buying stock in the Café). A letter from Dolly who seems to be enjoying her stay in Philadelphia. Cleaned up the place which had begun to show need of attention. After dinner, which I had at the Chinese restaurant, I started a puzzle. A driving snowstorm started this afternoon. . . .

January 17

A fearfully cold day outside. . . . Henri and Mrs. H. called later in the evening. He says that his school is now in full swing. Lights are ready for the evening classes and he seems pretty cheerful about it. He was greatly pleased at Lyon's sending him the book, not knowing him personally. . . .

January 18

Finished up and now have ready and mailed this afternoon, three Puzzles. Kirby called and asked for help on an idea for a Lincoln picture for Collier's. I gave him one which he thought might do: Lincoln sitting sad, very sad, with news of a *Northern Victory* in a newspaper in his hand—that ought to hit 'em, soft enough! As I went to mail Puzzles, I met Barrell on his way to see me. He showed me the article on "me" in the Craftsman for February and I was pleased with it, with the exception of classing me with Eugene Higgins whose

work is absolute "fake," patented by Rembrandt though that's not fair to old Rembrandt. Higgins just copied one thing from Rembrandt and made it answer for all his paintings. Well, it is awe inspiring to read an article speaking so well of one's own attainments, makes me feel that I should "hustle" to live up to it.... Went to Caveau de Paris for dinner ... not so good as usual. After dinner I took a wild fancy and went to Miner's Eighth Avenue Theatre and saw the usual burlesque show—green legs, and pink legs and poor jests. It suits the patrons though.

January 19

... Ullman phoned me to come down and eat spaghetti with him. Went, to a real Mulberry Street Italian restaurant ... very poor indeed compared to what Dolly makes.... Next, Ullman and I walked the Bowery—that name! so romantic to the youth of towns in the U.S. Nothing but a name it seemed this night, so dull and dark and safe and slushy. At 14th St. we followed the crowd into the Dewey Theatre moving picture show. Saw some right good films and one very amusing "yeller gal," buck and wing dancer, a very interesting type. I'd like to try to paint her as I saw her then. At about 11 o'clock left Ullman and met up with Louis Glackens, curious little codger like "something out of a book." At the Grapevine we talked long and long over our "flagons" of ale. He told me of his great admiration, in the past, for Nanette Lederer, now Mrs. Calder. The little odd bachelor must really have been in love with her....

January 21

A good solid night's rest put me in right good shape so that when the model, Miss Converse, came, I started to work with some good purpose. Worked three hours and have a much better start than I had on the former attempts to paint her. Not finished with it and, of course, not sure it will come out well....

January 22

This evening Joe Laub and Mrs. L. called and sat with me while I worked on the Century drawings. In the morning, I went to Collier's and had quite an interesting talk with Bradley. He told me that he felt that with all his varied and successful experience in the art of printing and designing he had never got at the work seriously enough, that if he died, there would be nothing to his credit.

January 23

The first thing in the morning, a call from Fletcher Ransom, illustrator whom I have met before. He had an offer for me to teach the portrait class in the National School of Art, run by Friedrichs the art supply dealer. They want me to take the class of F. M. Du Mond who is retiring from the school. The terms—one half the gross tuition fees of the class; bigger the class, bigger the pay. He said that Henri had recommended me. I told him I'd consider it and let him know. I rather think I won't do it. Ullman came up and returned $25. on account. . . .

January 25

Painted from Miss Converse again today—not much improvement on my start. Painted it all over (the head) several times but the result has not much stuff in it. Joe Laub sent a man who is in charge of advertising of a silverware concern, who wants some initial drawings for advertisements. I am to make a sketch of one to see if I can suit him. . . .

January 26

Went out to mail the Puzzle made last evening. A letter from Dolly says that the doctor has given her permission to come home for a few days, probably next week. I wrote her yesterday that she should come if she felt equal to it. But the dirt that has accumulated in her absence would lead her to pitch in and clean which would not be good for her. I'd like to see her little face around here again for a while. . . . After dinner, made sketches for the initial letter ad. Delivered drawings to Century this afternoon. Drake was away, but Miss Jackson liked them very much. I asked for a slight increase in price over the agreement and she said she thought I could get $150. Drake will decide tomorrow. If not, I said I wanted the originals after use.

January 27

Dr. Dunn did not come back to look at the initial sketches as he said he would. I phoned in the afternoon. In the evening, I went up to the Arcade Building and saw Henri's Men's Night Life Class at work . . . more than twenty men there . . . seems just as it has been at the

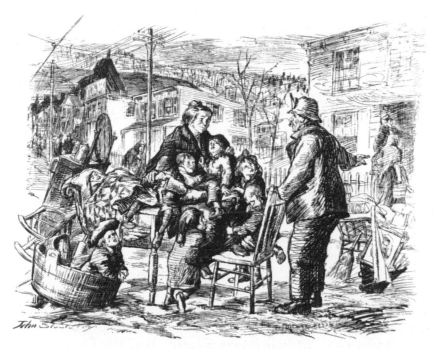

The Century Illustrated Monthly Magazine, August, 1909

New York School of Art, same faces in a general way, same good tendency in the work. . . . As a new member had joined the class, there was a treat at his expense, beer and sandwiches. There was not as much "cutting loose" as I remember on similar occasions in my youth in Philadelphia and I wonder if my own and Henri's presences were a damper. Curious, if so, for it again makes me feel old if my supposition is correct. Henri thought not. If there had been fun, I'm young enough at thirty-seven to hold up my end, I think. The Spanish sculptor, Villar, whom I had met at H.'s studio came in to see the class. . . . At auction today with Ullman. He bought, on my recommendation, an old painting signed 1455, G. V. Miere. It is a very good old thing, a Christ carrying the Cross. Beautiful treatment of the detail of the hill with crosses in background. A fine rich sky. He paid $7.50 for it. I envy him his bargain.

January 28

A day of right hard work—I painted from 10:30 in the morning till about 5 in the afternoon. First from Miss Converse and then from

R. Kirby, who dropped in in the afternoon. Seven hours on my feet rather exhausted me. I went to Coddington's for dinner . . . came home and finished up one of the initials which Dr. Dunn had selected in the morning. Sent it by mail at night. Dolly writes me a rather doleful little letter today, says that her nerves are not in good shape, that Dr. Bower may give her some electric treatment. I expect that she has suffered more than she has let me know in trying to get well. . . .

January 29

Joe Laub came in and asked me to come to dinner with them this evening . . . nice dinner . . . afterwards Joe and I went just down to the corner Broadway and 66th and visited the Henri School of Art night class. Joe is thinking of joining this class so that he will get a rubbing up on figure work of which he has done almost none. Looked up the painter of the "old master" which Ullman and I bought. Gerard Van der Miere born in Ghent, Flanders, 1427 or thereabouts. The steamer Republic of the White Star Line was run into and eventually sunk by the Florida of the Italian Line Saturday last. The Florida stood by and took on all passengers though damaged herself. The captain of the Republic stayed on till all passengers were off to the Florida and then retransferred to the Baltic White Star summoned by wireless operator, young man named Binns on Republic. This fool captain then stays on, finally orders the crew off except first officer or mate— the two still stay while Republic is being towed to shore. Suddenly she sinks as was expected. Searchlights play on the spot and the captain and mate are picked up from the water. And the Yellow newspapers yell. The last part of the captain's stay on board seems melodrama and exaggerated heroism to me. With searchlights he was safe enough, but he made unnecessary trouble for the towing boats and rescuers.

January 30

. . . Miss Converse, the model, came about 11 o'clock and I worked till two when she had to go to meet a skating party. This rather provoked me as I had a thing going and in a very interesting stage to me. I have today about the best result yet in her head. "Throbbing Fountain" returned from Corcoran Gallery exhibition, Washington, D.C. with a glass on it. I had sent it without glass. I suppose they put

it on to add "finish." I don't care for glass on paintings myself save where they are necessary to protect from atmosphere. Carnegie blanks for April ex. arrived. The Century (Mr. Drake) writes me a nice letter, says they like the drawings for "Mary Toole" story and enclose Check for $150. the increased price. Fine! . . . Tonight Dolly is at the Phila. Academy [Pennsylvania Academy] private view. Henri said he is going over.

February 1

Like some idiot in a comic picture, I decided that the stove should be more in the middle of the studio so I got to and moved it—hot. Added pipe and got in a mess generally. Then the studio ceiling in a section by the N.E. window cracked and fell with a crash and dust. . . . The Evening Sun's comment on La Farge's speech in response to the gift of a medal by the Architectural League is interesting.

February 3

Today I made another "stab" at the portrait of Miss Converse. Painted the entire head over, as usual—and rather feel that the thing is now at its best. A week from today she is to come again and I'll look it over and perhaps finish it up. Kirby came in the late afternoon, and he was much pleased with the canvas, likes it better than on any other occasion he has seen it . . . walked for exercise. . . . Had my dinner at Coddington's. . . . After dinner . . . I got started on the Collier Pirate story. I am as hard to start as a freight train on a grade.

February 4

The plasterers putting in the patch of ceiling which fell the other day took up a couple of hours of my time as I had to clean up after they left. The dust is remarkable in tenacity and penetration. A copy of Sunday's Phila. Inquirer came by mail today. It is unmarked but contains a very laudatory paragraph on the Eight show in the West. I have no idea who sent the paper nor do I know who writes art criticism on the Inquirer now. In the evening I got to work on the Collier's Pirate drawing and progressed quite well. . . .

February 6

Kirby and I came to New York together, stopped at the Manhattan Opera House to get tickets for Mrs. Kirby and her mother for next

week, Tetrazzini. Worked right hard all day on the Collier's drawings and had two about finished when I went to bed. After dinner, which I had early, I received another Caspar Day story from the Century. It enclosed a letter from the author of "Saints and Mary Toole" to which the new story is a sequel. He spoke of being thoroughly pleased with my drawings for the first story which is pleasant to know... letter from Dolly which says that she cannot get a definite date from the doctor, that she is not yet entirely through the treatments.... Monday will complete the fourth week of her stay in Philadelphia and I am very lonely now, though I don't think that I'll worry her by writing that fact. Editorial directed against old Sir Caspar Purdon Clarke, Director of the Metropolitan Museum–hits a mark that needs hitting. This fossiliferous product of South Kensington Museum is the stupidest judge of paintings in power today I really believe.

February 7

In the evening, Mr. and Mrs. Lichtenstein came in early. He wanted the price list of the Eight ex. pictures now in Cincinnati, O. He says that the Tissot business is about closed out. Now he is trying to get out of it what it owes him. De Brunoff is in Paris and says he is not going to return to this country. After L.'s had left, Mr. and Mrs. Henri called. Henri was enthusiastic in his description of Dolly's appearance at the private view in Philadelphia. Mrs. H. said she didn't know Dolly could look so really pretty. It warms my heart to hear my darling praised. I know she's pretty to me, but others don't often see her as I do.... Henri's paintings invited to Phila. Ex. are all stuck in out of way rooms!

February 9

Delivered the second Pirate story drawings to Collier's and Bradley was very much pleased with them which takes that off my mind. Found it necessary to "call down" the officious lad in the hall at Collier's who was discourteous as usual. The Cerberus who guards the realm of Pluto, has three heads, this one has hardly one! In the evening, after dinner at Coddington's, I started a Puzzle.

February 10

Worked like an Indian all day, three hours with the model, and then for five hours after she left–trying to get a decent head on the

288

Miss Converse portrait. But N.G. is the verdict when I quit dead tired out and hungry. Still, stick at it is the word. I can't spare the time to paint again till next Wednesday. Kirby called–says he has a story from Good Housekeeping that he wants me to work on with him. I said, yes. Mrs. Ullman says that she saw my Dolly in Phila. yesterday looking fine and fat. Dad writes that she is looking well and fat . . . anxious to see her before she gets completely round. Worked on finishing Puzzle in the evening. . . .

February 11

Went out to mail Puzzle and as I had had no breakfast, I dropped in at the Caveau de Paris and got their 35 cent lunch. It was very good indeed, included wine–wonderful for the price! Made a sketch of the proprietor and one of "Maurice" the waiter which pleased them. The proprietor told me that George Luks and Mrs. L. had been to dinner several times . . . and had been asking for me . . . dinner later at Coddington's and then came to the studio and started on a bull dog drawing for the collaboration drawings Kirby and I are to do for Good Housekeeping. Dolly sends me from Phila. a very laudatory piece of newspaper gush about Mrs. Henri and her portrait at the Penna. Academy private view. I wonder if it is sincere–it is written by a woman and I rather feel that there is a touch or two of satire (if that is the word to describe it).

February 12

Went on with Good Housekeeping drawing and got it about finished– Kirby is to put in the final "licks" so that it may have the appearance of his work. I sent baggage tags as Valentine to Dolly, Mary Kerr, Nell Sloan and Mrs. Joe Laub–marked "You're it" and in all cases save Dolly's, I added the legend "I've got my fingers crossed" which means I'm married and therefore not to be taken seriously. Colored proofs of Pirate story and sent them to Bradley in a package roughly imitating Max Parrish's elaborately decorated wrappings which he puts on drawings for Collier's. I inscribed it:

There are others you see
 Besides M. P.
Who can wrap up a package
 With A.R.T.

February 13

This morning I have a letter from Dolly which says that she will come back Tuesday to stay till the doctor sends for her.... I will count the hours till she returns.... Kirby and I worked together all day right industriously on the drawings for Good Housekeeping. He put some touches into the Bull Dog drawing which I finished last night, which not only made it more like his work, but improved the drawing.... Came home at 12 midnight and worked for a couple of hours on one of the "Syndicate" (Kirby-Sloan) drawings. Kent Crane called this afternoon.

February 14

I spent the afternoon with the Ullmans and went to dinner with them. They introduced me to a cheap dinner on Third Avenue that is simply wonderful in its satisfying capacity. I never had so much for the money in my life and twenty five cents is the price. It seemed like aiding and abetting a robbery of the proprietor.... Turned next to cheap amusement ... proceeded to the Moving Picture on 14th St. ... At about nine o'clock, Henri and Mrs., with no less a person than J. Wilson Morrice of Paris, and rarely of Canada, turned up....

February 16

Dolly came home while I was out–she arrived before the time stated in her last letter, so that I had gone to the Century to talk over the Caspar Day (T. J. Johnson, a lady by the way) story. Well, we were happy to see each other and went to Mouquin's to dinner where we saw Lawson, Gregg, Fitzgerald, Johnston of the World, Campbell of Everybody's, Summerville who is now a successful reporter on the North American, Phila. Lawson told me that Tommy Knox died last week of tuberculosis and was cremated. Now rests in the Crematory Co.'s vaults in a $45. urn and now he's scarcely a memory–thus it goes.

February 17

Today was a happy day with Dolly by my side. We went to see the work of the Spanish painter (French trained) whose pictures on exhibition at the Hispano-American Museum *[Sorolla exhibition]* are creating a great deal of excitement (for New York) and are being everywhere praised. Well–they are dashing, full of color, but I abso-

290

lutely condemn them myself–as thin, and what's more, academic. This last criticism is perhaps remarkable, for they are very loosely, freely, brilliantly painted but the underlying principle is the regular academic one. The stuff shows no philosophy being expressed in paint. Their popularity with the general run of those who think they know, proves their clap-trap nature. I'm glad I saw them however for now I know where to put them. The portraits are awful! Among some 150 "thumb box" sketches there are the best works in the collection, not very many, but some good. Dolly cooked a good steak for dinner . . . made a Puzzle in the evening.

February 18

And now my little dream is over. . . . Dolly returned to Philadelphia on the 1:55 train. I had painted from the model all morning, then took Dolly over the river. Came back and dabbled with the canvas which I had started in the morning. Fair start, it may turn out all right. . . . To Coddington's for dinner and then, as I felt that I'd be blue if I came home to the studio, I walked out on Broadway and suddenly took a wild notion to go hear an opera. Bought a dollar ticket from a "speculator" outside the Metropolitan Opera House and soon was seeing my first grand opera (that is to say, first by a big good company) Gadski. Tannhäuser it was, and I was getting an airship view of it from the "Family Circle" (high enough in Heaven to be a Holy Family). It seemed to be good music and bad stage pictures combined–too much continuity everlastingness in the music. But the shepherd's pipe combined with the Pilgrim's Song in the second act got me. I filled with sobs and could have wept, in fact, I may say that I really did. Just this one point affected me, but I liked it all right well.

February 19

Got up very late after a lonely night. My loneliness seems to have been accentuated by Dolly's visit. . . . Davis called today. He is looking for a position again. Wants to get an assistant managership of art department of a magazine. . . .

February 20

This afternoon I entertained J. Wilson Morrice. No–he entertained me would be more exact. He is a curious old codger, not old, not

young, but always bald. He is tippling a little too much though. . . . I have arranged with him to send some of my etchings to the Salon [*Paris*]. E. W. Davis came and took me to dine with them at their boarding house in Newark, 51 James St. . . . a pleasant evening. . . . D.'s fortunes are a bit low just at present. . . . I came home from Newark to 23rd St. New York in less than half an hour by train and tunnel under the river.

February 21

By appointment with Morrice, I went to the Brevoort Hotel and he gave me a very beautiful little sketch. This he had promised me three years ago. With Morrice to Glackens' where I saw little Ira walk. This is a two weeks old stunt of his. He rares right up on his toes like a dancer. He proffered and I accepted a bite of bread crust. He likes people. Lawson and Gregg were at Glackens' also Mrs. Morgan. Left Morrice at the Breslin. In the evening, started a Puzzle. The Henris called and were surprised that Dolly had gone back to Phila. so soon. I think that some things I said will result in Henri sending to the National Academy exhibition though at first he said no. . . .

February 22

Miss Converse posed again today and I worked on the head, keeping about what I had at the last sitting and going on with it. The thing has some merit now. . . . to the Caveau de Paris for dinner. . . . Came home and finished up another Puzzle. . . .

February 23

I painted in a hand on the Miss Converse portrait today without model but finally scraped it out. Mrs. Crane called in the afternoon . . . went to Bayonne. After a nice stew dinner . . . home to New York, but felt restless so went to the Chinese restaurant and was glad I did for I saw a strikingly gotten up girl with dashing red feathers in her hat playing with the restaurant's fat cat. It would be a good thing to paint. I may make a go at it. [*"Chinese Restaurant," Encyclopaedia Britannica Collection.*] . . .

February 24

It is still bad weather. Miss Converse came and I put in a more decent hand and now have the thing finished. It has been on hand so long, constantly repainted, that I can't yet decide whether it is

292

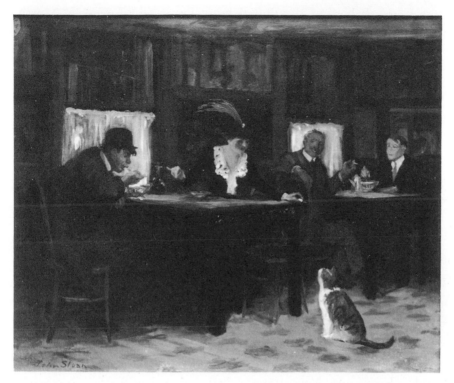

"Chinese Restaurant," 1909

important, but I'll send it to the National Academy jury, anyhow...
dinner at the Caveau again this evening... had another attack of
Grand Opera fever... dashed to Hammerstein's Manhattan Opera
house and got a nice fourth row balcony seat and heard Mary
Garden in "Louise." The first act I did not like her in, she fidgets
so much and every now and then through the performance, her
acting work brings a jarring cheap titter of mirth from the audience–
who don't seem to realize that Miss Garden is only giving the drawn
out edition of character playing which is better done by others on
the dramatic stage. The second act, with Paris lit up below the hill
of Montmartre, is much more suited to musical embellishment. On
the whole, I greatly enjoyed it....

February 25

The great incident today may prove a sort of critical point in my
life. A post card, written by some confessedly ignorant and anony-

mous "subscriber" of the Philadelphia Press, sent to me by March, Sunday Editor, with suggestion that it showed that people wanted easy Puzzles. It objects to fishes' name, women's wraps, and shades of red. Of course, this aggravated me. Then to cap the climax, later in the day comes the "names of Operas" Puzzle returned to me with a note from March–"too difficult for average reader." I thought the matter over for a couple of hours, then wrote to him and said that I would not do the Puzzles any longer unless they paid me for the Opera Puzzle, used what they had on hand, and began again with a system of my submitting the ideas before I drew them. I wrote to Dolly in Phila. telling her of this blow to our income. I know that she will take my view of the matter, come hard days or not. Sent Miss Converse portrait, "Girl with Fur Hat," "Night, Throbbing Fountain," "Making Faces," and "Picture Store Window" to the N.A.D. jury today. Davis called, also Kirby. I went to Collier's to see about color plates on the last Pirate story. Dinner at Coddington's, then to a ten cent moving picture show and home. I feel rather blue on account of the trouble with the Press Puzzles which mean $1250. a year to me, now, since the raise in price.

February 26

Today Kirby and I went on a little excursion to visit his partly completed house in Scarsdale. . . . His home is coming along rapidly and seems to be a very good plan, indeed. We walked from there to Mamaroneck, and as the day which had been cold turned beautiful, we enjoyed every bit of our walk. . . . I felt much benefited by the walk and tired, so that after going down to Thaler's Restaurant on Third Avenue and 14th Street to dinner, I came home and went to bed. . . . Miss Niles has written inviting us with Henris and Glackens to visit her and then go to Detroit by invitation of Mr. F. Freer and see his wonderful collection of Whistler's paintings and Japanese art. I am afraid we can hardly afford the trip.

February 27

A note from Press Sunday Editor, March, asks me to come to Phila. Tuesday at their expense, to talk over the Puzzle matter. This suits very well . . . can then come home with Dolly who has already signified that she is coming on that day. Davis called and talks of the possibility of getting an exhibit of the "Eight" for Newark . . . went

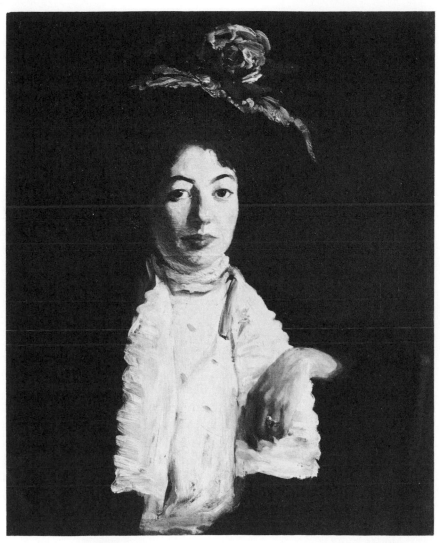

"Girl in Fur Hat," 1909

down to see Glackens in the matter but he was out. Davis asked me to Newark where we saw the exhibition of a local Artists Club. . . .

February 28

In the evening the Henris called as has been usual on Sunday evenings lately. He tells me that he sent two paintings to the N.A.D. jury and,

in looking over the notices, I find the name of Redfield in the jury list for the first time. This comes as a shock to me. I had not noticed the name, and, as he had never before served on a National Academy jury, it is unexpected. I think that I might have thought longer before sending had I known that he was among the jury. He has so openly opposed my work, that I feel there is at least that much less chance for my things to be hung.

March 1

Today I went . . . to Philadelphia, where I first went to Kerrs' on Arch St. Dolly and her cousin were out, so I went down and, at the Press Office, found that March was away. Came back and Dolly had arrived. We were glad to see each other again. . . . Dinner with the Kerrs and I stayed there all night to be with Dolly and also because I had not told the family in Fort Washington that I was coming and know that they are not the sort who are prepared for unexpected guests. In the evening, we went to a couple of moving picture shows.

March 2

In the morning I went to the Penn. Academy exhibition, which is rather unusually bad, especially in the prominent pictures. There is not one good painting in any of the places of honor, centre walls, etc. Henri's smiling gypsy child is about the best thing in the whole show. Met Anshutz, and J. E. D. Trask, the manager. . . . I take up my old burden of the weekly Puzzle which I had hoped was to pass from me though it is the only steady income I have. Dolly and I had dinner at the Rathskeller and then came home on 5:53 train. I'm glad to get her back–though Dr. Bower wants to see her again in two weeks.

March 3

Painted in the morning and became so hopeful and interested that I decided to have Miss Converse pose in the afternoon as well. Dolly asked her to lunch with us, and then I put in three hours more. The afternoon grew very dark, however, so that I did not get on as well as I had hoped–good excuse! Lichtenstein stopped in to tell me that the Eight show was to go to Bridgeport, Conn. after it leaves Pittsburgh at the end of this month. Later Davis came in and spoke

296

again of getting the show for Newark, N.J. In the evening, we went to Mouquin's to dinner . . . then . . . up town and call on the Laubs. . . .

March 4

The storm which we came home in last night turned out to be quite severe, especially in the South. The inauguration of W. H. Taft as President was much disarranged. . . . Washington is cut off by reasons of blocked railways and fallen telegraph wires. Kirby came in . . . tells me that Good Housekeeping (Fangell) is well pleased with our joint job, "Merriwether's Watchdog." We had lunch and then, with Kirby, went to see Davies' pictures at Macbeth's. I'd like to be rich enough to buy the whole collection. . . . Got some nice chops at Bisland's and had dinner at home and it certainly was good to have my girl back and sit at our old square table and eat with her there beside me. Started a Puzzle in the evening.

March 5

Finished and mailed Puzzle. Dolly had asked Lichtensteins to dine with us so she prepared a nice roast leg of lamb. They came and after dinner I told Lichtenstein that I would let him have the use of our reserve capital, $500., in order to help him secure the Tissot Bible business. He is absolutely certain that the books and portfolios will sell and I would be pleased to think that I had helped him at a time when help was necessary. We decided to cut Bridgeport to three weeks so that, if Newark wants the Eight show, they can open about April 28th.

March 6

Today I fell to work on that most difficult proposition–painting a portrait of Dolly–and I got a fairly good start, good general likeness. But I'll have to do the head again, it is not the thing I want of her. After dinner we went up to the Henri School and saw the first exhibition of students' work. . . . It is a very interesting lot of stuff. . . . Mrs. Roberts *[Mary Fanton]*, the editress of the Craftsman, was there with Mr. Roberts. We enjoyed talking with her, she is very bright and brings out the brightest things in one. Henri and Mrs. H., Dolly and I afterward went to Pabst's at the Circle and had a couple of glasses of beer. Just to keep us from being in perfect health. . . .

March 7

In the afternoon we tried another go at Dolly's portrait. It is not on the right move yet. After dinner, Henris came and a little later Mrs. Laub and Joe's sister Mattie.... Got out some pictures and showed them under the new "Street Light" *[gas]*.... Henri broached our old scheme of getting up a permanent Show room or Gallery–for about 15 men's work–to run for a whole year.

March 10

Entered for Carnegie Institute exhibition: "Foreign Girl," "Portrait of a Man" (W. S. Walsh), "Picnic Ground." I am sending my entries on the last day but the National Academy has kept me guessing as to what they have accepted. The Shipping Co. tells me that they have received as rejected "Night, Throbbing Fountain" but no other so far. Worked on Puzzles....

March 11

Worked on Dolly's portrait again but without catching it. Will try again, and again, and again! Kirby called, and as I had received the National Academy private view invitation, I asked him to attend tomorrow with Mrs. Kirby. Dolly went with Miss Pope to Henri's and saw a remarkable sight. The National Academy returned his full-length portrait, "Woman in Peignoir." I have not seen it, but the impudence of them! He could not possibly do anything as bad as some of the best pictures which will be on view there tomorrow!! The dogs. Redfield on the jury–"not up to Henri's standard." Reddy never saw a painting of Henri's that was up to this great "standard." Walter Pach called. Says that the "Gazette des Beaux Arts" (Paris) wants to borrow my copper plate (Fifth Avenue Critics) to print as supplement to his article. I wrote Peters in Philadelphia to send the plate to me. Sent Mr. Berg (530 W. 147th St.) my entry "Coffee Line" for the Alaska-Yukon Pacific Exhibition to which he invited it. Insurance price, $750. Jerome Myers called. Tells me that Sorolla, the Spanish painter, took $200,000. in sales out of this City!! As Jerome puts it–"a slap in the face for American Art." The furor proves their appeal to the ordinary taste.

March 12

And now the National Academy spring exhibition is opened to a hungry public. I went up to the Varnishing in the morning, where I viewed what seems a worse than usual show of paintings. I have three pictures hung and this seems remarkable luck–though they are above the line. Henri's "Picador" is the greatest painting in the show. Bellows has a good rainy day by the river uptown, Lawson had two good things, Glackens one. There is no Luks. I don't know whether he sent to the jury. Met Trask of the P.A.F.A. and had a short talk with Has. Morris, exhibition manager of the P.A.F.A., now interested in enlarging the galleries of the N.A.D. In the afternoon, Dolly and I, with Kirby, attended the crowded private view. The gowns on some of the women were immensely interesting–the high waisted Directoire style is in vogue. Met the Myers, and Mrs. Annie Nathan Meyer with whom I had a great deal of talk. Miss Pope took Dolly and me to dinner at Mouquin's. . . . Well, it was a tiring day.

March 13

Up to Henri's in the morning and spent most of the day with him, talking over the Permanent Exhibition Gallery scheme. His "Lady in Pink Peignoir" is a fine, beautiful thing, like a beautiful flower with all the finest spirit of womanliness. To think that this was rejected by the jury which formed the present N.A.D. ex. is disheartening and still, perhaps, encouraging too.

March 15

"Haymarket" returned from Nebraska ex. I delivered the three pictures entered for Carnegie ex., Pittsburgh to Budworth carters. Painted on second Miss Converse picture this morning. In the afternoon, I started a memory painting of the Chinese Restaurant girl I saw some four weeks ago. W. Pach called and I delivered the copper plate "Fifth Avenue Critics" to be forwarded to the Gazette des Beaux Arts in Paris.

March 16

A "party" at Shinn's. We attended. I found myself in plain clothes among a lot of people in evening dress. Gorgeous gowns, beautiful figures displayed by the present marvelous style, the high-waisted

Directoire. Rose Cecil O'Neill Latham Wilson the illustrator, buxom and child faced after two marriages. Her sister, who danced Spanish dances, plump breasted, hipped and thighed. Arthur Ruhl, special writer of Collier's, I met for the first time. An architect named Barber and his wife who is a Philadelphian, daughter of James Stoddard, editor of Lippincott's for many years. He was a friend of W. S. Walsh's. Wallace Irwin was present, he is fat faced. An English actress of the ultra modern type, her skin swathed in red by her flesh well in evidence so tight fitting and clinging was the gown. Gave a Dolly Dialogue by Anthony Hope. It was most dull. Shinn had told me to bring my black gloves and "do Parkhurst" which I did without coaxing and without fear. A Parkhurst stunt of my younger days when Parkhurst's beard was black–few noticed it. Shinn, bright swathed in red cheese cloth, parodied Miss X. in a recitation. N. C. White was there and strummed the guitar. Paul Armstrong, the playwright, and his wife were among the celebrities. Prestons were there and Glackens. Glack looks more and more character. . . .

March 17

Today at 1:55 P.M. I parted with Dolly in Jersey . . . en route to Philadelphia to report to her Doctor, so now I'm alone again for a while . . . walked back 23rd St., went in and sat with Kirby . . . had dinner at Thaler's, a large meal for 25 cents. Ullman came up and talked of the scheme to incorporate an art exhibition and then get patrons and patronesses to furnish the funds. The green flag with the harp is most abundant on the street today, probably more so than in Ireland.

March 18

Drew $500. from the Savings Fund account, nearly all our reserve, and took it to C. B. Lichtenstein who gave me his note, four months, 6% for it. Also his check for the 4% interest on the period broken into by its removal at this time. This loan will enable him to acquire the Tissot business as his own property, and I hope both for his sake and the sake of our own money, that he will make a success of it. . . . Met Davis at Lichtenstein's, who was talking over the possibility of an exhibition of the "Eight" show in Newark during May. Painted on my "Chinese Restaurant" picture girl with red feather–and went to the restaurant for my dinner to refresh my memory of the place. Just in time, for tomorrow they move to the corner below (29th St.).

Dolly writes that she only saw the doctor a few minutes yesterday, so cannot tell me the probable date of her return home. Old Davis at the studio while I was working said some very flattering things of my work. He feels that my city pictures are important. I hope so, and it would be pleasant to find some picture buyer with the same opinion. Note from Mrs. Glackens asking me to dine there Sunday.

March 20

Finished up a Puzzle. Kirby brought a model, a tall German girl, in to pose for him in my studio–his own is hardly large enough.... Arthur B. Davies called to ask about the "8" show.... Just a few minutes after he had gone, Mr. Hartley called *[Marsden].* He had come once before while I was out. Dolly saw him. She had met him at Henri's. Prendergast sent him down to meet the crowd and likes his work. Done in the mountains of Maine, he says. I am to go to the Glackens' studio Tuesday P.M. and see some of it....

March 21

Made a start on the "Boy, Girl and Union" story for the Century, just a start. Then dressed in evening clothes and, at 6:30, went to Glackens' for dinner. *[Sloan always believed in dressing neatly and properly. He thought it was affected to wear Bohemian dress, or to pretend to dress like a day laborer. For the openings of the Society of Independent Artists, he always came in tails.]* Mr. Ernest Gros (or Emile Gros) the scene painter was there and the Shinns. We had a very splendid dinner. After dinner Lawson, Johnston of the World, and E. Fuhr came in, and later, the Morgans who have the apartment above the Glackens also joined the circle.

March 22

Accompanied by her Mother, Miss Vida Talbot, aged 14 (looks 17), came to pose for me today. It was a curious experience. The old lady sitting in the background and chatting with me on matters of art, giving me "glimpses" of "better days," in her past life. She keeps a boarding house now and is, I suppose, a very estimable mother. I worked five hours and have done what seems to me at this short range a right good head of Vida, who, by the way, is "preparing for the stage."

March 23

Went to Glackens' studio to see Hartley's work. It is broken color "Impressionism." Some two or three canvases I liked—the more sincere nervous sort. Some of them seem affectations—the clouds especially like tinted buckwheat cakes. The work had, however, several good spots in it. Met Shinn at Glackens'. Everett doesn't like the Hartleys even a little bit . . . took my lonely way to 14th St. and 3rd Ave. and had my humble, frugal and altogether satisfactory 25 cent dinner. Walked home and spent the evening agreeably alone—writing a letter to Dolly. . . . Worked on Century drawings.

March 24

Mr. White, who writes on art for the Newark News, called on me today. Davis had sent him and he turned out to be a very entertaining caller. I showed him some of my stuff which he seemed to appreciate. He spoke of the Zuloaga paintings which are now being shown at the Hispano-American Museum. We agreed that the Spaniard sets out to see things as Velásquez and Goya saw them, rather than to see them for himself. He tells me that Macbeth is showing a collection of Henri, Luks, Blendon, Campbell, Hawthorne, and Millar. What a hodge podge!! I must go and see it. Worked on Century drawings.

March 25

Davis called today. He suggests that Henri make an address in Newark on the occasion of the Eight exhibition there. Seems to me a good idea and I am to ask him about it when I see him. . . .

March 26

Today Kirby came in. He has had an attack of the grippe . . . joined him . . . first at a moving picture show and then went to Macbeth's where we saw Henri, Luks and a bunch of rotters shown together. The contrast should educate the public but it won't—they will like the rotters best! Dinner next door and in the evening worked on Century drawings. What hope is there for Luks, and Henri and other good work? We live in just the worst possible period. The wonder is that such men have been produced from the loins of this age in America. . . .

March 27

Hartley dropped in and I had a better chance to become acquainted with him. His mysticism is a little too much for me and I hope it won't prove finally too much for his pictures. . . .

March 28

Miss Pope was kind enough to call this afternoon. . . . I am to call for her Tuesday P.M. and take her up to the Zuloaga show at the Hispano-American Museum. She has seen it and likes the stuff better than that of his so successful compatriot Sorolla . . . with Ullmans to dinner . . . came home and the Henris came. H. has a cold but seemed to cheer up. He liked my "Chinese Restaurant" very much. We talked over the proposed gallery scheme.

March 30

Delivered the "Boy, Girl and Union" drawings to the Century and they seemed to be well pleased with them. Charged $110 for the three. After dinner at Coddington's, I went, by appointment, to Miss Pope's studio and saw some of the things she has been painting. There is really very good stuff in her work. . . . We went together to see the Zuloaga paintings up town. I was rather disappointed. His stuff drifts here and there under different influences—now Velásquez, now Goya, now Greco. . . .

March 31

After an hour's encounter with a book agent, I came off uncaught. Good! Miss Sehon came in and in the course of our social chat, I asked her to pose Saturday, she agreed. I can use her on the "Repentance" story for Century. The day seems long to me, and kind o' dreary, because I'm looking forward to tomorrow when Dolly will, if all is well, come home to me. I enjoyed reading again, after many years, Lewis Carroll's "Through the Looking Glass" of Alice and the Queens and the Gnat and Walrus and Carpenter and the White Knight and all the dear queer peoplets in that beautiful work. I read it through in the evening. Old Tenniel's faithful classic drawings seem just right. They have grown fast to the book like moss to stone.

303

April 1

Spent the day waiting for 6 o'clock to come, then to Jersey City and met my little girl.... We had dinner at Shanley's and then went up to Henri's and spent the evening talking over the Independent Gallery or Exhibition scheme.

April 4

Henris have invited us to dinner, so we joined them at Pabst's up on 59th St. where we had a right good dinner. Then went with them to an exhibition in the Henri school. Some very interesting work by pupils. Henris came back to the studio with us and sat till about 12 midnight.

April 6

A.P. & S. Co. called for the "Coffee Line" for the Alaska-Yukon Pacific Ex. Put price of $750 on it. Dolly and I went out shopping. Ordered a new spring hat for her, bought myself a pair of shoes. A very lovely spring day. We were on Fifth Avenue and were entertained at great expense by some of the wealthiest people in New York who showed us their gowns and gay hats and automobiles and carriages and servants, all of which display we enjoyed much. Lichtenstein called. Says that he assisted in hanging the "Eight" show in Bridgeport, Conn. yesterday. L. says that he has not heard definitely from Newark in regard to the exhibition going there.

April 7

Davis called. He is engaged in getting advertisements for a special edition of the New York American. Mrs. Jerome Myers dropped in with little Virginia, who is doing finely, fat as can be ... went to Bayonne to the Cranes for dinner. Met with a poor woman, Hungarian, who needed just $1. to pay for a ticket to McKeesport, Pa. She had $8 but the price was $9. I made up the difference, saw her get the ticket and Dolly placed her in charge of the matron in the Jersey Central Station in Jersey City....

April 8

Miss Emily Perkins came to solicit a contribution in the way of a drawing, etc. for the building fund of the Philadelphia Plastic Club,

a lady artists' organization. I gave up a set of etchings, stipulating that they should not be sold for less than $25. the set. She agreed. This is an example of my sort of foolishness. I am not in sympathy with the Club, nor with any club, for that matter. C. Wisner Barrell called about 5 o'clock. Dolly asked him to dinner. He accepted, and we talked (on Socialist themes mostly) till 11:45 P.M. Feeling a bit out of sorts today.

April 11

In the evening, Dolly and Mrs. Ullman and I went to the 3rd Ave. restaurant. Ullman was out of town. Henris called later and we talked some of the gallery scheme. He did not seem to be very well. He is to paint at Haggin's studio tomorrow from a ballet dancer who is posing there for Haggin. Haggin gets a free lesson in painting.

April 12

Lichtenstein called. He has been to Buffalo on business. Kurtz, the director of the Buffalo Art Museum, has just died–after having had the Sorolla pictures there, felt that his life work was crowned, I suppose! Well, "tis an ill wind, etc.," for his assistant, who is going on with a Buffalo–St. Louis six months exhibition, asked Lichtenstein to have a picture sent by each of the "Eight." They already have a Davies. I promised him the "Chinese Restaurant–Sixth Ave." just about finished.

April 14

"As a personal compliment to Mr. William Macbcth and as an expression of appreciation for what he has done for American painting, a number of artists associated with Mr. Macbeth have decided to tender him a dinner" and so on. Signed: Charles W. Hawthorne, Paul Dougherty, A. V. Jack, Secy. The letter from which the above is an extract reached me this morning and I know by the hot resentment that rose when I read it, that I would not be one of those present at $5. to compliment Mr. M. by eating in his presence. Sycophants–in the lead of the suggestion–and others who just drift along thinking it the better policy. I will not attend.

April 15

Worked on Century drawings. In the afternoon, Barrell called and he and I took a walk. And as we walked we talked on Socialism. He is, of

course, a thorough advocate of the cause–and I can't help feeling that the movement is right in the main. I am rather more interested in the human beings themselves than in the schemes for betterment. In fact, I rather wonder if they will be so interesting when they are all comfortable and happy. . . .

April 17

Today we went to Coytesville and took Henri and Mrs. out to see the place. M. Richard, we found busy at his vegetable garden. He was glad to see us and stopped his work to make us a fine "Omelette au fines herbes" for our lunch. . . . Henri said the setting of the lunch, the food, the wine–took him back to days of his youth in France as an art student. Mrs. H. rather jars. This evening the sycophants give the dinner to Macbeth. Henri has sent his $5. but when I left him at 7 P.M. he had not decided fully to attend the dinner. . . .

April 19

Alas! Alack!! A polite printed regret from Carnegie Institute, Pittsburgh–tells me that the three pictures I sent to the International Jury–have been rejected! Schofield and Redfield were on. Henri has a note from Scho, saying that he'd be in New York Friday and would sail Saturday. It actually makes me have a twinge of a bluish twinge to be kicked out entirely in this way—but, "Portrait of a Man" (W. S. Walsh) is surely a good picture; and so is the "Picnic Ground." Yes, and so is the "Foreign Girl" (Stein in profile). So, what's the difference. I'm not painting to suit these people so why should I be downcast when I don't please them? Dolly and I went to Guffanti's on 7th Ave. for dinner. . . .

April 20

Made another Century drawing. Today is chilly and rainy. . . . We expect Henris and Lichtensteins to dinner. . . . After dinner we talked with Lichtenstein on the subject of a Gallery. He proposes that three or four rich men be found to furnish the funds–that they appoint a manager in charge of the funds. The expenditure to be only for stipulated purpose of rent, maintenance, salaries for manager and assistant. Profits to go into a contingent fund. The works shown to be invited by the Eight, and subject to their judgment so that the shows will be expression of their judgment.

306

April 21

... Dolly and Mrs. Ullman and I started to go to the Opera House, Eighth Ave. to see Genee the dancer, but we found that the matinee prices were not as low as we thought. So we went and had cakes and coffee at a bakery. I went in to Kirby's next door and met W. Balfour Ker for the first time. His studio is next Kirby's, his work, which he does easily and rapidly, is not good–full of detail. Seems strange that a man of this facility would not let out a peg or two and think bigger. Started a Puzzle in the evening. Wrote and invited Schofield to come here Friday and stay Friday night. Henri has asked him to dinner with them at Pabst's. Scho sails for England his home, Saturday A.M.

April 22

A circular from the National Academy of Art, a Washington organization–announcing a convention of art societies and other artistic organizations to form a National Foundation of Art Societies–sort of an official Art Trust–to meet in Washington, D.C. May 11–13. To officialize and regulate and systematize Art, to get the majority opinion on matters of the mind–to level things–! Schofield came today ... he missed the Pittsburgh jury meeting. So Redfield had things all his own way, without observation. This probably accounts for my things "all out."

April 23

Scho left in the morning. ... Henri and Mrs. H. came here about 11 P.M. ... Schofield asked me if I'd accept membership in the Society of Painters, Etchers, London. Said that Alfred East might propose my name. I gave Scho a set of my N.Y. Etchings so that he could show samples. ... Schofield is the private agent (confidential) of the Carnegie Institute, Pittsburgh, in England, France and Germany this year. He is to watch out for good paintings in the foreign exhibitions and let Beatty know of them.

April 24

After a three and a half hour "nap" we rose. Dolly got breakfast and I went down to the Minneapolis and saw Schofield on board. A nice clean big boat, very attractive. Watched her pull out into the North River and start away. The crowd on the pier was not great; not many pas-

sengers. But it was a beautiful sight. . . . Scant sleep for two nights past
has used me up a bit. Dolly and I went to "Maria's" for dinner. Then
she still had enough lift in her to take her way up to the Liberal Sun-
day meeting at Carnegie Hall. From there she went to Laub's and with
them to Dorlan's Riding Academy. Heard Davenport talk. . . . I was
not alone in seeing Schofield off. . . . I met J. M. Beatty who is the art
director of Carnegie Institute, Pittsburgh. A cheap kind of good fellow
(with Schofield, whom he respects); a "that reminds me of a story"
sort of man, probably well suited to contact with the National Acad-
emy sort of artist. In the ten words I heard him speak, I gathered the
positive knowledge of his ignorance of art (in the real sense of the
word, not in the clouds).

April 25

We made up our losses in the slumber line. . . . Joe Laub and Mrs.
dropped in to see us. . . . The Lichtensteins called in the evening. He
is to tell Newark that we will help hang the "Eight" show when it
comes there next week.

April 26

Delivered four drawings for the Century today. Drake says they will
send photos to the "author for approval." (Land Sakes! a new wrinkle)
before I get my money. Judging by the story, I don't feel that the
author would be capable of good criticism, which the drawings justly
deserve, but there may be haggling over details. After dinner at home,
Dolly and I went out and priced things at a couple of theatres but did
not buy seats. We went finally to moving pictures.

April 27

Kirby came in and I went in next door with him. . . . F. D. Steele came
in while I was there *[Frederic Dorr Steele, illustrator]*, also Balfour
Ker, whom I invited to come in and see my Daumiers. I went up to
the Gas Office at 125th St. to see about my return of 20% since the
courts have decided that we are to have 80 cent gas since May 1906,
they owe me about $20. . . .

April 28

A good day's work, painting on the subject that has been stewing in
my mind for some weeks. I have been watching a curious two room

household, two women and, I think, two men, their day begins after midnight, they cook at 3 A.M. *["3 A.M.," in the collection of the Philadelphia Museum of Art. In Gist of Art, Sloan comments on this painting: "Night vigils at the back window of a Twenty Third Street studio were rewarded by motifs of this sort; many of them were used in my etchings. Some of the lives that I glimpsed, I thought I understood. These two girls I took to be sisters, one of whom was engaged in some occupation that brought her home about this hour of the morning. On her arrival the other rose from her slumbers and prepared a meal. This picture is redolent with the atmosphere of a poor, back, gaslit room. It has beauty, I'll not deny it; it must be that human life is beautiful."]*

April 30

Dolly went to Newark to Davis's and I followed after with Davis. . . . Dinner in the boarding house with them. After dinner, Davis and I went to Market Street, Newark and he phoned the editor of the Star, telling him that the Fight exhibition opened next week and that they should get some photos of the paintings and have a notice of the show. Drake, the Century, sent back one of the last drawings I delivered. Said that the author was right well pleased but—one of the women might be so and so—etc. Lichtenstein phoned that he has had two or three places offered for our gallery scheme, one of them, J. P. Morgan's Stable on Madison Avenue.

May 1

Nell Sloan attended the Plastic Club sale to see how my etchings went. She writes that the sale was not finished Thursday, will be continued some day next week. I feel sorry I gave the etchings as they will probably not get any decent figure for them. H. W. Kent who has written in regard to a drawing for a calendar to be issued by the Greenwich School writes to tell me that he will call some day early next week. Mr. G. C. Hamlin (Miss Garrett's husband) dropped in on a business trip to this city. He treated us to a lunch at Mouquin's which we enjoyed. Kirby called and wanted me to look at a drawing so I went in and took my Century drawing for his criticism. We exchanged comments (favorable). . . .

May 3

Met Henri and Lichtenstein and we went to Newark Public Library, to assist in hanging the "Eight" show. The pictures were of new interest after their long absence in the West. We put in a rather tiring day. The ladies, Miss Winser in charge under Mr. Dana, "a remarkable man" who is "unfortunately away today." Everyone is quite intellectual and I think they were disappointed at our not being frock coat, high-hat nor long-hair flowing-tie artists.

May 4

Vlag a Socialist from the Rand School called and took away a set of etchings in frames and a set loose for sale at $75.00 ($25.00 per set; $5.00 each separate) to be exhibited in an exhibition at the school beginning May 15th. The school to get 25% of the selling price. Again the building wherein our attic is contained has been sold. B. J. Faulhaber & Co. (206 Bway) are the agents and introduced themselves today—to collect the rent. Paid them and said I wanted some painting and papering.

May 5

Vlag came again today and brought Herman Bloch who is art writer for the Socialist daily newspaper "The Call." I was glad to meet him. Told him that I had no intention of working for any Socialist object in my etchings and paintings though I do think that it is the proper party to cast votes for at this time in America. Bloch is soft spoken and not as alert and practical as Vlag. Bloch speaks of a man being religiously interested in his work. This may mean well but does not sound "healthy" to me.

May 8

Henri, Lichtenstein and I spent the whole day looking at top floors which would be possible situations for a gallery. On 36th St., 11 West, we saw the thing that seemed most desirable, a rental of $2,000.00 a year. Good skylights. We (Henri and self) finished the afternoon as L. had to go to his office. Walked down Fifth Avenue, beautiful afternoon, all the display was out. I came back sort of full charged with it and started to put some paint on canvas on the theme. Got a right good start. Dolly baked a fine big shad, a Delaware shad, which was

very good indeed. I must some day try to see a rich woman leaving vehicle and crossing pavement to enter a Fifth Avenue bank,—must be something in it to note.

May 10

Walked out and mailed two Puzzles to the Press. Loafed about Madison Square where the trees are heavily daubed with fresh green and the benches filled with tired "bums." In the center near the fountain is a U.S. Army recruiting sign, two samples of our military are in attendance but the bums stick to the freedom of their poverty. There is a picture in this—a drawing or etching, probably. . . .

May 11

Today the Gas Company sends me a Refund check for $20.01, in obedience to the order of court which decided that 80 cents was the legal rate since May 1906. No interest on the excess money which they have illegally forced consumers to pay (at $1.00 per thousand). I walked down town and avoided being called as a jury man. My excuse was "correspondent of a Phila. newspaper." He asked was I a reporter, an editor. I said no—an artist. This seemed to make my excuse sufficient.

May 12

I have been much interested in reading a copy of Horace Traubel's *Conservator* which was sent to me lately, so today I sent in my subscription for one year. Painted on the Fifth Avenue picture. A Miss Evenile, model, came in and I used her for one of the figures. Worked again on the "Tenderloin" and think that is now about in final shape.

May 13

Painted in the afternoon. Started a City Square with Recruiting Service sign displayed among the "bench warmers." After a nice dinner at home I went up to see Henris in the evening. Went alone as Dolly was not feeling well and was busy dressmaking. Henri showed me a new full length of "Marjorie." It is a very good thing, the best thing he has painted of her in my opinion. A shawl wrapped around her, a perfect portrait and a work of creative imagination or selection. Lichtenstein told Henri that the people who want to rent us the Morgan Stable on Madison Ave. had called on him and had practically offered a three

311

year lease and the alterations in the bargain–this seems to be first rate. Davies and Henri went to the 36th St. place and Davies approves of it.

May 15

"Comrade" Vlag and "Comrade" Zimm(?) of the Socialist Party called on me today in regard to getting some more drawings for the Rand School exhibition. Comrade Z. thinks that he knows much about pictures, I suspect. He is one of those men who are a little of *my type* of *face*–and whom I always dislike.

May 16

We dined with Henri, Mrs. H. and her sister "Vi" whom we met for the first time–a quiet dark haired dark eyed little girl. Older than Mrs. H. so she says, but don't look it. After dinner at Pabst's we went up to the school and saw an extremely good exhibition of the students' work. A remarkable collection of things as Mrs. Roberts (Giles Egerton) of the Craftsman said. "This is the thing from which the American art of the future is to spring." Henri is very proud of the show and he may well be. Of the students I met Miss Robbins from Colorado, Miss Tighe(?), Miss Elmendorf who has some very good things here. A girl from Texas she is and an interesting face. Talked with Bellows, one of Henri's "arrived" pupils, a very clever painter.

May 17

Getting ready to meet Henri and play golf. A phone message came from Bradley at Collier's so had to run down there first. He handed me a third Pirate story to do and a three section article on the "Loan Sharks" (usurers). So feeling well content I went with Henri to Van Cortlandt Park and we enjoyed a good game of golf. Not good in the quality of our play but enjoyable. A fine gray day, just cool enough. We went all the way by subway train in about 40 minutes. (Our score about equal, we had not pencil or paper.) . . .

May 18

. . . After dinner H. W. Kent who is a secretary or something in the Metropolitan Museum, called. He bought a set of my ten N.Y. etchings through Jerome Myers, two years since. He is a very pleasant man, one of the brightest men in his knowledge of prints etc. I have ever met. I gave him for use in the Greenwich House calendar a drawing of

312

a Jewish woman sweeping a roof. I must sometime make an etching of the long studio wall at night with Dolly working on the couch.

May 21

The weather has turned chilly again and damp—very depressing in the effect on me. I can't get at work. Very much interested in reading Oscar Wilde's "Soul of Man under Socialism"—his plea for individualism, had a strong tone to it, quite convincing. Read the platform of the Socialist Party on which Debs ran last fall. Can't understand why the workers of the country were so disinterested or intimidated as not to vote en masse for these principles.

May 22

This evening we had Mr. and Mrs. Roberts with the Henris at dinner. Dolly cooked an elegant big steak with mushrooms which was delicious. After dinner, Mrs. Roberts . . . looked over my De Kock etchings and expressed her approval. Mr. R. is an editor of the Literary Digest and a very pleasant and gentle man.

May 24

Golfed with Henri in the morning, started early. He tells me that Mrs. H,2 is thinking of starting at the game–a proposition which I received without enthusiasm as I can recall how two years ago he objected to Linda Henri or Mrs. Sloan in the game. Strange how a man changes with a new wife. I made a Collier drawing over again in the evening and it is better than the first. The agent of the property writes that he has communicated with the owner and that repairs will be done by the 10th of June. I fear that I will have trouble getting anything done now the property is a speculation and changes hands so frequently.

May 25

Dolly left for Philadelphia today. I saw her to the ferry for 9:55 A.M. train. Then met Henri and Harris and went to Van Cortlandt Park and played all day. Home and then to Renganeschi's for dinner. After which I dropped into Jefferson Market night police court. After seating myself I changed my seat and was ordered back by the (Irishman) officer in attendance. Held my temper and by waiting and watching

found that I had gone to the women's side of the room which explains my being ordered back. He would not have explained and I knew it. My heart melted one minute and grew red hot the next. These petty offenses with their small fines great sums paid for in jail at the rate of one day's imprisonment for $1.00 fine are dreadfully hard. Poor little women, habitual drunkards, get "fine $10.00" off hand with a kindly smile from the judge—good humored! They have no vote. The yell from the Irish "cops" at any discharged prisoner "Take off your hat!!" if he chances to put it on too soon in leaving the bar. These mean reverent Irish police and court officers.... Dropped in at the Grapevine, met Arthur Ruhl of Collier's Weekly and being full of rancor of what I had felt in the Night Court, I shot a lot of Socialistic (I suppose) resentful noticings of mine, at him. I suppose he thought me a radical fool.

May 26

Read some of Whitman's "Song of Myself." Then out for a walk in the sunshine. This seemed good after the exercise of the last two days at golf. Sat in Madison Square. Went to Harbison's book store. Picked up a nice two volume edition of Taine's "English Literature" to replace my present one volume copy. I saw a mother explaining to her little son (about six years) the vastness of the Metropolitan Insurance Building tower. He was not apparently impressed! Hardly considered it big. He would have thought an elephant much bigger, or a great Dane dog.

May 27

Notified agent B.G.F. & Co. that I would hold the owner of these premises (165 W. 23) strictly responsible for any damage to my effects which may result from the delay in repairing the roof etc. Kirby called. I got into an argument as to whether it was immoral to break laws. I held that it was not essentially wrong to break a law, that one might commit a greater moral wrong by obeying a law,—a bad law. Down to Greenwich Village to Renganeschi's for my dinner, enjoyed it. Then loafed through Greenwich Avenue. Saw a fine thing: six or seven little girls dancing around electric light in front of the prison tower of Jefferson Market Police Court. Lights from the barred windows of the "Conciergerie." ... Letter from Dolly today, says that Dr. Bower tells her she is in much better shape which is good news.

May 29

This day leaves me feeling defeated ("pro tem" I hope)—made a Collier drawing which I realize is right bad. . . . Potts dropped in and while I went on with my drawing, he and I argued on the Social problems of the day! He seems to think what's the use of trying to do anything to better the workers—they are not worth it. The rich have the money because they have the brains to get it—the others haven't the brains so they must pay the penalty. I feel that if 5,000 people in this city are wealthy and content and two million are unhappy, something is wrong. At any rate, the drawing I made during the evening is rotten!

May 30

I went up to Henri's as he had invited me by phone yesterday to take dinner with them. I got them to go to Renganeschi's. Mrs. H. was born just around the corner from West 10th St. on Waverly Place. We walked up Seventh Avenue and to my place where they stayed till 11:30. H. is in an unsatisfied mood over his work. Says he needs more golf, more health. I can match him in the feeling of dissatisfaction though physically I feel right fit. I lack vigor of attack on my work, in drawings.

May 31

Memorial or Decoration Day is observed today. There were great wagon loads of children being driven to a day's outing in the park. Reminded me of loads of cattle going to slaughter houses. Very beautiful they were, in light colored dresses, packed together—like flower beds of youth and beauty—but, ultimately, for the slaughter. A hot day— some of the wagons had but one poor beast to draw them, no holiday for him! After dinner I got to work and made one of the Collier drawings over. It seems better than the other.

June 1

Henri and I met at 8:30 A.M. and played golf all morning. I came home tired and hot, took a bath and then a nap. Waked by Barrell—I had left my keys in the door! He and I went to Renganeschi's for dinner, sat a long while. I got much strengthening in my Socialistic trend. He is well informed on this subject, really, has studied economics for years. He told me of the passage (very quietly) of a bill in 1903 Jan. 14th,

which makes every able bodied citizen subject to draft for militia—and can be therefor sent to subdue strikes in any state. Philippines or Porto Rico. We parted at 23rd St. ferry at about 11:30 P.M. We dropped in to the Night Court. Different judge on bench from the one on my first visit. It seems to change the rules of procedure a great deal. More disorder, less severe discipline under the judge. I don't know what his name is. . . .

June 2

Note from Newark Library says paintings of "Eight" exhibition will be returned tomorrow afternoon. Note from Lichtenstein asks me to write them Lawson's address but as I don't know it I wrote that. Went out and looked at a couple of places, as I'm thinking of moving again. Hear that this building has been sold again. Last owners only held it about five weeks. I can't even get them to fix the leaks in the roof. Worked on Collier "Loan Sharks" picture in afternoon and evening.

June 3

Kirby and I took quite a walk, first to Collier's where he delivered drawings, then over to the Glackens' studio—but Glack was not in. . . . We then walked up Fifth Avenue and through on 22nd St. where is Phong Fat & Co.'s (Chinese Importers). I bought for Dolly a pretty little kimono and slippers mailed them to her. After I came home the pictures from the Eight show in Newark arrived and though the carter said he would not deliver them up four flights of steps, and though I got "mad"—we afterward through a political turn to the talk grew more calm. I tried to convert him to Socialism but he is of the contented sort. Has a little home of his own etc. No revolt in him, and no care for his fellow workers' well being. At any rate the pictures were brought up (I carried two myself) and now the ten of them are back from their nine months and more journey through the cold, cold world "unwept, unhonored and unsung." After dinner, a bad one for 25 cents—I went and saw a moving picture. The Wilbur Wright machine in motion, pictures taken in France. Wonderful. An epoch mark, surely.

June 5

Another morning of rain. A note from P. Vlag took me to the Rand School where he had the agreeable news for me that he has sold a set

of etchings, separately. He gave me a check for $18.75 as agreed on. There met Eugene Higgins who etches and paints the melancholy in a sort of genuine Julien Academy composition manner, a black mass, a mass of middle tint and a light mass. He is rather an agreeable man personally—they always are, unfortunately. A letter from Dana of the Newark Library. Thanks for the Eight ex., says it was appreciated, etc. Dolly writes that she was much pleased by her kimono and slippers. Dearest thing in the world to me, she is. I'm glad they suited her, though I know anything I sent her would do that. . . .

June 7

Well 'tis a fine Monday surely! After Henri and I had played golf at Van Cortlandt Park and I had made a particularly bad score, I came back and took the drawings which I have made for Collier's and showed them to Bradley. He did not like them. Now in the case of two or three I feel they are fairly good but I can't "stick up" for half of them. I brought them away to see what I can do to better them. Met Joe Laub. He tells me the secret that Bradley leaves there after July 1st. I'm not so glad of this, for he has always been just to me, and is a better judge of work than most even if he did just "turn down" this batch—he is practically right.

June 9

. . . Will the great mass of the workers, when they find the power of the united vote, stand for differences in the rewards between their ordinary labor and mental labor? Of course all will have every necessary to existence, and comfort—but should not the higher faculties have some higher reward? Or is this feeling in me, only a surviving view of the present upper class feeling?

June 12

Just fussing around during the day. Took down the stove and stove pipe. Pushed the stove to the side of the studio, makes it look more like summer and the weather today justifies the look for it's quite warm. After dinner at Capp's next door I got at one of the Collier drawings and made it over. Looks as though it would suit better for their purpose. The Evening Sun prints Edward Everett Hale's (just died, quite old) "Man without a Country." I am too old or too much convinced

of the Socialist anti-military principle for this highly impossible tale to move me to a love of the plutocracy's government. Why should the workers fight each other in order to preserve or expand or destroy the trade relations in which they have no real interest? Suppose we agree to call this country a province of England or France or Germany? Does it make any difference to me? or to any laboring man?

June 13

Today redrew another Collier drawing and, I think, improved on my first. It really is a chastening and salubrious treatment I'm going through making these over. It will do me good, like a good spanking.

Henris called in the evening. H. is full of a scheme of color, a new set of pigments made by a man named Maratta. *["The palette is an instrument that can be orchestrated to build form. If we stumble around in colors we are like a musician who would have to tune every note on the piano each time he sits down to play or compose. I liked the Maratta colors because they provided the painter with a battery of pigments that were accurately mixed. We had twelve 'full colors' around the color wheel (a triangle is more accurate for purpose of mixing because there are only three primary colors, red, yellow and blue); twelve semi-neutral colors, and twelve neutrals very low down in the scale of intensity. With these twelve major notes, we could plan color chords, similar in some ways to those of music. For instance, a 3–4–5 chord might go from yellow to blue-green to red. I painted hundreds of landscapes, portraits and other subjects—and no two of them have the same color scheme. Before starting to paint, I would decide on a point of view about the color, whether it was to come out of a tonality (chiaroscuro) or perhaps I would emphasize some dominant colors with neutrals for foils. If the limited palette I had chosen to work with proved inadequate to get the kind of plastic realization I wanted, I could always open the palette up, using some of the colors that had been held in reserve. If you use all the strong colors and most powerful contrasts of light and dark right at the beginning, you have nothing extra to fall back on when you need to invent a more powerful or more subtle way of creating form."]* A regularly gradated sequence; red, orange, yellow, green, blue, and purple with the same "intervals" and a low keyed set of "hues" of the same colors. Henri thinks there are great possibilities. The palette which a painter uses now, certainly has big jumps in it.

318

June 14

Henri and I went out and played golf. I played particularly badly but got a good bath of six hours in fresh air and sunlight. It makes me feel physically fit. Pretty well tired out and feeling like a good dinner I walked down to 10th St. thirteen blocks and looked forward with appetite to my arrival at Renganeschi's. But at the corner of the street (10th) I remembered that I had left my money in my other clothes. My heart sank, my stomach groaned, I had not a "nickel" even so had to walk back. Too dispirited to go there again, I dined very well next door. Made a Puzzle in the evening. . . .

June 15

Up to Henri's this morning and saw the new Margo colors. The scheme looks good to me. Henri says that Mr. Maratta will call on me and talk them over. I may get a set and try my hand, no reason why a man shouldn't get the habit of thinking in these colors, as certainly as those I now use. The lower "hues" are particularly interesting.

Mr. George Hamlin from Lansdowne, Pa. on a trip to N.Y. called on me and took me to dinner. We went to Renganeschi's. I spouted Socialism to him and he seems to be thinking that way. I think from my own observation that the Socialist vote will show an enormous increase next election.

June 17

Not doing much but waiting around while the little colored girl cleans up the place. Dinner at Capp's chop house next door. Saw a Film d'Art by Pathé Frères with good French actors in a moving picture play called "The Reckoning." Very finely done, splendid acting, much better than with words. (The thing was melo-dramatic.) Made "over" another Collier drawing in the evening. Seems strange how little I am worried by my slowness in getting these drawings out. I seem to think rather that golf is the most important thing I'm doing just at present. Maybe it is. I feel much better in health for it. And with Dolly away, it keeps me from being lonely all the time.

June 18

. . . Circular from the Casalinga Club, a dining club—fifty cent dinners—being organized. Twenty dinners, ten dollars. A ticket of this amount, in advance, is all that's required of members. Guess I'll answer Yes to it.

June 21

Delivered the "Loan Shark" drawings to Bradley this morning at Collier's. They certainly are better than the first lot and now that it's all over (I hope) I'm glad I did them over. Bradley was well satisfied with them and gave me another Pirate story by Bergengren which is very funny–splendid! "The Original Lion Tamer" it's called.

A model came in, a Bohemian Girl. I painted a nude on the edge of the cot in the studio. Got a start which I think will do to go on with.

Lichtensteins called and I took them to Mouquin's and we spent a pleasant evening there. He says the gallery scheme had better wait till fall as the rich are out of town.

June 23

Dolly writes as though she is pretty sure to come home on July 1st. This is good news to me for I do get the most dreadfully lonely restless, unsettled spells. Simply can't work. The weather is extremely hot and today went by while I just perspired and watched the hours parade. I must be lucky though, not to be compelled to labor–and yet I watched a score of bricklayers on a tall building (about 25th St.) working in the blaze all day. Their wall grew nearly four feet–mine–but I'm not a bricklayer.

June 24

Another day of extreme heat. This has been a scorching week so far. I made some rough sketches to show Bradley of Collier's, very slight and overcome by the heat looking. *The Call* (evening Socialist daily of which I am a reader) announces that it will next week become a morning paper at two cents a copy. It is having a hard struggle to get along– naturally, since it can look for no patronage by the "great industrial interests." But once it does get hold it will be a tremendous adjunct to the cause of the workers.

June 26

This afternoon I worked again from the model I had on Monday. Another dreadfully hot day. Really takes the spirit out of one. I don't remember any such heat last summer, but then fortunately we don't remember these things when they are over!

June 27

Expected model again today but she never turned up so I just wasted my afternoon. . . . Henri came in the evening as usual on Sundays. An old fellow called. He had delivered here my etchings from the Rand School. He has been assistant sexton of Church of Ascension, sort of protégé of Alexander Irvine the liberal and Socialist who was until lately an assistant of the rector there. Henry Miller the name of the old man. I told him to come tomorrow and wax the floor in the studio.

June 28

Bradley was out when I went to Collier's to show sketches of Pirate stories. Got him on the phone and he told me to go ahead on the drawings, that he would send the sketches over to me. Young DeJules Casey his assistant, who according to rumor is to have charge when Bradley leaves, has been married and is on his wedding trip. Mr. Maratta, who invented the Margo colors, called today and gave me a very interesting demonstration of the working of the colors. I feel that they are important and I ordered a set. Henry Miller came and did the floor as per arrangement yesterday. He is honest–told me when asked, that he had been discharged from the church work. . . . He is loud in his praise of Mr. Irvine. After dinner at Renganeschi's I dropped in at Shinn's. . . . Mr. and Mrs. Glackens came in. They go to New London in a day or two, then to Whitford where the Shinns are also going next week.

June 29

The little Spanish girl posed today and as the Maratta colors came I made a try with them. I still feel that they are an improvement though I could not use them with any facility. I believe they are a more perfect "set of tools" than the old palette with its raw mineral colors and earth hues, irregular and unrelated.

July 1

Painted in morning. With a few hours' manipulation I put the nude I had started last week "out of the running." Worked with the Maratta colors. Dolly came home today, looks very well, weight 105 pounds– and is accompanied by Mrs. Hamlin whom I will refer to as Elizabeth. She is a gentle, affectionate sort on closer acquaintance. We all went

to Renganeschi's to dinner. The Restaurante della Republica de San Marino was very interesting to Mrs. H. (Elizabeth). In the evening we walked on Broadway.

July 4

We took Elizabeth for a ride on the motor bus on Fifth Avenue and Broadway to Riverside Drive. Walked as far as 97th St. then home by street car. Henris and Miss Pope at dinner. Mrs. Hamlin thought Miss Pope very fine indeed. Walter Schlichter (Dolly's ex-brother-in-law's brother) dropped in on us. He is always in some sporting venture. Now has his Philadelphia Giants, baseball players. . . .

July 5

Mr. Hamlin came over from Phila. and after dinner at home we went to Hammerstein's Victoria Roof Garden and saw a show. Princess Rajah in a danse du vent was quite fine. The rest of the show was quite satisfactory. Annette Kellerman in diving acts, a handsome piece of healthy womanhood in black tight shining with the water. We went to the Marlborough Rathskeller after the show.

July 6

Had Emma Pardo the little Spanish girl to pose today. Got nothing of any importance. Still trying to use the Margo colors and am having much trouble getting out of old habits of the palette. Mr. Hamlin came back during the afternoon. We had dinner at home, and he left about 9 P.M. for Phila. After a ride across the ferry we took a walk and went to the Hofbrau house, a fearfully decorated heavy German place on Broadway. . . .

July 7

Miss Converse posed in the afternoon. We went to Cavanagh's for dinner, then by boat to Coney Island. At Coney Island we saw the sights, and the people. And Elizabeth enjoyed the experience. We came home by train and in Brooklyn changed to subway, and came back by subway tunnel under the East River. The Spanish girl brought in her mother and brother to see me. They are all willing to pose.

July 9

To Van Cortlandt Park and played golf again this morning. Home about 2 o'clock. Made my best score so far, 113. Mrs. Hamlin left

about 3 o'clock. We have enjoyed her visit and she says that she has also.

July 11

Henris called in the evening as usual. We are invited with them to Mrs. Roberts' for dinner next Wednesday. . . .

July 13

. . . Met my sister Bessie at the Grand Central Depot. She is on her way home from a visit to Lily Wells at Portsmouth where Uncle Howard is chief surgeon in the Naval Hospital. Bess stayed to dinner with us and Dolly and I took her to the ferry at 23rd St.

July 14

Played golf with Henri. Started Puzzle. J. Horace Rudy came in late in the afternoon. We were sorry not to be able to entertain him for the evening but we had engaged to go to Mrs. Roberts' (of the Craftsman) for dinner. So we went, and had a unique dinner, a curry which she makes very fine indeed. Their apartment on 20th St. they have fixed up in black woodwork, very artistic looking but rather depressing to me on that account. A little too much "atmosphere." We joined Rudy at the Hoffman House at 11 o'clock, went to the roof garden there. A tawdry decorated place where there is no glimpse of the sky.

July 16

Out playing golf with Henri. He made a record 97 and is proud as punch. My own score was 112, one stroke better than a former record of mine. Dolly went out to Crane's in the afternoon, came home and cooked our dinner. In the evening I started on the much delayed Pirate story pictures for Collier's.

July 21

Worked on the Pirate story after returning from playing golf with Henri. We also got off at Kingsbridge and looked at some apartments. Rent $35.00, very nice. But in thinking it over they seem far away from the life of the city. . . .

July 22

Worked on the Pirate story during the day and finished in the evening late, after we returned from the "Casalinga" Club. Our first dinner

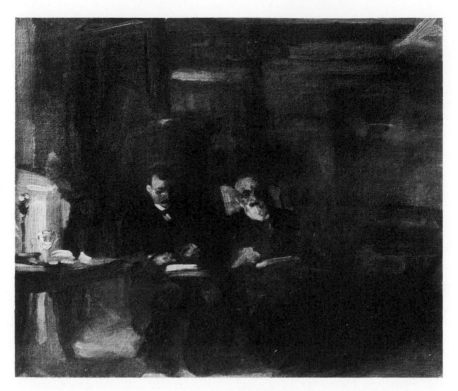

"My Two Friends, Yeats and Henri," 1910

there. The dining room is in the garden of a house on 38th St. We met besides the Henris and the Roberts, Mr. Yeats the father of W. B. Yeats, Irish poet. Mr. Yeats was a very interesting old gentleman with white beard. Kindly and well informed, he is a painter, I believe, also a writer. Met Mr. King who came to see me in regard to the Eight exhibition more than a year ago. He represented the Literary Digest. Also saw Mr. and Mrs. Craigie who are the promoters of the Club. Mr. Yeats made the statement that liberty-loving nations were peaceful, that it had a soporific effect. The principle being–don't interfere with your neighbor. On the other hand, a nation or people who love "Justice" are turbulent, restless–the French, for instance.

July 23

A down pour of rain which found many leaks in our roof so that we had to bail out the premises all day. And meanwhile phone the new

324

agents of the property which has again changed hands. I delivered the Pirate story drawings to Collier's. Bradley was much pleased with them ($200.00). He tells me he is going to leave Collier's and start a designing and special printing place of his own. His leaving Collier's is bad news for me, for I'm afraid I'll not come in for much work. Kent Crane came in the afternoon and stayed. We had intended to have Roberts and Henris to dinner but on account of the horrible leaks in our roof we postponed this. Crane came to dinner.

July 24

The roof is temporarily puttied up so that we feel a bit safer from the weather. Lichtenstein called and I agreed to take a new note on the $500.00 I loaned him. It will be a calamity if it's lost as it is all we have "ahead of the game" except my lots in East Lansdowne, Pa. and my Railways General stock which by the way is selling at 9, three points higher than when I bought it ten years or more ago.

I went to the Rand School to see Vlag. Got there at lunch time and took lunch in the garden, a nice meal for thirty cents. Balfour Ker was there and others whom I did not meet by introduction though there was general talk. Right interesting.

July 25

Dolly and I went to Casalinga for dinner. Same crowd there, Mr. and Mrs. Roberts, Henri, and young Mr. Forman (H. J.) and a Mr. and Mrs. Dodge and Miss Pope.

July 26

Dolly left for Philadelphia to spend about a week and have treatments as she has not been well for the last week.

July 29

. . . Dolly writes from Phila. that she likes her ring which I sent her for a birthday present. Piet Vlag, Socialist, came to ask me to be one of a party to go on a vapor launch trip up the sound on Sunday, to meet at Simpson St. Bronx at 7 A.M. Since Dolly writes that she may not come home till Saturday I'll write her to stay till Monday. Vlag says that Horace Traubel may be one of the party. I have a desire to meet him. After dining at Renganeschi's went to the Grapevine and had some ale; took a walk, then home.

July 30

Lost, and found, my mother's wedding ring which I wear on my little finger. Played golf with Henri. We did 27 holes. Martin of the Journal art staff was with us part of the time. A beautiful thunder storm came up in the afternoon. We were on the "hill holes" and had the whole valley above Van Cortlandt at our feet. Walked on 14th St., Sixth Ave. and 23rd St. all evening. Then took a trolley ride as far as 125th St. and back.

August 1

Out to Simpson St., Bronx, where I met Piet Vlag, Ker, a writer named Winslow (on Puck) and an artist named J. Jackson. We took Westchester Ave. car to the Sound and then a launch owned by some German friends of Vlag's took us up the Sound. We fished without success and stuck on a mud flat in an inlet, and crabbed with no great success–and talked some. They were an interesting crowd and seemed to enjoy making me talk on art. I too enjoyed it. They may not have greatly gained by the day, but I feel that I did. We came back to town about 8 P.M. and had dinner at a Turkish restaurant, Lexington Ave. at 22nd St. Ker, Jackson, the artists left at 4th Ave. but the writer Winslow and myself talked for near an hour at Fifth Ave. Home tired out. All people seem to be friendly and sociable across a few yards of wet, deep water–sort of "hail fellow well met" with the barrier between. Fun in the incident of the man in bathing suit beside girl in stern of boat–he consciously making his bare crossed legs appear to be hers in the profile aspect.

August 2

Dolly came home from Phila. as a sort of birthday present to me. It is the anniversary of my appearance on this sphere, thirty-eight years ago in Lock Haven, Pa. I have not seen much of the sphere but I know something of the people who inhabit it. . . .

August 5

Roof re-coated with tar-slate composition so that we feel safe from the elements again. This is a great relief.

Today is our eighth anniversary. Married eight years and neither Dolly nor I would have it otherwise. We have had our rubs but we

have been very happy together. . . . Balfour Ker called in the evening. He was much interested in looking at some of my Daumier lithographs and at my etchings.

August 7

. . . After dinner at home we went to the moving picture. Saw a very fine film, "Tragedy of Meudon," Pathé Frères Film d'Art. A splendid production makes the American made film look silly and worse than amateurish by comparison. The pantomime acting done by the French is so much better. This is so even in the comic films. Had some beer at The Oak, 23rd St., Eighth Ave. Then home, some more with pretzels. Then to bed, a hot night with little breeze stirring.

August 8

Miss Pope came for us and took us with the Henris and Mrs. Henri's sister to The Abbey Inn, 198th St. and Ft. Washington Ave. where she had ordered a splendid dinner. The house is beautifully located on the hills looking across the Hudson where the Palisades stood blue against a sunset sky. One of the hottest days yet. Railways General stock, of which I have 50 shares, is selling in Phila. for 10½. I think it is about time for me to clear out as this covers my investment with interest for the ten years I have held it.

August 10

. . . Miss Mary Perkins, who in winter teaches at Converse College, Spartansburg, S.C., and is spending her vacation at New Hope, Pa. with Lathrops–dropped in on us unexpectedly. We went to the Metropolitan Museum with her. I came back (it seems rank conceit to write it but I will) I came back with a very great esteem for my best work. Will go so far as to say that some five or six of my paintings are better than nine-tenths of the pictures in the collection.

August 11

. . . Joe Laub and Mrs. L. and her sister Mamie Devon, Otis, ourselves and Miss Sehon and her beau made quite a lively evening party. Laub tells me that Bradley has started independently to do designing etc. with offices in the top floor of the new Metropolitan Tower.

August 12

With Miss Pope and the Henris we dined at Camalucci's (38th St.). Miss Pope showed us a clipping which told of the death of Hartman K. Harris, Henri's pupil and friend. He was drowned near Boston while swimming. Promising good work, young, with an income. Everything to live for, died alone like a roach in a pail of water. No one saw him die, a friend who was swimming with him had started for a dory.

August 16

An out and out day of rain which broke up any thought of a golf game, as arranged. Mrs. Otis decided to postpone her return to Phila. till tomorrow. Started a cartoon for The Call, the Socialist paper. A fat pigmy who has mesmerized a big fire representing The Workers of the World, so that he goes on building up the heap of wealth on which the pigmy capitalist stands. J. B. Yeates *[Yeats]*, father of the Irish poet to dinner with us. Very interesting evening. *[John Butler Yeats came to New York on a lecture tour in 1909, and kept postponing his return to the old country year by year, until his death at the age of 84 in 1922. He became a close friend and admirer of both Dolly and John Sloan. At his death Sloan wrote a letter of sympathy to his daughters in Ireland telling of his deep devotion and friendship for this fine old man.]* Under the name of Josh Nolan I sent in $5.00 to The Call sustaining fund. They have quite a hard struggle for existence, naturally enough, and yet the Party should have a daily paper, if possible.

August 17

Dolly and Mrs. Otis left together to go to Phila. Dolly to have three or four days treatment with Dr. Bower. Otis and I went down to The Call office. I met young man, Mr. Copeland, city editor. He seemed to be pleased with the "Mesmerized" drawing. We came up town again after a short walk on the Bowery. Otis not feeling well with a cold. Went to Carlos' where we met Lawson, Gregg, Dirks, and Morgan Robertson, the sea story writer. Later on, Arthur G. Dove came in. First I have seen of him since his return from Paris, he has been back about three weeks. Walt Kuhn also joined the party and Block who is the "art" editor of the Journal comics. I had three Irish whiskies and got careless enough to suggest when Otis said he'd eat,

that we go in Koster and Bials cellar–a rather shabby low resort where we had good roast beef sandwiches and watched the women. A fat one with a lean old fish nibbling at the hook asked the piano player "Professor, can you play us the 'Glow Worm'?"

August 18

... Collected $200.00 from Collier's for the "Last of the Family" Pirate story.

August 19

... An interesting little Japanese American girl named Waki Kaji called in the afternoon. She says that she had posed a little over two years ago, for Henri and Glackens. She tells of her income from Japan being withdrawn on account of her refusal to marry a Japanese who had been selected for her, by them. Tells me she has written two dime novel love stories of the blood curdling type. Her mother's mother was one of the "Whitneys." I suggested that if she wrote an interview with Emma Goldman she might find a buyer for it. Otis and I cooked dinner together, and in the evening walked out to look at flats in Greenwich Village.

August 20

... Dolly came home about 4:30 and I was joyful to see her little blue eyes again, and to eat a good spaghetti dinner which she cooked for me and Otis, who worked today. After dinner Otis went out and Dolly and I stayed home alone but not a bit lonely.

August 21

Otis has eloped with my keys, so I had to get an extra front door key from the janitor.

Worked on a Puzzle. Dinner at home. Letter from Norris, note rather–with an amusing imitation of an antique woodcut representing me at Coney Island. Old Norris is a nice warm note in the background of my life. In the evening Dolly and I went to see the moving pictures at Keith's. An interesting encounter between a half breed Picket and a bull in the bull ring in Mexico City. The audience of Mexicans threw cushions, bottles and knives at Picket–his kind of courage didn't suit them at all.

August 22

The most notable thing about these days is my lassitude. I don't feel like working, have done nothing but my regular chores, the Puzzles, for some weeks. It worries me and it reacts on Dolly. We went to Renganeschi's for dinner which we enjoyed very much. Walked down and back and I came home feeling a bit more cheerful. Henris called. H. has seen the story which Pach wrote on American art for the Gazette des Beaux Arts, Paris. He says Pach called Alden Weir the best American etcher and, what warmed my heart—He told Pach that he was wrong, that Weir was the accomplished practicer of the art of etching but that I was the greatest etcher in the U.S.—that he knew of no better in the world. And then he spoke of his regret that my ten New York plates had not been followed by others.

August 23

... My cartoon "Mesmerized" appeared in The Call this morning, well reproduced.

August 24

Played golf all day with Henri. In the morning we met a young fellow who had played around the course with Henri last week one day. His name was C. May. Soon his voice, laugh, looks and general manner recalled John May who was a travelling salesman for Porter and Coates book store when I was there as a youth about 19 years old. I asked him if he was related—and strange, he said John May was his father! It made me seem old for this young man to have grown from babyhood in the time since then. When I came home a message of Dolly's told me that she was in Bayonne, so I had my dinner in town. Then went out to the Cranes' who kindly invited us to spend a week with them and we gladly accepted. We are to go there Friday to stay.

August 26

... Otis came in—it being the day before pay day, and we asked him to stay the night with us. ...

Francis J. Bennett, one of the P.A.F.A. students who made 806 Walnut Street (Henri's and my studio) sort of a headquarters on Thursday nights—dropped in. He is designing for Colgate and Co. Says he is prospering for the first time since his marriage to Virginia David-

son, a beautiful girl who was in Henri's class at 806. He tells me he has had seven musical compositions accepted by Ditson & Co. with prospect of more. Talks of his sensitiveness, odd chap–always was–taking his mental temperature.

August 29

Curtiss, an American, won the grand prize at Rheims, France, in his aeroplane. It is practically an adaptation of the Wright brothers' model. *[Glenn Hammond Curtiss won the James Gordon Bennett Cup for speed flight in this international competition. In 1902 he had founded the G. H. Curtiss Manufacturing Co.]*

September 2

The North Pole discovered! at last, if report of Dr. Frederick Cook of Brooklyn is to be believed. Seems to be creditable man, not familiar to the public like Peary. Poor Peary! Cook reached the pole April 21, 1908.

September 4

The boy "Making Faces" is invited to the Chicago Institute ex. this fall. Letter from Wm. R. French, director, asks for it. . . .

September 5

Crane and I took a short walk to the Bay shore. In the afternoon we all went to the Bayonne ball field and saw the local team, Knicker-bockers, beat a team from Brooklyn. The first game I have seen for years and I enjoyed it. It was new to Dolly also, but she became interested as soon as she began to understand the game. From the ball game to Bayonne Park, typical amusement park. The manager a Mr. Robbins. He was for several years on the Phila. Inquirer, knows Tom Daly and others of my acquaintance in Phila. A cool day so that the park was a rather deserted place. Breaking the New Jersey Sunday laws, we had strong drinks, cocktails served in demitasse coffee cups, a late supper at Crane's.

September 6

Invited to send any painting to the Society of Artists exhibition, St. Louis. A quiet day in the city, the holiday spirit, Labor Day. A parade of workers. We got up too late to see it. Enjoyed the luxury of the

return to our own menage with no stated routine for the day's meals etc. Henri's school opens today according to the announcements received. North Pole discovered by Com. R. E. Peary, such is the news today. Now for the battle between Dr. Cook and Peary as to the verification, claims. Wonderful, here lies the Pole undiscovered for years. Suddenly two claims for it inside of one week.

September 7

Promised Chicago Inst. "Making Faces" for fall ex. Wrote and declined the invitation to the St. Louis Society of Artists.

September 8

Dolly left for Phila. today. I went with her through the Hudson Tunnel to Penn R.R. station in Jersey City. Came back by ferry, took a walk ending up at the Café Carlos, where I met Lawson. Sat there some time, Gregg came in and an argument as to the reliability of Dr. Cook's claim of discovery of the North Pole ensued. I on Dr. Cook's side, he on Peary's and against Dr. Cook. Home, and made my dinner most enjoyably on a stew which Dolly had prepared for me to be heated over and taken internally very good. Notice from Railways Co. General that a ten percent dividend is declared for Sept. 15th.

September 9

... Mrs. Henri called me on the phone and I accepted their invitation to dinner. Went up to the studio. He has several paintings of Waki Kaji San, very good things. At Cammalucci's met the Roberts, Mr. Craigie, a Miss Goff who was educated in Spain, and after dinner she did some Spanish dances. Very unaffected and a very good dancer. Met a Mr. Herzog, an artist apparently.

Walked home with Henris and sat till nearly one o'clock. Walked home, too tired to write to my Dolly girl in Phila.

September 10

Stuart Davis stopped a few minutes to ask the address of the Art Students League. I was surprised that he should think of going to such a place–when Henri school is known to him. He told me that his father (E. W. D.) thought that the H. school was far too advanced.

332

September 11

Mrs. Otis writes and asks for a loan to help them move to New York!! Very great surprise to me. I thought they had some money saved. I can't do it I'm afraid. Will talk to Dolly. Dolly arrived about 6 o'clock with Aunt Mary who is going to make us a visit. We all went to Renganeschi's for dinner and took a walk on Broadway afterward. Dolly agrees that we cannot afford to loan money to the Otis's. Very curious that they should turn to me in this instance.

September 13

Hear that Chase has retired from the schools of the Penn. Academy of Fine Arts. Anshutz is now the head instructor–good! Now and then we read in the papers articles which give Chase the honor of being an instructor of Henri at the P.A.F.A. This is ridiculous as Henri left the school years before Chase started to teach there. The same error has been made in my case at times. Anshutz is the only teacher I had at the Academy of Fine Arts, Philadelphia. Two terms in night classes.

September 15

The redoubtable Wm. Miller Finney Magraw, once of the Press art staff, later of the Mercantile Princes (he's lately been interested in a bottle top factory) enters my quiet life and I soon discover that he is greatly interested in golf. Played it all day every day at Atlantic City this year. He will run over for me in his "car" Saturday morning. We will buzz over, pick up Henri and play at Van Cortlandt Park. All this he holds forth while buying high balls at the Hoffman House. I came home late for dinner.

September 16

Went up to Henri's in the afternoon after going with Otis to look at the apartment he has rented on 22nd St. right in front of us almost. Henri has a new full length of a young girl (model who called on me today) in white sweater. Mr. Yeates [Yeats] came in and told us of a play he has in mind called the "Haunted House."

September 17

I got to work on the first drawing for the new Pirate story for Collier's. Otis came in and worked in my studio in the morning and

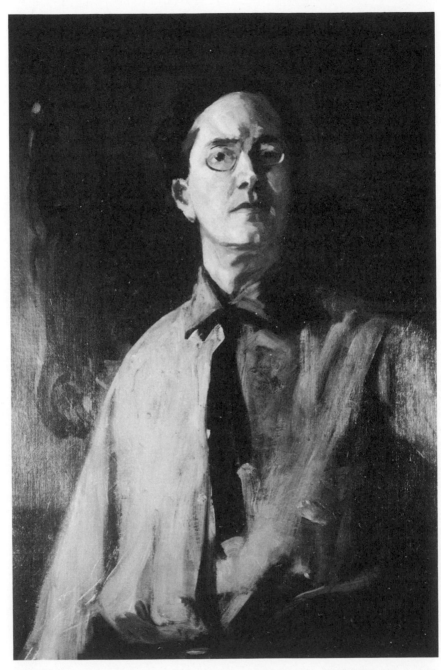

"Self Portrait," 1909–12

the example started me. A telegram from W. M. F. Magraw in Phila. The ride in his touring car is off!! The great golf game is off!! Alas! sic, etc.

September 19

Dolly, Aunt Mary and I went to Coytesville on the Palisades, to see the Richards and make inquiry as to accommodations for next Saturday's Hudson Fulton Celebration, Naval Parade. *[The Hudson-Fulton Celebration began on September 25 in New York and in other cities and towns up and down the Hudson River. It was the 300th anniversary of the discovery of the Hudson by Henry Hudson. Also included in the celebration was the 100th anniversary of the first steam navigation of the river by Robert Fulton, although the actual year for this centennial was in 1907. There were many land and water pageants commemorating both events.]*

Richard has added a porch all along north end of his house and has just finished building a dining room pavilion near the edge of the cliff—fine place. Noelie and Aidanis, daughters, are growing into fine girls. Aida is splendid, beautiful young figure and will be a large woman. We enjoyed the fine prospect of the Hudson below us.

September 20

An invitation to view the parade (naval) Saturday—from Reuterdahl came as a surprise. He is living in Karl Bitter's *[Karl Theodore Bitter, sculptor]* house on the cliff at Weehawken. In a way he occupies the position of "prompter" for this production. His article on the deficiencies of the Navy made a great stir last year or year before. Mrs. Crane and Roma called. Dolly took Aunt Mary to Davis's in Newark and though I had decided not to go, Davis called and I changed my mind and went with him. He has been quite successful in his Special Edition work for advertising in the American. Thinks of starting in this line on his own hook. His boy Stuart who is now 17, is about to start in at Henri's school. He showed me work which is very good. He should be good material. No one can tell what will happen though—an artist is made by accident and marred by chance. We are all shooting the rapids.

September 21

... Went out proposing to vote at the primaries but found that I was enrolled as a Democrat—so did not ratify the Socialist ticket. "Might

335

as well vote Democratic!" said the lame man in charge, "no thanks, Socialist or nothing" my reply.

September 22

Jerome Myers called. They are now at 61 W. 37th St., have two small rooms he says. Before dinner Dolly and I took a walk on Broadway. Decorations on many of the buildings in preparation for the great Hudson-Fulton Celebration which starts on Saturday.

September 23

E. Daecke writes that old 806 Walnut is to be remodelled. He has been ordered to vacate by Dec. 1st. I suppose this is the last I'll hear of the old garret where we all had such good, bad and mixed times in the days of old....Dolly busily engaged in cleaning her little kitchen all day.

September 25

The Hudson-Fulton Celebration is on. I went without Dolly, and with Kirby to the house built by Karl Bitter on the cliffs of Wee-hawken where Reuterdahl is living. Henri was there with Mrs. H. and Mrs. Lee. Met Gauley, a very nice sort of fellow apparently, awfully bad painter. It is always this way. Groll was there, Jones, Jacobs, Col. Benson. Met a Mrs. Emerson from California–talks of "art things" just "adores Sorolla." Crowds on the Palisades on every nook and cranny and corner and crag. The river "parade" as it was called didn't impress me. The copies of the Half Moon and Clermont were interesting.

After dinner at Shanley's Dolly and I went through the jam of sightseers which flowed ceaselessly in every direction–to 96th St. and after standing in the crowd on Riverside Park. Finally saw the fireworks and illumination of the fleet at anchor. We fared quite well in the crowds and the spectacle of crowds and automobiles and haze of smoke from the pyrotechnics was quite worth the trouble, though I was well fagged after my day.

September 28

Piet Vlag came in. He tells me that he has started an artists material shop on University Place (I think). We went along with him to see the "Grand Pageant," buffeted by the crowds, we finally mounted a

336

box (to which Vlag treated) and it was a rather small soap box. We all stood up on it and had a good view. The crowd was awe-inspiring. The "floats" just big old fashioned toys on a large scale, expensive I suppose. One representing the "Half Moon" was manned by real Dutchmen, and Vlag, being a Dutchman, joined in a national air they were singing. He has a fine powerful voice and it seemed good to us to hear him. The crowd about also were interested. Mr. and Mrs. Roberts called on us in the evening and we had a pleasant evening. They are surely nice, worth while, and interesting. They saw the parade today from Glackens' apartment on Fifth Avenue. . . .

September 29

Otis and I worked in the studio pretty much all day. He is much worried and I am glad I have not a wife such as his seems to be. . . . Otis gave up a drawing for the Bayonne Boys Fair at Mrs. Crane's solicitation. Seemed rather stiff to "bone" a man who is struggling in the start of a fight for a living in New York. I like Otis right well and he amuses me. I think he should be able to find a demand for his stuff. It's not of the good sort but might be popular.

September 30

While a great military and naval parade went on and the usual throng crowded to see it I stayed indoors and worked. Otis did the same. Parades like this make the "patriotism" which furnishes soldiers, workers to kill the workers that capital may hold its upper hand.

October 1

Invitation from Breckenridge to send a painting to Phila. Art Club exhibition. Accepted with "Gray and Brass" ($500.00). Worked on the Pirate drawings. Otis is also working and it seems to set an example of industry which helps me stick at my own job. . . . Dolly and Otis and I went out after dinner in the evening (about 11 o'clock). Walked on Fifth Avenue and Broadway. Much special electric lighting is on view. A string of electric bulbs on each side of Fifth Avenue and on many of the buildings. Search lights playing on advertising flags. Had a row with a chauffeur who seemed about to run into us.

October 2

A parade of school children is going on. I caught glimpses of sections of them from the windows. Crowds of children merry-making always make me sad, rather undefined in origin–perhaps it is the thought of this youth and happiness so soon to be worn away by contact with the social conditions, the grind and struggle for existence–that the few rich may live from their efforts. The struggle to be one of the rich which makes the earnest working slave. Collier's phoned asking how the Pirate story pictures were coming on. Worked hard all day on them. Miss Lawrence came from Englewood, took dinner with us. Then we (with the exception of Otis who went to the Herald office) went to see the night parade. The crowd seemed greater than before. I got into interior rages at things once or twice but managed to keep it in. We finally got two boxes in front of Tiffany's. Not private boxes of the ordinary sort but soap boxes on which we stood and saw very well. The gross tawdry toys called floats looked better than those in Tuesday's parade, the artificial lights help them. . . .

October 3

. . . Final tinkering on the Pirate story drawings. The Laubs called after dinner. They are, as usual, "sore" because we have not been to see them. Henris came later. They are bunking at a hotel as their new studio is not ready yet. In the afternoon Davis called with his two sons. Stuart a young man and John W. the baby–a mighty bright little boy.

October 4

Budworth & Son collected "Making Faces" for the Chicago Art Institute. (Insurance $400.00) Delivered Pirate drawings to Collier's. Casey, who is now acting art manager, seemed to like them. But of course the intelligent criticism and appreciation of Bradley was lacking and I missed it very much (price $225.00). I saw Joe Laub who is now reinstated in his work for Collier's. (Bradley didn't find much use for him.) Joe told me that about an hour before I came, he had seen the Wright flying machine come down the air above the Hudson. Dolly left for Philadelphia. I took her to the ferry in time for the 11:55 train A.M. Mr. Yeats called late in the afternoon and I enjoyed

338

his company very much. He is a fine unspoiled old artist gentleman. His vest is slightly spotted; he is real. I went with him to dinner at his boarding place on 29th St. West 300 plus. Three French sisters run the home–good dinner. Met Mr. King of the Literary Digest, and a clergyman who turned out a Socialist in conversation. Yeats said he had never shown so well. *[At Petitpas' Yeats had his own "salon" where friends came to enjoy evenings of delightful conversation. Van Wyck Brooks, Alan Seeger, "Willie" Yeats, Ezra Pound, Henri, Bellows, and, of course, John and Dolly Sloan. Yeats had become very fond of Dolly and Sloan agreed that one reason for his reluctance to leave America was this parental feeling that he was able to help them through difficult years. "He was a second father to me," Sloan wrote to the Yeats family in Ireland. "When I became too exercised about problems of social justice, losing my sense of humor and perspective on things in general, he scolded me." Sloan had exaggerated his "Irish" character to please Dolly, but when Yeats came along (he was half English) he was able to persuade Sloan that being Irish was of the essence.]*

October 5

Otis returned from Philadelphia in the afternoon. Mrs. Crane phoned and then came over with Mrs. Claffey. I signed the ordinary head in water color which I made for the Fair in Bayonne. They sold it for $25.00 in advance of the Fair's opening. Otis and I made our dinner on the stew which Dolly had prepared before she went away. After dinner we went to Miner's Theatre and saw a burlesque show. Same old thing but interesting as usual. A girl in a red sort of Spanish dress (stage Spanish) with long fringe and one shoulder bare, good dancer. The chorus appeared in jersey bathing suits in one dance.

October 6

What a day! Otis started out about 10 o'clock to show the drawing he has been making to Harper's. He did not return (writing this at 11:30 P.M.) and he had my keys with him. I went out over the roof to see Kirby next door, locking the door with the big key and carrying it–but also, fool that I was, forgot to take off the Yale lock catch. So after lunch with Kirby, I couldn't get in! Hung around waiting

for Otis. Took a walk and waited more but he didn't come so I climbed up the fire escape from the floor below (Mr. Vinter's studio), made my dinner on spaghetti which I cooked–pretty good too! Will Bradley came along while I was waiting downstairs but I couldn't ask him in (he is starting offices in the Metropolitan Tower 36th floor). He said he had seen my Pirate drawings at Collier's and that they were masterpieces.

October 7

Otis has not yet turned up so I wrote to Dolly for her keys. Kirby came in at about one P.M. I went out and had lunch with him, then walked on some errands of his. We had a right warm argument on Socialism. I held that profit taking was wrong, etc., in my feeble way–I am not a very good propagandist but I have a deep-rooted conviction that the fundamental ideas of Socialism are natural and right. When I came back to the studio I found Mr. Yeates [Yeats] waiting for me and we had another pleasant talk. He told me of his daughter's "crafts" business near Dublin. She employs more than ten girls. He read me a letter describing the marriage of one of these Irish working girls–very human and good. Yeates [Yeats] invited me to go to Cammalucci's but I could not as my front door key is with Otis. Ullmans called at front door. At about 7 o'clock Otis turned up. He lacks pluck. I cooked a good mess of spaghetti for dinner.

October 8

A note from Geo. Fox saying that he will be in N.Y. and will drop in to see us this evening. I'm sorry Dolly is away. Otis rather crest-fallen today, promised to reform after I had scolded him. George Fox came along about 9 P.M. and stayed the night. He is making his first visit since his exile–in Philadelphia two years now. He amused me by telling of his dining at Mouquin's tonight. He had all the things he likes, the first good dinner in two years. . . .

October 9

I went with Fox who attended to the business for the Phila. N. American which brought him to New York–selecting some photographs of the old masters for reproduction. We then went to the Hudson-Fulton special exhibition at the Metropolitan Art Museum.

A great collection loaned for the most part by private collectors. A number of fine Frans Hals and Rembrandts. Saw again Rembrandt's "Finding of Moses"–a small oval picture which I had seen in Mr. J. J. Johnson's collection in Phila. A beautiful flute player by Hals and boys singing by the same artist. Several Jan Steens and many other great things captured by the money of these American Bourgeois rich.

October 10

Otis and I walked up to the Metropolitan Museum and I had another look at the paintings in the special loan collection. Found many that I had missed yesterday. We scratched up a cold dinner at home. Henri called at about 11:30 at night. I'm getting "sore" at these very late visits. He had Louis Glackens and a friend of his named Schenck in tow. They sat about an hour. Henri is not yet in his new studio. It is not yet fitted up inside.

October 11

Dolly came home from Phila. today. She looks right well and says that Dr. Collier Bower is pleased with the progress in her treatments. Miss Sehon called, and as I felt like painting she posed for me in the afternoon. I worked with the Maratta colors and think that I begin to use them now more free from my old habits with the old palette. I am firmly of the opinion that they are a great instrument for a painter to use. . . .

October 12

Miss Sehon came and took lunch with us, then worked posing for me in the afternoon. I worked hard and got practically no result. Quite exhausted when I stopped. Miss S. stayed to dinner with us and Dolly and I took her to the subway. "Gray and Brass" was collected for the Art Club ex. in Phila.

October 13

Miss Sehon posed again today. I made another start and it is somewhat better but nothing to be elated over. . . . National Academy announcement. Glackens, Redfield and Schofield are all three on the jury. The first cold day this fall. We used the gas radiator in the north room (studio).

October 14

Again I worked on the portrait of Miss Sehon. It's a long row to hoe, painting is! Took a short sprint of walk after working all afternoon and had a sudden idea that Dolly and I too, would enjoy seeing a "show" so bought bill board tickets for two at a scalpers on Sixth Ave. for "Billy." Dolly rushed through a very good dinner of broiled kidneys with bacon on skewers and we went up to the Lincoln Square Theatre, 66th St. and Broadway (building where Henri's school is located). We enjoyed the "piece" very much. It was right funny and not very long. Billy loses his new false teeth. His sister was played by a very interesting and clever girl, Miss Marbury. Dolly wore a fine new hat with white plume. We walked home.

October 15

Miss Sehon again today and I worked all afternoon. She does her part splendidly. I wish that mine were done as well. I feel that I have made some progress in the use of the Margo colors and so do not feel discouraged when I consider the long time that has passed since I painted anything. . . . Dolly made spaghetti for dinner and we had a pitcher of beer as a treat. Francisco Ferrer has been murdered by the Spanish government. The Socialists of Europe have met in violent protest. He is said by the government to have incited the recent riots in Barcelona. He has evidently been a force in setting free the minds of Church ridden Spain.

October 16

Put up the big stove in the studio today and started a fire, so here cold weather begins for this year. I have had a bad throat for a day or two now, due I suppose, to the sudden cool weather. Finished up a Puzzle which Dolly mailed for me when she went out toward evening. The polar controversy still keeps up. Cook and Peary. Today there are sworn statements that Cook did not ascend Mt. McKinley in Alaska, a fact which he claimed in 1906. I dislike Peary's attitude so much that I hope Cook will get full credit for the Polar discovery.

October 17

Pretty well done up by my sore throat.

Ullman and Mrs. called and invited us to go this evening to

342

the Café Boulevard, 2nd Ave. and 10th St. for dinner. Miss Pope was another caller. She is going to Paris in a few weeks, has been delayed by her mother's illness. Miss Pope looked finer than I've ever remembered her looking. Wish she had been the second Mrs. H.

October 18

Gloomy, rainy day, made more so by my own condition. I felt very badly indeed. Drew a cartoon and wrote to The Call that they could have it if they would send for it tomorrow. Dolly asked the Ullmans to have dinner with us and they came and we enjoyed their company very much, though I'm so under the weather I couldn't get going very well.

October 19

Quite miserable with my throat. In the afternoon it got so bad that I could hardly speak, so I walked over to Dr. Westermann's. He treated my throat, said that the bronchial tubes were affected, gave me a prescription and told me to get a Benzoinal Inhaler. This proved to be an interesting kind of toy, cross between a coffee pot and a toy lantern, in which hot water vapor charged with compound tinct. of benzoin is used. Pirate story proofs were sent by Collier's for me to color up. I did this in the evening.

October 20

About six days ago I loaned $60.00 to Kruse, the Sewing Machine dealer in the first floor. He promised to pay back by the 19th. Asked him for the money today and he stood me off. Got angry. Strange how the one who does the money favor has usually to dog the person who has been accommodated! This will I think be a lesson to me. Went to (Dr.) Westermann and he gave me another throat treatment. H. Strunsky, one of The Call Staff, called and got the cartoon in my absence....

October 21

Made two cartoons for The Call (if they care to have them).

October 22

Took cartoons to The Call. Met Hyman Strunsky, one of the staff, and he introduced me to one or two others. One said the figure of

the "Workers" should be more starved and emaciated. I differed with him. Went again to Dr. Westermann. Paid him $18.00 ($12.00 to settle to Tuesday and $6.00 in advance for treatments which I am to start next week) a check which received from Kruse, West Hoboken bank....

October 23

The Call prints one of my anti-Hearst cartoons today. The Henris came in in the afternoon. We asked them to dinner and headed off another arrangement by asking Miss Pope by phone and Mr. Yeats. We had a bully good dinner which Dolly got up in quick order and followed it by an evening which is of the sort that I like. Sketching, making funny drawings, looking at picture books. A most successful night, we didn't break up till about one A.M.

October 24

Took my "Hearsed Vote" cartoon down to The Call office today. Met Mr. Kopelin, city editor, a very interesting young man. He spoke of an idea of starting a political Socialist humorous paper somewhat on the lines of Simplicissimus. Met also the editor in chief, Mr. Simpson, and one of the editorial writers Mr. Gearity(?). They were much pleased with my cartoon. We, Dolly and I and Miss Pope went as Henri's guests to the Petitpas table d'hôte, 317 West 29th St. and had an interesting evening and good dinner. Mr. Yeates [Yeats] amused himself by a discourse on Ghosts.

October 25

Started to work on picture of the little Spanish girl Miss Pardo. In the evening I went to the door in answer to the bell and there stood Alex. S. Calder, back just one week, he returns from Pasadena, Cal. Looks well (he went there to make a fight against tuberculosis). He is going to locate near New York if he can find a place. Enjoyed our talk with him very much. He has been out of things so long that everything was news to him.

October 26

Miss Lawrence came. She is to stop a couple of days with us. Painted Señorita Pardo, no success so far. Miss P. and Miss L. for lunch, Miss Pope also. After which the ladies went to see the Hudson-Fulton

special exhibition at the Metropolitan Museum, while I finished a Press Puzzle due last week. In the evening to Gane's moving picture theatre on Broadway where we saw some pictures and amusing vaudeville.

October 27

Painted from Miss Pardo in the morning.... Home in the evening and Miss Lawrence spent the night with us. She leaves in the morning. She is a fine character, good humored in difficult conditions.

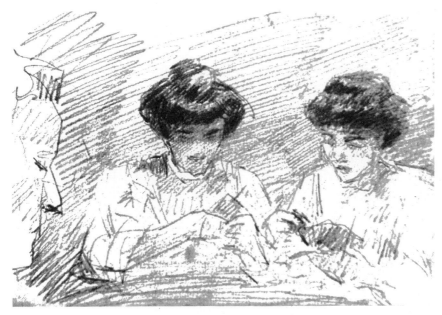

"The Mademoiselles Petitpas," by John Butler Yeats

She has a trifle too much "go" to suit my temperament but it's sort of an understood difference in make-up and her good qualities balance the account. Mary Hanford Ford called to talk and see my paintings. *[She translated some of the deKock novels for Quinby Edition.]* She is a Socialist in ideas, a bright little middle-aged woman. Is getting up this article for the American Magazine.

October 28

Painted on Miss Pardo's picture in the morning.... Henri told me that a young lady of his classes was coming to me for etching lessons.

... The Miss Pardo picture will probably hold its place on the canvas at least for a while. I like it now—painted it in the last twenty minutes of the four sittings. Went to Dr. Westermann's and he treated my old nose for the catarrhal trouble I have had for years.

October 29

A fallish day. Painted on a new canvas from Miss Pardo, Señorita Pardo—in the morning. Kirby came in, sat about and read in the front room while I worked. Took lunch with us and the señorita and then he and I went up to Hammerstein's Victoria and saw the cinematograph pictures of the recent fight between Ketchel and the negro Jack Johnson. The big black spider gobbled up the small white fly—aggressive fly—wonderful to have this event repeated. Some day the government will wake up to the necessity of establishing a library of Biograph films as history. In the evening we went as guests of the Roberts at the Vagabonds Club at a dinner at the National Arts Club. The affair was of great interest though I feel a little out of it in such social affairs. The club is composed of editors and others. I met Mr. Alex Harvey, editor, Current Literature, interesting, brilliant. Mr. Yeates [Yeats] was there, dear lovable old fellow, made a nice speech. Dolly met Mr. Kaempffert of the Scientific American, Mr. Dyer of Country Life in America made a bright speech. Miss Goff who danced at the Cammalucci was next to me at table. Mr. King was there, Mrs. Barker recited a poem on the Arctic Explorers—good. The Princess Cantacuzene was there (was Miss Grant). Walked home with Mr. Yeats.

October 30

Painted all day and was rather well pleased with my day's work. The new head of Miss Pardo with black velvet coat and feather black hat is a workmanlike piece of painting. I am pleased out and out with the Maratta paints. They are a wonderful instrument. Maratta should have a monument and make a million. Went to Dr. Westermann for nose treatment and Dolly has extended an invitation for him to dine with us. He was glad to accept, and we enjoyed his company. A Browning enthusiast (not a B. Society fiend), he read "Andrea del Sarto" to us and read it mighty well. Also "Letter of a Physician" (in "Bethany about Lazarus")—I forget the title. Caught in a new trap a big rat that has been frightening Dolly for the last three days.

346

October 31

Drew a cartoon to be used after election "The New Servant in the House" (of Dough Dough). Took it down and showed it to Kopelin. Strunsky was there, a nice rough looking but really refined in the best sense.

Thence to Ullman's (52 St. Nicholas Ave.) where we had an elegant dinner, steak with mushrooms, cocktails, wine and cognac and a bottle of champagne to crown the housewarming. We had all we could eat and all we could drink, then to bed after a talk. Ullman thinks of getting out of the Lincoln Memorial University scheme. He has an offer from Ladies Home Companion. He has proposed to Ridgeway who has just sold Everybody's that he start a fiction magazine, all star writers. . . .

November 1

Got down town late with Ullman. We stopped to look at apartments for me on St. Nicholas Avenue. $65.00 a month too much, I fear! Would make a good studio light knocking three rooms into one. . . . I made three heads for The Call cartoon "Servant in House" so that it would fit in case either Gaynor, Bannard (?) or Hearst won out tomorrow. Too much used up, after last night's festivities and a bad night's rest, to do any work in the evening so we went to bed early. My "Hearsed Vote"–Hearst on a hearse, was published in today's Call. It looks good to me.

November 2

Made a Puzzle in the afternoon and evening. Reading Joseph Conrad's "Lord Jim" which Kirby recommends. It is a splendid psychological sort of narrative–perhaps a bit "styled" (to be critical of it).

November 3

Making photographs of "Fifth Avenue" picture and the "Tenderloin Flat" today for Mrs. Ford to use or to show in connection with her article on contemporary art in the American Magazine.

November 4

Worked on a new canvas from Miss Sehon. In the evening we went up to Joe Laub's and had a nice warm friendly time and a very good

347

cold lunch. Joe is to write from Collier's and get Park sketching permits. He wants to get out and paint with me next Sunday.

November 5

Painted on Miss Sehon picture again. Don't seem to be catching hold right.

Miss Pope came and with Dolly went to the Met. Museum to see the Dutch paintings. Mrs. Laub met them there.

Mrs. Mary Hanford Ford called for the photos of paintings and we had quite a long talk together, chiefly on Socialistic topics. Went to Dr. Westermann's for nose treatment. . . . Dolly met W. Pach at the Met. Museum. Funny thing is transpiring. My plate etching of "Fifth Avenue Critics" is being held for duty in the Customs House here!! Plate made in New York! By an American! Pach has made affidavits and it will probably come through eventually.

November 6

Miss Sehon posed again today and I went entirely "to pieces" on the portait I was working on. Painted it out. Ran in to look at some oil sketches of Kirby's next door. In the evening we want over to Henris and saw the new studio. It is simply fine! A large room well lit and suitable for exhibitions, both in location and style. 10 Gramercy Park. He has elegant lighting by electric globes.

November 7

Went up to Joe Laub's and we, armed with our permits, *walked on the grass* of the Central Park of the City of New York with impunity and due pride and we sat down on the grass near a lake at 72nd St.– and made sketches and we were chagrined to find that anyone might at that place go on the grass without permit! . . .

November 9

. . . Couple of models came in and I engaged Yolande Bugbee, an odd sort of young girl, to pose for a week commencing tomorrow. Drew a Puzzle in the afternoon and evening. Dolly made a good big stew which we had a corner of for dinner and I'll make a couple of dinners from the balance in her absence. . . .

348

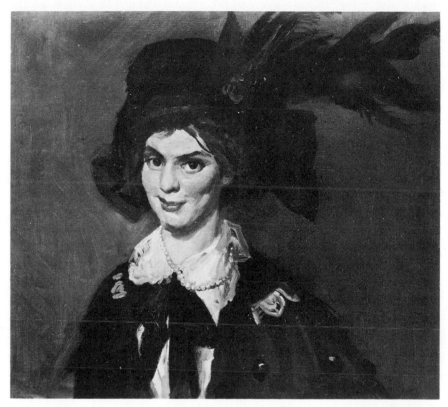

"Yolande in Large Hat," 1909–10

November 10

Took my Dolly girl to the ferry this morning. She left for Phila. on the 11:55 A.M. train–and here I am alone, for only a few days I hope. A most beautiful letter from old friend Norris who speaks of our meeting so seldom, of the solid understanding and sympathy of friendliness between us. Miss "Yolande" posed for me this afternoon A very bright nervous bird-like young lady of seventeen years. She was interesting, and I think that I have a good start on her portrait. Kirby dropped in toward evening to invite us out to Scarsdale for Sunday but on account of Dolly's absence I passed it up. . . .

November 11

A short walk at noon time. The weather is fine, perfect fall days, and the City is beautiful. Worked on Yolande Bugbee's portrait again

today and I feel that I have caught a good thing. This may be the enthusiasm of recent production before mature deliberation, but at any rate I feel elated over it. The Stew made my dinner again this evening, after I had returned from getting a treatment from Dr. Westermann. The young man from the agents came today and says that they can't afford to do the whole place over (paper and paint) just now, so I said–go ahead and leave out the studio. A beautiful spearhead came by mail from Norris in Florida. He tells me he picked it up on the shore of a little river Pithlachascootie, called "The Cootie" where it had been "lying at the water's edge lost by some red savage in a tussle with a deer or alligator centuries ago." Sent $5.00 in name of Josh Nolan to the Call, Socialist Daily, N.Y. This makes $10.00 I've given.

November 12

Went to Collier's to draw my pay for "King of Animal Tamers" Pirate story. I found that the check had been made for $200.00 instead of $225.00 as I had asked. Saw Mr. Casey and he tacked $25.00 on my bill for drawing color blocks, making it $65.00. Drew out $25.00 from Saving Fund to buy a suit of clothes as Mrs. Roberts has invited us to meet Miss Isadora Duncan the famous interpretive dancer coming Sunday evening. Dolly won't be back probably, so I'll go alone. Painted on Yolande picture and have it finished now. Rushed out at 5:30 and bought a black suit of clothes at Rogers Peet & Co. At Collier's Joe Laub introduced me to Mr. Gleason who is a Socialist, one of Collier's editors. He says that The Call don't get enough of the "human" into its editorials, guess that's right. . . .

November 13

Hurried, after my cocoa and shredded wheat breakfast to Joe Laub's and he and I went over to Central Park and made sketches. Little bridle path subject. There is good stuff in the bridle path for a picture. The leisure class taking their medicine in the morning while we poor artists have to work!! Back to the studio and started a new canvas of Miss Bugbee–Yolande is the prettiest part of the name. Made spaghetti for my dinner and after dinner went up to 37th St. and called on the Myers. They have two hall rooms, one as a studio, the other as living room. The baby is well. I was entertained in the studio of W. Hurd Lawrence who is crippled from a stroke of paralysis

350

two years or more ago. He is learning to draw with his left hand–sad sort of small studio. A Miss Clark who has taken very good care of him, is there.... Jerome Myers and I took a short walk on Broadway. Rich color and throng after theatre beyond any words of mine. Irish Socialist's street speech. In Spokane they are putting them "in the pen" for this!!!

November 14

The event today was the "reception" informal, to Miss Duncan at Mrs. W. Carman Roberts'. An affair which was pleasant enough of its sort. I got through it with much ease for me, though I had on my new plain suit of clothes. Others in evening dress, my usual error–the party being larger than I thought it would be.

Miss Duncan reclined on a large divan looking beautiful though she is not in the ordinary sense handsome. She was in no sense being worshipped, in fact more attention might have been paid to her, I thought. A light blue draped Greek sort of gown, plain dark hair in a fillet. I understand that some present resented the fact that she did not rise when introduced. But think myself that she was properly filling her part in life as an artist in the dance.

Glackens and Mrs. were there, Henris, Shinns, Lloyd Osbourne, Harvey Watts, Ben Ali Haggin, Irving Wiles (note the pun! wretch!).

Watts who has considerable scientific information worried me some by telling me of what to him seem weak points in Dr. Cook's case in re the North Pole discovery. Still I hope that he will make good.

After the Roberts' affair wound up, Ben Ali Haggin invited several of us to his studio, swell apartments on 66th St. He has some very good paintings in spite of the fact that he is accredited with great wealth. Henri (Mrs.), W. Funk! and Haggin went in a taxi-cab. Glack took Mrs. G. home then came up. I had three big high-balls and got sick.... Down town 4 A.M. in Haggin's taxicab and then from 23rd St. walked to Glack's house, then walked home alone.

November 15

Worked on Miss Bugbee and think I have another good one started. Dolly did not arrive home till after 8 P.M. She sent me a telegram so that I was not worried, waited for dinner till she came and then

we went to Mouquin's where we had a nice dinner. Then we walked to Henri's. Glackens's and Prestons were there. Mrs. G. is for women's suffrage which is growing nearer and nearer each year. I'll just put down *my* belief in the woman's vote *here* in black and white. I know it's bound to be a good thing for the race, and for that reason it will be in line with Socialism.

November 16

House messed up with painter working in the front room.

Isadora Duncan! Mrs. Roberts (dear kind woman) sent us tickets, box seats, and we saw Isadora dance. It's positively splendid! I feel that she dances a symbol of human animal happiness as it should be, free from the unnatural trammels. Not angelic, materialistic—not superhuman but the greatest human love of life. Her great big thighs, her small head, her full solid loins, belly—clean, all clean—she dances away civilization's tainted brain vapors, wholly human and holy—part of God. I'm in a way regretting that I did not know all her art stood for when I met her at Roberts' on Sunday....

Miss Pope took Henris, Mrs. H.'s sister and us to dinner on 46th St. French table d'hôte. Thence to moving picture show. One right good Pathé Frères film "Rigoletto"—the rest bosh! Ice cream sodas, then home. A Mr. Wallace called to show a little surreptitious sketching device to be attached to eyeglasses and enable the artist to draw the subject without directing a direct glance.

November 17

Went on with the Yolande Bugbee second picture, with shawl, and it's going all right. A thing with a certain amount of tenderness, but not sentimental. ("The Purple Shawl") Started a Puzzle in the evening. Got it pencilled in ready to go on with tomorrow.

November 18

Mary Perkins on a trip North to arrange art lecture for Converse College, Spartansburg, S.C., dropped in. Looks better than she has for some years. She took Dolly out in the afternoon, they went to the water color exhibition, say it is bad! I worked on hands of second Yolande B. with purple shawl and it seems to be a good thing

352

still. Miss Perkins stayed to dinner with us and took Dolly to see Mr. Forbes-Robertson play "The Passing of the Third Floor Back" by J. K. Jerome. They enjoyed it very much. Miss Perkins is stopping at the Hotel Martha Washington. I finished Puzzle in the evening. Oh these (I've got to hope) everlasting!! Puzzles. "The Pen is mightier than the Pig"–original adage to be used to express how a man is held in by circumstances.

November 19

Through Mrs. Roberts Dolly received two tickets to Philharmonic concert from Mrs. Untermeyer. Dolly had already promised to go to Brewer's to mind the baby so she handed the tickets to the J. Myers. Started a new picture of Yolande smiling, with a note of paper in her hand, low cut open bosom ("Iolanthe").

November 20

Walter Pach brought in my copper plate which has been in Paris. Gazette des Beaux Arts reprinted from it for the October number. The plate was held for duty in the Customs House here. Pach had all kinds of trouble getting it through. Quite funny exposure of the ignorance of the officials–plate made in this city! A copy of the Gazette which Pach gave me shows the plate, right well printed and with a French title lettered on it "Une Rue à New York" or something of the sort. Carl Anderson called with Kirby. He has recently returned from Spain etc. [Sherwood Anderson's brother.] Nell Sloan arrived from Phila. to stay a while with Dolly. Dinner at home. Baked ham, a great success. Miss Pope, Henris, and Laubs. Painted a "good one" of Yolande. The start of yesterday was easily carried to good end today.

November 22

I worked on gilding and repairing frames and getting four pictures ready to submit to their honors of the N.A.D. jury. I am sending

1. The new one of Yolande "Iolanthe"
2. "Purple Shawl"
3. "Fifth Avenue"
4. "Chinese Resturant"

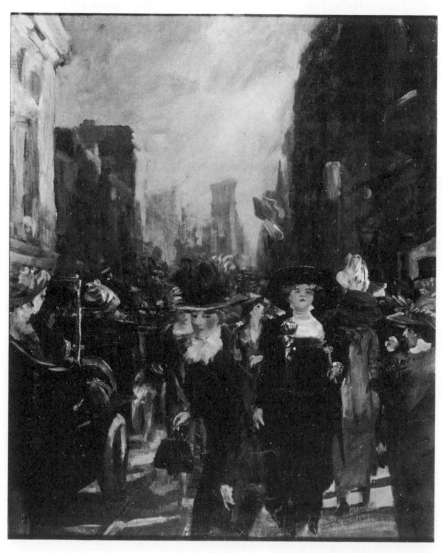

"Fifth Avenue," 1909

Jack Gearity one of the young men of the Call staff called on me and I enjoyed talking with him very much. Young Mr. Wallace, he with the surreptitious sketching eyeglass attachment, called again in the evening.

354

November 23

Pictures went to the National Academy. Painted from Yolande again today.

November 24

A rainy day. Painted from Yolande. Started on a gas light effect, girl singing. The idea was the outcome of the weather. It was so dark I couldn't see the model so lit the gas near her. *["Yolande Singing."]*

November 25

The big Thanksgiving Day Dinner Party which I have rather dreaded has come off. Twelve sat to dine. A big turkey which Dolly cooked was much enjoyed, five bottles of claret. Mr. and Mrs. Roberts, Henris, Nell Sloan, Miss Sehon, Mr. Felder ("Si"), Mr. Yeats, Laubs. After dinner we went to Henris'. As dinner started at 5 P.M. we got to H.'s about 8:30. Mr. Yeats read a short play of Irish peasant life by Synge, very good thing indeed and he read it beautifully. Mrs. H. was very generous with the Scotch, not to herself, but she poured with a bountiful hand surreptitiously in the glass of another lady present—evidently wished to see the latter tight. She had her wish. This gave me an insight into Mrs. H.'s character which will be useful.

November 26

Mrs. Roberts sent by messenger four copies of the December Craftsman, an article on American illustration which has a nice notice of my work. Worked on the singing picture of Yolande Bugbee and lost what I had in my first—so it goes.

November 27

Two seats for Thursday next came compliments of Isadora Duncan from her manager, Coburn. P.A.F.A. announcements out today. Schofield and Henri are both on the jury, which looks favorable but I think that I will stick to my idea of not sending to Philadelphia unless invited. Painted without result in the afternoon.... Dolly and I took a walk after dinner dishes were done, ending up on 8th Ave. which is very interesting and different. The avenue life is different in each case. Sixth, tenderloin, fast. Eighth, neat lower class, honest. Third, poor, foreign. Each has its individual character.

Cut down the old "806" Walnut Street posing stand. It had

always been too large for this studio at 165 West 23rd St. and I feel that it's a good job done.

November 29

It has happened as I had begun to fear in the matter of my loan of $500.00 to Lichtenstein. I called on him at his office today–and asked him to pay his note due the 21st of Nov. He said, just as he said in July when the first note fell due–"Oh I thought that was due next month!" This repetition of an old story seemed so untrue on the face of it that I was disgusted with him. I told him that I *must* have the money, needed it. As usual I have done a favor in a money way and lost what I thought a friend.

Painted on singing picture of Miss Bugbee and think it is on a better road now. After dinner Balfour Ker, Art Young and a man named Smith called. Smith went to the Spring Garden Institute, Phila. at the same time I did twenty years ago! He is an ex-Phila-delphian, paints some and works at lithographing designing. Art Young is a man of interesting character. His work I have long ad-mired, strong, simple, direct–the expression of a good mind. *[When I met him in 1928, he was a fine intelligent man with penetrating eyes and a kind of innocence.]* They were interested in pictures I showed. Dolly and Nell went up to see Ullmans. Found Kitty sick in bed, poor girl. When they came home Dolly prepared a little lunch and we finished up what to me has been a very pleasant, real evening.

Agent of property (165 W. 23) called in re plumbing repairs. Asked to see my lease and noting that the repairs were not excluded agreed to make them.

November 30

Kirby came in and at his suggestion I went down to see his friend Phil. Russell the Lawyer whom I had so often heard K. Westerman speak of. Russell is a fine fellow personally and so is his partner whom K. has also known since his student days in N.Y. when he kept books in the evening to make his college fees. Russell asked us all to lunch with him and I enjoyed the talk. They are such unassuming men and yet great successes in the law. Handed over to Russell the $500.00 note of C. B. Lichtenstein for collection. He is to push the collection as rapidly as possible. He tells me that a note has no "days

of grace" in N.Y.–that it was due on the 22nd, being dated 21st (Sunday). After dinner I pencilled in two sets of Puzzles, quite a big evening's work.

December 1

Jerome Myers happened in while we were at breakfast. After he had gone Arthur J. Elder the English artist who had called on me some time ago came to inquire where he could get an etching press. I suggested Peters, Phila. This "chap" is not of the sort that interests me. Worked all afternoon from Miss Bugbee. Dolly entertained Miss Sehon, Mrs. Laub, Mrs. H2 at lunch. Nell and Dolly went out shopping toward evening. Dolly got a set of white furs as my Christmas present to her.

December 2

Went with Eleanor Sloan to see Miss Isadora Duncan dance again. I am still enthusiastic over the work of this artist. Painted in the morning, no good.

December 3

Painted all day on Miss B. singing. Cut the old work out and painted a new head, which is about the sixth it has had–and I *think* I have it now. Miss B. took lunch with us and Stuart Davis also dropped in and joined us at lunch, on his way from Henri school. Philip W. Russell my attorney writes that he has taken two new notes from Lichtenstein $250.00 due Dec. 21st and $250.00 due Jan. Says this is about the only possible way to get at him.

December 4

Worked all day, about seven hours, on the singing picture–but did not touch the head which is about as I will leave it now. So far as result goes on the hand and waist I got nothing today. Told her to come Wed. and Thurs. next and paid her including those poses. Dolly and Nell went to the theatre, Grand Opera House with Miss and Mrs. Sehon. They saw Lillian Russell–this still well preserved beauty I have never seen!

December 5

While out for the papers I stopped in and saw Jerome Myers. Little Virginia Myers is growing into a most attractive little one. After

dinner Henris came in. Henri tells me that several if not all of my pictures sent to the N.A.D. jury have been rejected–so he hears. H. and I were trying to study out some arrangement of the lights in my studio which would properly show pictures at night for as he very rightly says–people don't get favorable impressions of my work at night and most people see them by night. I'll have to work out some scheme. *[The studio at 165 W. 23rd was only lit by gas.]*

December 7

Painting on the waist of Yolande Singing without model. Mrs. Kirby called with little Janet. As a matter of curiosity I showed the picture to Janet, asked her what it was. "A lady singing!" she answered and I felt that I had at least caught the action I was after, or signified it, rather.

Glackens called in the afternoon. I was glad to see him, he is a rather rare visitor here. He was on the National Academy jury. While he was here my three "rejected" pictures were returned to me. The "Chinese Restaurant" is the only one they hung. And Glack says that's in the overflow room artificially lighted. I was trying to persuade Glack of the excellence of the Maratta colors, but without much result. Kirby called and his two little landscapes were returned to him by the N.A.D. Mrs. Davis and Stuart took dinner with us. Stuart is now in the thick of his art study at Henri's school.

December 8

Today is the third (fourth) anniversary of Linda Henri's death. Worked on the Girl Singing picture from Miss Bugbee in the morning. She stayed and had lunch with us. Dolly and Nell went to hear the Philharmonic Orchestra in the evening. We went to the Turkish restaurant to dinner. They gave the girls very pretty wind bells as souvenirs. . . .

December 9

Yolande Bugbee posed today–the last occasion for the present. I have very much enjoyed the hours passed painting from her. She has a bright, fanciful mind and has been a great incentive to work. I hope to have her again before long. But models are an expensive luxury when no pictures are being sold. Walter Pach called in the late afternoon. I went to Dr. Westermann's and after a treatment for

358

throat and nose, I brought him to dinner. The Ullmans were there. Ullman after dinner insisted on giving a demonstration of the wonderful "One Minute Washing Fluid" which he is about to exploit. Very amusing incidents. He messed in the kitchen till it got on Dolly's nerves.

December 10

National Academy private view today. I did not go–not feeling enough interested to get dressed for it. Nell Sloan and Dolly went, rather late, toward 6:30 P.M. They say it is a particularly bad show. My "Chinese Restaurant" is hung above the line in the artificially lighted Society room with the "overflow" pictures. Jerome Myers is in the same disgrace. E. Daingerfield who was on the hanging committee has always shown a dislike for my work. I have always had a perfect contempt for his. Dolly wore her new dress which Nell has just finished for her, a light gray buff which looks fine with her new white furs.

December 11

Tinkering with the "Girl Singing" during the day. Kent Crane, who seems to have grown a couple of inches since I saw him last, called and as he had brought some oil paints I gave him a batch of color, partly used tubes, etc. E. W. Davis dropped in toward 5 o'clock and had tea with us and stayed to dinner. We enjoyed his company as is usual. He "certainly is one nice man" as Nell Sloan said. He is very enthusiastic over Stuart's good start at the Henri Art School. As he says, if Stuart will just "Keep his Eye on the Ball" as the Golfers put it–he will surely succeed. Davis recalled the way we were started–to polish up details–in our art school days at the Pennsylvania Academy. Such a contrast to the free boldness that Henri encourages in pupils. About 10 o'clock I started in and "got up" a scheme for night light on pictures. Went out and bought gas hose and had it finished by one A.M.

December 12

... Henris came in the evening and after he had seen and approved of my picture night lighting apparatus we played Fan Tan till nearly one o'clock.

December 14

Finished Puzzle. Mrs. Ullman came and we had a little tea and cakes. I went out and got a hair cut, an operation that I always hate.... "Making Faces" came home from Chicago.

After dinner I went alone to hear J. B. Yeats talk and read some of his son's poetry and parts of Synge's "Playboy" at Henri's studio. There were many people there. Glackens, Laubs, Pach, Miss Bell, Miss Goff, Fitzgerald, Gregg and about seventy-five others.

Mr. Yeats was very dear and interesting. I cut away as soon as he finished and came home to Dolly and Cousin Nell Sloan—rather sorry that we had not bought three tickets, though we felt $1.00 was all we could afford.

December 15

Dolly and Nell Sloan went to Philadelphia this morning, 11:55. I have passed the remainder of the day as a busy hermit, lonely and industrious. I made a small etching "Salvation Girl" with pot on tripod ringing bell, announcement of "Christmas Dinner for 25,000" and a lank hungry man loitering and wishing the Christmas dinner wasn't so far away from him. Made the plate, proved about 26 proofs and sent one to Dolly. We are going to send these around as Xmas Greetings to some of our friends....

December 16

Finished up the printing of the small "25,000 Xmas Dinners" plate in the morning and early afternoon.... The Spanish girl, Miss Pardo, called and was sorry not to see Dolly who has made quite a "hit" with her. I told her I didn't think I would be painting for a few weeks. Started a Puzzle in the evening.

December 17

By mail today received an invitation to exhibit the "Chinese Restaurant" at the coming P.A.F.A. ex. Trask writes that he'd like other entries beside. This will make me change my mind on the subject of sending to Phila. I had decided not to send this year, but since he is so kind as to ask one I'll try a couple beside on the jury. Kirby stopped in and we went to lunch together, after which I went to his studio. While I was gone Mrs. Roberts sent her secretary Miss Graban with

a note which asked me to give the Craftsman permission to photo-graph my "Chinese Restaurant." I did so by mail. Rotten old King Leopold, exploiter of the Congo, died today.

December 18

Started and finished a Puzzle which I will take over to Phila. Press next week when I go "home" to see Dad, Christmas. Had dinner at a very cheap lunch place in this block, 23rd St. All I could eat for thirty-five cents. Soup, fish (finnan haddie) and potted meat and spaghetti and coffee. All quite good.

Evening Sun has a sassy (à la Whistler) reply to a bump that Fitzgerald gave Lourvik in an editorial some days ago, in re an article on J. W. Alexander's work. Lourvik (who has never returned the set of etchings I let him have for publication about two years since) raps the "8" painters.

December 19

Went to Henri's to tell him I'd not be at home tonight, stayed a couple of hours. Mrs. Laub is sitting for him. He worked along while I talked with her, got on the Socialist theme. He quite agrees, but won't let it get such a monopoly of him as it does of me. I think however that I have passed the feverish stage and that it has now amalgamated with my make up. I feel much more quiet and in a sense happier minded. Leaving Henri's I walked up to Jerome Myers' to leave a little picture book for Virginia. They were out. I then went up to Ullman's where I was made much of and sat down to a splendid dinner, roast lamb. They do contrive to make me feel at home with them. He, Ullman, set forth to me a tremendous Art Show Scheme. He wants to put a huge collection of good, young healthy pictures into Madison Square Garden, a band of one hundred pieces. News-papers astounded! It really would be a great thing but it requires for a week about $9,000.00!! One idea is to charge $10.00 for each picture shown, but then some of the best painters are so poor! I stayed all night as they insisted and I was so comfortable I agreed. . . .

December 20

Up at about 10 o'clock (Ullman and I had talked till nearly 2 A.M. last night) and after breakfast came down town with him. Of course I had my coal stove to light up. During the afternoon I wrote cards

and addressed envelopes for our Christmas etching, getting them all ready. Dolly had sent a list of names from Phila. and I added others, about 26 in all. Dined at the Lunch Café. Then took a walk down Sixth Avenue. This being the Xmas shopping week many stores are open and little temporary wooden stands fill the sidewalk on the east side of the street from 23rd to 14th Streets. Great crowds are out looking, pouring into and out of the stores. A very interesting sight, suppose it will be the same all this week till Xmas day.

December 21

After a dull day broken only by a visit from Kirby, lunch with him and visit to his studio, I went to Henri's and had dinner cooked on his electric stove which is to be "discharged" tomorrow. At about 9 o'clock Henri started a sketch portrait of me, by artificial light of course, and got what seems to be a very good thing. Then I suggested another exhibition tapering from Ullman's Big Show at the Madison Square Garden to a smaller affair in the big empty first floor room that Henri and I looked at in the spring, on 35th St. near Sixth Ave. This idea we worked out till it looks as though we could put it through. At about $5.00 a picture, selected exhibitors. A show to last a month "The American Art Show."

December 22

To the building 29 and 31 West 35th St. and looked it over. It seems that the two lower floors would make splendid galleries for an exhibition. I went down town to Cedar Street, corner Broadway, No. 128– and saw Mr. Adams who offered to rent it for a period of five weeks for $600.00. This for the first and second floors, $500.00 for the first alone.

Wrote Dolly I'd be in Phila. tomorrow. Letter from Phil. Russell, attorney, says that Lichtenstein gave a check for $250.00 and interest, which is deposited. Letter from Trask thanks me for accepting invitation for "Chinese Restaurant" and for the two other entries. "If they are representative Sloans I hope they may be accepted. If accepted I promise they will be hung, but where and how the Lord only knows." This last phrase coming from Philadelphia will probably decide me on withholding the entries especially as I'll need them for our own show if we have one. Davies was out. Stopped and got May's to estimate on lighting of gallery–$100.00. . . .

December 23

I took ferry at 11:55 for Philadelphia, arrived at North Phila. where my little girl met me looking mighty fine in her new dress and hat and furs. She quite outshines the Phila. girls and her rig is not "loud" at all, just becoming. At Mrs. Kerr's, where Dolly is stopping, a small house on York Street, I found Mrs. K. somewhat better from her attack of neuralgic rheumatism. And I met Dolly's sister Margaret for the first time. She is about Dolly's size in height but much thinner and more worn looking. Has two children, Helen and Rose, whom I also saw.

Dolly and I went down town, she to the doctor's and I to the Press where I had a talk with March. Then up to Nell Sloan's. Uncle Albert not looking as well as usual. He has bad lumbago. At dinner we had the pleasure of meeting Jim Moore whom I have not seen for more than a year. He seems to be in good health and some of his old spirit is in evidence. He is with an appraisal company, estimates on value of art collections and libraries. Seems to be hopeful. He recited some of his old time Irish themes. "The Fenian Cat" and "Shanna-han's Old Shabeen." He says I may hope for a return of my hundred dollars soon. Back to Kerr's to sleep.

December 24

After breakfast at Kerr's, cooked by Dolly as Mrs. K. is not about early in the mornings on account of her illness—we went down town. I missed my train to Fort Washington so went and saw Tom Daly. ... With Daly to a jeweler's on Walnut St. where we met by chance H. Thouron, one time teacher of composition at the P.A.F.A. His arm was in bad shape, just recovering from a fracture. Asked me if I had been doing good work. I said Yes, I thought so, that he knew I was always self satisfied (I feel that is what he has always rated me as). Daly says that he hears that H. T. has finished a picture started in Rome twenty-five years ago! I have a dim recollection of having seen it about fifteen years since in his studio!! It, in all faith, should be good shouldn't it—but, by heaven, I'll bet it is not.

Finally left Daly and got train for Fort Washington. Dad was just going to Ambler to see the doctor. He's having bladder trouble again but he looks right well. Bess too looks well. Nan, Marianna, rather thin and worn looking.

Sampled a nice spaghetti dinner by Nan. Then took me to town with a large balance of appetite. Met Dolly, then the Hamlins and went to the Rathskeller as their guests. Had a pleasant evening in their company. Mrs. H. gave me date book for next year. Dolly and I missed the 11:02 train and had near an hour to wait for the 12:01 to Ft. Washington.

December 25

Christmas Day. Dolly had made Bess and Nan nice presents of stockings etc. I gave checks. Simple but useful cash. Nan gave me a set of gold buttons, very nice indeed–but Christmas is a rather dreadful institution. A big snow storm started toward noon and kept up all day and evening, by far the heaviest fall for the past two years it seems to be. Came out flatly in refusing to go to Church in the morning. Now that Mother is gone it would seem to me to be wasted hypocrisy to go to services which are full of ideas and formulas of life which I think positively against the intentions of that great Socialist Jesus Christ. He was a Revolutionist. The Church backs the Exploiters by preaching content to the victim. I know that my state grieves my hyper religious sisters–they probably pray for me, with tears now and then.

Dad made me a present of his gold watch, the only thing he has of value on earth. I appreciate the spirit which prompts him in this. Nan gave me a set of studs of gold. Dolly's present to me was two of W. B. Yeats' books (son of our friend John B. Yeats).

December 26

Woke up nearly snowbound, no roads open. Those sisters of mine tried to walk to church more than a mile away, got as far as Fort Washington bridge over Sandy Run and a quarter of a mile and came back. Had struggled for an hour through snow drifts. I wonder if they would have taken bread to a poor family that distance! Dad is very fond of the canary bird "Sunny." It is quite tame, flies about the room, comes to him when he taps on his chair arm. Dixie the dog is still alive although not very well. A sore over one of her teeth. She is eleven years old now. The country is very beautiful with its heavy blanket of snow. Some few, very few, sleighs are about, but

the roads are so filled with snow it's hardly good sleighing yet. No Sunday papers have come to Ft. Washington. I read in the papers Monday that this is the heaviest fall in Philadelphia since 1888.

December 27

Dolly feels all right today. After lunch (when Nan had returned from the long walk to "Church" through the snow covered roads more than a mile) we started–with farewells to the family–for Phila. Rode to station in "Grubb's carriage" for twenty-five cents. Got to city after one-thirty P.M. Went to Kerrs' where I got my Christmas fruit cake. Then we came down town to Dr. Bower's. Had a short chat with him and watched the procedure of a "treatment" on Dolly –a thing not often seen by men. I was interested to see how little exposure there is. Bower says Dolly will be cured next month.

From there we went to Broad St. station where I left my bag, then spent a while in a moving picture show on Market St. The streets are piled with snow and only a small part of the car lines are operated. We went to Dooner's and had a broiled guinea chicken and enjoyed each other's company very much, Dolly and I. Went to Broad St. station to get 8 P.M. train which on account of storm did not start till 9:20. Reached home in N.Y. at about 12:15. Started a fire in stove and got to bed at 2 A.M. Dolly is to stay at Kerrs' tonight and come home tomorrow after a treatment.

December 28

Behind some boards in the hallway today I found Xmas gifts for Dolly and me from Mr. and Mrs. Roberts, the kind people. A copper ashtray for me made at the Craftsman Shops and a silk scarf for Dolly. A big pile of Xmas letters from our good friends who all seem to be pleased with my etching sent them. A check from Russell settling the first Lichtenstein note $251.25 and a nice note from Russell thanking me for the etching I sent him. Xmas greeting from S. Walter Norris in Florida. A greeting from the Luks's. Dolly arrived on toward 7 o'clock and we hurried across to a light lunch café and I had something to eat while she took toast and tea. Then we went up to Sehons' to a Christmas at home. Rather interesting, no all round introduction so that you had not to remember a lot of names. . . .

December 29

The weather is the coldest we have had this winter and the fires are enough to keep me busy all day. We went to the Rand School to try the dinner there, and were glad that we did so. Piet Vlag introduced us to John Murray who is a worker in the cause of Personal Liberty –especially interested in Mexico. Secretary of the Political Refugee League which has just succeeded in having DeLara released from U.S. custody. He tells and shows photographs of the horrible Mexican prisons. He is evidently a good, clean type of man–not large in stature but with eyes that are earnest and related to the brain in back of them. After dinner Vlag took us up and Dolly saw the library where all manner of sociological literature is on hand. Then Dolly reminded Vlag that I was and had been for some time wanting to join the Socialist Party. Blanks were filled out and Dolly and I are now well on the way to being members of the Party of the Workers. On our way back we stopped to call on the Roberts's but they were out.

December 30

Mr. March of the Sunday Press has sent me an interesting book of Charades in Verse by Wm. Bellamy. He properly decided that it would interest me. I won't be right content till I have ferreted them out. I went out and walked a while after noon. Stopped in old book store and got copies of last September Century with some illustrations of mine.

Some thousands of shirtwaist makers, girls–are on Strike for improved conditions in workrooms and recognition of their union. Yesterday they sold papers on the streets, extra edition of The Call, and Socialist daily. They have been arrested for "picketing" the shops and in some cases have been sent to Blackwells' Island. Toughs have been employed by the manufacturers and very often have assaulted the strikers. One magistrate, Cornell, has said that they had no right to picket, and that he gave jail sentences because "fines were paid by unions."

C. W. Barrell called and stayed some time this afternoon. He has not been well and will probably go to Florida soon. Kirby also was a caller. He will on account of his health probably go away soon. Barrell had some interesting pottery by a man named Brouer who

366

has invented an iridescent glaze long sought by potters, so Barrell says.

December 31

For the third time Mrs. Samuel Untermeyer (at suggestion of Mrs. Roberts) sent us tickets for the Philharmonic Orchestra Beethoven Cycle. Dolly and I went this afternoon. I did not seem to get into the proper mind for appreciating music so did not find the time particularly well spent. Ullmans came after dinner and took us to see Maude Adams in "What Every Woman Knows" by J. M. Barrie. This I enjoyed quite well. Miss Adams is overly cute and too conscious of the humor of her part in relation to her stupid husband. We did not mix in the crowd of New Year's Eve celebrators but came home and got a pitcher of chop suey from the Chinese restaurant and at 12 o'clock began the New Year on tea and Chinese lunch. Talked till about 1:30 A.M.

1910

Saturday, January 1, 1910

After going to bed about 2 A.M. we get up nearly noon thus starting the year in our most characteristic manner. I sometimes think of my impudence of expecting a living from a world in which I am such a contemptible loafer. An idle afternoon with a slight improvement in spirits. Then we went up to Ullman's where we were invited to dine. Dinner was not served until he came home, about eight o'clock. We enjoyed a fine roast turkey stuffed with spaghetti and after dinner played cards (Fan Tan) till about 12:30 when Dolly and I came home.

January 2

Up late but not in the "Blue" mood. Went out and got the papers. The weather has grown warmer and the heaps of snow on the streets are melting and covered with dirt. The air is full of damp haze from evaporation of slush. Working on a puzzle in the evening after dinner at home. Henris called rather late. We calculated on expense etc. of an exhibition and talked on the subject considerably but don't as yet see a handle to catch hold by—money!

January 3

Jerome Myers ran in and oddly enough he is full of the idea of an exhibition. He has heard that the N.A. has secured a site for their proposed galleries, so he feels as we do that now is the time for a demonstration against them. Vlag sent me a circular outlining plans for a "Peoples Cooperative Wholesale," stock $25. per share, to supply stores that are already in operation and others. After dinner at home we went over to Henri's (10 Gramercy Park) and he and I talked over the exhibition scheme. He thinks the place rented by the year for a continuous series of exhibitions would be the best scheme to start a society of artists, the name "Independent American Artists" he suggests—then a list of patrons who, in advance, put up money to be balanced by equivalent paintings to be chosen at any time during the year's exhibition. Twenty artists to each contribute $100.00.

371

January 4

Today after mailing puzzle to Phila. I went up and called on Davies who by the way is rather in bad health, he is recovering from typhoid fever and says that he has not done any work for the last three months on account of it. He is quite favorable to the exhibition scheme, ready to put up money and enthusiastic and anxious to give the younger men a chance to show their work, as an incentive. As he and I together put it in shape– If *helping* the *younger men* ceases to *help us* –then it is time *for us to* fossilize, *get out*, go to the N.A.D. . . . We took dinner at Petitpas table d'hôte as Henris' guests. Met Mr. King and were introduced to a young Mr. Brooks *[Van Wyck]*, and a couple of others. Mr. Yeats was there, and Mr. King. A nice dinner. Then Henris and ourselves went to the N.A.D. exhibition. My picture is certainly hung in an outrageously bad place, the worst treatment I have ever had. Met Mr. Swift an art critic. Hear that Henri is to give a talk at the MacDowell Club. Home by 10:30.

January 5

Near where the Metropolitan
 Towers to the sky
And brazenly proclaims the fact
 That premiums are high
A peaceful ring of fragrant smoke
 Is seen by every eye
And J.S. sits beneath this ring
 And thanks *[to]* R-U-D-Y.

Burst of "poetry" occasioned by receipt of a box of cigars from J. Horace Rudy.

January 6

. . . Schofield, Henri, Anshutz and Hawthorne who are acting on the Penn. Academy Jury called for a few moments and upon Henri's suggestion I showed the "Recruiting" picture which they liked and invited to the exhibition. Schofield has just arrived from England and looks hale and hearty as ever with that big kindliness of his still in evidence. Phoned Budworth to call for the invited canvas tomorrow. . . .

372

January 7

Budworth Sons called for the "Recruiting" picture for the P.A.F.A. Ullmans came to dinner. Dolly baked a half ham, a gift from the butcher. . . . Miss Bugbee called and as I had been thinking of painting from her again this very day I took it as an omen and told her to come and pose next week.

January 8

Dolly went to the Hippodrome with Mr. Coulston. I had intended to go along but Jerome Myers came in, told me that he had asked Von Gottschalk to come to meeting on Monday night which we had planned the last time Myers was in. I suppose Von G. will be all right. He seems to be energetic and has told me that he could see ways in which money might be raised. Pach came in after Myers left, rapidly followed by Kirby with Philip Russell, to whom I was glad to show some of my pictures. He is a fine sort of man, lawyer, and has done the trick in getting Lichtenstein to "come up" with the money he owed me. After Kirby and he left, Mr. Yeats called and we enjoyed his talk so full of kindliness. Then Pach left. I asked him to come to Monday night's meeting here. Dolly came in and as Yeats and we had been invited to Laubs to dinner we saw Mr. Coulston off to Phila. and went up town together to a good dinner and a very pleasant evening. The artists of the party all busy drawing and we were so entertained that we never got home till nearly 3 A.M.

January 9

Up late, very late. As I was about going out to mail notices of meeting tomorrow to Glackens, etc. Mr. Yeats called with Mr. Brooks whom we had met the other night at Petitpas table d'hôte. They stayed some time. . . . We went to Petitpas with Yeats and Brooks. Henris came there also and Mr. King also sat at our table and we had a very nice evening. Then Henris came to the studio with us and we talked exhibition. It looks as though the meeting tomorrow was becoming a little too "mixed" in those invited to attend. But we'll wait and see how it turns out.

January 10

This evening the meeting to "pow-wow" over an exhibition or society or something was held and now that it is all over there don't seem

to be much to record. Jerome Myers was on hand first with Von Gottschalk, then came Shinn then Henri then Pach then Luks. Glack sent his excuses by Shinn. We considered the plan of organizing about twenty artists then going to people with money and getting some—giving pictures in return, to be selected during the exhibition period. A side discussion that was amusing was on the subject of the Maratta paints.

January 11

Went down to the Call and gave them a drawing of Pickets the Police Protect (street walkers) made today, in reference to the shirt waist strike now going on in which much police brutality has been cited by the "Call." I took four short stories from Mr. Kopelin which are to be illustrated for the Sunday Call—gratis. Met and had a short talk with Courtenay Lemon whose article roasting the new Theatre and its millionaire patrons of art is a very good one. I wonder if I'm consistent in this when I consider our exhibition scheme! But then I don't believe we will put through that plan by giving the rich the chance to be patrons. Glack was waiting to see me when I came back. I told him what had been talked of last night. Made a drawing for the Call (story) in the evening. Little Yolande Bugbee has gone into wage slavery. She called at noon and told me that she had taken a position in the National Cloak and Suit Co. Poor little girl I am sorry, but I suppose the regular income was needed.

January 12

Made two more drawings for the Call stories and am enjoying the work, though the stories are rather weak the subjects are of a human nature sort and offer right good chance to make pictures. Which is just what is not true of most of the paid illustration of the magazines of the day. Dolly is busily engaged in making a "net overdress" for her crepe de chine white gown. She is going to Phila. next week and will wear it at the private view of the Penna. Academy of Fine Arts.

January 13

. . . I made a drawing, the fourth, for the Call stories. Jerome Myers called and talked about the exhibition. He don't think it wise to get money from wealthy people even though the money is put as advance purchase price for picture. He seems to be afraid of the idea of the

young men coming in. I don't quite see where he stands. He certainly gives evidence of antagonism to Henri, there seems to be in his wife some strong anti-Henri idea. *[Mrs. Myers had studied with Henri and in later years certainly remembered him with respect.]* ... After dinner finished up all the Call drawings to deliver tomorrow.

January 14

A fine big snowstorm today. Kirby and I walked out in it. Coming back from 14th Street it raged furiously, beating into face, fine sight. This evening we had a dinner party. Mr. King arrived on time, a few minutes later Mr. Brooks and he left to look up Mr. Yeats, who had calmly eaten his dinner at the Petitpas and forgotten all about his invitation to our house. But he's such a dear old fellow, Dolly didn't scold him, and what's more remarkable I didn't either. We had a very enjoyable evening. Mr. Casey of Collier's called me up and asked me to submit cover design sketches.

January 15

Preparations for our "week end" trip to Scarsdale to visit Kirby's took up our morning. We got a 1:22 P.M. train at the Grand Central and Kirby met us at the station with a hired sleigh and woolly horse. A splendid day, clear blue sky, and the loveliness of the cold white snow so fine in the country.

January 16

Another beautiful day in the country. Walked over to the station with Kirby and enjoyed the beautiful snow spread landscape with the prosperous suburban homes here and there—for Scarsdale is exclusive that's one of the things Kirby likes about it, I really believe. For Kirby likes "niceness" but wouldn't like it called that. Fixed a clock so that it would properly strike the hour for Kirby. Also the electric bell in the kitchen. I like to do this sort of thing. We called at "Phil" Russell's in the afternoon. He has a very comfortable home. I still like Mrs. Russell and I like him better each time I meet him. After tea at Kirby's we talked in the living room before his open grate with logs burning. Very *nice*, comfortable. K. enjoys his home. I suppose I'd enjoy one too but I could probably never form one.

January 17

Back with Kirby on the early train. March, Sunday Ed. of the Press, writes and speaks of the difficulty he and others have had with Charade #55 in the Bellamy "More Charades" book. I had not solved it and really occupied most of my day trying to get at the answer. Finally, though defeated I had to go to bed, the nearest to answer being a guess of Barrell's ("scarlet"). This is not given in the Cryptogram answers in the back of the book so is probably not right. . . .

January 18

After another wrestle with #55 Charade I gave it up for the present and got at a puzzle. Mrs. Ullman came in and sewed with Dolly. Later Mr. Yeats dropped in and read us his article on the American Woman for Harper's Weekly. It was a very witty and entertaining thing, the fit product of his interesting mind. His side comments were fine too. He told of his experience in 1870 painting in the home of an Irish Lord (uncle of Balfour) Herbert, of the confidences which they placed with him, of the Rabelaisian jokes, etc. and of a visiting lady who "threw herself at him" and he was too much awed by to accept besides having a wife and children. Laubs, Henris, Mr. Yeats and Nellie (Mrs. Laub's sister) at dinner and after dinner fortune telling by cards, Mrs. L., and drawing by Yeats, Henri, and I painted a small sketch of Henri and Yeats. Nan, my sister, writes that she has sold a couple of pictures, paid off $500. of her mortgage.

January 19

This morning I kissed Dolly good bye and saw her started off on her journey to Philadelphia, for more treatments by Dr. Bower. I do hope and he has promised that this is to be the wind up of the year's siege of her inward disorder. And then she'll come back to me and we can feel settled and undisturbed in our little attic home. Went in and spent a few moments with Kirby, then to the American Art Galleries and saw the Lawrence collection of paintings, drawings and bronzes, soon to be sold. Some drawings by Daumier and one painting of his. The latter recalled my sister's earliest work under Henri in the School of Design for Women, Phila. I don't know why, it was technically like, probably, water color. Daumier's bronze of

376

the old cocky military wreck is great. Some good Monets, an interesting show. Mary Cassatt's work, several examples. I feel that she is a great figure in art! Took the four drawings to the Call. . . . Ullman wants to take hold of getting funds for an exhibition. . . .

January 20

. . . Barrell called and as this is cleaning day I went out with him leaving Lily, the darky girl, to wield the duster. Barrell and I went down to Greenwich Ave. . . . to the Show Bill Restaurant. Not much restaurant left, it is nearly obscured by the immense collection of dramatic curios, showbills, posters, costumes, etc. The collector and host is a fine character and his talk most interesting. He knows all the profession for the last fifty years, many of them personally. Invitation to Buffalo–St. Louis Exhibition for my picture at the P.A.F.A. exhibition. In the evening I read a small book by Zoë A. Norris, "Color of His Soul," a poor screed directed against Courtenay Lemon, who was at one time the "Boy Socialist." He had the book suppressed by the publishers as it was libellous. Barrell also loaned me Gorky's "Three of Us" which will be better worth while.

January 22

Letter from Daecke, says that he removed toilet and bath from 806 Walnut–which I had put in in 1902 signing an agreement to leave them at the expiration of my lease. Now owner is after him with a lawyer. He says he thought he was buying them from me. I answered that the extra $4.50 per month I charged him for the studio in my unexpired term was for no other purpose than to partially reimburse me for my $300.00 in various improvements. (Copy of letter kept.) . . . Got started at last on sketches for Collier's cover. Worked during the evening on these, and feel better now that I've got some roughed out, though I can't feel very hopeful of their "Landing" the work. It does not seem to be a hopeful case.

January 23

My "Pickets of Capitalism" came out in the Call today. It looks good. Working on the Collier sketches. A visitor! Bill Gosewisch arrived during the afternoon the same old Bill, aggravatingly nervous as always. He has a sort of a job to try out tomorrow here in New York. It looks as though I were in for a visit of several days. I in-

vited him to stay overnight, but I think he has accepted for several. ...Henri and Mrs. called in the evening. He criticized my Collier sketches severely and they are pretty bad I guess. I certainly am not keen in their defense. H. amused himself roughing out a couple of suggestions. H. tells me that my two paintings are on the line in one of the front small rooms at the Penna. Academy Ex. He did not stay for the private view and Mrs. H. did not go over. Spoke to Henri about Ullman's suggestion as to raising a fund by patrons, for an exhibition. Told him it would be necessary to have about $300. He did not seem to take to it much. Remarked how little spirit there seemed to be in the meeting, that is, real "do something" spirit.

January 24

Two letters from my Dolly girl in Phila. arrived today. She tells me the news of the P.A.F.A. private view. Says that her dress looked well and that the affair was a crowded one and a social success. She went with the Montgomerys in a carriage. So fine! Dear little girl. I took the sketches to Collier's and left them with Casey. He seemed to like a couple of them pretty well, at any rate I've "done my duty." Dropped in at the Rand School where Kopelin of the Call lives. Gearity is there with him. G. has left the Call and Kopelin leaves in a week or so. They are going to start a Socialist and Labor News Bureau. We talked of a semi-monthly magazine of a satirical, humorous, human life sort. Dinner at the Rand School. . . .

January 25

With Kirby at about noon time to a "moving picture" show–a feature that interested me was an Indian in full war bonnet of feathers and complete get up who gave in his broken English, a lecture. I had never before heard an Indian speak so that all his accent and pronunciation was new to me. Kirby tells me that they speak English differently according as they are affected by their original tribal dialect. One thing he said was "Joe people is pecoolyer." Of course his speech was probably written for him and learned but he gave it his own touches. During the afternoon I did a piece of useful carpentering work making an additional rack for canvases, between the windows over the lithopress (Dove's is still with me, he is back from Paris but I have not heard from him in regard to it).

Gosewisch came in after 6 o'clock–got himself a pitcher of beer,

to save expense!! And as I refused to join him he drank it all. Then we went out to dinner together at a cheap place in this block. He took my dinner check 20¢ and insisted on paying it. This made me so "hot under the collar" that I flew into a temper and told him just what I thought of him. Money chaser, mean, only using my roof to save a few dollars. I did let him have it. He took it all, too. He's too miserly to get mad about that kind of reproof. Started puzzle in evening. Gee whiz! I just notice that I have forgotten about Henri's lecture at MacDowell Club tonight. I had card from Mrs. Roberts this Tuesday morning and was going.

January 26

Finished puzzle in the morning. Mrs. Davis called in the afternoon. . . . Stuart Davis is busy painting, making portraits, throwing a lot of paint. Mrs. D. says his work is interesting. Ullman came in immediately after. He proposed that we, he and I, go ahead on the exhibition scheme without saying anything further to the rest than to ask them if they will send pictures. Even that to be held back a short while. Then when the thing is under way, ask certain (Henri, Davies, Glack, Luks, etc.) of them to be Directors. I walked out to Fourth Ave. with him, stopping at Hoffman House where we had a free lunch with high ball. The free lunch for the honorable Hoffman House's guests is better than most.

I am going to go at this thing with Ullman. I *believe* we *can do it* and it will be worth while trying anyhow. . . . Got some puzzle ideas in shape.

January 27

Up rather late as I had not gone to bed last night till nearly 2 A.M. and when I had my breakfast I started out to the Rand School. My mail box had two welcome letters from Dolly, whom I had not heard from since Monday. Also notices for her and me to attend meeting of 25 & 27 assembly district Socialist Party tomorrow night. I can't do it on account of engagement at Ullman's and so wrote. Kopelin gave me the cut of the "Pickets" drawing and the original drawing. I had lunch there. Piet Vlag introduced me to Mr. H. P. Richardson, Asst. Sec. Committee on Prevention of Tuberculosis, of Charity Organization Society. This gentleman wishes to have a large sign made, a blasted tree representing the fearful results of tuberculosis in N.Y.

If I can do it it will bring in $30. Kopelin and I talked further of the periodical scheme. When I got home I found a note from "Gosey" saying he was going back to Phila. This sad as it may seem to say it was a relief. Card from Potts who is to have an exhibition at the Madison Gallery. After writing to Dolly I walked out and went as far as Broadway and 40th St. Saw the crowd coming from the Metropolitan Opera House. Went to Collier's in the late afternoon. Casey referred me to Lee, the Mg. Ed., an up to snuff Mut. He doesn't care for any of the cover sketches. Tells me to try some more.

January 28

Kirby came in very much disturbed and looking like a Death's head. His wife is very ill with pleurisy and perhaps worse. He wants me to take a work on a story for Collier's that he has to get out by Friday next. I said I'd be glad to do so. Made a sketch on the tree of tuberculosis scheme for Richardson and took it up to him. He said he'd show it to the board and let me know soon. I told him the price would be $35. as that was what I had understood from Vlag. Cost of canvas extra.

Letter from Dr. Bower makes me feel rather blue as he tells me that I won't get my Dolly wife back for some time. He says she is coming round all right. Went up town to Ullman's for dinner and had a fine spread of pigs' knuckles and sauerkraut. Very good and quite out of my ordinary sort of feeding. I have been on quite a low diet lately, trying out the scheme of less food. I have felt brighter for it too. After dinner we played fan tan, and I suggested the name Associated American Artists for our exhibition. The device to be (monogram) on an Indian arrowhead.

January 29

A dismal raw day, slush on the streets and a drizzle of rain. I went out, walked to 14th St. and dropped in a second hand book store where I met Mr. King, of the Literary Digest. I bought a copy of Bernard Shaw's "Unsocial Socialist." He (King) tells me that Henri's lecture on Goya, etc. was quite well received the other evening. Made a sketch for the device of the A.A.A. in the evening and started to read Martin Eden by Jack London. It held my interest, I sat up till 2 A.M. reading it. . . .

380

January 30

I saw two little girls about twelve and fourteen years watch a "street walker" talking to a young man. After the bargain had been struck the couple started up the street and the little girls followed. The two went into a side door on Sixth Ave., and strangely the two little ones stepped into the door way and shouted some remark "O you–" (the last word I didn't hear) up the stairway after them. That's all. They walked along afterward and no results were apparent, a hard case to understand.

Made some drawings in pencil for the Kirby story. Up to Ullman's for dinner, a fine dish of lentils with ham and mushrooms. After dinner I walked up with them to 125th St. where there is a gay throng of life, another Broadway. And, Oh! before dinner Ullman and I walked up the rocky paths in Central Park north end to an old fort which dates back to the times of the early colonists. Very fine outlook through the winter bare trees on the city lights. Some snow and thin sheets of ice on the ground and rocks. Very fine stuff to paint. After I had been home some time near 11 o'clock Henris came, with Mr. King and Rockwell Kent. An interesting discussion on whether aesthetics were really an existent part of human make up. Kent is a socialist and a fine fellow anyhow.

February 1

Wrote and accepted invitation for the "Recruiting in Public Square" (now in Phila.) to Miss Cornelia B. Sage, Albright Gallery Buffalo and St. Louis Exhibition this spring and summer. Kirby called and seemed well satisfied with the Collier drawings I had made. He is doing one over tomorrow. Still this is better for it will give the lot a look of having been done by him. We lunched in the One Minute Lunch Room which has opened in the basement of this building. We told the proprietor that he should use the big room extension back for a picture gallery, drawings, etc., by 23rd St. artists of the neighborhood! My card, and Dolly's card–membership in the Socialist Party, arrived today. I mailed Dolly's to her in Phila. Now we are "Reds." *[Ramsay MacDonald, writing about socialism in 1911, described the movement in the United States as composed of intellectuals. Sloan's journal records how he met with Socialists in every walk of life, from editors to members of the Colony Club. These intellec-*

*tuals were seriously distressed by the effects of laissez-faire competition
at home and abroad. Their background was that of Christian human-
ism, and it was this quality in Eugene Debs which attracted Sloan to
follow his leadership. "Debs was one of the most Christ-like men
I had ever met. He would share his clothes or his last crust of bread
with any man who was poorer than himself . . . we all felt that we
were part of a crusade that would help to bring about more social
justice at home and prevent the outbreak of world war. We were
seriously alarmed by the new scientific discoveries which could make
warfare a thing of terrible violence. . . . We did not have any doc-
trinaire ideas about running the world. Every time we went to a meet-
ing, the speakers would talk about some new ideas for bringing about
more justice without getting the world into the tyranny of some huge
bureaucracy. Debs used to warn us that the socialist party should
never have power of its own, that the ideas of the movement should
be carried out through many different agencies of private and gov-
ernmental types. It is hard for the man living in 1950 to realize that
many of the things he takes for granted were considered radical pro-
posals back in 1910: Women's suffrage, income taxes, workmen's
compensation and social security, supervision of the stock exchange
and regulation of interstate commerce, the United Nations. . . . I had
great hopes for the socialist parties up until the time when the First
World War broke out in 1914. Then I saw how they fell apart. Some
of the leaders were killed; the emotional patterns of national pride
set one country against another. I became disillusioned. I used to
think that greed for money was the worst evil in the world, but after
we saw what happened under Mussolini, Hitler and Stalin, I realize
that the desire for power over other people is a far more terrible evil.
If most of us took our religion sincerely, as a real thing, of course we
would have no war."]* I sat up till after 3 A.M. reading "Martin
Eden" by London. I feel well repaid for reading it. It is a great
story not without faults. What a poor book a faultless one would be!

February 2

To Ullman today I gave in cash $75.00 and a check for $25.00, equals
$100.00 to be used in rent and preliminary expenses in starting the
Fund for an exhibition of our new Associated American Artists.
Made my first payment of $5.00 on one share of Amer. Wholesale
Cooperative, P. Vlag's socialistic scheme. . . .

February 3

Carl Sprinchorn, who is one of Henri's men, now is acting as manager of the School, called this morning and I enjoyed showing him some of my paintings. He is quite young, a Swede and a man of solid character. . . . A young man name Power came to get his book "Martin Eden" which Barrell had loaned me. A socialist, and very nice sort of fellow. He says that he will loan me London's "Iron Heel." After dashing off a short letter to Dolly I went up to Henri's for dinner. Mrs. H. had made a very good Irish stew–not easy to make perfectly, and this was a very good one. Henri and I talked. He has several new things and good ones. He told me Calder had been in today. Calder is living at Croton on Hudson.

February 4

Finished up puzzle and mailed it late afternoon. I went to bed last night *determined* to get up today and be energetic, but as I didn't get to bed till after 2 A.M. I could not rouse myself very early in the morning. My stomach is beginning to follow my heart now, it's missing Dolly. I can't seem to regulate my meals when she is away. It is 2:30 A.M. Saturday. I have just finished reading Gorky's "Three of Them." *That's* great work. Real power. A book that explains some great part of the fearful conditions in the whole present social system. Think of reading it in Russian. But how little difference there is in this U.S.! The conditions are the same. There the Czar is the permanent head, here there is perhaps no official head. I feel glad to have read this book. It is a life experience worth having.

February 5

Went out with Kirby to a book sale at Simpson Cratsford Co. and there found a nice copy of Traubel's "Walt Whitman in Camden" which I got for $1.75 (regular price $3.00), two of A. Morrison's books also at 21 cents each, was quite a bargain. After my dinner in the evening I went out to walk about and I enjoyed myself very well. Spent about two hours in the Night Court. This is much more stirring to me in every way than the great majority of plays. Tragedy –comedy. One moment I want to throttle or kill some one of the officers of "Justice"!! The next I will want to cry–rarely is there anything "funny." I'd like to laugh sometimes, but I would wish to have

a throat that would give out a sound like the harsh horn of a $300. automobile. Voting slip for Carnegie Institute. I voted for the following out of a very unappetizing bill of fare. Henri, Schofield, La Farge, Ochtman, Davis, Hassam, Wiles, Bogert, and Gierfenhagen and Zorn (foreign).

February 7

When Kirby came in at 12:30 P.M., found me just up, he, typical Puritan and moralist that he is, proceeded to give me a lecture. Said that I could get work to do if I would go about to get it. I had to admit that I didn't want it. I said I was lazy—not roughly. I should keep more regular hours. I told him I didn't care (I do though). Kirby, born in the West, must come of a stock Puritan of the hardest sort, a crest of some wave that tumbled across the country, so heavy it fell in Nebraska perhaps. Jerome Myers with a friend, Underhill, whom I did not like, called. I had just put out paint to try a go at the Pigeon Flyers on the roofs back of me. As the pre-sunset glow only lasts twenty minutes I had to give it up. *["Pigeons," collection of the Boston Museum of Fine Arts.]* J. M. talks of an exhibition International, small group. Attempted to dress to go to Mrs. Roberts' "at home" in the evening but couldn't find my gold studs and in my desperate search got candle grease on my dress clothes. So it's all off. Well, I hate going to this sort of thing anyway.

February 8

Following a suggestion of R. Hunter's in an Editorial in yesterday's Call I have written to J. D. Weeks Committee on Post Offices, Etc., Washington D.C. a mild protest against the proposed increase in postal rates on publications, etc. If this increase is put through it will probably effect the suppression of many radical and labor organs, and do great harm. The rates paid by the Gov't to the Railroads for carrying the mails is the real cause of the deficit in the P.O. But what will my postcard do? Wrote to Trask P.A.F.A. asking that he have damages done to my frame in the exhibition made right, Dolly has written that one of the frames is broken. Sent a money order for $15. to Barrell. I had a letter from him yesterday from Jacksonville. The orange crop, which he had counted on for employment, has been spoilt this year by a frost, so he had to come back to Jacksonville from Orlando.

A beautiful letter from my brave little wife today, so powerful in love, perfectly wonderful, a thing to keep. It makes me feel more lonely and yet she is so brave and in a way she's the worst off. This is home, she is visiting.

Mr. Russell sent me a check for $250.87 which settles the Lichtenstein account. "Here endeth the Second Lesson." Moral: Don't put money into a tradesman's business.

February 9

A note of appreciation for my work as appearing in the Sunday Call from Hayden Carruth of the Editors of Woman's Home Companion. One of those loving streaks of lightning out of a clear sky, which are very encouraging or should be. I suppose that Mr. Carruth while appreciating my work (and in the Art Editorship of the magazine) so Kirby tells me—knows that the "public" don't want "my kind of stuff." . . .

Started on a puzzle drawing. Went up to Ullmans' for dinner, spaghetti. After dinner we played cards till after 12, then in some way we got into a talk of death and the sensations of entering the shadow. From this we naturally turned to the universe, The Beginning! If ever such a thing could be conceived, or an End! I feel that it is against our instinctive understanding of the rhythm of the universe to say that we, who have no consciousness of a former state or states of the ego—will go on with this same ego to a future state. Anything is possible in the way of passing of the Spirit or the Life Force but hardly the "I." In other words why should I as I know *myself* ignorant of a past existence expect to be *conscious* of a future one?

February 10

After I had finished up and mailed puzzle I dropped in Harbison's Old Book Store and in rooting around I found a copy of Cheiso's book on Palmistry which at once struck me as the thing to give dear old Yeats. I bought it then started home purposing to work again on the Pigeons and Roofs picture which I roughed in the other day. But I was prevented by being beckoned into the Tuberculosis Exhibition by Mr. Richardson who is in charge. It occupies a shop room in the Fifth Avenue Building and I saw him in passing. He spoke of the sketch being held up. He is a socialist and a member of "my" Branch. After dressing I went to Petitpas' for dinner and

presented the book to Mr. Yeats who was I think pleased to get it. There was a young Mr. Davis with his wife, an interesting young woman with rather a cold look to her eyes, and an Aunt and Uncle, very dull people. I tried, foolishly enough, to talk Socialism with them! I will learn better some time. Mr. Yeats and I went to Henri's. Mrs. Roberts was there, some students, can't remember the names, and Miss Elmendorf, who paints flowers beautifully. I walked home with Yeats. I certainly find him charming. This word is used here in no ordinary social sense, but sincerely. Full of charm, he is. Everyone is asking for Dolly and my heart chimes in.

February 11

Dropped in to see Kirby and his English friend Wilkinson was there. We all went to lunch together. And after lunch at K.'s suggestion I asked Wilkinson to come up and look at some of my work. He and K. came up and I got out a number of things. W. says that I should send some paintings to Englind, that I probably would be well received. I am inclined to think him over-hopeful. After they had gone I tackled the job I've had in mind a long time–painting the woodwork of the kitchen. I think that Dolly will be pleasantly surprised when she finds it done. She will be back a week from to-morrow if all goes well. I have had the most lovely loving letters from her. Her letters are always so, but the last three or four have been particularly beautiful to me.

After I'd finished the kitchen I had just time to "wash up" and go to my first Socialist Branch Business Meeting at the Rand School where 1st, 25th and 27th A.D. meet. "Comrade" Mailly was the chairman. A pretty young lady Miss Cole (?) was secretary but she resigned. She made something nice to look at during the rather dry order of business. My friend Kopelin, late of The Call, was appointed secretary. Miss Thompson is treasurer and I paid dues for Jan., Feb. and March. $1.05. . . .

February 12

Today I went on with my "interior decorating." I finished the kitchen then went at the small bedroom and at about 6:30 I had it all finished after a hard day's work, but I'm looking forward to today week when "she" comes home and will be so pleased. I had intended

386

to go to Petitpas' for dinner but it was too late when I got through my work so I just went down to the very good cheap restaurant in our basement and had my frugal repast. Prunes had been my only food till then. I had been too eager to get my job done. . . . The Henris and Roberts called about 1 o'clock, coming from Petitpas'. Mrs. R. is very anxious that Dolly and I go to her dance at Haggin's studio next Saturday. It is to be a costume affair.

February 13

Writing a number of letters took up much of my time this afternoon –a long sleep took up my morning. I walked out a bit, just to the post office. Dinner I had at Ullman's and after we played cards, Fan Tan as usual. Being the "13th" I was lucky–after being "in the hole" for 75 cents I got back and won 15 cents. Did not get home till nearly 2:30 A.M. My hours have been dreadfuly regular. I never get to bed before two o'clock in the morning.

February 14

Today I was to go with Henri and Roberts to see about costume, but instead I phoned H. and went to see what Kirby would suggest. I went on a shopping trip with him and lunch we had together. The proprietor of the Lunch Place says that one of their customers is looking for an artist to draw a music cover page, said he referred him to me. Borrowed an old high hat and an old gripsack from Kirby, and wrote to Wilson the model, for further outfit for Mrs. Roberts' party Saturday night.

Toward evening I painted on my Pigeon Roof picture. Then Mr. F. H. Dewey came in and introduced himself as the man who wanted the cover for a song which he had written. He has a very complex idea of the drawing and only wants to pay $15.00. I took it with the understanding that I am to get $5.00 more if he prints a second thousand. I don't think he will judging by the words of the song. It is silly. But that may be its success, it's just stupid enough to make a hit, perhaps (I doubt it).

After dinner I worked on the drawing and finally got it in pencil. It's a big lot of work for $15.00! But that will pay our expenses Saturday night. Dear Dolly sent me a Valentine today, and I forgot all about the day.

February 15

Went on and finished the music cover. It's a "bad" thing but it pleases the man who is to pay—"right down to the ground," he's much tickled with it. I will probably hand it over to him tomorrow. It is a hard earned $15.00!

In the evening I went up to the little flat of Wilson the model who has kindly offered me costume of 1820 for my use on Saturday at Mrs. Roberts' party. He has a small place in a rather cheap neighborhood but when you go in you are surprised. He has a craze for antique furniture and good taste in that direction. Fine bureaus of the American Colonial period, beautiful tables, chairs, and a wonderful Sheraton sideboard—all too fine for the size of the place as he very well knows and says. His wife, who was in the kitchen, is a very nice looking girl, I heard him call her Laura, but though I went through the kitchen to the dining room to see the sideboard, I was not introduced to her! In the dining room is a small cot, two little ones slept cuddled up. I wonder if Wilson should not spend more money on fresh air, and less on heirlooms.

February 16

... Dolly writes of an odd incident in Phila. She was paying her fare in a streetcar when the conductor noticed her Red Card (Socialist) in her handbag. There were only one or two on the car and he told her he was a Socialist and talked to her of the conditions of the car men in Phila. They are evidently restless under poor pay and it is likely that a strike may come in the Spring. In the evening after delivering the sorry drawing to Mr. Dewey and being paid cash, I went to Ullman's for dinner—a good meat pie. ...

February 17

Kirby came in with news that a Pathé Frères' moving picture film of "Carmen" was at Proctor's so as I expected the girl to come and clean up in the afternoon I left the key for her and went with him to lunch and then to the "Show." It was good—we had about two hours entertainment of various sorts for ten cents. A short playlet and a couple of other variety turns and then several moving pictures. I have an idea that the stout woman in blue silk standing at one side of the curtain and singing as the illustrations for her song are cast

388

on the screen, would be a good thing to paint. I started a puzzle toward evening and after dinner, or rather instead of dinner, I painted the bathroom woodwork. I have told Dolly that there is a surprise for her but have not told her what it is. Two more nights alone. . . .

February 18

Knocked on the East wall of my studio, and Kirby called answering me. We made each other understand that lunch was due and met on the street outside. I came back and finished and mailed the puzzle, then as the sun was setting with brilliant orange glow I worked again on my "pigeon flying" picture. Wilson the model called, and inquired after my preparations for the costume party. This stirred me into action on the matter so after dinner I started and tried on the suit. The old coat needed mending so I got needle and thread and fixed it up. Made a white collar to wear with a stock and fixed up a pair of glasses, blue with big cardboard gold rims. Sat up till 2 A.M. Don't want to turn in alone till I have to. Tomorrow is the great day. My brave hearted girl comes home! She tells me that she has been taking two treatments a day this week in order to complete her cure. This takes pluck and I hope it won't have a nervous reaction.

February 19

In compliance with a short note from Dolly I went to meet the 1 P.M. train from Phila. and was much disappointed by not finding my little wife on board. Came home rather blue. Kirby and Mr. Russell called and I gave Russell two etchings which he seemed to like. While they were here Dolly came home, full of the news that a car men's strike is on in Phila. declared this afternoon. We pitched in and got ready for Mrs. Roberts' costume party. Dolly got from Mrs. R. a peasant costume. I painted a pair of her shoes red, with drier so that they might be ready for her. I put on the old fashioned togs that Wilson had loaned me. Made a fine false nose and was a great success. We went in a taxicab and came home in the same elegant style. Henri was funny, so was Glack as an Irishman. Mrs. Glack very good in a real 1808 dress. Mrs. Shinn in an old rig also fine. The Haggins in Turkish (Haggins' studio was the scene of the festival). Met P. Dougherty, Harrington Mann, Mr. Fromke. Mrs.

Haggin, Sr. is a fine woman. Mrs. Dan Morgan looked a starved beautiful tigress, interestingly thin. We did not get home till after 4 A.M. The party was a splendid success and I had a very good time. Young Davy *[Randall Davey]*, a student at Henri School, was very good in stunts and dancing.

February 20

Dolly remained in bed till about 5:30 when we dressed and went to Petitpas' for dinner, the chief object being to see Mr. Yeats. Henris were there, and we met Mr. Terry again in proper person. He is light, airy and a light comedy actor, a relative of Ellen T. A friend of more interesting personality, also an actor, Mr. Alexander, is also an Englishman. We went with Alex. and Terry to Henri's and saw a full length of Mrs. H. 2nd, which he has just painted. I liked it as a work though in character it is not as true to her as the one in the yellow and purple shawl. She is a "poor thing" and this last one don't have the sympathetic element. . . .

February 21

Dolly stayed in bed today to build up her nerves which are rather worn by the severe course of treatment of last week in Phila. The strike of Carmen in Phila. is quite exciting according to reports. There is much "rioting" by the rough sympathizers in the Kensington district. In the evening I wrote to Henri, Glackens, Luks, Shinn, Davies, Lawson, Myers, Golz, Sprinchorn and Bellows and Prestons for pictures for the exhibition in the dining room at the Rand School of Social Science.

February 22

Dolly is keeping to her bed just to rest up. I brought in her dinner from the restaurant in our basement. I just hung around waiting for my little dear to get "wound up" so that she can take her useful place in my life. She did in fact get up long enough to straighten things up a bit, and made the rooms look much tidier. This has been a holiday. Washington's Birthday has been celebrated in Phila. by great excitement and "rioting." Many cars have been wrecked, a couple of innocent lives lost. The police have been unable to "hold down" the crowds. There is talk of the Labor Unions calling a General Strike.

390

February 23

Dolly stayed in bed till toward evening when she got up and cooked a good spaghetti dinner which I enjoyed much. The first meal at home since her return. Finished up "Pigeons" and I think it is a good picture, very well content with it. . . .

February 24

Mr. Coulston from Phila. dropped in on us today and has accepted our invitation to stay for a few days. He is interested in seeing the Motor Boat Show at Madison Square Garden. We went to dinner with him at Shanley's and then to a moving picture show at Proctor's. Acceptances of my request for pictures are coming in. Mrs. Jerome Myers with Virginia called in the afternoon. Yolande Bugbee came in also. She has given up her position with the Nat. Suit Co. and I have engaged her for week after next. She is looking well and seems as attractive as ever to paint. Sent "Pigeons" and "Three A.M." to the National Academy Jury. The last one won't have a chance I'm sure. It is the Tenderloin picture I painted last year. One girl in her shift cooking, the other gossiping over a cup of tea. Quite too much for them.

February 25

. . . We went, Dolly, Coulston and I, to see Whistler's "Fur Jacket" at Macbeth Gallery. There we happened to meet Henri. It is a splendid picture, about the best Whistler I've ever seen, a beautiful conception of a woman. We went then to Montross Galleries where are two or three small Whistler landscapes, not very interesting. In the evening Dolly and I went to the meeting of our Branch at the Rand School. After the business of the meeting a Miss Perkins spoke on "What becomes of the Emigrant." She told how they come here and are unable, through bad handling and the idiotic reputation of ignorance, due to their not knowing English, to get the sort of work for which they may be fitted, and consequently get a lower start than they should from their natural abilities.

February 27

Dolly attended "Woman's Day" Socialist meeting at Carnegie Hall. She came home glad that she had gone. She spoke enthusiastically

of Charlotte Perkins Gilman, who was one of the speakers. The attendance was good. I walked as far as 38th St. to get a Phila. Press, then came home by 8th Avenue where I saw the usual Sunday crowds of working class people airing themselves on the holiday. Came home and started a canvas on the Sunday afternoon idea, but it was late and the canvas was very absorbent, so my work hardly shows. After dinner, a fine steak and a dandelion salad, Dolly and I read various papers, etc. which she had bought at the meeting this afternoon. I wrote to the Artists Packing and Shipping Co. to collect ten pictures tomorrow and deliver to the Rand School.

February 28

Jerome Myers was an early visitor today. He came in while we were at breakfast. Kirby also, dropped in at the time. Dolly went to Newark to see Mrs. Davis and I took a trip by way of the roof to see Kirby next door and give him some help on a cover design he is working at. As Dolly stayed at Davis' for dinner I went to the Rand School Restaurant for mine and after dinner I hung the pictures. Davies has not sent one. I had him on the list and the AP and SC stopped, I suppose. But the rest, nine, look right well. Henri's "Nigger Gal" ("Eva Green") looks fine. Glack has a head of a Russian Girl, a good thing in his latest "colorful" style. I was much helped by a Miss–an actress out of work, to whom Vlag introduced me not long ago. I finished about 10 o'clock. Dolly did not return till after I came in.

March 2

In the afternoon Wilson posed as a "Clown" for me and I have started a thing which looks as though it might turn out well. *["Clown Making Up," Phillips Collection, Washington, D.C.]*

March 3

The brass templet to mark out the spaces for the puzzles which Mr. Coulston has made for me arrived today, and it is a fine thing and will be a great time saver. Mrs. Roberts on the phone and I told her how bad I thought the reproduction of my "Chinese Restaurant" in this month's "Craftsman." The girl's face is badly scratched. Wilson posed again today and I went on with the "Clown" picture. I think it has possibilities. A young fellow, Mr. F. W. Pfeiffer, who is in

Rudy's Shops at York, Pa., and who has come to take a month's instruction of Henri, came in with a card of introduction from Rudy. A solid sort of fellow and about to become a Socialist. . . . After dinner Dolly went to call on Mrs. Roberts and then went to Henri's "Thursday Evening at Home." I stayed at home and worked on a puzzle.

March 4

Finished and mailed the puzzle. The puzzle must be mentioned respectfully nowadays, as it seems to be our only means of livelihood, good old job! To stand by me so well. In the evening after dinner and after Dolly had gone around to condole Mrs. English on 24th St. whose last has just died (and escaped poverty), we went up to call on the Laubs where we passed a pleasant time. I made a pastel sketch of Mrs. L. which is about the first time I've ever tried the stuff. Don't fancy it much.

March 5

Dolly who is the brains and hands tool of valise packing, got that ready and we took the 1 o'clock train to Scarsdale, or rather she did with Miss Wing. Mr. Russell kept me till the next train and we followed them. Talked all the way. I like him more the more I know him, he is so unassuming. At Scarsdale Mrs. Russell greeted us all most kindly. Their little boy, Billy, is through some nervous disorder rather a cripple, and I took some time and rather enjoyed amusing him to the best of my ability. Russell and I took a walk in the Spring-awaiting woods, all gray and brown with a big red sun setting, fine group of evergreen trees. After dinner we played poker. Miss Wing is a fine woman not pretty but fine eyes and a lovely character. Presented Russell with a small oil sketch of "Patton Line Dock" on the Hudson below 12th St.

March 6

. . . The General Strike in Phila. is on! Fully 50,000 men are out and there has been some more rough "goings on." To read of the trouble makes me feel really ill in sympathy for these people ground down and yet unable to see that only by united political action can they do the right thing for themselves. We are feeling the first throbs of

the Great Revolution. I'm proud of my old home–cradling the newer greater Liberty for America!

March 7

We rose at the early hour (for us) of 7 o'clock and came into town. ...We walked from the station home to 23rd St. with Kirby and arrived just in time to let in Miss Yolande Bugbee and worked all morning on a new picture of her in black silk and fur bonnet. Kirby came in to lunch after which he and I went out. He stopped at Collier's and submitted sketches for a cover which failed to "get them." Spent most of the rest of the afternoon with him and as Dolly had gone up to Ullman's I finished my time at a moving picture show. Came home and found Dolly entertaining Mrs. Walter Schlichter, her friend from Phila. W. Schlichter came in later and we had a spaghetti dinner for them.

After dinner he took us to Weber's Theatre where I met his friend Joe Weber's brother Max and we saw "Where there's a Will," a funny but vulgar show, vulgar enough to run without interference. (Shaw's "Mrs. Warren" was stopped by the police! And this thing can go on!!) We met Schlichter's friend Ed. Pigeon, press agent of the Orpheum Circuit. After the show we went with him and his lady, Mrs. Bachrach to Maxim's a gay Café on 38th St. A French woman "Café chantanted" and the place proved interestingly gay. Mrs. Bachrach agreed to pose for me. Schlichter spent the night with us.

March 8

We all rose "early" about 8 o'clock and at 9:30 Miss Bugbee came and I worked again on the Black Bonnet picture. I am rather too fagged out by my past four days of amusement and short cut nights to be able to do much that goes to make a good picture, but as the canvas is an unprimed one it needs paint filling and I at least did that. Stuart Davis came in and stayed to lunch. It seems odd to talk to this ambitious eager young artist and think of the time about sixteen years ago when he was a bunch of a baby in a coach–and I, newly acquainted with his father, used to go on Sundays to make sketches, the two of us riding (to the immense amusement of the street boys) a big clumsy tricycle then out of date and now prehistoric! ...

"The Hanging Committee"

March 9

Up just in time to get to work on the Bonnet picture of Yolande Bugbee in the morning. Mrs. Ullman came in afternoon and I went on without the model and got the picture into right good shape. It seems so just now at any rate. Back *rejected!* from the N.A.D. jury

came the "City Pigeons" and "Three A.M." the latter I sent them as much as a joke like slipping a pair of men's drawers into an old maid's laundry, so that its refusal I expected surely. The first, "Pigeons," I rather thought had a chance to pass but I evidently underrated it. It looks as though they had cut me off from the exhibition game: must find some way to show the things. Dolly phoned Mrs. Henri who told her that the new portrait of Mrs. H. in Brown is fired, also the Salome Dancer with naked legs. Of course the last was too much for them.

A young lady whom I had met at the costume dance and a young man from the Art Students League called this afternoon and asked me for a sketch for the "Fakir Show" catalogue. I told them I would not consent to any connection with the A.S.L. and gave my reasons for objecting to such an academic institution. They heard my lecture in good spirit and seemed even to agree with me. Wished that I could tell the Board of Managers what I had told them.

March 10

Worked from Miss Bugbee in the morning, made start on fresh canvas. Mr. Yeats visited us in the afternoon and as usual made himself interesting and most entertaining. He said some nice things of my work and read us an essay he has written for Harper's Weekly. Dolly and I took dinner at the Rand School Dining Room as thought the Branch met. The ten pictures are still hanging on the walls but are scarcely noticed, I think. At the meeting which followed it was suggested that the Central Committee be asked to send more moral and financial support to the Phila. strikers.

We went to Henri's after the meeting. There was a great crowd there, many strange faces. Met a Mrs. Hubbard, the mother of one of H.'s students, interesting woman, anti-suffrage, argued with her on this point and tried to make her see the Socialist idea. No use. Met a Mr. Fernandez who is a friend of H. Merton Lyon and says how well Lyon always speaks of my work. Mr. and Mrs. Roberts have told Dolly to propose them as members of the Socialist Party. After the rest went, H. talked of an exhibition scheme which Kuhn is anxious to put through. H., Kuhn, self and Davies to back it with $200.00 each, then charge each exhibitor according to his means.

396

March 11

Bad night's rest and not enough sleep. After working without real reason, consequently without result, on Miss B. picture, I gave it over and let her go home early. Henri phoned, and I met him and W. Kuhn at Pabst's. Then looked at a loft in Lincoln Garage Building. $500. for two weeks. We tried to see Davies but he was out. Got estimate of $125. on wiring for exhibition. Then we went down to see Henri. Met a Mr. Chapman who wrote the "King Jim" story which I illustrated for Scribner's two years ago. A good man, architect by profession. Rockwell Kent was also there. He is for the exhibition. It seems best to consider the 35th St. building which I looked at last Fall, as being cheaper to rent for a month probably beginning before April 1st. This would give us more time to prepare. Home at 7:45. Dolly made an appetizing dinner which cured me of the blues and made me feel rested. Laubs called in the evening later.

March 12

Henri, Kuhn and I were busy on the Exhibition of Independent Artists scheme. Kuhn found that the 35th St. building which H. and I had seen last Fall was the best and the rental which was quoted last Fall $600.00 is now $1000.00. We have each decided to back the scheme for $200.00. Dolly has given her O.K. to my making this use of our money, as she has all along said we *must* have a show and we must do it ourselves. Mr. Russell and Miss Wing were at the studio when I returned about 2:30 o'clock and I showed Miss W. my pictures which she seemed to like very much. She is one of the nicest women I know of and Russell still grows in my liking. . . . I missed Henri at Glack's, who was out, called at Shinn's. Mrs. S. said Henri had been there and seen Shinn. O.K. Then I called at Prestons, but they were away. Henri here in the evening. I worked on a puzzle. Rockwell Kent is in the scheme.

March 13

Up late. I phoned and made an engagement for later in the day, with Luks. Kuhn came in. Henri and I met at Luks'. . . . Luks does not seem to think he will send to our exhibition as he has a show at Macbeth's during April. We tried to make him see that this should not prevent him being represented in the Independent Ex. He says that he has

promised two "backers" not to show. We feel that G. B. Luks owes so much of his advertising to Glack, Henri and the rest of us that it is rather narrow of him to turn the proposition down. Glackens practically gave him the notion of painting in 1894 *[when]* he started to paint. He had years before worked in Munich but had done nothing but black and white and humorous stuff for years. Dolly and I went to dinner at Ullman's and afterward played Fan Tan.

March 14

Dr. Light, a very interesting woman Socialist member of our Branch, has invited us to dinner Thursday. By appointment Henri and I called on Davies. Found him dreadfully under the weather with a severe cold but he is for the exhibition and will come up with $200.00. We could not talk to him much, he looked dreadfully ill. At Henri's in the afternoon. The Union Mortgage Co. sent the lease which we are to sign tomorrow. Guy du Bois is in the ex. scheme. Beside being a good painter he is an art writer on the N.Y. American. After dinner at home I went back to Henri's in the evening. Glackens and Preston were there and are for the ex. We drafted a form of notice of the Ex. to be sent to those who are invited to contribute pictures. An entrance fee of $10.00 for one, $18. for two, and $25. for three and $30. for four pictures was decided on. If we get enough in this way we can be paid back (Henri, Miss Rice, Kuhn, Davies, and self) the excess backing money we are furnishing. Mr. Yeats was in during my absence in the afternoon. Dolly says he was particularly amusing and thought our Ex. scheme which she told him was likely to go, was great!

March 15

After Kuhn and I had breakfast we parted and met again down at Cedar St., Union Mortgage Co. He had Henri's check for the thousand dollars. Henri 200, Kuhn 200, Mrs. K. *[Kuhn]* 200, Sloan 200, Davies 200, Miss Rice 200, Du Bois 50, Evers 25, Mager 25. I endorsed the check and paid the $1000.00. Had asked Wilson to pose but let him go, paid him for his time $1.50. After lunch . . . went to Henri's. Miss Teiss (or Tise) *[Clare Tice]* was a caller there with Stafford *[P. Scott Stafford]* (one of the good men in the H. School). They both agreed to come in and to furnish extra backing money. W. Pach was there, and suggested that W. M. Chase, Alden Weir,

and Hassam be asked to come in. I opposed this violently, but finally agreed that they might be informed of the Ex. but not *asked* to exhibit. I also objected to Haggin's suggestion (phoned by Bellows) namely Paul Dougherty, marine artist. Dolly and I went to the basement restaurant for dinner. Wrote Ullman and called off the Associated American Artists scheme. He has had no time to do anything with it, and I'm satisfied that the Independent Ex. will be as good. I told him to deduct expenses on the AAA from the $100.00 I advanced and return me the balance when convenient.

March 16

After breakfast out and ordered the notices of the Independent Ex., typewritten manifold, one cent per sheet is the rate. Also ordered of Jacobs, Printer, the entry cards. $4.00 for 500. Paid $1.00 in advance. When I returned I found Kuhn and G. O. Coleman, the latter ready with his $30. and willing to help in the work. Kirby also dropped in and I told him to tell Carl Anderson of the show. . . . Mrs. Russell called and when Dolly came in from errands I left. Met Kuhn. We saw an electrician on estimates. Then after waiting about finally found Henri in. A pow wow then home to dinner.

After dinner up to Henri's, where I broached a subject suggested by Kuhn after he had talked with some "artists and others," in re Ex. The old idea that in going in to a show with Henri we are the "tail of his kite." I myself don't agree with this idea but since K. mentioned it and we had decided to ask Henri if he could shift the whole responsibility so far as newspapers went to Kuhn as manager, I opened the subject. And then Henri grew hot under the collar and proceeded to show how this was an impossibility. I feel he is right. If he said nothing there would be little notice taken of the show. And the reporters are bound to come to him on account of his record as Revolutionist. He is perhaps rather over-advertised but that cannot be stopped nor need it be, for his work stands on its merits. News article in the Sun tonight.

March 17

Up early after short night's rest and troubled sleep on account of the Exhibition excitement! Attended to application for current with May, the electrician at the Edison Co., 42nd St. Paid $40. deposit on bill in advance. Signed contract with May $275. for 101 tungsten

lights. A very bad morning in weather, rain and snow. The roof of "our" building, 31 West 35th St. is leaking badly so called up Union Mortgage Co. and Miss Kidney promised temporary fixing today and complete fixing to follow immediately.

Met Kuhn and Henri at 31 W. 35th and after pow wow Henri and I went down to look at Max Antler's work on 12th St., and selected two interesting canvases. Most of his work while sincere seems to try to please and is over-done, his best he calls unfinished.... Henri and I lunched at Child's together, then walked up town to get the additional typewriting. Then to the printer Jacobs on 24th St. and got 75 of the entry blanks, paid for 500. Then I came home and did an hour or two of work, addressing notices etc. The supplement notice (400) were delivered $2.00. Sent some to Henri. We dressed and took dinner with Dr. Light at the Women's University Club. She is a fine woman. The other guests were also most interesting people. Mr. and Mrs. Darnton, he's a newspaper man, and she is a bright and beautiful woman, and a Socialist. The change of atmosphere made me feel rested. Paul Kennaday was another guest. Back home and finished mailing notices. Editorial in Sun this evening on the show.

March 18

Busy about various matter in connection with the Independent Ex. Dolly went to see Mrs. Thos. Wing (wife of Russell's old friend and partner in the Law)–she, Dolly, says that they live in splendid style Central Park West. He can do it, as I understand his income is about $20,000. per year!! Phoned Henri toward evening and he asked me to come up after he had finished evening classes at the School. I went, after starting a puzzle, up to H.'s and he and Kuhn and I talked and schemed and decided on invitations to exhibit till 3 A.M. when I came home tired out. Noticed a "woman of the streets" dodge under the high outside steps in 23rd St. a few doors above my own steps. When I came along I gave a curious glance, saw vague whiteness of underclothing and such things–she was making her bladder easy! "Nymph of the pave."

March 19

A very busy day with the business of Treasurer of the Independent Ex. We were up before 9 o'clock, and Dolly helped me in address-

400

ing notices and sending out blanks to those who had paid fees. E. MacRae, a thin faced artist from Cos Cob paid fees for four pictures. *[Elmer Livingston MacRae was later an important member of the group that formed the Association of American Painters and Sculptors and was one of the originators of the Armory Show of 1913, acting as its treasurer.]* . . . A Miss Paddock arrived with her mother and although the notices cover the ground, they had to have it all told by word of mouth. They are classy people I should say— money made selling something or manufacturing undershirts perhaps. Such success lends much "tone" in this country. . . .

At nearly five o'clock I got my first chance to finish the puzzle and mailed it. Mrs. Russell had arrived early to see pictures but I could not stop work. Miss Wing came and then later Phillip Russell, and Mr. Yeats. We had dinner, Dolly baked a ham with cider and spices. After dinner Henris came with Brooks, Sneddon and Mrs. Roberts. The evening went very well. Kuhn came later. I gave him $50. in cash to use for current expense in fitting up the Ex. rooms. Mr. Roberts came later, and he and Mrs. R. stayed a while after the rest had gone. Dolly had Socialist Party blanks for them to sign but he said he could not promise not to vote the Liberal ticket if he went back to Canada. She, Mary Fanton Roberts, took her blank.

March 20

We needed a good rest and we took it, Dolly and I, we did not get up till nearly 12 o'clock. Then at once after breakfast got at mailing Ex. blanks and notices. I took the letters, etc. and mailed them, Dolly gave the place a good cleaning up. . . . Henri and Mrs. came in during the evening and he and I had a business pow wow in re Independent Ex. I wish the thing was over and a great success, though it is nearly sure to be the latter. There are so many things to do and so short a time to do them in. The strain is pretty severe to one of my inexperience in business rush.

March 21

The morning was taken up with business matters for the Independent Ex. Stafford called for blanks and with a note from Kuhn who is managing the work at the galleries, 31 W. 35th. I went out and after phoning to Henri went to the gallery and saw Kuhn. Bel-

lows was there and Henri arrived later. The plans were made for the woodwork and wall coverings. I went up to the Madison Galleries and got from Mr. Taylor, who manages them, his list of people for mailing invitations to the Private View. But we decided not to put this matter in hand just yet. Kuhn and I went to May the electrical contractor and paid $100. on account. Then he and I came home. Dolly had been kept busy with business too, a check of Bellows' had been returned N.G., and people had called in re Ex. Bellows said that he was sure he had money in this bank, suppose he has checked it out without keeping record–"like an artist!" as they say. Dolly and I went to Petitpas' for dinner and found Mr. Yeats all alone. We enjoyed him, therefore, to ourselves. He is still the dear old boy. Dolly asked him to dinner Thursday night.

March 22

The morning was taken up with the Secretary business of the Ind. Ex. which is going nicely. We are now assured of our expenses, though of course those of us who are "backing" the thing have as yet no chance of getting a refund of our money. Mr. Greacen who proved to be a very good sort of young fellow was a caller in re Ex., he paid up. *[Edmund Greacen founded the Grand Central Art Galleries in 1923. He had studied with William Merritt Chase, Robert Henri, Frank Du Mond and at the Art Students League.]* McRicard who is of the Dabo school also called and I made a conditional arrangement with him. Walter Pach came looking for photos for a possible article in Collier's. He also paid his entry fee $18 for three small pictures. He tells me that Stieglitz of Photo Secession is hot under the collar about our show. The whole curious bunch of "Matisses" seem to hang about him and I imagine he thinks we have stolen his thunder in exhibiting "independent" artists.

Went up to the galleries, 35th St. Phoned Miss Kidney, and she came up and promised thorough repair to the roof of the building. Jim Preston came in, also duBois. Coleman and Stafford are working like Trojans on the hangings. Dabo called while I was out. Dolly said he was not at all assertive. Young Hubbard the pink haired Henri student came in an automobile! After dinner we went up to the magnificent Ansonia apartments and saw an exhibition of Mrs. Dorothy Rice's work, splendid stuff, most of it. Fine heads with great psychological qualities. Those rich parents of hers deserve great credit

for giving her talent full swing. Henris, Kuhns and we came down to my place and we talked over the Ex. question till nearly 2 A.M.

March 23

This day begins the rush of business in launching the Independent Exhibition. I am putting down from Dolly's memory and my own what I can of the events of these days up to April 3rd. I was too much occupied in business to get to my daily diary writing. We have done a great thing in planning and executing this project and are showing now (Apr. 3rd) the New York public such an exhibition of American art as has never been seen before. The best exhibition ever held on this continent (that is, composed of American art exclusively). Mrs. Hamlin arrived from Phila. and visited us till Monday, 28th, and was a great help in addressing invitations, etc. Dolly pitched in to the end of the work in great shape and we got the field well covered.

March 24

Mr. Yeats came to dinner and Henri came to talk business. He stayed to dinner. Yeats was the only one who paid proper attention to the meal, the rest of us were too much interested in the great project about to be realized. Kuhn came in later. I sat up late working over my accounts, finance, etc.

March 25

Today and tomorrow the pictures are being received and they look good to me, in most cases. One or two will have to be considered and we will probably ask the painters to withdraw them. But the greater part of the show looks fine, invigorating stuff, full of force and interest. While we were at dinner Kuhn and Henris came in and we had a confab.

March 26

Worked on puzzle and attended to the incoming entrance fees for the exhibition. Then up to the show. Davies came in and liked the looks of the things arriving. Mr. Yeats dropped in in the late afternoon and invited us all to dinner at Petitpas'. We went, Dolly, Elizabeth Hamlin, Mrs. Ullman, and I and after dinner I stayed while Dolly and Elizabeth and Kitty Ullman went to see the "Chocolate Soldier," a

light opera from Shaw's play "Arms and the Man." At Petitpas' we had a very happy evening. Kent *[Rockwell Kent]* and I supported the cause of Socialism–against individualism with A. Friedman, black-eyed black haired and earnest. Kent and Mr. King sang and played piano. I also treated them to my only song "The Sport from Penn-syl-va-ni-a-a."

March 27

Finished and mailed a puzzle to the Press. Up to the Galleries and the Hanging Committee met. The walls are hung with cheesecloth from ceiling to floor, but it is too white and too translucent looking, so we are strongly thinking of putting some gray material at the base about ten feet up to back up the pictures. Hanging Committee who were present: Henri, Glackens, du Bois, Kuhn. Davies is too ill to attend. After dinner Henris came in and while Elizabeth and Dolly went on addressing envelopes H. and I came to the firm conclusion that hangings of a finer color must be bought and put up in order to make the pictures show to advantage.

March 28

Henris arrived at 7:45 A.M. to go with me to get the 640 Yards of material to hang the walls back of the pictures as decided last night. We had a hard task getting enough of a suitable color. Finally, after about four hours' work we secured through the assistance of the buyer in Siegel and Coopers Wash Goods Dept. a great batch of very fine colored "Linon de Paris." Mr. Legan the name of this buyer, he worked hard to find it among the jobbing houses. With young S. Davis, Coleman, Stafford, I went and got the stuff at about 2:30 P.M. and we at once started in to put it up. By we, I mean Stafford and Coleman principally. They have worked like a couple of beavers for two weeks and deserve practically all the credit for the mechanical success of the Ex. Kuhn is not at all competent in this direction, he is a spender of money, not a deviser nor, really, a worker.

March 29

In the evening at 8:30 a typewriter man came to assist in preparing the catalogue. Kuhn and I stayed with this job till about 4 o'clock in the morning of "tomorrow." Then dog tired we went to a Chinese restaurant and had a bowl of "yokaming." Then he home to bed

404

but I sat up the rest of the night working on the stenographic copy so that I might get it in the printer's hands in the morning. This then, the highwater mark of my labors on this Show and I'll give myself due credit for the effort.

March 30

A terrific thirty-four hours work and now there is not much to do. I had not been in bed since yesterday morning 7:30 o'clock. This morning I put the stuff for the catalogue in the hands of the printer at about 6 o'clock. Worked after coming from the Ex. at 5 A.M. on editing the typewritten copy and then after starting the printer went to the Ex. and made some other corrections, which I phoned to the printer. Half dead from fatigue and still did not want to go to bed. I dreaded it. And food as well seemed distasteful to me. So when Ullman came in the Ex. building and suggested sherry and egg as a bracer I agreed and had three of them with him. He thinks I should paint "Christ before the Stock Exchange"!! An idea of his —says it will make me famous. I think a better picture would be Ullman over a glass of whiskey at a table in Hahn's telling me his terrific idea—me a pale green tired over a glass of sherry and egg. Went to bed after a bath at about 5 o'clock. Took a couple of hours rest, then Dolly woke me and gave me a good dinner. Stuart Davis came in and took a batch of invitations over to the Rand School.

March 31

Today is the eve of the opening and I'm easier in my mind. The printer sent his proofs and I went over them and now have that job well under way with a promise of prompt delivery.

April 1 (Friday)

During the day the writers from the newspapers looked over the show, at a loss for the big stand-by names they were, and so they fall back on *us* as the big men. Henri, Glack, Davies, Lawson, Prendergast and even Sloan! Why do these well known men associate in the exhibition with unknowns.—Why? Because we pick our company for the most part. In the evening came a real triumph, the three large floors were crowded to suffocation, absolutely jammed at 9 o'clock the crowd packed the sidewalk outside waiting to get in. A small squad of police came on the run. It was terrible but wonder-

ful to think that an art show could be so jammed. A great success seems assured. Three small pictures have been sold. There were at least 2000 people on hand in the evening. *[The total number of entries was 260 paintings, 219 drawings, and 20 pieces of sculpture. A hundred and three artists exhibited, many of whom were Henri's pupils.]*

April 2

Today we had a good steady attendance, probably five hundred people came in to see the Ex. We had dinner at Petitpas' with Yeats, the Henris, King, Brooks, an Englishman named Bell, Mr. Blake, Sneddon, and others. After dinner Dolly and I went up to the Ex. and took charge of the desk. Coleman had his regular job to attend to but we have arranged to pay him a salary of $20. a week to enable him to give that work up for the present. At the galleries Dolly met Harris Merton Lyon the writer who wrote "Sardonics." He is on Hampton's Magazine. Dolly says he is a nice pleasant shy sort of man.

April 3

I finished up the puzzle! and mailed it to the Press, Phila. Afterwards went up to the Ex. and did not find a great crowd as I had almost feared. We are rather down town for a big Sunday crowd I suppose. There was a good steady attendance however. I brought Coleman home to dinner at Dolly's invitation and found Clifford Addams there. Dolly had entertained him for an hour or so and he was asked to dinner and accepted. After dinner Henris and the Roberts came in and we talked till nearly 12 o'clock. Clifford Addams seems to be not at all the weird eccentric we have heard him described during the last six years. Either he has changed or Dame Rumor is a liar, the last most likely.

April 4

Out to the galleries at about 11:30 and there took my turn on watch duty. There have been so far three small pictures sold. A drawing of Henri's $25. One of Miss Tice's pictures and a Miss Haworth, small sketch. J. Huneker the critic of the Sun was in and seemed to be quite interested in the show. Dolly, who came up in the afternoon, heard him say to his wife, "This is good. I must come up

406

again." Dolly and I came home and had a cold dinner and afterward went up to the galleries again. I met a Miss Case who is in the same studio building on S. Wash Sq. with Clif. Addams. Du Bois had a good article in the Morning American.

April 5

It seems to be necessary for me to go to the galleries every day. The crowd is still good, splendid steady attendance and the people seem most of them to be quite interested. George Wright and Ashe were there today and liked the show. Henri had a chat with Kobbe the critic of the Herald. There is an article in the Evening Globe, passable, written by Hober who is a poor sort of artist himself and was not, of course, asked to exhibit. At Petitpas' table d'hôte this evening Henri's students to the number of about twenty, had a dinner. I was invited and we all met at the galleries and went down together to 29th St. A very amusing and lively evening. Met Mrs. Rockwell Kent, a pale willowy young girl, and Bellows' sweetheart, another pretty girl named Story. Singing and dancing followed the dinner. Mr. Yeats who lives with Mlles. Petitpas was invited down and enjoyed the young people's frolic hugely. After Kent had taken his wife up to the Hospital where the baby was left he came back to our place and spent the night with us.

April 6

Kent went away to see Mrs. Kent off to Stamford, Conn. where they live. I went up to the Lawson show at the Madison Gallery. A fine lot of pictures, especially some of the more recent canvases which show that Lawson is going on. A great man. I wish I could afford to buy one or two of the works.

At the 35th St. gallery our show, I met Rockwell Kent again and after lunching together (he is a vegetarian and I'm convinced it is a good thing), we went walking up Fifth Avenue to the Metropolitan. It is a very warm Spring day. We saw the Whistler collection now on view. Some splendid canvases and unimportant Venice sketches. We rode back on a Fifth Ave. motor bus to the Galleries. There I received a phone from Henri. Went down to see him at 10 Gramercy Pk. South, his present studio. He has a letter from Columbus, Ohio. They want an Art Director for their school. He proposed that I take it, but I don't take to the idea of leaving New York just

now. He gave me the first refusal of the proposed job. Says he will try R. Kent next. Dinner at home and we went to bed quite early for us.

April 7

To the bank and then up to the 35th St. Independent Ex. where the attendance still seems to be quite regular. Met Chas. A. Davis of Phila. an old friend of mine and Henri's, once an art student, lately a manager of the Phila. Orchestra.

The Morning Sun (Huneker article) rather knocks the Independent Ex. He shows his ignorance by admiring such work as Blashki's, which is probably the most evidently insincere work in the Ex. J. M. Huneker always proves that he is merely a space filler if you read him at any length. One minute he strikes a really good picture and enthuses, the next he is in ecstasy over a piece of absolute rot. He simply does *not* know—like all the other critics of erudition. Met Joe Laub and Casey of Collier's at the Ex. Went through with them and back to Collier's with them. Talked with Joe about his proposed farm. He has been looking at farms near N.Y. with intent to buy. Home, Mrs. Ullman, took dinner with us, spaghetti very good. But I'm not in good health. I have a cold, a cough, tired all over, in bad shape generally. Made a puzzle in pencil after dinner. Dolly and Mrs. U. went to a moving picture show.

April 8

Today turned out to be a sort of "At Home" with us. Mr. Yeats came in shortly after our breakfast and asked to be excused from accepting Mrs. Russell's invitation to go with us to Scarsdale to spend Sunday. We go tomorrow to stay a week. Kirby also came in, and we had an interesting three hours or more visit from them. Yeats gave us the outlines of three stories he has written. They seemed to me good things, with romance and humor. He read a letter from his daughter Lily, and in it she asks him to please come home. He seemed in a fighting off depression mood. Kirby is feeling unwell and I myself have a bad cold and cough. Toward evening I went up to the Ex. Galleries. The crowd was quite good today as usual. Dan said, "Lot of people in carriages." Rockwell Kent ran in at about dinner time at the studio and went out for a can of beans for his dinner which he had with us. Then went off to a meeting to talk

over a party at the Henri School. He is to return and spend the night with us. A fine energetic character is Kent and a big painter.

April 9

Kent and I talked after breakfast. He left about 11 o'clock. Then Dolly packed up our things for a week out at Russells' in Scarsdale. Kent by the way, insists that I take part in the farce they are to give at the Henri School at the end of next week. As I have a severe and depressing cold in my head and a cough with it, I don't feel a bit like taking on this trouble. We arrived in Scarsdale at about 1:45 P.M. in a slight drizzle of rain and had to walk from the station about a quarter of a mile as there was no coach to be had.

April 10

Woke reluctantly after a rather disturbed night's sleep (my first is never a comfortable one in strange quarters) and after breakfast an old friend of Mr. Russell's came to spend the day, name Tom Creigh. He also is a lawyer with the Cudahy Meat Packers in Kansas City. A bright successful man with the interests of the corporation very much at heart. We, Philip Russell, Creigh and I, walked over to the Scarsdale Golf Club course at Hartsdale, about a mile and a half, a cool stiff breeze all day but the walk was fine nevertheless and we watched the golfers and desire to get at the game rose in our breasts. So P. Russell and I have decided to play next Saturday morning. . . .

April 11

Dolly and I were not wakened for the regular breakfast so we ate in state which we did not enjoy, making up our minds to get up with the city-goers hereafter. I enjoyed pushing the perambulator with little Billy, Russell's oldest child, who has some nervous trouble making him unable to control perfectly the action of his legs and arms. After lunch I went out and made two sketches in the fields North of the house. Not very successful but I enjoyed the work very much. In the evening we all played poker and had a good game.

April 12

Up betimes and enjoyed breakfasting with Russell and Miss Wing who of course went to town. Today I read Henry James' "The Turn of the Screw" a very good story, weird and with a curious twist to

409

it. I liked it very much. *[Sloan was offered the job of illustrating an edition of this book in 1945 but refused, feeling that his style was not suited to it, and suggested that they use Demuth water colors, a suggestion which the publishers thought well of.]* Dolly and I went to White Plains with Mrs. Russell, a larger town than I had imagined, 40,000 inhabitants. . . .

April 13

Each of these days is so pleasant in the country that I hated to go to the city today but the puzzle has to be done, so I went in and got one done, in pencil, bringing it back to Scarsdale to finish up.

April 14

We had a fine drive with Mrs. Russell in a carriage offered by a neighbor of theirs, Mrs. Orr. Mrs. Russell drove as I have never managed a horse. We went near Larchmont and along what they call Quaker Ridge to Mamaroneck. The shore near the Sound has lots of material for a painter, I think. In the afternoon after lunch Dolly and Mrs. Russell came to New York and went with Miss Wing as her guests to see Mrs. Fiske in "Pillars of Society." Dolly says it is very good.

April 16

Phil. Russell and I started about 8 o'clock for the Golf Course at Hartsdale and got at the game. I did not do so well in my play as I had done yesterday. The ladies went to White Plains and then came back and joined us on the Course. Russell had us served a nice lunch at the Club House. I phoned in to the City to Mr. Yeats and then Russell and I went in to meet him. Mrs. Russell, Miss Wing and Dolly returning to Scarsdale. While in N.Y. Russell and I went into Macbeth's and saw the exhibition of Geo. Luks' work there, a fine lot of pictures. The "Wrestlers" canvas does not look as well to me here as it did in Luks' studio. A striking likeness of Gregg of the Sun is fine, a full length of young Root is also very fine. The Duchess does not look as well to me as it did three years ago in the "Eight" show. We met Mr. Yeats in the Grand Union Hotel and all took train to Scarsdale. Mr. Yeats began in his brightest way to talk and he was a steady warm shower of reminiscences and ideas and kindliness and good humor for the rest of the day and evening. Yeats, Rus-

sell and I walked about three miles before dinner, and the evening was most pleasant.

April 17

Today it rained quite steadily so that we became a real "house" party. But with Yeats there was no dearth of interest indoors. He interested me all day and as usual has endeared himself to the Russell household. Kirby dropped in in the afternoon. He was not in a pleasant mood and I felt disturbed by his presence. A few ungracious remarks of his directed against his present *Irish* servant girl were particularly ill chosen but Mr. Yeats took up the cause of the servant girl and said that they must be regarded as human beings and treated as of the family. The rain continued but Kirby passed on and our party continued to be very enjoyable. The rain has made an instantaneous difference in the trees, etc. Much green is out while last week there were rather few signs of summer.

April 18

And now our visit to the Phil Russells' is over and I look back on it with great pleasure. Mrs. Russell came into the city with us and Mr. Yeats. It was raining still but Mrs. R. and Dolly went to the shops, saws the Luks ex., and Dolly returned near five o'clock. I had been up to the Ex. and saw Coleman. He has sold for cash $25.00 one of his drawings to Clifford Carleton. He did not have the cash so I deducted the 25% commission from his salary check. . . . Clifford Addams called and on being much pressed stayed to dine. Dolly had asked the Henris and after dinner and during dinner and for two hours, three hours more, we had some sort of proposed art exhibition talk. I did not care for it, it was of no use.

April 19

This is the third consecutive rainy day and for this or some other reason (idleness perhaps) I'm in poor spirits and not feeling well. Dolly keeps going though and I'm bound to come out all right with this little power of affection at my back. I'm not in a good way though–too little inclined to get at work. I seem to feel there is not sufficient reason for industry, as such. In fact, I can't say that I believe in such industry. Then the finances are low, very low, and while I have to some extent improved in my attitude toward them, I still

worry a bit, though I shouldn't. The Exhibition of Independent Artists is costing me nearly $200.00 (what I put in). As there will likely be no sales the promoter-backers will be out all they advanced. Rockwell Kent writes that Horace Traubel will be in the City Friday or Saturday and that he will have us meet him (Traubel) at the Petitpas' one of these evenings.

April 20

Up our four flights of stairs today soon after we had breakfast and read our morning papers, came Mr. Yeats, the welcome guest. He says. that his lecture at the Church of the Ascension is deferred to the end of May, so he is free to go on with us to Scarsdale on Saturday. The Traubel dinner at Petitpas' may interfere. Miss Sebon called, also Kirby, and we all had tea and jam. I walked out with Yeats and then went up to the N. Y. Times to see Alden March who is now Sunday Editor, having resigned from the Phila. Press. Of his own accord he said, "G. Luks in keeping out of the Independent Exhibition has shown that his self interest is stronger than his interest in an Idea. The rest of you have shown that you stood for an Idea."

Leaving the Times I went to the Galleries and found no one in charge, waited about. Then the boy, Harry Giffin came, Coleman was down the street with du Bois, who was drunk. I spoke to Coleman with disapproval. Later on a crash in the third floor. I ran upstairs, met by ankles and frightened female visitors. "A young man has a fit or is drunk!" Du Bois!! I led him gently down to the first floor and hid him on a chair under the stairway. Went to see Henri in the evening and we talked over matter of next year Ex. We decided to incorporate. To disqualify any artist who sent to the National Academy. J. Golz will probably take the Cleveland, Ohio, position which H. suggested to me week before last.

April 21

"The Craftsman" is out today with Henri's article on the Independent Exhibition. It seems to me a first rate statement on the subject. He speaks more than favorably of my work, he's prejudiced in my favor, the old man is! More power to him. I went out and phoned Phil. Russell to go ahead on the incorporation of the Exhibition of Independent Artists. He kindly offered to do this for us without fees. I then stopped in a moving picture show and saw some very poor films.

412

Then went and ordered post cards announcing the close of the show to exhibitors.

At the Galleries I found things apparently running all right though faithful Dan is still down with rheumatism. While I was there, Mr. Yeats came in and I walked over to 5th Ave. with him and we went to Knoedler's and saw a lot of "Knodles." This is my name for a villainously bad portrait. Some equally (almost) bad paintings by Kronberg and some Whistler etchings mostly of the Venice series and not good. Thence with Mr. Yeats to the Grand Union Hotel where he paid something on account of a bill he owes them. He was there for nearly two years. But he's far better off at the Petitpas' who take good care of him and charge him but little....

April 22

... During the afternoon Mr. Carrol of the Sun called wanting photographs of some of my N.Y. street pictures but I had none by me. Told him he could photograph them if he wished. He said he'd let me know later. Rockwell Kent came by Dolly's invitation to dinner which conformed to his vegetarian diet, being spaghetti. He talked with us in his intense way. A note from Ray Brown says that he has a story for me to illustrate for "Everybody's." Good news!

April 23

Mr. Yeats called to find out whether we were going to Scarsdale today and I phoned Rockwell Kent who tells me that Horace Traubel will not come to the City till Monday when we are to meet him. This left us free to go to Scarsdale and visit the Russells.... We met at the Grand Central Station, Russell, Yeats and I. Mr. Yeats was a most dilapidated looking old gentleman, his hat soiled, his coat rumpled and covered with dust. A bruise over his right eye, a bruise just peeping from the edge of his beard. The explanation was that he had tried to step on a street car just as it was starting, both hands held parcels. His night shirt wrapped up in one and books and papers in the other. The first thing he knew, he said, his head seemed to be taken by force and bumped on the ground.

When we arrived Russell went at gardening while Mr. Yeats and I took a walk which was a fine experience for me. I feel that I got much nearer to him in the walk of about six miles through fresh green of early spring.... The confounded comfortable auto-

mobiles whizzing by us, cowering at the sound of their raucous horns, and impudently plunging up the steepest hills at full speed. Made me respect and like the few horse drawn carriages which eased up and took the hills at a slow walk. In the evening Mr. Yeats read from John Synge's play "Playboy of the Western World" and it was great! Yeats reads this splendidly.

April 25

My exhibitor's ticket to the Paris Salon arrived. My first (10 etchings). Miss Pope sent to the jury for me. Six accepted, the rest not hung. After I had seen Dolly home I went at once to Everybody's and saw Brown who gave me one of Ralph Bergengren's Pirate Stories to illustrate. Bergengren had suggested that I be given the work to do, which kindness on his part I appreciate. Stopped in at Henri's, met him coming out and as he was going across Gramercy Park to see Miss Rice (he gives her criticisms) I went with him. She has a first floor studio bespattered with paint, herself also well besmeared, queer canvases about and a poor dirty creature of a woman, a kind of misery model, slunk about in the corners. Miss R. is very silly. After lunch at home Mrs. Mary Hanford Ford came in to talk of an article for "World's Work" which she is to write. Juley took two paintings, "Dust Storm" and "Fifth Avenue" to photograph for the Sunday Sun.

At Petitpas' for dinner where Kent brought Horace Traubel, Whitman's great friend and staunch supporter who has by his own writings done much to make Walt better known. He proved a fine likable man, short, thick-set, white bushy hair, heavy eyelids and though a bit slow in thawing out he was fine when he got started. Yeats asked him whether Whitman believed in Ghosts, fortune telling, etc. I don't think that Traubel had any remembrance of Whitman's ideas on those subjects. We left late with Kent and Traubel. Henris rode home. Kent spent night with us.

April 27

After breakfast Dolly and I took a walk. Later in the day the Kents arrived with the baby boy, Rockwell Kent third. Dolly took care of the baby while they went to the Independent Ex. Mr. Yeats called and stayed to dinner with the Kents. After the little one had been put to sleep Mrs. Kent played the piano—plays very well though Yeats

says not much expression. I liked her playing. I made a sketch for a book plate for Kent.

April 28

I went up to the Independent Ex. to see that pictures were sent out. ("Recruiting in the Public Square" of mine went to Buffalo, St. Louis Ex.) I put in a hard day's work helping take down draperies, etc. After dinner . . . I finished up the bookplate drawing for Kent and mailed it after 11 o'clock at night.

April 29

Dolly left for Philadelphia today to see her Doctor, Bower, and find out how her treatment has held. We hope that this will be positively the last of these trips. I am lonely without her but I know it's worse for her living away from home and having the pain of the treatment every day, and she too misses her other half. . . .

April 30

Rockwell Kent dropped in pleased with the bookplate which I had sent him. I walked up to 57th St. with him just out of fellowship and then while he was doing his errand I crossed the street to Friedrichs art store. When I came out I found that he had gone without me so I had a lonely walk back to 29th St. where I lunched with Mr. Yeats. Hurried away and got my bag which dear Dolly had prepared for me, came to the Grand Central Station and found that there was not a train till three-quarters of an hour later. Yeats had caught one ahead. I arrived in Scarsdale and of course found Yeats there. . . .

May 1

A pleasant, quiet day, left free, no bother being entertained at Russell's. Yeats kept me in my chair all morning making a sketch of me, pretty good, *they* say. He made P. Russell after lunch. Then we walked over to Kirby's, where the house *needs* joy and some carefreeness. The cocktail before dinner lasted me all through the meal and afterward. Phil. Russell put in some old Kentucky Peach brandy, the gift of Col. Henry Watterson, a friend of his. . . . Mr. Yeats read one of Lady Gregory's plays to us, it was very entertaining. A Fenian

"John Sloan," by John Butler Yeats

416

rebel escaping blandishing the sergeant of police and by rousing his patriotism escapes with his connivance.

May 2

Up early not having slept very well. Mr. Yeats decided to stay over till tomorrow after the Russells had pressed him. They did the same to me but I remained firm perforce of the work that is before me in the drawings for "Everybody's" magazine. . . . I hate the idea of working but came in town. No letter from Dolly! I have written her none so I am served right. I had lunch with Kirby, rapping on the wall to let him know that we were to join in this. . . .

May 3

Kirby called about lunch time and we had lunch here together, shredded wheat and grape jam. I went on with the first drawing for the Pirate story by Bergengren. He has sold this one to "Everybody's" and evidently asked them to have me illustrate it as it is in the series with those published by Collier's.

May 4

The morning was taken up by my business with the Edison Company in regard to settling bills. I went up to the one time Galleries, now empty, saw Dan, the watchman, and got bulbs which I took to the 39th St. Edison Building, as they want to charge for installing the meter I did not pay the bill. Started another Pirate picture and got it finished. Kirby came in and we lunched on strawberries, shredded wheat and oranges in fine style. . . .

May 5

Made another Pirate story drawing today. Late at night I felt hungry and went out and had chop suey at a little Chinese restaurant on 6th Ave. There were very few people in so did not find much to interest me. There is building going on all about us now on 23rd, 24th, 25th Sts. Big buildings are taking the place of the old one time dwellings of the neighborhood. Today I saw a shabby old team out in front, poor old broken down horse and shabby covered wagon, but a bright red flag waved front and rear and a dingy red sign said

"Dynamite." So it was respected by the traffic–automobiles even,– honor its credentials.

May 6

Mr. Yeats called. He returned from Scarsdale yesterday and enjoyed his trip very much though he says he broke too many of his food rules to suit his liver. He says that he had a letter from Dolly. Kirby came in and we had strawberries and "cream" for lunch. He is an aggravation to me! Like a monk's hair shirt I use him for penance, I suppose. He said Yeats was an awful example of the artist's life! Old, no great works done, poor! A failure!–The idiot. Mr. Yeats is a tremendous success. He has lived and had the poet's joy. He has *known* people. He is still young in spirit, attracts young people around him. If he were a sleek scoundrel of a tradesman or broker worth a million K. would call him a success.

Henri came in and he and I went to the Water Color Soc. Ex. to see the collection of drawings which Reuterdahl got together. It is a good lot. Sargent's portrait of W. B. Yeats is not good. It was loaned by Mr. J. Quinn. Augustus John's drawings from the same are not quite what most cognoscenti think they intend to be, classic or at least "art." A beautiful Leech pencil drawing and a fine boy on a fence by W. Homer. We went then up to the Henri School and saw a very interesting exhibition of the students' work. Sprinchorn, Barkley, Glintenkamp. After dinner I worked till one o'clock and made another Pirate story drawing.

May 7

The day is a Red Letter one for I have had a telegram from Dr. Collier Bower "Dollie returns on 4:50 Good job Brave Girl". Which means that his work with her is over and satisfactory and that she has borne well the pain of the treatments. I met her at the P.R.R. Ferry at 23rd St. 7 o'clock and she told me that she was feeling like a new girl. We went to Petitpas' for dinner as she had written Mr. Yeats and they had saved us seats. Henris were there. They left rather early but we stayed on and talked with Yeats, Bell, Brooks and Sneddon. The latter improves much as acquaintance grows. He is quiet but very kindly. Dolly says that my father is better of his severe cold and that Nan and Bess are well. She spent Sunday, a week since, with them at Fort Washington.

418

May 8

Mr. Yeats called with an invitation from Mr. Quinn for us to come up to visit him, so while we dressed for the occasion he went and added Brooks, Sneddon and Bell to the party, and the six of us marched into the elevator of the Pamlico Apartments on Central Park West. Mr. John Quinn, our host, was no doubt surprised by the troupe invading him but he concealed it in his manner. But as it was Sunday afternoon he could not quite hide in the quantity of the lunch set out by "Sadi" his Japanese valet. But we did quite well and I much enjoyed seeing his pictures, etchings, etc. *[One of Yeats's great friends was John Quinn, the lawyer, who was a collector of art and one of the patrons who financed the Armory Show in 1913. Every year, Quinn would buy Yeats the steamship ticket to go back home. At the last minute, Yeats would find some reason for not going, the ticket would be refunded, and this became a little scheme whereby Quinn slipped some spending money into Old Man Yeats's pocket.]* He has much of Jack Yeats' work, the first I had seen, practically. I like some, in fact the greater part of it. He is less interesting when he adopts a "poster" manner. The etchings of Augustus John were of great interest. They were entirely new to me. His fault is an occasional classicism. Paintings by a young Irishman named Russell were also of great beauty, some of them are akin to Davies' work. In many instances they pass Davies, that is when Davies is too symbolistic or literary.... Leaving Quinn's at about 5:30 we went to Petitpas' for dinner. There came Henris, Roberts, and Mrs. Henri's sister and Mrs. Roberts' father, Mr. Fanton. After dinner, H.'s, R.'s and Mr. Fanton came to our place where I continued my work on the Pirate Story for Everybody's Magazine. The Sun has an article on N.Y. City painters of the city. Two of mine are reproduced, poorly.

May 9

I delivered the drawings to Everybody's this afternoon. Brown seemed to be right well pleased with them, though not wildly enthusiastic, satisfied. $250.00 (6 drawings). The city as seen from Ray Brown's office on the 12th floor of Butterick Building was magnificent. Big shower laden clouds broken by rifts of sunlight. The distant city moist blue, jets of steam like white sprites and witches. Two or three

passing showers made the city beautiful today, helped to my eyes no doubt by the consciousness that I had $250. coming to me in the near future. I stopped in at Collier's Weekly to see Joe Laub. He has at last bought a place in the country outside West Nyack, 20 acres with a rocky ravine and woods and house, $5000. He seems very happy over it and wants us to come Saturday and see it. He will move from N.Y. on Thursday.

Home to good spaghetti dinner by Dolly and afterward to a plebeian treat in a visit to a moving picture show. No good, all American films with bad acting of poor common vulgar ideas, some of them with the approval of the National Board of Censors of New York City!! So they are guaranteeing their banality and vulgarity. So they will, perhaps, succeed in keeping out the superior French films, so much better for the most part in pantomime and plot, so much more interesting in pace.

May 10

Dolly and I had decided to go walking together conforming with a suggestion made by Dr. Bower. He suggested it as a health improvement for our little family. But our plan was upset by Mrs. Ullman calling. She and Dolly went out together and I, thinking that I'd strike the editors while the iron was hot (that is to say when I felt prosperous) went out with my proof "samples" under my arm, to hunt work. I turned to the nearest magazine office, McClure's, and arrived without foreknowledge of the hour (4 o'clock) when Miss Lewis, the young lady in charge of illustration, received applicants and wonderful! got a short story to illustrate!! I feel that as in gambling I had followed my luck and "hit it."

I came back and indulged in a piece of pie in the Lunch Room below us to mark the joyful day. When I came out I met Dolly. She and I then took a walk as far as 42nd St. We had a vegetarian dinner at home. I started a puzzle in the evening. Want to get a couple done so that I may have my time free for a week or two to do the McClure's drawings.

May 11

Dolly and I took our constitutional this morning and it was pleasant to thus get out–free! while everyone seems to be tied to a job! We are really very happy people. Our cares are so foolish and few. One

of the few cares at present is to get the business of the Independent Ex. finished and closed up, so we stopped in and settled the account with the Edison Electric Light Co. Much red tape. After we returned I remembered that I had still to see the Telephone Co. on 39th St. so I walked out alone and attended to this business. Came home and finished a puzzle after dinner, which was another vegetable one and quite successful, rice and beans. I worked on the start of another puzzle. Rockwell Kent wrote to me from Monhegan, Maine, sending me proofs of his book plate which looks quite well, I think. He is very much pleased with it. Invites us up to spend some of the summer with them.

May 12

...Mr. Yeats called in the afternoon, said that he had an excuse for his call in reminding us of our engagement to go to Petitpas' and go with Miss Coates to the Buffalo Bill Wild West Show. Of course Dolly needed no such reminder but we were glad to have him drop in, he is such good company. At Petitpas' there were Brooks (Van Wyck), Sneddon, Bell and Miss Coates. Bell introduced a young Mr. Loomis who is the son of Chas. Battell Loomis the "humorist." Nice looking son of a very curious looking father. Miss Coates came and after dinner she took Yeats and Dolly and I to the Wild West at Madison Square Garden. It was my first seeing of this greatly famed show. There is too much to see and the thing though probably done as well as can be is not very convincing to "grown ups." I'd like to be a little boy and see it. A huge light rubber ball used for equestrian football between four Indians and four cowboys was the feature that excited me most. I wished the Indians to win–they did not. The rest of the American Audience seemed pleased. Buffalo Bill is a stiff old puppet but as he advertised this as his farewell season he affected me as a pathetic passing figure. He had on the reddest red shirt in the whole aggregation of gaudy togs.

May 13

As Dolly was not feeling well I made a poor attempt at cocoa, eggs and toast (the latter burned but it's very wholesome that way). I walked up to 54th St. to settle my bill with the Artists Packing and Shipping Co. Some great blasting and excavating is going on about us. It seems wonderful how Dolly and I can sleep through it in the

mornings but we do. They can't dynamite us out of our bed before 10 A.M.!

Mrs. Ullman, Miss Sehon and Mr. Yeats were all visitors today and Joe Laub came in. Wants us to stay a week or two with Mrs. Laub in the new country place which he has named "Gartenlaub." Mrs. L. is very lonely he says. She didn't sleep last night, is "Frightened" out there alone. I wonder if she is acting, unkind thought. H. Traubel writes me asking me to come to the Whitman Fellowship Dinner May 31st. Wants me to make a speech, this I don't feel equal to. . . .

May 15

A rather blank day. Both Dolly and I feeling quite blue, mine is the blue resulting from too much idleness. In the evening I got at the accounts of the late Exhibition of Independent Artists and prepared my report as Treasurer. Those of us who backed the scheme at $200. apiece will get back about $57. each. A. W. Norris has sent me a package of cigars. Good old Norris, he don't forget.

May 16

Took my copy over to the Typewriters to have fifty Treasurer's Reports printed. Received my first copies of "The Appeal to Reason" to whom I had sent a dollar. As the subscription price is only fifty cents they send me two copies. I can hand over one to some one to whom I wish to open the subject of Socialism, but as I cast my mind over my friends I find that there are not many who would take hold. After dinner at home we went out to a moving picture show, very uninteresting indeed. Wrote to Norris in the later evening.

May 17

A letter from Miss Pope in Paris. She says that six of my etchings framed together are hung in the Salon. She sent the ten New York plates for me. The jury sent me notice a couple of weeks since that one frame was accepted. Miss P. had evidently had no notice of the rejection of the other four prints. She says that there is a card marked "Mention" upon the ones there hung.

Went down to Curb Market and looked it over for purposes of the McClure story illustrations. It is amusing. A roped in space with a crowd, mostly youths. Some bare headed, some with red

hats on, some with caps and hats. Signalling and shouting to other clerks in the windows of the surrounding office buildings. The deaf and dumb alphabet is used in communication from office windows to the street men. Much horse play goes on. Now and then the police officer comes around and makes them pull inside the ropes. Most of them are of a cheap looking type of men.

Dropped in to see Vlag about returning some of the paintings which I borrowed for the Rand School dining room exhibition. Henri called on the phone. He wants his back. Davies and Myers already have theirs. I went around to 15th St. and Stuyvesant Square to the rooms of the American Wholesale Cooperative and bought a suit of clothes from Vlag for $13.50 and a 23 pound box of macaroni for $1.50. In the evening sent out Treasurer Reports and checks to the backers 33⅘ cents on the dollar, winding up the Independent Artists Exhibition.

May 18

I went over to see Vlag at the American Wholesale Cooperative and got my new suit of clothes which seems to be quite nice. He wanted me to make a sketch of him for use in an article in the "Independent" on the Cooperative so I made it in the office. Got rather good likeness of him, I think. I picked up 23 cans of spinach for $2.10. This buying at wholesale rates seems quite attractive to me.

When I returned home Mrs. Ullman who had come before I left was there still sewing with Dolly. Mr. Yeats was chatting with them. He would not accept our invitation to dinner. At about 7 o'clock Mr. Fernandez called. He is on the N. Y. World. He had a news item in which G. de Forest Brush the painter of "ovals" is quoted as saying that he had seen in N.Y. not many days ago an "art exhibition that should have been stopped by the police." Mr. Brush had refused to definitely say that he meant our Independent Artists Exhibition. That is, he would not write such a statement but he did admit it in his talk with Fernandez. F. had me write an answer. Of course I could not say that he meant the Ind. Ex., in fact I wrote that he could not have meant it. That it was the best exhibition my pictures had ever been hung in. That the police might have shut it on the night of our dangerously crowded private view. Henri called later. Fernandez had seen him at Petitpas'.

We are now, according to the astronomers, passing through the

tail of Halley's Comet. I went on the roof tonight. Many of the neighbors were looking as well. Youths and girls laughing and looking but of comet no symptoms.

May 19

At last I have made a start on the drawings for McClure. Worked several hours today on the first one. Scene at the Curb Market down on Broad Street. I have tackled a good deal in this picture but have hopes of getting a passable drawing out of it. Mr. Yeats called and sat with us for an hour or two. He read us a letter from his daughter Lily in Dublin. She describes the mourning which was ordered officially in the Protestant Church. All the people dug up rusty black clothes. But W. B. Yeats' Abbey Theatre did not close as it is a strong Nationalist house of course. They had a good crowd. After dinner at home Dolly went on sewing and I got at my drawing again. Dolly wrote to Miss Pope in Paris today thanking her for her work in putting my etchings before the Salon Jury and telling her of the Independent Show here, where I had sent three of her panels which I borrowed from Miss Brewer.

May 21

Worked awhile in the morning. Dolly donned her best looking clothes and went to join the Socialist women and the Suffrage Party ladies in a parade and protest meeting at Union Square. I started out soon after but missed seeing the parade. Dolly told me that it was all fine. Each of the Socialist women wore a red sash and they carried the much feared Red Banner of the Party. The color of the Suffrage Party, as they call themselves, is yellow. I stood through showers and listened to the speeches of the women. Dr. Shaw, Mrs. Blatch, Miss Clark. Mrs. Carrie W. Allen (socialist) and others. They spoke well it seemed to me, though of course I was already of their belief that women should have the vote. After the regular speeches Mrs. Blatch and Dr. Shaw answered questions from the crowd. Very clever replies they gave and I think many a man in the crowd (which grew larger as the rain had stopped) got a better opinion of them in this ragging ordeal. . . . I got in a little hot worded row with a man who was ridiculing the women, no bloodshed.

May 22

Walked out Broadway as far as 39th St. to get the Phila. Press. The afternoon was passed working on my second drawing for "His Father's Faith," the McClure story. A very poor story imitating of course some popular success in its theme. It's hard to make more than half decent drawings for this kind of thing. After dinner, at home with Dolly, we were interrupted by a call from Miss Nannie (?) Giffin. She looked very stunning in a becoming black straw hat and long cloak. She said she would pose for me. The next evening caller was Mr. Barry whom we had met at Petitpas'. He is a very intelligent young man, a writer I'm told. Next came a crowd ringing at the front door bell downstairs. All had had dinner at Petitpas' and dropped in about 10 o'clock. Henris, Roberts, Mr. Yeats, Bell, the Englishman and a compatriot named Howe, the real self-satisfied Britisher. I know he has a contempt for us. Mr. Fred King, who of course got me and all of us in an argument on Socialism and Woman's Suffrage. The Englishman was of course opposed to both. Mr. Yeats and the Roberts left early. I'm sure Yeats was red hot at the Britisher.

May 24

Worked on the drawings, finishing them and cut mats for them to make more valuable looking! Walter Pach called. He is hoping to land an article in the Burlington Magazine on some of the Independent Exhibition artists. He took two etchings with him "Print Ex." and "Roofs." ... About 11:30 we heard fire engine whistles, bells, etc. and then a smashing of glass in the yards back of us. A fire had broken out in the first floor barber shop and printing office but was soon extinguished. All we saw was smoke and now and then the gleam of a fireman's lantern. The upper floors are thickly inhabited by negroes. A letter from Lamont (?) the Sunday Call Editor who says that Lemon is writing an article on the Independent Ex. for them. He also asks me to let them have the drawing for a short story for the Call which I have been intending to make for some time but neglected and put off on account of other work.

May 25

Stuart Davis came in with two of his paintings, one of Doyer St. Chinatown, the other a Music Hall. Both of them have very good

stuff in them. He seems to have made up his mind to paint and he is starting right. His stuff is uncompromising and direct and free from academic sameness.

Mr. Yeats called after noon and he and I walked over to Mc-Clure's first, where I delivered my drawings for "His Father's Faith" to Mr. Haggard, Miss Lewis being out of town. He seemed pleased with them. Yeats and I then stopped in to see Mr. King and Mr. Roberts at Funk and Wagnall's in the same building. We then walked down to the Astor Library where he read Montalamoret (?) on the "Monks of the West." I looked at a few numbers of the Burlington Magazine. Was much interested in the work of Cézanne, some of which was reproduced. A big man this, his fame is to grow. Yeats and I walked back about 5:30 and I got Dolly and we went to Petitpas' for dinner. We met Mr. O'Bryan who is an organizer of the Suffrage Party and he promised to arrange for interviews and sittings with some of the women leaders of the movement. We dined in the yard and afterward as a shower came up we retired to the inside dining room and had some singing. Mr. King as usual was the chief victim. Barry, Brooks, Bell.

May 26

Mr. Yeats dropped in about 11 A.M. and tempted by his charming company I went out with him, leaving Dolly alone at home, not without feeling myself rather selfish in thus taking a pleasure to myself, but she urged me to go and seemed quite happy. This is the good woman's greatness in her. Mr. Yeats and I footed it down as far as Chambers St. where he bought a Bill of Exchange or something of the sort to pay his studio rent in Dublin. As he says it seems a great waste of money, but I can appreciate how his heart strings keep him from severing the bond between him and his "fine studio" at home. We walked through Chinatown, his first visit, and then rode up to 6th St. and after a little lunch in a restaurant where the proprietor had the first dollar bill which he received after opening for business carefully framed and hung on the wall, we went to the Astor Library. I looked at some pictures in the Burlington Magazine, of sculpture by Maillol, a (young, I believe) Frenchman of great sort, very great work. Dolly had dinner for me at home and after, we went to Henri's where there was quite a large gathering for their last "at home" evening before sailing. Invited Yeats to come to the

Whitman Fellowship Dinner and sent Traubel check for three places, Dolly, he and self.

May 27

Dolly and Mrs. Ullman crossed the ferry and met Dolly's cousin Sallie Kerr who is to stay over Sunday with us. She arrived here about 5 o'clock and brought in her grip a fine chocolate cake. A fine day for skies, great cumulus clouds, some solid gray, others lumpy white, gleaming bits of blue sky and occasional showers which could be seen coming like gray misty tresses falling from the edges (apparently) of the clouds. We went to Petitpas' for dinner. There came and furnished argument for the whole end of the table, Mr. Yeats and I particularly, a Mr. Rose, two years from Dublin Ireland. And such a different sort from Yeats, an "English Catholic" whose ideas were red rags to Yeats and me. Strong anti-suffrage for women, whom he of course says are beautiful ideal splendid creatures but their duty is at home, etc. The old bosh, as though the home had no part in the State. Mr. Bell came with Miss Cable who is I think the daughter of the novelist by that name. Dolly and Sallie Kerr went to the Socialist Branch meeting after we had come home from dinner.

May 28

... After dinner we walked on Broadway. Mary Kerr came about 6 o'clock. Dolly met her at the ferry. After walking to Times Square we took the subway, got off at Manhattan St. uptown, walked over to Riverside Drive and joined the comet gazers. We were, I suppose, too late to see this curiosity but we saw the fireworks across the river at Palisade Park. We then showed the "up town Broadway," 125th St. to the Kerrs.

May 29

Sallie and Mary Kerr being good Catholics went to mass at the French church just by. I went out and bought the Phila. Press. Mr. Yeats called. He is now on the edge of his lecture at the Church of the Ascension, tonight being the date set. He speaks on the "Human Side of the Catholic Church" from the point of view of a Protestant. I worked on the drawing for the Sunday Call (prize fight story) and got it finished.

May 30

...We had a farewell dinner to the Henris. The Roberts and Mr.
Yeats we also had at the feast. Very good dinner indeed Dolly turned
out of her little cubby hole of a kitchen. During dinner Carl Sprin-
chorn called to see Henri on some business connected with the
School. After dinner Mr. and Mrs. Brewer called, also Sneddon, Bell,
Van Wyck Brooks, Mr. Alexander the ex-naval Britisher, a very nice
chap he is, and we had a very pleasant evening together, ending with
farewells to Henris. They sail for Holland tomorrow morning to be
gone for four months.

May 31

While I at ease in bed took a good morning nap Dolly got at the
huge stack of dishes, the aftermath of our dinner last night. Mrs.
Henri dropped in on the way to the steamer. She had forgotten her
veil, "The only one I've got and I look like a lobster without it."
"He's down in the taxicab–didn't wake early enough to shave or
wash his face before starting for the ship." ... I went down to the
Call and left there the drawing for the Sunday editor. I walked across
Brooklyn Bridge for the first time. I enjoyed it immensely. There
were fine clouds over the sky with sun-ladders of silver one of which
struck the Statue of Liberty. This sounds like a romantic touch but
it's true nonetheless. I walked a little in Brooklyn which was the town
Whitman knew so well, and on the bridge I thought of Whitman's
Brooklyn Ferry. I on one bridge and the two others in sight beyond
the bend at Blackwell's Island.

In the evening with Mr. Yeats we went to the Whitman Fel-
lowship Dinner at the Brevoort Hotel. We had a good dinner. Mr.
Yeats was called on afterward to speak and we were proud of him
he did it so gracefully and well. A Frenchman "got off" a speech
which I suppose was Gallic wit in English, puns, etc. and at one
point someone rose and asked that it be stopped. The majority of
the company said "go on" rather because they were in for taking
the medicine. The protester and his women folks left the room. The
speech was bad and decidedly indelicate, no not that word, French
vulgarity was perhaps the trouble, but the protest was rather too
Puritanic. If he had gone on and had no applause he would have been
better reproved. Traubel was kind and likable as usual.

428

June 1

Started today on a subject I have had in mind for some days, the scrub women in the Astor Library. Got the idea when there with Yeats last week. Yeats dropped in and stayed to have tea in the afternoon. Mrs. Ullman and Dolly were sewing in the front room. In the evening after dinner at home I started a puzzle for the Press got it pencilled in.

June 2

Painted on the Scrubwomen picture all day. Kirby called and paid me the $30. he owed me as half of Collier drawings some time since. Potts returned by mail the $5.00 I had loaned him a couple of years ago. Mrs. Sehon called and she and Dolly went out to do some shopping. Mrs. Ullman came and sewed on her dress. Mr. Yeats also dropped in. He seems to like the way my picture is going. We went to Petitpas' for dinner. Yeats, Sneddon, Brooks, Alexander and Bell were there....

June 3

Painting all day on the Scrubwomen in the Library. It's in a half dangerous state now. It may go on or blow up any time. In the afternoon a Socialist member of our Local called to ask Dolly what her committee had been doing. His name is Bullard, looks like an enthusiast. Has been in Russia and we hear has been in prison there for his Revolutionary Ideas. He is quite young....

June 4

Went over the whole picture of the "Scrubwomen in the Library," brought it up in key. It looks like a good thing now to me. In the afternoon Davis called. His family, Mrs. D. and the two boys, Stuart and little John Wyatt, are up in the Berkshires now and he is lonely. We accepted his invitation to dine and suggested Petitpas'. He met Mr. Yeats and they seemed to be mutually pleased with each other. Davis interested him with an account of the "Battle of the Crater" at Petersburg, Va. where Davis was born and "raised."...

June 5

A pleasant day of idleness, but since I have what I think a pretty good picture, the result of the last three days work, I took the day off and

"Dolly Sloan," by John Butler Yeats

felt right content. Yeats dropped in although it was raining all afternoon, and we enjoyed his chat. He likes Dolly so much. He made a sketch of her and one of me. His constant habit is to make pencil portraits. The World Sunday Magazine Section has a full page article on the late Independent Ex. A very good page display, it includes

two of Luks' pictures in spite of the fact that Luks was narrow enough and doubted the success of the Ex. enough to refuse to exhibit with us. Dolly and I in response to an appeal in the Call today, sent $3.00 to aid Fred Long of Phila., the veteran invalid Socialist who is bedridden and in absolute want. We had a fine vegetable dinner at home. Rice, string beans and spinach with salad.

June 6

Made an anti-Roosevelt cartoon which I will take to the Call. This took up the better part of the afternoon. Davis came to dinner by invitation. He tells us that he is doing considerable work for Borden's Milk Co. in the way of writing advertisements. He is prospering. Says that he believes in all the ideas of Socialism but has made up his mind to get money if he can. Deliberately shutting out what he really knows is true. In other words, as the "system" still stands to get what he can of the spoils. This does not seem wrong to me, it merely is the position of one who decides not to take up the cause and fight against the present. After D. went about 11 P.M. I started to work on the plate "Copyist in Metropolitan Museum of Art," which I had laid aside nearly two years ago. Worked till nearly 3 A.M.

June 7

Made a second anti-Roosevelt drawing and took the two down to the Call office. Editor Simpson is rather stupid as an art critic on the cartoon subject but after I had explained! them to him he was or said he was glad to have them. I do not charge for this work—like to do it, and am sorry that the eds. of the paper are not more interested or intelligent on the subject. After delivering drawings I took a walk through the East Side—most interesting afternoon. I went through the section between Brooklyn and Williamsburg Bridges. Life is thick! colorful. I saw more than my brain could comprehend, a maze of living incidents—children by thousands in the streets and parks. Jack stone season is on, they are bouncing marbles and clutching the little iron "jacks" on every piece of smooth paving and steps. The Jews seem to predominate in this section. I saw boys and girls coming from school with violin cases. The Jews believe in education.

When I came home I found Dolly had put in the whole day cleaning the front room. She had ripped up the old denim floor cover

431

and thrown it out. It has served there nearly six years. After dinner at home, I worked a while on the "Copyist" plate. Mr. Yeats called while I was out and as usual made a sketch of Dolly.

June 8

Horace Traubel sent me a number of "Conservators" containing a letter of Rockwell Kent's contra H. H. T.'s praising of the "International Studio." Kent and I had spoken to H. T. in the matter and he had told Kent to write his objections. Kent's points are very well made. Worked on the "Copyist" plate all afternoon and till late at night.

June 9

Worked all day on the plate. Great struggle to get a representation of my own self among the figures in the crowd watching the copyist at work. It seems hardly worth while but I hate to be too badly defeated at it. . . . Mr. Yeats called and borrowed two volumes of Whitman's to read. At dinner we had Mr. Quinn, Glackens and Mrs. Glackens. Glack is not very well, has had kidney trouble and a bad heart. After dinner Shinns came and we had a loud pow wow argument on Suffrage for Women and Socialism. Mrs. Glack shows that she is thinking right on these matters. Mr. Quinn was much interested in my Daumier collection and my etchings. The company had all gone by 12 o'clock. I took up my plate and got started on it again. Worked till nearly 4 A.M.

June 10

At 12 o'clock Mr. Yeats arrived and shortly after Leonard Abbott came to sit to Yeats for a pencil portrait. All during the sitting Yeats and he kept up a most interesting conversation. Abbott is an enthusiastic Radical, a socialist and anarchist keenly alive to all the present conditions, active in trying to preserve Freedom of Speech in the United States. After Mr. Yeats and he had gone about four or half past, I went on with the plate. Though I had been working while they were here I was so much interested I did not accomplish much. Still struggling with the head of myself. I feel it will have to go with a poor portrait in it. We went to Petitpas' for dinner and met there Brooks and Sneddon and passed a pleasant evening in conversation. Mr. Yeats said a most complimentary thing of my work,

that of all the contemporary painting and etching in America mine was most likely to last!

June 11

Worked right along on the "Copyist" plate–and sent off the "Opera" puzzle to the Press. This one was "turned down" by March last year but as there is a new Sunday Editor, *she* may take it.

June 12

A real rainy day, but lucky! Fairly early in the afternoon a ring at the bell and I let in John Quinn, who dismissed a taxicab and came up. He in high hat and frock coat and I roughly clad in gray flannel shirt and patched working trousers. I had just decided to pull a proof of my plate, but gave my attention to Quinn who looked at paintings. Priced the "Dust Storm." *[This painting was purchased by the Metropolitan Museum of Art in 1921 and was Sloan's first sale of a painting to a museum.]* I said I could sell it for $350.00 though the exhibition price would be about $500. He said he would *buy one* but would get Mr. Yeats' opinion. He *ordered* a complete set of my De Kock etchings! Some of these are very scarce with me as I have of them only one or two proofs, others I own five or six proofs of. While Quinn was here Mr. Yeats to whom I owe Q's acquaintance, came in. They left together to go to dinner. After our dinner at home Dolly and I got busy looking up a set of proofs to fill the order. My drawing for the prize fight article is printed in the Call today.

June 13

A Socialist, Mr. Kirkpatrick, called this morning. He is about to publish a book "War–What For?" He wants for this some pictures to illustrate his point of view. I am to make him five for about $5.00 apiece. I am interested in trying to make the workers see that capital and the shop keepers make use of them against each other in warfare. . . . Mr. Yeats came in to see some of the paintings which I had shown Mr. Quinn and to *help him to select one!* I can't believe that it will really come to pass that I sell a painting. I am not at all excited or elated even. I regret that the artist must *sell* his work. Printed some proofs of plate. About the time Dolly started dinner Courtenay Lemon called and accepted an invitation to dine with us. He stayed

the evening until quite late. I worked on my plate. Lemon is very radical and in addition has I think a little too much of a taste for Bohemia. This is just a guess of mine.

June 14

I printed five more proofs of the "Copyist" etching this morning and have now laid it aside as about finished. I do not think that the plate equals others I have done but I hate to have a rankly unfinished copper plate on hand. It's not that at any rate. I started on the "War —What For?" poster drawing today. Mr. Yeats called and coaxed us to come to Petitpas' for dinner and we consented as he is now to be honored and humored by us, we tell him, on account of the fact that he is acting as Mr. Quinn's adviser in the purchase of a picture.

June 15

... I went out for a walk and got a time table to use for our coming Saturday visit to Calders' at Croton-on-Hudson. It is a fine warm day. We have not had many such yet this season. The women were all out in their beautiful warm weather clothes. The streets seemed pulsing with human life and warm blood and a feeling of animal love, honest animal affection. Came back and worked on the War drawing. Mr. Yeats called and was much disappointed to find Dolly not at home. She went to tea at the Women's University Club with Dr. Light. Dolly has been appointed Secretary of our Branch Local, New York Socialist Party. Yeats is a very great admirer of my little wife and I love him for it. After a spaghetti dinner at home I worked during the evening finishing a War picture or cartoon at about 12 midnight.

June 16

Betimes this morning ... Kirkpatrick arrived and after I had rapidly dressed I showed him the War drawing. By adding a fierceness to the eyes of prostrate "Labor" I had it satisfactory to him, and he departed pleased, having paid me $11.00. ... In the afternoon I started a puzzle and at dinner we had as guests Mr. and Mrs. Chas. Darnton, a beautiful woman she is, and Miss Light, also Mr. Yeats. We had a first rate time together which was made more enjoyable by the visit at nearly ten o'clock of Mr. Quinn. He had phoned to Glackens'

434

residence, heard he was dining out and came thinking Glack might be here. He is most interested in Glack's illness and wants him to go to his own wonderful physician. And as Mr. Yeats says he is a man of strong purpose and having set on this he'll push it through. My absurd waking remark to Dolly:–"The cows are coming home–and we have no place to put them!!"

June 18

We rose early today. . . . Met the Shinns at the Grand Central Station, which is being demolished by the way to prepare for a new one. A long hour and a quarter made interesting by the Hudson River on one side and the bright and amusing conversation with Shinn and Mrs. Shinn who has an original cleverness. At Croton-on-Hudson Calder met us and up hill we walked to a fine walled-in estate situated on a terrace made on what would be and had been a hillside–property of Mr. and Mrs. Stephenson. Beautiful formal grounds and gardens on the far side of which Calders occupy a fine two story, broad, stone house and not far away his studio. We had dinner at Calder's. Then a thunderstorm came up. We went to the studio. He has some good things. A woman's figure lying on back with one knee up, stockings, a very real human thing, small; also a small figurine of Mrs. Calder in a robe, fine, modern in the spirit of the Tanagrines.

After the rain passed, the 7th Regt. Band arrived from New York City and we went up to the Mansion or Villa and the fête began. Not many attended but the foot races of boys from the village were "pulled off," prizes awarded. The "Lady of the Manor" Mrs. Stephenson in white lace gown and white stockings which showed moved about among what might be called the peasants. A dinner at which there was plenty to eat but where we had to wait on ourselves followed. Met Mr. Ralph Waldo Trine who is a writer. Calder has a commission for a mantelpiece for Mrs. Edw. H. Harriman. We came back, talked an hour at Calders' and took train to N.Y. at 9:56.

June 19

Today is quite the clearest hottest Sunday so far this year. We did not leave our bed till nearly noon and we both are tired from our trip of yesterday. I walked as far as 29th St. to get the Phila. Press and came back by way of Broadway and Madison Square. There I

joined for a few minutes the people sitting on the benches and watched the throbbing fountain and the "Sunday dressed" children. The trees are fat, full green and the grass brightly glared in the sun, on the hot gray paths a dappling of shade tied lawn to lawn. Mr. Yeats called later in the afternoon and at his persuasion we went to Miss Petitpas' for dinner. There we met Keegan, an English Suffragette, the real article, who served six weeks in prison for the cause. She was accompanied by a well known character actress Miss Mary Shaw who proved a really intelligent splendidly interesting thinking woman. She expounded her theory of Hamlet, not insane, not weirdly psychological but a young man whose ideals of woman have been shattered by his mother's disloyalty. Who has been *intimate* with Ophelia, the latter in fact probably "enceinte" by him. I am inclined to agree.

June 21

Another extremely warm day. I feel the heat more than usual. Went on with the drawing for "War." Mr. Yeats called in the afternoon. He wants to pose Miss Dix in the Studio tomorrow afternoon and of course I was glad to furnish him with the place. An Englishman Mr. A. Wade, I think the name was, called, sent by J. Gearity, wanted someone to make drawings for some comic verses, but I did not care to take on the work. Dolly has worked all this broiling day making strawberry jam for me to lick up this winter. She put up 32 quarts of berries making over 45 pints of jam!

June 22

I took up the plate of my mother which I started before she died and which I had laid aside, unsatisfied with the head. I had a small sketch of her which came in useful and I put in a head which is pretty nearly satisfactory to me. Miss Dix the miniature painter came to the studio to pose for a pencil sketch for Mr. Yeats. She is very nice on further acquaintance. He got a good sketch of her, a little sweet as most of his pencil sketches are. Davis insisted on our going to dinner with him to Petitpas'. We were late so there was no place at the table with Mr. Yeats but we moved after dinner. Miss Dix was there. Mr. Fernandez the half Hindoo educated in England now a reporter on the World. Mr. Sneddon also....

436

June 23

Dolly received a letter from Mrs. Henri. They are located in the same studio in Haarlem that Henri occupied two years ago, and he has started to work from one of the same children that then posed for him. I made several proofs of the Mother plate which I had put into nearly finished state late night. Mr. Yeats paid his usual call. We are so happy to have him drop in regularly on us, he must be so very lonely. At dinner Alden March (now Sunday Ed. of The Times) was a guest, also Davis and Mr. Yeats. March was very pleasant and he keeps young in his outlook on things. Mr. Quinn, who had to decline the dinner, called later and we had a pleasant evening. March likes to talk of my puzzles which he so much favored while editor of the Sunday Press in Phila. He tells me that I should write short stories. I think he is mistaken in this impression of my potency in the direction. Davis who had left after dinner to attend to a business matter, came in as they were leaving and we sat a while. Then he spent the night on our extra bed in the studio.

June 24

Davis had gone when we got up. I got Mr. Quinn's set of etchings (51) the De Kocks, photogravures (19), the De Kock portait (1), a Japan proof of my Mother (1), Copyist (1), Canzoni Frontispiece (1), Memory of Last Year (1), and the Gold Fish lithograph (1) –ready to deliver. He sent a boy for them in the afternoon. *[After John Quinn died, Sloan bought back the whole collection from his estate. This occurred on February 11, 1926, when Sloan paid $300 for the lot.]*

June 26

Walked out and got the Sunday papers as usual. Mailed a puzzle. In the afternoon Mr. Yeats called and persuaded us to come to Petit-pas' for dinner. Miss Dix, Brooks, Sneddon, who asked me to do a drawing for the "Old Volume" London Charity Annual. After dinner Mr. Quinn phoned Mr. Yeats and followed in person. He said that he was pleased with the prints I had sent him. I sent him a memorandum for the lot amounting to $340.00. This went to his office so he as yet had not received it. I can't make up my mind whether this is a large price or not. At any rate it is the smallest price

I'd care to part with them for. I rated the 51 De Kock etchings at $250.00. . . .

June 27

As we got up in the morning at a reasonably early hour I took a walk, incidentally looking about for a possible apartment and studio. In case of finding such I think we should move as 165 West 23rd St. is becoming rapidly surrounded by business loft buildings. I came in shortly after noon and got at the "War" drawings for Kirkpatrick. Finished the one started last night and made two others. This kept me very busy till 12 o'clock at night.

June 28

In the mail box this morning reposed a note with Mr. Quinn's check for $340.00. He expressed his satisfaction with the price so that nicely finishes my first large sale (excepting orders for illustrations which I don't count in importance). . . .

Mr. Yeats came in in the forenoon just for a short while. He says Miss Dix wants us to come to her studio tomorrow afternoon. She will read from a privately printed book of Mark Twain's "What Is Man?," a philosophy of life.

June 29

Stuart Davis dropped in today. He has just returned from the Berkshire Hills where his mother and he have been for the last weeks. He had made some sketches which he showed me. I thought them very interesting. . . . At about 3 o'clock Mr. Yeats came and waited till we were ready to start up to Miss Dix's. She is in the Sherwood Building, 57th St., where we lived for four months when we first came to N.Y. The old building seems just the same and her place is on the 4th floor just opposite the one Henri had. I thought of the pleasant evenings we had there when Linda Henri was alive. Miss Dix read about half of the Mark Twain "What Is Man?" Mr. Yeats thought it rather elementary philosophy for beginners–true enough but well accepted by all who know anything of such matters. It was not new to me but the human touches in the dialogue between O. M. and the Young Man were very much worth while. . . .

438

June 30

Kirkpatrick called and was much pleased with the drawings for his "War–What For?" I made one more today, finishing them. . . . Yeats and Brooks came about 4:30 and Brooks stayed to have some tea and jam. Mr. Yeats had to go and work on his "damned article," things he writes now and again for Harper's Weekly. After a fine seasonable vegetable dinner which Dolly got up (a centre of spinach with an egg on it, next a ring of string beans, next a ring of tomatoes stewed, then a big ring of boiled rice, fine!) we went for a walk, we rode to the Battery and walked along the landing there. Couples sitting on the string piece with the dark water behind them, all sorts of attitudes. The excursion boats stopping, lights and steam and blue to red-purple sky over all. Rode up town, stopped in Virginia Café and had a glass of beer–only customers so it was dull, then walked up Broadway–and scanned the social evil–evils? shall I say–goad thee, to paint. I'll try it. Broadway light. Walked home on 6th Ave.

July 1

I went out and looked for apartments for rent. As usual this time of year I get thinking of moving. I looked at a new building at 19th St. and 9th Ave. where a north light place can be had for $50.00 with all improvements. Another place on 20th St. for $40.00 had good north light but poor light in the living room. Came home and Dolly and I rather decided that unless we could get something very desirable we had best stay where we are till the march of progress orders us out and the building is torn down. Mr. Yeats came in in the afternoon toward dinner time and we weakly accepted his suggestion that we dine at Petitpas'. We met there Dr. Miller, a harsh voiced "single taxer" who expounded Henry George trying to show how it surpassed Socialism. I admit that I couldn't see it. . . .

July 4

A nice breeze today which is not quite so noisy as usual. The Mayor (Gaynor) having ordered the sale of fireworks, etc. stopped. Walter Schlichter called about 2 P.M. We went up by the subway to Bronx Ballground 167th St. near Simpson St. Station and we much enjoyed the game between Walter's Black team the "Cuban Giants" of Phila. and another colored team the "Black Sox" of N.Y. Our team won

439

13–7. The first half of the game was quite exciting. We waited with Schlichter and Mr. Nat. Strong who is the booking agent of these games till the team was paid and sent off to play at Pough-keepsie N.Y. We parted with "Slick" and Strong at 42nd St. Station, then went to Mouquin's where we had dinner and sat for the evening. Met A. G. Dove who tells us that he is a father today, a boy! James Gregg of the Evening Sun came up to our table and chatted a few minutes. He says that Chas. Fitzgerald who has been ill with pneumonia has got over that but heart complications have arisen. The great Jeffries-Johnson prize fight was fought in Reno, Nev. today. Johnson, colored, won easily in 15 rounds. . . .

July 5

Another fine cool breezy day. A great relief after the hot spell of last week. I walked over to East 19th St. to look at chances for studio apartments, found nothing. Stopped and bought a couple of pairs of shoes. . . . Mr. Quinn sent me 16 reproductions from John's drawings in his possession. They are fine and interesting things. Quinn proves to be a good friend to me, and I admire him for a kind of broad fairness of mind. He is a good example of the "trained" mind as he calls it and advocates it. But it does not always prove as fair and really considerate as his.

July 8

These are fearfully hot days and I'm weaning myself from the tobacco and feebly trying to get ahead on puzzles. Work comes hard under the combination of circumstances.

July 9

Theodore Dreiser Editor of the Delineator Magazine and an ex-novelist, at least I think he's "ex," wrote me today asking if he might call at the studio and see some of my work. (I responded favorably to the above but never heard of Mr. Dreiser's desire to view my work again. I suppose he wrote to me in a trance or delirium.)

July 13

In the afternoon A. Bullard and his sister called. Mr. Yeats was here having come with an invitation from Mr. Quinn to take dinner with him uptown. This I declined by phone to his office. We had iced

440

tea with the Bullards and some conversation and then it was suggested that I show pictures. A hot job and a dusty one and the pictures didn't look very well to me! In the evening after dinner at home we went to Coney Island as I thought Mrs. Hamlin should make this trip before her return home. Down there we met E. W. Davis and he insisted on our Dropping the Dip and other hazardous amusements which are exciting and perhaps invigorating. We enjoyed a Stomach Dance which we saw at one of the concert halls, right good. There is a lot of fine material for pictures down here. Home at 3 A.M.!

July 16

Mr. Yeats came and read us a short story he has written. It seems to me quite a good thing. A young Irish barrister who refuses to marry the girl who loves him but who has by her family been led to treat him with coolness during his period of struggles. He succeeds, the family tries to get him to marry, he is huffy, proud and refuses, etc. Mr. Yeats started a portrait group in pencil of Dolly and myself in the afternoon. We had dinner at home.

July 17

Mr. Yeats went on with the drawing of Dolly and me. In the afternoon, about 1 o'clock, Walter Schlichter called and asked us up to 135 and Lenox Ave. to see a baseball game between his Giants of Phila. and the Royal Giants, both "colored" teams, and the field is right in the heart of the colored district up in Harlem. The people mostly black and well dressed and of splendid behaviour. Mr. Yeats was immensely delighted with the afternoon, he has never seen a game of baseball before. The Phila. Giants won in a hotly contested battle. We thanked Schlichter for a pleasant afternoon and went down to Petitpas' for dinner with Mr. Yeats. . . .

July 18

Mr. Yeats came and we both took much of our time to posing for him. W. Pach sent entry slips for the Automne Salon Paris. He wants me to send pictures there and says he will attend to their going before the Jury. . . .

July 20

I posed about five hours for Mr. Yeats and he finished the drawing of self and Dolly to our satisfaction. He says he'd like to try another some time. We dined at Petitpas'. Mr. Yeats and I first took a walk for an hour or less. We went to the City Rubbish Pier at 30th St. (I think) and watched the flat scows of offal being loaded; men with pitchforks work among this filthy refuse, worse than Hell's devils' doom is theirs. Dolly joined us at dinner. Sneddon, Brooks, and two young Harvard men, Reeves, who is likely to do something is now on the N.Y. Sun; another, who looks like the departed genius Aubrey Beardsley, was Alan Seeger. I think he's too young in the sense of being too romantic. He greatly admires Maxfield Parrish's pictures! We had an interesting evening of discussion. I'd rather be working.

July 22

Mr. Yeats worked on the new drawing of Dolly and me. We went to Miss Dix's studio in the afternoon, Mr. Yeats, Mr. Brooks, Dolly and I. Then to Petitpas' for dinner, where we met Miss Finch who joins the Socialist Party tonight. She is a leading "Suffragist" and runs a school for girls. She seemed interesting. *[Miss Jessica G. Finch founded the Finch School in 1900, and it became a highly successful finishing school for the upper classes. Miss Finch later married and became Mrs. John O'Hara Cosgrave.]* Mr. Barry was also there and Mr. O'Brien who is in the Woman Suff. Party movement. A Mr. Jenkins of the "Anti" Tuberculosis Organization or some such order was another. Satirical Element at the Board, he is one who in order to be "Radical" and at the same time do no harm to things as they are, declares himself to be an Anarchist! Knowing that this gives the economically ignorant a thrill, especially the young ladies. I brought Sneddon to the studio where we selected "Goldfish" and "Woman's Page" to send to his friend the editor of the Annual "ODD Volume" published in London. Sneddon is good company, and an out and out straight fellow. Dolly attended the meeting of Branch 1 as ours is now called.

July 23

Mr. Yeats finished the new drawing of Dolly and me. It is much better than the first one. In the evening Dolly and Miss Dr. Light

442

went to a meeting of the striking Cloak makers. I walked about 6th Ave. and 14th St., heard a religious speaker who was being asked for his permit by the police say that if this was a meeting of Socialists it would be permitted but the Gospel of the Lord Jesus was hated! I put in to say that Socialists were being arrested in Brooklyn with regularity and then withdrew. These preachers of a sickly, soft succumbing hope in Heaven. "Where the weary shall rest." Faugh!

July 24

Walked out for the Press and stopped a while in Madison Square where I surreptitiously left three copies of "The Appeal to Reason" Socialist Weekly (very rabid) on the benches in the fond hope of spoiling someone's peace of mind. In the afternoon we (Dolly and I) went up to the Ball Grounds at 135th St. and 5th Ave. and saw W. Schlichter's Black team, the Phila. Giants, defeat the "Black Sox" of N.Y. with ease. We brought Walter Schlichter home to dinner with us and after he had gone we went down to the N. Y. Press with the score, owing to his neglect of the score by innings I had to phone till I got one of the Black Sox players who gave me this, which I then phoned to the Press. Mr. Price the Sport editor was amused at "Slicks" forgetting this detail.

July 25

Nice letter from S. Walter Norris, who is in Atlantic City. There is a note of sadness loneliness in his letter. His life has been too much out of the fight, while the fight is on. . . .

July 26

In the evening Dolly and I with a little bunch of "Appeal to Reason"'s under our arm went to a Socialist meeting in Battery Park. There was no banner as the organizer, Miss Dexter, failed to appear. An elderly speaker, J. C. Frost, was the principal of the evening. There was a small crowd who "stuck" right well. I handed out some "Appeals" with a few words to each victim. There is a serious kind of humor about such an affair and it seems curious that I have gone into it. And yet it surely is better than to paint pandering pictures to please the ignorant listless moneyed class in this U.S.

July 28

Today is Dolly's birthday. I presented her with two necklaces and they pleased her very much. One is of blue beads like her blue eyes. The other, three cracked crystal pendants on a gilt chain. Mrs. Roberts sent her a fine bunch of long stemmed roses which must have cost a great lot of money. They are nice thoughtful people. We went to Petitpas' for dinner. The Roberts were there. Mr. Yeats of course at the head of the board, Sneddon and Mr. King. We left at about 10:30. Mr. Yeats started out to walk with us but found he was too tired. Dolly and I had a glass of beer and took a walk on 6th Ave. and back on Broadway.

July 29

Mr. Yeats called and then went down town. I went up to see May the electrician. He agreed to settle the balance on the Ind. Ex. electric bill $1.81 which will I hope wind the affair up. I dropped in at Macbeth Gallery. Mr. Macbeth happened to be in and I had a short chat with him. He is quite aware of Redfield's political position in the art world. I told him that John Quinn had bought a set of etchings from me. Mr. Yeats had lunch with us, then went down town to Harper's and they asked him for two articles. Dolly has been cleaning the frame and canvas section of the studio today and was tired so we went for dinner to the café in the basement of this house. I finished two puzzles in the evening.

July 30

In the evening we had a very pleasant experience. Mrs. Roberts had sent us tickets to an open air performance of the Coburn Players on the green of Columbia University, so we went up and enjoyed it very much. To see it was fine, the night, the trees, the quiet crowd of audience and the players with soft light on the stage–very handsome sight.

August 1

I painted the open air performance picture which stuck in my mind from Saturday night. I think that I have a right good thing of it.

August 2

My birthday. I happened to wake this morning at 5 A.M. which was about the hour when I first saw daylight in 1871 at Lock Haven,

"The Coburn Players," 1910

Pennsylvania. I worked on a new canvas, the Petitpas' Yard "our table," Mr. Yeats at the head of it. *["Yeats at Petitpas'," collection of the Corcoran Gallery, Washington, D.C.]* Mr. Yeats came in to ask us to go by John Quinn's invitation to dinner on the roof of the Majestic Hotel apartment house, Central Pk. West. We met Mr. Quinn there at 7 o'clock and up on the roof as on a steamer deck with a hazy blue city to every side instead of an ocean, we had a fine dinner and afterward went to Quinn's apartments where we sat and talked till 12 o'clock. A splendid kind intelligent man is Mr. Quinn.

August 5

Worked all day with great resulting fatigue on the Petitpas' Yard picture, and Mr. Yeats called and asked us as usual to please come around and have our dinner there. We agreed as I wanted to see the subject of the picture again. I was dreadfully fagged out however

and didn't enjoy the evening much though Mrs. Johnson and Mr. King were there. Mrs. J. has a young lady friend Miss Armstrong who seems to be an employer of girls in some business or other. The young poet Seeger and his friend Reeves were late comers. Seeger annoys me when I'm not feeling in good spirits. He has so much I call it priggishness. Mr. Yeats says it is harmless and that every young poet is that way. He knows for he "raised a poet." Today is the ninth anniversary of our Wedding Day. Dolly and I agree that it was a great day in our lives–we are happy. Dolly is a bit plumper than she was then but she looks really younger and happier than when I first met her in June 1898.

August 6

I painted all over the Petitpas' picture and have it in better shape now. Mr. Yeats called and while he was here Mr. Bullard dropped in and interested Yeats in his account of a trip to Morocco last year. He has been much about the world. A young woman, Mrs. B., French name, called for the drawing for Kirkpatrick and afterward brought me six copies of "War–What For?" I have looked through it and think it will probably do good work though it is to be sure written in a rather "high key" all "on the scream" all shouted out. I hope that it will sell well. The pictures are nothing much. But as most of the ideas were dictated to me I prefer the one "Strikers Grave, Widow and Children" which is more original. Still the "Blindfold Soldier Leaving Home" is mine and many of the faults in the others are shared equally by Kirkpatrick and myself. After dinner at which we had Miss Light (Dolly phoned for her) and Mr. Bullard, Mr. Yeats called with Sneddon. He read a letter from Mr. Quinn in which Q. repeats that he intends to buy a painting of mine.

August 7

After going to 29th St. for the Sunday Press Dolly and I had a light lunch of ice cream on 8th Ave. and then went over to Ridgewood, Brooklyn and saw two games in which Schlichter's Phila. Giants won the first and were beaten in the second. This is the first time we have seen them defeated. Both games were full of excitement and interest. We enjoyed it. Back to N.Y. on the elevated by Brooklyn Bridge. The new Manhattan Bridge looms red painted and seems very near the old B.B. It is not yet ready for general traffic I believe.

446

We walked through lower Bowery and had spaghetti and zabouillon (spelt wrong) at an Italian restaurant on Mulberry St. near the Bend. We walked a few blocks through the Italian quarter. They seem to be preparing for some religious festival, arches fitted with electric lights colored bulbs, span the streets. The new big yellow arc lights throw a fine rich glare over these teeming streets. They are few (in front of moving picture theatres)....

August 9

Painted all day on the Petitpas' picture but without getting much along with it. Mr. Yeats called in the afternoon and his criticism seemed to be useful to me. I hope to be able to do better tomorrow. I have little strength, entirely exhausted after a few hours on my feet painting. After dinner at home I finished up the puzzle started yesterday. Mr. A. Bullard sent me a bundle of "Assiette au Beurre's" French Papers very interesting drawings of the modern radical school. Mayor Gaynor of this City was shot in the back of the neck today by an ex-employee of the City Dock Department. He seems to be likely to get through without fatal results. He is in a Hoboken hospital as he was shot on board a ... steamship at the Hoboken docks just before a proposed trip to Europe. He has been a right good sort of mayor of the old fashioned stripe.

August 11

Dolly's sister Margaret (Mrs. John McGready) arrived today with her two little girls, Helen about 8 yrs. and Rose 5 yrs. They are nice little girlies. I went across the river to meet them. Their father was there too. I met him for the first time, a pale man, he's a pattern moulder. Works in great heat and long hours. Good example of the man working to live and keep his family and getting nothing but a hastened death at the end of it all. I talked Socialism to him, he seems to be inclined to hear and think. I went without Dolly to Petitpas' for dinner and felt selfish for Dolly had to stay and cook dinner for the McGready family who are to stay with us a few days till their furniture arrives and they get their home started in Brooklyn Borough. Mrs. Johnston was there also "Charlie." Mr. Yeats of course, Sneddon. Mrs. Johnston (Russian) is a niece of the famous theosophist, Mme. Blavatsky. Mr. John Quinn arrived after dinner. Art Young was there and introduced Mark Fenderson who wore a

big artist's tie and had eager looking teeth. Mr. Pound *[Ezra]* the poet was with Mr. King. I was interestd in him, he studied at the U. of P. in Phila. and knows Frank Whiteside and Breckenridge. From what I have heard he is a "very good" poet. I have not as yet read any of his work.

August 13

Went out to buy a few brushes and met Mr. Yeats on the street, he walked with me. He really does give me many very important helps in my thought about my work.... At 3 o'clock Mr. Yeats came and he and Dolly and I went down town. Met John Quinn and Mr. King and Mr. Pound at the World Building and as Mr. Quinn's guests we saw Coney Island. Had a splendid time. Got off at Brighton Beach, walked to Coney Island, by carriage to the Raven Hall where we had dinner (at great expense, I'm sure) we dined and talked till nearly 10 o'clock, then went about the "shows." Rode the elephant (my first elephant ride), shot the shutes. Went in some tubs in a wild ride which Mr. Yeats found "much worse than it looked." Ate popcorn and in short did the thing up in great style. John Quinn was full of boyish enthusiasm about the whole place. He has a personal pride in all New York's good things. At about quarter of twelve he put us all in a big touring car and while at first he intended to take it to Sheepshead there to go home by train he decided to send us all the way to 23rd St. by automobile so we had a swift ride in to town (my first long ride in an auto, I see why the rich like them).

August 14

"Uncle John" and Aunt Annie (Self and Dolly) were left in charge of the little McGready girls and I took them walking when I went out for the Sunday Press. Rose was very much surprised at the great number of candy stores we passed. Her comments reached the point where they became hints so to finish the walk we took home a small bag of chocolates. I showed them the tower of the Metropolitan Building and they were not at all impressed by its size. I think that children have more real reserve in their nature than older folk. They were much more amazed by my ability to move my ears, an accomplishment that I show to children with inordinate self satisfaction. I painted a while in the afternoon. John McGready and Margaret

448

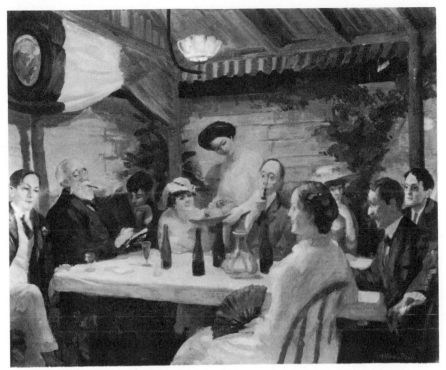

"Yeats at Petitpas'," 1910

came to dinner and after staying the evening went to their new home in Brooklyn. There I hope they may find happiness and good fortune.

August 15

I got at the Petitpas' picture again today and moved it along a bit. After noon Mr. Yeats came in and spent some time with us, the company being further increased in attraction by a visit from Van Wyck Brooks who told us (confidentially) that he will be married in about fourteen weeks. I had him sit while I put in his head on the extreme left of the Petitpas' picture. A slight cold in the head has resulted from my trip through the night from Coney Island by "auto" Saturday. Mr. Yeats told of a father who died. Some time after the children found his cane–"Mamma! Papa forgot his stick!"

August 16

I went out and bought a steamer trunk, a thing we've often wished for. While I was out an agent called in re the house on 24th St.

about which I had enquired. Ground is rented, house can be had for about $2500.00–$1000.00 cash, the bal. on mortgage at 6%. Taxes, interest, rent, water, insurance would amount to about what we pay now, nearly $600.00 per year. I wrote a letter to Mr. John Quinn and thanked him for our pleasant time at Coney Island and also asked his advice about the house proposition. We each had a post-card from the Henris (Mrs. H.'s writing).

August 17

Went on working on the Petitpas' picture. Mr. Yeats called about noon time and stopped to lunch with us. I phoned to Mr. Quinn as I had arranged in my letter–he said that he was sorry not to be able to accept our invitation to dinner tonight or tomorrow. Later in the day he sent me a long letter advising me in re the proposed house on 24th St. He suggests that I must *really* want to live there and that I must have an expert examine the house to see that it is in good repair etc. He also reminds me that if I move away in six years it will have cost me nearly $1000.00 a year, taxes, interest and rent of ground. In fact, his letter weakens my idea of doing it. . . .

August 19

. . . Mr. Yeats lunched with us and saw us off on the car. We felt quite sad at leaving our dear old friend behind. If we were richer we'd find some way to take him along. We arrived at Fort Washing-ton late afternoon. Bess, my sister, is recovering from her latest op-eration. Looks very thin. Dad seems smaller than ever. He met us at the station.

August 20

Woke up among the country sounds of morning. The early morning clucking of the chickens and the thump thump of Dad's chopper in the shed getting the morning meal ready for them. It is pleasant weather, not at all hot. My sister Marianna (Nan) went to the City. A Miss Gilpin wants her to help get up a series of tableaux "Angels in Art." Dolly did the cooking for the day. In the evening after Nan's return a young man friend of hers, her beau they call him in jest, Mr. Laner, called. He has through Nan's talk of the subject become interested in Socialism. I tried to help him along.

450

August 21

Eleanor Sloan came out and had dinner. She seldom comes here to Fort Washington save when Dolly is here so I think she is not in very great favor with her cousins. Of course my sisters being quite desperate church goers are not to be deterred by the presence of a visitor. They indulge themselves in this recreation under all circumstances. Bess is chafing under her enforced stay at home today but of course she's too weak to go.

August 22

I made a sketch in the garden today. Dolly and I walked to the Post Office. The new postmaster is regarded as a very wicked man, "he drinks"! In fact he is only deputy P.M. as the man appointed to the office is his brother in law and after getting the position put this "dreadful" character in his place! To live in a country village requires great hardness of villainy or strict uprightness or else great secrecy in evil doing.

August 23

Dolly left in the afternoon to go to Phila. and spend the night at Mrs. Dawson's on Spruce St., her "old" landlady and almost mother has been quite ill, operation and all that. Dolly says she fears that Mrs. D. won't live long, though she is not old, not more than 39 years, I imagine. I saw Dolly on train then went and called on Tom Anshutz my old teacher at the P. A. Fine Arts, Phila. He has a studio and home near the pike. I found him after meeting his only son Ned, who now has a man's voice and is growing to be a very large young man. Anshutz was engaged in front of a mirror painting his own portrait for the Nat. Academy of Design which has just recently made him an "associate." He is nearly sixty years of age. They have just elected him an associate! And think of the idiots who have been full members for years!! We had a good talk. I praised the Maratta colors and told him he should adopt them.

August 25

Tom Anshutz called in the evening to see Dolly. As he would not come inside we went to the porch and left Miss Morris an earlier arrival with the girls (Nan and Bess) in the parlor. She went home

in a short while. T. Anshutz seems to be aging some in the last year. He is slower in movement and carries a cane.

August 26

Dolly and I went over to see Mr. Anshutz at his school on the pike. The summer classes are about over now, only four or five left today which is the last indoor pose. I met and was much interested in the work of an Italian boy. I think the name was Paladino. Portraits. Mr. Pancoast whom I had met at Anshutz's three years ago, was there. Ned Anshutz was posing for them. . . . Made a sketch after lunch. Letter for Dolly from Mr. Yeats in N.Y.

August 28

Today is the third aniversary of Mother's death in this house, Fort Washington. Nan hinted that we should go to Church with them but Dolly frankly told her we had not gone to church for years and the incident closed, with heart ache for Nan of course and the same for Dolly I'm sure, for of the two the non religious one will surely have the *real* tenderness. *[Sloan described his sister as a "pious crab." She became a real miser in her old age, and shocked her friends by leaving nothing to the church which had meant so much to her. The rector said that she was cross with him because he would not have morning service at an hour she wanted!*

[In 1945, the Philadelphia Museum held a retrospective exhibition of work by the Philadelphia newspaper artists—Glackens, Luks, Shinn, and Sloan. On the way to the opening, we stopped at Germantown to pick up Sloan's sister Marianna. She was still living alone in the little two-story house, full of the old furniture made by their ancestors, and her own pictures which she kept repainting decade after decade (like Washington Allston), while she continued to run her Blue Book Shop to earn a living. Sloan had not seen her for many years, not since an exhibition at Wanamaker's in Philadelphia back in 1939. She always felt that a trip to New York to see him or his work would be too expensive. . . . Marianna came to the door in great excitement, looking even more like a witch than when I met her in 1944, a wild thatch of gray hair under a faded velvet tam o'shanter, dressed in a rumpled suit and shirtwaist that looked as though newly unpacked from an attic trunk, her feet encased in loafers and stock-

452

ings in need of mending. With a great display of affection that embarrassed him, Nan flew at her brother. "Oh my Jack, my brother Jack!" Now Sloan never liked public displays of affection, he was always uncomfortable when anyone laid hands on him even in a friendly meeting at an art exhibition. But I could see that he was really shocked by Nan's behavior and appearance. Before I could temporize in the situation, he had taken hold in a way that revealed things about all the years back to that day when he was sixteen and had been obliged to become the head of the family. "Do you want to disgrace me in front of all Philadelphia! When our sister Bessie was alive she used to make you behave more sensibly. Go right upstairs and change your clothes." Five minutes later a subdued lady came back dressed in her Sunday outfit. One suspected that thoughtful friends had made her buy the smart new hat, but she also had on a good black dress and slippers, and a nice gray squirrel coat.]

In the afternoon by invitation we went to call on Mr. Pancoast and I was interested by his landscape sketches, small things but many of them very interesting where he has not tried to be an "artist." He has half of an old country house, is a bachelor, and works in the Art Department of the North American in afternoons and evenings. (As I did for ten years on the Press.)

August 31

Nell Sloan called us about 9 o'clock and we got up. Breakfast was reminiscent of my youth in Camac St., Phila. Fried potatoes, fried eggs and "twist" which is I think distinctively Phila. and not very digestible. I had some talk with my Aunt Mary and her sister Mrs. Hartrauft. Eleanor Hartrauft her daughter of whom I painted a full length a few years ago is a stenographer. *[This was the painting "Girl in White," which Sloan destroyed in 1935 as an anomaly in his work. He said that it would have been better done by Henri and was the type of thing for which Henri should be remembered rather than he. "Besides, it was a nuisance to cart around each time I moved."]* I noted a young well dressed woman whose old gray haired mother was seeing her off on the N.Y. train. Silent yearning under control on the mother's part and eagerness to get back to the City in every action of the younger woman who did not want to hurt the mother, but who wouldn't have stayed for anything–quite right. . . .

September 2

A letter forwarded from N.Y. from Julius Golz who is with Rockwell Kent on Monhegan Island. He asks for the Independent Exhibition of last spring to be sent to Columbus, Ohio, where he begins as Director of the Art School this Fall. I am inclined to think that it would be hardly possible to send the same exhibition.

September 5

I walked to village Post Office then to Anshutz's to say good bye. T. Anshutz and his boy Ned had gone on a trip to Bermuda. Dolly came in on the train with me as far as Wayne Junction where I changed for New York. I arrived about noon. The great city looked splendid. I was glad to get back to it. The two large buildings on 23rd St. near us are barely completed externally. Our own old building is very dusty and shabby. Before dinner I walked over to Broadway and there met Miss Sehon and her "Si." I went to Petitpas' for dinner but had already learned through a note left on Friday that Mr. Yeats would not be home till tonight. Seeger the poet was there. Courtenay Lemon and a friend of his, Mutter I think the name is. A Mr. Howland of the World whom I seem to have met before, was at the table, with him a stout young woman who is on the staff of the Sun. We had a considerable argument on Socialism. After they had gone Seeger and I went to Lemon's table and sat till quite late. Mr. Yeats came home about 11 o'clock. He beamed on me and asked for Dolly. He was glad to see one of us, I'm sure.

September 6

Julian Outerdonk who selects pictures for the Texas State Fair, Dallas, called today and asked for "Clown Making Up" and "Pigeon Flying." I showed him some water colors of my sister's and he invited two of them. I sent her the entry slip to fill out. . . .

September 7

Wrote Golz that I could not officially accept invitation to show the Independent Exhibition in Columbus, Ohio, but that Henri would (privately) make a selection of the exhibits in that show or that I would be glad to make suggestions. But that Columbus must write individually as there is no organization. . . .

454

September 8

Golz called today. He had not of course received my letter in re ex. at Columbus, but he agreed with me in the matter. I am not feeling in good shape, don't feel like attempting any new work. The place is very dirty and in disorder. The ceiling in a place 5 x 7 feet having fallen, I called the attention of the agent who came today for the rent. I told him to call again for his money.

September 9

Dolly's letters from Atlantic City are all cheerful. Bess and she seem to be having a good time. Mrs. Hamlin is there. I am feeling quite under the standard in health. "Liver" I suppose, at any rate I cannot work. Mr. Yeats, who called in the afternoon, said that it was because I am unhappy, perhaps that's so. I am going to take a "physic" tonight nevertheless. I went to dine at Petitpas'. King, Brooks, Sneddon, Reeves, a friend of King's named Triggs, and an actor (friend of Alexander's I understood). After dinner André Tridon and his wife I think though not introduced came to Mr. Yeats's table, and with them an old gentleman named Freeman most interesting. About 75 years old brisk and hearty. Has been in British Army and seen the world since as farmer in Canada, War Correspondent for London Standard during Turk-Russian War. Is still in journalism on some Irish-American paper here. He is a Socialist and a good one.

September 10

I wrote to Nan and Daddy this morning. Then went out for a walk. I feel somewhat better after my treatment last night (oil). My walk turned into a house hunting trip as is usual or frequent with me. I feel restless in my present quarters. The main trouble with the places I look at is that they are too small, the rooms too many in number. . . .

September 11

Dolly writes each day to me from Atlantic City. She says that they are having good weather. The Press prints a puzzle "Press Advertisers" today. Clark wrote me Wednesday that it had been ordered by the Business Office in a hurry so he had it made in the Press Art Dept., hoped I would not mind. I wrote that I did not like it. Today I bought the Baltimore Sun and find that it carries my make of puzzle as usual.

I'm curious to see if the Press will try to do a bit of double dealing in this matter. I went to Petitpas' for dinner. Mr. Yeats had been in in the afternoon. I also had a call from Stuart Davis. They are living up town in N.Y. near 110th St. He says his mother does not like it. . . .

September 12

A new acquaintance today, a Mr. Rogers of Manchester, N.H., called. He had seen my N.Y. (10) etchings at Harbison's book store and was so much interested in them that he got from them my address. He sells prints, books, etc. and he took away some lithographs, paying me $5.00 for one and taking the others on sale. He seems very enthusiastic in his liking for my work. He has real blue eyes. Mr. Yeats called and I introduced him. When he found he was the father of W. B. Y. he was most intense and real in his pleasure at the meeting. Mr. Yeats took along a volume of Gautier to read. . . .

September 13

The great event of the day was the return of Dolly from Atlantic City. She arrived at 23rd St. ferry at about 6 o'clock P.M. I met her. She is somewhat sunburned and looks right well and I feel as though some weight had been lifted from me. I have missed her dreadfully the last week. Mr. Rogers, my new enthusiastic "agent" from Manchester, N.H., came again today and I let him have a set of the New York etchings. Mrs. Calder came in while he was here and after he had gone I showed her some of my pictures. She seemed to be pleased with the work. The first she has seen of my studio in nearly six years. Dolly and I went from the ferry to Petitpas' where Mr. Yeats was all smiles to see Dolly back. . . .

September 14

Dolly and I got up late this morning. She needed the rest for she tells me she has been going to bed late and rising by six o'clock while in Atlantic City! Mr. Yeats came to lunch with us and after read us an article for Harper's Weekly which he is at work on. He has sold them several in the last year.

September 15

I finished up a puzzle and mailed it in the afternoon. Rather delayed but I have rather felt like tempting fate in this puzzle matter to see

if it "pass from me." Joe Laub called, the first we have seen of him for some weeks. He looks much more content in facial expression and is full of his country place. Is going to get 1000 peach trees he says and plant them on his hillside. He says that Mrs. L. likes it out there now. This doesn't agree with what Miss Huntington said to Mr. Yeats. She said that Norrie wants to get to the City for the winter. We will await developments. Mr. Yeats called. He has been reading a volume of Poe which I loaned him. Much of Poe is entirely new to him, and he is pleased.

September 16

Dolly busied herself at cleaning up the studio this morning. I walked out on errands to grocery and butcher shop, etc. It is growing cooler. The men have of course stopped wearing straw hats altogether, simultaneously stopped on Sept. 15th. Mr. Berlin who runs a picture shop next door and a restaurant beyond that wants us to rent a top floor studio and living apartments in the restaurant building, $60.00. We have each seen it but don't think it worth the difference. We pay $50.00 here (at 165 W. 23). Mr. Yeats came around in the afternoon and read me a choice selection from one of my own books, a volume of Gautier I had loaned him yesterday. Essay on Paul Scarron the French satirist. He well knows how to read the cleverest parts and make them tell, does Mr. Yeats. We went to Petitpas' for our dinner, the dinner was a good one. King, Sneddon, Brooks were all of the "crowd" present. . . .

September 19

The cool of autumn is in the air, summer is dying away. Some of the men in the streets have on overcoats. Most of the women have thin dresses on. . . . Dolly went to the Rand School and helped Miss Dexter in sending out circulars on the Russell meeting at Carnegie Hall. Hardesty G. Maratta called and tells me that the Ruxton Co. no longer makes his paints. He is making them for himself now. He has improved them and still better he has reduced the price. $.45 for the colors and $.25 for the hues.

September 20

Finished up a puzzle for the Press and later mailed it. Stuart Davis dropped in to ask us to dinner with them up town, Cathedral Park-

way, #110. Mr. Yeats appeared with his little satchel of chalks and insisted that Dolly should pose for him an hour before she went up to the Davis's. This she did and then went up town. I followed later arrived about 6 o'clock. We had dinner in the apartment house dining room and Davis entertained us with his talk the rest of the evening. Stuart Davis is making very interesting drawings.

September 21

Walked out to see Maratta and pay him for a set of colors. He is working on a permanent Tin priming for canvases. Walked over to Stuyvesant Sq. along 14th St., 13th, Broadway and back 5th Ave. Went in the Reliance Book Store and got a volume (1901) of Punch. When I returned home Mr. Yeats was there working on his pastel of Dolly. He interested himself in my back ache which I have had a great deal for the last two weeks. So much so that he insisted that I should try with him his cure, a good walk. *[One day as we were walking up Ninth Avenue, near Petitpas' Restaurant, Sloan told me, "Yeats used to go on long walks with me, said it was good for my health and disposition. He always carried a walking stick, not so much for support but when you are walking at a good pace and using your eyes to observe the life around you, it is well to have a third leg in case you start to trip over a banana peel. I got the habit of using a cane from him."]* We therefore walked for about an hour, returning to Petitpas' where Dolly met us and we had dinner. King, H. J. Freeman, a Mr. Edgar (one of the Literary Digest staff) and young Mr. Perkins were there at Mr. Yeats' table. We all left, Mr. Yeats very cross at being left alone about 9:30. Dolly and I walked to look at the new Penna. Terminal, 7th Ave., which has just been opened partially. One may now go under the East River to points in Long Island. They will soon open the Hudson River tubes for general traffic to Phila. and the West.

September 22

Mr. Yeats, pursuing his intention to show me that my infirm back can be cured by walking, called this morning and I gladly accepted his challenge to take the road with him. We therefore bid Dolly good bye, she to clean the house with the assistance of Lily Brown who comes Thursdays. We first rode up town to 57th St. by subway train, then we walked along the Riverside Drive north from this point.

A beautiful walk with the city crowding its way into the landscape just enough. New houses building near the brow of the hills. The red brown purple blue Palisades across the river. Mr. Yeats kept me moving, the medicinal feature of the walk according to his theory being no dawdling to admire, look and walk and talk. I enjoyed it with him. At Dyckman St. we took the tram to 225th St., then walked under the elevated (subway station) to Van Cortlandt Park, golfers dotted the course on the hills. We took a car to Yonkers. This country is new to me, my only other visit being at night about four years ago. We found a ferry, the "Daisy" to Alpine, N.J., passed the replica of the "Half Moon" moored on the Jersey side of the river. This is the boat used in the Hudson Fulton Celebration. We climbed by a zigzag roadway up the thickly wooded hillside to Alpine, the scattered village on the top. The cliff formations of the Palisades are south of this point. The Alpine houses seem to indicate a class of rather poor people, perhaps the dwellers work in Yonkers for as Mr. Yeats said, "they surely can't live by taking in each other's washing." From a pale faced woman with small children about her and her man back chopping wood I inquired the way to the nearest railway. She directed us to Closter about three miles away on the Erie R.R. (Northern N.J.) so we walked on the country slopes gradually to the Hackensack Valley, at least I think that's its name, and it was all very beautiful with variety in trees and pretty houses. As we got nearer to the railway the houses had an air of more wealth though of course not so immediately in the village of Closter. We waited right tired an hour for the next train and in another hour stepped out of the Hudson Terminal at 23rd St., N.Y. . . .

September 23

Mr. Yeats worked again on a pastel portrait of Dolly today. I just hung about feeling better in my back but not up to working. We went to Petitpas' for dinner after which Dolly went to the Socialist Branch meeting. I stayed at the table in the yard in company with Mr. Yeats, Sneddon, Brooks, Seeger, King and others. The talk was interesting. Mr. Yeats holding, I am not sure how sincerely, the opinion that one in four Colonial soldiers in the Revolution were Irish! And denying the domination of Puritanism in the American life of today. Mr. Brooks says Mr. Yeats has an inclination to judge this country by New York City. . . .

September 24

Mr. Yeats worked this morning on his pastel of Dolly and while it was good at one stage, he worked on and spoiled it, as we all do. We had him at lunch with us. Afterward Dolly went to help Miss Dexter at the Rand School, work on the Ratification Meeting, Chas. Ed. Russell, Carnegie Hall, Socialist Party. I made a puzzle during the afternoon and evening and mailed it 10:30 P.M. (Dining puzzle.) ... Mr. Yeats surprised me by coming in about 10 o'clock in the evening to tell us of the meeting, to go to see Alexander's act tomorrow afternoon. I left him at home and reading while I went to bring Dolly home. Met Miss Dexter, a strong character apparently. Bought beer for us and some Vermouth for Mr. Yeats and we spent an hour till midnight talking. He is a bit gloomy.

September 25

When I returned from my short walk to the green grocer's and had bought my Phila. paper I met Brooks leaving the house. He had come to tell us to meet at Petitpas' at 1 o'clock, not knowing that Mr. Yeats had called on us so late last night. We joined them, Brooks, Sneddon and Yeats, at that hour and went to 125th St. and the Alhambra Theatre and there passed a fairly well amused afternoon. The chief object of our visit was to see Mr. Alexander the young English ex-Naval man in a short sketch. He did his work rather well and (this is the "try out" of the piece) it seemed to "take" with the house. Mr. Yeats, with all of his years of life in London and Dublin, is not sophisticated or "blasé" and it was a pleasure to note his interest in some of the vaudeville turns. We came to Petitpas' for dinner. There came Miss Elmendorf with her mother, a pleasant bright-eyed woman, not old. She came from Texas, her first visit to New York. She is a trifle proudly worried by her energetic offspring paddling about in this great pond alone. We came away right early. I grew a bit tired of the same company so many hours running and Dolly, as she says, is always tired of them.

September 28

At noon Joe Laub called with De Sales Casey and Mr. Hare of Collier's. Hare is quite distinguished as a staff war correspondent in the photographic way. He covered the Russo-Japanese War for

Collier's. Joe wanted us to go out to W. Nyack with him tomorrow evening to stay till Monday but as Dolly has previous engagements and as Rudy has just written me that he will probably be in the city Saturday and thirdly but not least, Casey handed me a story to illustrate in a week or quicker if possible, I had to decline. Have read the story but can't enthuse over it. A little boy in an English pantomime, his discovery of self consciousness in his acting, etc. . . . F. Van Slaun and his chum Bohnen were there dining. Dolly went up after dinner to work with Miss Dexter. Van Slaun, Bohnen and I went across the street and saw the exhibition at the National Arts Club. Rather poor show of course. Bellows has an amusing canvas, boys swimming on the Jersey side of the river. . . .

September 29

A note from Mr. Roberts saying that they, with Glackens, will be at Petitpas' tonight. Dolly helped at the Rand School in the morning. Mr. Yeats called in afternoon and he and I walked down to the Astor Library. I looked up the subject of Pantomime in London for use in Collier story. Later we met at Petitpas'. Glackens was on hand, looks well but still takes pills after dinner. There was a large party at Mr. Yeats' table–King, Brooks, Sneddon. The Roberts, who bought a bowl of pretty glassware for Dolly as a present, a dark little man named Leeds (I think) (with King), Mr. Edgar and Glack. We had a pleasant dinner time. Then Dolly with Edgar went to a street meeting which did not materialize (the speaker not turning up). Sneddon has some pantomime material for me, having heard that I need it. He is a fine fellow, one of the best. He and Roberts's and Glack came to the studio with me. Dolly with Edgar and Alexander, whom they met on the street, came in about 10 o'clock. The Roberts had just gone. Glackens who seemed a bit lonely as Mrs. G. has not come home yet (she and the baby are at Hartford with her folks) stayed till the last left about 11:30. He is good solid stuff. I wish I felt that he liked the three last things I've painted.

September 30

Dolly is busy still, helping Miss Dexter get up the Russell meeting (Chas. Ed.) candidate of the S.P. for Governor of N.Y. to be held in Carnegie Hall in Oct. She put in the afternoon at the Rand School on this work while I went to the Library near here and

461

looked up Collier's to see what they had been doing lately, get a line on their general style as it were. I then took a walk and met Barry, Socialist young fellow, he with O'Brien also Socialist now and Woman Suffrage Party organizer have taken a flat in Grove St., Greenwich "Village" section. I looked at it with him and the janitor showed me another. Left him and started up 6th Ave. where at 11th St. near the corner I noticed To Let sign and went in and looked at the finest flat I've ever seen at any reasonable figure. Asked $70.00, would take $65.00. Only about four flats, old fashioned house but all "modern conveniences," without elevator. I do wish I had seen it before today, the last of the month. I believe we would have taken it. I talked it over with Dolly (we had dinner in the lunch room downstairs) and then walked up to the Herald Square Theatre with her. She is to meet Mrs. Davis there and see "Tillie's Night Mare," Marie Dressler.

October 4

Dolly brings a lively account of the Noon Meeting at the Battery. She sold lots of Socialist "Literature" and said that there were fully two thousand or more people there. She says that Kirkpatrick is a fine street speaker. I worked quite steadily on my Collier drawings and by night late I had two of them nearly in shape. Most difficult for me to take up this sort of thing, I have such long periods between "jobs"!

October 5

Quite busy enough rushing the finish of the Collier drawings, but on top comes the colored man, a nice fellow, to do the kalsomining of the studio for which I have been worrying the agents for some time. It was a most difficult job to help him get his kalsomine the right color gray. I got all in a mess grinding color and then had to rush at the drawing and deliver it in response to repeated messages to hurry. I went to Collier's about 4 o'clock and they seemed satisfied with the work. I'd like to be more so myself. Think I'm getting rather old to do things like this without meaning more earnestly to do the best I can. . . .

October 6

. . . Rockwell Kent arrived early in the day. He has brought Mrs. K. to stay in the city for the winter. He is going to live in Monhegan,

first making a two week trip to Newfoundland to look over the ground up there. He proposes to buy some acres of land and perhaps start a "colony." Wants me to take the Newfoundland trip with him. Mr. Taylor called and said he had read enough to be interested in Socialism. I hope to bring him over to the "only way." Mr. Yeats made the third guest at lunch. He read a short story of Poe's to us and read it very well. "Count and Devil." After they had all gone Dolly went up to help Miss Dexter and I returned to work in the studio. Dolly had a nice roast of lamb for our dinner, very good indeed. After which she went out again to work in the evening. C. B. King, Sunday Editor of the Press, telegraphed for answers to puzzle, I sent a duplicate "Dinner and Lunch Terms" as near as I could remember it. Homer Boss came in with Kent in the evening. Dolly at the Rand School till late.

October 7

Kent had flown when we arose at 9 o'clock and we saw no more of him today. He is busy with his exhibition of his pupils' work at Monhegan Island. I rearranged pictures on the walls of the studio and the place after its condition of turmoil now looks quite nice. Dolly and "Lily," our weekly assistant, worked all afternoon cleaning....

October 8

After breakfast Kent (who had worked late hanging the exhibition of his pupils' work at the Henri School and had stayed the night with Boss who is there) phoned me to come up and help decide on the scholarship to the Henri School. We gave it to Miss Sarah Hunter who had some fine works there, full of the simple humility of great work. I met through Kent, the son of Hjalmar H. Boyesen. He is a very intelligent and well educated young man.... On the whole I rather enjoyed my day. The work was most of it very interesting and vigorous. Macbeth the pleasant dealer was there. I told him of Calder's sculpture. He said that he would show some of Nan's water colors in an exhibition he is having in December....

October 9

Mr. Yeats came in the afternoon with Mr. Fred King. He had stopped in for a few minutes in the morning to show Dolly an account of the death of George Polixfen, his brother-in-law in Sligo, Ireland. He

hopes that this bachelor brother of his wife has left some money to Mr. Yeats' daughters, particularly Lily. I showed King the Petitpas' picture, which is still unfinished, and made a sketch of him to use. He was not satisfied with my bright red presentation of him. Mr. Yeats finished up the drawing of Dolly in our lead pencil group which he had made some weeks ago. . . .

October 11

A telegram from the Press starts me off on a puzzle in a rush. Mr. Yeats called and enjoyed reading some from "God and the State" by Bakunin which Kent has given me. . . . Dolly, as is usual these days, has been out all day on the Russell Socialist meeting affair. We went to Capp's restaurant next door for our dinner. Rockwell Kent still sleeps here at night though we see very little of him, he is so energetic! At request of young Boyesen, who is assistant professor of English at Columbia College, Kent went up and gave an informal talk to students in a club of undergraduates of the University.

October 12

I painted some of the woodwork in the studio dark gray "green hue." I feel a pleasant sense of newness by the complete change of color in the studio. It may move me to get some worth while work. Kent and I walked down town to Forsyth St. and he bought a sketch box of Rabinowitz, ready for his Newfoundland trip. By invitation of Miss Pope we dined with her and Mrs. Brewer at Mouquin's tonight. A very good dinner with two chickens and a bottle of Burgundy and all sorts of nice things. We came back to the studio where Mr. and Mrs. Kent were having a quiet last evening together by Dolly's invitation. Mrs. Kent, who with the baby Kent is in Brooklyn with a sister, stayed the night. They sang for Dolly and me after Miss Pope and Mrs. Brewer had gone home.

October 13

We were up bright and early as the Kents left–he to take a 10 o'clock train (to Gloucester, Mass., I think)–he is going to Newfoundland by a fishing vessel if he can get passage or work his way. Mrs. Kent seems a rather pathetic figure. . . . Mr. Yeats called. He is very restless waiting for news from Dublin. . . . Dolly came home rather late but made us a good dinner of spaghetti, then she went out to attend to

the sale of pamphlets at Madison Sq. meeting. She had the oil cloth banner and its pole under her arm and a large package of booklets.

October 15

Started a puzzle today. Dolly of course is gone all day helping on the Russell meeting. Mr. Yeats called. He has had no news from Ireland for more than a week, is consequently rather uneasy. L. Hiller called and asked me to send something to the Illustrators' Travelling exhibition.... In the evening Dolly and I went to the Meeting at Carnegie Hall. It was a great success. Chas. Ed. Russell–Hillquit, Miss Jessica Finch, and Alex. Irvine, the speakers. I heard only Miss Finch as I was busy assisting on the doors and various entrances and stairs. The house was quite full and with all these hundreds of "dreadful Socialists" no incident of bloodshed marred the occasion. . . .

October 16

We stuck to our comfortable bed till late this morning. Dolly needed the rest after her hard work of last night and the week before. . . .

October 17

The cumbersome Miss Dexter weighted down with flesh and sense of importance called this morning and took away the money collected Saturday night at Carnegie Hall, which we took charge of. She is a fussy old party and one of the sort who take all the possible credit to herself, though I'm quite sure that she would have been "in a hole" if Dolly had not helped her the past three weeks. She is a "boss" and is taking credit for making the S.P. Branch 1 what it is. . . . Dolly went to Rand School and helped on straightening out accounts, very tangled job I should imagine. I walked out, stopped and got July Everybody's and when I got home found that they were a year older than I wanted! Dinner at home–chops–good. The Portuguese have within the last few days established a republic, exiled the King Manuel and banished the House of Braganza. Curiously they have made Braga, a man of letters of some note, president. . . .

October 19

At about 5:30 P.M. Henri and Mrs., looking all well and healthy appeared at the door of the studio. The "Barbarossa" on which they

arrived had been down the bay held up by fog since 6 A.M. today. Mrs. H. went up town to see her people. H. stayed to dinner with us. Kirby was here also. Henri has seen the Automne Salon. Says Miss Pope's picture is a good one. I felt much ashamed of my small showing for the past five months' work. He liked my "Mother" portrait etching. Also liked the "Scrubwomen in the Library."

H. described a prize fight, American rules, which he and Mrs. attended in Paris. The ring and auditorium clean and roomy and all the disreputable conditions which obtain here replaced by conveniences and comfort. I was much interested by his ideas of the "Matisse" movement in Paris art. The resignation blanks for me to sign as candidate arrived today. These go into the keeping of the Party and may be handed in at any time a Socialist office holder turns false to his pledges. *[Sloan received 102 votes in his unsuccessful race for assemblyman.]* Bought a copy of "Eliana"–some of Chas. Lamb's fugitive writings. "Ulysses," "Pawnbroker's Daughter" etc.– very fine.

October 20

I had a fine walk down to Maiden Lane. The day had started with a very heavy rain (the first downright rain this section of the country has had for three months past), but it cleared off by one o'clock when I started. I first went to Collier's and delivered colored proofs for "Animal Trainer" which is to be printed soon. Saw J. Laub and squared myself for not going out to his West Nyack "farm" Thursday two weeks since. Then leaving Collier's I took to Old Bleecker St. and many by-streets on my way down town. St. John's Lane back of the old church of that name, fine old battered dignity–warehouses are encroaching on it, and, I believe, services have been discontinued. Read something of a row, injunctions to force Trinity to continue service in St. John's etc., in the newspapers a year ago. I went in to lunch free in a saloon on West Broadway, a glass of beer and a very good lunch. Quiet hour of the day. The bartender was amusing himself writing the name "Joe" in the white foam of a glass of beer, using a purple copying pencil to stain the foam. I saw the sign "Irish dulce" in a grocers, Callahan's, on Vesey St. near Church and bought some, having a recollection that Dolly likes it. I haven't tasted it for years. I remember my cousin Tom Priestley took me for a walk when I was

466

small (he about 19 years old), he bought some of this strange salt purple thing for me. He has disappeared from my ken. Perhaps he's dead. He was a black sheep even then, I faintly remember. His father, my great-uncle Alexander, was a sort of family "disgrace"–a man of great intellect and I now feel sure he was a most interesting old fellow. I appreciate him post mortem.... I must not forget to record the show case I saw on the sidewalk down town.–A Jewish man, manufacturer of Flavorings–Bottles marked "Cognac flavor," "Jamaica Rum flavor," "Gin flavor," "Sugar color." Corks burnt with the word "Cognac"–Labels for whiskey–all these sold quite openly–for the manufacturer of imitation liquors!! Lord knows what drugs may be sold in secret in such a place.

October 21

A postcard from Rockwell Kent who is now in Newfoundland. Says he was down in a mine. "You should have heard me planting discontent in the minds of the miners." I had about started a puzzle when I had a caller, Bayard Boyesen whom I met though Kent, came in to visit me. I showed him some paintings. He has rather good judgment though I think for some reason or other he is an admirer of the work of Dougherty the marine painter, very "arty" and leathery things.... Dolly and I went to dinner at a German restaurant on 20th St. near Broadway. Had some nice sea bass and Piel's beer. In the evening later, F. M. Dewey called. He has written a sort of "Condensed Socialism" which he hopes to have printed. I read it, it is a good scheme. Miss G. Light called also on Socialism so that my evening disappeared in talk and I wound up another absolutely useless day! *I pass many such this year past.*

October 22

Enter a gentleman introducing himself as Mr. Green a decorator who buys painting for houses of his clients–"has customers who trust to his taste." He knows Rockwell Kent or knows of him. I hauled out several pictures for his inspection though I warned him that I hardly would expect my work to be fancied by the picture buyer. He was an agreeable sort of man to talk to and he stayed quite a while taking, as he said himself, much of his time and mine. In fact he said "wasting" which shows that we agree as to the unlikelihood of my

paintings gracing the walls of any of his patrons' houses. He had been to see Glackens and G. had shown him some Lawsons.... I walked out and saw some hard shell crabs which I brought home. Dolly is quite fond of them. I like them of course, being omnivorous. Worked on a puzzle.

> Donnerwetter! If the German
> People should disturb my ease
> Seek to rid themselves of ermine
> Like a flock of Portuguese
> Ach! Mein Gott bring gun and saber
> Wilhelm won't like Manual labor.

October 23

Kirby came with trouble (a constant companion of his) knocking at the door this morning. He had a telegram from Mrs. K. who is at Saranac Lake and ill with tuberculosis as all visitors to that resort are, that she is probably going to die before long. K. wants me to finish a page on the air meeting at Belmont Park–he has just started it–I agreed to do so. Finished a puzzle today. This evening we went to have dinner at the Roberts' and it was a very good dinner indeed, nicely served too. Fried bananas, very fine ripe olives. The Henris were the other guests at dinner. After dinner Glackens, Mrs. G. and her sister Irene arrived. The sister is large and beautiful and smokes a pipe. She cuts her own plug tobacco. The brier pipe she is smoking I thought too thick stemmed for her, told her she should get a thinner one, that I thought a pipe should be becoming to the smoker. Miss Dimmock may have thought that I was ironical! I really was not so intending. I find that ordinary conversation leads to subjects where I differ so strongly with smugly contented minds that I don't enjoy it much–it's my loss!

October 24

Mailed "Household Tasks" puzzle today, Reg. With great weariness and little wit I finished up the Kirby drawings, signed it "R. Kirby" and sent it to Collier's with his bill for $150.00!! Robbery of the Rich! False pretenses! Forgery! Prostitution! What a tablet of sins that messenger boy bore away down to Collier's. Like Moses from Sinai, descending with *broken* commandments. Mr. Yeats came about

noon time, he walked out with Dolly who brave little woman went to do the Pamphlet distributing at a meeting at Broadway and 14th St., Union Square. I feel proud of the way she is rising to the work. She is a little wonder woman–(that will please her when she reads I'm sure and the best of it is that I mean it).... I had a fine interesting letter from Rockwell Kent written on steamer from North Sydney to Newfoundland. He says that he is or was tempted to take a job in the mines of N. Sydney as carpenter or miner's helper. He is a hard-liver is Kent in the sense that one says "hard-drinker"–but he is more to be envied than the latter and yet *I* could not possibly do his way. A fine young heart. I hope his young wife is keeping happy enough. She is to spend a couple of days with us this week....

October 25

A. M. Simons the editor of the "Coming Nation" wrote returning the samples of my work sent to him by Mr. Shoaf. He said he knew my work and would probably have something for me in the near future. ... After dinner Dolly trimmed her little brown beaver turban with my assistance. Of course I couldn't keep my fingers out of it. She bought me material for a couple of gray flannel shirts which she intends to make for me this week.

October 26

Today having a pass (which Kirby left with me Sunday) I went to see the *Flying Machines* at Belmont Park. Great crowds were going by the new tunnels from the Pennsylvania Terminal just opened a few weeks. At 70 cents each return, the L.I.R.R. must be reaping quite a harvest. The wind was high so that though I did not arrive till near 3 o'clock I saw the first flight of the day. Johnstone in a Wright Biplane. So much does one become familiarized by photographs and "moving picture" films with strange inventions of this popular sort that the first sight of the actual object loses some of its surprise. But I did feel the beauty of the scene and was thrilled by my first sight of a turn into the wind with the machine slanting nearly fifty degrees. The wind was quite strong so that a speed elimination race was put off, "across country" fly for ten miles and back was pulled off. Latham the Frenchman, one of the starters, finished in 32 minutes. One of the others beat the Antoinette machine by cover-

ing distance in 28 minutes. A fine experience it was. . . . Mr. Simons of the "Coming Nation" sent me a blood curdling story by Alex Irvine to illustrate. They can pay $25. for the work. It will be a great satisfaction to do a good set of pictures for this new Socialist weekly.

October 27

A big policeman stood at the "kitchenette" door when I clad in white pajamas answered the bell. He said that I was registered in voters' list as living at 165 W. 24th St. A building in course of erection there, "a clerical error of course" he said but he has a "warrant for me." I must straighten things up by going to the Supt. of Elections, 42nd St. and 6th Ave. So after breakfast I did so. They explained that their list was correct, 165 W. 23rd St. so by the advice of the clerk I went down to W. 20th St. Police Station. Here I explained again and by their advice went to 26th St. and 6th Ave. and looked at the Public Book of Registry. This has me wrong, 24th St., so I phoned the Elect. Supt. Office. They said go again to 20th St. Police Station. And back I trotted to be told that when the officer came back with the warrant it would be returned to the Magistrate and cancelled. I am to vote "swear in my vote" if challenged. This mess of red tape required about three hours of my time. Dolly was "hot" at hearing, as she sat up in bed, the words *warrant for you.*" Later in the day Mrs. Ullman came in. They have just taken an apartment at 170th St., Michigan Ave. . . .

October 28

Mrs. Kent the silent girl and her baby boy "Rockwell, Jr." arrived this afternoon. Dolly had had a phone message saying that she'd like to come but had not let us know decidedly of her coming. She is a vegetarian so we are on a vegetarian diet till she goes. This I don't mind as it suits me very well. . . .

October 29

I had a model today and painted for the first time in a long while. The little girl cousin of Yolande Bugbee's was the victim. I did not find her very interesting and have a rather poor start except perhaps in color scheme which won't carry me far. Dolly had a meeting to attend to as is her almost daily custom lately. Her work in these street meet-

470

ings is becoming quite noticeable. . . . I went off to the Glackens' for dinner. The Henris were also asked (in Dolly's place). We had a very good dinner, a pair of ducks and good white wine for 'em to disport in. Glackens had been fishing during the day, his first day "off" for two weeks. He has been serving on a jury "doing his duty as a citizen" he calls it. He won't see my Socialist arguments. Mr. Yeats called while Dolly was out in the afternoon. He is not feeling very well. Said Mr. Quinn had asked him to go out to see the aviators at Belmont Park Track but that he was too shabby.

October 30

Painted again today from the same Miss Ingraham, little girl, dark eyes and hair but she's awfully quiet compared to her vivacious cousin Yolande B. I have not gone ahead much and have told her to come again tomorrow. Mrs. Kent still with us. The baby is a fine beautiful straw white haired boy, a perfect specimen. She is the most curiously quiet woman I ever met, you simply can't make her say more than six words "in a chunk." She walked out this afternoon with Clara Rabinowitz, who is the handsome young Jewish girl who was at Monhegan Island with Kent's mother and sister this year and who was sent home because she associated with the Rockwell Kent crowd. . . .

October 31

Painted again and made an abject failure of this canvas. Scraped it all off. Time wasted–and four dollars and a half of money gone along! Makes me feel blue which blue is set off and to an extent neutralized by a telephone from Collier's, Mr. Lee says he wants me to make a Christmas page of drawings for them. My own choice of subject, etc. I went down to see him. Joe Laub and I came away together. He is still interested in his "farm" at West Nyack and is still asking me to come down. I told him that we really thought Mrs. L. could have come in to see us at some time during the past summer. . . .

November 1

. . . Mrs. Kent still quietly stays on. We are sorry for her but it does get rather tiresome to entertain one who is so unentertaining. And the baby fine and dear as he is a nuisance, in three rooms and bath . . . and this entertainment adds to our household expenses and keeps us

on a vegetable diet for Mrs. Kent is a vegetarian made such by her devotion to Rockwell, of course. So poor Dolly and I have been "on the Nebuchadnezzar" as you might call it ever since she came and will be till she goes.

November 2

... Toward dinner time and after dinner I made a pencil layout for some city life incidents of Christmas for the Collier page. Mrs. Kent and the boy are still with us. He is the finest baby boy I've ever seen, he's quite gentle and intelligent–reasonable. The Publication Committee of Branch 1 met here tonight and discussed the proposed pamphlets.

November 3

Today is a sorry specimen of weather, wind cold and rain in torrents. I with hopeful heart and my sketch in the rough under my arm went to Collier's and showed same to Lee, who instantly said "it won't do!" On my asking for his reason he intimated that they had already arranged for N.Y. City sketches and now told me that I was expected to do Pirates, something funny. I held my retort violent down to a remark that he seemed to know that he didn't want rather better than what he wanted. I should have liked to have told him that he should be out "scabbing" on an express wagon (a strike is on just now) rather than keeping an art editor out of a job. I can't afford to say such things and perhaps it's just as well. Since I have stopped smoking I do not feel half the effects from indignation that I used to. I can get gloriously angry and have no heart fluttering! This day gave me another test. A note of mine in regard to the poor engraving on Press Puzzles had been handed to some one in that department of the paper who had written a reply in pencil on the back of it and sent it to me. I countered this in a letter to the Sunday Editor which will I think square the blow and plant a thorn in the Yowling Yahoo who wrote the note. . . .

Dolly went to the funeral of her brother Henry Wall's wife. She returned by cab and brought along Margaret (her sister) and Miss Mary Wall her niece, youngest daughter of her brother John Wall. Miss Mary is a large well formed blonde girl of seventeen years who seems to rather fancy the calling of the stage which her sister Edith Wall has taken.

472

November 4

Up after a rather restless night and after breakfast I sat down and took a pencil and paper and before long I had made a "funny" pirate series of pictures which which I hied me in the rain down to Collier's and showed them to Lee who seemed to be quite well pleased with them! Hurrah! That money won't pass by me! I am to deliver the drawing by the 15th inst. Oh what a fine day! And how glad I am I didn't knock [his] head off yesterday! (Confidentially though I can't for the life of me wish him any good fortune.) After lunch Mrs. Kent and Rockwell the baby left to go to Brooklyn and continue their visit with Mr. and Mrs. Grebbs who must be very long suffering people or have musical tastes or something of that sort. Dolly and I had a fine tête à tête (vegetable) dinner. . . .

November 5

In the morning went to the Astor Library to look up data to use in the fight story by Alex. Irvine ("Coming Nation"). I met Van Wyck Brooks there. He works on an Encyclopaedia, has blanks to fill out on each word from other encyclopaedias. Mr. Yeats called in the afternoon and we decided to go to Petitpas' for dinner. Our first visit since the dining room has been enlarged by taking in the hallway. . . .

November 6

Dolly not well today. She stayed in bed till evening. Mr. Yeats called while I was out getting the papers. I returned and found him sitting by Dolly's bedside. He has been quite worried by her cold (or whatever 'tis). He still has a bad cough himself. Mrs. Joe Laub called with a Madame Obry. The Frenchwoman was interested in my pictures on the walls. Mrs. Laub went in to see Dolly and told her all about Joe's farm, their cow and chickens and guinea hens all have names. They are to have Mary Garden for dinner tonight (that's a chicken). She says it's lonely out there but they have to stay out as all the livestock needs their care.

Dolly and I went to 3rd Ave. and 14th St. (Thale's) for dinner. Twenty-five cents! and plenty to eat. We from there went to Henri's and found him busy "triangulating," working at the geometric theory of Maratta. The "crop" of pictures from Holland this summer is a very fine one. Many small canvases, heads of Dutch loafers and chil-

dren. A fine solid lot of pictures, about sixty of them all together made in about six weeks! Of course many will be weeded out. A few years from now one of them will pay for the whole summer's outing. Mrs. H. is attempting to cook and making rather a poor fist at it I should judge, but he don't complain for he seems to want to eat at home.

November 7

Dolly is feeling better today and that makes the whole house and man thereof feel better too. She went down to 14th St. and Broadway and sold pamphlets as usual at a street meeting. She seems to get along nicely with the policemen who are detailed to guard these affairs. Tries to make Socialists of them. I got started on the drawing for the Alex. Irvine story "Coming Nation" sent me. Made the largest drawing before I went to bed tonight. Mr. Yeats called and was glad to hear that Dolly was better and out. He is very fond of my pretty blue eyed little wife, which pleases me. Post card from R. Kent, drawing of a large area of rolling country inscribed "Proposed site of the Newfoundland University Borin N.F. view inland from my harbor hill.–R. Kent." This is in line with his community scheme which it was suggested should be called a "University." We had a fine steak for dinner, by Dolly. After which she in her pretty brown corduroy dress which she made lately went uptown to a Socialist meeting at Harlem Casino 122nd St. and 2nd Ave. . . .

November 8

Today those of the male sex voted in N.Y. State and will of course put the eminently stupid Mr. Dix into the chair of Governor of this great state–to reprove Roosevelt who has bossed the other party and chagrined its bosses. . . . I worked on my drawings for "Coming Nation" and finished them before "bed time." Walked out to vote and on my way back found a "selling out" book store which I picked up "Nostromo" by Jos. Conrad for twenty-five cents. By arrangement we went to dinner at Petitpas' with Henris. Mr. Yeats still has a cold. Brooks was there. He voted Socialist ticket. King a split ticket (R. and D.). . . . King spoke of a new "Poetry Society" in formation which of course met with disapproval from all. Henris and we left together. They are making this their at home evening instead of Thursday, but

474

I came with Dolly home and got to work on finishing the Irvine pictures for the "Coming Nation."

November 9

"Democratic landslide" "all over the country" but the Socialist vote in New York City is nearly doubled in the last two years! Returns from S.P. in the rest of the country are of course slow through lack of financial facilities to have them sent, but suppose they will come in a day or two. Victor Berger of Milwaukee is the *first Socialist* to go to *Congress*. (In ten years there will be fifty Socialists in Congress.) ... I met Kirby on the street and went with him to his studio. He is foetid with conservatism. Says he don't see why I–how any artist– could be interested in Socialism. I told him that no man could do good work and *not* be. Poor Kirby, his wife is on her death bed and he with his nose to the most tiresome grindstone of making money by average illustrating. I wonder if he pities me. He should have his head cracked if he does. Dolly sewed when she had a chance. Miss Dexter called on her late afternoon and after cooking and serving dinner Dolly went up to the Martha Washington Hotel to help Miss Dexter on settlement of Carnegie Hall financial affairs.

November 10

I made and finished a puzzle for the Press which I sent off by Special Delivery 10 P.M. (Diplomatic). Toward evening the Publication Committee S.P. B.1 met at the studio. I made the acquaintance of Ernest Poole for the first time. I liked the stories of his which I illustrated about three years ago for the Saturday Evening Post.

November 11

W. F. Taylor–"Comrade" Taylor (as he has joined the S.P.)–called this morning, and I walked out with him. We stopped in at the Madison Gallery. Lawson has a fine "May Day Central Park" picture, also a Coney Island one which I don't like so well. "Shermy" Potts, our old friend, has two; one of them he called "Orange Hue" so I suppose he is using the Maratta colors. It is quite good in a small-ish way. We next went to Macbeth's where I told them Mr. Macbeth had said he would look at some of Nan's water colors which I have on hand. Bought a pair of button hole scissors for Dolly.... In the evening I started on my Collier Pirate Xmas Page, while Dolly went

to the Branch Meeting S.P. She was elected temporary organizer till next election of officers.

November 12

By mail there came a story from the "Coming Nation." Mr. Simons wants one drawing for it. He also wants me to finish up the group of sketches which I sent in pencil. If Collier's had taken it the price would have been $150.00. To the "Coming Nation" the price is $30.00. The Express Companies are having strike trouble. Mayor Gaynor has been trying in his old fashioned way stupid honest ? way to bring about a settlement. The strikers having not as a mass accepted the negotiations, he *"threatens* to put the *police back on the wagons* to protect from riot." This statement is to my mind positive proof that the Police are used as *agents provocative* and that they are used as such with *intention deliberately*.

I finished laying out the page of pirates for Collier's and greatly enjoyed writing the ten stanzas of rhyme to go with them.... Dolly sewed on my new flannel shirt and finished it in the evening. We had a very happy day together. We are living a life of happy days together.

November 13

Dolly's niece Mary Wall (from Phila. who is visiting with Dolly's sister Margaret in Brooklyn) called in the afternoon. Mr. Yeats was here and seemed to be interested in her. She is a nice looking young girl. We took her to Petitpas' for dinner which was sort of a new experience for her. Henris were there, Mr. King, and old Mr. Jos. Stoddard once editor of Lippincott's Magazine in Phila. (old friend of W. S. Walsh's). The Henris came back to the studio with us. Dolly first saw Mary off on the subway to Brooklyn. The strike of Expressmen is over. They have got nothing but vague promises.

November 14

A note from Mr. Jones of the American office of the Strand Magazine asking me to draw a design (humorous) about a playing card. I got at the Collier page to finish it today. Mr. Yeats came in and asked Dolly to pose for some figures he is putting in a playing card drawing for Jones. Kirby also came and said he had the same request. K. says Mrs. Kirby is not doing at all well. He is thinking of sending her to Asheville, N.C. Mr. Yeats stayed to lunch with us. Post card

476

drawn by R. Kent from St. John's, Newfoundland. We had dinner at home. I finished the Collier drawing at night. The verses which I have written for it are the only parts of it that please me, the rest looks so tame! I don't see why I can't draw this sort of thing as well as I draw the Puzzles for small pay. At any rate it shows that the money incentive of the present system is not at all necessary to inspire good effort. Young Mr. McIntyre from Macbeth's came today and selected three of the four water colors by Nan Sloan to go to his exhibition opening next month.

November 15

Finished up the Collier Pirate drawing. Gilded up frames of Marianna's water colors ready to go to Macbeth. Mr. Yeats came and worked on his pencil drawing for the Card (ace of clubs). Used Dolly as model. Also pressed into service Miss Sehon who called in the afternoon. Yeats and I walked together over to Collier's. I left him in Joe Laub's office while I took in the drawing. Mr. Lee seemed to like it. Mr. Yeats said that the smell of the Collier building depressed him as it brought back his visits to Cassell and Co.'s in London where he submitted drawings with I suppose varying success.

Dolly and I dressed and went at 7 o'clock to dine as guests of Miss Jessica Finch, at the Colony Club. We were a half hour ahead of time as the hour set was 7:30. I met Chas. Ed. Russell for the first time and his young wife, very pretty woman. He has just relaxed after his hard work as Socialist candidate for Governor of N.Y. He has a dry humor. I had a few words with him. Mr. and Mrs. R. Bruere. Miss Finch looked huge and pink in an evening gown–she is kindly. Miss Charlotte Teller and Miss Light, Mr. O'Brien and Mr. Barry also there. I don't feel particularly improved or amused by the affair.

November 16

We got up quite late today and Mr. Yeats came in while we were at breakfast and read some parts of a play written by an English woman, a Xmas play, very religious, sentimental "Eager Heart." They had asked Mr. Yeats to play the part of an old shepherd. He turned it down promptly as Mr. Quinn said when told of the offer "Tell her to go to hell!" Rockwell Kent arrived back from Newfoundland, which would indicate a change for the better in his plans for the win-

ter. Mrs. Kent came later and we had tea together. He had some interesting experiences, though of a strenuous sort that hardly appeal to me. He makes a full statement of his stand on every subject, social and religious, and of course creates excitement among the simple folk, business men and bankers. He is enthusiastic over his project for the small art colony in Newfoundland. He has arranged for special rates to visitors to his art school (if he starts it)....

November 17

Rockwell Kent came in today and looked at the rooms below in this building (165 W. 23). He was pleased with them, saw the agent and agreed to take them at $22.00 per month. He is greatly joyed at the prospect of being our near neighbors and says that Mrs. K. is also overjoyed. Myself, I am more reserved. I suppose I don't know how it will turn out. I hope we will all be satisfied with the arrangement. He is still set on going to Monhegan for a month. Dolly gave a dinner tonight to Miss Jessica Finch, Jos. O'Brien, the Henris and Barry. (The last does not improve with age. He's too young and a bit treacherous I fancy.) We had a very successful evening. Henri I think liked Miss Finch, who is a "lady pedagogue," has a large fashionable school for young ladies and evidently makes a fine income from it. She inculcates Socialistic and radical ideas and does not as yet find that it hurts the school attendance. She tells me that she has written to the Taxicab Co. whose chauffeurs are at pressent on strike hoping that they would soon meet the demands of the men. Her school patronage of the company amounts to a couple of thousand dollars a year. So her letter should have weight.

November 18

After exercising on the polishing brush applied to the studio waxed floor I pegged away on the large "Coming Nation" Christmas drawing (the sketch made for Collier's but by them refused). I enjoyed making this drawing greatly as I felt more free from the dry as dust restrictions of the magazine "art depts.".....

November 21

Mrs. Henri called right early today and after consulting Dolly went out to buy some cretonne for a book case which she brought back and Dolly hemmed and joined it for her. Miss Sehon also called, and Dolly joined her in a shopping trip. She (Dolly) is starting early to

478

get the Xmas gifts this year. She bought a fine handbag for my sister Nan, a beautiful little silver chain for Elizabeth Garrett Hamlin, a long one for my sister Bessie and other things, not to forget three suits of real swell wool underwear for my immediate use. Mr. Yeats called in the afternoon and he and I had a long chat together. He had intended going to the Astor Library but was interested enough to stay. He agreed with a theory of mine which I told him of—that the world and the women of the world would be better when they were more economically independent of the men, so that a man's "heart could be broken" as easily as a woman's now is. . . .

November 22

This is a remarkable day. First of all Fred. Warren the fighting editor of the "Appeal to Reason" must by the (delayed till after election) verdict of the Court of Appeals serve his sentence of six months imprisonment and pay $1500.00 fine!! This is bad news for Warren but will *make Socialists!* Next, the revolution of Madero in Mexico seems to be a real one giving the beast Díaz some real trouble. Of course the news of these Mexican matters is so manipulated that it is hard to decide whether this scare news with its accompaniment of "Mexican hatred for Americans" is intended to create feeling against Mexican patriots or not. They have just reason for Hatred of Americans as Díaz has been squeezing the life blood out of them for years benefitting himself through the American capitalists' loot.

The great *personal incident of the day* is a letter from Townsend of the Press Phila. He quotes a note from the "Art Editor" who says that my *puzzle drawings* are too "*sloppy and scratchy*" and that for this reason they have been able to sell them to but two papers!! and that at a nominal rate!!! In other words they have not been able to get back all the money they pay for the use of the puzzles in Press by syndicating them! I wrote to Townsend and gave notice that with 25 Dec. issue I would quit. Then I went to the N.Y. Times and tried to see Alden March the Sunday Editor, but after I had waited two hours! he did not come home from lunch, so back home. Kent and Mrs. K there but left. He is painting the rooms downstairs.

November 24

Thanksgiving Day and Dolly has invited a crowd for dinner, so for her the day is full of work. She cooked a turkey which was relatively

479

about twice her size. The Henris are part givers of the dinner, Dolly doing all the work and they paying half the expense, about $15.00. Eleven diners: Mr. Yeats, Henris, the Roberts, Mr. King, Brooks, Sneddon, Kent, and our two selves. The dinner went off smoothly, the turkey was brown and very juicy, a fine bird. We had a gallon jug of California "Burgundy" which was emptied. Cocktails before and highballs after. Mr. John Quinn who had dined elsewhere came about 9 o'clock and seemed to enjoy the evening. R. Kent is a good entertainer and Fred King always at Mrs. H.'s mandate (peremptorily given) must do his share in song. I was prevailed on to give some extempore imitations which did not seem to bore the company. Sneddon don't talk but he is busy soaking up the whole affair. Brooks is a bit formal. I wonder if Mrs. Roberts had a good time? I think that Mrs. H.'s off hand manner rather amused and pleased Mr. Quinn. Altogether the party was a decided success. Kent stopped with us the night.

November 25

I worked on a plate "Girl and Beggar," street walker and cripple turning to note an approaching wayfarer (who is not shown in the picture). We had asked Henris to dinner for being half providers of the feast they were entitled to partake of the turkey hash aftermath. They came and brought with them Dr. Frank Southern (Henri's big brother). He is bluff and cheerful as usual but does not seem so hearty as of old. He is aging. This seems mean of me to say for he told Henri that I "did not seem to grow older like the rest of us." They have more wrinkles outside than I but I think that I have interior crowsfeet. Henri left after hash to go to the school. Mrs. H. went home, Dolly to the S.P. Branch meeting, where she is still organizer, and Dr. Southern and I talked for an hour or more of Mexico. A revolution is going on with scant success I fear. Southern is rather prejudiced by his acquaintance with Mexico and Americans who are there interested (and justly hated), profiting by the work of slaves.

November 26

A letter from Yesell (?) who has charge of the Press Art Department. He says "he will be in N.Y. Monday. Has several people to see and would like me to call at the Breslin." I telegraphed back that I could not be at the Breslin, that I would be in my studio between 10 and 2.

480

I guess that will hold him where he should be. Mr. Yeats called. He said that the Thanksgiving Day was a great success. I went on working on the "Girl and Beggar'" etching. First ground turned out too much heated, chipped away, so much trouble will be the result.

November 27

Out to buy the papers and took a little "constitutional" about the neighborhood. The Press puzzles are poorly engraved as has been usual lately. Well, unless the unexpected should happen I will not see them in the old sheet much longer. Mr. Yeats called. I put in the afternoon and evening drawing one–two more and the "job of a lifetime" will be finished. Dolly and I can't help a wee bit of timor-ousness as we look ahead on the prospect of no assured income, but I'm a fatalist in these matters. I feel that always these changes, if not too much forced by me, will turn out to be in the rhythm of exist-ence and will prove to be therefore beyond improvement. A fine dish of spaghetti was Dolly's production for dinner. I ate so very much of it that I am extremely drowsy during the evening. Kent spent the night on the studio couch.

November 28

Today was supposed to be full of events but it fell rather flat. Yevell (?) of the Press, the Art Editor no less, was supposed to be in New York. He did not come to my studio if he was in town. I printed a few trial proofs of the "Girl and Beggar" plate. It will need further work I think. Kent is busy downstairs getting in a stove and doing various jobs of carpentry on his new home. He borrows many things. Kent stayed with us over night.

November 29

I printed a couple of dozen proofs of the "Girl and Beggar" plate and it looks right good to me. Mr. Yeats called in as usual in the afternoon. He last night dreamed of catching a very large fish which is, he believes, with him a sign of good fortune. His interest in clair-voyance, palm reading and fortune telling is very great. When a man of his great intelligence takes stock in this sort of thing it rather makes me feel inclined to give it credence myself. The Kents started in to "keep house" today, the Baby arrived and they had their vegetarian

dinner at home. I left, by request, proofs of some of my woodcut style drawings with Chapin of Scribner's. He told me that the Grolier Society is desirous of getting some illustrations made for a book on New York City. I was printing till late at night, the Kents came up and entertained us with some music.

December 1

Working again on the small "Hock Shop" plate. Mr. Yeats called in the afternoon, Dolly was out shopping. Mr. John Quinn had accepted an invitation to dinner with Mr. Yeats and ourselves tonight and Dolly had proposed to serve a fine spaghetti dinner. Mr. Yeats was the only guest. Possibly Quinn forgot the engagement. We had a very pleasant evening with Mr. Yeats alone. R. Kent is packing, ready to start for Monhegan Island tomorrow morning. He has by my direction and with a few instructions provided himself with material to do some etching while he is away. He "hopes" to be back by Xmas. It seems sad that his young wife and baby must live alone downstairs. "Recruiting" came home from St. Louis Ex. (Buffalo, St. Louis) with a break in corner of frame. I wrote to Halsey C. Ives, told him $5.00 would cover it or that I'd have it mended and send the bill.

December 2

Received a note from Alden March, Sunday Ed. of the N.Y. Times. He says that the Times could not use puzzle sort of thing, but that he has put the proposition of my puzzles up to Mr. Ochs of the Phila. Ledger and will let me know. I would be pleased to have them appear in direct competition with the Press puzzles (if the Press has some one make them in my place). I went to Wanamakers and selected and bought some books for the nieces of Dolly in Los Angeles and the Montgomery children in Phila. On Fifth Ave. in the manufacturing section the noon time rest was enjoyed by the workers on garments under strict Police supervision. Nothing like a group of talkers was allowed. All the throng kept moving by the Policemen, a solid mass for about eight blocks between 16th St. and 24th, like convicts taking their sun and air under guard!! Stuart Davis called at studio. . . .

December 3

Dolly was quite sick with grippe this morning. And I am beginning to feel the premonitory symptoms, so we stayed in bed late. A ring

at the bell by Wm. Mailly who on letting him in told me he had written a story for the "Coming Nation" on Shop Girls at Xmas and that he wanted me to make a couple of pictures for it. So this took up the greater part of my working day. A rich stale beer smell went with a German from Vlag's Wholesale Cooperative who landed me for a $27.00 suit of clothes. Took my measure on the spot....

December 4

While out for the Sunday Press I met up with Mr. Yeats who had been down to the docks and saw young Terry and his wife back from England. He says the chorus girl bride is glad to get back to N.Y. City! His folks probably snubbed her. While talking to Mr. Yeats on 29th St. we recognized Mr. Vissard across the street. He was about entering the old Daly Theatre, side entrance. A rehearsal is on. He has a part in some new production. Came home and started a puzzle which I finished late at night. Working under the disadvantage of the grippe cold which is quite sufficient handicap. After 10 o'clock Henri and Mrs. H. came to see us. Brought back a set of my etchings which had been at Connah's school and were by Connah given to Mr. Tompkins to give to me. I had forgotten them. Henri is quite hot over a big page on "Artists who Marry their Models" in the N.Y. American today. Mrs. H. is in the list with a rather dashing sort of photograph of her!

<div align="right">

FORT WASHINGTON
DEC. 4TH, 1910

</div>

Dear Jack

Your letter with check received yesterday for which I am very much obliged.

You certainly did write a great lecture on socialism. I am sorry to hear that you was defeated but better luck next time.

I suppose Nannie told you I voted the strait ticket, was one of four in F.W.

Nannie says you are going to bring Mr. Yeats with you at Christmas. I would like very much to see him.

I have been keeping very well (for me) this winter so far. I get a slight cold now and then but manage to get rid of it. I wish the cold weather had kept off a few days longer as I had started to fix up my chicken house, more on the modern style, think it will be alright if I can get it finished. Nan won't let me work out in the cold, so it will be some time before I get it done.

Thanking you again for the check. I hope we will see you and Dolly, at Christmas. Give my love to Dolly. Excuse this writing as my hand is not as steady as it used to be. With much love from your

Father

December 5

Today we rose late. Dolly's cold is much better and mine is largely headache or neuralgia today. I printed a number of proofs of my new little Xmas card plate. . . . The first noticeable fall of snow started this afternoon. After a very exceedingly good dish of liver sauté with onions and brown gravy, delicious! we went out for a "constitutional." We went as far as Broadway and 42nd St. The glaring advertising electrical displays are the most noticeable feature of Broadway at night and they struck me as a clear demonstration of the vulgar commercialized age we live in. This electrical lighting of the street might be done for light and beauty instead of clash and clamoring of tradesmen. In response to a suggestion of mine Nan, my sister, has written and invited Mr. Yeats to spend Xmas in Fort Washington, Pa. with us.

December 6

Finished printing enough Xmas plate to serve for our friends. Then started on another plate, at least made the pencil sketch for it. Night, man on roof–woman at window in act of undressing. Mr. Yeats called about 5:30 o'clock. He was pleased to accept Nan's invitation to go down with us Xmas. Mr. Chapin of Scribner's wrote (late today received), asks me to let him have my De Kock proofs to show Mr. Scribner. I suppose in re the Grolier Society book. . . .

December 7

I took up some etchings to Mr. Chapin at Scribner's. He said that the Grolier book matter would be decided in about a week probably. Then to 14th St. where I got four copies of the July Everybody's Magazine with my pirate pictures in it. G. Kirkpatrick came in in the afternoon. He wants a couple more drawings for "War–What For?" in the new edition. A wash drawing which I am to charge $15.00 for instead of the merely nominal $5.00 heretofore. He says he has sold 6000 copies so he surely is making some money. . . .

484

December 8

My pay (in the shape of sub cards) came from the "Coming Nation." I had proposed this instead of money. Halsey C. Ives of St. Louis Art Museum writes that damage to frame of "Recruiting" will be made good, that it came from Buffalo in damaged condition. . . . After dinner I made a start at the last puzzle for the Phila. Press. Got it pencilled in and will finish it tomorrow and end the chapter!

December 9

The Ninth is a lucky day! and while 'tis well known that to start on Friday is unlucky it must be true that to *finish* anything on that day should be very lucky. Well today I mailed my last puzzle to the Phila. Press. Yevell! Requiescat! Scat!! To think that my request for better engraving should have resulted in the ending of the whole matter and that the Press Sunday Jan. 1, 1911 will be about the first Sunday Press to be without drawing of mine for sixteen years! This is probably slightly exaggerated but it comes near being true save for three months in 1898 when I was on N. Y. Herald. Dolly went to the S.P. Branch 1 meeting this evening. I started on the new wash drawing for frontispiece of "War."

December 10

I spent most of the day making the wash drawing for "War." A very poor thing. It seems too bad that I could not turn out some more important sort of drawings for the purpose but for some reason I seem to lack the "steam" necessary to do so. I have had for some time a "lack of steam" feeling, fearing that I am losing my grip on my work. I suppose that the thing will blow out of my system. It makes me feel entirely too humble! . . . Dolly went out shopping and finished up her Xmas buying. She has a beautiful warm fur-lined pair of gloves for me, sort of millionaire's gloves. . . . We had good chops for dinner and I went on with the drawing after.

December 11

The streets are fresh covered with a new layer of snow and being Sunday it has not been much disturbed nor discolored by the turmoil of traffic. I went out and got the papers. During the evening Henris called and we had a very pleasant talk with him. He liked my new

plate "Girl and Beggar" very much and told me that Johnston of the "World" had spoken very enthusiastically of page Pirate picture with verses in Collier's, just out. Stuart Davis had a copy with him this afternoon.

December 12

With Kirkpatrick over me waiting for them I finished the new drawing for "War–What For?" I started a new etched plate after dinner (which we had at a small restaurant on Seventh Ave., a decent "Hungarian" dinner for twenty-five cents). The subject of the plate is one which I have had in mind–night, the roofs back of us–a girl in deshabille at a window and a man on the roof smoking his pipe and taking in the charms while at a window below him his wife is busy hanging out his washed linen. *[Night Windows.]*

December 14

Working on my plate (man on roof looking at girl dressing). Vernon H. Bailey called in the afternoon. He wants me to give him some instructions in etching "on a business basis." I told him I'd give him his first lesson at $3.00 per hour. . . .

December 15

The "Coming Nation" today's issue (dated 17th) contains the Alex. Irvine story for which I made drawings and they look fairly well though they are slightly thinned in engraving. . . . After sunset turned clear and cold so that Dolly and I had a cold but pleasant walk over to the Henris' where we spent the evening talking, the ladies on their own interests, and H. and I on Maratta colors principally. . . .

December 18

Went out to buy the Press as usual and was surprised to find that they had not used my puzzle this week (though they have two left). They have a set of world animals which are *pretty well* done though the pronunciations are rather poor–I suppose I'm prejudiced! Henris came in the evening, after Mr. King and young Seeger the poet. King is enthusiastic over some French 1840 lithographs which he has picked up on Fourth Ave. lately, proofs from a publication called "L'Artiste." A number of Gavarnis among them but no Daumiers.

486

The Henris are going to a play (H. is in the play in a "super" part) given by the MacDowell Club at the Plaza.

December 19

My "pupil" arrived on time at 2 P.M. to take his first etching lesson. V. Bailey has had some talk and demonstrations by Otto H. Bucher a year or more ago, but he was much pleased with my suggestions today though it seems presumptuous on my part to undertake to teach anyone the technique of etching. I am so uncertain myself and at night late I went to bed with much sadness for my "Roof and Windows" plate has turned into a mess of line which will give me much trouble. Mrs. Henri called this evening and has impressed Dolly into service to make her a masquerade costume ("Moyen Age" from my Racine books). Dolly is always ready to do a good turn for anyone but herself.

December 20

Today I walked up to the Times and saw Alden March in regard to the letter from Geo. Ochs of the Ledger, Phil. He advised me to talk the puzzles up to Mr. Ochs when I am in Phila. next week, holidays. To remember that these upstate readers are very much interested, etc. The day started out stormy but cleared up beautifully. Dolly worked steadily all day on Mrs. Henri's dress for the MacDowell club dance tonight. Mrs. Ullman came in and brought me some "Yahoo-das" as we call them, the Jewish cakes which she buys uptown. I worked all afternoon on the "Roof and Windows" plate which is in a pretty bad snarl just now and I have a few hopes left. . . .

December 24, 25, 26

With Mr. Yeats in tow and accompanied as well by W. F. Taylor (Canadian New Yorker and by us made Socialist) we started early for Phila. The weather which started out rainy turned to cloudy. Dolly left the train at Wayne Junction (Phila.) to go about and deliver her Xmas packages. At the time Yeats and Taylor were in the smoking car ahead. The cars became crowded to and beyond the limit at the next city stop. Xmas shoppers in their last plunge "down" town to buy. I was left alone with three bags, two umbrellas, two overcoats and a package, some scattered and all covered by strange Philadelphians. At the Terminal Station, Phila., Taylor came back

after the crowd had detrained itself to get his valise and coat. Mr. Yeats strayed off not knowing that we were in Phila. Asked persons the "next train to Philadelphia" and finally bethought of his handbag, came back and we found him. I scolded him of course, my worry turned at once to indignation! Taylor went on to Washington and after missing one train and having fried oysters (good in Phila. and cheap) we arrived in Fort Washington, Pa., and were welcomed by my sisters Marianna and Bessie. My father is quite sick. The doctor (Conover) told me that he had bronchial pneumonia but that he had it about in check. His anxiety over our visit made him a bit excited. Mr. Yeats made himself at home and we had quite a happy Christmas party. Nan had made me a fine big bathrobe woolly and gray and trimmed with red. Dolly had already given me new furlined gloves. There were handkerchiefs and socks for Mr. Yeats. . . .

December 27

I went to see Mr. Ochs of the Ledger in Phila. today and had an interview with this short stocky Jewish man who owns the famous old newspaper, once the property of G. W. Childs. Hardly was satisfied with his point of view on the puzzles. He is more interested in syndicating them than in buying them to improve his own paper. I talked steadily and I think clearly to him and finally agreed to let him have one to try. But I have since come to the view that it will be better not to go into the thing with a man who is apparently only interested in whether he can make money on the work as done by me. Dolly advises me to quit making them and she thinks I will get more work of an important sort done with them out of mind. . . .

December 29

. . . About noon Mr. Yeats and I went over to see Pancoast on the Ingletown Road. P. keeps but one room in his old stone house warm in winter, deserts the rest of the house. He is pegging away at landscape and Mr. Yeats "liked the delicacy" of some of his sketches very much. He (Pancoast) is on the staff of the North American in afternoon and evenings. Miss Mary Perkins, looking well, with W. F. Taylor (back from Washington, where his sister is head nurse in a hospital) came to lunch. Nan also home and glad to see Mary Perkins. After lunch, Nan away, we (Mr. Yeats and I) to the City, went to the Penna. Academy of Fine Arts but though it was four o'clock it

488

was dusk and no lights were lit, though we peered about with no satisfaction till four-thirty, still no lights lit. Poor P.A.F.A., thousands for prizes and scholarships in the Art Schools but not enough money to light their galleries! We strolled about the neighborhood, Arch St., Logan Square, Race St., all mucky with mud but despite my decrying Mr. Yeats likes Philadelphia and I confess that the "centre" of the town is all right, but it's a very small centre indeed and I hate the miles and miles of dingy small "homes," its boast! We dined at Nell Sloan's. Dolly met us there, and Mrs. Blackwell with her Cooks tourist knowledge of Europe amused Mr. Yeats I'm sure. She has taught school all her life nearly and has much information of facts and a memory. She's bright indeed and must be over seventy years. Mr. Yeats stayed at Uncle Al's the night. Dolly and I went back to Fort Washington.

December 30

A *little Black Friday* for me, this. Last night Uncle Al Sloan spoke of an embezzlement of one Robin in N.Y. involving a bank with a name "Bank of Northern N.Y." as the Philadelphia papers had it. We were scared a while as my bank in N.Y. is the "Northern Bank of N.Y.," but we felt that the name was different. But today just as we were leaving Philadelphia (Dolly excepted) we saw a paper, a N.Y. paper, and it *is* my bank, and it has closed indefinitely, etc. So the trouble which we had thought escaped us we had sure enough to face! Mr. Yeats and I came back to N.Y., the day cleared and such a beautiful ride on the Reading (New Jersey Central), beautiful hills near Bound Brook, warm slanting light, blue distances. Dolly stayed in Phila. to have her teeth attended to, and we had found out our loss just a moment before we said good bye to her. I hope she won't worry over it as much as I am doing–which is foolish of me. One regrettable thing about the bank failure is that Dolly as Organizer (pro tem) put $400.00 of the S.P. Branch One money there just a few days before it busted!

December 31

Rose late (about ten o'clock) awakened by an express man with the box which I had packed with our Xmas gifts received in Fort Washington. I went out as soon as I had fed myself (but poorly) to the Savings Bank where I drew out $100.00. I then took a walk to look over the city. I found that it still pleased me; it has a happy look, the

people have a happy air. Maybe it's the "foreign" element. Rollin Kirby hailed me on the street. I walked with him to his bank where he transacted business. Then we together went to the café in "165" basement. He mentioned a visit he had had from the Potts. Said P. was thinking of going to Los Angeles. I said it might not suit a conservative like P. as it was likely soon to be either a Socialist or Union Labor city. He responded there have been a number of explosions there lately referring to the absolutely unproved charge made against the unions in the blowing up of the Los Angeles "Times." I said this, and also asked him if he did not know that had there been a strike on, Union Labor would have been blamed for the recent N.Y. Central Power House explosion. He said he didn't want to talk of these matters, they bored him, that I constantly brought the Socialist idea into my talk, that I had "lost my sense of humor," and though I was really very good tempered about it, he forced such a personal element into the talk that when he finally said we must end friendship I emphatically agreed. So he left and I without regret, have a "friend" the less to end the year. Kent asked me to dinner. Vegetarian, with Golz and his brother Walter Golz who is a splendid pianist and an interesting looking young man. I passed the evening with them in Kent's room on the floor below us. Lonely without Dolly. I smoked one pipe today, but did not enjoy it so won't start smoking.

1911

January 1 (Sunday)

Alone, which means my house in disorder, for I don't keep things tidy when Dolly is away. Before noon I walked out for the papers. The Press has not yet used the last two puzzles which I made for them. The drawings are now made by Weed who signs them today. The drawing is good enough but the puzzle's pronunciation is right bad in cases. Mr. Yeats called while I was out but dropped in on Kent below. He came up after I had returned, bringing me the book "Green Helmet," Willie Yeats' last book of verse. . . .

I went to dine at Petitpas'. There was an all night New Year party there last night. Mr. Yeats, King and Brooks were there. King has recently talked with Ellen Terry. . . . King and Brooks and I away leaving Mr. Yeats very cross at our going "so. soon." As Brooks says, "Mr. Yeats can't see why anyone should wish to go from Petitpas' after dinner." King and Brooks stopped at my place to get a book which K. had left. We went into Kent's on his insisting that we join his New Year party. Henri was there, Mrs. H., the Roberts and Mr. and Mrs. Coburn (the Coburn Players), the Dressers, the Bellows, the two Golz's. On their request I took the Coburns upstairs and in my studio showed them the picture I made this summer of their outdoor performance on the campus of Columbia University. They were evidently very much pleased with it. He is a nice big fellow and she seems very charming. After the party broke up at Kent's, Henris came up and sat an hour with me.

January 2

A foggy, rainy gloomy day which reflects itself perfectly in my state of mind. I have done nothing since my return from Phila. A kind of glum loneliness has settled down on me and the fog with the distant wailing of the fog whistles on the North River has to me no touch of cheer. Dolly is still away in Phila. I had a short post card note from her written Saturday. I think she is suffering with the operations of Dr. Beale the dentist.

Mrs. Henri called in to invite me and Dolly if she comes home to take dinner with them tonight. I was glad to accept and after read-

493

ing and sluggishly dozing all afternoon I went over to 10 Gramercy Park. Henri was glad of my company and seemed a bit put out when Haggin and Davey phoned that they would come in later. They came. Davey is a character out of interest, Haggin is money spoilt and double chinned. He thinks of going to Tangiers next month to paint the sun and the people. It doesn't sound good to me. They went about 11:15 and Mrs. H. to bed. Henri and I sat up talking and experimenting with the Maratta pigments till nearly 2 A.M. when I came home and to a lonely bed.

January 3

A registered letter from "Appeal to Reason" with two manuscripts to illlustrate for the "Coming Nation." Mr. Simons writes that $25.00 is about all he can pay for pictures. It is very small pay. I hope that he is squarely truthful as to the financial ability. A letter from Dolly which says she will come home on a 2 o'clock train–I suppose today though the letter is headed Sunday and was mailed yesterday evening. The weather is quite worth remarking, worse today than yesterday– rain and mist. I met Dolly at the ferry and we came home–not very happy through the rain and mist. She has had a hard siege with the dentist and I have been in a kind of home-made Hell during her absence. She cooked ham and spinach for dinner. The ham is a present from our butcher Mr. Bisland.

January 4

Wrote C. B. King Sunday Ed. "The Press" calling attention to the fact that they still have on hand two puzzles of mine (sent by registered mail), one "Words and Parting," the other "Names for Winter Weather," as I shall bill these puzzles to the Press in my final settlement with them. . . .

A collection of paintings from J. H. Converse of Phila. estate, at American Art Galleries. I went up to see them. A mixed lot, some by famous names but only about two good ones. A W. Homer, old picture about 1867, two men playing duet on violin and cello; the other a small Corot, a big crucifix on the shore of a river, a grove of trees, two figures on the ground–very good indeed. Another Corot very poor, larger. . . . Dolly cooked a good mess of spaghetti for din-

494

ner which we enjoyed. After dinner I started on my drawing for the "Coming Nation" story.

January 7

Leaving paintings in the hall and framed prints with Kents below to go to Columbus today we started with Mr. Yeats for Scarsdale where we arrived about eleven o'clock and were welcomed by Mrs. Russell. The children have been sick much this winter but Billy is greatly improved in the nervous management of his muscles.

After lunch Mrs. R., Dolly, Mr. Yeats and I took a walk of about three miles. The country is gray and orange—with some traces of snow in the creases. We saw an owl in a tree not far from the turnpike. I hooted and he scooted. Some of the hillsides were covered with dried grasses, tall and soft turning over the ground, looking much as a dog's coat would to a flea therein travelling.

Phil. Russell came home about five o'clock. Miss Alice Wing, his partner's sister, with him. They were glad to see us and we had cocktails before dinner in which Mr. Yeats delights. They break the conversational ice. The evening was spent in talk. Phil. Russell telling me that my bank would probably be able to pay in full to depositors. . . .

January 8

. . . After dinner and some entertaining talk Mr. Yeats read the "Green Helmet" out loud. This is W. B. Yeats' last play and it was a beautiful thing to see how old John B. Yeats the father filled up with proud tears as he brought it to a finish—his voice fairly crooned the words. He is proud of this son, Ireland's son, and proud of this particular poem.

January 9

We came down late to breakfast. Mrs. Russell and Mr. Yeats sat at table with us and after talking in the library with the morning sun streaming in the East bay window, we took coach and caught the 10:50 train to New York—ending a very pleasant visit. As Mr. Yeats says, the host and hostess are the key to good hospitality. . . .

January 10

A Pirate story arrived from Everybody's, by the same Ralph Bergen-gren, so my days till the end of the month must be full of pirates. This is quite pleasing in the absence of the puzzle income. I have an answer today to my letter to Mrs. King of the Sunday Press. She handed my letter to Mr. Townsend. Says she cannot express our opinion of the Art Editor in a letter. I agree with her delicately expressed interpretation. I walked to 54th St. and delivered "Memory" group etching to A.P. & S. Co. to be sent to Columbus. This makes 13 framed prints (10 N.Y. City set, 1 "Girl and Beggar," 1 litho "Twenty-seventh St.," and "Memory"). Nan writes that Dad is better but not yet himself. She asks me to send "Storm Wind" to Rome exhibition. This is H. S. Morris, "Commissioner General of the U.S. of America to the International Exposition of Art and History at Rome 1911" *[who was making the collection of American art for exhibition in Italy]*.

R. Kent and Mrs. Kent went to musical evening at Carnegie Hall. To Dolly's indignation they asked us to take the responsibility of the baby! I agreed but afterward felt that it was rather cheeky in him to ask it. "Just to open door and get it in the case of fire"!!

January 12

Got in a good day's work today on the Collier Pirate story. I wrote to the Auditors Dept., the Press Phila. to inform them that my check in payment for November puzzles had not been received. Mrs. W. Mailly called to ask me to illustrate a story of Mailly's for "Coming Nation." Told her I could not do it for at least five days–price to him to be $5.00 per drawing.

After dinner R. Kent came up and sat a while, while we finished our salad. He is quite anxious that we should have another exhibition. I told him that I was in a state of Grouch about the whole exhibition game and did not feel disposed to go in to get up another show though I'd go in one if it came along. Kent is not in such high spirits as is usual with him. He went downstairs and in a few minutes the notes of his flute oozed through my floor. He is learning to play. It may seem a long time to him, this student period, but I find it long

496

myself. He is out working in Ewing and Chappel's office at Architectural drawing during the days.

January 13

... I took a walk before dinner. It has been misty and rainy all day and the streets were beautiful in gold lights and blue distances. I walked down as far as 11th St. and noticed that the apartment I was looking at has been taken. Of course I'm much too hard put for money, now that the Press Puzzles are no more, to go to such an expense, but it was a fine place! Press check for Nov. Puzzles arrived, $100.00. Now in a few days I can begin operations to secure payment for the four puzzles sent for Dec.... Kent asked us to take the responsibility of the baby (downstairs) while they went out. Dolly had courage to say no and with her example I chimed in. The Kents stayed in!

January 14

... After dinner—ham and spinach—we dressed and went to Henri's. Glackens and Mrs., Preston and Mrs. (who is looking thinner than when I saw last nearly a year ago I think), C. Fitzgerald who is looking much better, he has gone to Ireland and returned since I last saw him. Johnston the editor of the Sunday World and his wife.... She is rather thin and dark with pale skin. George Luks arrived alone with a "Jag" on. He was funny to start with but as he drank more he became tiresome. Mrs. Luks telephoned but did not come down. The Roberts, he first—she came later. My old, old but well detested beast of a friend Wikefrund was there to spoil my evening. Had not seen him for some time. *[Wikefrund was Sloan's anagram for "wife drunk."]*

January 15

This is the day after the "party." What a stupid affair it was. A crowd of supposedly intelligent people sitting about listening and giggling at the maunderings of a drunken fool whose whole idea seems to be to lay claim in some remote way to Irish ancestors. Of course he is German, Luks, every bit of him, every bit of his "cleverness" is pure Saxon. He blurts about "Bill Yeats" and Synge—all because the highly sensitive and vindictive James Gregg and also, to

497

a less extent, C. Fitzgerald are so full of adulation for the great G. Luks. I still think him amusing, sober, but I'm ashamed to think that I hadn't the courage to leave that beastly boredom of booze. It would have been difficult to get Dolly away especially after Mary Fanton Roberts arrived!! Luks is of course far above the average painter of today—but he puts himself on such a pinnacle that, when he ceases to be picturesque, he's porcine. His strongly implied criticism of Henri's work is scrofulously offensive to me. All this is my opinion with no lessening of my respect for "The Wrestlers" and certain other of his pictures which are very great works of art. The day passed with such thought seething in me—this Katzenjammer in spite of the fact that I had but one small drink during the whole of last night's entertainment, but I had practically no sleep on the studio couch. No work. A blue day. Dolly cooked dinner.

January 16

The fact that we refused to take the responsibility of the Kent baby last Friday evening has proved to be too much for them. To be sure we had housed R. Kent for a dozen nights—given him a dozen meals—had the baby and Mrs. Kent for a whole week with the baby wash hung out all over the front rooms all day, lived entirely on vegetables during that time though of course there were plenty cooked, loaned them tools, chairs, dishes, tea and god knows what—but, we could not take the small job of just remembering the baby while they went to a concert! So, today when Dolly passed the namby pamby willowy green and oh so childish Mrs. Kent on the street she put her Berkshire bred nose in the air and then snubs her—I had noticed that Kent had not borrowed anything for two days past so was not much surprised to hear of this dreadful rebuff. Oh well, I suppose we can live through it. I don't think I set much store by friends at any rate. ... We had a good dish of lentils, rice, onions and string beans for dinner. I eat about as much as an animal at the zoo, a large full grown animal.

January 18

In the afternoon Dolly and I, through the kindness of Mrs. Roberts, went to hear the great French tenor Edmond Clement in song re-

cital at Carnegie Hall. I enjoyed it much more than I had expected. What an exceptional human this is, probably not more than one in a million has such a voice but no! probably if more opportunity were given, more encouragement for art, there would be several such voices arise in a thousand, when the whole life of the people is not given over to finding food and shelter and a grave to fall into. . . .

January 19

"Cleaned up and signed" the Collier Pirate drawing "Delilah" and took them down where Casey approved them. Mr. Lee is in Europe and everyone seems happier. Joe Laub had a bad fall on his "farm" in Jersey a week ago. A ladder slipped and he dropped about fifteen feet. He don't look at all well. . . .

January 20

Dolly and I went to a German restaurant on Broadway and 13th St. A right good dinner at a small figure but extra for beer. We walked afterward till time to go to the Branch meeting on 22nd St. where I left Dolly and came home and read.

January 21

I started the day (late) by writing a letter to the Evening Sun in re this editorial of last night on the Japanese Anarchists (so called). A score or more Jap. radical thinkers have been secretly tried and found guilty of treason! (Socialists and advocates of liberty.) The sentence has been commuted in the case of more than half of them. The Sun editorial is possibly written by James Gregg–sounds like him, so prim and peremptory. I thanked the Sun for reminding news readers that they had perhaps lost sight of the sacrilege involved in the crime in the mass of news reports of the details of the trial (not a thing appeared as the trial was secret). They probably won't print the letter.

I received a surprising slap from Collier's. Casey writes that he put through a voucher for $200.00 for my drawings (I asked $225.00 same as last story "Animal Tamers") and that if this is incorrect I am to take it up with Mr. Lee on his return. I am right well cast down by this, for they have me on the hip. If I object my work is not sufficiently in their high esteem to prevent their cutting it out

entirely. I can hardly afford to quarrel with them. I have no hold anywhere sufficient to make my work missed on its nonappearance. Dolly went up to the Henri School with E. W. Davis and Mrs. D. Stuart did a "stunt" at the "vaudeville show" tonight. A dance followed. Dolly came home before this. Stuart bunked in the studio. He said he came home about 3 A.M. Police made him show the interior of his satchel!!

January 22

I made unavailing and weak attempts to go on with the first Everybody's Pirate story illustration. Hadn't enough spirit to really do any work. F. H. Dewey called in the afternoon and he took the trouble to come all the way around later to give me a puzzle prize page in the American which he thought might be useful to me.

The Henris came to dinner. Dolly roasted standing ribs of beef very successfully and H. enjoyed his dinner very much indeed. After dinner King and Sneddon called and Dolly told Mr. King of her new scheme to have a lecture for him at the W. T. Union League (Women's Trade Union, not Temperance). King was not very hopeful but Dolly still thinks it can be successfully "pulled off." Mr. and Mrs. Roberts came in later so that we had quite a party. I don't care for parties especially as I'm "low in my mind" about my work, etc. Henri had opportunity at dinner to tell me of the fact that a Committee of Censors had decided that certain pictures sent to Columbus were not proper for public exhibition!!! Davies, Bellows' prize fight, my etchings! and a landscape with nudes of Kent's! These are to be hung privately in a separate room. Think of the vulgar indecency of ignorance!

January 23

I went to Collier's, saw Casey and had the price matter for the Pirate picture settled $225.00. Walked out with Casey, Joe Laub and Hare the photographer, who were going to lunch. We had a cocktail together then I came home, stopping to look at an apartment on 21st St. $46.00 but so small compared to this old garret (at 165 W. 23) that I can't but feel that it's better to stay here while we can. Of

course, I suppose we will have to go before very long as the big twelve story buildings are coming up around us. . . . D. G. Phillips, writer, was shot by a man Goldsboro who because he was boarding at the Rand School and was identified by Algernon Lee has been called by the Evening Sun in big three column headlines a *"Socialist* Crank." It is a fact that he is not a Socialist and is a violinist and from Washington. The way the papers jump at the least chance to hang villainy on Socialists. . . .

January 24

I read a criticism of an exhibition of "The Pastellists" at the Folsom Galleries writen by Comrade André Tridon, a Frenchman, who writes silly stuff for the "Call." He says that the "Anglo Saxon" temper is not delicate enough for pastels, says that the Glackens are "brutal." I went out and saw the pictures and met there Jerome Myers. The pictures are bad and good mixed—the ones Tridon likes are bad of course. Glackens are very good especially two of them. I met young Mr. Folsom and a middle aged salesman who in the one case don't know and the latter much worse off! Jerome and I went to the Madison Gallery and saw a collection of Bellows' pictures. Vigorous, brilliant but not really great *but* so much better than most work done that they must be admired. I left Jerome at 42nd St. and walked back, stopping at Macbeth's where I saw a very pretty comedy, Mr. M. showing paintings to a prospective buyer. I told Henry and MacIntyre the clerks that I should perhaps make a picture of the scene. . . . Mr. Yeats came later and he and Dolly talked over her scheme to have a lecture by him at the Women's Trade Union Hall. . . .

January 25

Davis had asked me to lunch with him yesterday but I had forgotten it so today I phoned him and luckily he had also forgot yesterday, so I went down to the "Globe" office where I found him in charge of a section of the advertising department. He saith unto one man go and he goeth and to another do this and he doeth it. And he likes to talk of the old times when we were together first on the Phila. Inquirer, then on the Press. He took me out to "Whytes" and we

had a substantial lunch which cost over much money and I saw brokers and money seekers and money getters dining or lunching. I walked back home along the West side. Dolly had a tasty and light dish of oysters à la poullet for dinner because I forsooth was not very hungry. Immediately after dinner Fernandez called and sat till about 8:30. He is a dark skinned young man of Harvard education. He has East Indian blood I believe. Makes statements in a positive way though not unpleasantly so I don't take him up though I differ with him a good deal.

January 27

. . . I had a call from Guy Pène du Bois of the American. He is looking for pictures to illustrate a story on the Columbus exhibition which is now on. It has leaked through Bellows that certain of the pictures are not to be hung in the exhibition on account of their immorality! as I heard from Henri Sunday. H. made a stand that he would not lecture in Columbus as agreed unless *the Davies* were replaced. (In a way this makes the vulgar judgment on the rest of us justifiable.) I loaned du Bois a proof of "Connoisseurs" as one of the set which was suppressed. . . .

January 29

We were quite alone all day. Henri is out in the West talking in Columbus and Toledo, Ohio. Kents are still below us but I have not even seen him since the evening when I refused the care of the baby "in case of fire"!

January 30

I went to Everybody's Magazine in the Butterick Building. There saw Mr. Jacobson . . . a young blond man. Ray Brown is still head of all the Art Dept. of all the Butterick publications. In the afternoon I had a visit from two gentllemen, one an artist and elderly man. I forget the name. Another younger not an artist, named Arnold. They want a picture for an exhibition at the City Club. They liked "Nursemaids, Madison Square." I told them that I insisted on good hanging. Dolly went up town to Mrs. Dunbar's to tea and S.P. business. I took up again the "Man on Roof" (looking at girl dressing) plate

and worked on it till quite late. The "American" this morning has du Bois story about the Immoral Pictures excluded from the exhibition in Columbus.

February 1

H. W. Kent of the Metropolitan Museum (Asst. Sec.) writes that he will call to see me at a time for me to arrange. This is, I suppose, in relation to the book for which Mr. Chapin of Scribner's has had me submit some specimens of my work. It is to be brought out by Grolier Club and Mr. Kent is to have charge of it. . . . I went out and took a walk as far as 42nd St. and back by 8th Ave. and through the new Penna. Terminal Building which is certainly a marvel. I am not sure that I like the idea of maps as mural decoration but I am sure that the blue of the maps is bad color. This is in the big main hall. . . . I started on a new plate, made a sketch during the evening. The "Picture Buycr" at Macbeth's, thing I saw last week. . . .

February 2

In the neighborhood on 23rd St. ordering some letters printed for Dolly's Branch 1 business I stopped in to see Harbison at the book store. Saw several books I'd like to have but refrained as I can't feel so prosperous without the steady puzzle income. This will wear off in time I suppose. . . . Mr. Yeats called and Dolly asked him to stay to dinner as we expected Arthur Young the cartoonist of "Life" and "Puck" (a Socialist). Mr. Yeats refused and then after leaving returned and decided to stay to dinner. So we had a very pleasant evening. Perhaps we talked a bit too much on the thing nearest our hearts, Socialism, to amuse Mr. Yeats. Still he endured it very well. He is not very happy, his funds are so low—nil in fact.

February 3

W. Mailly sent his Mss. story in to me again, but I wrote telling him that I did not want to do work except on order from the Coming Nation as it would be thrusting my work on them. After dinner Mr. Yeats came in a great hurry and excitement. Quinn wanted him and me to come to meet him at the Belmont then go to see the sale of Felix Ismans pictures at Mendelsohn Hall. We were off in a rush to

get to Belmont at 8:15 but Mr. Quinn was fifteen minutes late. We watched him eat some oysters, his "first solid food" the day, he is on a diet. Then by taxi to M. Hall where we saw many poor pictures by famous names sold. Three decorative panels by Millet were curious Summer and Winter, Daphnis and Chloë–but not very good. A Hobbema was also curious and good too. The twenty-five paintings brought about $50,000.00 and one fourth what Isman probably paid. By taxi to Mr. Quinn's home after stopping at Shanley's where he had chops and Mr. Yeats and J Irish whiskey. . . .

"I can't paint to suit myself. How then can others paint to suit me." In criticism of a picture by a French Impressionist which Quinn bought lately for about $1200.00! Mr. Quinn has a portrait by Augustus John which is a good crude strong thing it seems to me. Perhaps it misses some of the nobleness of Q.'s head. Mr. Yeats says so. Q. also has a Chas. Shannon, an actress in Spanish dress in part of Donna Anna in "Superman" Shaw's play. Interesting but not great– $2000.00! Just got it. Mr. Yeats and I stepped out of this house of riches, or rather apartment, crowded with pictures and books–into a slushy wet night and home we rode in a street car, but there was a row of interesting faces opposite and a wife at home for me!

February 4

Started a picture! It makes me feel glad to be able to write the words. I got at it this afternoon, while Dolly was at the theatre with Mr. Yeats seeing the "Scarecrow" a play (which is to fail) by Percy MacKaye. I worked on a theme I have had in mind for a couple of years. Children playing around Jefferson Market Police Court Building.

At five o'clock Mr. W. H. Kent called and talked to me of the plan of the Grolier Society to make a book Essay on old New York by H. W. Mabie and to be illustrated in the style of T. Bewick. He wants my price on six drawings. I am to write him estimate. When Dolly came home she and I went down to a little Italian restaurant on Bleecker St. where we enjoyed "Ravioli" and in addition I had some Tripe à Parmigiani or some such title, very good. We had two small bottles of wine and cheese afterward. The lot cost 75 cents. We must go again. (519 Bleecker St.) The Henris came in the evening late, after dining at Petitpas'. H. seemed to have a chip on his shoulder

about *Columbus "Immoral" incident*. He flew up at Dolly who he said made him definitely say that my prints were not restored to the show. Then he said that if she were as ready to fight for Sloan's work and was as faithful as he she would be all right. This seemed unreasonable remark as he was angry at her for doing just that thing—fighting for my work with him.

February 5

I painted during the afternoon on the "Evening Jefferson Market" picture. Mr. Yeats called about four o'clock and read a letter from Lily Yeats in which she described a remarkable dream. A white rose and a flame. The brown young East Indian Fernandez also dropped in to see us. He had Reg. Kauffman's book "House of Bondage" with him and was sorry we had read it, etc. I finished with the day's work and with Fernandez walked down to look at my subject (the Jefferson Market prison), then home to dinner with Dolly. As we were finishing R. Kent came upstairs!! He has the promise of a room for an exhibition 33rd St. near Fifth Ave, Architects Beaux Arts Society. He has friends in this society. We are going to get a number of men to agree not to send to the N.A.D. during this year 1911, signed agreement. We wrote a letter to Davies at once, he is in Italy. Kent saw Henri today who flew into a rage at the suggestion!! What the dickens does that mean? The names we intend to ask so far thought of are: Kent, Sloan, Henri, Davies, Luks, Boss, McPherson, Du Bois, Coleman, Prendergast, Shinn, Golz, Myers, Stafford, Mrs. Preston, J. Preston, *Redfield!!* Glackens, and Lawson.

February 6

Kent tells me that he did not send the letter to Davies as Macbeth told him that Davies is on his way home.

February 7

Went to lunch with R. Kent and his bosses Ewing and Chappel. After which Ewing, Kent and I went to 33rd St. to look at the proposed exhibition room. A fine big room, looks as though it would need no additional lighting. A carpenter there said that a picture rail could be put up for $13.00. In the evening Dolly and I went to Henri's, Bellows was there. I talked to H. of the Kent scheme,

asked why he didn't favor it. H. was really angry about it. It appears that Kent saw H. and used the expressions *"force these men"* Glackens (Lawson, Bellows) to *"come out and not show* their pictures at the Academy." H. says that Kent said that he and the rest of us (meaning the "Eight") had not got anywhere in our "fight." I felt after a long argument with Henri that he was most nearly right in his attitude. Henri is right in saying that we have never put the "screws on" anyone in our exhibitions. I came away quite undecided with a bias in favor of H.'s position.

February 9

Had a nice friendly letter from Reginald Wright Kauffman. Made some liquid ground and used it for the first time to protect a ground which before biting showed some symptoms of weakness—the "Picture Buyer" plate. Henri came at noon and in a quiet talk he showed me quite plainly R. Kent's attitude in the no exhibiting at the Academy restriction in the proposed exhibition. He, Kent, said that Glack was practically "down on his knees to the Academy" in sending his pictures there! Old Glack never had any such an idea! He wouldn't take the trouble. . . . Kent admitted that he had tried to see Henri twice in the matter of this proposed exhibition before he saw him and had been turned down—and then he broke his scheme with me—the first glimpse I had seen of him since we balked on taking care of his baby. He needed me! . . .

February 10

Mr. Yeats called in the afternoon with Patrick J. Quinlan. I was busy on some touches on the "Fifth Avenue" picture which went to Newark with "Recruiting" and the "Chinese Restaurant." Quinlan stayed after Yeats had gone. I think Y. should have taken Q. with him as I was busy. I think that Yeats was tired of him. Q. is a very interesting man, Irish with a Capital "We" and a good deal of a scholar too. Well up on Irish literature, general sociology, etc. A Socialist and a hard working one too. But I was distracted by him. Kent called noon and again in the evening. Bellows came in late in afternoon and made some inquiries as to starting to do some etchings. I gave him necessary information and told him to come and get a lesson when he got his tools, etc.

We went to Shinn's party in the evening. A crowd, not too big. We, Glackens, Shinn, Preston and I, did an extempore charade and I enjoyed this part of the evening very much. The small talk with persons I hardly knew was unattractive to me so I located in the "bar" and in due time I had enough high balls to make me pretty well drunk. Wikefrund there. Shinn's Scandinavian servant girls had made a curious lantern of snowballs in the yard, a strange spooky looking thing. It burned all through the night. Home in a messy way at about 2 A.M.

February 11

This was Mr. Fox's first visit (he called before but I was out). He is inclined to like "The Cot" for the Rome Italy Ex., but I think one of my New York street pictures would be more interesting. We dined at invitation of Glackens' at Mouquin's and afterward went to G.'s house where later C. Fitzgerald came also. We had a very nice evening. I always like the smaller gatherings. Last night was one of the most terrible nights in my life!

February 14

A Mr. Rogers who is an expert on typesetting and artistic printing for many years with the Riverside Press, Cambridge, Mass. called on me in the morning. He said that Mr. H. W. Kent had sent him to talk to me about the book for the Grolier Society. This would seem to indicate that there is a chance of my getting the work to do. . . . Miss Isadora Duncan sent tickets to her dance at Carnegie Hall tomorrow afternoon. This will be a great treat for Dolly and me.

February 15

Mr. Yeats called with two tickets for Miss Duncan's dance this afternoon to take Dolly with him but of course we were provided so he went to the "Literary Digest" and invited Mr. King. The great thing of the day and the year was the afternoon. Dolly and I went to see Isadora Duncan. It's hard to set down how much I enjoyed this performance. Isadora as she appears on that big simple stage seems like *all* womanhood–she looms big as the mother of the race. A heavy solid figure, large columnar legs, a solid high belly, breasts not too

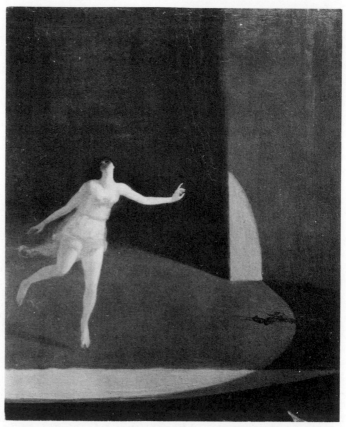

"Isadora Duncan," 1911

full and her head seems to be no more important than it should to give the body the chief place. In one of the dances she was absolutely nude save for a thin gauze drapery hanging from the shoulders. In none was she much clothed, simple filmy coverings usually with a loin cloth.

Dolly went to Crane's in Bayonne for dinner and saw Roma in a little play.

I went from Carnegie Hall walking downtown on Fifth Ave. with Mr. Yeats and King. I went to Petitpas' for dinner. Met a Mr. Paul, an Englishman purser on a W. Indies vessel, brother of a liberal writer named Herbert Paul. Also met Mr. Chapman who is a decorator and picture dealer. Came home early and worked on Coming Nation drawing.

February 16

Soon after breakfast I had a call from Mr. Weitenkampf curator of the Print Collection at the N.Y. Public Library. He asked me if I'd agree to an article on my work in the "Studio." I told him go ahead if he made them pay him for his writing. I don't like the "Studio," it has no taste whatever, too broad and bad to be called "Catholic." He asked for a proof of my unfinished plate of the picture buyer but I refused to give it to the N.Y. Library. Told them I'd wait till they had to buy it. I am making a new drawing of the first illustration for the "Coming Nation" story, pen and ink, and am having a great deal of difficulty. I have such long stops between illustrations that I get out of the swing of the thing. It makes me feel poorly in my mind–and that worries Dolly. She said tonight that she wished I was a brick-layer. I said so too. Then I could etch, paint and draw when I was out of bricklaying work (and not looking for a Job)!!

February 17

I finished the second drawing for the "Coming Nation" story and mailed them registered. Miss Forbes, one of the Branch 1 members, called to see Dolly today in the morning. Miss Sehon came after noon and we had lunch. She treated to a lemon pie which I went out (it was raining) and purchased. She is a bright visitor and I think gives Dolly the needful cheering up which Mr. Yeats thinks that she requires, being inclined to melancholy in his opinion. . . .

February 18

Dolly went in the afternoon to the Rand School to do a lot of circular letter addressing. Shortly after she had gone Miss Roberts phoned and invited us to come as Miss Isadora Duncan's guests to a Box in the New Theatre to see "The Blue Bird" (Maeterlinck). I decided to let work go and take the chance. I dressed in a rush and had to walk Mr. Yeats away, he had just come as I started out. I arrived first of the invited ones. Miss Duncan sat alone in the great luxurious Managerial Box–alone, because she has insisted on being an artist and has not kowtowed and done the social game to suit vulgar American tastes. I reintroduced myself to her and we were soon joined by Roberts

and Mr. Anspacher (who Dolly tells me is Kathryn Kidder's husband). Then Miss Hildegarde Hawthorne arrived and finally Mrs. Roberts. "The Blue Bird" is a piece of sentimentalism for the most part and is put on much too elaborately at the New Theatre. Miss Duncan said that she had seen it in London where there was not much money spent on it–better. After the show Miss Duncan invited us all to tea at her hotel the very grand "Plaza," but I came home to Dolly, avoiding this what I feared difficult piece of "social function" though I'm sure Mrs. Roberts could have put me at ease.

February 21

Back of us a slight fire with lots of smoke. A young greasy fat woman managed to squeeze herself through a very small dangerously small window onto a fire escape, where she stood like a much frightened lump of dough. A brave Jew lad from a 7th Ave. delicatessen shop climbed the ladder to the railed iron platform where she stood. He tried to get her over the rail to nearby fire escape but she was too fat and inert with fear–also she was too big to go through the opening in the platform to the ladder. The smoke poured out of the windows and an older woman was pulled out of the same small window by the Jew lad, who was brave enough. The little window was very high from the floor so that these exits were most difficult. Neighbors passed a long fur coat which the young piggish woman put on. A gray sweater did for the old woman. The selfish terror of the younger was comic. Three firemen came to the windows but evidently told the women to stay on the "escape out of the smoke," the fire being under control. Great difficulty in getting themselves back through the window.

Kent came up at noontime and showed me a letter of invitation which he has got out for his independent show. Dolly and I went to the Globe office and there met Davis and with him to Newark to dinner. Then with Mrs. Davis to the Newark Library where we saw the small but interesting collection of pictures Mr. White has (?) got. My "Fifth Avenue" and "Recruiting" and "Chinese Restaurant" are shown. Stuart Davis has two very interesting things. This mere child is going ahead in great form and not too cleverly. Luks has a street scene, very fine, woman looking at chickens with a child in arms, a chicken under inspection laid upon the baby! as an incident. Glack's "Parade in Washington Square" is good. . . .

February 22

Mr. Yeats, whom we had not seen since Saturday came in today. He had had a dream, something of a bird killed by a cat which he says will prove a bad omen! He has a portrait order from Mr. Quinn but has not started on it yet. I worked all day on the "Picture Buyer" plate till about 8 o'clock after dinner when I went out for a walk in a new fallen layer of snow which fell very rapidly to the thickness of a half inch in less than ten minutes. Dolly during the afternoon had gone to the Rand School and then to tea at the Little Club, where she met Miss Finch and Mr. O'Brien. Miss Finch asked Dolly whether I'd care to teach, she "passed the answer" and I hope I don't have to answer it myself. Mr. Dewey called about noon, we have not seen him for some time. He is very busy on his Standard Dictionary work.

February 24

I stopped in at Collier's to see about my check for last story. Casey told me that Joe Laub has not been there for nearly a month! Was home sick for a few days then taken worse. Mrs. Laub thought it pneumonia but the doctor found him to be badly fixed with Bright's disease and hurried him to the hospital in Nyack where he was more than two weeks. Seems odd that Mrs. L. never let us know word of this. H. Reuterdahl called late in the P.M. He had heard of Kent's exhibition. . . .

February 25

Worked on "Picture Buyer" plate and printed several proofs. Kent Crane, big and with a new changed voice, manhood coming on him, came in the afternoon. A friend of his, a nice clean looking lad who is going to Columbia College came later. They are interested in etchings. Kent seems to feel a tendency toward painting. . . .

February 26

After dinner the Henris came in with the Roberts and later Mr. Yeats arrived with Mr. Quinn and we had a very pleasant evening indeed. (Mr. Quinn had called on Mr. Yeats to bring him around to see us.) He ordered one of each of my new etchings, in fact says that he wants each thing that I do in the way of etching.

February 27

Katharine Sehon invited Dolly to dinner and we had a merry time on two glasses of wine each. Dolly and I are quite used to it but Katharine it made quite lively and we caught it. After dinner Katharine took Dolly to see "Naughty Marietta" a musical comedy at the New York Theatre. I stopped for them at 11 o'clock and Dolly and I saw K. on the car. Then home, walking on 6th Ave.

February 28

We went to Henri's in the evening. There was a small crowd there. . . . Bellows was there, Sneddon, Yeats, who had several highballs and took on my "failing" of argumentativeness. Baylinson and a friend also Semitic and a pretty young bright Jewish school girl also. Sneddon showed me a letter from England. My "Goldfish" *[lithograph]* is to be used in some English magazine and I am to be paid one pound six-pence for the privilege of publishing.

March 2

Called at Scribner's. Chapin gave me the order for six volumes of Gaboriau at $120.00 a volume, four pictures each $720.00. Twenty-four drawings!! Oh Lord, what a job! but 'tis opportune and will keep off the old wolf. Another delightful afternoon. Dolly and I went to Carnegie Hall to see Miss Isadora Duncan dance again. We are splendidly favored! A lower tier box seat and that real ecstatic enjoyment I get from her beautiful work, it's tremendously fine.

After, we went to Petitpas' for our dinner. I "rowed" with F. King on the matter of Miss Duncan's dancing. I hold that she is great, he that she "passes the limitations of the art of dancing." If she does, I still think she is great! Chapman the picture dealer and his wife were there. Sneddon too. Came home late and started to sketch in charcoal on canvas an idea for painting of Isadora. As Dolly and I were leaving home to go to Petitpas' R. Kent was just coming up the stairs to our floor. He started to say something about the exhibition. I told him that I would not go into it if Henri decided to stay out of it. Told him that while I perhaps might give other reasons that this would suffice. He seemed a bit taken aback. After we had returned from dinner quite late about 11 o'clock, Rockwell Kent came up again and told me that he had been to see Davies (I

had told him that H. told me that D. was going to see Kent about the *no exhibiting* at the N. Academy restriction), that Davies said he and Luks and Prendergast would be in the exhibition. But that he (Kent) had decided not to insist on the restriction.

March 3

Mr. Yeats worked on his portrait from a mirror, ordered by Mr. Quinn. I on a small easel worked all day on a start of the Isadora Duncan dance. Got it in good shape and feel that I may get a good thing out of it. Dolly out with sister Margaret shopping. Dinner, a fine steak, at home. Dolly went to organizers' meeting at 84th St. in evening. I read one of the Gaboriau novels and at 11 o'clock went to 3rd Ave. elevated station and met her. We stopped and had some Bock beer, with the "compliments" of the Lenten season.

March 4

Painted all day (several hours). Mr. Yeats did not turn up to go on with his picture of himself. He gave a lecture this afternoon at the National Arts Club, an afternoon with the Gaelic Renaissance.... The morning brought a flurry of short lived snow and by mail arrived a box of beautiful violets from Miss Mary Perkins in S.C. R. Kent who stopped at my door for a few moments told me that he had not heard from Henri in re the invitation to go into exhibition without any "restrictions." He said, "I wrote him a letter and told him to answer at once but don't understand his not answering." He intimated that he had showed the letter or told Davies its contents "and Davies said the letter was just right." This makes me wonder if there wasn't something queer about the letter.

March 5

I painted on the Isadora Duncan canvas and it is going pretty well I think. We had an unexpected visit from Reginald Kauffman and his (third!) wife. She is a well opinioned neat blonde little woman who it seems to me takes too much credit for his work to herself. But then this is a first impression and she was very nice indeed. They are to stay in New York for a week or two and are then going to go to France for a long stay.

Mr. Yeats came in late in the P.M. and Dolly and I went with the Henris to Petitpas' for dinner. We met there Harvey J. O'Higgins,

the writer and his wife. She is clever and I imagine can be keen edged and a good "head." Also met Arthur Stringer, also a writer, poet. I made a "layout" for a poem of his years ago when Shinn was for a short time "Art Ed." of Ainslee's Magazine. Mrs. Stringer is very large and was famous at one time as a model for the "Gibson Girl" (Jobyna Howland). Also Mr. and Mrs. Arthur Brown, he is an artist. Henris came home with us and we had a talk over this darned Kent Ex. The letter from K. to Henri is impudent and H. won't go in the show. It looks much as though Kent had fixed Davies by some diplomatic lying or half facts. I got the letter and will see Davies. At one A.M. I wrote a note to R. Kent declining to go in the Ex. Put it in his mail box as he has gone to bed and I won't be up till late in the A.M.

March 8

Scraped and repainted the "Isadora Duncan" picture and it's much better now. God Bless the Maratta Colors. I can think in these! When I paint a thing I know where I got the pigment I used, I know how I made it. I have some common sense idea of what I'm doing. I resent the fact that I can't go on and paint all the time so as to get ahead with these splendidly organized "tools." Henri told me last night that Maratta is ill and not in good spirits. He says that it is the exception when he finds an artist who is polite enough to listen to his explanation....

March 9

I lay abed till 12:30 noon today. I am in bad condition with a bronchial cough. Dolly ministered to me. Our Benzoinal Inhaler helped the soreness in my throat considerably. In the afternoon I had intended to go for a "constitutional" walk but got busy on my Isadora Duncan picture and put in all the P.M. on it. Mr. Yeats came in about 3:30 or so and painted in a way on his portrait of himself.

After dinner Dolly and I went out on amusement bout and bought at a ticket scalpers on 6th Ave. a pair of tickets for "Alma Where Do You Live?" at Weber's, where we saw a show which has perhaps in the German original been witty but has been emasculated, effeminated and neutered to a condition where it is just stupid. It may have been suggestive once but it's been brought to the end (dead?) level.

514

We went to Mouquin's afterward and had Scotch Highballs. Myers, the Mouquineer, came in and called at our table and remembered the evening long since when he and I had the bellowing contest.

March 10

Again feeling bad with my throat I stayed in bed till after 12 noon, I like the scheme. Breakfast Dolly served on a box with a drawing board across it, a cloth, and she sat by it so I felt perfectly happy though poorly. I decided not to work today though the Duncan picture needs my attention. I went out for a walk and being in Greenwich Village looked at places with an idea of moving perhaps. Saw a top floor for $24.00 (less than half what we pay here at 165 W. 23rd St.) Dolly and I talked it over at dinner and she seems to think favorably of it. I'm putting off the Scribner's work in a shockingly reckless way. I must get at it, but the Duncan picture is on my mind. The Kents went out this evening. . . . We saw them go, with another man and woman. And another K. baby is on the way. . . .

March 13

. . . I went up town for a walk and for a packet of bronze powder and being in the neighborhood I stopped in to see the N.A.D. Ex. on 57th St. It is as usual, dull, pictures painted with that great object in view to make them like some other painter's wares. The Academy therefore does serve a purpose, it shows the predominant mode. J. Myers has a couple of interesting little canvases. And Ben Ali Haggin has a picture in the "Morgue" under artificial light which is very good. A brazen blond in a tight silk skirt of black.

After I came home Bauer the artist whom we met a couple of summers or more ago in Ft. Washington and later summer a year ago at Pancoast's, came in. He is painting on the Palisades. He told of a scheme to buy a canal boat for $200.00 and live in it, moving now and then from place to place and painting. His work is landscape and the plan sounds very attractive! No rent to pay! I wish I had more spirit of adventure. P. J. Quinlan also called and we invited him to stay to dinner. He talked interestingly of the Irish language and history. In the evening I gilded several frames, getting three ready for Pittsburgh jury.

March 14

Made a last grand slam at the Duncan picture and now I like it! It has been a drag and a problem but I think that I have pulled out a good thing. Of course, that's a fresh judgment. It may be qualified in a day or month. The "Chinese Restaurant" and "Clown" went by Budworth today to the Pittsburgh jury. They said they'd call on Thursday for the "Isadora Duncan." . . . My cough still holds on to me and I'm about "tuckered out" at the end of a short day. Collier's sent proofs of the "Delilah" pictures to be colored.

March 15

I colored the proofs for Collier's and in the afternoon took them down. Saw Joe Laub who is back at work after his very serious illness. He is looking pale but says that he is feeling better than he has for a long time before he was taken down with his kidney trouble. When I returned home Dolly told me that a Mr. McGoodwin had called. He represents the Technical Institute for the Carnegie Institute, Pittsburgh. They want an instructor in illustration and "freehand" drawing at a salary "from $1800. to $2500. a year." This sounded as though it would be necessary to consider it! Shinn had suggested my name to him and Chapin of "Scribner's" had also said a good word. We took dinner, Dolly and I, at Petitpas' where a noisy argument arose on the present movement of the U.S. troops towards the Mexican border, as I take it, to interfere with the Mexican Revolution. Does not suit the Money Kings. Vizzard took the conservative view, also Chapman. I went to the Hotel Algonquin after and saw McGoodwin and talked the Pittsburgh affair over with him. He says he will write to me later. He merely is inquiring for the Director of the Institute.

March 16

Varnished the Duncan picture and it seems still O.K. to me. Mr. Yeats called. He is worried with his illustrations for Harper's article.

March 17

"Isadora Duncan" picture was carted away by Budworth's this morning, taken from under my brush. I had done some work on a spot before breakfast. As soon as breakfast and morning work was dis-

posed of and her case packed Dolly went to Philadelphia to see Dr. Bower. She has had some symptoms of her old trouble. I took her to the Reading (N.J.C.) ferry. The Penna. ferry houses are deserted and as they got most of the Phila. traffic it has made things very quiet comparatively. Took out the Scrubwomen canvas and did a bit of work on it. Then went to the Henri School. Met him and we together to Watrous studio in the old Sherwood Building. Here came Fitzgerald, Glack, Luks, Lawson and Preston. We decided to have about fifteen men represented at this small show in the Union League Club. Henri, Fitz, Glack and Davies to be on a committee to select pictures in a few cases. The rest to go on judgment of painters themselves when invited. Henri and I came home to his studio, 10 Gramercy Pk., and Mrs. Henri cooked dinner. I ate too much, touch of indigestion. H. and I passed the evening with Maratta paint experiments.

March 18

Card of invitation to private view of "An Independent Exhibition" arrived in mail box in morning. R. Kent, Davies, Prendergast, Maurer, Hartley, Coleman, Boss, DuBois, Marin, McPherson, Golz, and Luks is the list of names. Opens 24th. . . . I painted on the "Scrubwomen" a couple of hours. Went out and took a walk and had my dinner at a Chinese restaurant. Dolly writes from Phila. that Dr. Bowers says there is nothing serious the matter with her and that a few treatments will fix it up, so that she can come back to me right soon. I seem to lack ambition to get at my drawings for Scribner but hope that tomorrow will find me in the "mood." Henri has had another letter from R. Kent. "You may perhaps remember that some years ago I gave you a painting and on it a frame" etc., most distant and formal. Poor Rockwell Kent! Little man with IDEALS. . . .

March 19

During the morning while I lay abed the sun shone bright and the day was beautiful so the newsdealer at the corner told me. But the afternoon! of all the dreadful chill rains this was the dampest. I just sat about feeling a perfectly harmonious blue. Wrote a letter to my girl in Philadelphia and went to Petitpas' for dinner where at the long table with Mr. Yeats, Sneddon, the Henris, her sister [Violet], and young Davey. Things seemed brighter afterward. Henris came to

my place and we sat H. and I till 12 o'clock and he cheered me much. Got me to get out some pictures "W. S. Walsh" "Mrs. R." and others and when he left, waking Mrs. Henri up (who had dozed all along on the sofa), I felt much more myself. Or is it me? Is the gloomy one me? I dunno. I'm not old surely, not quite forty years, I must get up more steam and do something.

March 20

Another job for the "Coming Nation" to be done by April 6th! And a small check which settles their account with me for past work. I painted some on the Public Library picture (with Scrubwomen). Stuart Davis called. Asked about where to find a studio—also about Anshutz summer school at Fort Washington. Said also that he had quit at the Henri School day class. Life is getting too small (the men's class). He's going to take a studio. E. W. Davis and he are going to live in the city and Mrs. D. goes to Atlantic City. Took Nan's pictures to Berlin's to be packed and shipped to her. Dolly writes a note to tell me that she will be back tomorrow. This is good news! Van Wyck Brooks sent a pamphlet which he has published out in California on The Soul—an essay, etc. I read it. It is quite beautiful in places. I can't say that I'm able to digest this sort though.... Decided on places to illustrate in the first of the Gaboriau books for Scribner's.

March 21

At five in the afternoon Dolly came home. She had a hard siege of it with the Doctor (Bower) in Phila. Several treatments, mechanical, and extremely painful, but he says she'll be all right now (for a while). Fussed with the Library picture to no good purpose, spoilt one of the heads. After Dolly and I came home we set out for Petitpas' for dinner. There was quite a large crowd at "Mr. Yeats' Table." Miss Goth who danced in the yard at Cammalucci's a couple of years since was there. She is a very talented girl and was splendidly dressed. This made as Mr. Yeats said a great difference. She met Anatole France in Paris, spoke of his wit and polite irony and satire, etc....

March 22

Taking medicine today making myself feel worse in order to feel better later. Mr. Yeats came in and said that last night he had told

518

Henri his work was getting too empty, I got "on my ear" and told him that it was not the thing to say at an evening at home to one's host. I don't think that some of Henri's critics are able to see the whole of his work. He don't mind taking a new step, burning bridges behind him at it were, and studying instead of fossilizing. . . .

March 23

Mr. Yeats came in with a note to him from Mr. Quinn asking him Yeats and me to go to the Manet exhibition at Durand-Ruel's and give our opinion of a picture "L'Amazone" which hangs with ten others. We went, taking Dolly along and I was glad that I had not missed the show. A "Café" picture larger than the "Amazone" was better I think, and a very small sketch of a full length woman is a little intimate gem. I wrote Mr. Quinn that I thought it would be better to buy Manet in Paris where he'd probably find more to select from but that Café, Amazone, small sketch and Bullfight were all good.

I worked on my first Scribner drawing today and now feel that I have a start. . . .

The Evening Sun tonight has a letter signed F. J. G. These are Gregg's initials and I fancy it is intended to be the first shot in the Kent Independent Exhibition "fight." *Gregg quite surely* would *not allow* George Luks to show in our big Independent Show last year. This year Luks is in the Kent exhibition!! Henri, Glack, Lawson, Shinn and myself are not showing. Gregg has a chip on his shoulder and an Evening Sun vitriolic pen. I hope no one notices the letter to answer it. . . .

March 24

Working on the first Gaboriau drawing for Scribner's today. I have a start at last. In the afternoon Dolly and I took a walk and in conformity with my habit we looked at an apartment on W. 20th St. opposite the Seminary between 9th and 10th Aves. Cheap enough and clean enough with steam heat but dark. The clock in the chapel in the Theological Seminary opposite struck while we were there and we saw a funny sight, the students hurrying to chapel putting on their long black gowns as they ran along the paths, very human students of divinity. I had a letter from Mr. McGoodwin of the Carnegie Tech. School or Carnegie Institute. He says that the director won't

make a final decision for some weeks, meanwhile I am to write, give my lowest terms and send samples of my illustration. I suppose it would be a good position if I take it, if I'm offered it! but–...

March 25

I finished the first Scribner drawing today.... After dinner, a spaghetti vegetable "hash" and very good, Dolly went to Miss Jessica Finch's on 77th St. to attend a meeting to talk over the establishment of a first class Socialist magazine. She tells me that more than twenty well known literary and publishing people were there. Over one hundred and forty shirtwaist makers were burned to death in the Triangle Factory. These girls made the successful strike of last year! This is a sort of holocaustic celebration in honor of the fact that the Supreme Court of N.Y. yesterday declared the Employers Liability Act of last session unconstitutional. It wasn't much of an act but it was a move in the right direction!

March 26

After breakfast I got at a cartoon idea in re the frightful fire of last evening in the Triangle Shirtwaist Factory. A black triangle each side marked ("Rents," "Interest," "Profit") death on one side, a fat capitalist on the other and the charred body of a girl in the center. Dolly took the drawing down and after waiting (meantime going to Brooklyn and seeing her sister) she saw Mr. Solomon and he was very much pleased to get it and seemed she said to really appreciate it. I next went at a Scribner drawing and worked hard all afternoon and evening, got it pretty nearly finished by bedtime.

March 27

Today by 1:30 train Dolly went to Phila. This trip she is to help Mrs. Hamlin decide on a gown. She goes at Mrs. H.'s expense and will combine misery with pleasure by seeing the Doctor again.... After I saw her off I came home and Mr. Yeats came in with his two drawings (he had been in earlier in the day) and he and I worked over them for two or three hours. I got them in better shape for reproduction. I went to Petitpas' for dinner.... With F. King I went walking up Fifth Ave. to 44th St. and saw in auction rooms the collection of antique furniture paintings, china snuff boxes, doors, gates, tapestries and every sort of junk got together by the late successful playwright

Clyde Fitch. One great blonde tapestry with large female figures very interesting, an alleged Reynolds painting also. We left and walked to King's apartment on 17th St. where I much enjoyed looking at his lithographs, prints, etc. He has the gabardine worn by Booth as Shylock.

March 28

Did not get at any work today as I was disturbed by the knowledge that I had to go out to dinner. Mr. Yeats came in in good spirits. He took the drawings to Harper's and they liked them and are to pay him $30.00 each! This is fine news!

Well I went to dinner at Comrade Morris Hillquit's. He has a private house at 246 W. 139th St. Very comfortable. He is with his family whom we did not see. The evening was arranged to talk over plans of the "Coming Nation." A. M. Simons the editor did most of the talking though everyone put in an oar, and he said that he got lots of good ideas. He says that they have 30,000 circulation already. Eugene Wood was there, and many others whose names I didn't catch. Ernest Poole was there, a reverend Eliot White, whom I liked very much. Hyman Strunsky, young Russell (Chas. Edw.'s son), Ryan Walker who is an old time Socialist artist though a young man (and a poor artist!) There were about thirty present. W. Mailly was not there. Art Young and I rode downtown with Simons who was interested as we all were in some cartoons which Young had with him. Splendid things.

March 29

Dolly wrote from Phila. that she has just heard (yesterday) that Mrs. Elizabeth Dawson is dying! She had a letter from her only last week. Mrs. D. was a kind of mother, friend and councillor to Dolly during our three years "courtship" in '98, '99, 1900 in Philadelphia and I have a great love and respect for her. She has by hard labor kept herself, boarders, and I sincerely hope that he does not fall heir to any of her hard earned money if she has any. More than this I hope that she is not dying. To think that she will have to go out of life without burying him! [Her husband.] Today I tried the experiment of eating nothing but a cup of cocoa till dinner at 6:30 P.M. in the café downstairs. I did very well and worked on the third Scribner drawing.

Worked during the evening and at 11:30 went out and had "Yocka maing" at the Chinese restaurant across 7th Ave.

March 30

Telegram from Dolly says that Mrs. Dawson died this morning. Asked me to telegraph to her whether she can stay over. I didn't do so as I had already written that she could stay as long as the Doctor advised. I hate to waste money on telegrams. Important ones are always delayed and unnecessary ones are an aggravation. . . .

March 31

Working on the fourth and last of the first volume of the Gaboriau novels and before dinner time I had it "well under control." Organizer Gerber with a request for a cartoon.

Mr. Yeats came in during the afternoon and said that he had decided to go out to Russells' tomorrow. He also told me that he had tickets to the Isadora Duncan dance this evening and offered to take me, who received no tickets. As I had my last drawing in right good shape I agreed and went to Petitpas' for dinner. Harvey O'Higgins had a large party of friends at dinner. Mr. Yeats being at their table he told me he had decided not to go to the Duncan dance and so Sneddon and I went. It was the Iphigenia in Aulis thing of Gluck and splendid she was. The house was enthusiastic! And I had the pleasure of hearing her give a simple, tender, brave little farewell speech so honest claiming only to have started something an American expression in dance. She hoped that her work would start little girls of America to cultivate that means of human expression. It was fine to hear a real artist make a statement of simple principles. Henris were there and after we went to Pabst's and had some beer. Then home. Met Power O'Malley at the Hall and curiously enough again on 23rd St. Went to Chinese restaurant and talked with him awhile. He's an interesting Irish type. Born there. Has high ideals but is busy "making a living." His wife an invalid and a little child too. It does seem as though he had a reason a keep his nose grinding.

Dolly writes that she will stay till Sunday to Mrs. Dawson's funeral.

April 1

A telegram from Dolly saying meet me at 6 P.M. at Penna. R.R. I was glad to get it but felt that my letter of yesterday was too much of a

522

whine for her return. . . . Well, I met Dolly at 6 o'clock at the new big terminal on Seventh Ave. Her old dear friend Mrs. Dawson died yesterday. She left her real and personal property such as it was to her family but her husband gets her life insurance $2000.00. From the station Dolly and I went to Petitpas' for dinner. The Henris were there and we came home and later (after a visit to the School exhibition) the Henris came in to see us. H. Says that at R. Kent's exhibition a picture of Davies has been sold, $2,000.00. That Davies is still completely charmed by the eager Kent. . . .

April 3

I took in the Gaboriau volume drawings to Scribner's this morning and Mr. Chapin expressed himself as much pleased with them, which pleased me, as I will be able to go on with the rest more easily with that assurance. I walked as far as 14th St. Dropped in bookstore and bought a translated Homer's Iliad. Dolly went out and was pressed into service handing out circulars on the mass meeting of Socialist In Memoriam the burned Shirtwaist makers. She hurried home from the National Suit and Cloak Co. Building and we had a fair dinner in the restaurant below us. Then she hurried out again to work at the mass meeting in Cooper Union. Brave little woman. I stayed home and drew a cartoon for the S.P. leaflet on the Murder of the Workmen's Compensation Law by the Court of Appeals.

April 4

Finished up the Anti-Court cartoon A Bloodhound (Courts) who has killed a child (The Compensation Bill) looking up at his idol a "scarecrow" marked "Rights of Property." It turned out a very rainy day but I went out and took a good walk in the afternoon. Stopped and bought a beautiful hatchet, my old one is missing. After dinner, good chops, at home Dolly and I went to the (Proctor's Theatre that was) moving picture show and passed the wet evening being cheaply amused–15 cents each!

April 5

The Memorial Funeral Procession for the Victims of the Triangle Waist Co. Fire was held today. A steady pour of rain did not prevent a great turn out–all in silence 200,000 in marching line (the Eve. Sun gives as the number). Dolly was in the Socialist section. She left before noon and didn't return till nearly six o'clock. Started march

at one o'clock. She said it was a big thing, it should make for working class solidarity. I worked on "Coming Nation" drawing. Glackens called in the afternoon. He wants prices and insurance value. He suggested that I send the "Jefferson Market" instead of "Throbbing Fountain" and I will take his suggestion, sending it with the "Public Library," $650.00 each (insurance $300.00) these to the Union League exhibition. Glacks says he can't get in touch with Davies, has written and called but D. out and no answer to his note as yet. . . .

April 6

Today I wrote in answer to Mr. H. McGoodwin's letter in re my terms, etc. to Carnegie Institute School of Design. I said that I would come out if they wanted me, salary first year to be $2500.00. I also sent by registered mail a tube of proofs, etchings, etc. as "samples" and now I rest in the hands of Fate. I don't know whether to hope for or against their acceptance. One thing I am sure of I can't be disappointed by their unfavorable decision. . . .

April 7

In the morning and through the afternoon I worked on the Jefferson Market picture struggling with the foreground and having no success with it and it already entered for the Union League Ex. Glackens' fault for suggesting that I send it! Dern him.

We took our dinner at Petitpas' and had a pleasant evening. After dinner Mr. Yeats prevailed on Vizzard to tell the reading of Dolly's hand which he did interestingly and with many true indications. He also read mine and found either a curious displacement of "life line" and "fate line" or else a very short life line, so short indeed that I should be dead already! But he is going to look up his books on the subject. Dolly left a bit earlier than I did as she expected Margaret her sister and her niece Mary Wall. They were there on my return and Horace Traubel was also a chance visitor. He is gentle kindly man and we had an interesting talk with him. I looked again on the face of Walt Whitman's watch which he had left to Traubel, his library executor.

April 8

Today we rose early and hastened to . . . West Nyack and walked over to Joe Laub's farm "Gartenlaube." We were joyfully received. Joe is busy making a rustic bridge across the stream and I helped. We went

up into his woods on his hillside near his waterfall, once "Buttermilk Fall," and cut saplings. Joe is not very strong and don't look right in color. His severe sickness this winter has still left its effects. Norrie Laub's brother Bert Farrell is with them acting as man of all work about the place. They have a cow who gives good milk from which they make butter which leaves good buttermilk of which we drank quantities. Their house is very comfortable though it lacks some of the conveniences, hot water and inside toilet principally. It started to snow before we went to bed.

April 9

Woke to a snow covered country scape about three inches! Mrs. Laub insisted that I make a sketch so Joe got his pastels and a piece of board and I got busy making a "showpiece." Meanwhile old Sol was busy on the landscape and by the time I had finished my work my subject had become a muddy spring day! I gave Joe the drawing–my second pastel. He has my first also, a sketch of Mr. L. I made more than a year ago. It was muddy about in the afternoon with snow on the wooded hillside but we took a climb up to the falls which the rapid thaw of snow had trebled in volume. It is really a romantic place to own. Joe Laub suffered with a fearful headache all day, he is not well by any means I'm afraid.

April 10

We drove with Joe Laub to the station where we missed our train, then home where he phoned to Collier's and was told he not come in. So we were driven over by Bert Farrell and got the next train. Arrived home about 12 o'clock noon. . . .

April 11

Union League exhibition collected "Public Library" and "Jefferson Market." A note by messenger from March of the Sunday Times says he wants to talk of the Puzzles (is it to be a resurrection of the dead?) so I went and had lunch with him at the City Club. On the wall of the exhibition room a collection of drawings by Boardman Robinson of the Tribune, a young man, good stuff, "Out of Forain by Glackens" a horseman would put it. March and I had an extended chat on general subject of the Puzzles. Finally I told him I'd want $35.00 to make drawing for The Ledger. He then hit on the idea that I might place them with McClure Syndicate on satisfactory basis.

I am to call him up and he is to make arrangement for me to talk to Viskuisky (once of the Phila. Press now with McClure Synd.) . . .

I took dinner with a mess of literary and artistic and newspaper Socialists at Cafe Boulevard. Each guest paid for himself $1.00. I thought it an invitation but of course The Call is too hard pressed for funds to indulge in such an extravagance. Kahn, editor of Forward (Jewish Daily), was there and an extremely bright man he was. The editor now in office though a year and a half on Call, MacDonald is a narrow faced man with a broad smiling faced wife. Mrs. Anita C. Block was pleasant. Miss Finch was there. Met "John D."–whose name is Walsh. Courtenay Lemon also present. These spoke: W. Atkinson Pres. of Call Assoc. called on me for last speech. I suppose I got too frightened or funny or Furious but it was well enough received.

Dolly went over to Maggie's in Brooklyn for dinner and though I got home after 12 she was later and did not come home. Spent the night with her sister in Brooklyn. Wikefrund.

April 13

I went to see Mr. Viskuisky of the McClure Syndicate but he was not yet back at his desk, still sick. I stopped to see the Kent Independent Exhibition. It is interesting but the Davies work is the chief interest to me. . . . Mr. Yeats working on his portrait. It is an almost aggravating thing to watch the struggles of another man. He teaches me that concentration on the work is most necessary. . . .

April 15

Today in response to a "command" from John Quinn, Mr. Yeats and I met Q. at the Union League Club to look at the exhibition. Q. liked the show and said that it was much better than the Independent Kent show, more art. Lawson has a little beauty, winter picture, a tree in foreground and ice on small stream back. From this exhibition we went with him to Kuhn's show at the Madison Gallery which is very interesting. Kuhn has gone ahead splendidly in the past year. The color of the obvious sort as all the new things are–even Glackens is in the obvious color class just now. Quinn priced a couple of Kuhn's and then at my earnest plea he is considering a drawing of Jerome Myers of which a number are shown in the Madison Gallery. I insisted that many of them were better than any painting we

526

had seen today. Mrs. Ullman and Yeats at lunch after I with Yeats had gone to clothiers to pick out a suit of clothes for him to wear to T. F. Ryan's southern home in Virginia where he goes tonight with Mr. Quinn. Mr. Y. loves millionaires he says. He painted in my studio in P.M. I worked on C.N. drawing also in evening. . . .

April 16

Mrs. Ullman came in the morning and stayed through the day and night. She helps Dolly a good deal and is no trouble, but she is another man's wife and I can't help resenting the fact that he got into me for $100.00 and now his cast off poor wife looks to us for lodging and some meals. She says that Mrs. Murray puts her up when she is not here with us.

Worked on "Coming Nation" drawing. We went to bed early.

April 17

"Isadora Duncan," my picture, has been Rejected by the Carnegie Institute Jury. I had hoped it would be shown. The "Chinese Restaurant" is also declined. I'm beginning to think that a picture must be "in fashion" to go but then they accepted the "Clown Making Up." A criticism of the Union League exhibition calls my two pictures there "colorless but containing figures that live" but they compare Kent's "Burial of a Young Man" to Manet's Funeral Procession in the Metropolitan Museum!! They have swallowed the Impressionists and all the imitators that paint with crudities lashed into shape by palette knife. Of course the Kent picture is done under the influence of Davies. . . . Dolly went to Phila. today. . . .

April 18

And now by the Grace of God I get a 50% dividend on my own money which was caught in the Northern Bank failure! There are hopeful rumors of a further dividend later. I put the $155.00 in the Savings Bank (Greenwich) and then I took a walk and on my return "fussed" about the studio without doing anything. P. Quinlan called in the afternoon. He is a little tiresome with his way of superior historical knowledge. He is accustomed to be with people who are so uneducated that he just habitually slides to a higher plane in talking but he means well of course, and except when this manner touches on art (which is seldom) I don't mind. I had dinner at Chinese Restaurant. *Again* I have a notice to qualify or disqualify

as a Juryman, and this time I'm afraid I can't get out of it. I can't see why my turn comes so often. . . .

April 19

. . . Mr. Yeats took me to lunch at Petitpas'. He has just returned from a short visit with Thos. F. Ryan in Virginia. He went with John Quinn who is a great friend and probably legal adviser of T. F. Ryan's. . . . Mr. Yeats liked Ryan, said the hospitality was easy, do as you please. Took a ride twenty miles, negro cabins, etc. Mr. Quinn not wishing Mr. Yeats to wear his overcoat–made him put on one of T. F. Ryan's from the hall rack. Dolly home at 10:25 P.M. Glad!

<div align="right">

FORT WASHINGTON
APRIL 19, 1911

</div>

Dear Jack

Your welcome letter received, with enclosure, for which I am very much obliged. We expected Dolly out today but she did not put in a appearance for which I am very sorry and disappointed.

We are having a very raw cold spring. I have very little garden made only a few peas planted. We have ten nice little chicks so far with four more hens setting expect to have a new lot today. We have to keep a watch on as there is an old cat stealing Grubbs. I shot at him twice this morning but without hitting him. It is hard for me to hit with a revolver. My hand is not very steady. I have dug very little garden as I don't feel strong enough. We want to get a man to dig it but when you want one you cannot find one.

I am feeling pretty well at present but have a good deal of trouble with my bladder. Things do not go right there. Otherwise I am feeling pretty good. I suppose you know that Nannie has painted a set of screens for a Mrs. Dr. Hart in Phila. She took them away today in her Auto and liked them very much. If Dolly had come out this morning she would have seen them. I think they were very well done. There was three canvases I think the size was 21 x 65. I suppose she has told of her trip to Europe. I dread to have her go so far away alone, she will have so much to contend with language and home sickness, but I hope she will get along all right.

Dear Jack I hope you will not think this too long a letter so will close thanking you again for the check.

<div align="right">

YOUR LOVING
Father

</div>

Bessie and Nannie send their love.

528

April 22

Post card from Henri and Mrs. in Washington where he has been for nearly two weeks painting a portrait, whose we don't know. H. is very uncommunicative. Mr. Yeats working on his own portrait. He gets it in a very interesting state and then piffles along and (I think) forgets to intend to paint it and at the end of each day it is just a mess. I worked on (Scribner) Gaboriau drawing. . . .

April 23

Finished up Scribner drawing and then got another idea for an Anti-"Boy Scout" picture for The Call and made it. I'd like to land a strong thing against this organization! This one today won't sink 'em but seems good enough to be printed ("Train the B. S. in their Real Duties!" Boys using a dummy of a workman as target for rifle practice). *[Back in 1911, Sloan's objection to the Boy Scouts was based on his strong pacifist convictions. In* Gist of Art *he said, "I hate war and I put that hatred into cartoons in the (old) Masses. But I didn't go sentimental and paint pictures of war. I went on painting and etching the things I saw around me in the city streets and on the roof tops."]*

April 24

An officer of one of the Labor Unions McNamara has been arrested charged with the dynamiting of the Los Angeles Times Building in Oct. last. Detective Burns of San Francisco in employ of Manufacturers Association claims to have case against him. Dynamite stored in barn, suit cases checked in his name with fuses, time exploding devices etc., found in plenty. I think the whole thing is a put up job trying to "bust the Unions." I made a cartoon on this today and The Call sent a man up for it. Mr. Yeats worked on his portrait again this afternoon. A Tenement Inspector in performance of his duties called in the morning. He said something which made me know him to be a Single Tax advocate–he said so–said he voted the Democratic ticket. A pretty poor means of expression of his opinion I think. He said Socialists were numbskulls. I kept in perfect good temper! Sent drawing on Boy Scouts. . . . to the Coming Nation as The Call got the new drawing on the Dynamite Charges.

April 25

Walked down town to qualify (or disqualify) as Juror being notified
to that effect. I stopped in at Washington Square and saw Glackens
who said that he'd like the walk and went down with me. I was ex-
cused on my statement that I did work for "The Call" Socialist news-
paper!! Glack stopped to look in every sporting goods window, being
interested in fishing. Mr. Yeats worked at his portrait from 3 o'clock
on. Ars longa–vita–he is seventy-four years about! . . .

April 27

In the morning Dolly and I walked out and stopped in and ordered
a summer hat for Dolly at Miss Glaenzer's Shop. A nice nervous little
Russian girl, a Socialist. We met Mrs. Roberts on the street. She is
in the throes of moving to new apartments on 18th St. East. Sent
Mr. Quinn a number of etchings by messenger. The three new ones
in finished and advanced states of the plates. A proof of the J. B.
Moore portrait and a finished proof of Mother's portrait, also a trial
proof of head of latter. After dinner at the café downstairs we went
to Brooklyn to Dolly's sister where I made pencil sketches of the
little girls. They ask me to work and seem to pose. Mr. Yeats worked
in afternoon on portrait.

April 29

Dolly has Mary cleaning the place today so out I sallied with a mighty
good grace to take a walk in the warm (too warm for Spring) weather.
I walked but little only as far as Stuyvesant Square where I sat and
watched the mothers and children and young girls between the two
states. And soaked myself in sunlight. The Jewish mothers are won-
derful creatures many of them I saw today whose breasts looked to
weigh as much as a child of ten years! I came home. Mr. Yeats was
working on his portrait. Dolly put in a long hard day's work with
the cleaning and the woman who helped got $1.00–Dolly gets her
$5.00 a week (our scheme for the last several months). I worked on
the Gaboriau drawing. We had a good macaroni dinner at home.
Both pretty well tired, Dolly legitimately so. I sympathetically per-
haps?

The Evening Sun editorially chides Rev. John Haynes Holmes
of Church of Messiah, who after being quoted as saying that "he

is sorry for loss of life in Los Angeles but not ounce of regret for Gen. H. G. Otis (owner of Times) he has reaped what he has sown" goes on to say that Canadians are thankful that they have no Constitution nor Supreme Court. And The Sun makes the following clear statement of creed. "The Constitution is not a divine institution but it represents the great weight of learning (sic) and the distillation of experience as framed for the greatest good of the nation. *The Supreme Court stands next to divine authority* as the *rule of justice and right.*" (!)

May 1

Got underway on another drawing for Scribner's. Mr. Yeats also worked on his portrait during the afternoon. Dolly was out shopping. She is finishing a beautiful tunic overdress for Mrs. Hamlin to wear on her "Musicale" in June. It is a great success. We had our dinner early as Dolly went uptown to join the Socialist May Day parade starting at 84th St. About 7:30 I went out to join in the demonstration in Union Square. The parade was very late in arriving from uptown but finally it turned up—and little Dolly trudged along after the band. I had brought a bundle of Ghent's pamphlet "To Skeptics and Doubters" and we both turned in to sell these to the crowd. I was a little slow in warming up to this but when I got started it went easily enough. I was surprised to find how interesting "hawking" was (to be sure no bread and butter depended on my results!). We came home about 11 o'clock. There was a good crowd and some good speeches, notably young Jack B. Gearity and Algernon Lee....

May 2

Mr. Yeats and I both busily working in the studio and Dolly also in her front room finishing up Mrs. Hamlin's tunic, which goes away tomorrow. Dolly gave us our lunch. Mr. Yeats is in good spirits today. He had a pleasant dream last night. "A happy dream lingers with me the whole day" he said. A post card from Henris. They ask us to come around tonight.

A letter from J. Horace Rudy, curious, years ago when we were youths at the P.A.F.A. he was a disciple of William Morris and Walter Crane. Today his letter says that the S.P. is extreme in saying that the employer and employee are opposed. "My men would come to me with their troubles rather than trust a fellow workman *which is*

as it should be."!!!!! I got my Socialism recently but it will stick better than that I hope.

May 3

Working on Gaboriau drawings. Mr. Yeats working on his portrait. After dinner at Petitpas' where we went to show Mr. Yeats Dolly's new hat (made by Miss Glanzer and very pretty indeed) we went up to 39th St. to the MacDowell Club to talk over with Club members and other artists the new plan of exhibitions (Henri's scheme) which is to be put in effect next winter. A few members of the Club, notably the empty pated Mrs. A. N. Meyer opposed the scheme as they felt it was discriminating against the other arts in favor of painting! The same old cry. After the members had commented and Henri had replied (J. W. Alexander chairman) visitors were asked. I responded and got to my feet and said that I thought it would be ridiculous to attempt to demonstrate an "open gallery to groups" scheme in one small gallery unless they confined themselves to one branch–painting having been selected by the Committee. I met elderly Mrs. Dunlap Hopkins of the Women's School of Design. She politely chid me for turning down her offer to teach at the school (Shinn communicated it to me). Mrs. James Haggin very splendid mother of Ben Ali Haggin is the leading financial backer of the Club, agreeable and kind, Mrs. MacDowell, relict of the musician charming lady with crutches, spoke decidedly in favor of Henri's scheme. *[The widow of Edward MacDowell, the composer, and later founder of the MacDowell Colony in Peterboro, New Hampshire.]* Dolly and I after walking down with the bunch went to Shanley's together.

May 4

Note from Chapin. Went to Scribner's and promised four drawings by Monday. Mr. Yeats had met Dolly and let himself in with the key and was working when I got in. Gas cock accidentally turned on by him in front room–horrible smell. He might have perhaps asphyxiated himself.

We had dinner early at home. Then Dolly hurried up to Carnegie Hall to the Berger Meeting, and a little later I followed. A *great occasion.* Victor Berger is the first Socialist in U.S. Congress. He is smiling, clear headed, practical and not ultra revolutionary. He said that he had been in Congress now four weeks and has introduced

four resolutions. To withdraw the troops from the Mexican border. 2.... 3. To inquire as to the illegal extradition of McNamara. 4. To abolish the U.S. Senate and install Referendum. He was cheered for nearly fifteen minutes on his appearance. He was followed by Franklin Wentworth of Connecticut with a splendid speech, though he read it. Overflow meeting of about 500 outside. I clapped my hands till they were swollen and yelled myself hoarse–in a dress suit in a box at that! Dolly was busy selling pamphlets. She is well known in the Party as a hustler. W. F. Taylor walked home with us and we had some beer and sandwiches and went to bed at 2 A.M. Great night –makes one feel that the time is coming!

May 5

Taft plans invasion of Mexico in next few days! Call for 200,000 volunteers ready to be issued. These are the headlines in the Call today. States that Taft had on Tuesday called the slaves of Capitalism, the newspaper men representing the papers of the country in Washington, and had to them outlined the policy for the next weeks. That he will be forced to invade Mexico in order to satisfy foreign (!) capital invested there! The Call says that they and the Daily Socialist Chicago are the only papers printing this story. *If it be fact,* I'm proud of our "scoop" on the servile capitalist sheets of the world.

Mr. Yeats and I both working today. I on Gaboriau drawings, he on the portrait of himself which really seems as far from a start as it ever was. A fine spaghetti dinner of Dolly's manufacture at home. Sneddon called after dinner. He had some copies of "The Open Window" a small monthly brochure published in London which used my "Women's Page" in halftone reproduction.... Miss Glaenzer the milliner came to get at Dolly's suggestion her assistance in balancing her books. Her "business" is in a sort of disorder and Dolly as usual wants to help someone.

May 6

Mr. Yeats met a lady in Phila. a few weeks ago who told him his "Fortune." Among things she spoke of a steady occupation in his future. He mentioned this today and was amused when I told him that it evidently pointed to the present portrait of himself. He put in a good day's effort of his sort. I'm convinced it's not concentrated effort. In the evening Henri brought Schofield who has been in U.S.

for some weeks in the Pittsburgh Jury, etc. He is bigger than ever and looks in splendid health. His work sells and is liked by everyone. We all went as H.'s guest to Pabst Restaurant and had a lot to eat and some "good old times" talk which we all enjoyed. Then for old times' sake to Henri's studio where we played a four handed game of poker–Dolly, Scho., Henri and I, and it was an enjoyable game, having this difference from the games of old in that I was a winner, Dolly also. H. and old Scho. victims about equally $2.50 each. Scho. said that he said a good word for me as instructor in Pittsburgh. I hope I don't get it though. We came home quite early in the morning of Sunday 3 A.M. when we went to bed. Scho. came with us as Henris have no accommodation for visitors.

May 8

Finished drawings for "Clique of Gold" and took the four over to Chapin in the afternoon. He approved them and gave me a story to illustrate for the Scribner's Magazine. This is quite good news although I have so much work on hand now that I feel quite bothered. So hard for me to get it out of the way and no chance to paint (at least I make none).... Invitation to the opening of the American Pavilion in Rome Ex. (for April 22nd last!).

May 9

After a talk in the morning Dolly and I went out house hunting. We went to East 18th St. and stopped at Roberts' new apartment house, no vacancies. We walked further out 18th St. and saw a fine parlor floor and basement 335 E. for $50.00. We were charmed with the idea of taking it. (Mr. Yeats came to work on his portrait and was with us at lunch.) After lunch I went to see the owner Dr. Eife, 175 W. 10th St. in Greenwich Village, but here my hopes were dashed –the place had been rented this morning at 9 A.M. I felt fearfully disappointed–so bucked up and saw many places. Walked about all afternoon till dinner time, coming home once to tell Dolly of our disappointment, then out again. Mr. Yeats worked in his idling fashion all P.M., stopping constantly to talk to Dolly in the front room. She said she scolded him for it....

May 10

Dolly and I went forth together to see if we could find a home. We took the direction of East and on 22nd St., 155 E., we found a top

floor apartment. Owner lives on the first floor, name Weinstock, seems a nice and pretty German woman. We like the place so well that agreed to take a lease at $45.00 a month rent. I paid a (check) deposit of $10.00 to bind the agreement and we feel pleased. Mrs. W. agreed to paint and paper and repair the place and said she'd have the lease ready tomorrow. Went to Chapin and talked over pictures for Magazine story–to cost $300.00.

We went to the Roberts' new place on E. 18th St. for dinner. The Henris were there. The place is a very fine old apartment, spacious but painted to suit Mrs. Roberts, black dull finished woodwork, rather gloomy....

May 11

At about eleven o'clock I went to see about the lease. Mrs. Weinstock said that they would prefer me to come in June with lease to Oct. 1st, then a new lease for a year from that date. I said that I'd prefer a lease from May or June, she agreed to my stand in the matter. I went over and got Henri to come back to 155 E. 22 which is only two minutes away from him (10 Gramercy Park). He seemed to like the place very well and helped me decide on the question of light. I had thought of adding fixtures but he thought them unnecessary. *Will have electric light, steam heat and hot water* in this new place and *Dolly will have a real kitchen "with a sink."* She has had to cook under great disadvantage in our old 165 W. 23rd St. place. We will also be paying $5.00 a month less rent. Called on L. Heller in 23rd St. to find out about models. He has a curious junk shop of a studio. Two cats and about seven kittens! Mr. Yeats worked on his portrait today but I asked him to take a day off tomorrow.

May 12

Over again to Weinstock and there found a letter from Mrs. W. who says that as leases begin Oct. 1–they want me to sign one to that date then to renew for a year. As this puts me rather in the position of moving for a four months lease I went around to Mr. W.'s butcher shop and saw him. He is a small bright faced German and I soon showed him that it would be better to have a lease from me to Oct. 1912. He said he'd send one by mail for me to sign in duplicate. I made some rather poor drawings from Miss Converse for use in the Scribner Magazine story illustrations in the afternoon. After dinner

at home Dolly went to S.P. Branch meeting, I out to buy a pair of shoes, and after dressing I met her at 9:30 at subway station and we went up to Haggin's studio–where Shinns are producing a "melodrama" and we enjoyed it very much. Well "put on" it was and was very funny. Mrs. Glackens was splendid in a character part as New England farmer's wife, flat chested hump back. As Dolly said, it's fine the way she sacrifices looks to doing the part well. Haggin's mother most gracious to me. Wants me to come into the MacDowell Club, Calders there, Bellow's and a "raft" of people I didn't know or remember. Home at 1 o'clock.

May 13

No lease arrived from Weinstock as promised yesterday. This bothers me so after breakfast (Mr. Yeats came for a half hour and though I told him he could paint for two and a half hours he didn't start.) I went to 155 E. 22nd, asked for Mrs. Weinstock and was told I couldn't see her till 5 P.M. That provoked me. I felt that they were playing me fast and loose so I spent more than two hours walking about looking at apartments but with little satisfaction. Came home, Dolly out....

May 14

I spent much time today trying to get hold of a man model to pose for my Scrib. Mag. drawings. Finally called up W. S. Potts on phone and asked him to dinner. He brought some addresses for me. We sat and talked through the evening. Potts has been turning to the "New Thought" or mental science cult. He certainly seems better in health but he can't see Socialism so it's hard for us to agree.... I feel that if there be anything in his philosophy that Socialism should be part of his means to the end–helping the whole race to reach that mental advance necessary to abolish most human ills.

May 15

Dolly phoned to W. F. Taylor for me and proposed to him to pose for my Scribner's drawings. He consented gladly and came down about 1 o'clock. Stuart Davis called in P.M. late. Lease for new place arrived and I signed and returned one copy. This makes us feel more settled. I notified the agents of present studio 165 W. 23 that we were about to go. As I said to Miss Sehon the other day we have

tried the place for seven years and don't think we can stay. I ordered the electric cluster in the new apartment from S. May on 6th Ave. ($6.50 and time).

Worked all afternoon from Taylor and he took dinner with us. After dinner a messenger from Dolly's sister asked her to come right over and stop the night. Dolly hurried right off and phoned me at 9 o'clock that her sister is quite sick, hemorrhages. Taylor and I walked out as it was rather warm in the house. At Fifth Ave. and 30th St. we took a Fifth Ave. Bus and rode atop up to 90th St. Took a walk through the deserted Central Park after midnight. Many many lights have been added so that it seems much safer than formerly. We met his roommate going home. I left them at Madison Ave. and rode home arriving after 1 A.M.

May 16

...I worked on the first Scribner Mag. drawing during the afternoon and a struggle it is. A man from the agents of this property called. Said they would do anything to keep me as a tenant, make any repairs or do the place over! and even *reduce the rent to $40.00 a month!!* This is fearful, it don't tempt me to stay, but it does show that I have been paying too much rent ($50.00) for at least two years past. In other words I might have got a reduction by threatening to leave before. . . .

May 17

...I worked on a new drawing of the same subject for the Scrib. Mag. drawing. Am making wash drawings and certainly I have trouble with this sort of "he and she" story. In spite of myself the regular style in illustration enters into my calculation so that I do not do what I can do best–am distracted by ideas as to what it is they "want." . . .

May 18

...I finished up (not to my great satisfaction) one Scribner Magazine drawing and started on another. The pace I'm going in this work is exceedingly slow. I feel that I am puttering over the work. To think that I once dashed out big pen drawings for a daily newspaper! They were bad I suppose but they were out of the way in short order. . . .

May 19

I put in many hours today on Scrib. drawing. I went over to our new place in the afternoon. The painters and paper hangers are at work and it looks as though it would be a cheerful place when we get into it.... I met Dolly at the Third Ave. elevated station. She having been at a meeting of the City Executive Committee of which she has been made a member to my chagrin. I feel that she's taking on too much work, still I *am* proud of her too!

May 21

...A pathetic little sign board is hanging out our front window. It reads "Floor to let." It makes me sad, nearly seven years since one like it was taken down and we moved in–September 1904. Now we are going I wish we were past the parting and the carting....

May 22

At last word came from the Carnegie Tech. Schools in re the teaching position. Mr. McGoodwin writes that they are still undecided but that in justice to me he will tell me that their plans won't take my direction (or words to that effect). Curious human nature! If he had said I was the teacher selected I would have replied that I had made plans (I signed a lease on the new place for 16 months ahead) but now that he practically tells me I'm dropped I feel a sense of chagrin! ...

May 23

Today we had in a second hand dealer and sold him the stove and refrigerator, ice chest, bed and springs and marble top washstand for $6.oo! I worked all day on the Scribner drawings. I'm working hard on these things but I'm not very proud of them so far. Mr. Yeats worked on the portrait of himself all day....

May 25

Wrote Davies, Luks, Shinn, and Prendergast asking them to go in Group Exhibition at MacDowell Club next winter as per offer of Club. Sent stamped envelopes for reply. Editor of The Call, Mac-Donald, called and asked me to make a cartoon for the special Third

Anniversary number of The Call. I told him I'd try and would let him know tomorrow evening. . . .

May 26

Davies answered my note in re Group Ex. that he wished to be free from the "dreadful thought of an exhibition" so would not go in the MacDowell scheme. . . .

May 27

I phoned Morgan Bros. and accepted their offer of moving us for $40.00. They said they would start Wednesday P.M. and finish Thursday A.M. Mr. Yeats worked on his portrait all day. Left it in the evening in a very good shape which Henri, who called with Mrs. H. in the evening after dinner, liked very much. Dolly went to Central Committee S.P. meeting. I walked over with Henris, leaving them at Lexington Ave., went to Third Ave. Elevated Station and met Dolly on her return.

May 28

Worked all day on the last Scribner drawing. Not very brave at heart over it. And Yeats worked on his portrait. I told him how Henri had liked it as it was last night. He seemed pleased and then in spite of my warning to go easy and finish it, he got to work and beat it · to death–so that at lunch time I let out at him and scolded wickedly and with my own trouble in my own work in the back of my mind I talked cruelly and I'm sorry for it. For the thing was painted out and away, and no scolding could bring it back. I was ashamed and he was disheartened for the first time. I, in a glass house, threw cruel stones. . . .

May 29

Mr. Yeats on his portrait and I on Scribner drawings worked the whole day most industriously. With hope to spur us on. We really enjoy these days of work in the studio together. Dolly brought her sewing in today. (She is making a coat of silk for Henri to wear in summer weather painting.) Then our lunches of tea and bread and butter and jam. We all enjoy them and Mr. Yeats is always full of good conversation. Mrs. Henri called twice in regard to the coat which H. is waiting for. We had dinner at home, fine mess invented

by Dolly–rice with tomato and mushroom sauce. After dinner we took a walk. Dropped in moving picture show and saw among other films a villainous scurvy thing against union labor "unreasonable demands" of miners led by a "demagogue Agitator." Brutality of said agitator, etc. The good old miner tears up the paper of demands and they kick out the "demagogue" and go back to work!

May 31

Today I delivered the drawings for "Old Johnnie" to Chapin–he seemed to like them. At any rate I gave "money's worth." In the afternoon the packer came to put my books in boxes. Mr. Yeats worked all day at the portrait which has become a sort of boogaboo to me.

June 1

Oh dreadful day of moving! And Mr. Yeats worked at his portrait while the Lares and Penates and books and etching press and piano were being hauled away. Finally while movers were away with first two vanloads he finished. And they came back and took away the easel and mirror from which he worked! Dolly was at the new place 155 E. 22 and superintended the disposal of the things as they came. I arrived at about 6 o'clock and they worked till after 7 P.M. It looks as though we had more things than space! We went to a Third Ave. restaurant for dinner.

June 2

After a hard day's work we have put things into such shape as makes the place look possible now. But everything is still in disorder.

June 4

We went with Henri, Roberts, Glackens, Mr. and Mrs. Dick Dwight (she is amusing) to Petitpas'. Mrs. Glack's sister (Miss Dimmock) there–large beautiful quiet self controlled and full of modern sense. Roberts and Henris came home with us to look us over. We are still in the rough.

June 7

... Am having book box shelves made by carpenter, a nice Jewish chap named Paul Sussman. He is quite aware of the struggle of the

days, but is inclined to think that Socialism and political action won't do as well as Syndicalism as is now in practice in France.

June 8

Down town in the afternoon to see Mr. Mar *[Publishers Press]* but he was not in, "called out of town" so I went up to the Times office, told March that I had tried to see Mar ineffectually and was inclined to let the whole thing go. He said I'd better try again. I walked down from the Times Building. Seems curious, the city looks different to me on account of my new location. Called up Luks in re the Mac-Dowell Club Group. He said he'd see Davies.

June 9

Mr. Yeats called to see our new place for the first time today. He liked it very much. Made a drawing for the third Scribner Gaboriau book today. I've promised four drawings by Wednesday next. Dolly to S.P. Branch meeting in evening. I took a short walk after I had finished drawing—by electric light if you please. Not that it's new to others but to us it's our first treat at home. We had it at Lansdowne but that don't count.

June 10

About 10 o'clock a messenger from Mr. Mar, of Pub. Press, asked me to come down to see him at noon. Went. Met him at Astor House. My first sight of the interior of this old land-mark reminded me of the old Continental Hotel in Phila. Mr. Mar pleasant—about forty-eight years. I told him I didn't want to take up the puzzles unless they would pay me near $50.00 per week. He said he'd see Mr. Ochs of the Phila. Ledger on Monday and would let me know during next week. Worked on Gaboriau drawing and got into a mess over it. Cross and hot. Heavy thunder storms during the evening and night.

June 13

Phoned to see if G. Luks had decided about coming in to the Group. Mrs. L. said no, he had just written me a letter giving his reasons. I said O.K. A reporter from the Sunday Times called in the afternoon. Said he wanted an opinion as to the "most beautiful spot in New York City." I told him any spot when one felt it was beautiful.

Loaned him three panel sketches for purposes of illustrating article. "Bridle Path," "Lafayette Fishers," and "Lake, Central Park." He said that Mr. March sent him, that he would also see Henri. Henri and Mrs. came late after Dolly had gone to bed tired out. He wrote notes to Sprinchorn and Kuhn in re filling the places on our Group for the MacDowell Club ex. Thunder storm again tonight, the fourth day in succession. A post card from Nan Sloan, sailing on the Haverford from Philadelphia on Saturday last. *[Marianna Sloan had asked Henri what to do and what to see when she went to Europe. The following fine letter was his reply.]*

<div align="right">

10 GRAMERCY PARK
MAY 29, 1911

</div>

Dear Marianna Sloan:

You should not have any hesitation in writing to ask me anything for it will always be my pleasure to respond as best I can. Your question, however, this time is a "whopper," and so broad that it's rather difficult to tell where to take it up.

I should advise you to *see* as much as possible—of course I mean by this that you should see and understand; penetrate, and avoid molestation in order that you can get your own thoughts. I'd advise you to work in between the seeings: do things in your room—things that will be thought and experience registrations—notes, in fact, of what you have found. You might, in case of need, enter a school, but not for the instruction or criticism of either teacher or fellow-students, but for the use of the model and the place. And only use it for the purpose in hand: the thing you are travelling and seeing to develop. If anything you find in the school, or the teacher's criticism, seems to fit in with your purpose—use that too; but stick to your one purpose, that of gathering and developing, letting your work record your progress and serve as means of trying out, practically, your conclusions. In this way only may a class be of service to you. You have had enough instruction from without, good and bad. The only instructor and the only critic must be yourself.

Copy! But don't make copys to be copys; make assays of the pictures for what is of particular value in them for you. These two propositions are easier to accept than to act upon. It is hard to go into a school and use it for your own purposes, or to copy under the public eye just what you want to copy and not what the watchful public would expect.

I should think you would profit a great deal between the seeing of things by doing street scenes or landscape sketches. I don't know of any school or any movement to suggest for your particular attention.

542

I believe strongly in working along with seeing–putting your ideas in action. People who develop exclusively the habit of listening find that they have little to say although they have heard much and thought much. When you get something put it to use.

For your purpose, I should say, of the moderns, you can learn very much from Rodin, Puvis de Chavannes, Manet and Whistler. They are men who have not only created beautiful things, but they *knew what they were doing when they created them.* They knew a great deal about *construction,* a matter of which the art crowd in general knows practically nothing–no matter how often and with what air of possession they pronounce the word.

Some of the "ultra moderns" will tell you that design for design's sake is the thing. Beautiful design! But a great thing must be an organization of perfectly related parts and the result must itself be a unit. There must be an underlying motive to bring this about. In an Ibsen play there is always a philosophy; there are personages and events, but back of all this there is the still deeper Ibsen motive. Each varying creation of Rodin is added evidence of the strength of central motive–nymph, dryad, Eve, a bust of a man–all intense, dealing profoundly with the state of each; very dissimilar, yet through them all flows the Rodin idea, the Rodin philosophy, understanding and principle.

Great things spring from great natures. Design that *is* beautiful is the *gesture* of a great nature. The grace of its lines is in the *delivery* of their meaning. Among the old masters there are so many examples, and such varying methods–Donatello, Botticelli–some in all the schools of painting. I think of valuable principles of the *science* of expressing in the early sculptures, great matters in the *use* of form and proportion (how I have looked at them without *seeing!*) and principles of the science directly related to your use in the early architecture–not the Beaux Arts view of it. There are two things: Profound appreciation, deep love of life, emotion, enthusiasm, imagination, powers of projection; and: The science of expression through paint on canvas. The masters are strong in both; the greatest masters make a wonderful servant of the second to the first.

We have churches with pygmy ideas about religion, governments with pygmy ideas about human brotherhood, schools with pygmy ideas about education, artists with pygmy ideas about art. No one even expects an artist to have the merest common sense in the use of his simplest tools. For an artist to be a practical man is quite enough to damn him artistically in modern judgment, and if he believes the study of mathematics to be of direct value to him in his science of expression he had better keep it to himself unless he doesn't mind the patronizing smile of pity. Music is better off; architecture *was*–and sculpture and painting, too–at times.

You will find schools, old and new, over there. I don't believe in schools; they are only superficial evidences. Some are more interesting evidences than others.

As I have said of Ibsen and of Rodin, it's the undercurrent which one much reach. Hedda Gabbler is interesting, her surrounding, the other people, their acts, their social condition—these are all documents of a time and place—but beneath them is an everlasting principle which Ibsen expounds, suggests, and opens up.

See the schools and see beyond them. Don't look at pictures as an artist; artists are too narrow, too hemmed in. Their manner of seeing is too much prescribed for them. There are certain things they must not do —else they will not be artists. They have such little ways! I know artists who will not use a mall stick, who would fall from grace in their own eyes were they to use a small brush, who would *not measure* anything for the world, who *will measure* everything and consider those who do not as insincere.

The greater art is, the less it is an imitation of nature, but it looks the most like nature.

The great masters knew what they were about. They were practical. There is a profound science in what they did to express their thoughts. The lovers of pictures may sit and dream. The student *must* dream and he *must investigate the means by which he is made to dream.*

I don't know whether this sort of thing is any sort of an answer to your question. Perhaps there is a suggestion of an answer in it.

I hope your trip will be a wonderful experience, and with best luck,

VERY SINCERELY,
Robert Henri

June 14

A letter from sister Bessie who with Dad is at Fort Washington and they are very lonely without Nan. The two are a strangely uncommunicative sort when alone together. Letter from Luks says that "possible" sitters in the West will prevent his having anything new for exhibition next winter so decided not to go into Group Ex. scheme! What will we do without our "Old Master"? The Sun has made so much of G. B. L. that he is reaching the stage of coyness which any herring would under the constant beams of Sol.

June 16

Casey of Collier's I called on phone (as requested, by letter). He has another Pirate story! And I promised him the first one which I have

544

now had for several weeks and not touched–by two weeks from today. Went down town in response to a request by note from Mr. Mar, Pub. Press. He as usual was not in at time appointed so I rather huffed went away. A beautiful storm sky with wind seen over City Hall Building which is under construction, towering high with broad spread back of the old building in the square. Mr. Yeats came in late in the afternoon, so was asked to dinner during which Henri came in to talk over Group exhibition matter. Dolly suggested Schofield's name and we jumped at the idea. Delivered drawings to Scribner's (for "Luck of His Life" Gaboriau)....

June 18

Wrote to Schofield, asked him to go in MacDowell exhibition Group with us. Dolly went to Socialist Party Picnic before noon. I worked a bit on Pirate story for Collier's, then went up to the Harlem River Park Casino, and enjoyed the sight of the throng of nice clean dressed working people, men and maidens. The greater number were what the Irish call foreigners, and there was a tremendous crowd all having a good time. A roast ox, merry go round and Dolly selling chances on books where she with Miss Dexter and an energetic Hollander DeYong took in $130.00 (gross). We had a snack-dinner roast beef sandwich, frankfurter ditto and beer. After she got through we went and watched the dancers for a while. Met Louis Kopelin again, once of Call now Correspondent of Socialist Press at Washington. Ellis O. Jones and I had a talk.

June 19

In response to his request I went down town to see Mr. Mar of the Pub. Press, but as he was not in I told his stenographer to tell him to let me alone unless he had something that he could put in writing, that he was wasting my time. Walked uptown. Stopped in Fussell's and had ice cream. This place is connected in my mind with my Uncle Alfred Ireland–my sisters years ago came over to visit in N.Y. and this was the famous ice cream then. He lived with Aunt Annie at the Oriental a boarding house in Lafayette Place. After dinner Dolly and I went down town to Elizabeth St. and saw the illuminations and fireworks in celebration of some Italian Saint's feast days –17, 18, 19 June. I had seen the cards in my walk. We enjoyed it very much–the good natured Italian crowd, fire escapes filled to dan-

gerous point with women and children. Stopped at Allaire's Scheffel Hall and had beer on way home.

June 20

... In answer to note I wrote Mar that he could come any time between 2 and 6 P.M. if he wanted to see me in regard to Puzzles, but he didn't come. Mr. Yeats came about 11 and sketched a pencil drawing of Dolly which was not a success though she worked very hard. He forgets what he's doing (I think). I worked out in the library—our front large room we call the library. We had dinner at home. We addressed post card notices for Branch S.P. meetings.

June 21

Worked all day on Collier drawing and got one well finished. These are in the woodcut style of course like all the rest of the Pirate story drawings have been. Dolly went out to a Ways and Means committee meeting in the afternoon, after "house cleaning" her kitchen in the morning. We went to Stell's on 3rd Ave. for dinner and I ate a big supply. Then she took car to go up to City Committee meeting and I took a walk. Stopped in to see for the first time the new Public Library Fifth Ave. and 42nd St. Very "marble"ous with plafonds in the ceilings which give opportunities for paintings but are filled with poor colored clouds! Waiting for the day when the artist worthy to paint them shall arrive I suppose. Walked over to 7th Ave. and back 23rd St. looked in on 165 West and locked my mail box there. Seems strange to think that we lived there nearly seven years, one tenth of a long life!

June 23

... The folding bed, enamel one that Henri took out of storage for us, came today, and it was a fearful thing to get upstairs. The men wanted to give up the job and hoist it up the front of the building but I took it apart and it came up but was fearfully hard to manage.

June 24

... Worked about the house and Dolly also worked on curtains and cover for bed, etc. After dinner she went to the McNamara Defense Fund Meeting and said that it was not a great success. This was

546

rather a triumph for Socialists as the Trade Unions ran this meeting with Socialist Party help (by request). Dolly again met Victor Berger, the first Socialist Congressman. He particularly asked for her and gave her a signed copy of his first speech on the Floor of the House. I worked on Pirate drawing in evening. Note from Mar today says he will call!

June 25

Made ice cream today in our new freezer. (Pint of cream; pint and a half of milk; nine ounces sugar; one teaspoon vanilla.) Very quick, less than six minutes, not turning all the time. I had to twist the freezer's handle thirty-five minutes down cellar at 1921 Camac St. Philadelphia. With the jam shelf swinging overhead. I can bring the whole thing back, the old damp piece of red carpet, ingrain, that I used to cover over the finished job. The twist of the wooden stairs going down cellar. The heaving ruggedness of the earth floor, the joists overhead where toward the front and opposite the round furnace I had a trapeze. Out there the gas meter that I so longed to take apart. The hole of mystery under the marble stairs front. . . .

June 28

Sent check to Ada M. Quennell, Sec. of the Committee on Painting of the MacDowell Club Group Ex., entry fee on deposit with Club as guarantee of good faith. It's up to me to collect from the members of the Group.

June 30

In the afternoon I delivered my drawings to Collier's but Casey was out, not to be back till Wednesday next. I walked over and on my way back unfortunately stopped to look at old gas meter in "165" (registered locked 23500). I say unfortunately, for I met Frank Crane and old George Folsom (of the N.Y. Herald while I was there in '98). We had a high ball Scotch at Carlos' on 24th St. and another and then went by invitation of Zinzig the pianist who was there with Gregg to another table (Gregg left) and I there was re-introduced to Tom Powers the excellent fine caricaturist of the Journal, whom I had met one night thirteen or more years ago with Luks, Glackens and (I think) Shinn here in New York on occasion

of my doing football match for the Press, Phila.–a memorable night for me–Well–all this old times recollections etc. and especially the etc. made me forget my home and the Seidel (Mayor of Milwaukee) dinner for which I had paid $2.50 for Dolly and self. I got home ... very drunk indeed and Dolly cared for like a mother or a mother cat with a wet kitten (only this kitten was wet inside). I felt so rottenly ashamed of myself for forgetting our plans of the evening!

July 3

Put letter in Weinstock's box downstairs asking that the roof be repaired, shades supplied, basin in bathroom fastened, stoppers for tubs and paint on floor be made to dry. (It is still sticky.) I stated that I had pictures and frames stored in one of the rooms where the leaky roof put things in danger of damage.

In the evening we went over to Henri's. Dolly had a coat to try on him. She is making at his expense a silk painting jacket. He is deep with Maratta in the geometrical problem of rhythm in construction and design of pictures and form. There is a great deal he is sure and so am I. Maratta claims that it was well understood by the ancient Greeks and Egyptians, etc. Henri says that of course most of "them" would call him crazy to experiment in this line. He goes into the thing with his usual thoroughness. He has a large full length shape black board cloth on canvas stretcher ruled with scratches in the geometric triangulations, dividers, compasses, T squares, etc. I am the one let in to the secret he says as I am in belief with the idea. Many would of course regard him as in his dotage. I don't believe it–he has my entire confidence.

July 5

Reading proofs of Gaboriau story in the terrific heat of the day though I am lucky among the city folks. I work at home in extreme negligé and there was a good breeze through the place all day. Dolly was out on errands and handed over to Henri the coat she has just made for him. There (at Henri's) she met "old Stein," Zenka S., and was joyfully greated by Stein and brought her over to see me. I was glad to see her, same Stein but the skin on her face is a bit looser. She is making dolls and raffia straw work, poses very little

548

now. A note from McGoodwin says that they have taken C. J. Taylor as instructor for Pittsburgh. This is a first rate choice, a good man.

July 6

Another stinging hot day–but suppose it must be dryer for I have not felt it so much. Reading proof of Gaboriau story. I wouldn't pick it to read this weather, so long winded and with uninteresting mysteries.

In the evening we had Algernon Lee and his wife Dr. Lee (dentist). She is a pleasant German woman who has lived in Russia in her youth. The Henris were also guests. He is foolish with the heat, letting it get the best of him. After dinner the Roberts came. On account of the extreme heat a man and woman in a small furnished room opposite the room in which we sat, front, were in extreme deshabille. It was interesting to watch Mrs. H. as she looked at the man (finally naked) and tittered. Mrs. R. who should do better merely imitated "Marjory." This all occurred with the full knowledge of the people observed. I am in the habit of *watching every bit* of human life I can see about my windows, but I do it so that I am not observed at it. I "peep" through real interest, not being observed myself. I feel that it is no insult to the people you are watching to do so unseen, but that to do it openly and with great expression of amusement is an evidence of *real vulgarity.*

July 7

A relief from the past five days' terrible heat came this morning after a dreadfully hot night. Dolly has started to make me a lot of China silk shirts which will be a great comfort. I was going to say luxury, but, I think, that the things usually *called* luxuries are necessities forbidden to the "lower classes." There are really two sorts of things–necessities and absurdities. A horse dropped on our street today. They worked over him for two hours. A veterinary doctor attended with hypodermic needle, many with kind hearts helped but finally the patient gave six or seven leaps (lying on his side) and hurdled into paradise. His body lies in the gutter all afternoon and evening and through the whole night. Swarms of flies use him for meat diet and then buzz over to the fruit stand and wash his juices down with lemonade and soft drinks, cherries, apples and such. Dolly and I took a walk after dinner. Broadway–stopped and had ice cream.

July 8

The weather today is gray and cool. Short letter from Nan who is in London with our Uncle Wm. Ward and family.... Nan wants Mr. J. B. Yeats our friend to send her a letter of introduction to W. B. Yeats the poet (his son). She wants to give it to a friend she made on the steamer going over.

July 11

Terrific heat today. I worked with not great steadfastness on a drawing (Gaboriau). Dolly sewed (her usual indomitable energy) on another silk shirt for me. And at the end of the day we went out to Scheffel Hall (Allaire's) to dinner, where we each drank three glasses of beer with our meal and I for one suffered for it. I had a poor night's rest. We took a walk after dinner. Stopped at Henri's, they out. We watched hundreds of men and some women sleeping out on the grass in Madison Square. The heat was terrific.

July 13

A note from Walt Kuhn says that he can't decide on going into my group at MacDowell exhibition. The weather today is much cooler but I did not get down to my work. Dolly went to distribute papers and sell books at a street meeting at noon time. We took a walk in the evening and stopped in to see Mrs. Lee at the Hotel Martha Washington. Mrs. L. is looking very well but Dolly seemed to feel that she is failing a little in health. She has been back about six weeks from St. Louis, Mo. where she passed a year with relatives. She referred to one of them as a physician. Her maiden name was Gatewood, from Western Virginia (Henri's antecedents are all mysterious and therefore interesting).

July 16

Working on Gaboriau drawing and waxed the library floor to keep it from sticking as the paint has now quite dried.... Mr. Yeats called in the afternoon. I told him of Simons' request that I write some articles on artists and suggested that he do one and we submit it. He says he will start right away and write something about Millet.

550

July 17

...Gramercy Park is private. Those who live about have keys. It is beautifully kept with a high iron fence about it. I outside saw pretty ladies in morning dresses cool and white with crossed knees–and very handsome prettily filled stockings.

July 18

Mr. Yeats came and read me his short article on Millet for the approval of the "Coming Nation." I liked it very much and took a couple of hours off to go around among the picture stores to find a cheap reproduction of Millet's "Sower" but couldn't find one. Will have to send a brochure that I have. I hope that Simons will like Mr. Yeats' article and will want more. Dolly went to a street meeting at noon. Finished up drawing for Gaboriau story and after a bit of going over by daylight will take them around to Scribner's tomorrow I hope. Met a young Socialist reporter on The Call ... on the street today. He says he saw my Triangle Fire cartoon reproduced in a paper from Australia or some out of the way place. It is certainly my most successful work judging by publicity.

July 19

A roofer (contractor) came to look at the leak in the roof. Reported that it comes from the fact that the supports of the water tank on the roof are broken and leak comes through the casing of tin on the tank. This looks serious to me as there are a couple of tons of water in the tank. I delivered my drawings to Mr. Chapin of Scribner's today. He seemed pleased with them. They are cheap enough–that's sure! $30.00 each. Miss Cowles came at 2 o'clock and I gave her all the afternoon at a lesson in etching. Dolly had a street meeting a 14th and University Place. Vaughan speaker. I was at a bookstore in the neighborhood and stopped for her. She was busy trying to sell pamphlets to the crowd and was glad to see me. I picked up a few etched illustrations by Leech. We went to Allaire's Scheffel Hall for dinner. Then Dolly went up to Committee meeting and I sent off Mr. Yeats' article on Millet to "Coming Nation" with copy of two pages (mine) of Millet's drawings. Walked after posting the parcel to the C.N. and finally stood at corner of 23rd St. and Third Ave. and watched till I saw Dolly coming on surface car. ...

July 20

Miss Cowles came this morning and I gave her all my time till 4 o'clock P.M. and charged her $10.00 for her lesson both days. Cheap enough I hope though I feel quite humble as to my ability to give help at etching. The technical masters are always getting the best of me. I'm so long between "etches." Took a walk before dinner. Dolly had a street meeting at Park Row today. Brown of Maine speaker. . . .

July 21

Dolly at noon meeting at Broad and Wall Sts. Speaker, Chas. Solomon whom Dolly says is a great success, held a crowd of nine hundred people all the time. . . . After dinner at home we went to Henri's in the evening. There came Potts who said he had called at 155 E. 22 (our new place) and found us not in. George Bellows came over later and we had a right pleasant evening. Dolly and I went to Allaire's afterward and had a couple of glasses of beer. The weather these days is making amends for the fierce treatment we had last week. It is beautifully coolish.

July 25

I walked on the East Side of town down to the Battery Park where Dolly was having a S.P. meeting. Algernon Lee, speaker. I enjoyed my walk a lot. Stopped in [Hamilton] Fish Park and watched children on swings. Also little ones trying to climb up to get their thirsty faces above the patented "water saving" cocks on the free drinking fountains. Stopped in at "Call" office but MacDonald, editor, didn't come though I waited till nearly 1:30 for him. Came home from Battery with Dolly. In evening I started and nearly finished a drawing for "Call," cartoon on Burns the detective as an artist with the magnificent defamatory "portrait" of McNamara beautifully "framed up."

July 26

In the morning I finished up the cartoon for The Call. Miss Sehon called and Dolly delivered the dress she has been making for Katharine, who looked very well and frail in it. Walked down to The Call

552

office with my drawing which was received with warm thanks by editor MacDonald.

July 27

Sent off drawing for Mrs. Kauffman's story to "Coming Nation" registered. Stopped in at Harbison's bookstore and there saw a copy of the first book on etching I ever had–Chattock. Told him to write a card to Miss Cowles who might buy it. Borrowed (50 cents), rented rather (my proposal) a copy of Salannes "Treatise on Etching," such a fine bound copy I can't afford to buy it. . . . In honor of Dolly's birthday (tomorrow) we went this evening to Lüchow's on 14th St. to dinner. We had a very pleasant evening together. A very plump German girl and sweetheart at next table–she in black net and red trims and hat, had big thick ankles–side view interesting. We had a bottle and a half of Lauberheimer Hock, very good.

July 28

Am still worrying because I have no tendency toward work–a dizzy head a great deal of the time. Walked down to Bislands, the butcher, with order. Then through Greenwich Village and over Waverly Place to Washington Square. And thence to Bowery and Bleecker. Near here at Barth's I bought a tray and goblets, tumblers, for Dolly as a supplementary Birthday Gift. She is thirty-five years old today and seems as strong and spry and prettier than she ever was. May she live happy twice as long again. Mr. Yeats was paying her a party call when I returned. He read us a letter from Willie Yeats, who says that his company of Irish Players is coming over in the Fall–he with them. . . .

July 29

Walked down town and exchanged a defective tumbler from the ones I bought yesterday. Then wandered as far as East Houston and Mott St. There is a splendid little blacksmith shop on East Houston St. near Mott. I must look at it again for a picture. How many smithy pictures in the world? Left punch to be ground at Klein's, to be ready Monday. It will make a good etching needle. Mr. Yeats was calling when I returned. Dolly cleaning house. Mr. Yeats at lunch. I had bought a couple of crabs of which Dolly is very fond. Stuart Davis called. Still at Belmar, N.J. Collier's have the audacity to send me a

check for $150.00 for the five drawings and border I made for the "Idols Eye" Pirate story. I am red hot about it, but will have to sizzle till Monday. The copy of pictures for Mr. Yeats' Millet article I sent "Coming Nation" came back–reproductions having been made I suppose the article is accepted. He was glad.

July 30

Henris came at about 10 o'clock P.M. He looked like a French "Apache" without collar or shirt, just silk jumper that Dolly made for him over underclothes. She, Mrs. H. was dressed, I believe. We (H., Dolly and I) played cards till 12:30. Dolly won which seems to me eminently just and satisfactory.

July 31

Went to Collier's and after a rather brief argument with Lee, I succeeded in making him promise an additional check for $75.00 on the Pirate story–$225.00 in all. The drawings are used smaller than usual and that is probably his reason for the low estimate. I had a talk with Joe Laub. He says he feels and looks better than on my first sight of him. That fall from the tree in his country place has been a turning place in his physical life. Struggled with Gaboriau drawing which is giving me trouble. I don't draw enough to keep "limber." . . .

August 1

In spite of the fact that they have never deigned to answer my note of a month ago in which I asked for certain necessary matters for the apartment, the owners sent up for the rent this A.M. I went down and had a bit of spirited conversation with Mrs. W. in which we both became too cross for either to feel victorious. She refuses to put up shades, says that they have notified the painters of the floors, and that the roof and tank will be fixed at once. I worked on Scribner drawing, Gaboriau story. The weather is hot today! Very hot! Miss Cowles called in P.M. and I helped her on plates and printed proof for her. . . . Wrote to Abe Simons of the "Coming Nation." Said that I couldn't and wouldn't write an article such as I think he wants showing how art is being democratized. I told him that when propaganda enters into my drawings it's politics not art–art being merely an expression of what I think of what I see.

554

August 2

I turn forty today!! It don't seem to be aged to be forty now that I'm there. My sister Bess wrote me a nice birthday letter. She says Dad will be disappointed if we don't pay them a visit this summer.... I took a very good walk down town on East Side. Passed public bath building on Rivington St. where I must go in some time and look at the bathers. Walked back on edge of East River to East Houston St. recreation pier where the air was full of the "salt" of the sea side. I saw there a big crowded barge of poor "excursionists" who had been out for the day–returning to the pier tugged by a tug. Faces all happy and the band playing and dancing going on until the slow tie up was made and all were ordered ashore–interesting thing to paint.

After dinner at home Mrs. Sehon and Katharine called, but Dolly had to go to the Executive Committee meeting so I entertained mostly by setting forth the beauties of Socialism, ad nauseam, perhaps!

August 4

Short note from L. C. W. (owner), says that he has notified painters of our floors condition and will let us have globes for lights. Dolly has a meeting at Broad and Wall St. so after she had gone I decided to take a walk and as Chas. Solomon is the speaker I walked down to Wall St. and heard first a little Kirkpatrick–then Solomon and he justifies all the praise that Dolly has given him. Young–bright, good talker–solid basis of ideas and information. I was enthusiastic and he held a crowd of fully two thousand along side of Pierpont Morgan's office! Came home with Dolly who had disposed of 75 pamphlets. These make Socialists. We stopped in at The Call office, saw Mac-Donald. Then came home to have tea.

After dinner, as I was puttering about, it was about 10 o'clock, Henris came in with the Roberts. H.'s are going to Monhegan next week. Wonder how she will like such a quiet place, yet she really don't crave a crowd. We walked out–Roberts went home and Henri took us to Allaire's where he ate ice cream, frankfurters, sauerkraut and sarsparilla! Temperance?

August 5

This is another of our festivals. The anniversary of our wedding, ten years at 11 o'clock in the morning, and I know neither Dolly nor I

have a whole regret. We have had ruts to jolt us once in a while but it's all happiness. [*They were married in the Episcopal Church of the Annunciation in Philadelphia by Dr. Henry Batterson.*] We decided to take the day off, and in the afternoon we went to S.I. ferry and trolley to South Beach. We were here once before, 1908 I think. The lower end of the beach has a long line of bungalows and tents. It is very pleasant and interesting during the day but after we had had a good dinner with a bottle of Chianti we bowled and Box Ball and shot rifles at target and then found it rather dull and came home. The bathing seems very good, not crowded, and you can see people separately and in small groups—makes much easier and simpler to watch them.

August 7

We got up rather late and shortly after our breakfast we had a call from Yolande Bugbee–she looks a little taller and has not so much natural color as a few months since. She says she has been working very hard in an office. That next week she is going away and thinks that when she comes back in the Fall she will be married. Don't think she is in love but is tired of the work! At Dolly's suggestion I decided to paint from Yolande. She had on a pretty blue and white dress. I worked all afternoon. . . .

August 8

Sent premium on policy to Wray, Phila. Check from "Coming Nation" for Mr. Yeats came to me. I took a walk over to hand it to him. Told him to answer Simons' letter to me in re an article on Revolution in Art, or something of that sort. At his urgent request I stopped to lunch with him. . . .

August 10

Painted again from Yolande Bugbee and a dismal result after these three days work! I felt dog tired and rather disheartened. I do so poorly for a man of forty years! But then what's the difference? Cheer up! Mr. Yeats called during the afternoon but Dolly entertained him in the front. I went on ineffectively trying to paint. Before one o'clock I "dropped over" to Madison Square to hear Chas. Solomon talk Socialism. I'm sure my conservative artist friends would say that's

what's the matter with Sloan. Too much Socialism. I don't agree with this theory of my present poor efforts at painting. . . .

August 11

On the stump!!! Today I went down to hear Chas. Solomon talk at a Socialist street meeting, with Dolly,–and made my maiden speech being called on to introduce the speaker. A good meeting it was (at Broad and Wall Sts.). The heat was terrific, 94 degrees in the shade– we were in the sun! Took Solomon and Rheinlaub and Dolly to lunch afterward.

August 14

Sister Nan writes from Paris a letter which sets forth her dismal straits alone in that City, without much money and knowing no French. It seems as though she must be stupid. She mentions no reference to guide books, etc. as to fares on cabs, restaurant charges, etc. She is probably doing better than her letter would indicate. Says that the Misses Yeats have asked her to visit Dublin. She hesitates, this because with my family hospitality is really unknown–she can't believe it in others. . . .

August 16

Mr. Yeats climbed our stairs twice. They are no joke to my forty year legs and his are near seventy-six! The first time he came a bit dismal and I suggested that he go right down to Harper's and see the editor. He did so and caught him on the moment of his leaving for three weeks vacation so I feel that I had a lucky inspiration. The article is accepted ($75.00). Dolly left to go to street meeting S.P. at Park Row and Nassau Sts. I walked down town and came up at the finish of the meeting. Horace Greeley's statue in front of the "Tribune" odd–seems to be intently listening to the speaker of the S.P. who is under the friendly hand of Franklin. (I suppose that is who it is intended for.) Dolly and I went to Stell's on Third Ave. for our dinner. Then she went up town to Exec. Com. meeting. I walked a bit. Sat down in Madison Square which was full of silent tired people sitting under the electric lights–boys playing a curious kind of pile on leap frog with little girls sitting on the grass watching.

August 17

Reading proofs of the last of the Gaboriau volumes. At noon I walked over to Madison Square where I found Chas. Solomon waiting for the platform to begin his speech. Finally it arrived and was put up following a Bible Society meeting at the Park side of the street. Solomon talked on patriotism and what it meant to the working class. Told the historical facts of the master class, framing of the Constitution, showed how all or most of our country's fathers were inspired by business interests in their Revolutionary actions. How the Constitution was framed, secret sessions and class, ruling class interests taken care of. Dolly invited Solomon and Rheinlaub to lunch at our home, and we had a good stirring Socialist afternoon. Solomon is young and attractive. Socialism looks good in him.

August 18

Great doing in the labor world in England. Some 300,000 men on strike. The Sun says that England misses the means which (traitor) Briand of France had in the recent R.R. strike–the ability to order the strikers into army service, making them liable as traitors and rebels if they did not respond to the "call to the colors." I walked down town by Sixth Ave. and Broadway. Took with me a cartoon on Labor Wages and the Profit System and stopped in The Call to give it to them. Talked to Joshua Wanhope who is assistant editor, MacDonald away. I also showed him a Suffrage cartoon sketch.... Wanhope thought it a great thing but feared it was too broad to publish. Said he'd speak to MacDonald who returns Tuesday next....

August 19

Letter from Bess, who reminds me that tomorrow is my father's birthday and that I should write to him which is true enough. Dolly and I had been speaking of him a day or two ago, thought his birthday had passed. Dropped in at Harbison's on 23rd St. on my way back from The Call (where I had taken a cartoon on the English labor situation which he had me make general by removing the flag from J. Bull's vest). At Harbison's I found a lot of interesting art stuff. Spent $3.00. Fred King came in while I was there. He's on the scent of lithos, etc. I found an interesting book on Degas and another on

558

Constantin Guys–this last a revelation–personal expression. I had only seen one or two examples.

August 20

Dolly and I in the afternoon took a street car ride to Classon's Point on the Sound. A treat to the eyes, not too many bathers–so that one could get a fine understanding of the life about the blue waters of the Sound. Back of all, rocks on the shore. Prendergast would like it. A fine girl diving coming out of the water with her wet skirt gleaming like a water snake skin. I enjoyed so much through my eyes. Dolly not feeling very well, she has a cold. We came back by 7 o'clock and had dinner at Singer's on 4th Ave. German restaurant, very good dinner.

August 22

Dolly's cold is no better.... George Shoaf who is a reporter and investigator in Los Angeles for "Appeal to Reason" has disappeared– foul play is suspected. He was working on the McNamara case (of accused dynamiting of L.A. Times Building). He is said to have had important evidence in re that explosion derogatory to "Gen." Otis's part in the matter.

August 23

Worked on Gaboriau drawing in the morning and painted from "old Stein" in the afternoon, and I enjoyed it with that sort of wan enjoyment which comes from an attempt to paint. It seems to be a promising start....

August 24

Worked again at illustration in the morning and Stein posed in the afternoon. I went on with the picture started yesterday (she sitting on edge of posing stand which is covered with a large turkish towel, one stocking off, one on). I don't feel very much elated over the work. E. W. Davis and Mrs. D. came to dinner and as usual Davis was very interesting. He has the Socialist idea but is busy making money and stands staunchly back of his boy Stuart who is doing good work in paint. Mrs. D. and the boys are living at Belmar, N.J., this summer. We are invited to come to stay a few days, Monday Sept. 4. A

hard rain came up before they left. Had to put bucket to catch leak from roof.

August 26

Started a picture of Bowery, rainy night–memory of a walk I took last night. Saw a poor wretch drunk, decrepit and drivelling mouth dripping strings of saliva, hat off, in a cracked cackle cheering the "stars and stripes" hung out over a cheap eating house. Went with the Roberts's to Mouquin's where we had a nice dinner and pleasant time. After which came to our place and spent rest of evening.

August 29

Painted on the old canvas of Yolande singing. It rained quite a good deal during the day so that Stein did not come to pose. I was just as well satisfied.... After dinner we went up to Miss Sehon's where we had a nice evening playing cards. I met Mr. Leicester Sehon, Katharine's father, for the first time. He is a very nice man, Kentuckian, knows all about the quality of whiskey, and thinks that Socialism is a good thing but will "hurt individuality"! Just fancy our present system as an encourager of that quality. Of course persons are warped, maimed, coarsened, contaminated, defiled, to various degrees by the fight with starvation....

August 30

... Mary Wall called to say good bye. She is going "on the road" with the "Chorus Lady." Her sister and she go tomorrow. They open in Middletown, N.Y. tomorrow evening. I wish them luck, girls, still children. In the evening after dinner Dolly went to Ex. Com. S.P. meeting and I took Elizabeth Hamlin to the Acad. of Music 14th St. to see "Resurrection" by Tolstoi dramatized. It is cheap to go there but we were surprised to find how much we enjoyed the play. It has Socialism in it! And I clapped loudly and was not by any means (alone) in my pro-revolutionary applause.

September 2

Working on paintings, touching here and there. Wrote to Henri who is at Monhegan Island, Maine. Have had two letters in "her" handwriting purporting to be from "him." H. spent many happy weeks on Monhegan with Linda in 1903 (I think that is the year). It

must be reminiscent but I suppose having had three years of second wife he is inured to all such echoes of the past. Dolly went to tea at the Women's Union Club. She brought Dr. Gertrude Light home with her to dinner. We sat at table a long time, until 10:15 o'clock. The talk was of interest to us,–Socialists.

September 3

Working on a new Scribner drawing during the day. Mrs. Maupin, Socialist and magazine writer full of talk, talk, came with a sister from Phila. and invited themselves to take tea. What they probably wanted was to be asked to dinner! This is what is called at this time "nerve." It is unnecessary for me to say I dislike Mrs. M. After dinner the Sehons called and while they are unaware of the class struggle they are very nice and we had a pleasant evening. Mr. Sehon is interested in books and we after a while played "Coon Can" the card game which Henri showed us.

September 4

The Call Labor Day issue is out. They use one of my cartoons Otis and Capitalism admiring the work of Artist Detective Burns, a defamatory portrait of McNamaras. But I'm disappointed as they used not one line of caption, just chucked the cut into the page over a bunch of advertisements. We leave for a visit to Davis's at Belmar, N.J. today.

September 5

These next days all spent at Davis's at Belmar. A splendid time so pleasant to be entertained at a friend's private house rather than to live in hotel at Seaside. I did a very little sketching. Made one rather large one of the sea, gray day, which seems right interesting for a first attempt at such a subject.

September 8

Today and Saturday Stuart Davis and I had great fun. An old hulk, ribs and keel or rather worm eaten remains of them is ashore. Many copper bolts have been taken from her in her history along the coast, they say that people got 300 pounds of copper from her while she (or rather as there is so little of her we should call her "it") lay on shore at Avon. Stuart and I worked like heroes and got two or three

long keel bolts, solid copper, also some smaller copper spikes, bruised and banged up my tender feet and hands but I enjoyed this salvage very much.

September 11

Back from Belmar with Davis and Mrs. D. in the morning. End of a fine outing. Feel much "set up" and so does Dolly. A Mr. Beoury or Beaury for the "Bookman" took a copy of my night roof "Peeping Tom and Wife" for reproduction in article. "Painters of N.Y. Bohemia"! is the article. He is to send a photographer to take picture of Tenderloin "Three A.M." also.

September 14

Walked over the Williamsburg Bridge to Wms'bg. Brooklyn—for the first time over this. Fine air and bigness of feeling to be had. Strange so few people there to seek it but the need of the search for work and work itself and foolish search for pleasure keeps them away I suppose. . . .

September 15

Letter from Simons "Coming Nation" in relation to illustrations for serial story (with a list of suggestions for pictures by the author!). Worked on Scribner Gaboriau drawing during the day. . . . I went in response to a post card from Ellis O. Jones to Scheffel Hall for dinner with a small group of Socialists. The proposition is to meet at dinner every Friday. I enjoyed it much as one enjoys squeezing a painful boil and yet I think it was a good thing and will be repeated. Those present were: Jones, Art Young, Gollomb, a cartoonist named Rockwell, and myself. After dinner we went to Arthur Young's studio at 9 East 17th St. and stayed till very late, nearly one o'clock. More talk, argument. One subject, Art,—I got wild at their views (Jones and Rockwell had left before). Dolly went up to 84th St. and did work on the Debs Meeting.

September 16

Started the last drawing of the Gaboriau series today. . . . I walked out toward evening. Everything fine in the city. The light has that sad tinge that comes with early autumn. All beautiful but with poignancy. The time of year to die. I must feel this final touch of life some day.

562

I hope it is a day in autumn. Dolly went up to 146th St. to help Branch 10 at a meeting. Solomon was there, speaker. I wrote a letter yesterday to The Call, to score Morris Hillquit who wrote a nasty open letter to Chas. Edw. Russell and deliberately misconstruing a paragraph in Soc. Review in which Russell says that a proletarian movement must have nothing to do with the "game of politics" (not political action but the dirty game).

September 18

Went for a walk. Delivered Scribner the final drawings for Gaboriau novel which were received O.K. Chapin gives them very little attention, no criticism, perhaps because they are done at a bargain price. ... Met Aunt Mary Sloan at the Penna. Station. She is to pay us a visit for about a week. After dinner time Kitty Ullman called. She says she is working for the Carbonn Co. at 148 W. 23 addressing envelopes etc. She looked as pretty and as well as a young girl. Dolly thought her a bit nervous. I made a drawing for the Debs Meeting poster today. A gift of course, to Local New York Socialist Party. Aunt Mary says that my sister Nan is expected back from her trip abroad today in Philadelphia.

September 21

Gerber, Organizer Local N.Y.C., called with my Debs Meeting drawing for my suggestion as to engraving. I told him I'd have it engraved and he left it with me. We had a hot argument about Hillquit's letter to Chas. Edw. Russell. A lot of exhausting unnecessary rubbish we talked. I was tired and ashamed when it was over.

Dolly and Aunt Mary went out shopping in the afternoon. I took the drawing to Walker Eng. Co. and they are to make cut for it for less than $10.00. Dropped in moving picture show on Third Ave. Stuart Davis called, followed by Mr. Yeats. He was disappointed to find that Nan had not gone to Ireland to see the Misses Yeats. We had a letter from Nan today. She's home in Fort Washington, thinking of taking a studio in Phila. this winter.

September 23

Got the cuts from Walker Eng. Co. and sent them to "Coming Nation." Also sent drawing for "Blood Will Tell" and bill for the two serials and engraving. $7.50–3.50–7.50–and engraving 2.68. Dolly and

Aunt Mary went out to see the town this afternoon. I took a walk and went into the new Public Library. Saw Mr. Weitenkampf and had a chat with him. We all (Aunt Mary and Dolly and I) to Scheffel Hall for dinner and afterward I saw Aunt Mary to 9 o'clock Phila. train. She's the typical "good soul" of conversation. A life so narrow it would be in a draft in a lemonade straw. May God forgive me for having been thankful that something prevented me from having such a life. And Dolly! she, on the streets in argument and friendly chat with policemen and selling her pamphlets, attending committee meetings and busy as Organizer of Branch 1. Then making dinners and beds and love–she's living some! She went to Central Committee meeting tonight.

September 24

Dolly busy for four hours cleaning the house. . . . I bought a copy of Oscar Wilde's "Soul of Man under Socialism." I had read it long ago but want to read it again. I watched a suffering woman–a girl in front room opposite who has been there for about three weeks, young man who comes in the evening–not there this afternoon. She went out and got a big tin of dark beer or stout and drank six large tumblers of it! Jibbering and weeping with a rage she nursed–maybe he has left her. Finally about 7:30 she shut the window, which seemed strange. She was in her petticoat when I saw her a few moments before–saw her take off skirt. I wondered if she turned off the gas to die! None of my business? Dolly came, cooked spaghetti for dinner.

September 25

Across the street the room seemed deserted till toward evening when I saw the young fellow narrow faced, slim nose, raw amber hair with tufts forward in the proper tough pretty manner. The girl was out of my vision but he was talking, raging.–Packed two suitcases with his clothes. I saw him ransack the place sorting his from hers. Then he disappeared. She came to the window disheveled and drunk (the cause of his anger I suppose), then threw herself on the bed, on the mattress–he had stripped it of sheets. Light left burning.

I went to Rand School where Dolly had worked all afternoon on the Debs Meeting addresses. We had dinner at Singer's and took walk. Went over to look at the renovated 165 W. 23 (our old home) all changed, furbished–ready for the seven other devils! When we came

back a huddled mass on the bed opposite showed things the same. Then he came back–sat at window, looked at girl on bed disordered, her thigh bared as she restlessly turned in her sleep. Then he took off his coat and turned out the light.

September 26

Sent check for E. Lansdowne taxes. $1.20 School, $2.20 Twp. and State to W. H. Garrett Twp. Treas., Upper Darby, Pa. Dolly out before noon on S.P. business. Street meeting didn't pan out as speaker didn't turn up (Dan White of Milwaukee). She spent the afternoon working on the Debs Meeting tickets and mailing, at 84th St. Phoned me and stayed uptown. I went out to dinner at Martin's a small chop house on Third Ave. Then took a walk along the Bowery and across Rivington St. to the East River, then by zigzag route through the East Side home. Dolly arrived shortly after I did. The couple opposite seem to have patched up differences and are happy over a can of dark brew of some sort.

September 27

... When Dolly was still out John McGready called to ask her to come over to Brooklyn as Margaret her sister seems to be threatened with pleurisy. He left. Dolly came home about 11:30 too late to go over.

September 28

Dolly left as soon as possible to go to Brooklyn. She called me up later in the day and told me that she had telegraphed Miss Pope not to come to dinner as engaged–but should Miss Pope come I was to take her to dinner. I went to noon meeting, Madison Ave. and 23rd St. I intended to just deliver books to Mullin but got into the thick of trying to sell booklets and stayed till meeting ended at 3:30. Horatio Winslow whom I had met on Vlag's East River launch trip came by. He is now editing the "Masses," Vlag's paper. Miss Pope of course came, and would not go out to dinner. She said Miss Brewer was alone and she'd be glad to go back to her. I walked down to 11th St. and Third Ave. and had Italian dinner in a real Italian dining room.

September 29

Working in a rather desultory fashion. I have a bad headache today. It may be from the wet weather or just perversity and peevishness. After making myself a dinner of rice–I went over to Brooklyn to Dolly's sister's and there found Margaret some better and Dolly looking very tired, so I persuaded her to come home. . . .

September 30

Henris are back. H. came in afternoon (late) to ask me and Dolly over to look at his sketches made in Monhegan Island, Maine. After dinner we went over. Two hundred and sixty panels 12 × 15 inches!! In less than six weeks!! And such wonderful things. Beautiful sunsets, and woods, interiors. Phoned in response to note from Collier's. Promised Pirate story drawings for the 14th Oct.–("Friend of Man").

October 3

Went to Scribner's and had my last $120. check stopped. I have mislaid or lost it somehow. Took a walk, stopping at a book store, and got a copy of Meredith's "Diana of the Crossways." Dolly went to street meeting at the Battery. I went to the Bronx Zoo and made some sketches of an Indian elephant, getting ready for a story (Pirates) for Collier's. After getting our dinner Dolly went up town to a Women's Committee Meeting. While she was gone W. S. Potts called and he and I had a pleasant evening chatting and playing a game of Coon Can or "Rum" as he called it. Dolly home at 12 o'clock. We then had tea and sat up till nearly 2 A.M. when Potts left.

October 4

Mr. Yeats called, said he had had a cold not bad but enough to keep him in the house. He is enthusiastically reading in preparation for some Art articles. Son William B. Yeats is in Boston and doing fine. Great audiences flock to see his Irish Players in Synge, Yeats and Lady Gregory plays. Y. (W. B.) will be in N.Y. on the 10th prox. . . . Young Juley, photographer, called and I delivered him painting "Three A.M." for reproduction in article by arrangement with Mr. Beaury, who called here some time since.

566

October 5

...Edward Epsteau of the Walker Engraving Co. asked me into his office to talk about Socialism. He said he was a Socialist! and proved conclusively that he was not. He has some conservative radical ideas— but does not vote. Miss Lawrence came in from Englewood and brought some quinces and Japanese pears which she and Dolly put up into jam for me! ... Dolly had been given tickets to see "Rebellion" a play by the late Jos. Medill Patterson, and though I was starting on a bad throat we went out and I am thankful that we did for it was a fine thing! I have not enjoyed anything so well for a long time, a great play. Young Irish girl married to a drunkard, the priest insists on reconciliation. A good man appears, she loves him. The husband slips back of course, baby dies. Finally comes the Rebellion of the Girl against the Church. She declares her intention of getting a divorce. Came back to feel very badly. My throat seems to be under its usual bronchial siege.

October 6

Still feeling badly with cold in my throat. Did not get up till noon. Dolly went to Wall St. street meeting. She said that George Kirkpatrick was very good in his talk today. Solomon also answered questions. I tried to work on Collier's drawing, Pirates, but couldn't get up any steam. Dolly came back about 3 o'clock or thereabouts and Miss Sehon called. We had lunch, then Dolly went up to 84th St. Headquarters and worked on Debs Meeting tickets, etc. Dinner when she came home at 8 o'clock. "Steam heat" today in our apartment. The first experience we have had in N.Y. with this mode of heating. In fact, I have never before had it in all my years of studio life. I've always run a coal stove with ashes, etc. Its advantages are few but important. We have been chilly for a week and had I had a coal stove that would not have been.

October 7

Worked on Pirate story for Collier's. As the weather is milder today the "steam heat" is recalled and our pipes are cold. My cold is still bad—a low fever and aches. I took a long walk according to Mr. Yeats' principle—and finally came, as near as buildings, etc. would permit, along the East River where the air was fine. On 16th St. I saw that

the street ran right down to the river edge so followed along some Hospital Buildings. Saw the sick through the open doors, thought "how salubrious the situation." Stood at the end of the street looking off toward Brooklyn, enjoying the fresh air and the sight of tugs and a schooner scudding before the wind. Then my eye caught a huge sign to my left in letters twenty inches high "Receiving Hospital for Contagious Diseases–Keep Off." Not a soul in sight, but yet I did not hurry away. I went away with a pretended saunter, I strolled away. . . .

October 9

Took a walk still trying to shake off my cold. Walked over 23rd St. East. The old ship (Stamler) which used to be anchored at 22nd St. Hudson River is now berthed at 23rd St. East River. It is a "Marine Hotel," run as a sort of benevolent Boarding House by J. Arbuckle the Coffee Man. Took ferry to Greenpoint and walked on the L.I. side as far as the L.I. City ferry to 34th St., then home. Miss Lawrence came in the afternoon and spent the night with us.

October 10

Miss Lawrence and I took a walk over the new Blackwells Island Bridge (59th St.). It was full of interest especially looking down on the "Island" where we saw squads of striped coated prisoners going under guard to the southern end of the island, I suppose to get their dinner. One squad of about one hundred with a cripple in stripes hobbling on crutches some yards in the rear, his privilege of infirmity. We saw the remains of a little woods with a stream, and fine rock outcroppings–gradually being blasted, trees and rocks too, by the on-coming city factories. A man down below us there walked through the woods and underbrush with a sling shot shooting at birds and we in the position of the Almighty God . . . looked down on him and knew his works and also we saw the sparrows fall and an old horse drink and ducks and geese in sunshine. Dolly at Battery saw a man jump off into the river. Miss L. left late in afternoon.

October 11

. . . Mr. Yeats came with Sneddon who has just returned from his trip to England and Scotland. He said he was glad to get back to America and that he had surprised himself by vigorously defending

568

these States whenever attacked by his countrymen, Scotch, or the English.

The great news is that Wm. B. Yeats is to be at Petitpas' tonight and Mr. J. B. wants us to be there to meet him, so we went to dinner there and about 8:45 "Willie" arrived. Looks just like his photographs, and as his father had told us he talks a great deal and interestingly. Mrs. Roberts and Billy R. and another young man of the same name but no relative, who said he was a Socialist, Sneddon. Schenck (the "Buccaneer" as old Mr. Yeats calls him), Fred King and a Miss Squires who "just wanted to see young Mr. Yeats because old Mr. Yeats would like it." The Chapmans had an attack of fear that they would seem to lionize W. B. Yeats if they waited too long so they left when he did not come fifteen minutes after the time he was expected.

October 12

To Henri's in the evening where he tells me that I have been elected to membership in the MacDowell Club. I am not enthusiastic but I suppose it is my duty to pay my dues. We played cards till nearly 12:30 then talked Maratta colors till after one A.M.

October 13

We are wishing that our one day of steam heat had not been so unique. We have had none since, perhaps we did not show sufficient gratitude for the landlord's mercy.

October 15

Henris came late in evening. They had been first to hear a lecture by Emma Goldman. H. is a great admirer of her, I think that some political action with its educational result on the workers will be better than pure quiet education. All helps though! We played cards a while.

October 16

In the afternoon I delivered my "Pirate" drawings to Collier's. Lee liked them, price $225.00. Plenty on their own merits but comparatively cheap. They pay Maxfield Parrish $500.00 for a cover, so Joe Laub says. Old Joe Laub has just got back working again. It

appears quite likely that he has had a stroke of paralysis! Could not talk, lost use of his hands. He seemed a little dazed.

October 19

Went down to The Call twice today, once to take my mss, for the cartoon and again with a graver to cut out some botched spots in the cut. I had to "blow up" on the subject of the G. Nye cartoons which they have admired so much and which are vile but strong, like ordure. We went to Petitpas' as Henri's guest this evening and stayed quite late. Mr. Yeats grouchy, impatient at Henri's talk on sociological and painter's science. . . .

October 21

Today's Dolly's busiest day! though she has had many lately. The Debs Meeting tonight. She is in charge of all the ninety-nine girls who are to take collection and sell pamphlets, etc. . . . In the evening to the Debs Meeting. I had a box and my guests were Mr. and Mrs. Davis, Henris and Roberts's. All came. The house was crowded! People were turned away, some had been sold tickets!! Debs is a remarkable figure tall, gaunt, stooped, large hands and feet. Some parts of his speech run off too glibly–he talks hundreds of evenings in a year consequently some of his phrases are too often on his tongue. But when he let loose on Burns the private detective and McNamara case he showed where his power lay.

October 22

My cartoon "Loyal to the Leeches" in The Call today. They announce it for a campaign broadside as well. The writing below it is also my work and I'm more eager for praise about it than the drawing.

Tonight a very interesting thing. Henri took Mrs. Roberts and we Sloans to hear Emma Goldman speak on Maternity. I was greatly impressed by her bravery and clear thought and untrammelled point of view. She seems as an Anarchist to have few differences with the Socialist but I suppose these few differences are of great importance. A henchman, Breitner, was strongly anti-Socialist. There seemed to be particular stress on anti-religion and atheism. I wonder if in order to wake up the great working class to a sense of its wrongs and its "rights," it *is* necessary to destroy its faith in a God! Miss Goldman

is small stocky strong and earnest, almost in fact is handsome. A wonderful character, hounded by police for years. . . .

October 23

Worked on Collier's drawing during the day. Dolly went up town to S.P. Headquarters. A policeman came who wanted her as a witness in the matter of a row cause by a S. Labor Party man a few days ago. In the evening Dolly had a "hen party" at home while I attended a little dinner at Turkish Restaurant where Chas. Edw. Russell was the guest and where there was talk of what to do to help build up the Socialist Press and Magazines. Russell, Gollomb, Hertz who runs the "international," Hyman Strunsky, Larric on the Herald, Art Young, Michaels McMahon of the Liberal Club. Dolly's guests at home were Mrs. Chas. Edw. Russell, Miss Thompson, Miss Light, Mrs. Bruère. I brought Chas. Edw. Russell home to Mrs. R. at our place but everyone left so that only Dolly, Art Young and I remained. We talked things over with Young. Young don't care for women. I have heard that he was married but no mention is ever made by him to me of the fact if such it is.

October 25

Today's Call announces that owing to an "unfortunate accident in the press room" the cartoon (mine on the Leeches) intended for use in the broadside sheet had been injured and a C. Nye must be used instead. I got a bit warm under the collar, went down and saw Epstein the bookkeeper of The Call. He knew "very little of what had happened to the cut." U. Solomon had told of its being necessary to substitute another. I openly intimated that I did not feel satisfied with the account, or rather the absence of all detail as to the accident made it fishy to me. I felt so hurt (although I had not asked and in fact at first told Solomon I did not make it, for a broadside circular) that I went back to The Call and saw MacDonald the editor who also was hazy as to just what happened to the cut. I am pretty well satisfied that Solomon (who shakes hands like a piece of liver off ice–he hands you his handle) has sidetracked it, regarding it as not suitable–Why not tell me the truth!

I worked on C.N. drawings. Dolly had a good street meeting at Spruce and Nassau Sts. Chas. Solomon got up. Dolly (Anna Maria Sloan) attended special meeting of City Committee S.P. where they

decided (about evenly divided), to print a lot of bill boards "Vote the Socialist Ticket!!" Such bosh. Dolly voted and spoke against it, but the advertising agents who perhaps see a "bit" of graft from the printer, were eager for it.

October 28

Worked on C.N. drawings. In the evening I went to Henri's where came the Glackens's. Glack looks a little less stout. Mrs. G. beautiful in a beautiful black gown. Mr. and Mrs. Shinn also were there. Shinn the same as ever, young in mind but he is very nervous. Everett still fond of me I think. Mr. and Mrs. Roberts also there. Henri showed some of the last Monhegan sketches. Mrs. R. said some of them were "too beautiful"! picking out the worst ones. . . .

October 29

In the afternoon Dolly attended a meeting of the Woman's Committee S.P. I walked part way up with her, she got on car at 55th St. (to 84th). She said they had a rousing meeting. Gerber (organizer Local N.Y.) antagonized the Suffrage side of the affair, but his talk made them unite and Mrs. Block told of donation of $500.00 for Socialist Suffrage Women's Organizer. In the evening to hear Emma Goldman on "Government by Spies," private detective system. The frightful application of these scoundrels, blacklegs, informers in the McNamara case in Los Angeles–which is now under way–at least the jury is being secured. The prosecution trying desperately to keep jurors who declare a prejudice against the prisoners. The lecture itself was not very interesting, but the discussion afterward was. She expressed her sympathy for Czolgosz who killed McKinley, not sympathy for his act but for him, a lone human creature without one friend in the whole world.

October 30

Finished the C.N. drawings, including the 11th installment and took them to the engravers–promised for Wednesday noon. . . . Met Lawson on the street and while talking to him Jim Preston came along. Walked up as far as 28th and B'way with Jim. In the evening on a sudden impulse Dolly and I went to see "Disraeli" with George Arliss in the role of the English Premier. A very interesting play and Arliss

"George Arliss in Disraeli"

was most splendid in character. The costumes (about 1870) were very fine indeed. Du Maurier and Keene period.

October 31

A great fleet of battleships is in the river. Tomorrow and Thursday there are to be great naval reviews. I had an idea for a cartoon this morning so got at it and made it. Took it down to The Call and saw MacDonald and Wanhope. They say they will use it on Thursday morning. I walked back as far as the Williamsburg Bridge, beautiful in the early evening (gray day), under the bridge were booths lit by torches. Dolly made a good vegetable dinner at home. Then she went up town to a Woman's Com. meeting. Henri and Mrs. came around. He said he needed to play cards but as Dolly was out and Mrs. H. don't play, we talked social questions and then the Maratta pigments and the various color themes which they make possible. I wish, so does H., that we had studied music harmony. The colors and musical scale are perfectly parallel. A color can be made "dominant" and chords can be determined as in music. Dolly was offered Organizer-

ship of Woman's Suffrage Socialist Committee. A salary goes with it. She declined the job but felt more than gratified that her work during the past year should have been appreciated.

November 1

... Bought a copy of "Brand" by Ibsen, which I want to read. After a good Hamburg steak dinner at home, Dolly went to an Exec. Com. S.P. at 84th St. and I took a walk. Stopped in Public Library and looked at the magazines. They seem to be doing poorly. Took a look at 14th St. opposite Tammany Hall. All sorts of shows, moving picture and vaudeville, diseases of men museums. Social ills walk the street and old Tammany Hall, red brick, glares at it all.

November 2

My cartoon on Naval Review in Call today. . . . Started a picture of Night, Fourteenth Street–Tammany Hall lit by glare from moving picture theatres. Mrs. Maupin called, going to Alabama Single Tax colony. In the evening Dolly stayed at home and I went aboard a taxicab with Henris and Roberts's to the new MacDowell Club gallery. Fine room it is, splendidly artificially lit walls. The exhibition, the first of the series of groups to be shown there this winter. Henri's full length of Mrs. Becker (Miss Dix) is splendid–black velvet and furs. Met Mrs. Louis Anspacher who was Kathryn Kidder actress. She is getting up Shakespeare tableaux for December. Asked Henri and me to go in it. Met Jonas Lie painter and a good one, his wife is a charming French woman (I think French), she is the kind I can talk to. Most of the women met at these affairs I find freeze me up.

November 3

Mr. Yeats, who has been rather less attentive to us than usual, called today. He has been quite busy, had some pencil portraits to do–one of J. P. Morgan's niece. He went with Bell to see the "Scotch" Players in "Bunty Pulls the Strings." He left with Dolly at quarter before noon–she had a good Wall St. meeting. Chas. Edw. Russell spoke followed by the young wonder Chas. Solomon. Big sale of booklets. I painted again on my Fourteenth St. picture. I think it is coming through. Dolly went to a tea given by Mrs. C. E. R. Russell at the Liberal Club 19th St. She met Mrs. Fremont Older of San Francisco, a leading Socialist woman, wealthy, and Dolly liked her.

574

J. B. Larric came to get points from me for a write up in Coming Nation. He is a Socialist and a great bore–college education but still a gamin of N.Y.C. Every phrase he used is trite. He may have ideas but they could never be recognized they are so dressed up in tattered, cast off garments. A Mr. Marsh [*Robert McCurdy*], nice good looking gentle Republican, called to get me to vote for Rep. Candidate for Assembly. I talked Socialism to him. These two callers coming at 6:30 and 8 o'clock soon used up our evening so that we did not have our dinner till 10 o'clock. The Rep. gentleman I liked, he was reasonable but I couldn't bring myself to my vomit again. The Socialist I don't like but the idea is bigger than the men.

November 5

Went to hear Emma Goldman on the "Failure of Christianity" in the evening. I was already quite convinced of the fact and was not much impressed by her talk. I was, however, interested in the questions afterward and her replies were in many ways better than her main address. She has splendid strength and courage, a really great woman she is. I can't criticize her–her admirers, however, like many Socialists and other followers are horridly appreciative of the points in their creed, as they are trotted forth they smile the "ah! isn't that a crushing truth?" smile at platitudes of the propaganda. Just like Socialists, I say.

H. G. Maratta was with Henri and after the meeting we stopped for Dolly who had been at a party at the Rand School of Social Science and then all to Henri's. Where we talked sociology. Maratta is all immersed in his theories of art and form and color. He is a great innovator in these ways. The pigments I'll swear by, and their possibilities are boundless, unguessable.

November 6

Went to Collier's and they want me to draw the color plates for Pirate story so to Walker's where I got blue proofs. Dolly had meeting at Broad and Wall and two others in her districts, but rain shortened them. With Mr. Yeats, Dolly went to a dinner at the Press Club Building given by the Dickens Fellowship, which she reported as very very dreary. She met the Rev. [*Dr. X.*] Unitarian clergyman and real ass, sort of cad–boasting vulgarly. Made Mr. Yeats quite ill and bored Dolly terribly. Mr. Yeats had intended to talk but decided to pass

it up as too late when his turn came. By this means, as he said he could not take up their time, he cut *[Dr. X]* short who could hardly follow and extend his address over long time. I worked till 2 A.M. on Collier color plates.

November 7

My courage mounted to the striking point today and I took on a "watcher" certificate and did duty in this election District 20th (25th Assembly). I found it very exciting in contemplation but quite tame in practice. I met the "Captain" of the District, Republican Mr. Marsh, who had called on me in his house to house work last week. He turns out to be a friend roommate of an acquaintance of mine, Arthur Ruhl of Collier's staff, who came to the polls in the P.M.

Dolly as Organizer for S.P. 1st, 25th, 27th Assembly Districts, was at Rand School. She only secured about a dozen watchers, needed over seventy for these districts. Apathetic voters who have not very much faith in political action probably the real reason. At Rand School I met Gustavus Myers and W. D. Haywood. Haywood is a big one-eyed kind-faced man, who says that his life belongs to the S.P. They saved him and Moyer from being railroaded to the gallows in Colorado some years ago. (Alleged dynamiting.)

I saw a blind voter who marked his ballot privately without assistance by cutting a hole in the sample ballot and putting it as a frisket over the registered one in the booth, then put his mark in the hole in the "frisket." I wonder why he did not ask for assistance? Could it be possible that he votes to suit himself! and pretends to vote for the bosses? Impossibly romantic. My day's work at the polls resulted in a report of eight votes for Socialism which would have been counted anyway, there was no inclination to cheat. Some few came in from reports in other districts (to Dolly). Some split Socialist tickets like splitting hairs, I said. . . .

November 8

Election returns seem encouraging not in New York City but in Schenectady N.Y. Socialist (? he's a clergyman!!) mayor and board of aldermen, etc. This means "reform" but is good advertising perhaps. The Call says that Reading, Pa. is also Socialist. This is not confirmed by Morning Sun, but may be true.

I delivered the color plate drawings to Walker Co. for Collier's

576

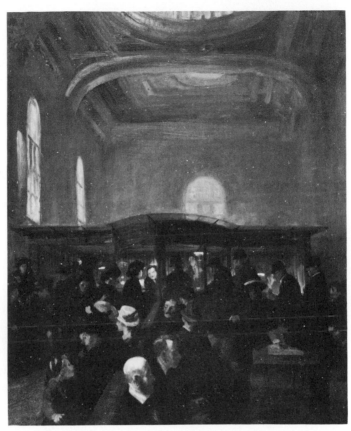

"Savings Bank," 1911

cover today. They were quite a lot of work. I hope that the effect will be good though I am a little uncertain through inexperience. Epstein of the W. Co. spoke of the Socialists carrying Schenectady and gains in the West. Quizzically said that the West was probably a foreign element votes. I said Yes, if he would include the Irish in the foreign element. . . .

November 10

Went to the Savings Bank and put away the new $120.00 check of Scribner's which they sent to replace the one lost by my carelessness in September. Good thing to paint, the Savings Bank. I've had the idea before. Dolly out in the evening at a Branch 1 meeting. Chas. Edw. Russell there said more members should attend the branch

meetings. He's right. I started on Savings Bank interior. Drew with charcoal the figures and planned the composition. Looks good to me.

November 11

Dolly as a treat, gave me Breakfast in Bed! Then as it was late she hurried me off to see the Savings Bank interior as they close at twelve o'clock. So off I hied me and put away $5.00 as an excuse to enter the sacred home where the poor thrifty should stand and sit in awe of the columns and gold and glass which their own money builded. Back then, and after setting the palette (which is no quick job with the present scheme of color arrangement–Oh great Maratta!) got to work on the picture. Dolly at a Woman's Committee meeting (street).

November 12

Hear Emma Goldman on "Art and Revolution" this evening. She was good but here and there demanded too much social consciousness from the artist. For instance, she said that if the great painter (therefore revolutionist) should paint a wealthy lady he would show the parasite covered with diamonds–this is too far, takes it out of art –which is simple truth as felt by painter.

November 13

Strange news–a letter from Miss Jessica Finch says that she has the selecting of an artist to paint the portrait of a millionaire Omaha, Nebraska brewer and thinks I'm the man to do it! I'm stage struck about it, feel as if I'd been told to stand up and walk–though I have painted good heads, W. S. Walsh for instance. The idea of a commission is staggering.

Bauer who has been living on the Palisades and painting all summer dropped in and asked us to come to dinner next Monday evening. He seems genuine. I grow in liking for him. Stopped to see Henri after Dolly had gone to Mass Meeting of Socialist Party for Garbage Driver Strike. H. was out so I went to Cooper Union and enjoyed the meeting which was a rousing success. I felt for the first time I think, the awe and fear which the power of a large crowd of

workmen thus gathered can inspire and that's what leads to the massacres by police and soldiers–fear of this force, unarmed but terrible even without demonstration.

November 15

Working today on the "Savings Bank" picture and at the conclusion of the day's work I feel that it is a good one. Dolly at home till evening when she went up to Exec. Com. S.P. meeting. I took a violent walk at 5:30, four times round Madison Square. I did it in five minutes each round. Wrote to Miss Finch and told her that I'd do the portrait of the Omaha, Neb. millionaire for $1000.00 and expenses. And now the die is cast and I'll wait developments. I almost feel timid enough to say that I hope it falls through. When I was out in the late afternoon Larric came with his mss. of the account and interview with me for the Coming Nation. I don't care for it.

November 16

Painted from Max Sherover, a young Socialist enthusiast, an Austrian Jew, without the religion. Quite young, a friend of ours and has been a great help to Dolly all summer at her meetings in the streets. Asked him if he'd pose, as I feel that in case I get the Millionaire Brewer's portrait I should be as it were in "practice." We went out to dinner to Singer's on 4th Ave. where Dolly and I had a bully time together. Then we went to Henri's. There we found the Henris and young Bayard Boyesen visiting. He has been forced out of Columbia University (Eng. Lit.) and is now "teaching" in the Modern School of the Ferrer Society, 12th St. He is, of course, a professed Anarchist, and it itches him a good deal but he is a nice young chap with great learning who is a great advocate of the Ferrer method of freedom in education, drawing out from the child mind, not cramming in head with authority. Henri was glad to hear of my portrait possibility.

Letter from Schofield asks to be excused from taking part in our MacDowell exhibition group!

November 17

Had Sherover again today. He is not over twenty years old but born in Austria, has travelled all over the Western States, and been a Socialist for six years. I'm painting poorly but will perhaps get the rust off in a few days more. . . .

November 18

... In the evening we went to what seemed to me to be a riot at Mrs. Roberts'. About one hundred and fifty guests. I was most miserable and don't like myself for being so either.

November 19

Dolly had arranged meeting at the Rand School. Mr. Yeats read one of Synge's plays–"Playboy of the Western World." She took him around. He dropped in here to have a cup of tea. I had intended to go hear Emma Goldman but too late, when I decided to stay home. Henris came around shortly. The E. Goldman lecture had been postponed, she was ill. He and I talked. Mrs. H. dozed on the couch.

November 20

Walked out and bought tickets for Yeats' "Irish Players" who arrived in City after some three weeks in Boston and on tour. They play three short plays this week each evening. Stopped in to see Davies but he was not in. Nice letter from Pach in Paris... who has been busy preparing some of the Art Publications there for articles on my work, also Glack and Jerome Myers. We went over to Jersey 427–31st St. on the Palisades to see Alex Bauer. His mother is a fine example of the German American Mother. He is really an Anarchist in thought and a fine fellow.

November 21

Wrote to Pach in Paris. Went up to see G. B. Luks, returned a small panel picture of his. Asked him to take place in our group for Mac-Dowell Club exhibition. He said no. Stopped again to see Davies but he was out.

In the evening Dolly and I to the "Irish Players" at Maxine Elliott's Theatre–and a great evening it was. First and I think probably best was Lady Gregory's "The Rising of the Moon," a thing which was played simply, staged very simply, left me with a gulp in my throat. It should make for Irish freedom if any play can. Next was "Birthright" a tragedy–splendid in the truth and simplicity of the Irish home religion and the other great beast that sucks the blood out of all of us–property. Brother finally slays brother. Those who come to see these plays to be *entertained* are likely disappointed. The

third was also by Lady Gregory, a comedy. Sinclair who played the leading male part was splendid. One of the women had such a rich Irish voice, full throated, deep. After we went to Mouquin's where we met Mr. and Mrs. G. B. Luks! . . .

November 22

Letter from Miss Finch says that the millionaire has not replied to her letter telling of her choice (myself) as portrait painter. Maybe he is getting more special and academic advice in which case it will be all off! I can't bring myself to care a great deal. I still feel quite bashful at the idea of making my debut as Portrait painter.

November 23

I today started to paint a portrait of Dolly–and I had all the trouble that I too much anticipated. She is difficult but I don't cut loose enough. Have so fixed an idea that she is a hard proposition that it stands in my way. Another Pirate story from Everybody's Magazine, to be done by Dec. 6th! In the evening around to Henri's where we found them evidently not prepared for company but for us an exception. Mrs. H. was comically frowzy–really strange how badly she can look when she's messed up. Henri and I talked Maratta colors.

November 25

Another attempt to paint my girl–but the five hours work of the two of us ended in dismal defeat or let me hope repulse. Scribner's is out with the story I illustrated for them last summer "Old Johnnie." The pictures are no better than they should be. American Illustration is at a very low ebb just now. Maybe the lull before some throb of advancement.

November 26

Dolly and I, both delegates to the S.P. City Convention attended the session today. It was interesting but tiring too. Much of the work seems hardly useful but the penalty of self government is that you have to govern to be part of the government. I will insist though that the majority in its action always squashed foolish things (according to my view of course). We came home at adjournment for the day and Dolly bravely cooked dinner, a nice mess of rice with the spaghetti as a sauce from last night's dinner. After dinner, though tired,

we went around to hear Emma Goldman. Her subject was Mary Wollstonecraft and it was splendid to hear her show the brave spirit and original genius of this pioneer of woman's freedom. Her living of her life especially was her most important contribution to posterity. Her intense love passion for Imlay, her despair at his desertion and then the crowning love of Godwin and her death at the summit when a clear road lay before her. Died giving birth to the future wife (second) of Shelley, and author of "Frankenstein." Henris came home with us. He proposed that I ask the rest of the group about taking in Ernest Fuhr who is just back from a year and a half in France and Africa. Bought "Love's Coming of Age" (Carpenter) for Dolly at the Goldman meeting.

November 27

Painted a bit on the Tammany Hall picture in morning. Dolly gave a dinner party to Shinns and Glackens's and Miss Dimmock (Mrs. Glacks's sister). Owing to a sprained ankle Mrs. Shinn and Shinn couldn't come, so we put Henri on the list instead. We had a great dinner. Dolly cooked two chickens with ham! Fine it was! After dinner Miss Dimmock, who had been delayed in her trip from Hartford, Conn. by a railroad accident (none hurt) came and had a warmed over dish. She is a very beautiful big healthy girl, very modern, a free woman in her ideas; studying medicine. She don't smoke her pipe in public any more but she seems just as emancipated without it. We had a violent talk on Race prejudice. Mrs. H. showed her narrow Irish point of view especially against the Jews. Lively time, which I enjoyed and I think all the rest had enough sense to like it as well. Of course this is not good form, one should never speak of anything of importance in company.

November 28

Wrote to Fuhr, inviting him into MacDowell Gallery group. Also wrote to Prendergast, Shinn, Glack, Lawson, Preston–giving dates Jan. 24th to Feb. 6th. Also asking each for share of estimated expenses $20.00 on or before Jan. 1st. Read in paper that the "Playboy of the Western World" was hissed and hooted at Irish Players performance last night. They went on with the play and disturbers, many in the orchestra chairs, were ejected. Poor mis-begotten "Irish-

582

Americans!" In the evening Dolly and I with the tickets I bought two weeks ago, went to see the "Playboy." Positively this is a wonderful work of Art! J. M. Synge has died but this is near immortality for him. The theatre contained hundreds who enjoyed–also there were about fifty persons who came to disapprove, but being dirty brainless cowards and Irish (as I am Irish I'm not biased I hope) the fact that the street outside the theatre had a squad of police ready made them for the most part hold their peace. Occasional hisses in the first part of the play were drowned by clapping applause, but near the end of the last act hisses increased–more applause to counteract it–but as the dramatic ending of the comedy is reached, those who enjoyed were much more hindered by the hisses. Snakes hiss–Saint Pat drove 'em out of Ireland, they say. There are lots in N.Y. and yet the hisses were quite few. One hiss has such fearful power to disturb. I say again this play is great great art. I enjoyed it, Dolly also. Poor creatures who think it makes the Irish love a murderer. By the way, great murderers are always the recipients of bouquets in jail in America.

November 29

Working on first of new Pirate drawings for Everybody's. Dolly out in afternoon. She went to Brooklyn to see her sister, who wants us to come over to Thanksgiving dinner tomorrow–declined. At 5:30 I met Brinley and Henri at tea at Mrs. L. Anspacher's (Kathryn Kidder, the actress). We talked over the tableaux for the MacDowell Christmas festivities. I am to be "Wall" in the yokels' "Pyramus and Thisbe" from "Midsummer Night's Dream." It seems as though there might be some fun in the doing of it.

Dolly after dinner went to S.P. Exec. meeting at 84th St. I stayed home and worked on drawings. She said a man Tohansen from Los Angeles Trade Union Socialist combination was there to ask for the floor at Carnegie Hall next week. Wants funds for McNamara trial out there. His accounts of the nine million dollars which the National Association of Manufacturers has raised to break unions–private detectives sneaking, lying, persecuting, a criminally inclined Grand Jury and all the fearful venom that has been in evidence made it, she said, very interesting to hear his personal account of affairs. The Women of California having just been enfranchised, to be inclined to be rather reformistic not Socialistic, but the count will show.

November 30

Letter from Miss Finch enclosing note from Miss Olga Storz of Omaha, Neb., the daughter of the rich brewer whose portrait I am estimating on–asks me to write to her father stating what "expenses" in my terms, would cover. Wrote–told him that I could possibly finish work in two weeks though of course painting was an uncertain "trade." That expenses would comprise hotel expense and if his house had no proper room to paint in, hire of temporary studio.

December 1

E. Fuhr called and says he will be glad to go in our Group Ex. Stuart Davis called in P.M. His Group Ex. is now open at the MacDowell Club.

In the evening took dinner with the Laubs who are stopping at Petitpas' (in from their country home for the winter). There we passed what should be called a merry evening. Dolly had a fine time dancing after dinner when they pushed back all the tables. Mr. Yeats, with a full outfit of new teeth presented by son Willy the poet who noted with shock the loss of the originals from his father's mouth. Joe Laub silent and not fully himself. Changed after what was evidently a stroke of paralysis. Ellis O. Jones was there, very merry. He is the ideal "cut up." Miss Henry, one of the old regulars at Petitpas', introduced for the first time. Dolly made a great hit with her. Art Young there. Mr. Yeats has a letter from Van Wyck Brooks in which latter speaks very flatteringly or perhaps that's not a fine enough designation, at any rate, very well of me and my work. I can hardly feel that I am able to live up to the imagined standard. Or perhaps Greatness isn't much from the inside point of view!

December 2

A bolt from a clear sky–comes the news that the McNamara brothers have confessed to dynamiting as accused in Los Angeles. Curious the fact that the election there takes place Tuesday, Dec. 5th. It makes one feel dazed. Treachery smells all around. "Guilty" plea accepted–court to *sentence* them on *election day*. Pat. L. Quinlan called to talk about the Irish Players, proud as a mother hen. I was able to go as far as he in my praise of them.

584

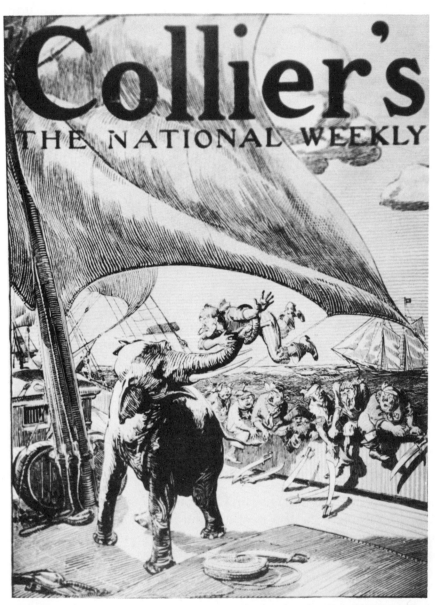

Collier's, The National Weekly, December 2, 1911

December 3

I stayed home and worked on Pirate drawing. Dolly went to hear Emma Goldman on "Socialism in the Political Net." I suppose that's what is the matter out in Los Angeles. There had been hope of electing Job Harriman Mayor (Socialist) but no doubt as the Socialists, quite rightly, have been loud in denouncing the kidnapping of McNamaras (in Indianapolis), the confessions of the McN. brothers will turn the election.

December 4

This afternoon I had a telegram from Mr. Storz, the Omaha man. He accepts my terms and asks whether I can come at once! I must put on double speed and get these Pirate drawings for Everybody's out of the way.

I went around by appointment to Henri's as the bunch who are to take part in the tableaux of the MacDowell Club met there this evening. I went early so that I might tell H. the great news. He was very glad, says I'll do a good thing. Later Brinley, Bellows and Davey came and we had a sort of rehearsal of the clowns Pyramus and Thisbe from "Midsummer Night's Dream." Though, of course, I have to give up my idea of taking part in it. Something was said that led us to speak of our old studio "806" Plays–so H. got out the mss. of "Widow Cloonan's Curse" and I read it to them, enjoying it much myself and I know H. did also. Though when the lines of the part come back to me I feel the shortness of life. Thus at the age of ninety years some events of youth will return vivid, looping the short cord of life.

December 5

Dolly sent for me telegram to G. Storz saying I would start for Omaha Saturday. She also went and did lots of shopping in the way of shirts and collars and socks, for I must look prosperous. I worked on the Pirate drawings all day and in the evening. . . .

December 6

A note from Miss O. Storz dated Dec. 4th repeating her father's telegram of acceptance. Dolly spoke of my job to Mrs. Mailly at the Rand School. Mrs. M. says that Storz is probably the wealthiest man in Omaha. She said too that the people out there are nice kindly

586

sort. I went down with Everybody's drawings and delivered them to Ray Brown who liked them very much–price $250.00, which I am to get in extra rush on account of my leaving for the West.

Dolly and I met at Grand Central Depot where she had made all inquiries as to trains, etc. for me. It can be done with only one night on the train which is good news to me for I don't rest well in sleeping cars. After I met her there we went shopping for my "trousseau à tableau" as it might be called in Stratford atte Bowe French. I have never spent so much on clothes for myself (or anyone else) at one time. Soft hat of velour all fuzzy as is the swellest style now. Two pairs of fine shoes and a splendid pair of high galoshes and also gaiters. A fine new black suit of clothes and very English travelling bag. $78.00 all told with what Dolly bought for me yesterday. This is my stake on the wager that I can paint Gottlieb Storz's portrait!! We had dinner at Singer's and then home to a quiet evening together. We have not been separated for nearly a year now.

December 8

Henris to dinner in the evening. Then Dolly went to Branch meeting. H. and I were not very mutually entertaining. We seem to be waiting for me to go West, tomorrow.... Dolly and I up late packing my trunk. She does the thinking. I just bungle around.

December 9

Waiting the time of departure today. The last hours before going are the worst. One should be etherized till they pass. Z. Stein called just before I left. Dolly and I went to Grand Central and finally four o'clock came and with a good bye kiss I was off. Brave little wife this of "mine." What a word for the purpose, tangled up with the messy mesh of "property."

December 10

Breakfast on the Chicago train. Set my watch back one hour. A gray day, raining a little. Flattish country; dingy factories surrounded by the kennels in which the "workers" live. We all spend our time misbuilding the world and die. One in a thousand has made it worth while to live, the rest waste their days paying rent and toiling for the "owners" of things. There is little difference to the eye in the scrub towns and the suburban towns from towns between N.Y. and Phila. on the Penn. R.R. The farm lands are much more extensive. A

beautiful day, after we left Chicago. Fine clouds, sunlight breaking through. Not cold. Sunday quiet over every place, few people to be seen. Horses and cows enjoying their "day off." West Illinois, fine rolling hills wooded, no snow. Winter seems late here too as well as N.Y.

Crossed Mississippi at Davenport, Iowa. Big muddy river under a gray sky. This crossing seemed to make "the" River exist to me— heretofore a thing on the map only. Actress travelling "loved art"— told her to come pose in costume when in N.Y. Dancer. Mrs. Bert Fisher, the mother of two boys, constant talk. Arrived in Omaha 10:35 P.M. on time.

December 11

Young Mr. Storz, fine red cheeked bright eyed boy of about seventeen years, called at the Rome Hotel for me and took me to the Storz home. Fine house, splendid design, the finest in the city probably. Comfortable inside but rather poor pictures on the walls. Miss Olga is an ash blonde; she has a rather long nose and a short chin. Looks as though she was a little shy but probably well read. A cousin "Lou" is a very attractive and pretty girl. I think that Olga would be more attractive if she just let herself feel so; I think she thinks she's too plain. But the mother is splendid, ruddy cheeks, kindly clear eyes and in the midst of servants (not many though) she longs to do some of the housework herself. Well, we searched the house for a place to paint in, even went to the trouble of about two hours work in the big ball room on the top floor, but the windows are too small, so finally gave that up. Decided to use the south room which is the girls bedroom I think as it has college flags and such on the walls.

Mr. G. Storz, the victim of all this, is a quiet solid man with a fine head to paint. He looks like E. Lawson if E. L. were sixty years and German instead of Scotch. He is just suffering this job to be done, not very enthusiastic and very full of his business. Dinner late in the evening at the Hotel Rome in the Vanyard, like N.Y. cafés but larger. Little latticed booths and imitation grape vines on the ceiling.

December 12

I'm home at the Hotel Rome after my first day's work at the portrait —awfully blue and tired to death. Feel abjectly defeated. Mr. Storz

588

gave me two hours of his time this afternoon but I couldn't get hold of the thing at all. Looking back at it now I don't believe I really tried, only nervously tried to do it! The whole family, rather the boy and Cousin Lou and Mrs. S. all looked at "it" scraped out. And the room was full of reflections from the sun streaming in. I'm done up but I guess tomorrow will start it O.K. 13th is my lucky number.

December 13

Today's battle with the canvas resulted in a draw. I feel better about it–have something started at any rate. Mr. Storz gave me two hours, one to three in the afternoon and he really posed quite well. There is not one speck of snobbery about him; I admire him very much. We had a talk about woman and her "rights" today. He is extremely conservative on the point though he admires Miss Finch very much. Says she is broader than most radical women. The younger boy Arthur I think his name, came in late in the afternoon. He is a really nice boy and seems to have a little interest in the idea of drawing and painting. I'm going to suggest that he cultivate the notion. In fact, I hinted at it to his father. I had a fine brave letter from my Dolly dear this morning. I take it to be one of the reasons I worked better today. Kept quiet at the hotel all evening. Don't feel inclined to see the town till I have the brunt of the work passed by. I did take a short walk. The city has more electric display than Phila. and in proportion much more than N.Y. Plenty of amusements but bars are closed at eight o'clock.

December 17

An interesting day. My work went quite well. Mr. Storz sat for about four hours and like a Trojan–he's a brick! Deserves a better portrait than this one will (probably) be. Oh well! things may turn any moment. I was asked to stay to midday dinner today and it was a fine dinner, not lavish just right. All the family there, Father and Mother, young man of twenty-three (Albert), Louis about seventeen, Olga twenty (?), Cousin Lou eighteen (?), and "the children," boy Robert (seven) and the girl Elsie (eight?). The latter is very pretty.

Supper at the hotel. Had a cocktail served in a demitasse cup! And people about were drinking pale looking tea from the tea pots and tea cups. It had a slight foam on it! Made acquaintance with a young Iowa business man named A. S. Honette. Thought I knew

him but it was only a very striking resemblance to some one, don't know who! At any rate it led to a very entertaining evening spent chatting in the corridor of the Rome. Snow today for a couple of hours but while I supposed it might at last be the Winter of Western Plains it wasn't. I started out with high galoshes but they were entirely unnecessary.

December 18

Seems strange to my ideas of the Great West to be sitting in a hotel room with the steam turned off and a window open two feet and still warm! Today I got well along on the portrait. Two hours' pose in the afternoon. I have the hands pretty well done and the figure looks like his. Everybody in the family seems to like it and I have suggested gently that they have the mother's portrait done. Last night I wrote a long letter to Dolly and lost it! Left it in the Reading Room of the hotel–gone–now somebody knows we love each other! For the finder read it I'm sure for it had my name outside under the Hotel Rome address, and any decent body would have turned it over to the clerk. Made a second drawing for the Coming Nation and will send it tomorrow. "One thing I don't like about the artist business– if you will pardon me–is that they don't leave anything. They die and it all dies with them!" So said Mr. Storz.

December 19

Everything went well and as all are pleased I am to do Mrs. Storz. This is another great Chance. She is fine, some forty-six years, she claims, but she is fresh as a daisy! God give me the ability to do her as I see her–maybe that won't suit her but it will me, and if I'm paid for one I don't care much if I'm paid for other or not. My time is paid for "paid while learning."

December 22

Worked from Mrs. S. as usual, starting in the morning. I get along with her very nicely and she poses splendidly, but the work is not up to scratch. To think of being paid money for stumbling about the way I have done on these two pictures! Mrs. Storz is quite plain with a desire to get into company of "nice people." After her lunch–(I don't lunch) she came up as rosy as could be and looking at the painting she chucked me under the chin! "Don't gif me too much

590

dere in de dupple chin" she said. Their German accent, Mr. and Mrs. Storz's, is of the regular "Wepper and Vield's" sort. "I always like a glas of goot wine after my dinner."

December 23

During last night I was quite sick with a diarrhoea. I was up about ten times and had quite terrific pains. I don't know what it was unless it was caused by the roast duck which I had for dinner. Got up and painted all day as usual, eating no breakfast as that seemed best.

December 24

While I passed last night all right I was up before dawn with bad stomach upset. Hot water I drank and cleaned out the stomach but was no sooner back to bed and asleep when I woke with terrible itching all over my body and found that I had numberless red lumps all itching like fury. I took a bath, first hot then cold and this seemed to relieve me. Very light breakfast of coffee and hot milk and then went to work. Mrs. S. posed and I went along some. She has asked me to come to Christmas dinner with all the family tomorrow noon. She gave me three pairs of silk socks and a box of chocolates as a Christmas present. I had two etchings framed and presented them.

Walked across the Missouri River bridge this afternoon. A fine sight, blocks of ice floating in a winding muddy stream. Flats covered with snow, factory chimneys belching forth black soft coal smoke, an orange and blue sky; the air brisk and very cold on face and ears. Enjoyed the experience immensely. Lunch at the hotel at about four o'clock. Poached eggs and consommé. Nan sent me a pocketbook for Christmas.

December 25

There will be some crowing cocks even in a freight car full of crated fowls on the way to market. This bit of philosophy I noted in a short walk over the bridge 16th St., overlooking freight sidings and South Omaha. A ten cent store manager killed in a fight Saturday night by a young man McGrath "of one of the nicest families" who strolled into the store and knocked over a box of alleged candies. The coroner's jury brings in verdict of death from natural causes! Had it been the rich man's son who died the verdict would have been impossible. Dinner at Storz.

December 26

Letter from Henri, and one from Dolly.

FORT WASHINGTON

DEC. 1911

Dear Jack

It seems so wonderful that you are way out in our great West! What things you must have seen on your journey. I wish I could have taken it with you, to have had the pleasure of much that is new.

We shall hope most ardently to see you back here in time for Christmas, and I can't tell you how desperately dreary we will all be, if you do not come. It will be such fun to hear of all your experiences. I am so glad for you in this—and I know you will "make good." I expect you have been through all kinds of things this first week. Perhaps scraping out many times, but all the while you will be storing up your forces to make the thing in the end. It must be a frightful nerve strain, and I am sure the consequence to anyone would be to grope around like a fool,—but I hope you have not had these discouragements, and that perhaps you are today looking at your completed work. Whatever may have been the outcome of this week, you will come out all right, and I am so thankful this chance has come to you—oh! I hope you leave behind you a splendid thing!

As for my work on the old painting—I have done nothing more, but I am most grateful to you for your letter. I believe I will take your advice and hand it over to a man who rebacks pictures and have him do it for me and let me do all the final retouching of places which have peeled off and varnishing. I got a name of a man from Mr. Repka yesterday and I will have him call.

I have just completed an order for a lamp shade ($20) and have a fan to do next week. I don't mind this kind of thing, for Watteau and Fragonard did fans and so on. The lamp shades are my own idea, and do look so lovely with the light back of them.

Good luck to you Boy!

AFFECTIONATELY
Nannie

DEC 29 1911

Dear Sloan

I'll bet you are doing better than you think—you demand so much more of yourself than a professional portrait painter demands of himself

and so your road is a hard one to travel. I think I know all the troubles you have had–for your letters describe the situations of mind I have so often been in over a portrait. If by the time this reaches you you have not already landed with the portrait of the lady and you are still in the wrangle over it–holding on to one thing while you reach for another–you might do a good thing by laying off your sitter for a day–and have a private go –taking up a new canvas and laying it in just like the old with whatever composition changes you might think advisable–virtually a fresh copy of the one in hand.

It's a job to do but I think you might in the doing of it find out just what is the matter.

The reason one picture does not go as well as another is because there is "something the matter"–some out-of-relation thing which perhaps for imitation sake you hold on to.

As for your sitters having such good faith in Miss Finch's judgment –they are bright for once–for they have an honest man instead of a confidence man, a real artist instead of a Julien Academician, a man of wit instead of a mutt trying his level best to do the thing worth while–and whatever he does will be worthwhile.

Things are still at a standstill as to the group–have not yet the extra man but don't let that bother it is still time and I expect to see a lot of the people inside a week–Glack and the others and may probably get them to suggest some one will see Luks and Davies and will let them open the matter if they like. The thing that bothers me about it is that it looks to me very unwise for me to exhibit (on account of the previous exhibition) because there is a big fight afoot against the idea. However, American Artists fighting hard (pointing towards virtues of Academy). None of the others seeing the drift and none of our own tongue-tied waiters for the safe turn saying a word. So I fear that they may misrepresent my second appearance. It would be very easy to quote the "no twice in same season" clause and overlook the facts of that first group being a makeshift to fill the space vacated.

However we shall have to see how that will arrange itself–I think however if you others will agree to my putting someone else in my place I will withdraw if I can find the one to put in. What do you think?

Don't hurry–I say this because I imagine you would like to be back on the old stamping ground–but this is an important job and worth sticking at until you are satisfied–it may–it can result in your getting a whole series of portraits in Omaha or the west and that would be worth while– and you would soon get so that it would not be such a strain–you are in an unusual field now and it would soon become as easy to you as making a drawing for an editor.

So don't hurry and don't leave the field until everything has been done that is to be done for the present or the future prospects.

About the McD of course I can attend to the business of that and your stuff–if you don't get back in time.

YOURS
Henri

1912

Friday January 19

Train an hour late but there waiting at Grand Central Station is a bouncing little red faced girl who welcomes me back to love and N.Y. City. G. O. Hamlin has been rooming in the front room and Dolly has had Miss Mary Perkins as her company for more than a week. Henris to dinner.

January 24

With Miss Perkins we went to see "Sumurün" German pantomine play. Very fine parts with enough of the musical comedy element to make it a success. The good scenes are good, free from the garish "Broadway" touches which spoil the thing as a whole. It is however a move in a good direction. We went to dinner at Petitpas'. Dolly and Miss Perkins, F. Taylor and I. Afterward T. and Miss P. went to theatre, Dolly and I spent evening at Petitpas'. Dolly danced when the tables were pushed back as seems to be the frequent custom at Petitpas' these days. Dull for me. Afterward we went up to the Laubs' room and my statement that the present system made women parasites got Mrs. L. up in a red rage. Group exhibition at the MacDowell Club opens today. Henri, Glackens, Lawson, Preston, Fuhr, Reuterdahl, Boss and Sloan. Show looks well. I have "Isadora Duncan," "Girl Singing," "Tammany Hall," "Wet Bowery," "Hudson Sky," "From the Palisades," "Scrubwomen in Library."

January 25

Out for a walk, down to Bleecker and Carmine Sts. where I think I have soaked in something to paint.

January 26

Started "Carmine Theatre" memory of yesterday. *["Carmine Theatre," the collection of Joseph Hirshhorn.]*

January 27

Mr. Chester of Buffalo called (from Mrs. Roberts), looked at "Clown" $750., "Cot" $850, "Sixth Ave." $850. Said he would take Mrs. Chester to the MacDowell Club exhibition. In the evening for

dinner Henris and Laubs and Miss Perkins. G. Hamlin went back to Phila. We had a fine old fashioned high jink time "cutting up." Very enjoyable for a change, sort of reminiscent of our youth!

January 30

Worked some on "Carmine Street" picture. In the morning mail a letter from Yevell of the Press (Phila.) asking me to do puzzles for them! More than a year since I had my fall out with them! In the evening we went to have dinner at Petitpas' with the Laubs. Joe seems quite himself again. Mr. Yeats and I got into a hot argument with Mr. Griffin, Catholic Irish twenty years in this country or more, widower well off. He, of course, ran down the "Playboy of the Western World" Synge's play. Mr. Yeats and I defended and finally the discussion became a religious argument. The Catholic Church against art that leads to thought.

January 31

Worked on Carmine Street picture. Dolly and Mary Perkins who is still with us (and a nice cheerful visitor she is) went out together had lunch at Shanley's and Mary went to the Henri School and Dolly over to Brooklyn to see her sister. I took a walk, a dismal chilly gray day, the streets full of slush, that is the workers' home streets. The business thoroughfares are right well cleaned. I wrote to Mrs. Storz, letter of good will, etc. Wrote to The Press. Quoted them $40. each for puzzles, one year. No less time or money. Dolly went to Ex. Com. meeting in evening after dinner at home. She is reelected for another year.... Mrs. Mailly called on me this afternoon after Dolly and M.P. had gone out. She is arranging tableaux for the Rand School benefit, wants my help. Loaned her two books of W. Crane's pictures.

February 2

In evening to Carnegie Hall debate between Emma Goldman and Sol Fieldman. Goldman for direct action and anarchism. Fieldman for "Political Action," Socialism. S.F. got too noisy and ranted too much. Henri and Mrs. H., Dolly and I and George Bellows and wife went to Pabst's afterward–the place swarmed with radicals. Emma Goldman, Fieldman, and henchmen of both. Jack London and wife were pointed out to me by P. Quinlan.

February 4

In the evening went to Republic Theatre and heard a second debate between Emma Goldman and Sol Fieldman. This time Fieldman easily had the best of the argument. Miss G. fell quite flat after the statement of the broad theory of anarchism. She was unable to meet his argument. She attempted distortions of his statements but he effectually nailed all of these. Met Henris afterward with Mr. and Mrs. E. Fuhr. First I had met Mrs. F. She's pretty, dark, small, nervous looking. Bellows also with them. They went into a cafe afterward but Dolly and I walked home up Madison Ave. Nice brisk walk, cold night. . . . In the morning gave Miss Grandin her second lesson in etching.

February 7

Mrs. Bernstein had her second lesson in etching today. She's a nice girl, mother of two children and two adopted ones. Studies art "makes her a better mother and a better artist" she says quite truly. Letter from Yevell of Press says my price is beyond their reach, I'm glad that this puzzle making cup is to pass from me again. In evening to Petitpas' for dinner. Sat at Laubs' table. Griffin there. We had quite amiable talk, keeping off religion. Saw F. King, Yeats, Vizzard. After eight o'clock Dolly and I left. She went up Third Ave. El to a meeting of Exec. Committee S.P. I home and worked on drawings for Collier's.

Pictures back from MacDowell Club ex. There was not a very large attendance I'm afraid but the scheme is being displayed and if only four or five public galleries were open on this same plan the result would be great for the artists and public.

February 8

G. R. Kirkpatrick ("War–What For?") came in and I put in half an hour's work altering drawing for him. He thanked me, thus saving me the embarrassment of refusing compensation for my time!

February 9

Dolly went to Branch One meeting (she is reelected organizer for the year.) Henris called and I entertained them to the best of my ability. Much of our talk is of economic subjects these days.

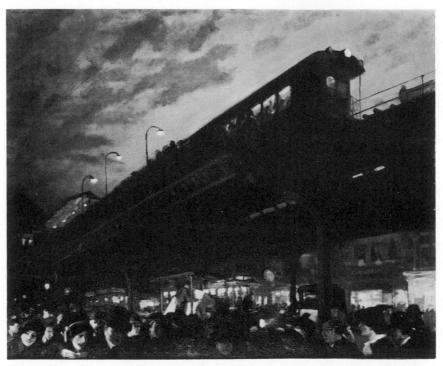

"Six O'clock, Winter," 1912

February 10

Dolly out early to help with the little strikers children from Lawrence,
Mass. Woolen Mills where 22,000 are out. The Fathers and Mothers
speak sixteen languages! The strike is now in charge of Bill Haywood
and the Industrial Workers of the World. Mrs. Malkiel and Dolly
are on a committee of Socialist Party who have been asked to help
with the children. *[Working conditions were very bad in the textile
mills and typical of the sort of social injustice that the Socialists of
that time, mainly intellectuals and humanists not politicians, fought
against. After the strike was won, the following comment on Dolly
Sloan appeared in the New York* Evening Journal *on March 30,
"Mrs. John Sloan, wife of the artist, who has taken great interest in
the Lawrence strike and the welfare of the children, was with the
party, and had provided great baskets of sandwiches, 100 quarts of
milk and many cases of oranges. The children will arrive at Lawrence
late this afternoon, and be met by their victorious parents."]*

600

I went out after starting a picture ("Third Avenue, Six o'clock")
["Six O'clock, Winter," the Phillips Collection, Washington, D.C.]
went to Grand Central Station where I found a huge mob of about
a thousand people—train with children not to come till 6:52 o'clock.
They had missed their train in Boston, some of the "wild Indians"
(Anarchists, I.W.W.'s and Italian Socialists Fed's) made the state-
ment train had been held by a capitalist plot on the N.Y. Central
R.R.! I told one of them he flattered himself. At any rate the parade
of the children down Fifth Avenue as planned was called off. After
a long wait Dolly and I, Mrs. Malkiel, Mrs. MacDonald and Mrs.
Boyalton had lunch in a 42nd St. "Beanery," then more waiting. I
was really sorry I had come except that I felt I must see Dolly
through the event. Train came, mob wild with excitement. Only
about six police. Station porters lined up to take care of the children
(Dolly's idea). Dolly met them inside the gates, marched in a surging
mass around the wan poorly clad little ones to Third Ave. Elevated
up town. I came later as I was only part of the unauthorized mob.
Up to the Labor Temple with Miss Light and Miss Nagle. Met them
in the street. Another fearful jam of people as the Labor Temple
had no room for them. Children were fed and then distributed to
persons who had volunteered to house them till after the strike is
over (all had been investigated). The wild Italian element in the
crowd made things exciting. Anarchists were there in force sneering
at Socialists—they would have been in a fine fix without the Socialist
women as it was fearful—children crying, crowd struggling to get in
the rooms—photographers with flashlights glaring and banging—little
tots and big, oldest about fourteen years.

February 11

Making a cartoon for the Lawrence Strike Edition of the Call. In
the evening went to dinner at Mrs. Malkiel's 141 W. 111th St. En-
joyed the experience. They are Russians (I think Jews though I'm
not certain of this). F. MacDonald, Ed. of the Call and his wife,
Mrs. Marion Lang and others. A large table full and a very good din-
ner. A Suffragette dinner Mrs. M. called it for it was all arranged so
that she could attend a party discussion in the afternoon (Dolly also
attended). After dinner Dr. Ingermann and Mrs. (also Dr. Inger-
mann) and several others came in. . . .

February 12

Painted on the ("Six O'clock, Third Ave.") picture and feel that I have a good one. First I finished the Call cartoon and in the evening about 6 o'clock took it down to the Call office. Saw MacDonald, he liked it. Dolly out all day working on the Strikers' Children committee. She says that the I.W.W. people are very hard to deal with; they seem to intend to use the children to get money for the strike in Lawrence and are most interested in exploiting them in this way. Five children who had been taken by a doctor in Brooklyn and put in his private sanitarium were withdrawn by the I.W.W. man who went to see them! Too much routine to amuse the kids, they kicked. Dolly came home about 10:30 P.M. and had had no dinner. I had made myself a snack about 8:30.

February 13

To the Glackens for dinner, Prestons there. Glack is on a short trip to England or France, back in a few weeks. Pleasant evening. The waste cans on Fifth Avenue are marked "It's against the law to throw litter into the streets–use this can." Think of the Anarchist joy in plunging into the can and scattering the waste over the avenue! Also think the thoughts of the poor slut stout with pups who might read the inscription–

February 14

As Dolly was full of the business of the Strikers' Children I went alone to Orange to a birthday dinner for John Wyatt Davis. Davis I met at the Globe office. We carried between us the big cake in a box.

February 17

In the afternoon late I went to the Arlington Hotel on 8th St. where the new batch of Lawrence Strikers' Children were received and distributed. Dolly was up to her ears in work. She had paraded with them down Fifth Avenue (she got the Parade Permit from the Police after it had been refused to the Italian Federation). They were set eating at three long tables–some were hungry but others hardly took of this orderly repast. A great mob of people eager to "get a child" were waiting in a big room in the basement, and the giving out of

the children was slow. Little boys were in the last remainder and some started to weep feeling that they were not wanted. One batch of three or four girls about ten to thirteen years were taken to Hoboken among others, but not liking the houses prepared for them insisted on returning to New York. By this time all applicants for children had gone so these girls had to be temporarily lodged.

February 18

Painted from myself, a thing I have not done for many years. Dolly out a while in the afternoon but came home and prepared a fine spaghetti dinner for us and she stayed home with me in the evening which we spent together reading.

February 19

Went to Collier's and saw Mr. Stuart Benson the new Art Manager about the "Promoters" article which I am to illustrate for them. Walked about for a couple of hours as I am feeling sort of "grippy." Went on to Macbeth's Gallery–dull lot of boiled art there. Then to Madison Ave. near 40th St. where I saw a collection of pictures in the Neo-Impressionist style by Max Weber. These things are strange, some "passing" strange, but there is fine color in them and they don't leave one with the deadly dull impression that the average lot of paintings does. Something of the beginnings of art in them with more knowing color. A strain from this frenzied blood will get into art of today and make an advance.

February 24

With Henris and Roberts's to Mouquin's where we were guests of the two houses. We had a nice dinner with discussion. Gregg stopped to speak to us. Fangal, ex art editor of G. H. Magazine now illustrating on his own hook. Saw also Von Gottschalk and Mrs. After dinner we walked home to our place and had some beer.

February 25

Miss Sehon posed today but I scraped out and made a quick sketch of her whistling which is not at all important but might better stay than the poor attempt I cut out. In the evening I took quite a long walk while Dolly went to the Woman's Day meeting at the Republic Theatre where she took charge of the collection and sale of book-

lets. Young girls of fifteen and sixteen and a little younger stand on the corners with the boys Sunday evening–a sort of rough and ready love making goes on, something like the play of animals; a smack in the face expresses the warmest regard. The girls are in their best togs and for the most part have solid looking legs. If there be one thin she must be extra fresh and tease cleverly to get on otherwise she is but a hanger on to the "bunch." In the evening a reporter from the American (Hearst's) called to find out what we knew about the Children of the Lawrence Strikers in N.Y.C. Dolly and I had no information for him, said that the children had all been taken into good homes.

February 26

In Lawrence, Mass., Strike Police and Militia prevented by force the sending away to Phila. of the children of strikers. Mothers were there to see the children off by train–the police charged–took children away–clubbed mothers and men who protested. This is a most unpleasant move and should have great results as a storm of protest against this lawlessness has come from all over the country. Dolly out seeing to the children in the afternoon. I worked on plate (sketch of it) *["Anshutz on Anatomy," etching]*–Tom Anshutz delivering his clay muscle talk on anatomy at the N.Y. School of Art, about seven years ago or so.

February 27

We had a nice dinner party this evening. Fitzgerald of the Sun (Gregg sent his regrets!), Mr. Yeats and the Henris. The Roberts's came after dinner, and we had a right decent sort of an evening.

March 2

Printing plate, first proofs not very cheerful. I forget so much between etching periods that I have great trouble with over and under biting. Miss Katharine Anthony called as per arrangement by letter, to look at some of my work. She was a small reddish haired woman, very self possessed and well spoken. I don't know anything of her, she may be a writer. She liked my paintings. Dolly busy all day on the Children of Lawrence which are now much noticed by the newspaper.

604

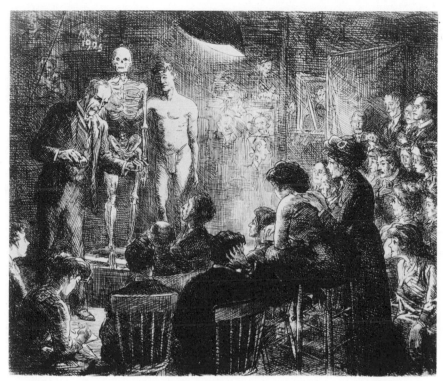

"Anshutz on Anatomy," 1912

There was to be a lot sent down to Phila. today but the scheme was postponed for some reason. Congressman Berger in Washington has some young strikers, boys and girls, before an investigating committee of Congress. The Socialists are using the strike now that it has become famous. It is an Industrial Workers of the World Strike however, and Ettor is still in jail.

March 3

Worked on the Anshutz Lecture plate in the morning. Then we went to dinner at Algernon Lee's up town, 87th St., where we met a college friend of his from Minnesota, named Prof. Galloway. His wife was a pretty woman also from College in Minnesota, a "co-ed." ... After dinner Chas. Edw. Russell and Mrs. R. called. He was nice and kind in his grumpy way. The professor is not a Socialist (they got rid of such at Columbia where he is lecturing). Much of our

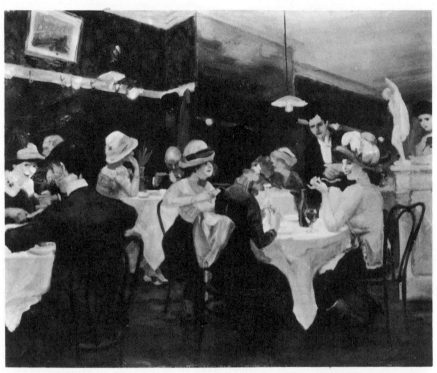

"Renganeschi's Saturday Night," 1912

talk was of the Lawrence strike. C. E. R. don't think it will succeed as the move of the Company offering 5% increase in wages (based on the cut rate!) has been refused and they will lose the public sympathy so easily lost. Worked on my plate again in the evening.

March 4

Worked on plate, great trouble I'm having with it–but I've got a right good portrait (memory) of Tommy Anshutz so I'll stick at the job. Stuart Davis and Glintenkamp called and asked for a picture for a Minnesota State Art Ass. Exhibition. I promised "Recruiting in Public Square." Dolly out on Strike Committee business during the afternoon. Mrs. Henri called to remind me to send money for Mac-Dowell Club dinner but as I can find in the list of members no "Mrs. Ramsay" the name she told me to send the check to, I'll have to let it go for today at least. After dinner worked again on the plate.

March 6

Scraping, polishing, hammering up, printing–struggling with the plate of Anshutz today. Dolly brought in three of the Lawrence children strikers who are on their way back from Washington where there has been for the last three days an investigation of the Strike condition. All three of the girls look rosy and bright eyed–good peasant stock is hard to down. In the evening I went to Henri's and thence with Bellows, Henri and Boardman Robinson, who I met for the first, I went up to Ben Ali Haggin's studio where we talked over a long strip of sketches on the occasion of the MacDowell dinner Sunday. Bellows had a long rough sketch worked out which for some unknown reason is on the subject of the "Durbar" in India. Why they want this subject is beyond my guessing, snobbish? Met Montgomery Flagg the illustrator. . . . Dan Smith, H. B. Eddy. Miss Brinkley was also there.

March 7

"Six O'clock" and "Pigeons" entered for Carnegie Inst. Ex. Sent in blank today. Sent titles and prices to Miss Esther McGroome, State Normal School, West Chester, Pa. "Coburn Players at Columbia College" $750. "Roofs Night" $8.00, "Night Windows" $8.00, "Connoisseurs" $8.00, "Fifth Avenue" $8.00, "Women's Page" $8.00, "Fun One Cent" $8.00, "Memory" $15.00. After sending of the entry of "Six O'clock" for Pittsburgh I got at it and have been painting all over the thing today.

March 8

In the evening with G. O. Hamlin (who is still our roomer for three nights a week) I went to the Branch One meeting to hear Max Eastman talk on Syndicalism. He has a nervous manner but a fund of interesting knowledge of the subject. He started early in the Nineteenth Century and showed the history of French Industrial Unionism. He showed that not for years have the French workers had any faith in the narrow individualistic *Trade* unionism–an important point to make just at the present time when the Socialist Party in the U.S. is so divided on this question. Bill Haywood was there and as he was called upon to speak, rose opening with a rather sarcastic attack on Branch One which I interrupted to resent with great and I

suppose unnecessary heat. Order was finally restored by Bruère's gavel and now I feel rather ashamed of my outbreak. Haywood and I had a friendly understanding afterward. George Hamlin and I went to Singer's afterward, but Dolly went off by herself to the Rand School Ball, where she stayed till 3:30 in the morning. I was sound asleep when she returned.

March 9

A big policeman called after Dolly had gone out this morning–told me her permit to parade was ready at the Central Station for her. Then came a German orchestra leader to see if she'd give him a job in the coming Children's Ball (Lawrence Children). Miss Lou Rogers came to see me, wanted me to take some suffrage Poems by a Miss Bannister to illustrate. Miss Rogers said she was afraid to attempt the work herself. I passed up the job, told her I had not time to attempt it. . . . Dolly's parade of Red flag bearers came off in good shape. A collection in cigar boxes was taken from bystanders along the route. A wildly excited man came to Dolly at Union Square and said he had by mistake contributed a five dollar gold piece. He wanted the boxes opened there, was told to come to Strike Headquarters where he'd be given his money if it was found. He had to go back to work. His story being proved by the finding of a gold piece in the boxes, so after dinner Dolly and I went to the address he gave "A. Goldstein 304 E. 9th St." where the man, foreign accent, middle aged, who answered the bell said there was *no one by that name in the house*–so we came away with the poor man's five dollar piece still in our charge.

March 10

Sent a letter to the address given by A. Goldstein, telling of our effort to find him last evening and asking him to call for his money. During the afternoon I made an attempt at drill on the big drawing scheme for tonight at the MacDowell Club dinner. Finally the dreaded evening arrived. We went to the Fine Arts Building on 57th St. where we dined amidst the for the most part vile pictures of the Nat. Acad. Ex. (An awfully fine small canvas portrait by Thos. Eakins and about three other good things are hung–the T. E. above the line!) Many well dressed women, also many who looked like pros-

608

perous prostitutes, though I don't think that there were any of the actual demimonde there.

Henri backed out of the sketching stunt, phoned Bellows last evening as B. was quite rattled. He had Irving Wiles and J. W. Alexander as substitutes for Shinn and Henri. Seems to me strange that H. should show the white feather. We sat at Mrs. Roberts' table with Mr. and Mrs. Coburn, Bellows (Mrs. B. not well) and Henris. The dinner was very poor indeed, at $3.00 for members and $4.00 for guests per plate. Then came a young violinist child whom the MacD. Club hopes to send abroad to study, after which a blow of a whistle and we the condemned ones dashed to the long strip of paper against the North Wall of the gallery. About sixty-five feet long, and in sixteen minutes it was filled with a heterogeneous lot of drawings purporting to be a representation of the "Durbar." Of course many merely made funny sketches. Art Young did a good one, I think R. H. must have felt a little sorry he didn't go into it, it was so easy. I did not succeed nearly so well in my sketch as I had in rehearsing myself in the afternoon. I made the famine sufferers being hidden from view of the King and Queen by an officer's broad cloak. Montgomery Flagg did the central King and Queen drawing. Luis Mora worked quickly and skilfully and afterward he gave an imitation of a Jap juggler which was wonderful. He danced too. Ruth St. Denis also did a poor sort of comic dance.

March 11

Painted a woman hanging out wash on fire escape. A thing I saw back of us. Rather interesting color I think. Felt good getting at it at any rate. *["Woman's Work," collection of Miss Amelia Elizabeth White, Santa Fe, N.M.]* A. Goldstein called for his $5.00. In the evening Dolly and I met at Petitpas' for dinner. She told me how horribly she had fared at the Hospital for Skin Diseases 2nd Ave. and 15th St. where a young woman superintendent had said that they did not approve of bringing the children from Lawrence (Dolly has two little ones to get in hospital who have developed exzema in bad form). Mr. Yeats was entertaining until after his second small bottle of poor wine—he then becomes a bit querulous. Schenck the jeweler there, came to our table, brought vermouth after dinner. Nice plain, patriotic American—says what we need is a big war!

March 12

Two stories today by mail, a Pirate story from Everybody's and a special article from Collier's–both in a rush! But I painted on my "Wash Day" picture anyhow. It is a rainy day. Dolly out in the afternoon and put in a couple of hours in 14th St. Old Bookstore. Got a copy of Synge's "Riders to the Sea" which I have heard Mr. Yeats read and have wanted to own. A great wonderful work of art. Union Square rainy evening is a beautiful subject. I'll try to paint it some day perhaps.

March 13

Dolly came home with the glad news that the Lawrence Strike is won. All terms as asked. This is a great victory for *Non Trade* Unionism as the Industrial Workers of the World have run the strike. Increase of wage will affect near 300,000 workers in the woolen industry! In the evening Henris came. Geo. Hamlin is here the later day of the week so he and I entertained the Henris.

March 14

"Six O'clock" and "Pigeons" called for by agents of Pittsburgh Inst. Ex. today. Working all day on the drawings for Collier's, having my usual trouble cutting loose in pen work. Dolly out all afternoon. She is working on a Ball and Fair for the Lawrence Strikers which is to be given Monday next.

March 18

Pictures and etchings went to West Chester, Pa., Ex. today. In the evening I went to the Fair and Ball for the Lawrence Strikers Fund. Dolly of course was there. She is taking a great deal of the work of the Committee. Met Mrs. Watson, wife of Wm. S. Watson, one of the members of the Branch. She seems interesting sort. Miss Light was there and Miss Thompson of Branch One. But Socialist Party members were not very plentiful, they look askance on the I.W.W. affairs. I felt sorry that I could not dance. This accomplishment I despised (perhaps thought I did) in my youth, and now in my age–or is it prime–I wish that I had acquired it.

March 21

Worked on start of drawings for Everybody's Pirate story. Dolly out in afternoon on the Strike Committee work. I took a walk which I enjoyed, along the streets nearest East River. It is cold today, snow and sleet entering with gentle spring! Walked as far as 3rd St. and Ave. A. Stopped in and bought some dried mushrooms from an importer's place. . . . Spent the evening at home. G. O. Hamlin is with us still. A delicatessen window, Third Ave., and about 10th St.–fine at evening with night lights and the Jewess proprietoress leaning on the inner edge with all the hams and sausages and her arms.

March 22

Out looking for studio today, I found finally a loft with fine North by West light. Eleventh floor of new triangular building at 4th St. and Sixth Ave. Saw one of the owners, a very nice young Italian, profoundly religious Catholic, romantic poetic religious ideas. Talked Socialism to him! We talked for nearly three hours. He is to see if he can come down to my price for part of the loft ($40.00). His brothers and sisters have to be consulted. If I get the place it will be the most magnificent light I have ever had. Not a thing big enough in the neighborhoood to reflect light. A view across Greenwich Village section of N.Y. I can see the Hudson. Dolly is all for my taking it. Then if Hamlins want to come to N.Y. and share our place (apartment where we are) we can afford the rental. If not, we can give the apartment up in the Fall as Dolly is quite willing to go to a smaller place. Director of the Worcester Museum Ex. called while I was out today. Sorry I missed him.

March 23

As my Italian friend had not come by 11 o'clock I walked down to 4th St. and 6th Ave. looking at studio in the old 10th St. Studio Building where Davey is. But I didn't think it large enough nor light enough compared to the 6th Ave. place. So took Randall Davey with me and he thought the light in the 6th Ave. place fine. I took in two more windows, making the Northwest front (eight windows) about forty-three feet long. It is to be partitioned off with fireproof bricks and the walls painted and the pipes (with electric wire in) covered. I paid a deposit of $25.00. Am to pay two months' rent $65.00 more

611 MARCH 1912

($45.00 a month) when I sign the lease. I feel quite as though I was taking an important step uprooting myself for a new sort of life–working away from home. I do hope Dolly will not feel too lonely during the days–but she has so much Socialist and Industrial Workers work to do that I guess she'll keep in good spirits. Worked on Pirate drawings during latter part of the day. Dolly and I to Central Committee meeting tonight. O'Brien called before dinner. They have a motion to propose from Branch One–to withdraw the Locals' motion to take Haywood off the National Exec. Com.

March 24

Working on the Pirate story illustrations today. In the evening about 9:30 Mr. Yeats came, routed out of his roost by Mr. Quinn who brought him around to see us. We were glad to see Mr. Quinn who takes a very material interest in my work. He told me he had just bought two of my lithographs from the Berlin Photo. Co. (Mr. Birnbaum). I was glad to hear that but surprised that Q. had not known I had some few lithographs. Quinn wanted to buy from me the drawing illustration to De Kock "Madame Dubotte Callé" which I have on the wall in the hall, but I with regret told him I did not want to sell it. The truth of the matter, which I told him, is that it is one of the best drawings I ever made and I could not ask enough for it to compensate me for its absence as a sort of pace setter. I have so few really fine drawings, have made so many inferior things. I said all this except the fact that I couldn't ask enough for it. He very much liked my "Recruiting in a Public Square" picture. It seems strange, as Dolly said to me afterward, I would sell any painting I have made but wouldn't part with the drawing. One of the reasons is that a good drawing is really worth as much and is as dear to me as a painting, but one can't ask nearly so much for it.

March 25

Worked again on the Pirate pictures. In the afternoon I went to see the new place again. Had a talk with the young John C. with whom I have had all dealings. He said he would paint and kalsomine doors and window frames and walls for me; put up electric fixtures and put small irons to hold screens out of the windows–two of them in slight bays get a little sun late in the afternoon. My scheme is to have a shade, upright strip of canvas about fifteen inches wide the height of

the window, to cut off sunlight. My possible landlord walked with me all the way to 23rd St. subway. We talked Socialism vs. Catholicism of course. Dolly went to a meeting of the I.W.W. in the evening after making me a good dinner of rice and mushrooms.

March 26

"Recruiting" (marked $500.00 bargain price) went to Minnesota Art Assoc. Ex. today. Worked on second Pirate picture. Miss Sehon called and told as a great secret that she and her "Si" Felder are to be married in September. She is all eager for wedding presents! and quite frank about it. I could not detect much maidenly hesitancy on the brink of connubial bliss, but she's a nice little girl anyway. I hope she is happy. Dolly went to Woman's Committee meeting in the evening. A vote of three to two decided that they would not accept the invitation of the Women's Suffrage party to parade with them. Idiots!

March 27

Walter Pach writes a postcard from Paris. He says that the art periodical "L'Art et les Artists" have ordered an article from him on my work. They will use five or six photos of paintings and five etchings! This is very pleasant to hear. Went and signed lease for two years on the studio at 4th St. and Sixth Ave. They agree to pay half for my electric fixtures and say I can get in in about a week. In the evening I worked on Pirate illustrations. Dolly went to City Exec. Com. meeting. She is busy making arrangements and getting money to send the Lawrence children home Saturday.

March 28

Geo. Hamlin back from Phila. today. Dolly asked what Mrs. H. had thought of our proposition that they come live with us. He only said it came as a surprise so I guess it's rejected which is as well. Worked on Pirate picture during the day. An interesting man called in the afternoon, John Weichsel. Came to inquire about the proposed sale of pictures for benefit of Lawrence Strike. Not a Socialist, not an Anarchist, but a radical thinker who thinks that none of the movements concern themselves enough with the immediate present. He seems like an opportunist Socialist in some ways. Liked pictures of mine which I showed him very much, and he was a man whose ap-

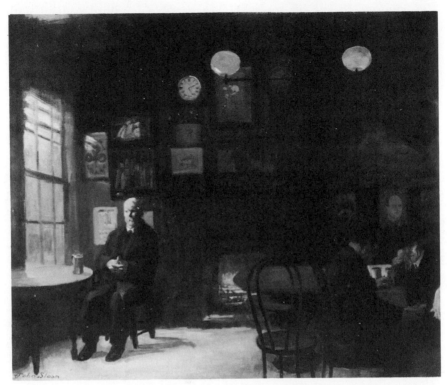

"McSorley's Back Room," 1912

preciation is clearly worth having. After making spaghetti for dinner, Dolly went to a committee (Strike) meeting.

I took a walk as far as McSorley's "old house at home" Tavern on 7th St. Had a glass of ale and walked home. Dolly got home ahead of me about 10:30. [*In 1912 Sloan painted "McSorley's Back Room," now in the Dartmouth College Collection, and "McSorley's Bar," in the Detroit Institute of Art. In 1928 he returned to the subject, a rare thing for Sloan to do, and painted "McSorley's At Home" (1928), "McSorley's Cats" (1929). "McSorley's Saturday Night" was painted in 1929–30, and Sloan worked on it again in 1945.*]

March 29

Wakened early this morning by three delegates from Lawrence who came to see Dolly. She talked to them nearly half an hour, told them

614

that all arrangements were in good shape. After breakfast I finished a sketch portrait of her requested by the New York Call and then walked down to the Call office with it–where I had a talk with Mac-Donald and U. Solomon. Henris called about 10 o'clock en desha-bille, he in his working breeches, she in a kimono or something like it with a long coat over it.

March 30

Dolly got up at 6:30 this morning (and left me in bed). She goes with her 200 or more Lawrence Strikers Children back to Lawrence today. It is a big thing but it's quite clear she is equal to it. During the day small contributions still coming in to pay the expenses of the children. They have been a strong element in this fight–they and the solid stand of the workers, men, women and children workers. I took a walk and sat for a while in Stuyvesant Square where there is a touch of Spring in air and scene. The mothers and babics and sun-light and waking green grass. . . . I went to 84th St. to County Meeting but they had finished up with the perfunctory meeting just to comply with N.Y. Election Laws. Went down to Art Young's studio (met him at 84th St.) and sat a while. Then home.

March 31

Dolly away all day today, but I was kept busy by an unfortunate incident. A Miss L. from Brooklyn who had one of the Lawrence Striker girls, about fifteen years old and her brother seven years– called with her mother (who waited downstairs). She says that the girl has stolen several articles of jewelry from them and one from a neighbor in apartment above them! I took details to Nieri, Italian Soc. Fed. and he scnt a special delivery letter to I'Erossi who is in Lawrence. Dolly had telegraphed that she would be home at 11 P.M. so thought I could not let her know in time to stay over and investi-gate.
Dolly came home at 11 P.M. I met her at the Grand Central Sta-tion. Her account of the fearful poverty of the mill workers in Lawrence is very sad. She feels rather disheartened. Says that rents have gone up and the wage increase is so tiny. Thirty cents to about a dollar per week. Still they have perhaps learned a little of their real power. The children on the train going up kept her busy tending

them but I know that she enjoyed mothering the two hundred of them.

April 1

Worked on Pirate story. Mrs. Davis called in afternoon. Dolly, who had been out winding up her work in Children's Strike committee, came home in time to give us tea. After dinner Dolly's sister Margaret came in. I went to a 25th Assembly and 26th Aldermanic District Committee meeting in the evening at the Rand School. I was chairman. Bruère, Wheat, and a new applicant for party membership were present. Name J. A. Kapp, nice young man. While these meetings are merely held to observe the letter of the State election laws—this had the result of getting a new member for Branch One.

April 2

Worked all day on Pirate pictures. Stuart Davis called. He showed me several remarkable water color drawings of his. Street life and character. Very interesting and good in color, not at all ordinary. I'd like to own some of them, that's how well they suit my fancy. Another District Committee meeting at 112 E. 19, Rand School, this evening. I attended and conducted it. Lee, Wheat, and a nice German Jewish I think, named Wm. Lavine. Got through in an hour and came home and finished up the Pirate drawings.

April 3

Yolande's mother, Mrs. Bugbee called today. Yolande comes by her attractions direct, that's plain. Her mother has of course made use of more of the artifices of the toilette than Yolande found necessary, but still she's fine and dandy to paint. I sent her to Henri with reluctance. I'd rather paint her myself first but I have no decent place to work. And Yolande has married and Dolly was told by Mrs. B. that Yolande is to have a baby, poor girl. Mrs. Bugbee fully agrees with the idea that this wonderful mother love is much of it pure sentimental romance. She has four children but she says she loves only one of them, Yolande. I walked down and delivered to Ray Brown the Pirate story drawings. He liked them ($275.00). Came home, then out again and walked up to Berlin Photo gallery to Hokusai, Japanese, drawings. Some of them very interesting. Stopped in 35 Sixth Ave. *Nothing has been done* on my *studio* there. Went to Pub-

lic Library to see more Japanese work. Prints, very interesting lot. One a mother suckling her child under a netting shield. Very beautiful and unusual. Fifth Ave. all alive this afternoon with brisk well dressed crowd.

April 4

In the afternoon I walked out. Stopped in and had a mug of ale at McSorley's. Heard two men, seemed to be Union Delegates, talking of the emigration problem. "If these foreigners would only go to the farms where they are needed we wouldn't have any need of Socialism." Seemed to me to be a hopeful remark. Scouted around my new building to see how early old Sol strikes the N.W. side of the building where my new place is located.

April 5

Dolly with Miss Light went to Passaic. Two men of the City Exec. with Dolly were appointed to see if they could help by taking children to N.Y.C. Dolly with Miss Light came home about 7 P.M. They say that the strike does not seem to be a good one. Too much interior factional fighting. They are more against Haywood and the Chicago I.W.W. than against the mill owners. The Socialist Labor Party is on the field antagonizing the Socialist Party. I painted "McSorley's Back Room" today and I think I have nearly finished a good thing of it. R. Bruère came in, asked us to come to a box party at the opera this evening but we decided after dinner (Miss Light stayed) that we couldn't make up in time. Mrs. Sumner Boyd came to see Dolly with proposition from Branch Five that Branch One and Five have protest meeting for benefit of Massachusetts strikers.

April 11

Dr. Beale named the day and hour for my teeth to have their filling so Dolly and I are off to Phila. on 2 o'clock train. There arrived, I went at once to Dr. Bower who looked me in the tongue and heard my statement of condition and rather thinks my liver is out of condition. I hoped it was to be more interesting than that. Dolly and I had dinner at Boothby's Oysters. They are so good here in Phila. We went to Fort Washington by the 7:32 train. Dad looks well, so does Bessie. Nan looks thin though that's not unusual with her. We talked together en famille till pretty late for country folk.

April 15

The steamship Titanic, largest vessel afloat, is wrecked on her maiden voyage. Hundreds of lives are probably lost.

April 16

In to the dentist, both Dolly and I and we are finished up. Then we had lunch at a German restaurant Ostendorf's on Market St. We dropped in to see J. Fincken the engraver and had a chat with him. His son has had a nervous breakdown and Fincken is of course very much worried. We went in to the Rathskeller and sat a while, then took 6 o'clock train for New York. The Titanic disaster is the only thing in the news today. Nearly thirteen hundred lives are probably lost. The Campania has some eight hundred survivors on board. Everyone is horrified. There have been more killed in mine disasters in the last three months, but the news has not been so dramatic....

April 17

Dolly went house or rather flat hunting with Elizabeth today–tiresome job. I suffered with dizzy head all day, am taking medicine Dr. Bower gave me in Phila. "Six O'clock" a very good picture and "Pigeons" also good, are rejected by the Carnegie Institute, Pittsburgh. Sad news. Is the exhibition game lost for me? Oh well, I paint them for myself. New issue of "Black Mirror" received today. Many good things said and many I don't agree with. I wonder what connection L. Dabo has with this mysterious publication. I'm sure that the MacDowell Club list of artists is used....

April 19

Made a drawing of two miners talking in a "gallery" of mine over lunch reading news of "Titanic Horror, 1490 lives lost" in a newspaper–one says "The dry land for me, Bill. I always said so and I stick to it!" Seems too good for The Call. I might sell it for money but on second thought I'll give it and get something in the way of an ad. for the Branch One Ball from The Call in exchange. Dolly phoned to meet her at Petitpas'. I did so with Geo. Hamlin. Mr. Yeats there. He is getting deafer which is sad. Such a fine intellect groping for connections in a conversation.

618

From Art Young I got a drawing and with my two took them to the Engraving Co. Promised Monday A.M., cut 3½ inch made for the Branch One "Propaganda Gram" for the Branch Dance. After lunch when Mrs. Hamlin said "good bye"—I went down to the Call office and after a foolish wordy encounter with U. Solomon the Business Manager, I got in exchange for two cartoons the Branch Dance ad for six days. Coming back I meditated over my anger with Solomon, based on his proceeding in re the "Leeches" cartoon and I felt rather frightened at my mental attitude . I have no right toward myself to damage myself by such rages. Stopped in the Old House at Home (McSorley's) and there I heard some English men of the sea talking of the Thames and "Chipside" and still more of syphilis which seems to be in the iceberg class with the salts. In the evening Dolly and I went to see Henri. He has sprained his knee and has lost a week lying about with bandaged knee—he did it playing at Bellows' last Saturday.

April 21

I saw a girl looking out of a window in rooming house opposite and tried to paint her from memory. I don't think I have it yet but will probably go on with it tomorrow. [*"A Window on the Street," the Hamlin Collection, Bowdoin College, Maine.*] Miss Light and Miss Thompson called on Dolly in the P.M. to talk over the Branch Dance affairs. We had spaghetti for dinner. I got an order of Chop Suey from the Chinese restaurant across the street and Dolly cooked the macaroni. It was quite a success. A fine article on the Titanic disaster by Joshua Wanhope in today's Call. Scarcity of life boats—real cause is that each boat means four "seamen." They only had sixty *seamen* in the crew of eight hundred men. More seamen would mean less dividends.

April 24

John Weichsel called in the afternoon and stopped an hour with me. He is a good acquisition to my small acquaintance list. A man of clean life and good mind. I like his interest in my paintings. I drew a cartoon for Il Proletario today, which Dolly took to them and which they were very much pleased with. It is on the recent indictment of

Haywood, Yates, Thompson and others for their Lawrence strike activities. Dolly made a good dish of rice with mushroom sauce for dinner, then she went to the Ex. Com. meeting.

April 26

Dropped in to see Henri. Had a pleasant afternoon with him. His mother is there, looks well. He wants me to go to Monhegan to get my health in better shape. He goes to Spain. Branch One Ball in costume. Dolly pretty in German peasant dress. I in false eyes and nose that's not so pretty. . . .

April 27

. . . Randall Davey . . . liked the pictures which I showed him. He has just had the misfortune of having a full length which he had sent to Pittsburgh Jury rejected—cost him $18.00 to send! The picture a woman in black with a scarf is a good one. . . .

May 1

Beautiful May day weather. Afternoon I walked to Union Square and watched the thousands of Socialists come in from their parade. Saw H. Traubel in the crowd. Got in talk with S.L.P. member. . . .

May 2

The "World" and I suppose all the rest of the capitalist papers have exaggerated to the size of a "riot" the incidents which Dolly *told* me occurred at the Union Square meeting yesterday. Some few, about five silly Italian Anarchists, protested against the American flag on the platform and it brought about a wordy dispute. Finally the flag was removed. The "Call" lies for the Political Socialists and said that it remained. This all happened within thirty feet or so of me and I never knew it. Think of being within a "Rioting mass of Anarchists tearing down the American Emblem" and not knowing it!!

May 10

Moved into my new studio, 35 Sixth Ave. The light is fine, eight windows to the N.W. I get a little sun late in the afternoon but this is not any trouble and in winter, it will be so late that it won't figure at all.

June 3

Worked from "Charlie's" sister, bright snappy brave little Italian miss. She has posed quite some, a couple of years since. I have her engaged for the whole week.

June 4

Henri sailed for Spain today. Dolly saw them off. Miss Boltz of Phila. through Dolly's suggestion, joined the class which numbers twelve. Randall Davey and his bride go also. I went up to the roof of the building and watched the Carpathia sail down the Hudson. Waved a big sheet hoping H. might look my way. I enjoy the great expanse of sky from my windows (on the eleventh floor). Very few big buildings between me and the river.

June 5

An interesting and provoking incident. I discovered that some of the Italians helpers about the building where my studio is located have to gratify a salacious appetite–bored several holes in my studio "walls." Wooden partitions covered with sheet iron–to see the artist and his model! Oh thrilling. Fortunately I'm not given over to giving way to the carnal appetite promiscuously; also I've had no nude pose. And this afternon I have put arras about the walls. Had intended to do so anyway. This cheats the prying eyes and improves the background of my walls.

June 17

A letter from Nan Sloan announces the death of Thomas P. Anshutz the teacher of all of us–Henri, Glackens, Shinn and all the rest–Schofield, Redfield. About thirty years of service, splendid manly service as instructor in the Pennsylvania Academy of Fine Arts. We have heard recently that his highest wages was twenty-five dollars a week. This is less than an organized bricklayer gets! He leaves a widow and son who has just lost four toes in a railway accident. *[After Anshutz' death, Sloan sent a copy of the etching "Anshutz on Anatomy" to Mrs. Anshutz as an expression of sympathy and friendship. On January 4, 1913, she wrote:*

My dear Mr. Sloan,

It was very good of you to send me the beautiful etching. A memorial of a most interesting winter. I took great interest in hunting out the members of the group personally known to me. Whenever Mr. Anshutz came home from one of these trips to New York, he would go over the various incidents of the evening and tell what "Henri said" or "Sloan thought," with such pleasure and interest and always spoke so warmly of the hospitality of "Mrs. Dolly" and the time he was with some of you at the Henri studio for breakfast or some meal prepared by Mrs. Henri (Linda) and Stein, "fair, fat and besides crazy to quote Mr. H.," came in. He spoke of Mrs. Henri's being a "fine cook" to my surprise for I thought she was too ethereal for that.

Well, you all did your best for him and he appreciated it highly. For, when sick, he said all he wanted was "that my friends may love me." And I think they will always remember him with warm affection.

Thanking you so much, with kind regards to Mrs. Sloan and yourself,

VERY SINCERELY
Effie Russell Anshutz]

Had (in years fourteen) Miss Wenzel, to pose today. She is a splendid figure, not little in size.

June 18

Dolly went to Philadelphia and Fort Washington this afternoon to attend Anshutz's funeral tomorrow. I worked again from the nice little maid again. She is beautiful to draw and so clean in her mind, so natural. In the afternoon Dolly dropped in before leaving for Fort Washington. I worked on my Collier's Pirate drawings. Dinner at Chinese Restaurant.

June 19

I worked again from Miss K. Wenzel. Afternoon at the Collier's drawings again. Dinner at the Chinese Restaurant. Dolly came home soon after I got back. She had looked for me at the Italian restaurant on Bleecker St. and had her dinner there. She said the funeral in Ft. Washington was well attended. Fred. Pitz, much older than Anshutz I think, and still hale and hearty, Thouron (Henry D.) and many more.

622

June 21

Worked from model in morning and on Pirate drawings in the afternoon. In the evening we went to Mrs. Hamlin's for dinner. Mr. Yeats the other guest. We had a fine steak and some wine which George got in Reading, Penna. This was very good and had a "personality." I smoked a cigar after dinner! out of compliment to the wine and the occasion! I suppose in another month it will be two years since I ceased the smoking habit, I would have to relearn the habit now.

June 22

Dolly saw Mrs. Lee, Henri's mother, and she has finally accepted our offer to take her as a boarder to help pay our rent and to save her money as well. She is now under large expense at the Martha Washington Hotel. She is nice to get along with as we know by experience and as Dolly is willing to help out by taking on the extra work everything should be much relieved in the expense way. So we will be able to keep our present flat which is quite comfortable.

June 23

In the afternoon I went to the studio and worked on Pirate drawings for Collier's. George Hamlin and Elizabeth called. I took them to the roof whence a fine view of the city can be had. "Skyscrapers" piling up toward the southern end of N.Y. and scattered skyscraping buildings, not quite so much massed toward the North. Down below us we notice on tenement roof (Carmine St.) clever little roof summer houses built by the Italians. Some quite quaintly ornamental with tiny spires and flags and lattices.

June 25

Put in the morning painting from Miss Wenzel. Nice little girl, bad attempt to paint. Afternoon, finished up the Pirate Story drawings and took them to Collier's. Casey liked them, Benson was away. Asked $250.00 for them. Dolly came down and though she had already done hard work canvassing a vote of German Branches at Local Headquarters, she wiped up with mop the whole studio floor and

then we oiled it and it looked fine. We went to the Restaurant Bologna and had Tortellini and Ravioli for dinner. Walked home, stopping a few minutes to listen to the poor but earnest efforts of a speaker talking Industrial Workers of the World to a crowd at University Place and Union Square. Made me wish that I could be inspired, mount the soap box and really state the proposition.

1913

January 1

"Thirteen"–my own lucky number. But this New Year's Day seems to be awry. Up late, for Dolly had been to a Ragged Party at Dr. Halton's (we met her at a tea at Miss X. a few weeks since). I spent New Year's eve at the "night court" in Jefferson Market, the women's court where women are on the basis of their being separate cattle treated "special." One habitual drunkardess pleaded "For the honor of God, Judge, let me go this once!" She repeated this a bit too often, passing the point of effective art. The Judge said "In the cause of justice I give you ten days on the Island." Thus was Justice served!

W. Watson, secretary of our "Masses" Publishing Co. called. I was painting the floor. We talked over a couple of whiskeys. Dolly, who had been up town to Dr. Halton's for some part of her Irish peasant costume forgotten last night, returned. We finished the whiskey. I had dinner at Chinese restaurant, as last night also. Then took a rambling walk and home to bed. A bad day–a black day.

January 2

The second number of "The Masses" since my connection with it (it ran at the expense of Rufus W. Weeks, actuary of the New York Life Insurance Co., Socialist, for eighteen months up to August)–is out and we have turned in the material for the third (February) number. [The Masses (*old*), *for the two years before the outbreak of World War I in August, 1914, was a remarkable, liberal magazine. All of the contributions from artists and writers were made with no thought of payment. Max Eastman, who had been John Dewey's assistant at Columbia University, was invited to become the managing editor at the modest salary of $25 per week, which he had to provide for himself by soliciting money from well-to-do intellectuals who were interested in keeping the magazine going. Sloan at one time offered a "package," one of his city life etchings and a subscription ($1) to The Masses for $2. There were no takers. Articles were written on behalf of women's suffrage, workmen's compensation, safety conditions in the mines and even about that more revolutionary idea, the League of Nations. John D. Rockefeller, Jr. became a subscriber to study the criticisms of his family's business interests. The things he*

627

discovered must have made a deep impression on him and may have had something to do with the development of the Rockefeller Foundation. Both he and Mrs. Rockefeller had great respect for Sloan's integrity. For many years Mrs. Rockefeller answered Sloan's appeals for funds to make up the deficits of the Society of Independent Artists. Mrs. Harry Payne Whitney did also until she had to focus her interest on the support of the Whitney Museum of American Art. This period of collaboration between people from all walks of life for the betterment of working conditions, culture and social justice, is a high moment in American History. Sloan resigned from the art department of The Masses *in the spring of 1916. He felt that his work was being used for political purposes with which he could not agree.]* Dolly is business manager and treasurer of the Company. I'm a stockholder, though I have no shares. (We are trying to take over the concern legally.) From the "Coming Nation" a serial story ("Mexican" by J. K. Turner) to make eight pictures for.

January 3

Mrs. Felder (Miss Katharine Sehon till Sept. last) was to pose but bad rainy weather prevented her coming down. Magraw (W. M. F.) has been with me in the studio since Nov. 14th and is sporadically painting with a view to coming back to Art–having put in the last six years or so in various business schemes. Says he has made money, at any rate rumor gives his wife money. Stopped in to see Glackens after lunch at the Italian Ravioli Restaurant on Bleecker St. Brought Glack to look at loft next to me in 35 Sixth Ave. Large room but perhaps not light enough for him.

Saturday January 4

... Stopped at Siegele's, 96 Bowery, and ordered 4 frames. Deposit $5.00, about $5.00 each. Ernie Grebbs who moved out to California in November gave me the address, said the frames were good as well as cheap. Still living at 61 Perry Street, small old fashioned house, second floor. No modern conveniences. Bought a water tank to keep water heating on the stove. We think we never should have tried to live here, yet I think I like the place; but the discomforts are quite certainly there.

Notices from Association of American Painters and Sculptors of which I am, no thanks to me, a member–continue to come but I can't

feel interested enough to attend the meetings lately. They are going to show what they think "good in art"!

<div align="right">305 MADISON AVENUE
NEW YORK CITY
JANUARY 3, 1912</div>

JOHN SLOAN, ESQUIRE
Dear Sir,

It gives me great pleasure to notify you, that at a recent meeting of "The American Painters and Sculptors," you were elected a member of that Society. The next meeting takes place on Tuesday, January 9th at 8 P.M. at the above address. Kindly favor us with your presence.

<div align="right">RESPECTFULLY YOURS,
Walt Kuhn, Secretary</div>

[The full title of this organization, which organized and exhibited the 1913 International Exhibition of Modern Art (Armory Show) from February 17 to March 15, was the Association of American Painters and Sculptors, Inc. Although the first real discussions which led to the organization of this group and the Armory Show began among the artists who were of Henri's group and their associates, Henri himself was quite opposed to the "modern movement." Sloan, on the other hand, welcomed the showing of these paintings. He said, "The ultra-modern movement is a medicine for the disease of imitating appearances." However, Sloan did not take as active a part in the organization of the Armory Show as he had in previous large group exhibitions because he was very busy with his own work, not quite as interested possibly because of Henri's attitude. He did exhibit two paintings and five etchings in the exhibition. "Sunday, Girls Drying Their Hair," collection of the Addison Gallery of American Art, and "McSorley's Ale House (Bar)," now in the Detroit Institute of Art, were the two paintings. The etchings were "Girl and Beggar," "Mother," "Night Windows," "Anshutz on Anatomy" and "The Picture Buyer."]

January 5

Went to the studio and set my glass palette (Maratta colors of course!) and placed it in my new water pan to prevent drying out of the paint. Henri has been doing this and he says it is working splendidly. As there is no steam in the studio on Sunday I felt the cold

considerably. Magraw dropped in a few minutes. George and Elizabeth Hamlin called in the afternoon and stayed to tea with our dinner. We have, or rather Dolly has, a colored maid. Irene her name, pretty light hued girl–as Dolly is making $20.00 a week at the "Masses" she pays for the "servant." Dolly at Hippodrome meeting in afternoon. Big Garment Makers Strike Meeting. Girl shirtwaist makers waiting to get in break a door! Hurrah for the girls. In the evening Dolly up to the Spargo lecture at Carnegie Lyceum.

January 6

Magraw and I worked from a pretty little model, Miss Polack.

January 7

Frames from Siegele (196 Bowery) came today and I think they will be quite satisfactory and cheap they surely are. An average of about $4.00 each.

January 8

Clifford Addams called in the afternoon. He is reported to be "odd," but I have seen no particular evidence of his oddity. He has been now three times to see me. I think he likes a studio where constant concentrated work is not the religion of the artist. Addams is making a number of plates of American cities, a London publisher has arranged with him to sell them. He is quite an enthusiast about etching, has been doing it about a year or so, recently–though he made some plates during his great master's (J. M. W. Whistler) lifetime. He does not speak much of Whistler to me. It seems strange to hear how much London takes to etchings at this time when here in America they go begging–though some foreigners' work does sell to a considerable extent. Stuart Davis and Glenn Coleman dropped in. Coleman is not drawing or painting much–too bad! He has a great talent but the bread and butter problem takes all his time. Working at night, he has a coat room job in one of the theatres! and runs a small card press in the Five and Ten Cent Store during the day.

January 9

Painted from Miss Polack today–not altogether bad, hopeful. Finished up two drawings for Coming Nation Mexican story and sent them to the engraver's. Dolly up early, 5:30 A.M., to help the Women's Trade

Union League organize the new strike of the waistmakers, girls. She told me when she came home (from a suffrage meeting in Brooklyn where she went to sell "The Masses") that about 15,000 girls went out. There are already nearly 75,000 garment workers out in New York now and they say that there will be 150,000 strikers in town in a week or so!

Magraw is still with me at the studio and I am trying French lessons from Miss Besson the model and teacher. I don't get on much. *[Sloan studied French for a time with a poor little old lady who came to pose for him. He had great compassion for her. She lived poorly, fed stray cats and lived on chopped meat. The Sloans loaned her their apartment for ten days during the summer. While there, she "borrowed" from Sloan's penny collection. She returned it all. Sloan never told her that it was a historical sequence collection from 1871 on.]*

January 10

Miss Sehon, now Mrs. Felder, posed for self and Magraw in the morning. I took her to lunch at the Tortalini place on Bleecker Street. A model engaged by Magraw came for the afternoon session, Miss Wilcomb her name. Large girl, good figure. I got a rather good sketch from her. My palette, which I keep on glass and under water when I'm not using it, is beginning to serve me better than it did.

January 11

... Called in at McSorley's on Seventh Street about 2 o'clock. The sun streams in the front door and window, lighting the sawdust of the floor and here and there the soft and gentle faces of Irish patrons. Thence to Glackens'. He had been working on a lot of rough sketches of his drawing for The Masses. Old chap looking at an undressed show window figure, to be called "The Show Girl." He makes a lot of charcoal sketches preliminary. French lesson in the P.M. 5 o'clock. Sent 2 cuts, 1 × 2 for Mexican story to C.N. by our new institution the "Parcels Post."

January 12

In the afternoon in answer to the bell I hastily wiped the shaving lather off my face and went down to find Max Eastman (editor of

The Masses) and Ida Rauh Eastman his wife. He had rough page proofs of our forthcoming February number of The Masses. These we went over together. They invited Dolly and me to dinner with them and there we went. He showed me a story by young James Hopper, well known short story writer. A good thing of two men in Paris eating live rats! for a franc a day! Dolly went after dinner to Spargo lecture on "Syndicalism" at Carnegie Lyceum. The Eastmans went to see a production of Julius Hopp's theatrical for the "peepul." I took a walk, then came home and worked on a drawing for C.N.

January 13

Finished third installment drawing for the C.N. story. Magraw dropped in for a short while and he and I went to lunch at Ravioli Restaurant. Dolly did not come home to dinner so our Irene made a good stew to which I did full justice—devoured, in other words.

January 14

Drawing in the morning. And an Irishman, short, honest looking, came in and sold me three dozen "pure linen" handkerchiefs for $4.00!!. I don't know linen handkerchiefs from tin ones—at least I didn't when I bought these and more than that—in order to buy, having only a $20.00 bill, I took the clever rascal out and bought him a drink and also myself, to get change. And over and above that though I had suggested that buying a beer would give the necessary chance to get change he ordered whiskey. He couldn't drink beer till after his dinner. And now at the end of the day, Dolly having passed on the handkerchiefs and found them to be barely just what I paid for them—I think I have a faint sprout of knowledge of linen in handkerchiefs.

Miss Polack posed this afternoon. Magraw for some reason did not come down. Had an interesting talk with her. She's eighteen years old, her mother is nervous and has a bad temper, at times beats her! Yet she says "sometimes home is very happy and at any rate any home at all no matter how bad is better for a girl than no home." Told me of her unrequited love for someone, an artist. She writes. Has wish to accomplish something in this art some day. Wants to be married. Knows the world pretty well but is ingenuous at same time. A very interesting young girl but I didn't get much of a sketch. The

632

talk may have been too interesting–but the afternoon was well spent at any rate. Dolly stayed home with me this evening, sewing and darning my socks. She is so often out that I feel overjoyed when she's home an evening.

January 15

Painted again from Miss Polack. Don't seem to get the right hold. In the evening after dinner I went to a meeting of The Masses staff at Art Young's studio (9 East 17th St.). The usual bunch were there except Becker who didn't come. Wm. English Walling, Max Eastman, Chas. Winter and Alice Beach Winter, Mrs. Walling, Turner, Max Endicoff–and "our lawyer" Wm. Karlin. Art Young seemed to be much perturbed as host–not used to it I suppose. Funny old preacher and actor and splendid strong draughtsman he is. Eugene Wood was also there, he adds gayety. Our new (February) number is out and we all felt very good over it. It's coming on in splendid style. Artistically I of course don't thoroughly like some things in it but they add variety and are the very things that some people like. Editorially it is a splendid success with me. I think Max Eastman besides a poet is a brilliant untrammelled thinker. No steam heat in my studio from two to five o'clock in the P.M. No coal they tell me!

January 16

Drawing in the morning. In the afternoon Miss W., the large figure, came to pose. I was entertained by her open attack on the easily taken fortress of Magraw's heart. Perhaps this was not flattering to me but I nonetheless seemed to enjoy it. But I failed to take a hint that I might be so kind as to go out and get her a dill pickle–persisted as chaperone unasked. After the pose a Miss Merrick representing American Art News called and I showed her a few pictures. We had an interesting talk on the subject of the new movement–Matisse and the "neo-Impressionists" and Cubists, etc. I think these a splendid symptom, a bomb under conventions. Some of the painters are nothing but flying splinters imagining themselves highly explosive forces but the explosive force is there–revolution it is. Miss Merrick was much surprised when I told her that I had never yet sold a painting! I suppose I should not have told that fact. Dolly not home at dinner. Out all evening at various meetings.

January 17

Miss Merrick of the American Art News called to look at some of my work. It was after sunset and I unwillingly brought out some things.

January 18

Meeting of The Masses Co. at Art Young's studio . . . Walling, Eastman, Winters, Turner, W. Karlin, H. Brubaker, Eugene Wood, Young and others there. I am to do the next cover. The February number just out seems fine to us—hope we can go on improving.

January 20

In the evening I went to the Ettor, Giovannitti meeting of the Intercollegiate Socialist Society at Carnegie Hall. Behold! on the stage seated to exhibit them the better—forty Sheriffs' Deputies, and Julius Harburger, the Sheriff of the City and County of New York. They had come to see that Ettor nor Giovannitti neither spoke disparagingly of "our" country's flag! Caused by a clever bit of press work during the last few days which brought the meeting to the front in the newspapers. Rumors were spread that Ettor would talk violence and "down with the flag," etc. The sight was disturbing even though it was amusing. It showed that free speech in Free America has shackles forging. Frank Bohn opened his speech by a scathing address to the Sheriffs. Giovannitti talked on "Sabotage," the great bugaboo at present. Said that it amounted to the one weapon of the wage slave which could not be legislated against . . . although . . . the Socialist Party . . . had passed party law against it.

 Joseph Ettor is a tremendously impressive, forceful man. His talk was straight real "Industrial Unionism."

January 21

Magraw and I painted from Miss Polack in the P.M. Budworth called for "Renganeschi's" picture. I sent them to Folsom for it—It goes to the Charcoal Club, Baltimore.

January 23

A friend of Magraw, a playwright, Porter Emerson Browne, called to see him today at the studio. As Mac was not there I entertained

him and got a subscription for The Masses from him. He is bright and interested in pictures. Knows Ed Ashe and other artists of my acquaintance. Bad rainy day, depressing, and I dozed all afternoon, couldn't work. Dolly didn't come home to dinner on account of strike committee meetings, etc. Wrote John Quinn thanking him for his third contribution of $20.00 to The Masses. Sent him this sketch of his name to show that he comes of a seafaring race.

January 26

To see Henri in the evening with Dolly. Looked through some of his play drawings to pick out a couple for The Masses. He has just painted a big full length nude (girl on her toes in a dancing pose), a fine interesting thing. Though as he says the life student sort will say it is "tight" as it has no obvious brush facility.

January 28

In the afternoon at studio Henri came to see pictures and invited as juryman for the Penn. Academy of Fine Arts two pictures: "Sunday in Union Square," "Carmine Theatre."

January 29

Painted with Magraw from Mrs. Harrison. I got a rather good thing in color sense, brilliant rather. To lunch at the ravioli joint on Bleecker St. Then at about 5 o'clock went down town to The Masses office to hand in drawings. (Glackens made a fine thing, Dummy show figure in window on Broadway.)

February 2

Dolly and I spend the day at Cedarhurst, Long Island, with the Wm. English Wallings. A very pleasant time. Kind loving people. Mrs. Walling (Anna) is a splendid type of the Russian Revolutionary blood, full of life and human kindness. Her little sister Rose Strunsky is a sort of elfin beauty. Anna is and has been a literary worker of some importance. The whole family charged with intelligence. The Walling children are fine little ones. Rosamund, about three years old, is a perfect little beauty and she liked me I think–which I regard in this case as a kind of reward or prize. She liked pictures I drew for her, an appreciative public of one. We walked to the beach about

a mile and a half away. Cold brisk day with some wind. Color at the beach fine, gray, orange and blue. Courtenay Lemon was also a guest.

February 11

Mrs. Harrison posed. Magraw did not come down. We went to Ravioli Restaurant for lunch. Coming away I went to see her to the Newark Tube. Then got into a ruction at 10th St. and Sixth Ave. in front of a garment factory where strikers were picketing. Thugs employed by manufacturers–a cheap lawyer–myself. I insisted on going into the building asking for a fictitious firm name, threatened with fisty destruction. . . .

February 12

No heat at the studio and I go over there to fuss about it and get a little bit too much of John Cavenato who is the superintendent and one of the involved owners, a Catholic. . . . Magraw came in and he and I went out and we drank three whiskies which befits the holiday– Lincoln's birthday. Magraw gave me a discourse on my possibilities as an etcher, worldly wise and too true I trow. But I can't follow can I? We are going to move to 240 West 4th St. That's on my mind. And then one number of The Masses follows the other so rapidly I'm busy and doing nothing. I lack energy and with reason.

In the evening, after I had taken a nap, Dolly and I went to the Ravioli Restaurant and then though nearly 9:15 o'clock we went to Glackens' and Dolly talked to Mrs. Glack who had gone to bed early while I passed a pleasant three hours with her wonderful sister, Irene Dimmock, with the basilisk eyes. This finished up the day splendidly. We did not leave till after one o'clock A.M.! Glackens was out at a dinner or some play affair of the Illustrators Society. The time passed so well with fine Jamison high-balls fixed by Miss Dimmock that neither Dolly nor I had an idea how late we were keeping them.

February 13

I painted without Magraw from Mrs. Harrison the blonde "lady from Philadelphia." I have made a head from her which is neither bad nor good. Magraw probably sick. He had been rather ill with a cold for the last three days. Dinner alone with our maid as Dolly phoned that she would not be able to get up to dinner.

636

March 26

John Cavenato showed me check for two hundred and I think forty odd dollars, which he said he had taken on account from the Davis Co. hat manufacturers for rent on three floors in building 35 Sixth Ave. I said that I could not move and vacate my lease unless he built studio on roof for me. He proposed a place in fifth floor. I said it had not enough light. He also proposes to give me an agreement to build me a studio on roof of new building when he has it finished. (It is not even started now.)

March 27

J. Cavenato again took up an hour of my time talking and threatening by some means *[to]* put me out on my lease, it having a "subordinate" clause "fake sale or mortgage." (Mrs. Harrison who was posing for me heard him say he could use this method.) He tells me that the Building Department "practically refused to allow a studio on the roof."

March 29

Stopped in to see the rooms over the bicycle store on Washington Square and they agreed to let me have the front two rooms as far back and including the large side windows to the West for $37.50 per month rent. To start April 15th. I made a deposit of $5.00.

March 30

Saw John B. Cavenato on the roof of 35 Sixth Ave. repairing the water tank with a couple of men helping him (Italians) and there told him that my mind was made up on the terms under which I would give up my lease hold on the 11th floor—namely $500.00 bonus to be paid me before two o'clock tomorrow afternoon.

April 1

J. Cavenato up for the rent. Postponed payment till tomorrow. Proposed to him that I would quit my lease for $350.00 cash immediately, with a week to move in. Also proposed that I would take the 8th floor place same size and position as mine, at a rental of $30.00 per month for one year, with renewal privilege of one year at $35.00 per month. He said he'd see his principals . . . Dolly and I out to

dinner in the evening then to moving picture variety show on 14th St. Stopped afterward at Pabst's Rathskeller 14th St. and had beer. Cabaret show, all the rage in New York now–pathetic rather. Jim Preston agreed to go into group at MacDowell Club.

April 2

John Cavenato in, proposed 8th floor studio $35.00 for first year, renewal privilege at $40.00 second year. I stuck to my offer of $30.00 first year, $35.00 second and there we left it. He said he would let me know definitely by Friday morning. Mrs. R. called in P.M. Out walking with her downtown. Stopped in at 6:30 and got Dolly at The Masses office, then to the World Building and looked at her painting, night City Hall Square and the Woolworth Building, just completed. Right good picture. With Dolly and Mrs. R. to the Ravioli Restaurant on Bleecker St. then home. Left Dolly and with Mrs. R. to her home in Brooklyn where we found Nat Roberts and a Pittsburgh friend, Ridge his name I think.

May 19

Dolly is going to retire from the Business Managership of The Masses, giving place to a dizzy blonde, girl friend of John Reed, who says she has experience. Dolly retains the treasurership of The Masses Publishing Co. She wants to "come back home."

May 20

Mrs. Schindel, wife of Capt. S., U.S. Army, has been working with me at the studio for about a week. I'm showing her "etching." She is a cousin of J. McN. Whistler and in his famous class in Paris some years ago. A good companion she is. Went to Leroy Scott's for dinner and there met English mezzotint artist named Fred Millar, nice man but his wife is a domineering sort of black haired English woman. He subscribed to The Masses and $1.00 to the sustaining fund.

May 21

The Masses is going to move to 91 Greenwich Avenue from 150 Nassau St. I don't think it very good business but it will be more convenient. Mrs. Harrison pretty blonde whom I have had a great deal lately (some months) posed for Mrs. Schindel and me today. We made drawings.

638

CONCLUSION

by Helen Farr Sloan

Sloan's death, ten days after a perfectly successful operation for a small cancer, was a complete mystery to the doctors at the Mary Hitchcock Hospital in Hanover, N.H. Everything before the operation had shown him to be a man in good condition, with remarkable stamina, testing as though younger than a man of sixty even though he was eighty years old.

The last time I heard him teach, Sloan was showing Piero della Francesca's "Resurrection" to the floor nurse: "See how the artist has surpassed himself, done more than he understands. The dignity and nobility of the subject is reflected in the design and drawing of the forms."

Sloan had tremendous nervous stamina. At the age of eighty he thought nothing of sitting up for hours after midnight to work out a double-crostic, and would awake fresh as a twelve-year-old at seven o'clock, full of curiosity about the new day. He was never bored by life, but was naturally bored by some human visitors. At such times he might be endlessly patient, but if he saw that patience was going to be a real waste of time he could cut things short abruptly.

He was fond of small animals, field mice, and chipmunks. Once when Sloan was feeling depressed I called up a laboratory supply house and explained that while I really wanted a chipmunk, I would settle for a white rat who would enjoy being a house pet. The clerk was much amused, and selected a real character, who arrived at the desk of the Hotel Chelsea (where we had an old duplex apartment) and surprised the elevator boy, who thought he was carrying a nice quiet box of cigars to our front door. We made friends with the little creature, who was so dignified, rearing up on his hind legs like an aristocrat viewing the world through opera glasses, that we dubbed him "The Duke."

He liked to climb up Sloan's sleeve, tickling and playfully nipping, like an excited puppy dog. At night, the Duke led his own life in the cage which contained his private possessions and a supply of food. We could

hear him nibbling at his store of dry spaghetti sticks. It sounded exactly as though a skillful typist was at work in the living room. "Writing up my memoirs," Sloan chuckled, the first time we were awakened by the Duke's nightwork.

In July of 1951, we traveled by coach train up the Connecticut Valley to spend the summer in Hanover, N.H., where Sloan's cousin John Sloan Dickey had invited us to feel at home in the community around Dartmouth College. The train was full of irate passengers, annoyed that more tickets had been sold than the number of seats needed at the beginning of the trip. The Duke saved the day for the conductor. All the children in the train established a system of group visits to see the Duke in his shoe box. Sloan was delighted and forgot that he was supposed to be cross about not going to Santa Fe for the summer.

After Sloan had settled in Hanover, and fallen in love with the place, he started to design a new house on a cantilever system to be built over a gulch with a running brook below, from which he could raise water with an Archimedes pump. He reached his eightieth birthday on August 2, 1951, and started a new chapter in his life. He forgot all about the ex-exhibition being planned for the Whitney Museum of American Art and the nuisance of having critics "yapping at his heels," "research people like insects exploring my past." He completely accepted the advice of his old Philadelphia "friendly rival," Maxfield Parrish, who had invited us to call a few days earlier. The men had not seen each other in over fifty years. Bygones were bygones. Parrish had stopped producing pictures long ago, had retired to a beautiful mountain home and taken up his avocation of making fine locks. Looking out over some real estate in the valley, which he planned to acquire, Parrish said, "Sloan, when we reach our age, we must live each day as though we had thirty years ahead of us."

Up in Hanover, we had many pleasant unexpected visitors—old students and new acquaintances brought in by President Dickey. I might come home from market, or carrying a load of art books from the Carpenter Library, to find Sloan at the door simply glowing with joy. "We have visitors!" He was happiest of all when these were the neighbors' children, come to call on him—and the Duke.

I am very happy that I have these memories of John Sloan's last summer—his discovery of a new place to see pictures, his delight in the children who were in and out of the apartment all the time.

The last time I saw him smile radiantly was the day before he went into deep shock, when I brought him the gift of a marigold planted in a tin can. All the lines of suffering disappeared and his face lit up with joy. "Oh, from the children!" And then, "Maybe if I could have some peanut

butter to eat and have the Duke here for company, I might be able to live.... I can't understand why I am dying." This gallantry and good humor left memories for everyone at the hospital and for me.

"He was the last of the Sloans in our line," said President Dickey when my husband died.

On St. Valentine's Day in 1952, I took John Sloan's ashes and scattered them beside the gravestone of his grandfather, John French Sloan, in the cemetery on the high tor above Lock Haven, Pennsylvania. Then I said my prayers alone as I looked out over the Susquehanna River.

A CHRONOLOGY

1871 Born Lock Haven, Pennsylvania, on August 2nd.

1876 Moved to Philadelphia and attended Philadelphia Central High School.

1887 Began work at Porter and Coates, booksellers and fine print dealers.

1888 Taught himself to etch with *The Etcher's Handbook* by Philip Gilbert Hamerton.

1890 Went to work for A. Edward Newton designing novelties, calendars, etc. Joined night freehand drawing class at Spring Garden Institute.

1891 Began as free-lance artist doing novelties, advertisements, lettering certificates and diplomas.

1892 Began work in the Art Department of the Philadelphia *Inquirer*. Shared studio at 705 Walnut Street with Joe Laub. Entered a class (cast drawing) at the Pennsylvania Academy of the Fine Arts under Anshutz. First met Robert Henri through Charles Grafly.

1893 Helped found Charcoal Club, a brief (five months) breakaway from the Academy. With Laub, rented Henri's studio at 806 Walnut Street.

1894 First public recognition of illustrations and poster style came from the *Inland Printer*, a technical magazine, and the *Chicago Chap Book*.

1895 Started to work for the Philadelphia *Press* on the Sunday Supplement staff.

1897 Began to paint seriously, inspired by Henri, mainly portraits.

1898 Began to paint Philadelphia city scenes. Spent a brief trial period in New York but returned to work on the *Press*. Met Anna M. (Dolly) Wall.

1900 Included for the first time in the Pennsylvania Academy Annual. Also exhibited in the Carnegie Institute and the Art Institute of Chicago.

1901 Began first major work in etchings, 53 plates for illustrations for a deluxe edition of the novels of Charles Paul de Kock. Married Anna M. Wall (Dolly) on August 5.

1903 Left Philadelphia *Press* Art Department but continued making "word charade" puzzles for the *Press*, which he continued to do through 1910.

1904 Moved to New York in April.

1905 Began series of ten city-life etchings.

1907 Instructor at the Pittsburgh Art Students League in October, November, until December 6. Mother died August 28.

1908 February, exhibition of the "Eight" at the Macbeth Gallery. In May began to make lithographs.

1909 Met and became friend of John Butler Yeats. Introduced to the Maratta color system by Henri.

1910 April, 1910, Exhibition of Independent Artists. Joined Socialist party.

1911 Beginning of MacDowell Club Exhibitions.

1912 Began as acting art editor of *The Masses*.

643

1913 Represented by two paintings and 5 etchings in the Armory Show. First real sale of painting, NUDE IN THE GREEN SCARF, to Dr. Albert C. Barnes.

1914 Resigned from the Socialist party and stopped contributing to *The Masses*. First summer at Gloucester, Massachusetts.

1915 Received Bronze Medal for an etching at the San Francisco Pan-Pacific International Exposition. First met Mrs. Gertrude Vanderbilt Whitney.

1916 First one-man exhibition at the Whitney Studio January 26 to February 6. Began long-time association with the Kraushaar Gallery. One-man exhibition at Hudson Guild. Taught privately at Gloucester during the summer and then at the Art Students League.

1917 Hung the first exhibition of the Society of Independent Artists at the Grand Central Palace. Father died. First one-man show at Kraushaar's March 19–April 7.

1918 Made president of the Society of Independent Artists.

1919 Trip to Santa Fe, N.M., with Randall Davey.

1920 Bought house in Santa Fe where he spent four months each year except 1933 and 1951.

1921 First sale of a painting to a museum: DUST STORM to the Metropolitan Museum of Art.

1922 Death of John Butler Yeats, his close friend.

1928 Began new technique, underpainting and glazing. Subject matter now includes more single figure pieces.

1929 Elected to the National Institute of Arts and Letters. Substituted tempera for oil underpainting and began using linework superimposed over glazes. Death of Robert Henri.

1930 Received Carroll H. Beck Gold Medal for his VAGIS THE SCULPTOR at the Pennsylvania Academy.

1931 Made honorary member and elected president of the Art Students League.

1932 Joined staff of Ecole d'Arte (Archipenko's School) and taught drawing and painting there until February, 1933. Resigned as president of the Art Students League. President, Exposition of Indian Tribal Arts.

1933 Refused an invitation to Moscow by the American Section of the International Bureau of Revolutionary Artists.

1934 Elected head of the George Luks School by the students and executors and taught there until May, 1935. Treasurer, Artists and Writers Dinner Club.

1935 Returned to Art Students League and continued to teach there until 1937.

1937 Made the plates of the illustrations for Maugham's *Of Human Bondage*.

1938 Retrospective exhibition at the Addison Gallery of American Art.

1941 Testimonial dinner at Petitpas' by the directors of the Society of Independent Artists in celebration of its 25th Anniversary and Sloan's 24th as president.

1942 Received first prize of $500 for the etching, FIFTH AVENUE, 1909, in the exhibition called Artists for Victory. Elected to the Academy of Arts and Letters.

1943 Death of Dolly Sloan on May 4.

1944 Married Helen Farr on February 5, a pupil and long-time friend of the Sloans.

1945 Twenty-two paintings, some etchings and lithographs in the Artists of the Philadelphia Press exhibition at the Philadelphia Museum of Art.

1946 Seventy-fifth Anniversary Exhibition at Dartmouth College.

1948 Retrospective exhibition at the Kraushaar Gallery.

1950 Awarded the Gold Medal for painting by the American Academy of Arts and Letters. Elected to the American Academy of Arts and Sciences.

1951 Died on September 7, after an operation, at Hanover, New Hampshire.

1952 Retrospective Exhibition at the Whitney Museum of American Art, which had been selected before his death.

644

INDEX

648

650

656

657

658